Exploring Visual Design
The Elements and Principles

Teacher's Edition

Contributors

Authors of student text
Joseph A. Gatto, Albert W. Porter, Jack Selleck

Senior Contributing Editor
Kaye Passmore, Notre Dame Academy, Worcester, MA

Senior Art Education Consultant
Eldon Katter

Additional Contributing Editors
Susan Grossberg, Franklin Avenue Middle School,
 Franklin Lakes, NJ
Barbara Levine, Clarkstown High School, New City, NY
Carolyn Peck, Park View Junior High School, Cranston, RI
Abby Remer, A.R. Arts and Cultural Programs, Inc.,
 New York, NY
Richard Shilale, Holy Name Catholic Junior Senior High
 School, Worcester, MA

Copyright © 2000
Davis Publications, Inc.
Worcester, Massachusetts U.S.A.

Publisher: Wyatt Wade
Editorial Director: Helen Ronan
Production Editors: Nancy Bedau, Carol Harley
Manufacturing Coordinator: Jenna Sturgis
Editorial Assistance: Robin Banas, Colleen Strang
Text Editor: Kevin Supples
Copyeditor: Lynn Simon
Design: Douglass Scott, Cathleen Damplo

ISBN: 87192-380-7
10 9 8 7 6 5 4 3 2 1
Printed in the United States of America

Art Education Consultants
Cheryl S. Adams, Quabbin Regional High School, Barre, MA
John Allen, Chicago Public Schools
Candice Anderson, Oakmont Regional High School, Ashburnham, MA
Janet Armentano, Holliston High School, Holliston, MA
Catherine Tacci Beck, Palisades High School, Kintnersville, PA
Sara Behling, Dakota Ridge School, Littleton, CO
Louisa Brown, Atlanta International School, Atlanta, GA
Judy Cassanelli, Leicester High School, Leicester, MA
Diane E. Chisdak, Fleetwood Area High School, Fleetwood, PA
Scott Collins, Marion High School, Marion, SC
Sadie DeVore, Stonington High School, Pawcatuck, CT
Nancy Gallo, Wachusett Regional High School, Holden, MA
Mary Alice Gilley, Asheville High School, Asheville, NC
Jane Higgins, David Prouty High School, Spencer, MA
Marsha Hogue, Lake Highlands High School, Dallas, TX
Tim Hunt, Plano Senior High School, Plano, TX
Cyndy Jensen, Mercer Island High School, Mercer Island, WA
Del Klaustermeier, Dakota Ridge School, Littleton, CO
Angel C. Kuo, Clarkstown High School, New City, NY
Ann Lada, Bartlett High School, Webster, MA
Susan Leavey, Marlboro High School, Marlboro, MA
Jane Lowenstine, Portage High School East, Portage, IN
Sallye Mahan-Cox, James W. Robinson, Jr. Secondary School, Fairfax, VA
Mariana Palmer, Haverford High School, Havertown, PA
June Quill, Nashoba Regional High School, Bolton, MA
Merceda A. Saffron, West Springfield High School, Springfield, VA
Karen Skophammer, Manson Northwest Webster Community School,
 Barnum, IA
Sheila Tetler, West Boylston Middle/High School, West Boylston, MA
Janice L. Truitt, Plano Senior High School, Plano, TX
Ken Vieth, Montgomery High School, Skillman, NJ
Mark Wangberg, Haverford High School, Havertown, PA
Patricia Welch, Shrewsbury High School, Shrewsbury, MA
Sharon Williams Welch, Whittier Regional Technical High School,
 Haverhill, MA
Charleen Wilcox, Wachusett Regional High School, Holden, MA
Tom Williams, Asheville High School, Asheville, NC

Page T-259: Henri de Toulouse-Lautrec, *May Milton,* 1895. Lithograph, 31 ¼"
x 24" (79.5 x 61.3 cm). The Cleveland Museum of Art, Mr. and Mrs. Lewis B.
Williams Collection, 1952.10.

Contents

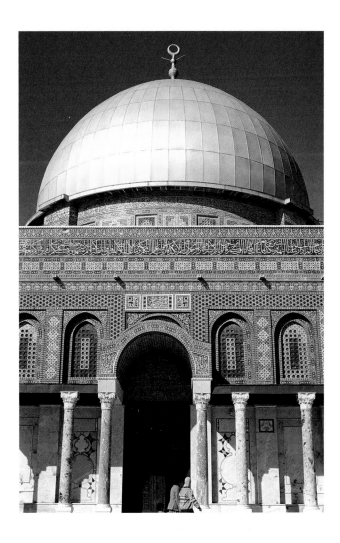

Teach to your strengths.
Teach to their interests.

Chapter Organizers

The comprehensive chapter organizers allow you to scan the entire chapter and map your teaching strategy. Select the topics, activities, and extensions that match your course structure and move easily between chapters to suit your teaching style. You're in complete command with an array of teaching tools that provide opportunities for enrichment and further exploration.

Reflecting a comprehensive (disciplined-based) approach to art, the **chapter objectives** are also correlated to the National Visual Arts Standards.

This quick-check **pacing chart** helps you modify lesson plans to meet your individual time constraints.

This culminating **Studio Experience** provides a manageable hands-on activity that reinforces and extends the chapter's content.

Chapter 4 Organizer
Color

72a

Objective: Students will perceive and identify color properties and harmonies. (Art criticism)
National Standards: 2. Students will use knowledge of structures and functions. (2b)

Chapter Overview
• Color has an important impact on our environment and emotions.
• Artists and designers use color harmonies, varying the value and intensity of hues.

• We perceive color when light
• Some colors seem cool; others

Objective: Students will mix pigments and utilize art color harmonies in their own artworks. (Art production)
National Standards: 1. Students will understand and apply media, techniques, processes. **2.** Students will use knowledge of structures and functions. (2c)

Objective: Students will deve of the use of colors in a variet history/cultures)
National Standards: 4. Stu to history and cultures. (4a)

	8 Weeks	1 Semester	2 Semesters		Student Book Features		Teacher Edition Referen
	1	1	1	**Lesson 1:** The Source of Color	Chapter Opener / The Source of Color, Neutrals	Try it: experiment, About the Artist	Warm-up, HOTS, Conte Connection, Design Exte Internet Connection
	0	0	1	**Lesson 2:** The Properties of Color	Hue, Value, Intensity	Try it: color wheel, Note it, Try it: mixing colors, About the Artwork	HOTS, Design Extens Tip, Performing Arts,
	0	0	1	**Lesson 3:** Color Harmonies	Color Harmonies: analogous	Try it: analogous colors design, The Interaction of Color	HOTS, Context, Inq
	0	0	1	**Lesson 4:** Color Harmonies	Color Harmonies: split-complementary	Try it: color experiment, The Interaction of Color	HOTS, Context, I
	0	0	1	**Lesson 5:** Color Harmonies	Color Harmonies: triadic, monochromatic	Try it: triadic colors design, Discuss it	Design Extensio Learning
	0	0	1	**Lesson 6:** Warm and Cool Colors	Warm and Cool Colors	Note it	Design Extens Connection,
	1	1	1	**Chapter Review**	Another Look at Color	Review Questions	Design Exte

Studio Experience: *Color Harmonies with Pastels*
Objectives: Students will understand that color schemes may be used to create mood or emotion in art; perceive and understand analogous, complementary, split-complementary, triadic, and monochromatic color schemes in artworks; create a pastel painting using a specific color harmony.

National Standard: Students will identify artists' intentions, explore implications of purposes, and justify their analyses of particular arts purposes (5a); create art using organizational structures and functions to solve art problems (2c); conceive/create artworks demonstrating understanding of relationship of their ideas to media, processes, and techniques (1b).

Time
Three
Lesse
colo
Lesse
past

Key Components: Where you need them. When you need them.

This handy reference defines **key vocabulary** and translates the term into Spanish.

Large Reproductions

Two large reproductions per chapter supplement the text and expand your visual options. With teaching strategies on the reverse side these reproductions can be integrated into a lesson or stand alone.

Slides

Six slides per chapter extend the wealth of art and design images available to you. A separate teacher's guide allows you to tie the slides into a lesson or use the slides as a lesson on their own.

Studio Resource Binder

At least five additional "Studio Experiences" per chapter offer alternative hands-on activities for students of varying ability. Full-length interviews from "Career Portfolios" are provided in blackline master format.

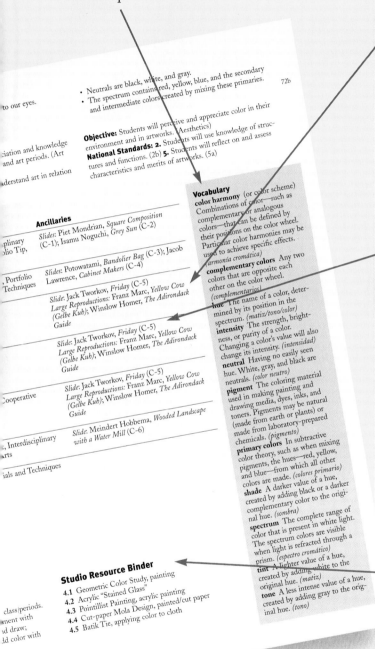

- Neutrals are black, white, and gray.
- The spectrum contains red, yellow, blue, and the secondary and intermediate colors created by mixing these primaries.

72b

to our eyes.

Objective: Students will perceive and appreciate color in their environment and in artworks. (Aesthetics)
National Standards: 2. Students will use knowledge of structures and functions. (2b) **5.** Students will reflect on and assess characteristics and merits of artworks. (5a)

ciation and knowledge
and art periods. (Art

derstand art in relation

Ancillaries

plinary
folio Tip,
Slides: Piet Mondrian, *Square Composition* (C-1); Isamu Noguchi, *Grey Sun* (C-2)

, Portfolio
Techniques
Slides: Potowatami, *Bandolier Bag* (C-3); Jacob Lawrence, *Cabinet Makers* (C-4)

Slide: Jack Tworkov, *Friday* (C-5) *Large Reproductions:* Franz Marc, *Yellow Cow (Gelbe Kuh);* Winslow Homer, *The Adirondack Guide*

Slide: Jack Tworkov, *Friday* (C-5) *Large Reproductions:* Franz Marc, *Yellow Cow (Gelbe Kuh);* Winslow Homer, *The Adirondack Guide*

Cooperative
Slide: Jack Tworkov, *Friday* (C-5) *Large Reproductions:* Franz Marc, *Yellow Cow (Gelbe Kuh);* Winslow Homer, *The Adirondack Guide*

, Interdisciplinary
arts
Slide: Meindert Hobbema, *Wooded Landscape with a Water Mill* (C-6)

ials and Techniques

Studio Resource Binder

4.1 Geometric Color Study, painting
4.2 Acrylic "Stained Glass"
4.3 Pointillist Painting, acrylic painting
4.4 Cut-paper Mola Design, painted/cut paper
4.5 Batik Tie, applying color to cloth

class/periods.
ment with
d draw;
d color with

Vocabulary

color harmony (or color scheme) Combinations of color—such as complementary or analogous colors—that can be defined by their positions on the color wheel. Particular color harmonies may be used to achieve specific effects. *(armonía cromática)*
complementary colors Any two colors that are opposite each other on the color wheel. *(complementarios)*
hue The name of a color, determined by its position in the spectrum. *(matiz/tono/color)*
intensity The strength, brightness, or purity of a color. Changing a color's value will also change its intensity. *(intensidad)*
neutral Having no easily seen hue. White, gray, and black are neutrals. *(color neutro)*
pigment The coloring material used in making painting and drawing media, dyes, inks, and toners. Pigments may be natural (made from earth or plants) or made from laboratory-prepared chemicals. *(pigmento)*
primary colors In subtractive color theory, such as when mixing pigments, the hues—red, yellow, and blue—from which all other colors are made. *(colores primario)*
shade A darker value of a hue, created by adding black or a darker complementary color to the original hue. *(sombra)*
spectrum The complete range of color that is present in white light. The spectrum colors are visible when light is refracted through a prism. *(espectro cromático)*
tint A lighter value of a hue, created by adding white to the original hue. *(matiz)*
tone A less intense value of a hue, created by adding gray to the original hue. *(tono)*

Designed for the way you teach.

Planning Pages

The unique interleaf design of the Teacher's Edition provides concise, at-a-glance lesson plans and full-sized student pages. The initial planning pages (shown below) provide easy to follow step-by-step directions. The annotated student pages (shown on the following spread) provide point-of-use notes that encourage spontaneous exploration and discussion.

Chapter Review

72i

pages 90–91

Assess

• Have students write answers to the review questions, either outside of class or by pairs of students in class. Check students' answers...
any misconc...

Reduced **facsimile pages** provide clear visual links to the student book.

Proven teaching **hints and strategies** are integrated at point-of-use.

Lesson **objectives** tell you clearly and concisely the lesson's instructional aims.

Scripted questions and **in-text page references** provide a structure on which to build.

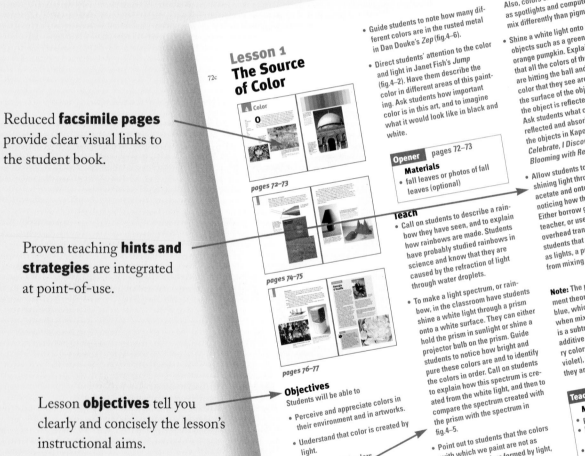

Lesson 1
The Source of Color

72c

pages 72–73

pages 74–75

pages 76–77

Objectives

Students will be able to

• Perceive and appreciate colors in their environment and in artworks.

• Understand that color is created by light.

• Identify neutral colors.

Chapter Opener

• Ask students to look at real fall leaves or the photo of the leaf (fig.4–1) and to describe the colors they see. Encourage students to note the variation within just one leaf, and even the many colors in the predominately brown background of the photo.

• Guide students to note how many different colors are in the rusted metal in Dan Douke's *Zep* (fig.4–6).

• Direct students' attention to the color and light in Janet Fish's *Jump* (fig.4–2). Have them describe the color in different areas of this painting. Ask students how important color is in this art, and to imagine what it would look like in black and white.

Opener pages 72–73

Materials

• fall leaves or photos of fall leaves (optional)

Teach

• Call on students to describe a rainbow they have seen, and to explain how rainbows are made. Students have probably studied rainbows in science and know that they are caused by the refraction of light through water droplets.

• To make a light spectrum, or rainbow, in the classroom have students shine a white light through a prism onto a white surface. They can either hold the prism in sunlight or shine a projector bulb on the prism. Guide students to notice how bright and pure these colors are and to identify the colors in order. Call on students to explain how this spectrum is created from the white light, and then to compare the spectrum created with the prism with the spectrum in fig.4–5.

• Point out to students that the colors with which we paint are not as bright as the colors formed by light, such as those from the prism or on computer monitors. In fact, when graphic artists design on a computer, they must be aware that not all light colors can be reproduced with pigments: some of the colors are so bright that they cannot be printed.

Also, colors created by lights such as spotlights and computer monitors mix differently than pigments do.

• Shine a white light onto colored objects such as a green ball or an orange pumpkin. Explain to students that all the colors of the spectrum are hitting the ball and all except the color that they see are absorbed by the surface of the object. The color of the object is reflected to their eyes. Ask students what colors are reflected and absorbed by each of the objects in Kapoor's *As If to Celebrate, I Discovered a Mountain Blooming with Red Flowers* (fig.4–8).

• Allow students to experiment by shining light through colored gels or acetate and onto various objects, noticing how the colors are altered. Either borrow gels from a drama teacher, or use colored acetates for overhead transparencies. Remind students that these colors are mixed as lights, a process quite different from mixing with pigments.

Note: The primary colors in the pigment theory are red, yellow, and blue, which create a brown color when mixed together. Therefore, this is a subtractive color theory, the primary colors cyan (blue), magenta (red-violet), and green create white when they are mixed together.

Teach pages 74–75

Materials

• prisms
• bright lights (projector bulbs or bright sunlight)
• colored items such as a green ball or orange pumpkin
• colored acetate or gels, several colors per 4 students

Teach: N
• Write the...
chalkbo...
ors they...
trum c...
that bl...
trals a...

• Have...
77. P...
abs...
refl...
abs...
re...
al...

• A...

A list of inexpensive, available **materials** helps you plan.

By addressing different learning styles and abilities these strategies help you **meet individual needs**.

T-7

Direct students to select either an object in their environment or an artwork that employs color in a manner that is especially appealing to them. They should use the color property and harmony names to write a description of this use of color and to explain why they appreciate the colors in this art or object. **(Aesthetics)**

eck color wheels created by students to ascertain whether they derstood how to mix colors. production)

Reteach

• Focus on James Rosenquist's *House of Fire* (fig.4–38), and ask students to name some analogous colors in the painting. (the varying reds of the lipsticks)

• Ask students to select a warm and a cool image from this page. (*House of Fire* is warm, and *Zodiac* [fig.4–40] is c
Re

Meeting Individual Needs

Students Acquiring English

y vocabulary words ard. Integrate lanaving students riptions of objects om. Present useures or formulas bulary; for exam-
... will give

72d

Students with Special Needs

ADD or ADHD

Depending upon the student, use judgment about how and when to distribute materials. For example, distribute only one paint color at a time. Once students are familiar with the materials, gradually provide additional colors for completion of the activity.

Gifted and Talented

• Have students examine the images in this chapter or other visuals that you display. Challenge them to identify and compare and contrast how the various artists used the three qualities of color (hue, value, and intensity) in their artwork.

• Encourage students use colors in a drawing or painting to express moods.

72j

trals on the udents what colfind in the spece prism. Explain , and gray are neuin the spectrum.

o the **Try it** on page at because black light, and does not s known as the lor, whereas white, the light, is the sum of

study the neutrals in *Calico Flower*, fig.4–12, m that O'Keeffe was one a's most famous abstract Challenge them to explain painting might be considabstract. If they do not rememdefinition for abstract art, ould look it up in the glossary.

on the many colors in ffe's painting, and note how as created grayed shadows to cate the form of the flower.

Lesson 2
The Properties of Color

pages 78–79

pages 80–81

pages 82–83

Objectives
Students will be able to

• Identify primary, secondary, and intermediate colors.

• Demonstrate their understanding of how to mix primary hues to form the secondary and intermediate colors and arrange these hues in a color wheel.

• Perceive and identify the color properties of value, tint, shade, tone, and intensity.

• Identify complementary color harmonies in a color wheel and in artworks.

Rachel Legsdin (age 16). *Reaction*. Acrylic, 18" x 14" (45.7 x 35.6 cm). Oakmont Regional High School, Ashburnham, Massachusetts.

Teach: Hue

• After students have read the text on page 78, introduce them to color terms and the mixing of pigments. To model how colors are mixed to create a color wheel, first write the word *hue* on a large sheet of posterboard. Lead students in creating simple, quick color wheels. As you demonstrate, have students do **Try it** on page 79, making their own color wheels. Give each student a small amount of red, blue, and yellow paint. Explain that these are the primary colors, with which they can create all the colors of the pigment spectrum (color wheel).

Demonstrate putting a dot of each primary color on the posterboard, spaced so that you can add the secondary and intermediate colors later. Have students mix the secondary colors by combining two primaries on smaller posterboard with tempera paint. (Alternately, have them mix either watercolor or tempera on heavy paper.)

Demonstrate placing a dot of each secondary color between its primaries. Students can mix the intermediate colors by combining a primary with its neighboring secondary color.

• Write *complementary colors* on the demonstration posterboard. Explain to students that complementary colors are opposite each other on the color wheel. Call on students to list various complementary color schemes, such as red and green, and violet and yellow. Ask them to name the complement of one of the intermediates, such as red-orange. (bluegreen) Have students make a complementary color scheme with two dots of color. Suggest that they look at Grant Wood's *Death on the Ridge Road* (fig.4–15) as an example of a painting with a complementary color scheme: most of the composition is composed of green, but the truck is red.

the
the

n as
t

's

8 Georgia O'Keeffe wanted viewers to notice flowers, both in her paintings and in nature. The size of these flowers might startle viewers, causing them to stop and take a second look.

9 In pointillism the paint is applied to the canvas in small dots or dabs. Georges Seurat is known for his pointillism.

Computer Connection

In a drawing or painting program, guide students to create a color value chart. Create a row of nine rectangles and fill the center one with 50 percent of a chosen color. Fill each rectangle to the right of center with decreasing amounts of the color, at 10 percent intervals. The first will be 40 percent, the next 30 percent, and so on. Fill each rectangle to the left with increasing amounts of the color. Call on one student to print the chart in color, and display the chart. Ask students: Does this chart show tints of a color? (yes, because the white paper adds white to the color) Does it show shades? (no, because no black is added, only color pigment) Which rectangle shows the highest level of intensity? (the 90 percent filled rectangle)

These practical computer activities **give your class a technological edge**.

Samples of student art graphically show the concept discussed.

Designed for the way they learn.

Full-Size Annotated Student Pages

In addition to providing you with a full-size student page, these annotated planning pages highlight individual points of interest allowing you to tailor instruction to your concerns and your students' needs. A menu of easily identifiable icons help you select the teaching tip, learning strategy, or background note that suits you best.

Chapter Warm-up

These observation-oriented activities jump-start every chapter by encouraging students to apply the chapter's content to their own world.

Higher-Order Thinking Skills

Thoughtful questions and ideas for discussion enable you to promote the development of critical and creative thinking.

Cooperative Learning

Designed for pairs or small groups, these activities encourage learning through sharing and collaboration.

Design Extension

Reinforce and personalize the content through hands-on activities.

Color

84

Higher-Order Thinking Skills
Ask students to find other images in this chapter that have analogous color harmonies. They might select Porter's *Soldado Senegales* (fig.4–34) or Kandinsky's *Russian Beauty in a Landscape* (fig.4–36).

Color Harmonies

Have you ever said that certain colors "go well together"? Or that other colors "clash" when placed side by side? When designers and artists use combinations of colors to get certain results, they are using *color harmonies*. You have already read about one example of color harmony: complementary colors. Following are descriptions of other color harmonies that you might see in a design or wish to use in one of your own.

Analogous colors are next to each other on the color wheel. They have a single color in common. Because of this common color, they naturally relate well to each other. Fragonard used analogous colors in *A Young Girl Reading* (fig.4–24). The color group is yellow, yellow-orange, and orange. These analogous colors give a warm and soothing quality to the work. What additional color is shown in the color wheel in fig.4–25?

Another color harmony is *split complementary* (see fig.4–27). This is made up of a color plus the two hues on either side of that color's complement. For example, blue with yellow-orange and red-orange forms a split complementary. Such a combination forms a sharp contrast within a design. In fig.4–26, the blue urn creates a startling contrast to the yellow-orange of the ceiling and red-orange of the floor.

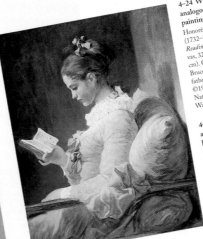

4–24 What are the analogous colors in this painting?
Honoré Fragonard (1732–1806). *A Young Girl Reading*, c. 1776. Oil on canvas, 32" x 25 ½" (81.1 x 64.8 cm). Gift of Mrs. Mellon Bruce in memory of her father, Andrew W. Mellon ©1998 Board of Trustees, National Gallery of Art, Washington, DC.

4–26 Color studies such as this student work heighten our awareness of how color can help create a dynamic environment.
Iza Wojcik (age 17). *Down the Hall*, 1996. Oil on matte board, 18" x 24" (45.7 x 61 cm). Lake Highlands High School, Dallas, Texas.

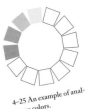

4–25 An example of analogous colors.

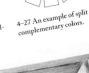

4–27 An example of split complementary colors.

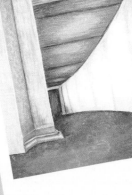

Try it

How many groups of analogous colors can you discover on the color wheel? Make a painting or design, using only analogous colors. You may add black, white, and gray to make shades, tints, and tones.

Interdisciplinary Connections

Integrate the arts across the curriculum with engaging teaching strategies and hands-on activities.

Performing Arts

These insights and background information link the content to dance, drama, or music.

T-9

Context

Spark discussion and encourage a more in-depth understanding with these lively and interesting facts about an artist or work of art.

Portfolio Tips

Help your students polish their portfolio with these practical tips on how to document and present their work.

Internet Connection

Take advantage of today's technology with these Internet tips and ideas.

Materials and Techniques

Extend your artistic repertoire with an up-close look at a specific material or technique.

Inquiry

Promote a comprehensive, in-depth understanding through these timely research projects.

The Interaction of Color

Artist Josef Albers began a study of color in the 1950s called *Homage to the Square*, which he continued to develop until his death in 1976. His series showed that a color can produce unpredictable effects upon the colors in close proximity to it. For example, in this painting, Albers caused three colors to appear as two. The vertical ochre stripe, interrupted by yellow and dark blue stripes, appears to be two squares of different brown hues.

Josef Albers (1888–1976). First plate of *The Interaction of Color*, 1963. Bauhaus-Archiv Museum für Gestaltung, Berlin. ©1999 The Josef and Anni Albers Foundation/ARS, New York.

Context
A Young Girl Reading (fig.4–24) is one of a series of paintings that depicts young girls in peaceful solitude. Fragonard seems to have painted the series on speculation: Parisians at the time were decorating their homes in the late Rococo style, which favored such intimate scenes.

85

Context
Douglas (fig.4–28) was a leading figure of the Harlem Renaissance. From the 1920s to the 1940s, he was the most well-known name in the African-American visual arts.

4–28 Describe the colors used in this work.
Aaron Douglas (1899–1979). *The Creation*, 1935. Oil on masonite, 48" x 36" (121.9 x 91 cm). The Gallery of Art, Howard University, Washington, DC.

Try it
Depending on the color next to it, any color may vary in appearance. Cut a square of bright color from a magazine, or use paint to create a 2" x 2" sample of color. Place this color swatch in different color environments: on darker and lighter solid colors, on neutrals, on patterned paper. Observe how the color appears to change when placed against different environments.

Inquiry
Have students investigate the psychology of color and how color affects people's moods. Some colors make us excited, sad, or happy. For example, the color pink tends to increase feelings of tranquility, an association that has led to using it for prison walls. Studies on personality types and preferences for certain colors indicate, for example, that extroverts tend to prefer red, whereas introverts like grays.

Heads-up Teaching.
Hands-on Learning.

Studio Experience

Reinforce and extend the chapter's content with a manageable, hands-on Studio Experience. Building on the key concepts and studio exercises of each chapter, this culminating studio project stretches students as they express themselves through a range of media and techniques.

A **familiar three-step lesson cycle** — Prepare, Teach, and Assess — allows you to plan your classes quickly and easily.

Samples of **student work** graphically show the scope of the Studio Experience and how a student responded to the activity.

A list of inexpensive, readily-available **materials** help you prepare and plan.

Studio Experience

93a

Color Harmonies with Pastels

Dhavani Badwaik, *Beatle Blues*, 1995. Detail.

Prepare

Time Needed:
Three 45-minute class periods (extend as needed)
Lesson 1:
Experiment with color schemes and draw.
Lessons 2, 3:
Add color with pastels.

Objectives
Students should be able to

- Understand that various color schemes may be used to create mood or emotion in art.

- Perceive and understand analogous, complementary, split-complementary, triadic, and monochromatic color schemes in artworks.

- Create a pastel painting using a specific color harmony.

Materials
- objects such as toy animals, plants, or leaves to draw
- pastels, sets of at least 24 colors
- scrap paper for color experimentation
- 9" x 12" drawing or pastel paper
- tortillons or tissues for blending
- fixatives, both workable and clear acrylic spray

Notes on Materials
- Although pastels may be blended by layering one color on another, students will find this project easier to do with a large selection of colors.

- Soft pastels are easier to blend than hard pastels, but they are also more expensive and create more dust. Hard pastels produce less contrast. Point out to students that a velvety effect can be achieved by steaming or wetting the pastels. Several

brands are rated safe for school use. If any students are allergic to pastel dust, have them wear protective dust masks. Oil pastels, which do not create dust, may be used instead.

- At the end of each work session, the pastel paintings should either be covered with a protective sheet of paper or sprayed with workable fixative or hair spray. Instruct students to read the directions on the fixative container to determine how far to hold the can from their art. Occasionally, a can is not shaken enough or a defective can does not spray smoothly, so students should begin spraying off the edge of the page to check that the can produces a fine mist, not large drops of liquid. Use spray fixatives in a well-ventilated space, or outdoors.

Before You Start
- Students could do the initial drawing of objects in an earlier lesson on line; or they could do the preparatory sketches as homework.

- If students are to draw the objects in class, either you and/or students should collect interesting items beforehand.

Teach

Thinking Critically
Take a look. Ask students to look again at the art in select one artwork and notice how the color contributes to the emotion. Ask students to imagine what music wou go with this painting. Have them wri a list of words describing the mood the artwork, and ask how it would change if the colors were changed instance, from a bright to a pale scheme, or from cool to warm.

Clas
- Fo
w
o

Proven teaching **tips and strategies** are provided at point-of-use.

Student artwork from chapters 9, 10, and 11.

93b

anagement

it, have students ative-learning groups ch student analyzing work, and the entire a chart of the ques- wers. Ask each group painting with the most st) color intensity.

ents in the cooperative- oups to check one abeling of color schemes ampler before having it by you.

e that the paintings will prob- e very realistic. The mood of should override considera- ealism.

sess

luation

r students complete the paintings, e them evaluate their art with ther student, or write an evaluation the project, using the questions in eck it as a guide.

Extend

Meeting Individual Needs

Challenge
• Have students create three paintings of the same subject, each in a differ- ent, specific color harmony.

• Ask students to look through the text and identify another image of each color harmony. Direct students to make their own interpretation of one of the images by creating a painting using the complements of those in the image. For example, if a red apple had violet shadows, the stu- dent's painting would be a green apple with yellow shadows.

Simplify
• Have students add color to the contour drawings with markers instead of pastels. To identify color harmonies, students set out only the colors that comprise their color scheme.

• Assign one color harmony.

Linking Design Elements and Principles

Shape
Direct students' attention to the shapes that they create as they overlap the objects in their drawing. Point out to them that the shapes formed around their objects become negative space or shapes.

Emphasis
Discuss with students different ways to emphasize a part of their composi- tion. Suggest that they create a strong contrast of either color or value to emphasize one section of their paint- ing. Point out that overlapping the shapes near the center of the picture will probably create a center of interest.

Interdisciplinary Connections

Chemistry
Ask students to read a chemistry text- book to learn which colors are pro- duced as chemical precipitates and in specific chemical flame tests. Discover which colors are associated with cer- tain elements. For example, cobalt is associated with blue, sulfur with yel- low, iron with red, and copper with green.

Physics
Hold a prism in front of a white light so as to separate the light into the colors of the rainbow. Display the spectrum on a piece of white paper. Instruct stu- dents to notice the relationship of the positions of the colors, and to compare these positions to the placement of colors on a color wheel.

Technology
Direct students to research the differ- ence between additive colors and sub- tractive colors. Ask students to use a color monitor and a drawing program such as Adobe Illustrator™ or Freehand™ to find colors in a computer color-selection palette that cannot be duplicated with paint or printed with ink. The very intense shades of magen- ta and green are dependent on more light than is possible to mix into an opaque paint.

Inquiry
Have students research artists (such as Matisse, Derain, Gauguin, and van Gogh) associated with nontraditional uses of color to discover how critics reacted to their paintings. (Critics were so shocked by Matisse's and Derain's explosive use of color that they described the gallery where their art was shown in 1905 as a "wild beast's cage." *Fauve* means "wild beast," so their art became known as Fauvism.)

Extension strategies help you tailor your instruction to meet individual needs.

Interdisciplinary Connections seamlessly integrate the arts across the curriculum.

Don't Miss Your Professional Handbook and Resource Guide

• Career Resources
• Portfolio Planning
• Alternative Resources and Supplies
• Professional Articles
• Safety in the Classroom
• Art Materials Chart
• Art Suppliers
• Spanish Glossary
• National Visual Arts Standards

Scope and Sequence

National Visual Arts Standards	Discipline-based Content	
	Art Criticism and Evaluation	
2 Students will use knowledge of structures and functions.	Design Element or Principle	Line
5 Students will reflect upon and assess the characteristics and merits of their work and the work of other artists.	description analysis expressive technical interpretation judgement	Line types: structural, outlines, contour, gesture, sketch, calligraphy Line personality Line quality Line as pattern Line combinations
	Creative Studio Experience	
1 Students will understand and apply media, techniques, processes. **2** Students will use knowledge of structures and functions. **3** Students will choose and evaluate a range of subject matter, symbols, and ideas.	Featured studio experience art forms, media skills, processes, inspiration sources, design skills	Wire sculptures from gesture drawings inspired by Calder and Dali, using line movement.
	Try it studio experiences in student text	Contour drawing Line as pattern using various media
	Teach studio experiences in teacher edition	Letter names with calligraphic lines with pencil or markers
	Other studio projects	Brush and ink lines Draw to music
	Art History/Cultures	
4 Students will understand art in relation to history and cultures.	Non-western cultures	New Guinea *barkcloth*, Turkish *tughra*, Maori *house front panels*, Japanese Hakuin, Aboriginal *Tjampijinpa*
	Western art styles/periods	Surrealism, Impressionism, Art Nouveau, Renaissance
	Works of western artists and styles 2-D drawings, paintings, graphics	Shahn, Dali, van Gogh, Sage, Schiele, Tintoretto, Wyeth, Durer, Tenniel, contemporary artists
	photography	Cunningham, contemporary artists
	3-D sculpture	Calder, contemporary artists
	crafts, environmental arts	Stepanova *textile design*
	architecture	*Eiffel Tower*, Wright *Falling Water*, Greene and Greene *Gamble House*
	Aesthetic Perceptions/Responses	
5 Students will reflect upon and assess the characteristics and merits of their work and the work of other artists.		Discuss lines in the environment, nature and art.
	Links to other Disciplines	
6 Students will connect visual arts with other disciplines.		Performing arts: Drama, Dance; Literature; Mathematics
	Careers	
		Cartoonist

Shape and Form	Value	Color
Categories of shapes: geometric and organic, curved and angular, positive and negative Qualities of shape: light and heavy, smooth and textured, static and dynamic Form and Light	Using value in a design Light and dark values Value contrast	The source of color Neutrals The properties of color: hue, value, intensity Color harmonies: analogous, split complimentary, triadic, monochromatic Warm and cool colors
Create paper collage with positive/negative, and organic/geometric, shapes. Study art of Matisse and Demuth.	Draw still life using charcoal and white conte crayon emphasizing a range of values. Study art of Chardin.	Create pastel painting using a color harmony. Study art of Wood, Douglas, Feininger, Karaja, and Rosenquist.
Draw angular and geometric shapes Cut paper positive/negative shape collage Still life painting or drawing: shapes Drawings/sculptures: heavy/light forms Pencil or crayon texture rubbings Static and dynamic sculptures Paper collage: vertical/horizontal shapes Shadow designs: black and white media	Pencil, charcoal, or crayon value charts Magazine print value charts Pencil drawings of a white and a dark object Magazine print value collage Value study with black, white and gray papers	Create a color wheel with paint Experiment with mixing colors Colors in various environments: collage or painting Triadic color harmony design (collage, markers, or paint)
		Experiment with light and color Split-complementary design Magazine collage of warm and cool colors
	Ink wash painting Mixed-media painting	
Minoan octopus vase, Pre-columbian *urn*, Popayán *pendant*, Egyptian *Hippopotamus and Colossi of Ramses*, Japanese Sharaku *woodcut*	Byzantine, *Christ, Deesis*, mosaic, Hagia Sophia, Istanbul	Islamic *Dome of the Rock*, Jerusalem; Panama (Cuna People) *Child's Blouse*; Amazon *Lori-lori headdress*; African (Baule) *Raffia work*
Cubism, Minimalism, Surrealism, Pop art, Impressionism, American Realism	Rococo, Surrealism, American Realism, Impressionism, Baroque	Minimalism, Photorealism, Realism, Impressionism, Post-impressionism, Rococo, Expressionism, Cubism
Miro, **Lawrence**, Moran, Desmuth, Monet, Matisse	Chardin, Matta, Sargent, Morandi, Morisot, Church, Antunez, Whistler, La Tour	Fish, Kelly, **O'Keeffe**, Wood, Eakins, **Seurat**, Fragonard, de Kooning, Feininger, Kandinsky, Rosenquist, Albers, Degas
Atkins, contemporary artists	Adams, Browning	Schulthess, contemporary artists
Smith, Botero, **Oppenheim**, Nam June Paik, de Rivera, Indiana	**Nevelson**	Kapoor, contemporary artists
Sky's the Limit, Chicago		
St. Francis of Assisi, Ranchos de Taos; Portman, *Bonaventure Hotel*, Los Angeles		Chartres, *stained glass window*
Imagine selecting artistic shapes and forms for a museum.	Discuss precepts of Baroque, Surrealist, and Realist art.	Write description of environmental or artwork color.
Science, Performing arts, Literature	Performing arts, Science, Literature	Science, Social studies, Performing arts, Language arts
Type designer	Cartographer	Art therapist

T-14

National Visual Arts Standards	**Discipline-based Content**	
	Art Criticism and Evaluation	
2 Students will use knowledge of structures and functions.	Design Element or Principle	Space
5 Students will reflect upon and assess the characteristics and merits of their work and the work of other artists.	description analysis expressive technical interpretation judgement	Two-dimensional space: positive and negative space; picture plane; composition; point of view Illusion of depth: nonlinear methods; linear perspective Subjective space: space that deceives; Cubism; abstract/non-representational
	Creative Studio Experience	
1 Students will understand and apply media, techniques, processes.	Featured studio experience art forms, media skills, processes, inspiration sources, design skills	Form clay sculpture using negative space inspired by Mayan sculptures, Houser, Goodacre, Pfaff, and Noguchi.
2 Students will use knowledge of structures and functions. **3** Students will choose and evaluate a range of subject matter, symbols, and ideas.	**Try it** studio experiences in student text	Collage from cut magazine photo Draw object from unusual angle Cut paper collage with depth illusions Draw linear perspective lines on photo Cubist drawing: combine views of object Outline drawing of overlapped objects Cut paper collage: color indicates depth
	Teach studio experiences in teacher edition	Clay sculptures with flowing space Perspective marker drawing on acetate Subjective space drawing
	Other studio projects	
	Art History/Cultures	
4 Students will understand art in relation to history and cultures.	Non-western cultures	Chinese fan painting, Persian *Meeting of the Theologians;* Mayan *Model of a ball game*
	Western art styles/periods	Renaissance, Cubism, Surrealism, Op Art, Medieval, Impressionism
	Works of western artists and styles 2-D drawings, paintings, graphics	Mantegna, Canaletto, Crockwell, Kertész, De Chirico, Masaccio, Magritte, Gris, Braque, Dove, Vasarely, Houser, Escher, Caillebotte
	photography	Eisenstaedt, Weegee
	3-D sculpture	Hepworth, **Moore**, Mills, Pfaff, Goodacre, van Gogh, Bell, **Picasso**, Ferren
	crafts, environmental arts	
	architecture	Noguchi, *California Scenario,* Costa Mesa, California; Revell, *Ontario Civic Center;* Johnson, *Glass House; Getty Villa*
	Aesthetic Perceptions/Responses	
5 Students will reflect upon and assess the characteristics and merits of their work and the work of other artists.		Select and discuss works which utilize space as specific artists did and also which conveys mood or message.
	Links to other Disciplines	
6 Students will connect visual arts with other disciplines.		Performing arts: Dance, Music; History; Mathematics/geometry
	Careers	
		Architect

Texture	Balance	Unity
Surface qualities: real and implied textures Texture and light Artists' use of texture in 2- and 3-dimensional arts Texture in your environment	Symmetrical balance Approximate symmetry Asymmetrical balance Radial balance	Dominance Repitition of visual units Use of color to create unity Surface quality
Create a textured, coiled basket inspired by Native American baskets and the art of Eckert.	Create a balanced drawing; develop into a painting. Study a Gothic window, a mask, and art by Close and Calder.	Create a painting demonstrating unity. Study art by Kelly, Stella, and Noguchi.
Implied texture landscape collage	Symmetrical cut paper design Mobile of assorted media	Analogous color landscape (markers, colored pencils, or paint) Artwork with unified surface texture (various media)
Pencil or crayon rubbings of textures Textured clay tiles Photograph or sketch local textures		Expressionist line drawing
	Sketch radially symmetrical objects	
Chinese, Qing *incense burner*; Navajo *saddle blanket*; Guatemalan *woven belt*; Austral Islands *fly whisk*	Indian, **Taj Mahal**; African, Ivory Coast, *mask*; Pueblo, Martinez, *Plate*; Alaskan, Tlingit, *robe*; Japanese, Sotatsu, *scroll, The Zen Priest Choka*	Peruvian, Nasca, *tunic*
Pop art, Realism, Cubism, Baroque, Renaissance, Abstract Expressionism, Art Nouveau	Pop art, De Stijl, Gothic, Photorealism	Minimalism, Expressionism, Op art, Impressionism, Post-impressionism
Alma-Tadema, Man Ray, Still, **Vermeer**, Desiderio, Schmidt-Rottluff, Frankenthaler, Audubon	Katz, **Mondrian,** Close, Estes	Mackintosh, Wilson, Kelly, **Kollwitz,** Stella, Degas, Cézanne
contemporary artists	Tanqueray, Newman	
Hanson	Calder	**Noguchi**, Lipchitz
	Stained glass window, cathedral of St.Maurice	Newcomb Pottery, New Orleans, Louisiana
Ellis Island, *Main Building*; **Gaudí,** *Güell Park*	Graves, *Portland Public Services Building*, Gehry, *Nationale-Nederlanden Building*, Prague	Meier, *Getty Museum*
Students select and discuss examples of excellent use of texture in artworks.	Explain why they used particular types of balance in their artworks.	Discuss examples of unity in art and environment and why artists create unity in their works.
Geology/earth science, Performing arts, Biology/psychology	Performing arts, Mathematics, Geometry, Biology	Performing arts, Social studies
Weaver	Web-site designer	Gallery owner

National Visual Arts Standards	**Discipline-based Content**	
	Art Criticism and Evaluation	
2 Students will use knowledge of structures and functions.	Design Element or Principle	Contrast
5 Students will reflect upon and assess the characteristics and merits of their work and the work of other artists.	description analysis expressive technical interpretation judgement	Contrasts of: line shape, form, and size dark and light color texture time, style, and ideas
	Creative Studio Experience	
1 Students will understand and apply media, techniques, processes.	Featured studio experience art forms, media skills, processes inspiration sources design skills	Create a Pop-art sculpture emphasizing a contrast of size. Study art by Segal and Oldenburg.
2 Students will use knowledge of structures and functions. **3** Students will choose and evaluate a range of subject matter, symbols, and ideas.	**Try it** studio experiences in student text	Collage or sculpture of found objects contrasting elements Add value contrasts to a photograph Painting using color contrasts
	Teach studio experiences in teacher edition	Ink wash self-portraits Magazine collage with shape contrasts Collaborative installation/sculpture
	Other studio projects	
	Art History/Cultures	
4 Students will understand art in relation to history and cultures.	Non-western cultures	African (Kuba) *mask*, Mbuti, Nigerian, *Bark cloth*; Benin culture ***Warrior and Attendants***; Native American,*Cliff Palace*; Spanish,*Court of the Lions*
	Western art styles/periods	Baroque, Renaissance, Realism
	Works of western artists and styles 2-D drawings, paintings, graphics	Metsu, Leonardo da Vinci, Rembrandt, **Bonheur**, Neel, Klee
	photography	Käsebier, White
	3-D sculpture	Segal, Oldenburg
	crafts, environmental arts	Christo and Jeanne-Claude
	architecture	Pei, *Louvre Pyramid*
	Aesthetic Perceptions/Responses	
5 Students will reflect upon and assess the characteristics and merits of their work and the work of other artists.		Sort student work according to contrasts. Consider contrasts in art and environment.
	Links to other Disciplines	
6 Students will connect visual arts with other disciplines.		Performing arts, Language arts, Music
	Careers	
		Industrial designer

10 Emphasis	11 Pattern	12 Movement and Rhythm
Emphasis	Pattern	Movement and Rhythm
Emphasizing one element of design: Line, or shape and form; Value, color, space, or texture. Using simplicity. Using placement and grouping. Using size and repetition	Patterns in nature. Patterns in manufactured designs. Basic types of planned patterns: rows, grids, half-drop, alternating, radial, borders and bands. Random patterns	Actual movement. Recorded action. Compositional movement in three- and two-dimensional art. Types of rhythms: regular, flowing, alternating, progressive, unexpected
Create a photomontage of magazine images that emphasizes one center of interest. Study art of Jess, Coe, and Rosenquist.	Draw natural patterns, develop one into linoleum-block to print repeat patterns. Study patterns in nature and in art of Ringgold and Lockwood, and Islamic ceramic tile.	Draw action sequence comic strip. Develop one frame into acrylic painting with compositional movement. Art examples by Schapiro, de Brunhoff, and Lichtenstein.
Sketch and write description of nature objects. Depict one subject in three different media. Magazine collage exploring simplification of background	Design a patterned object. Natural and manufactured object prints. Draw grid pattern. Create 3-D grid pattern. Print in half-drop or alternating patterns. Draw radial design. Create random and planned pattern designs	Construct a mobile showing movement. Create overlapping figure drawings with markers. Paint or draw patterns with compositional rhythm. Experiment with various media to musical rhythms
Illustrate emphasis. Installation or collage altering scale. Cut paper repeated shapes collage	Stamp repeat patterns with nature objects into clay tiles. Design a band or stripe for a vehicle	Make strokes to the beat of music. Create a series showing a metamorphosis.
		Create an animated sequence on film
African, Nigeria, *Woman's Shawl*; Chinese, *Bowl*; Chinese, **Wang Yani**, *A Happy Episode*; Japanese, Ogata Korin, *Cranes*; Cooke Islands, *Ina and the Shark*	Native American *pot*, Navajo **Beeldlei**, Indonesian *batik*, Persian (Iran), *ceramic tile wall*	African, Zimbabwe, Kamangira, *Elder Wrapped in Blanket*
Minimalism, Romanticism, Renaissance	Art Nouveau, Pop art, Secessionist, Renaissance, Celtic	Baroque, Gothic, Minimalism, Cubism, Pop art, Ancient Greece
Castanis, Jess, Kelly, Gericault, Coe, Piero della Francesca, Ruiz	Ringgold, Warhol, Andri, Roszak, **Michelangelo**, *Campidoglio pavement*, *Book of Kells*	Schapiro, **Hals**, de Brunhoff, **Matisse**, Thiebaud, Biggers, Lichtenstein, Smith
Park, *Wallace and Gromit*; Lange; Weston	Abbott, Lockwood	*Tin Toy*; Edgerton, Sherman
Robus, Giacometti, **Ahearn**	Winsor, Abakonowicz	Le Parc, *Nike of Samothrace*, Houser, Stella, Judd, *Jockey from Artemisium*, Smith, Bernini
Turrell	Tiffany, Dedham Pottery	Nauman
Lin, *Vietnam Veterans Memorial*; Athens, *Acropolis*	Rodia, *Watts Tower*	Kahn, *Kimbell Art Museum*, Ft. Worth; *Salisbury Cathedral*; Graves, *Library*
Discuss the differences and similarities between art and architecture.	Identify and describe natural and manufactured patterns. Research art incorporating these patterns.	Discuss how beliefs and values in various cultures have influenced art and architecture
Mathematics/geometry, Literature, Performing arts	Performing arts, Mathematics, Science	Performing arts, Music, Literature
Photojournalist	Fabric designer	Storyboard illustrator

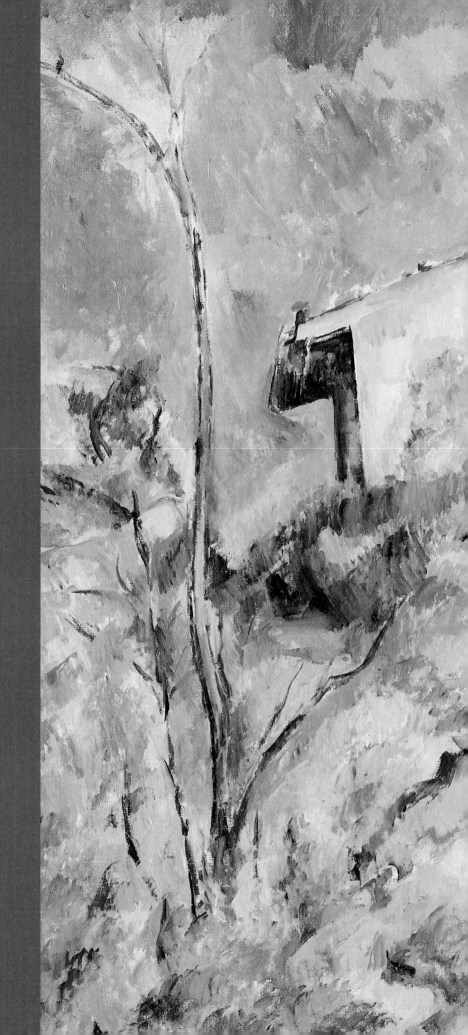

Davis Publications, Inc.
Worcester Massachusetts

Exploring Visual Design

The Elements and Principles

Third Edition

Joseph A. Gatto • Albert W. Porter • Jack Selleck

For Bryan, Jennifer, and Glenn

For Sean and Lara

Cover: Michael Hayden. *Sky's the Limit,* 1987. Neon tubes and mirrors, controlled by computers with synchronized music, 744' long (226.8 m). United Airlines Terminals, O'Hare International Airport, Chicago. Courtesy of United Airlines. Digitally enhanced photograph.

Title page spread: Paul Cézanne, *Maison Maria with a View of Château Noir,* c. 1895–98. Oil on canvas, 25 ⅝" x 31 ⅞" (65 x 81 cm). Acquired in 1982. Kimbell Art Museum, Fort Worth, Texas. Photo by Michael Bodycomb.

Facing page: Maya Lin, *Civil Rights Monument* c. 1989. Southern Poverty Law Center, Montgomery, Alabama. Black granite, 138" (350.5 cm) diameter, 31" (78.7 cm) high. Courtesy of the artist and Gagosian Gallery. Photo by John O'Hagan.

Publisher: Wyatt Wade
Editorial Director: Helen Ronan
Production Editors: Nancy Bedau, Carol Harley
Manufacturing Coordinator: Jenna Sturgis
Editorial Assistance: Robin Banas, Colleen Strang
Copyeditor: Lynn Simon
Text Editor: Kevin Supples
Design: Douglass Scott, Cathleen Damplo

Library of Congress Catalog Card Number: 98-73425
ISBN: 87192-379-3
10 9 8 7 6 5 4 3 2 1
Printed in the United States of America

We are connected to one another through time by our creations, works, images, thoughts and writings. We communicate to future generations what we are, what we have been, hopefully influencing for the better what we will become.

MAYA LIN, ARCHITECT

DESIGNER, CIVIL RIGHTS MEMORIAL

Contents

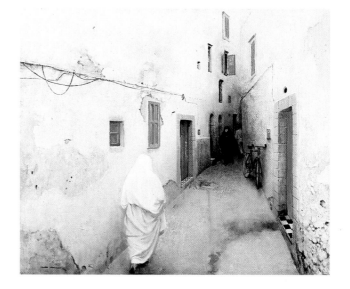

Part Two: The Principles of Design

Learning to make art is like learning to write — only wetter.

Each Chapter Opener introduces an element or principle of design.

These overviews set the stage for a more in-depth exploration. Note how examples from fine art, architecture, and nature begin this exploration of color.

Color Harmonies

Have you ever said that certain colors "go well together"? placed side by side? When designers and artists use comb results, they are using **color harmonies**. You have already rea harmony: complementary colors. Following are descriptio you might see in a design or wish to use in one of your own.

Analogous colors are next to each other on the color whe common. Because of this common color, they naturally relate used analogous colors in *A Young Girl Reading* (fig.4–24). The orange, and orange. These analogous colors give a warm and s What additional color is shown in the color wheel in fig.4–25?

Another color harmony is *split complementary*. This is ma hues on either side of that color's complement (see fig.4–27). Fo low-orange and red-orange forms a split complementary. Such contrast within a design. In fig.4–26, the blue urn creates a startl orange of the ceiling and red-orange of the floor.

4–24 What are the analogous colors in this painting?
Honoré Fragonard (1732–1806). *A Young Girl Reading*, c. 1776. Oil on canvas, 32" x 25 ½" (81.1 x 64.8 cm). Gift of Mrs. Mellon Bruce in memory of her father, Andrew W. Mellon ©1998 Board of Trustees, National Gallery of Art, Washington, DC.

4–25 An example of analogous colors.

4–26 Color studies such as this student work heightens our awareness of how color can help create a dynamic environment.
Iza Wojcik (age 17). *Down the Hall*, 1996. Oil on matte board, 18" x 24" (45.7 x 61 cm). Lake Highlands High School, Dallas, Texas.

Try it
How many groups of analogous colors can you discover on the color wheel? Make a painting or design, using only analogous colors. You may add black, white, and gray to make shades, tints, and tones.

4 | Color

Key Vocabulary
spectrum
pigment
neutral
hue
primary colors
complementary colors
tint
shade
intensity
tone
color harmony

O NE OF THE MOST EXCITING AND POWERFUL ASPECTS of our environment is color. Color appeals directly to our senses and emotions. We walk along streets and shop in stores filled with color—and we often make purchases because of it. Perhaps some colors, such as school colors, cause you to cheer and feel pride. Other colors might affect your mood, making you feel happy or sad. Look around you at rusted signs, neon lights, patterned clothing, flowering plants, and other everyday objects. Color is a necessary part of our lives. Knowing where color comes from and its properties will help you learn how to use it in your artwork.

4–1 In some regions, fall is when we are most mindful of color in our natural surroundings.
Leaf in Lexington, Massachusetts. Photo by H. Ronan.

4–2 The brilliant combination of sunlight and bright colors on a sunny summer day is captured in this painting. Consider how these objects would look on a cold winter's day.
Janet Fish (b. 1938). *Jump*, 1995. Oil on canvas, 54" x 70" (137.2 x 177.8 cm). D. C. Moore Gallery, New York. Photo by Beth Phillips.

4–3 This painting can be seen as a color chart that shows the move from one color of the spectrum to the next.
Ellsworth Kelly (b. 1923). *Spectrum II*, 1966–67. Oil on canvas, 80" x 273" (203.2 x 693.6 cm). Funds given by the Shoenberg Foundation, Inc. 4.1967, The Saint Louis Art Museum (Modern Art) (15192).

4–4 The exterior of this Islamic mosque is decorated with brightly colored ceramic tile. The tile and the dome's gold covering both take advantage of the direct, brilliant sunlight of the Middle East.
Dome of the Rock, Jerusalem, Israel, detail. Photo by L. Nelken.

Look for the Key Vocabulary.
They are listed in the order that they will appear. When a vocabulary word is introduced it will be shown in bold italic type and explained. These key terms are also defined in the Glossary.

Captions help you link the visual to the text.
These captions will challenge you to think critically as you analyze and interpret what you see.

Note how the visuals are referenced in the text.
Follow these connections as you read and you will achieve a full understanding of the topic.

Sub-topics are organized spread-by-spread.

Look at both pages together. See how the text, the visuals, and the captions work hand-in-hand? Here, after the text verbally defines analogous colors and a diagram visually defines analogous colors, a piece of fine art shows the same analogous colors in action.

Key concepts are visually and verbally reviewed at the end of each chapter.

A "gallery style" review requires critical thinking as you analyze the works of master artists and other students. The review questions help you integrate and interpret what you've learned.

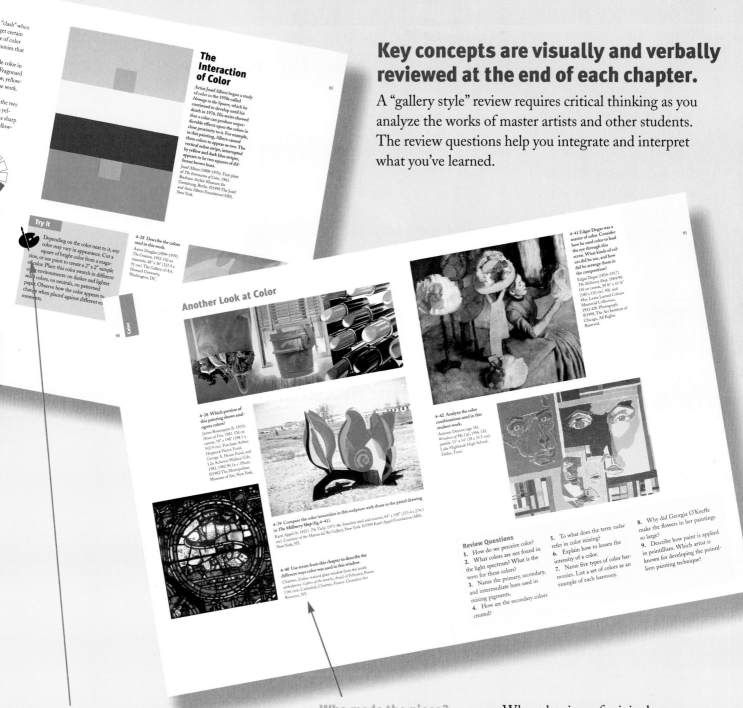

This icon highlights an opportunity for hands-on learning.
These "Try it" demonstrations make abstract concepts concrete experiences.

Who made the piece?
When was it made?
What is it made of?
These and other important questions are answered by the credits that accompany each visual.

When the sizes of original artworks are given, take time to imagine the art in real life. Works may be as small as a postage stamp or as large as a billboard. The size affects how you experience a piece.

Get up-close and personal with artworks and artists.

What inspires you?

Which artist began his career in the basement of a New York Public Library? Which artist found inspiration in the small details of nature? Through short biographies you gain a sincere appreciation for the **diverse influences that have directed a master artist's career.** Not only does this provide new insight into the works they created, it also helps us better appreciate the importance of an artist's inner voice in making art.

Art is not made in a vacuum!

To understand the subtleties that distinguish a piece and the common threads that unite artwork across time and space it helps to take an in-depth look at **the cultural and historical influences that shape a work of art.** Consider an Aboriginal dot painting and a Moslem tomb. They are drastically different in design and scale yet they both reflect sacred beliefs and values.

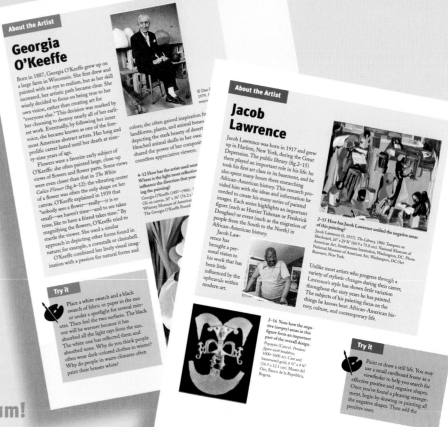

77

About the Artist

Georgia O'Keeffe

Born in 1887, Georgia O'Keeffe grew up on a large farm in Wisconsin. She first drew and painted with an eye to realism, but as her skill increased, her artistic path became clear. She wisely decided to focus on being true to her own vision, rather than creating art for "everyone else." This decision was marked by her choosing to destroy nearly all of her earliest work. Eventually, by following her inner voice, she became known as one of the foremost American abstract artists. Her long and prolific career lasted until her death at ninety-nine years of age.

Flowers were a favorite early subject of O'Keeffe: she often painted large, close-up views of flowers and flower parts. Some views were even closer than that in *The White Calico Flower* (fig.4–12): the vibrating center of a flower was often the only shape on her canvas. O'Keeffe explained in 1939 that "nobody sees a flower—really—it is so small—we haven't time—and to see takes time, like to have a friend takes time." By magnifying the flowers, O'Keeffe tried to startle the viewer. She used a similar approach in depicting other forms found in nature; for example, a cornstalk or clamshell. O'Keeffe combined her lively visual imagination with a passion for natural forms and

colors; she often gained inspiration from landforms, plants, and animal bones, depicting the stark beauty of desert bleached animal skulls in her own. She shared the power of her composition with countless appreciative viewers.

4–12 How has the artist used neutrals? Where is the light most reflective? How does the direction that influence the direction that you travel when viewing the painting?
Georgia O'Keeffe (1887–1986). *The White Calico Flower*, 1931. Oil on canvas, 30" x 36" (76.2 x 91.4 cm). Whitney Museum of American Art, New York. © The Georgia O'Keeffe Foundation.

Try it

Place a white swatch and a black swatch of fabric or paper in the sun or under a spotlight for several minutes. Then feel the two surfaces. The black one will be warmer because it has absorbed all the light rays from the sun. The white one has reflected them and absorbed none. Why do you think people often wear dark-colored clothes in winter? Why do people in warm climates often paint their houses white?

About the Artist

Jacob Lawrence

Jacob Lawrence was born in 1917 and grew up in Harlem, New York, during the Great Depression. The public library (fig.2–15) there played an important role in his life: he took his first art class in its basement, and he also spent many hours there researching African-American history. This research provided him with the ideas and information he needed to create his many series of painted images. Each series highlights an important figure (such as Harriet Tubman or Frederick Douglass) or event (such as the migration of people from the South to the North) in African-American history.

Jacob Lawrence has brought a personal vision to his work that has been little influenced by the upheavals within modern art.

2–15 How has Jacob Lawrence unified the negative areas of this painting?
Jacob Lawrence (b. 1917). *The Library*, 1960. Tempera on fiberboard, 24" x 29 ⅞" (60.9 x 75.8 cm). National Museum of American Art, Smithsonian Institution, Washington, DC. Photo National Museum of American Art, Washington, DC/Art Resource, New York.

Unlike most artists who progress through a variety of stylistic changes during their career, Lawrence's style has shown little variation throughout the sixty years he has painted. The subjects of his painting focus on the things he knows best: African-American history, culture, and contemporary life.

2–16 Note how the negative (empty) areas in this figure form an important part of the overall design.
Popayán (Cauca), Pendant, Agave with headdress, 1000–1600 AD. Cast and hammered gold, 6 ½" x 4 ¾" (16.5 x 12.1 cm). Museo del Oro, Banco de la República, Bogotá.

Try it

Paint or draw a still life. You may use a small cardboard frame as a viewfinder to help you search for effective positive and negative shapes. Once you've found a pleasing arrangement, begin by drawing or painting all the negative shapes. Then add the positive ones.

About the Artwork

Flying Ant Dreaming

Did you know that the oldest continuous culture in the world is the Aboriginal people of Australia? The continent has been occupied by humans for at least 40,000 years. An integral part of this culture is the idea of dreaming. This concept is very difficult to define, but it refers to Dreamtime, or several states of time and place. It reaches back to the beginning of life in Australia.

Dreaming incorporates a time when the Aboriginals believe that ancestral figures traveled the unformed earth. These beings shaped the natural landscape and created

everything on the earth. Where they walked, valleys were formed and where they bled, lakes were created. The Aboriginals believe that they are descendants of these ancestral figures.

Aboriginals view Dreamtime as a state of being that encompasses both the past and the future. When they engage in certain rites, such as dancing, art making, and ceremonial walking, the Aboriginals believe that they share in Dreamtime and become one with the earth.

Dreaming forms the basis of much Aboriginal art. Dreaming designs first made their way to the modern medium of acrylic on canvas in the 1970s. Ancestral figures and natural landmarks are depicted in an abstract style. Sometimes called dot paintings, these works are composed of a series of painted dots generally arranged in curving lines. Each dream painting relates to the personal and tribal Dreamtime of the artist. The works depict sacred beings and sites. Only the initiated members of the artist's tribe can fully understand the meaning and symbolism of a dream painting.

29

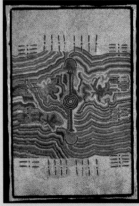

1–35 The artist used a series of evenly spaced individual dots of color to create the lines in this composition.
Norman Kelly Tjampijinpa. *Flying Ant Dreaming*, 20th cent. Collection of Tom Raney, NY. Aboriginal Artists Agency, Sydney, Australia. Photo by Jennifer Steele/Art Resource, NY.

About the Artwork

Taj Mahal

What kind of monument comes to mind when you think about a well-loved person's tomb? For a Mughal emperor in the seventeenth century, the Taj Mahal is such a monument. Its design and construction was ordered by Shah Jahan (ruled 1628–1658) in memory of his beloved wife Mumtaz Mahal, who died unexpectedly in 1630.

Built from 1632–38 on the bank of the Yamuna River at Agra, this architectural treasure is one of the most famous landmarks in the world. Twenty thousand workers participated in the creation of the structure, which is surrounded by four minarets (slender towers from which Moslems are called to prayer). Each minaret has three divisions, echoing the levels of the tomb.

The octagonal tomb and its supporting platform are built from gleaming white marble. On each side, the building has a large central *iwan* (a vaulted opening with an arched portal) flanked by two stories of smaller *iwans*. These openings make the building seem weightless: it appears to float magically above the reflecting pool. The surrounding garden (1,000' x 1,900'), divided by water channels, is laid out in total symmetrical balance. Trees and flowers are planted

along broad walkways with inlaid stones in geometric patterns. Originally, fountains were a part of this outdoor environment.

In the tradition of the Moslem religion, the style of the building is entirely symmetrical, with panels of carved inscriptions and flowering plants for simple images of each, smaller buildings, mirror images of each other, are set behind the tomb. One is a mosque, and the other a resting hall. They share a base with the mausoleum's marble platform, but are constructed primarily from a contrasting red sandstone.

The Taj Mahal is the crowning achievement of Islamic architectural design. It represents, by its form and location, a description found in the Koran: "the Throne of God above the gardens of paradise on the Day of Judgment." For the power of its presence, the Taj Mahal might be compared to the pyramids in Egypt.

7–8 The plan of this famous building and its grounds are perfectly symmetrical.
India (Agra). *Taj Mahal*, 1632–54. Photo by David Gyscek.

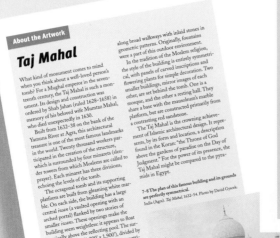

7–7 Can you think of other

Are you considering an art or design career?

A crucial part of any job search is an informational interview where you might ask:

- "What is a typical workday like?"
- "What kind of skills will I need?"
- "How do I get my foot in the door?"

Career Portfolios are **informational interviews with real working artists** in a host of art-related occupations. In addition to detailing the practical issues of a career in the arts, Career Portfolios highlight how the arts shape our world today. The entire interview from which each excerpt is drawn is provided in the *Teacher's Resource Binder*.

Career Portfolio
Interview with a Web-site Designer

While still in high school, **David Lai** learned the basics of computer design on his own. "Just for fun," he wrote and published a book on how to design computer-screen icons. Born in 1975 in Manhattan, Kansas, David now works for a firm in California that specializes in interactive design.

What do you call your occupation?

David I'm in the design profession, but we almost always talk more about solving problems. Good design does have aesthetic components, which is important, but there is also a very important functional aspect. You have to create something of utility and value. We solve real-world communication problems.

We look at computers more as a tool than a specialty. Otherwise, I'd be nothing more than an operator. You can always learn a tool, but the more difficult things to learn are conceptual—sketching your ideas out on paper before you go to the computer. Too many people these days want to go straight from whatever is in their mind—and it's usually not very clear—directly to the computer. They think they need to buy all these computer books to learn the program, but the truth is that they need to know how to conceptualize more than they need the tools, the applications.

How is balance important in Web-site design?

David Well, there are so many different elements involved. There's content. There's visuals. There's audio. There's text, the copy itself. There really has to be a synergy between all of them to get something to work. You're always balancing different spaces or different shapes.

Can anybody design a Web site?

David Well, theoretically, yes. Just like anyone could be a doctor, if they really put their mind to it. There's such a wide range of people in this industry because it's very easy to enter into. Anyone can pick up a book and learn some basic HTML and some basic graphic stuff. HTML is the

basic programming language that you use to create Web pages. It's the foundation; it's the starting point. The No Web site can be created without knowing some of that.

How do most people learn it?

David A lot of people learn it by looking at sites they really enjoy or respect, by taking them apart and looking at how the code was done. I think that's one of the great things about the Internet—it allows people to share information quickly. That includes sharing how sites are built, in that I can download the source code of any site and see how it was put together and learn from that.

What would you recommend to people interested in doing this for a living?

David I would recommend that they read as much as they can about the subject. There are so many good books out there on Web design. Obviously, there's a more formalized way as well. There are a lot of good art-design schools out there, especially with today's booming computer-design industry. You can take courses on Web design, multimedia, interactive learning for CD-ROM work, 3D modeling for special effects for Hollywood—whatever. The important thing is that you just have to go out there and take risks.

While interning with a design company, David Lai sold his ideas to Nintendo for a Web site. "We wanted to create a site that made teens feel like they were breaking into Nintendo at night and could explore the different areas of the company. Our goal was to make visitors feel special, that 'hey were seeing something ly a few could."

Career Portfolio
Interview with a Photojournalist

Photo ©Barbara Hakim.

Capturing images from the world of possibilities around her, **Dorothy Littell Greco** works with emphasis every time she frames and shoots a photograph. Whether on assignment or pursuing her own ideas, her aim is to compose a shot that makes a statement, tells a story, or records an event. Born in 1960 in Franklin, New Jersey, Dorothy lives in Boston, Massachusetts.

How do you describe your career or your type of art?

Dorothy I make still photographs which appear in newspapers, magazines, books, and corporate publications. I work in an editorial/reportage style, which means my images are naturalistic, rather than ones that are conceived and executed in a studio.

How did you enter into this type of work?

Dorothy As a child as young as five or six, I can remember taking my Kodak camera with me on vacations. As a teenager, I began to get more serious about photography. I taught myself using my dad's old camera and took a course at night school my senior year. For two years, I worked as the high-school yearbook photographer, which influenced my decision to study photography in college. I have a B.S. degree in journalism, with my concentration in photography.

Describe what your working day is like.

Dorothy Since I am self-employed, no two days are the same. Some days, I get a phone call at noon from a newspaper asking me to do an assignment at two. I spend some days in the darkroom, printing, or at my

light table, editing slides. I rarely have more than one assignment per day, and generally each shoot takes me three to four hours.

If I have to make the photograph inside, I may have to take several cases of lighting equipment with me. Occasionally, I hire an assistant to help me carry my gear and set up lights. I may also be asked to fly to a location and spend several days or weeks making photographs for a client. Since the sun is so important to my work, I often get started about an hour before sunrise and continue shooting until just after dark. At midday, when the sun is at its peak, I caption my film, eat, and rest.

I have photographed presidents, princes, and refugees. I've sat courtside during the NBA Championship and shot the World Series. I've also waited for hours, sometimes even days, in a fire station, a hospital, and a courtroom for something—anything—to happen so that I could

make a photo. Every day brings new challenges, and I can no longer imagine having a "normal" job.

How would you describe your creative process?

Dorothy Normally I go into a shoot with some vague ideas about how I want to make an image. Sometimes it is very specific, and sometimes very general. When I actually arrive, the light may be poor, or my subject might inform me that I have only ten minutes to get the photo. My equipment has to be an extension of my body so I don't have to think about the mechanics. Then I just try and let the situation unfold, responding as best I can, working as quickly as possible.

Each time I have an assignment, I make an attempt to gain my subject's trust and to give something back to them. When this happens, both of us know it, and it's tremendously rewarding. It's also very satisfying artistically to enter a situation wit! few vague ideas, to emerge an ho later with exposed film, and to see the image in the paper or n zine a short time later.

This teenag photograp book proj Dry Ros publish Menr Com gran wi c

Career Portfolio
Interview with an Art Therapist

Color provides an important clue in the work of **Anna Riley-Hiscox**, who uses art as a means of communicating with her clients. Anna grew up in East Harlem, in New York City, earning scholarships that put her through college. She has a bachelor's degree in art, and a master's degree in marital and family therapy and art therapy. Anna currently works with children and adolescents at a nonprofit agency in California. Off the job, her favorite form of artistic expression is painting gourds.

What is the purpose of art therapy?

Anna I think of art therapy as a vehicle of expression. Sometimes, people have problems or concerns they want to address, but they have a difficult time sitting and talking about emotional issues. We use art as another way of communicating, to help clients learn about new ways to handle difficult situations.

Please give an example.

Anna I was working with a fourteen-year-old client. Every time he came to the office, it was pretty superficial. Even after three or four sessions, he really had a difficult time expressing why he was in counseling. One day, I decided verbal therapy wasn't working. So, I said, "Hey, how about doing some art with me?"

He was a little reserved; he wasn't sure whether he actually wanted to do art. He said, "Well, I don't know how to draw." I said, "That's okay." I told him that he didn't have to be perfect. I showed him how to use markers to draw a mandala, a technique that many art therapists use. A mandala drawing is organized in a circle, and is used by many Native Americans and indigenous people to express themselves.

I told my client to simply use line and color to draw, in the circle, how he was feeling. As soon as he started drawing, the room became very, very quiet. We didn't need to talk. He was really engaged in the process of art-making.

This client had taken a wrong turn in life, which resulted in him being arrested and released on probation. Through his drawing, he was able to express how he was feeling. He talked about how he could take the right path in life or the wrong path. Although his drawing was very simple, he was able to use it to express his vision of making the right choices in the future.

Describe what your work is like.

Anna I work with a variety of clients who have problems they would like to resolve. Like other mental-health professionals, I see my clients in weekly sessions. Art therapists work in many different situations. Some are in private practice; some work for mental health institutions. Others work in schools, prisons, halfway houses, or shelters.

What aspect of your work is most important to you?

Anna Seeing the transition of the kids and the teenagers that I work with. Seeing them come in very confused, with a very chaotic life, and watching them evolve by using art. I've had several kids tell me later that the art was really good for them, and that they're still doing art.

This simple mandala was drawn by a client of Anna Riley-Hiscox (discussed in this interview). He described his artwork by saying, "This represents the paths I could take in life. The blue could be the right way, the red could be the wrong way. The green represents in the middle. I can go either way, which is why I have the diamond shape in the middle." Anna's job is to help him problem-solve so he will have the information he needs to find the right path.

It's time to make your mark.

Think with your hands!

Remember how learning to make art is like learning to write—only wetter? Well, it's time to get wet. The end of each chapter is capped off by **a comprehensive *Studio Experience* that helps you practice and apply what you've learned.** An example of a student's artwork lets you see how others responded to these hands-on activities.

Collaboration is key!

These three distinct features demonstrate a fundamental concept either through a hands-on activity or through a discussion. While requiring only minimal time and resources, these active learning opportunities still **encourage sharing and self-expression.**

Studio Experience
Color Harmonies with Pastels

Task: To demonstrate understanding of a color harmony by using it in a pastel painting.

Take a look. Review the following images in this chapter:
- Fig.4–15, Grant Wood, *Death on the Ridge Road*
- Fig.4–28, Aaron Douglas, *The Creation*
- Fig.4–29, Karajá, *Lori-lori*
- Fig.4–32, Lyonel Feininger, *Blue Coast*
- Fig.4–35, James Rosenquist, *House of Fire*

Think about it.
Study the five artworks listed above and the diagrams of the color schemes.
- Describe the color scheme or harmony in each. List the main colors in each painting; then label the color scheme. If a painting does not quite fit into a specific category, select the closest color scheme and explain how the colors in this art vary from that scheme.
- Compare the intensity of the colors among the paintings.
- How did each artist use color to emphasize certain parts of the composition?
- How did each artist treat the background?
- Describe the mood created by the color scheme in each painting.

Do it.
1 Choose a real-life object—a plant, leaf, shoe, hand, or insect—for your subject.
2 Select pastel sticks that form analogous, complementary, split-complementary, triadic, and monochromatic color harmonies. On scrap paper, experiment with various colors of pastels and color schemes. Try blending the pastels with a tissue or tortillon to create transition tones.
3 Look again at the diagrams. Decide which color scheme you will use to set the mood that you want. Consider the mood that will be created by the colors, rather than what color your subject is in real life. Pick a color of pastel paper that goes with your color scheme.
4 On a 9" x 12" piece of pastel paper, make a sampler of the colors that you will include. Lay down several large strokes, state the type of color scheme and mood, and check your work with your teacher.
5 With a pastel close to the color of the paper, sketch the outline of your subject on an 18" x 24" sheet of pastel paper. Draw the object twice more on this page. To fill the page, draw the objects large, overlap them near the center of the paper, and make them touch the edge of the page on at least two sides.
6 Before adding color, plan the colors for the various areas and shapes: not all need to be a flat color. You may want to vary the color in different areas, blending from one hue to another, or making the color shade from dark to light.
7 Complete your drawing with pastels.
8 Look at your pastel from a distance to evaluate it. If you wish, add more color or lighten or darken an area.
9 In a well-ventilated area, spray your pastel with fixative.

Helpful Hints
- Before you add pastels, consider the background. You could divide large areas of background into shapes or areas of color, as in fig.4–28.
- Thick, velvety applications of pastels that cover the whole surface of the paper are usually considered a painting; lighter applications with visible strokes are more like a drawing.
- Pastels sprayed with a workable fixative may smudge. Spray completed pastels with a clear acrylic spray

Check it.
After you have completed your pastel painting, prop it up. With a classmate, study it from a distance, and answer the following:
- What is the mood? Is it what you trying to achieve?
- What is the color harmony?
- Would the work be improved with greater differences in hue, or with tints between areas of color?
- Would the colors go together if some were repeated?

Dhavani Badwaik (age 16). B
Pastels, 18" x 24" (45.7 x 61
Academy, Worcester, Massa

Discuss it

Study a reproduction of a famous painting. Then discuss the answers to these questions: How does the artist lead the viewer's eye through and around the painting? Is the movement accomplished with line, color, shape, value, or some other device?

Try it

You can experience actual asymmetrical balance by placing a ruler across an outstretched forefinger, while resting your hand on a desk. Experiment by placing lighter and heavier objects on each side of the center. Move them until the ruler balances.

Note it

Explore indoor and outdoor environments to find patterns. Look for obvious, broad, large patterns, such as those on the sides of buildings. Then look more closely for smaller patterns, such as those in pavement, bicycle stands, and landscaping. Note how patterns create rich surface appearances and help us identify forms.

Studio Experience
Pattern Prints

Task: To draw natural patterns, carve one as a linoleum-block print, and then print several patterns with repeat schemes.

Take a look. Review the following photographs of nature images:
• Fig. 11–6, *Peacock feathers*
• Fig. 11–21, *Artichoke*
• Fig. 11–23, *Silversword cactus*

Then review these illustrations of human-made patterns:
• Fig. 11–3, Faith Ringgold, *The Wedding: Lover's Quilt No. 1*
• Fig. 11–34, *Ceramic tile wall* from Friday Mosque
• Fig. 11–37, Lee Lockwood, *New York Hilton Hotel Under Construction*

Think about it.
• Study the nature photographs listed above. Note that the focus in each is on the zoomed-in pattern of the natural object. In each image, what element created the pattern?
• Study the human-made patterns, and identify several of the motifs in each pattern. Notice how some motifs have been joined together to form a larger unit that is repeated. How do the motifs vary from row to row in each pattern?

Do it.
1 On drawing paper, make several pencil drawings of patterns found in nature.
2 Select a portion of one drawing as the design for your linoleum-block print. Later, you will print this many times as a motif. Transfer your pencil drawing to the linoleum block: place your drawing facedown on the linoleum, and rub over the back of the paper with the side of a pencil or the back of a spoon. Your print will be the reverse of your carved print block.
3 Use linoleum cutters to carve away the areas of your design that will be the

color of the paper. Do not carve too deeply. Always keep hands behind the blade. If bench hooks or C-clamps are available, use them to hold the linoleum in place.
4 Make a proof print by inking the block with water-soluble ink and printing it on paper.
5 Pull the paper from the block. Study your print to decide if you want to cut away any more of the linoleum. Using your block as a motif, print repeated patterns on larger sheets of paper. Try different types of repeated patterns. Print your block in grid, half-drop, radial, and random patterns. Experiment by turning the block in different directions, leaving varying amounts of space between the prints, and using several colors.
6 Mount your two favorite patterns on colored paper or cardboard.
7 *Option:* To produce an effect similar to the student work on this page, vary your block prints by using different colors of ink and paper. Then, cut the prints in half diagonally and reassemble the blocks.

Helpful Hints
• To get an idea of what your print will look like before you ink the block, make a rubbing by placing a piece of thin paper over the block and rubbing the paper with the flat edge of pencil lead.
• Each time you ink your block, work on a clean page of a recycled magazine or telephone book. This will keep your work surface free of wet ink.

Check it.
• What type of repeat scheme did you use in each pattern?
• Consider the craftsmanship of your artwork:
— Did you ink and print your block correctly?
— Did you put too little or too much ink on your block?
— Did you apply enough pressure to create an even, sharp print? Does this matter in your pattern?
— Are there any stray spots of ink on your paper? If so, does this interfere with the effectiveness of the pattern? Do they accidentally add to the success of your design?
• What do you like best about the two patterns?
• What might you do differently the next time you create a similar piece of art?

"Complementary color systems of paints and colored paper were followed during the printing process. For instance, warm-colored paints were printed on cool-colored papers, and then cool-colored paints were printed on warm-colored papers. I also looked at artwork made by quilt makers to influence the way I arranged the finished prints."

Erica Wallin (age 16). *Butterfly Wing Quilt*, 1998, detail. Linoleum print on colored paper, 17" x 17 ½" (43.2 x 44.5 cm). Clarkstown High School North, New City, New York.

227

Student artwork from Chapter 9, Contrast

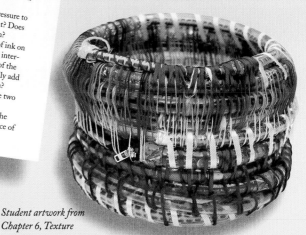

Student artwork from Chapter 6, Texture

Notable resources you don't want to miss!

The **Guide to Artists** provides clear pronunciations for the names of all of the artists in the text.

The **Glossary** defines key vocabulary and other important terms.

The **Bibliography** lists resources for both the student and the teacher.

The **Index** serves as a study aid and assists students in finding particular artists and topics.

This book will teach you about the "grammar" of art and how people from other cultures and times have used a common visual language to express their own unique perspective.

With time and practice you too will become fluent in this language.

Introduction

What is Design?

The design of a work of art is its plan. Design can refer either to the way a piece is organized or to the piece itself. We might talk about the design of a fine piece of sculpture, a startling painting or photograph, an unusual building, or an interesting layout for an advertisement. When someone says "That's a great design!," he or she is recognizing a sense of visual order—different parts brought together to make a whole.

A work of art sometimes holds an element of surprise. This image represents the artist's mother. It recalls a simple snapshot, but the artist has manipulated the design. The space within the image and its overall shape are unexpected, and therefore attract our attention.

David Hockney (b. 1937). *Mother, Los Angeles,* 1982. Photographs, 52 ½" x 38 ⅝" (133.4 x 98 cm). Estate of Frederick R. Weisman.

The human figure has been a favorite subject of artists since ancient times, providing an endless number of visual problems to solve. There are many challenges in designing a graceful and balanced figure such as this seated girl.

Seated Girl. Palazzo dei Conservatori, Rome. Alinari/Art Resource, NY.

The elements and principles of design may be used to communicate or emphasize a message or a concept. Using the title as a clue, what do you think is the idea behind this work?
James Doolin (b. 1932). *Last Painter on Earth*, 1983. Oil on canvas, 72" x 120" (182.5 x 304.5 cm). Courtesy of the Koplin Gallery, Los Angeles, California.

Design surrounds us—in nature or at home, in a flower or a dinner plate. Design affects the print displays in magazines, the furniture styles in department stores, and the shapes and colors of cars and bicycles. You probably use design without even knowing it. When you buy one piece of clothing rather than another, or decorate a wall with this poster instead of that one, you are reacting to issues of design.

To know when or why one design is better or more successful than another, ask what makes it work and how it is put together. Does the design hold your interest? Is its purpose meant to entertain? To convince? To frighten? Does it achieve that goal? Also consider how the piece makes you feel and why.

Appreciating Design

Appreciating or creating a work of art takes time and effort. One way to improve your design sense and judgment is to stop and carefully look at some of the hundreds of objects that you encounter daily. Although there are no absolute rules in art, this book will help you know what to look for. It will help you understand and be able to discuss your personal reactions to design. And it should improve your ability to communicate feelings and ideas in your own creations.

With practice, we can learn to recognize elements of design in everyday objects. Consider the lines used in the design of this umbrella. There are the straight, rigid lines of the spokes and the broad, freer lines of the written characters.
Umbrella. Photo by A. W. Porter.

This painting is a self-portrait of the artist. Artworks can capture the very personal feelings of an artist.
Frida Kahlo (1910-53). *Autorretrato como tehuana (Diego en mi pensamiento)*, 1943. Oil on canvas, 30" x 24" (76 x 61 cm). Gelman Collection. Courtesy of the Centro Nacional de las Artes, Biblioteca de las Artes, Mexico. Reproduction authorized by the Instituto Nacional de Bellas Artes y Literatura.

The same elements of design used by the creator of this masterpiece over 1,200 years ago are still used to create art today.
Portrait vessel of a ruler, Peruvian, Moche culture, 300/700. Earthenware with pigmented clay slip, 14" high (35.6 cm). Kate S. Buckingham Endowment, 1955.2338. Art Institute of Chicago.

Elements and Principles of Design

This book contains two parts. The first part is devoted to the elements of design—the ingredients that artists use to create an artwork. The second part discusses the principles of design, the different ways in which artists combine the elements to achieve a desired effect or outcome. Although this book presents each element and principle separately, no one of them appears alone in a design: the elements and principles work together.

Throughout the twelve chapters are images of a variety of fine art, architecture, crafts, advertisements, and designs from nature. There are designs from different time periods and cultures. Each image is intended to help explain some idea in the text and to help you develop your looking skills. But remember: the elements and principles of design work together. Although each image is carefully placed to illustrate a particular principle or element, many of the images could illustrate a different concept in another chapter.

Some works of art, such as *Peasant Dance,* are quite complex in their design; others are rather simple. Each presents its own visual problems for the artist to solve.
Pieter Brueghel the Younger (1564/5–1637/8). *Peasant's Dance,* c. 1566–67. Panel, 44 ⅞" x 64 ½". Kunsthistorisches Museum, Vienna, Austria. Photo Erich Lessing/Art Resource, NY.

Observing Design

Although the hundreds of images may also offer guidance, inspiration, and solutions to problems in creating your own artwork, be aware that they are only photographic reproductions. An image may be quite different from the real thing, and it often does not or can not accurately reproduce a work's actual size or color. The best way to experience art is to study it in person—whether at museums and galleries, or in public parks and buildings.

Successful visual artists and designers are careful observers and collectors of ideas. Their designs reflect intimate knowledge of the world, as well as a desire to share their personal feelings and reactions with others. If you wish to achieve similar results, you must continue your exploration and study of design both in and outside the classroom.

The shapes and forms that create a building's design can vary from ordinary to spectacular. How might your house, school, or church be considered a designed space?

Le Corbusier, Chapel of Notre Dame du Haut, 1951–53, Ronchamp, France. View from southeast. © 1987 Oliver Radford.

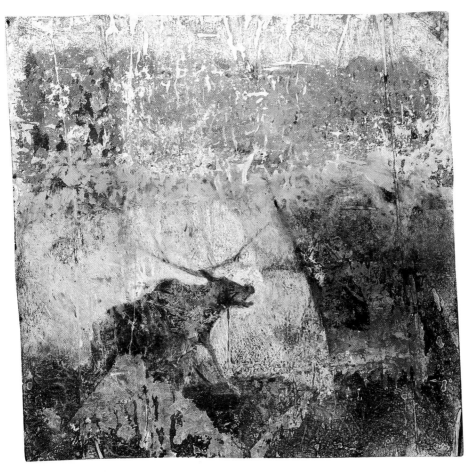

A photographic reproduction of an artwork can be beautiful and inspirational, but it does not always give us an accurate view of the work. For example, note the measurements of *Howl from the Past*. In life, it is approximately five times larger than Kahlo's image shown on page 4.

Sylvia Glass (20th cent.) *Howl from the Past*, 1987. Acrylic and pastel on cloth, 55" x 56 ½" (140 x 144 cm). Courtesy of the artist.

The designer of this graphic sought to convey an immediate message. Do you think the image is a successful communicator? Why or why not?

Graphic for New York Knicks 1997–98 season. Courtesy of Mecca Studios, New York.

An understanding of the elements and principles of visual design will make you a more careful observer; as a result, you might more fully enjoy the pleasures of design in fine art, manufactured objects, and nature.

Philip Moulthrop (b. 1947). *White Pine Mosaic Bowl*, 1993. White pine and resin; lathe-turned, 14 ¼" x 20 ½" (36.2 x 52.1 cm). White House Collection of Contemporary Crafts. Photo by John Bigelow Taylor, N.Y.C.

Part One: The Elements of Design

Every creative process has its own tools and ingredients. Writers use paper and pen or computers to put together the ingredients of language, such as nouns and verbs. Chefs have ovens, pans, and spoons to create food by mixing assorted ingredients, such as flour, eggs, and fruit. Artists and designers might use brushes, paint, and canvas to combine the basic ingredients of art: the elements of design.

The elements of design include line, shape, form, value, color, space, and texture. You can see these elements all around you: nature offers an almost unlimited supply of them. The element of line, for example, can be seen in the thin stem of a flower, the curving ridge of a sand dune, or the intricate markings of a tropical fish. The six chapters of Part One define and provide many examples of each element.

Although the elements of design are the basic parts of any work of art, there are many ways to use them. Like a writer or a chef, each artist and designer must make choices. An artist might choose to express ideas and feelings visually in pastel drawings, acrylic paintings, or sculpture. A designer might choose to express him- or herself in the design for a towering office building. In the following chapters, each element of design is isolated for study and discussion, but in both nature and art, they are rarely seen alone. Their many combinations provide a rich diversity of visual designs to explore.

Shape and form are emphasized in the design of this skyscraper. Another essential element of its design is the shiny, reflective glass.
Henry N. Cobb (1859–1931) of Pei Cobb Freed & Partners Architects LLP. John Hancock Tower, Boston, Massachusetts. ©1980 Steve Rosenthal.

Some artworks are crisp and clear in their construction. Notice the sharp lines and simple shapes used by this artist.

Edward Ruscha (b. 1937). *Standard Station*, 1966. Silkscreen print, 25 ¾" x 40" (65.4 x 101.6 cm). Edition of 50. Courtesy of the artist.

The designed artifacts of ancient civilizations provide us with clues about their history and culture.

Hieroglyphics. Photo by A. W. Porter.

9

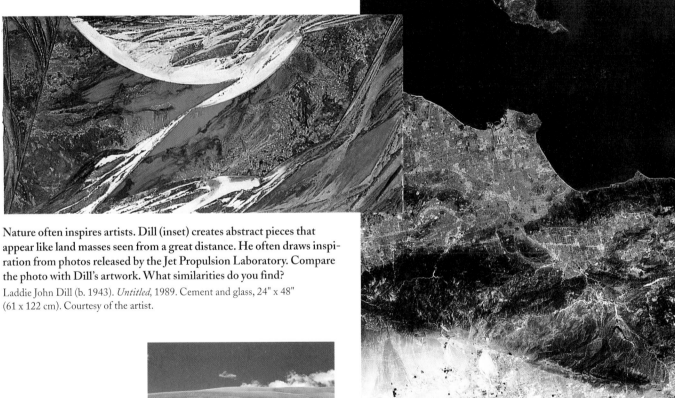

Nature often inspires artists. Dill (inset) creates abstract pieces that appear like land masses seen from a great distance. He often draws inspiration from photos released by the Jet Propulsion Laboratory. Compare the photo with Dill's artwork. What similarities do you find?

Laddie John Dill (b. 1943). *Untitled*, 1989. Cement and glass, 24" x 48" (61 x 122 cm). Courtesy of the artist.

This satellite photo of the Los Angeles area was released by the Jet Propulsion Laboratories in California. It marked the beginning of a computer and animation project sponsored by NASA's Office of Space Science and Applications that would allow scientists to study the three-dimensional nature of global cloud cover.

LANDSAT satellite photo of Los Angeles area. Courtesy of the Public Information Office, Jet Propulsion Laboratory, California Institute of Technology, National Aeronautics and Space Administration, Pasadena, California.

The elements of design can be found in nature. Artists often use nature as a guide or inspiration when designing.

Sand dunes. Photo by H. Ronan.

Chapter 1 Organizer

Line

Chapter Overview
- Line is one of the most basic art elements.
- Structural lines form the framework of a design.

Objective: Students will identify contour, structural, gesture, sketch, calligraphy, and implied lines in natural and fabricated environments and in artworks. (Art criticism)
National Standards: 2. Students will use knowledge of structures and functions. (2b)

Objective: Students will create drawings and sculpture using various types of line. (Art production)
National Standards: 1. Students will understand and apply media, techniques, processes. **2.** Students will use knowledge of structures and functions. (2c)

8 Weeks	1 Semester	2 Semesters			Student Book Features
1	1	1	**Lesson 1:** Line Types	Chapter Opener Structural Lines, Outlines, Contour Lines	Try it: drawing
0	1	1	**Lesson 2:** Line Types	Gesture Lines, Sketch Lines, Calligraphy	
0	0	1	**Lesson 3:** Line Personality	Vertical and Horizontal Lines, Diagonal Lines, Curved Lines	About the Artist, Try it: drawing
0	1	1	**Lesson 4:** Line Quality, Line as Texture and Pattern, Line Combinations	Line Quality: Implied Lines; Line as Texture and Pattern; Line Combinations	Try it: different techniques, About the Artwork
1	1	1	**Chapter Review**	Another Look at Line	Review Questions
1	1	2	**Studio Experience:** *Wire Sculptures from Gesture Drawings*		

Studio Experience: *Wire Sculptures from Gesture Drawings*

Objectives: Students will understand how line can indicate movement; make a series of gesture drawings emphasizing motion; use gesture drawings to analyze lines and forms in a subject; create a sculpture based on a gesture drawing.

National Standard: Students will evaluate artworks' effectiveness in terms of organizational structures and functions (2b); create art using organizational structures and functions to solve art problems (2c); evaluate artworks' effectiveness in terms of organizational structures and functions (2b); use media, techniques, and processes to achieve their intentions in their artworks (1a).

- Line qualities contribute to an artwork's mood and feeling.
- Different types of lines can suggest personality.

- Sometimes, artists do not actually draw lines, but imply them.
- Artists can combine types of lines to create texture and pattern.

Objective: Students will compare, contrast, and appreciate commonalities in various types of lines found in the works of European, American, Aboriginal, Asian, Turkish, and other artists. (Art history/cultures)
National Standards: 4. Students will understand art in relation to history and cultures. (4e)

Objective: Students will consider lines in nature, in the environment, and in artworks and discuss which of these lines might be considered art. (Aesthetics)
National Standards: 6. Students will connect visual arts with other disciplines. (6a)

Teacher Edition References	Ancillaries
Warm-up, HOTS, Context, Design Extension	*Slide*: Kathë Kollwitz, *Self-Portrait* (L-1) *Large Reproduction*: Charles Rennie Mackintosh, *Spurge, Withyham*
Design Extension, HOTS, Context, Performing Arts	*Slide*: Master of the St. George Codex, *Historiated Initial C* (L-2)
Design Extension, HOTS, Context, Materials and Techniques, Performing Arts	*Slide*: Helen Frankenthaler, *Harp* (L-3)
Design Extension, HOTS, Context, Interdisciplinary Connection, Inquiry, Internet Connection, Cooperative Learning, Materials and Techniques	*Slides*: Maruyama Okyo, *Screen: Winter Landscape* (L-4); Navajo, *Eye-dazzler Blanket* (L-5); Lydia Buzio, *Round Blue Roofscape* (L-6) *Large Reproduction*: Edgar Degas, *Edouard Manet Seated*
HOTS, Context, Portfolio Tip	

Vocabulary

calligraphy Precise, elegant handwriting or lettering done by hand. The word "calligraphic" is sometimes used to describe a line in an artwork that has the flowing elegance of calligraphy. *(caligrafía)*

contour lines Lines that describe a shape of a figure or an object and also include interior detail. These lines can vary in thickness. *(líneas de perfil)*

gesture line An energetic type of line that catches the movements and gestures of an active figure. *(línea gestual)*

implied line A suggested line— one that was not actually drawn or incorporated—in a design. *(línea implícita)*

line of sight A type of implied line from a figure's eyes to a viewed object, directing the attention of the viewer of a design from one part of it to another. *(línea de la vista)*

line personality The general characteristics of a line, such as its direction, movement, quality, or weight. *(personalidad de la línea)*

outline A line that defines the outer edge of a silhouette, or the line made by the edges of an object. *(contorno)*

sketch line A quick line that captures the appearance of an object or the impression of a place. *(línea de bosquejo)*

structural lines Lines that hold a design together. *(líneas estructurales)*

Studio Resource Binder

1.1 Blind Contour Drawings
1.2 Designing a Petroglyph, acrylic/sand etchings
1.3 Brushstrokes
1.4 One-color Block Print
1.5 Scratchboard: Thinking in Reverse

Time Needed
Two 45-minute class periods.
Lesson 1: Do gesture drawings;
Lesson 2: Form the sculptures.

Lesson 1
Line Types

pages 10–11

pages 12–13

Sarah Guimond (age 15). *Intertwined*, 1997. Scratchboard. Shrewsbury High School, Shrewsbury, Massachusetts.

Objectives
Students will be able to

- Perceive and appreciate a variety of line types in the natural and human-made environment.

- Identify and draw contour lines and outlines.

Chapter Opener
Direct students' attention to the lines in the images on pages 10 and 11. Have students note the importance of line in each composition.

- Focus on *Barkcloth* from New Guinea (fig.1–1). How would the students describe the lines and the creatures on this cloth?

- To encourage a discussion of aesthetics, pose the question, "Which of the three illustrations on pages 10–11 do the students consider to be art?" The question might be used as the basis for a journal essay. Call on students to give reasons supporting their stand on why or why not each image is art.

- Focus on aesthetics throughout the course by encouraging students to consider what makes something a work of art and to expand and develop their own definition of "good" art.

Teach: Structural Lines, Outlines, Contour Lines

- Call students' attention to the structural lines in *Spider web* (fig.1–4). Explain that even though these are fine, delicate lines, they form the framework for the whole web. Encourage students to identify the main structural lines in the images on pages 10 and 11.

- Give students a few minutes to look at the images and captions on pages 12 and 13 so that they will understand these different line types.

- To quickly illustrate the difference between outlines and contour lines, have students trace around one of their hands on a sheet of paper, creating an outline. Then show students how to draw a blind contour drawing

of their hand. They should look only at their hand, not their paper, as they draw and define the shape, including details such as wrinkles, fingernails, and rings. Have students make several contour drawings of their hand in various poses. Remind students that contour drawings should include some detail.

- As students complete the drawings, have them do **Try it** on page 12, a contour drawing of a simple object.

Try it page 12
Materials
• pencils or markers
• 8 1/2" x 11" paper, white

Lesson 2
Line Types

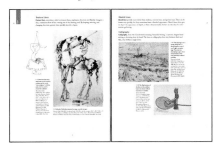

pages 14–15

Objectives
Students will be able to

- Identify gesture, sketch, and calligraphy lines.

- Draw using sketch and calligraphy lines.

Teach: Gesture Lines, Sketch Lines, Calligraphy

- Call students' attention to the line quality in the *Wire Sculpture by Calder* (fig.1–7), Dali's *Cavalier of Death* (fig.1–8), and van Gogh's *Fishing Boats at Saintes-Maries-de-la-Mer* (fig.1–9). Have each student write a word to describe the line quality in each artwork and share these with the class. Ask students how these lines vary from the out-lines and contours in the images on pages 12 and 13. They will probably notice that the lines in the images on pages 14 and 15 are more fluid and spontaneous.

- As students study Dali's *Cavalier of Death*, remind them that Salvador Dali was a Spanish Surrealist artist who often painted dreamlike fantasy scenes. Point out to the students that this drawing is not absolutely realis-tic. Dali has used both thick and thin lines to heighten the emotion in this art as well as to provide variety and interest.

- To encourage an aesthetic discus-sion, ask students to explain why or why not they would consider Dali's gesture drawing to be as good artis-tically as a very realistic drawing. (Dürer's *Young Hare*, fig.1–30, is an example of realism.)

- Instruct students to make several quick sketches of different views of the object that they drew as a con-tour drawing in **Try it** on page 12.

- Fig.1–10, the example of Islamic cal-ligraphy, was originally in a firman or edict from an Ottoman Turkish sul-tan (ruler.) These sovereigns loved fine books and kept skilled calligra-phers at their courts. Lead students in remembering examples of callig-raphy within our own society (invita-tions, greeting cards, package design). Another example of callig-raphy can be found in fig.1–33, Hakuin's *Portrait of Daruma*. Point out that artists often use lines that

resemble the free-flowing quality of calligraphy. These lines are often described as "calligraphic" as in fig.1–20, the poster by Zayas.

Students should notice the date the tughra was created. Do they con-sider this to be very old? As students look at other artworks in this chap-ter, call their attention to when they were made and how old the pieces are in relationship to each other.

- Guide students to note the flowing thick and thin lines in the calligra-phy in fig.1–10. Have students write their name on several of their sketches by using a calligraphic first letter with thick and thin lines.

Teach | pages 14–15
Materials
- pencils or markers
- 8 1/2" x 11" paper, white

Jestine Senchowski (age 17). *Cluttered Mind*, 1997. Pen and ink with gold metallic paint, 10" x 13" (25 x 33 cm). Leicester High School, Leicester, Massachusetts.

Lesson 3
Line Personality

pages 16–17

pages 18–19

pages 20–21

Objectives

Students will be able to

- Understand and appreciate that line characteristics and qualities including weight and direction can add personality, mood, or feeling in artworks.

- Create a drawing utilizing curved lines and a variety of line weights.

Teach: Vertical and Horizontal Lines, Diagonal Lines, Curved Lines

- Instruct students to fold a sheet of notebook or typing paper into fourths. (Demonstrate by folding a paper in half and then in half again.) Ask them to draw a series of vertical lines in one quadrant, horizontal lines in another, diagonal lines in the third, and curved lines in the fourth. For each line series, motivate students to write a title for the feeling or mood that the lines suggest to them.

- Have students read pages 16–21 to compare their ideas about the line types to the descriptions in the text.

- Focus on the images on pages 16–21. Call on students to identify the main lines in each image as vertical, horizontal, diagonal, or curved. Encourage them to describe what feeling or mood is suggested by the lines in each image. Refer students to fig.12–35 for Lichtenstein's interpretation of thick cartoon lines.

- After students read about Imogen Cunningham's life and work, assign them to write a short paragraph describing how *Agave Design I* exemplifies what Cunningham and Group f.64 were trying to achieve in their art. (She was showing an object in detailed focus, without dramatic setting or manipulation.) Select a few volunteers to read their paragraphs to the class.

- In the early 1900s photography was not generally considered an art, but a craft. Photographers such as Alfred Stieglitz and Imogen Cunningham worked to establish photography as a fine art. Organize a debate, with some students stating reasons why photography is an art form and others explaining why it is not.

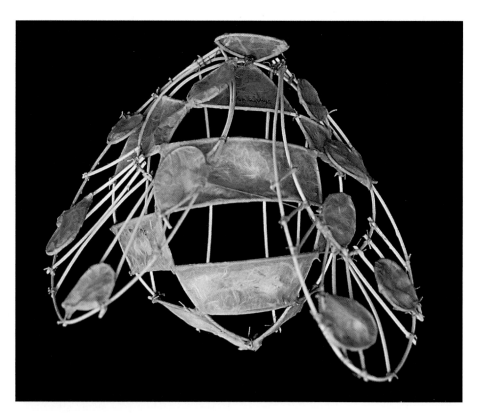

Stephanie Blount (age 13). *Ladybug*, 1997. Reed and rice paper, 12" x 9" (30.5 x 22.9 cm). Atlanta International School, Atlanta, Georgia.

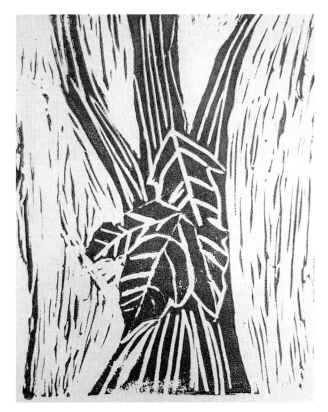

Jenna Skophammer (age 11). *Leafing Tree*, 1997. Linoleum print with water-based ink, 5" x 7" (12.7 x 17.8 cm). Manson Northwest Webster Community School, Barnum, Iowa.

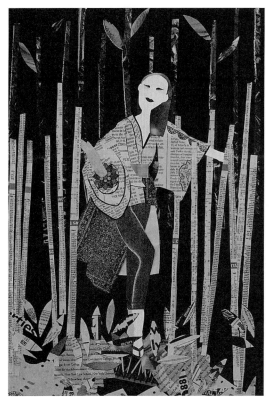

Kate Thompson (age 15). *Value Study*, 1998. Newsprint, chalk, magazine paper, and construction paper, 12" x 18" (30.5 x 45.7 cm). Atlanta International School, Atlanta, Georgia.

- Lead students to do the **Try it** on page 21. Encourage students to think of the objects as transparent so they see the lines of overlapping objects. Notice how varying line thickness creates interest.

Try it	page 21

Materials
- pencils or markers
- 8 1/2" x 11" paper, white
- protractors, scissors, or other objects to draw

Meeting Individual Needs

Students Acquiring English

Vocabulary plays an important role for students for whom English is a second language. Define and discuss the vocabulary words. Repetitive pronunciation of the vocabulary will further aid in the comprehension of the subject matter.

Students with Special Needs

Diminished eye to hand coordination can sometimes pose a problem for some students, especially when required to draw. Providing broad markers or crayons to draw lines may help to alleviate this difficulty.

Gifted and Talented

Using a common theme such as a landscape, have students create several pictures of that scene. A different mood should effectively be conveyed in each of the pictures, using different line qualities.

Lesson 4
Line Quality, Line as Texture and Pattern, Line Combinations

pages 22–23

pages 24–25

pages 26–27

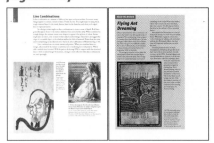

pages 28–29

Objectives

Students will be able to

- Identify implied lines in artworks.

- Recognize lines used to create pattern and texture.

- Draw texture and pattern using lines.

Teach

- Ask students to compare the line quality of Wong's *Kicking Horse* (fig.1–22), the neon light sculpture in the Columbus Museum of Art (fig.1–23), and Tintoretto's *Study for a Bowman* (fig.1–25). Inspire them to think about how long it took to create each piece of art.

 Tintoretto was noted for the speed with which he could create an action figure. (The grid was drawn over the figure so that Tintoretto could enlarge it for a painting.) Tyrus Wong's drawing shows the traditional Asian brush-painter's concern for representing the essence of the subject (here, the moving horse), rather than the specific subject itself. The neon sculpture includes only a few lines and appears to have been done quickly, but designing their placement within the whole composition could have taken some time. Point out to students how few lines are used in each artwork. Ask what the artist was trying to achieve in each.

- Explain to students that not all lines in art are actually drawn, but can be implied, or suggested. Guide students to find the implied lines in the fountain (fig.1–26) and Greene and Greene's *Gamble House* (fig.1–27).

- Direct students' attention to Wyeth's *Christina's World* (fig.1–28), and ask them to point out some of the lines that were actually drawn, and some of the implied lines, especially the line of sight from Christina's head to the farmhouse. Encourage students to answer the questions on page 25.

- Assign students to compare other drawings and paintings in this book that were completed within ten years of *Christina's World* (from 1938–1958). During this time abstract styles such as Cubism, Surrealism, Expressionism, and Abstract Expression were the focus of the art world. Some American artists, however—Regionalists including Andrew Wyeth and Thomas Hart Benton—continued to depict their world realistically.

- As students study the lines in *Christina's World*, guide them to see the multitude of lines in the grass and in the woman's hair. Each line was painted separately, but together they indicate texture. Andrew Wyeth used egg tempera, a medium widely used during the Renaissance in Northern Europe, to create his fine details.

- Focus on Dürer's *Young Hare* (fig.1–30), and lead students to notice how Dürer used repeated lines to create texture. Ask them to describe this texture.

- Direct students' attention to Stepanova's *Textile design* (fig.1–31) and the Maori *House front panel* (fig.1–32), in which lines form patterns. Have students note how both straight and curved lines were combined in the textile design.

- Ask students to look around the room to find any textures or patterns formed by lines. On the chalkboard, make a list of the linear textures and patterns.

- Focus on one of the options in **Try it** on page 27. Demonstrate how to dip twigs into india ink and draw a variety of different natural textures. Either have students go outside and draw tree bark, leaves, plants, stones, and shells; or, set up some of these natural objects for students to draw. Encourage students to experiment with different line combina-

tions and various twigs. When they have completed their designs ask if students can clearly identify texture and pattern in their work.

- Call students' attention to the crosshatching in Tenniel's *Alice and the White Rabbit* (fig.1–34). Ask students to compare the lines indicating form in the folds of the materials with the lines in the hand in the Ravielli image (fig.1–38).

Computer Connection

Instruct students to create an outline drawing of a hand using the pencil tool in a painting or drawing program. (They may use their nondominant hand as a model.) Students can then experiment with creating pattern and texture from line by selecting their drawing and repeating overlapping copies of the image across their screen. Call on students to discuss line combinations that develop during this process.

Chapter Review

pages 30–31

Assess

- Check students' portfolios to see that they created drawings using various types of line. (**Art production**)

- Direct students to identify the contour, structural, gesture, sketch, calligraphy, and implied lines in their own artworks. Students should label the type of lines that they used in each of their drawings from the chapter projects. Check to see that these labels are correct. Reteach if necessary.

- Review the various line qualities and types with students, to ascertain that they are able to identify these both in artworks and in natural and fabricated environments. (**Art criticism**)

- Lead students in comparing and contrasting various types of lines found in the works of European, American, Aboriginal, Asian, Turkish, and other artists. Divide the class into cooperative learning groups to compare the quality and types of line found in a piece of Western art and one from another culture. They should present their findings to the rest of the class. (**Art history/cultures**)

- Review with students the discussion from Lesson 1 in which they considered lines in nature, in the environment, and in artworks, and why these lines might be considered art. (**Aesthetics**)

- Have students answer the review questions.

- Direct students to compare the line quality in any two of their drawings. They should mention the width and direction of most of the lines. Are there any implied lines? Do any lines create texture or pattern?

10h

Reteach

Focus on the images on pages 30–31. Ask students to point out an implied line. Which image consists mainly of contour lines? Have them identify an image in which a series of lines creates texture. Call on students to identify an image in which line creates a pattern. Encourage them to describe the line personality in each image.

Answers to Review Questions

1 Horizontal lines usually suggest calmness, repose, and balance. Vertical lines convey height, stability, and dignity. Diagonal lines express action, movement, and tension.

2 An outline is usually the line made by just the outer edges of the object, whereas a contour outline of an object usually includes some interior detail.

3 The two basic characteristics of line personality are its direction or movement, and its quality or weight.

4 Implied lines are lines that are suggested without actually having been drawn or incorporated. Images on pages 24 and 25 illustrate implied lines, but students might identify other examples.

5 Dürer's *Young Hare* (fig.1–30), Wyeth's *Christina's World* (fig.1–28), or other reasonable choices.

6 Imogen Cunningham is best known for her close-up photographs of flowers and plants.

7 The lines in the piece of Aboriginal art, *Flying Ant Dreaming,* are composed of small dots that form straight, rounded, and circular lines. Most of the lines are the same width. Aboriginals live in Australia.

1 Line

EXAMPLES OF LINE ARE EVERYWHERE. In nature, you see them as the stem of a flower and the stripes on a zebra. In architecture, the edge of a skyscraper and a fence surrounding a house both form lines. In art, lines may be the path made by a pencil or the stroke of a paintbrush. They are created by the wires of a mobile or the carvings in a stone sculpture. Lines are also formed when two objects meet or overlap, such as the line made by your upper and lower lips when you smile.

Lines can be thin or thick, continuous or interrupted. In general, they connect two points and are usually longer than they are wide. Whether you draw on the wet sand of a beach or write your initials on a chalkboard, you are using one of the most basic elements of design—the line.

1–1 This work is from the island of New Guinea, near Australia. What words would you use to describe the creature or creatures depicted? How do the lines used by the artist help you describe the image?

New Guinea (Lake Senteni, Irian Jaya). *Barkcloth,* collected 1926. 68 ⅞" long (173 cm). Museum der Kulturen, Basel. Photo by Peter Horner.

Chapter Warm-up

• Ask students to draw a line on a sheet of paper with a pen or pencil. Discuss the various types of lines that they drew. Did some draw straight lines? Curved lines? Call attention to the various widths and the lightness or darkness of the lines.

• Point out examples of lines in the room and those that can be seen from a window. These might include writing on the chalkboard, lines formed by the edge of the board, an electrical cord, or the molding around a door.

• Have students work in groups of four or five to list more examples of lines that they can see in the room or from a window. Have a member of each group name a line until all the lines from each group are compiled

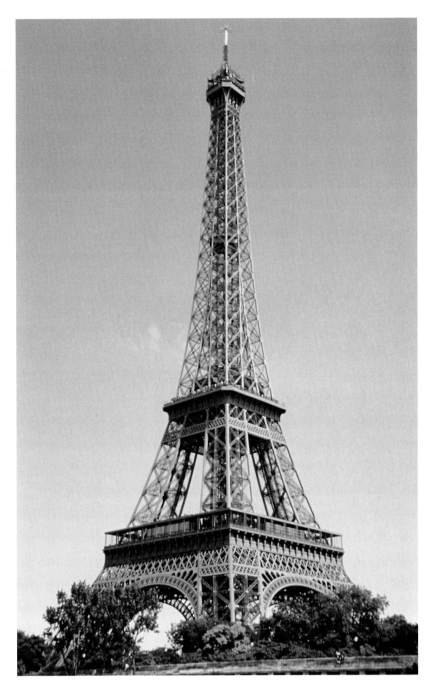

1–2 Had you ever thought of this very famous structure simply in terms of line? Its sleek profile foreshadowed modern skyscraper construction.

Alexandre-Gustave Eiffel (1832–1923). *Eiffel Tower*, 1889. Paris.

11

Higher-Order Thinking Skills

Lead students in imagining and describing an environment without lines. Where might such an environment occur? (Students might imagine an area in outer space, in dense fog, or underwater.) Could you give directions to help someone reach a destination in an environment without lines?

Context

Cast iron was an innovative material that permitted the construction of the Eiffel Tower. Previously, designers were restricted to stone and wood, which were too heavy to allow very tall, unsupported buildings. By the late nineteenth and early twentieth centuries, buildings began their climb into the clouds, and the skyline of major cities changed forever.

1–3 The lines, or stripes, on a zebra serve as camouflage as it roams its natural habitat. In what type of environment might these natural lines best blend?

Zebras, Ngorongoro Crater, Tanzania, 1996. Photo by David DeVore.

in a master list; have a volunteer use a marker on a large sheet of paper to compile the list. Discuss with students whether their perception of their immediate surroundings changed during this process.

Line Types

Many types of lines are used to create art. Six of the most common are described below.

Structural Lines

Structural lines are the lines that hold a design together. Structural lines come in a variety of types with different characteristics and qualities. They can be delicate and thin like a spider's web, or thick and bold like a row of telephone poles.

Outlines

An **outline** generally refers to the outer edge of a silhouette, or the line made by the edges of an object. An outline makes an object seem flat and is usually the same thickness throughout. Tracing around an object placed on a sheet of paper is one way to create an outline.

1–4 Note how these delicate lines of nature also communicate a sense of strength.

Spider web, early morning, New Zealand. Photo by John Scott. Courtesy of the artist.

Try it

Choose a simple three-dimensional object, such as a chair or a shoe. Create a contour line drawing of the object. As you draw, work slowly and try not to remove your drawing tool from the paper. Keep your eyes on the object, not your paper. This is called "blind contour drawing." (It is acceptable to draw back over lines to get from one point to another.)

Contour Lines

Contour lines describe the shape of an object, and include interior detail. For example, a contour drawing of a person's face would include a line defining the shape of the head and additional lines that describe the surfaces and planes of the facial features.

1–5 Why is an outlining technique particularly appropriate for conveying the physical characteristics of these objects?

Ben Shahn (1898–1969). *Empty Studio (Silent Music)*, 1948. India ink on paper, 26" x 40" (66 x 101.6 cm). The Museum of Modern Art, New York. The William S. Paley Collection. Photo ©1998 The Museum of Modern Art, New York.

1–6 This contour drawing gives an indication of general physical features and folds in clothing.

Jeremy Mann (age 18). *Untitled Contour*, 1994. Pencil, 14" x 14" (35.6 x 35.6 cm). Plano Senior High School, Plano, Texas.

Context

Ben Shahn (fig.1–5) was born in Lithuania and immigrated to the United States with his parents when he was eight. He grew up in Brooklyn, New York, and studied at the National Academy of Design and the Art Students' League. Shahn was part of the Social Realism movement in American Art. Many of his works date from the time of the Great Depression and are commentaries on the plight of the poor and downtrodden. *Empty Studio* shows a lighter side of his art.

Gesture Lines

Gesture lines, sometimes called movement lines, emphasize direction and fluidity. Imagine a thin, continuous flow of line coming out of the drawing tool. By looping, twisting, and changing direction, gesture lines quickly describe a figure.

1–7 Note how the artist used irony in this work by writing out the words "wire sculpture" with the same wire he used to create the sculpture.
Alexander Calder (1898–1976). *Wire Sculpture by Calder, Variation: Acrobat Sign*, 1928. Wire, 48 ¼" x 25 ⅞" x 4 ⅞" (122.6 x 65.7 x 12.4 cm). Collection of Whitney Museum of American Art Purchase, with funds from Howard and Jean Lipman, 72.168. Photograph ©1998: Whitney Museum of American Art, New York. ©1999 Estate of Alexander Calder/ARS, New York.

1–8 Salvador Dali often depicted strange, macabre images.
Salvador Dali (1904–89). *Cavalier of Death*, 1934. Pen and ink on paper, 38 ¾" x 28 ⅜" (98.4 x 72 cm). The Museum of Modern Art, New York. Gift of Miss Ann C. Resor. Photo ©1998 The Museum of Modern Art, New York. ©1999 Fundacion Gala-Salvador Dali/ARS, New York.

Higher-Order Thinking Skills
Call on students to note what medium was used to create each work shown on pages 14 and 15. Ask them to suggest how the medium affected the line quality in each.

Design Extension
Have students look at van Gogh's *Fishing Boats at Saintes-Maries-de-la-Mer* (fig.1–9), and note how he used ink and graphite in delicate, bold, curving, thick, and thin lines.

Encourage students to emphasize varied and rhythmical lines in their own landscape drawing.

Sketch Lines

Sketch lines provide more detail than outlines, contour lines, and gesture lines. They can be drawn very quickly, but they sometimes have a finished appearance. Sketch lines often give an object the appearance of depth, or three-dimensionality. Artists use sketches for information-gathering.

Calligraphy

Calligraphy, from two Greek words meaning "beautiful writing," is precise, elegant handwriting or lettering done by hand. The lines in calligraphy often vary between thick and thin, even within a single letter.

1–9 This drawing is not a nature study, but is a sketch based on one of van Gogh's own paintings. The artist was attempting to give a freer interpretation of the more precisely rendered painting.

Vincent van Gogh (1853–90). *Fishing Boats at Saintes-Maries-de-la-Mer,* 1888. Reed pen, brown ink, and graphite on wove paper, 9 ½" x 12 ½" (24.3 x 31.9 cm). Gift of Mr. and Mrs. Joseph Pulitzer, Jr. 137: 1984, The Saint Louis Art Museum (Prints, Drawings, and Photographs) (ISN 26606).

Performing Arts
What's My Line?: Ancient Greek Drama

Ask if lines can tell a story. What kind of story do the lines in Dali's *Cavalier of Death* (fig.1–8) describe? Explain that drama usually tells a story as well; the plot is called the story line. In ancient Greece, an individual actor was like a simple, bold "line": he spoke the bare minimum of the story. The chorus was like more intricate, interweaving "lines": its members would fill in the details or the drama's action or emotions.

15

1–10 The fluid motion of the lines in this emblem had to be drawn without hesitation or mistake.

Turkey (Istanbul). *Illuminated tughra of Sultan Suleyman,* c. 1555–60. Ink, paint, and gold on paper, removed from a firman and trimmed to 20 ½" x 25 ⅜" (52.1 x 65.4 cm). The Metropolitan Museum of Art, New York, Rogers Fund, 1938. (38.149.1) Photograph ©1986 The Metropolitan Museum of Art.

Context
Van Gogh created this drawing when he was in Arles, France—from February 1888 to May 1889—during which time he completed 200 drawings and more than 100 paintings. *Fishing Boats* is one of two drawings he did after his painting *Seascape at Saintes-Maries-de-la-Mer,* which is now in the Rijksmuseum, in Amsterdam.

Context
A tughra was an imperial emblem used by Ottoman rulers on official coins, seals, documents, and buildings.

Line Personality

Artists often rely on *line personality*, or the general characteristics of a line, to convey a specific mood or feeling. You may have noticed that a thick line with sharp edges and sudden directional changes produces a feeling quite different from a thin, flowing one. The two basic characteristics of line are its direction or movement, and its quality or weight. The direction of a line may be vertical, horizontal, diagonal, or curved. You can use each of these directions to help give your artwork a different personality.

1–11 What aspects of a mountain landscape are emphasized through the use of line? Keep in mind that the black area at the top is also a part of the painting.

Sylvia Plimack Mangold (b. 1938). *Schunnemunk Mountain*, 1979. Oil on canvas, 60" x 80 ⅛" (152 x 203.5 cm). General Acquisitions Fund, and a gift of the 500, Inc., Dallas Museum of Art, Dallas.

1–12 Korisheli often combines animal and plant forms in an effort to make the viewer aware of the relationships among all forms of nature. In this piece the heads and ears of canines are discernable near the tops of each section of the sculpture. How did the artist use vertical lines to convey the characteristics of a forest?

Margaret Korisheli (b. 1959). *The Forest*, 1996. Steel, 102" high (259 cm). Private collection. Courtesy of the Sherry Frumkin Gallery, Santa Monica, California.

Context

Sylvia Plimack Mangold has experimented extensively with simulated borders, sometimes painting tape "frames" around her subject matter. In *Schunnemunk Mountain* (fig.1–11), painted-tape borders utilize the element of line to impact our view of space, planes, and depth.

Vertical and Horizontal Lines

Vertical lines remind us of ourselves; they run straight up and down, as if they were standing. They might also bring to mind fences and forests, skyscrapers and soldiers. Artists use vertical lines to convey height, stability, and dignity.

Horizontal lines run from side to side. They call up images of the vast ocean, the horizon, or the body at rest. Artists use horizontal lines to suggest calmness, repose, and balance.

1–13 Frank Lloyd Wright was particularly interested in making his structures compatible with their environment. Note how he used construction materials that blend well with nature. How does he use line to bring together the building with its surroundings?
Frank Lloyd Wright (1867–1959). *Falling Water (Kaufmann House)*, 1936. Bear Run, Pennsylvania.

1–14 Note how this student work has been tightly structured through the use of an informal grid made by horizontal and vertical lines.
Rebecca Moyer (age 15). *Rustic Wall*, 1998. Oil pastel, 18" x 24" (45.7 x 61 cm). Nashoba Regional High School, Bolton, Massachusetts.

★ Higher-Order Thinking Skills

Have students compare *Schunnemunk Mountain* (fig.1–11) and *The Forest* (fig.1–12). They should notice immediately that the first relies primarily on horizontal lines, the second on vertical lines. Ask if they can find similarities between the two works.

Context

Because it is built over a waterfall, the *Kaufmann House* is popularly known as "Falling Water." The sound of water can be heard throughout the house. Ask students how they would feel living in such a house. Is constant noise a positive feature? Why?

Diagonal Lines

Diagonal lines run at an angle. They may describe a plane soaring across the sky, a tree falling down, or rays of sunlight. They can express action, movement, and tension. Diagonal lines often add a dramatic and dynamic aspect to a design.

Look at the black-and-white photograph of an agave plant (fig.1–17). The edges of the plant create sharp diagonal lines that shoot from the bottom of the image. Notice how the shadow continues the line of the plant into the upper left corner of the photograph. By using strong diagonal lines, the artist created a work of energy and action, even though her subject is a stationary plant.

1–15 The familiar sight of paintbrushes propped diagonally in a can are captured in glazed ceramic. If the ceramic brushes were made to lie on a table or hang from a wall, how might the visual impact differ?

David Furman (b. 1947). *Savarin Bouquet (for JJ),* 1995. Ceramic and glaze, 13" x 14" x 12" (33 x 35.6 x 30.5 cm). Courtesy of the Sherry Frumkin Gallery, Santa Monica, California.

1–16 How are diagonal lines used in this composition?

Kay Sage (1898–1963). *All Soundings Are Referred to High Water,* 1947. Oil on canvas, 44" x 62" (112 x 158 cm). Davison Art Center, Wesleyan University, Middletown, Connecticut. Photo by R.H. Phil.

⭐ **Higher-Order Thinking Skills**

Surrealist Kay Sage (fig.1–16) often depicted landscapes and environments in this style. Draw students' attention to the angular, diagonal lines in the lower part of *All Soundings Are Referred to High Water,* and note the lines formed by shadows. Have students write a short description of the mood that the diagonal lines help emphasize. Give students an opportunity to read or hear one another's descriptions so that they can better understand the wide range of results that are possible when interpreting a work of art.

Imogen Cunningham

Imogen Cunningham was born in Oregon in 1883, the same year that the National Federation of Women Photographers was formed. At that time, women had little opportunity to succeed as artists; however, they were encouraged to enter the field of photography, a relatively new medium invented in the mid-1800s.

The photography bug bit Cunningham when she was in her early twenties. She pursued her interest by studying photographic chemistry, art history, and life drawing in Dresden, Germany. In the 1920s Cunningham turned her attention to photographing nature. Today, she is best remembered for her close-up studies of flowers and plants.

1–17 Compare these diagonals, which provide a sense of openness and freedom in this work, with those in fig.1–16.

Imogen Cunningham (1883–1976). *Agave Design I*, 1925. Gelatin silver print. San Francisco Museum of Art, San Francisco. Clinton Walker Fund Purchase. ©1978 The Imogen Cunningham Trust, Berkeley, California.

Self-portrait with Korona View, 1933. Photo by Imogen Cunningham. ©1978 The Imogen Cunningham Trust.

Agave Design I (fig.1-17) is an example of the crisp, unadorned technique that led Cunningham to become a member of the famous Group f.64. This group of photographers believed that objects should be photographed in a sharp, detailed manner, without a dramatic setting, and without manipulation on the part of the photographer. *Agave Design I* clearly demonstrates this approach with its stark diagonal lines that create an image filled with strength and vitality.

Cunningham eventually shifted her attention from nature to portraiture. In the 1930s she worked for the magazine *Vanity Fair*. A popular figure in the world of twentieth-century photography, Cunningham was a special favorite among students until her death at the age of 93.

Materials and Techniques

A gelatin silver print is the most common type of black-and-white photograph today. The process of creating such a print relies upon gelatin-coated paper sensitized with silver nitrate. In a darkroom, the paper is exposed to strong light directed through a negative, then developed, fixed, and washed to produce an image of metallic silver.

Context

Group f.64 photographers included Edward Weston and Ansel Adams. Their name was taken from a particular camera setting. When the aperture, or lens opening, is set at f.64 the smallest possible amount of light enters the camera. This setting allows the photograph to show an extreme depth of field (the area of the composition that is in focus).

Curved Lines

Like diagonal lines, curved lines also express a sense of movement. But the motion of curved lines is fluid, not tense. They may represent rolling, turning, curling, or bending. If you've ever drawn a cumulus cloud, the rings of a tree trunk, spiraling smoke from a chimney, or the steep dips of a roller coaster, you've used curved lines.

1–18 This figure is depicted at rest, yet the curved lines of which it is composed give it great liveliness and energy.

Alexandra Otwinowska (age 16). *Untitled,* 1995. Mixed media, 18" x 12" (45.7 x 30.5 cm). Plano Senior High School, Plano, Texas.

1–19 Note how line so easily communicates a mood or emotion.

Niklaus Troxler (b. 1947). *Poster for South African Jazz Night,* 1990. Silkscreen, 35 ⅝" x 50 ⅜" (90.5 x 128 cm). Courtesy of the artist. ©1999 ARS, New York/Pro Litteris, Zurich.

Labanotation symbols 3
4

Performing Arts
Line in Motion: Labanotation

Artists use lines to describe objects or to create abstract images. We all use lines to create letters that make up words that, like art, communicate ideas. Rudolf von Laban (1879–1958), a Slovakian dancer and choreographer, invented another way to use lines to communicate information: a system of linear markings called Labanotation. This very precise system can note body movements

Look at the black-and-yellow poster (fig.1–19), an advertisement for a jazz concert. The curved lines provide a feeling of fun and festivity. The bold strokes capture a sense of motion in the figures. As a whole, the design conveys a sense of spontaneity and improvisation—important aspects of jazz music.

1–20 The artist created a swirling tornado of lines for this award-winning poster which he designed while still a student at the Art Center College of Design in Pasadena, California. What qualities of symphonic music does the poster evoke?

Victor Hugo Zayas (b. 1961). *Poster for the National Symphony Orchestra*, from the *Movement Series*, 1985. Acrylic on board, 24" x 36" (61 x 91 cm). John F. Kennedy Center for the Performing Arts. ©National Symphony Orchestra and Victor Hugo Zayas. Photo courtesy of Art Center College of Design, Pasadena, California.

Try it

Select an interesting but common object with a curve, such as a protractor or a pair of scissors. Use thick and thin lines to draw and repeat the shape. Create a design by interweaving the images so that the curved lines and shapes break up and overlap. What kind of movement do the curved lines in your design create?

Design Extension
Play recordings of jazz music as students look at Troxler's *Poster for South African Jazz Night* (fig.1–19). Discuss how the energetic, curving lines of various thicknesses enhance the jazz theme. Then have students look at Zayas' poster (fig.1–20) and imagine what type of music would highlight the lines in this image. Next, play several different kinds of music, and encourage students to capture the feeling and rhythm of each piece with only lines.

1–21 Nature contains a variety of lines. What are some other natural examples of curved line?

Fiddleheads. Photo by T. Fiorelli.

Context
Fiddleheads are the coiled young fronds of certain ferns, some of which are eaten as greens.

from the most simple to the most complex. It is used to notate and copyright all the steps in a ballet, and can be applied to study an athlete's movement in a sporting event or a worker's movement in an industrial job.

Challenge students to create a five-second movement sequence and to repeat it until they have it memorized. Then ask them to draw linear marks on paper to record their movement. Have them trade papers with a partner and see if each can recreate the partner's original sequence. Next, discuss if students remembered to indicate the exact placement of every part of their body, such as hands, feet, elbows, fingers, and waist.

Line Quality

Line quality adds to the personality of a line. Structural lines may be thin and delicate, or thick and bold. These changes in line quality can emphasize—or contradict—what is conveyed by a line's direction. An artist may use broken or jagged lines to convey fear or irritability. Nervous, quick strokes can heighten the sense of tension or drama. Fuzzy, blurred lines might suggest a dreamy or mysterious mood. Horizontal lines usually convey calmness or rest.

1–22 How would you describe the line quality used in this work?
Tyrus Wong (b. 1910). *Kicking Horse*, undated. Lithograph, 4" x 6" (10.2 x 15.2 cm). Collection of Shirl and Albert Porter.

1–23 Why do you think that the artist chose these types of lines to construct an entryway sculpture for this museum? What do the lines suggest about the museum?
Stephen Antonakos (b. 1926). *Neon for the Columbus Museum of Art*, 1986. Neon, glass, and stainless steel, 336" x 294" (853 x 746 cm). Columbus Museum of Art, Ohio: Gift of Artglo Sign Company, Inc., and Museum Purchase, Howald Fund.

An artist's purpose or mood will determine the kind of line used. To represent an object as it actually appears, artists may choose simple, thin outlines and add many carefully drawn surface details. Cartoonists, on the other hand, may use thick outlines. They might exaggerate certain features and describe surface details with only a few well-placed lines. Other artists may use line to represent an object so that it isn't recognizable at all!

Remember: the personality of a line can suggest many different moods and feelings. This will help you view designs with more understanding. It will also help you convey meaning more effectively in your own creations.

23

1–24 Note that this is a portrait of a painter. How do the jagged lines of the clothing convey the creative energy of the sitter?
Egon Schiele (1890–1918). *Portrait of Painter Paris von Guetersloh*, 1918. Oil on canvas, 55 ⅛" x 43 ¾" (140 x 111 cm). ©Minneapolis Institute of Arts, Minneapolis.

1–25 Tintoretto was known for the speed with which he created his sketches and paintings. His hasty style is evident in the short quick lines that bring this figure to life.
Tintoretto (1518–94). *Study for a Bowman in the Capture of Zara*, before 1585. Black chalk, 14 ⅜" x 8 ⅝" (36.5 x 22 cm). Gabinetto dei Disegni e Stampe, Uffizi, Florence.

Interdisciplinary Connection
Literature—Have students illustrate the mood of a scene from a short poem, with watercolor on paper. Then ask students to note the types of words the poet used to verbally create the mood of the poem. Have students choose a style of writing that sug-gests the mood; for instance, a style with bold or delicate or playful lines. (For inspiration, they can look through books of calligraphy or refer to books on Asian, medieval, or Islamic art.) Students may use ink, felt-tip marker, or dark paint to write the words.

Implied Lines

Implied lines are suggested lines—lines that were not actually drawn or incorporated—in a work of art. Large objects or groups of objects may appear as lines when viewed from a distance: a winding road or river, a train speeding across the landscape, a row of tall trees. Your eyes fill in the spaces between a series of widely distanced marks or objects, thereby creating an implied line.

When objects or areas of color meet within a painting, collage, or sculpture, they also create an implied line. Where the shapes touch or overlap, they share an edge. On opposite sides of this edge may be two different textures, patterns, or colors. This shared edge may not be sharply drawn or defined, but it functions as a line within the overall design.

1–26 Implied lines are created in the space below the two arches of water.

Fountain, Century City, California. Photo by J. Selleck.

1–27 What implied lines can you find in this image?

Greene and Greene (Henry Mather Greene, 1870–1954; and Charles Sumner Greene, 1868–1957). *Gamble House,* 1908, detail of doorway. Located at 4 Westmore Place, Pasadena, California. Photo by H. Ronan.

Another type of implied line is a *line of sight*, an imaginary line from a figure's eyes to a viewed object. A line of sight can help direct your attention from one part of a design to another. Look at the painting *Christina's World* (fig.1–28). The woman gazes into the distance, and the line of sight is an implied diagonal line that runs from her head to the farmhouse on the hill. What do you think the artist tried to convey with this painting? How did a line of sight help him achieve his result?

25

1–28 Christina Olsen, who was partially paralyzed and unable to walk, was Andrew Wyeth's neighbor when he summered in Maine near her farm. In this painting, the lines in her body and her line of sight indicate how she is straining to reach her house.
Andrew Wyeth (b. 1917). *Christina's World*, 1948. Tempera on gessoed panel, 32 ¼" x 47 ¾" (82 x 121 cm). The Museum of Modern Art, New York. Photo ©1998 The Museum of Modern Art, New York.

1–29 How has this student juxtaposed shapes of different textures and patterns to create implied lines?
Ulysis Kullick-Escobar (age 18). *Mexico Revisited*, 1996. Colored pencil, 14" x 17" (35.5 x 43 cm). Lake Highlands High School, Dallas, Texas.

Line as Texture and Pattern

Texture is the surface quality of an object—for example, whether it is rough, smooth, or scarred. Pattern is the repetition of a surface element; examples are the stripes on a shirt and the polka dots on a dress. Although texture and pattern are further discussed in Chapters 6 and 11, here we look at their relationship to line.

1–30 This artist was interested in science and often depicted animals and plants. Note how carefully he used line to show the familiar soft texture of a rabbit.
Albrecht Dürer (1471–1528). *Young Hare,* 1502. Watercolor with opaque white, 9 ⅞" x 9" (25 x 23 cm). Graphische Sammlung Albertina (Albertina Museum), Vienna.

Context
Dürer signed and dated all of his work, a fairly unusual practice in the Renaissance. A signed and dated self-portrait that he drew when he was thirteen still survives.

Materials and Techniques
During the Renaissance, artists used watercolors most often for preliminary sketches, which were later discarded. Dürer was a master watercolorist and used the medium to create complete, detailed studies of nature.

Artists often use a series of lines to suggest texture or pattern in their designs. In the watercolor of a hare (fig.1–30), Dürer's finely drawn lines capture the texture of soft, fluffy fur and lengthy whiskers. In the textile design (fig.1–31), the artist's short, bold lines combine to create a repetitive geometric pattern.

Sometimes, an artist achieves texture or pattern through the lines that occur in materials. A sculpture may display the grain of wood. A collage may include a piece of plaid fabric. Texture and pattern can also be increased by marking, carving, or otherwise altering the surface quality. In the Maori sculptures (fig.1–32), both straight and spiraling lines are etched into painted wood to create an intricate surface pattern.

1–31 What two types of line did the artist use to create this pattern?
Varvara Stepanova (1894–1958). *Textile design*, 1924. Gouache on paper, 12 ½" x 10 ⅞" (31.8 x 27.7 cm). ©Rodchenko and Stepanova Archive, Moscow and Varvara Stepanova/ licensed by VAGA, New York, NY.

1–32 The Maori of New Zealand have a tradition of carving wood panels to decorate the interior and exterior of some of their buildings. Careful examination of these carvings reveals a series of stylized human forms. These figures often represent ancestors.
New Zealand, Maori. *House front panels*, 19th cent. Painted wood and haliotis shell inlay, 108–132" high (274.3–335.3 cm). The Nelson Atkins Museum of Art, Kansas City, Missouri.

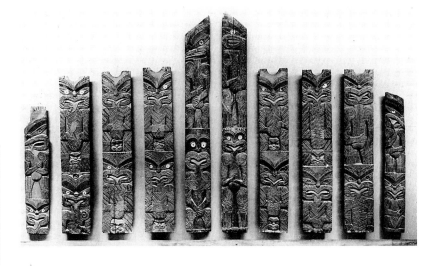

Interdisciplinary Connection

Mathematics—Direct students to write their own definition of line. Then have them look up the definition in an unabridged dictionary and compare it to their definition. Ask them to find the definition of line as used in mathematics and in art.

Call on students to compare how they draw lines in art and in mathematics classes. Lead students to find images in the text in which lines reflect a mathematical approach to design. Possibilities are Mondrian's *Composition with Blue and Yellow* (fig.7–14), Stepanova's *Textile design* (fig.1–31), and *Eiffel Tower* (fig.1–2).

Try it

Experiment with different techniques to discover ways of using line to create texture and pattern. You might draw with twigs and ink, erase lines into a charcoal drawing, or carve lines of varying thicknesses into a plaster block. For ideas, look at natural objects in which texture and pattern are prominent: the bark of a tree, the stripes on an animal, the veins on a leaf, the walls of an eroded canyon.

Higher-Order Thinking Skills

Collect samples of textile patterns, preferably from various world cultures. Ask students to bring in any textile patterns that reflect their family heritage or ethnic background, such as Indian batiks, Scottish plaids, or African weavings. Encourage students to compare the types of lines in the different fabric patterns. Direct their attention to the patterns in Stepanova's design (fig.1–31).

Line Combinations

A line combination is a mixture of different line types and personalities. In nature, many things appear to contain a variety of lines. Think of a tree. You might depict it using thick, rough-textured lines for the trunk, thinner lines for the branches, and short, soft-edged lines to represent leaves.

In a design, artists might use line combinations to create a sense of depth. Bold lines generally appear closer to the viewer. Indistinct lines seem farther away. When combined in a single design, the mixture causes some shapes to appear to be in front of others. Artists might also use short, criss-crossed strokes called crosshatchings. These lines can suggest the edges of a rounded object or the shadows within the folds of material. Notice how the artist used crosshatchings in his illustration for the book *Alice's Adventures in Wonderland* (fig.1–34).

Line combinations can create texture and pattern. When you combine lines in a design, ask yourself if the texture or pattern you're considering has a real purpose. Will it add a needed visual interest? Will the pattern be boring? Will it compete with the structural lines or with crosshatchings? Sometimes, a design is most effective when line combinations are used sparingly.

Design Extension
Ask students to compare the lines in Hakuin's *Portrait of Daruma* (fig.1–33) with those in Wong's *Kicking Horse* (fig.1–22). Have them note the efficiency of line that is characteristic of Asian painting. Direct students to experiment with bamboo watercolor brushes and india ink, drawing nature objects with as few lines as possible.

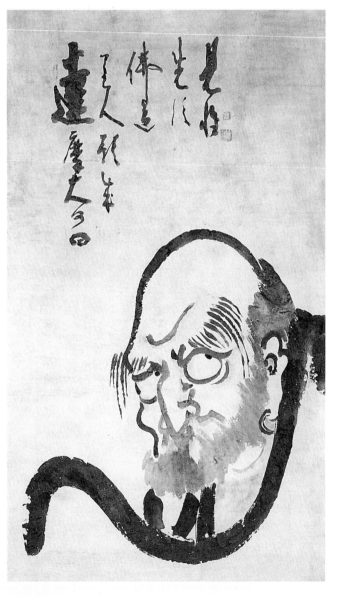

1–33 The artist used the curved line of the bald head and the curving thick line below to tightly frame the portrait.
Ekaku Hakuin (1685–1768). *Portrait of Daruma*, undated. Ink on paper, 63" x 36 ⅝" (160 x 93 cm). Freer Gallery of Art, Washington, DC.

1–34 Illustrators are adept at using line to contribute to the illusion of space and rounded objects.
Sir John Tenniel (1820-1914). *Alice and the White Rabbit*, Illustration from Lewis Carroll's *Alice's Adventures in Wonderland*. ©1995 Macmillan Publishers Ltd. Reproduced by permission of Macmillan Children's Books, London.

Context
Daruma was the founder and first patriarch of Zen Buddhism. He is believed to have come to Japan from India.

Flying Ant Dreaming

Did you know that the oldest continuous culture in the world is the Aboriginal people of Australia? The continent has been occupied by humans for at least 40,000 years. An integral part of this culture is the idea of dreaming. This concept is very difficult to define, but it refers to Dreamtime, or several states of time and place. It reaches back to the beginning of life in Australia.

Dreaming incorporates a time when the Aboriginals believe that ancestral figures traveled the unformed earth. These beings shaped the natural landscape and created everything on the earth. Where they walked, valleys were formed and where they bled, lakes were created. The Aboriginals believe that they are descendants of these ancestral figures.

Aboriginals view Dreamtime as a state of being that encompasses both the past and the future. When they engage in certain rites, such as dancing, art making, and ceremonial walking, the Aboriginals believe that they share in Dreamtime and become one with the earth.

Dreaming forms the basis of much Aboriginal art. Dreaming designs first made their way to the modern medium of acrylic on canvas in the 1970s. Ancestral figures and natural landmarks are depicted in an abstract style. Sometimes called dot paintings, these works are composed of a series of painted dots generally arranged in curving lines. Each dream painting relates to the personal and tribal Dreamtime of the artist. The works depict sacred beings and sites. Only the initiated members of the artist's tribe can fully understand the meaning and symbolism of a dream painting.

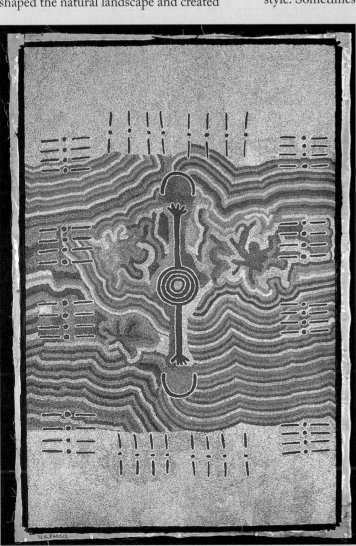

1–35 The artist used a series of evenly spaced individual dots of color to create the lines in this composition.
Norman Kelly Tjampijinpa. *Flying Ant Dreaming*, 20th cent. Collection of Tom Raney, NY. Aboriginal Artists Agency, Sydney, Australia. Photo by Jennifer Steele/Art Resource, NY.

Inquiry

Have students investigate Asian brushstroke painting to learn about the artistic philosophy and the artist's relationship to the subject. For example, the fourteenth-century artists of traditional Chinese "flowers and birds" brushstroke painting felt that humans were a small part of nature, which was made up of many life forms. This belief, reinforced by Buddhist teachings that the human soul could be reborn in an animal or plant, influenced the way in which the artists approached their subjects. They tried to portray the essence of the subject. They did this by carefully analyzing their subjects and by adhering to a realistic style of depiction.

Internet Connection

Discuss *Flying Ant Dreaming* (fig.1–35). Point out how lines were formed by a series of small dots. Suggest that students research other images of Australian Aboriginal painting on the Internet. Their inquiries should focus on the variety of stylistic traditions and the use of linear design in each.

Another Look at Line

1–36 What sounds and images does this painting and its title bring to mind?

Pat Steir (b. 1938). *Painted Rain*, 1994–95. Oil on canvas, 108" x 108" (274.3 x 274.3 cm). Courtesy of the Robert Miller Gallery, New York.

1–37 Can you tell what contradictory sensations the artist created by use of a variety of lines?

Will Rollins (age 18). *Untitled*, c. 1989–90. Welded and galvanized steel, plaster, and acrylic traces, 9' x 8 ½' (2.74 x 2.59 m). Los Angeles County High School for the Arts, Los Angeles, California.

1–38 The artist used line to emphasize the roundness of the hands. The crisp quality of the line also ensures the clarity of the image, an important aspect of instructional illustration.

Anthony Ravielli (1910–97). Illustrations for *The Modern Fundamentals of Golf*. Scratchboard, courtesy of the artist.

Context

Hassinger (fig.1–40) is a California-born African-American sculptor. She uses wire, branches, and plaster in her work; in many works, she includes abstract linear wire or branchlike forms that move across the floor or wall surface. One of her sculptures, *In a Quiet Place*, was included in a show of twentieth-century American sculpture at the White House garden.

1–39 Common objects can form interesting linear compositions that we often overlook.

Wires and shadows. Photo by J. Selleck.

31

1–41 A petroglyph is a carving or inscription on a rock. How does the material affect the types of lines used?

Petroglyphs, Utah. Photo by H. Ronan.

1–40 Lines frequently convey a strong sense of energy. Find two other images in this chapter that are "energized" by line.

Maren Hassinger (b. 1947). *Walking*, 1978. Wire rope and wire, 148 units, 2' x 10' x 12' (60 x 308 x 370 cm); 1 unit: 24" x 8" x 8" (61 x 20.3 x 20.3 cm). Courtesy of the artist.

Review Questions *(answers can be found on page 10h)*

1. What feelings and moods do horizontal, vertical, and diagonal lines usually suggest?

2. What is the difference between an outline and a contour line?

3. What are two characteristics of line that give the line personality and help convey a specific mood or feeling?

4. What are implied lines? Give an example of an artwork in this chapter that illustrates implied lines. Be prepared to point out these implied lines to other members of your class.

5. Name an artwork in this chapter in which the artist used lines to create texture.

6. For what type of artworks is Imogen Cunningham best known?

7. Describe the lines in the piece of Aboriginal art, *Flying Ant Dreaming*. On what continent do Aboriginal people live?

Career Portfolio

Interview with a Cartoonist

Cartooning is an art form with an emphasis on line. Bold outlines are the principal—often the only—element in a cartoon drawing.

Gene Mater is a free-lance artist, caricaturist, and graphic artist who has been active professionally since 1971. For seven years his cartoon strip *Gremlin Village* appeared in college newspapers, and his cartoon illustrations have appeared in numerous magazines, books, and other publications. He is best known for his good-natured cartoon portraits. Born in 1949 in San Bernardino, California, he currently lives and works in Bethlehem, Pennsylvania.

What would you call your occupation?

Gene Artist, cartoonist, or artist-entertainer, because I'm using the artwork to entertain people. I don't know anyone who does exactly what I do. There are a lot of people who call themselves caricaturists, but they're not artists who really talk to the people, and find out things about them that they include in the drawings to make them a one-of-a-kind statement. Also, the drawings that I do for people are generally more cartoon portraits than caricature. A caricature, where you're really using major distortion, is a harder thing to do well, and not everyone's face or

Gene Mater uses his sense of humor on the job—in this case, a cartoon portrait of himself.

temperament do I find suited to that. Mostly what I do is cartoon portraits of people; that is to say, they are recognizable drawings/renderings of people, done in a cartoon style.

Tell us about some of your first paying jobs.

Gene My first work was political cartoons, but they didn't pay very well, even though that's what I concentrated on right out of college. I was trying to build it up enough so that I'd have a following and get good enough to show it to the syndicates [who buy and market cartoon strips nationally]. But I was moving very slowly, and I was just not confident that I was good enough.

A lot of kids know they like to draw, but don't know what to do with it.

Gene Well, sure, because there is such a breadth and width of possibilities. You can do everything from cartooning to formal oil portrait painting and everything in between. You can do fine arts, or you can do commercial arts. You can just work on paper, or you can do mixed media. There are so many different things, and that's just for drawing. I think one of the best things a person can do is to play with as many options as possible.

What would you tell teenagers about pursuing an art career?

Gene If I could get any point across to a teenager who liked art, it would be to just accept the fact that you're going to doubt your work, that you're going to feel insecure, and that everybody else's work is going to look better, including a lot of your peers. It's not just how good an artist you are at any given point that matters. It's also how much you pursue it. I have known many, many artists who didn't have the drive and they didn't stick with it. You can always learn to be better. You can acquire skills like in any other line of pursuit.

Talk about your future goals.

Gene I would like to continue doing the kind of cartoon portrait entertainment I enjoy. Because I do enjoy people and I enjoy that instant gratification, both for them and for myself, of spending six minutes on a drawing and then having it done and having the person just sit there, look at it, and laugh. I really like it. That was one of the problems with the cartoon strips. I could never see anybody's reaction. So, sit somebody down in front of me, and let me draw him or her, and let me see those smiling faces when I'm done.

Studio Experience
Wire Sculptures from Gesture Drawings

Task: To make a series of gesture drawings and create a wire sculpture that emphasizes motion.

Take a look.
- Fig.1–7, Alexander Calder, *Wire Sculpture by Calder.*
- Fig.1–8, Salvador Dali, *Cavalier of Death.*
- Fig.1–22, Tyrus Wong, *Kicking Horse.*

Think about it. Compare Tyrus Wong's drawing of a horse with that of Salvador Dali. Notice how Wong emphasizes the movement and shape of the horse with a few quick lines, whereas Dali has created rounded forms with many overlapping lines. In both drawings, note the main lines that run through the body. In Dali's gesture drawing, follow the lines that extend from the horse's head through the body and into the legs. Follow the implied line that runs through the rider's bent back. These lines suggest movement and form in the gesture drawings.

Do it.
1 Do a series of gesture drawings of figures in action poses, such as dance or sports positions. Use a black marker or a pencil on drawing paper. Draw quickly, looking for the main action lines in each pose. Select one of your sketches to turn into a wire sculpture.

2 Bend sculpture wire with your hands and pliers to create a form that emphasizes the major lines in the figure. Try to create a three-dimensional sculpture. Turn it around to view it from several different angles.

3 Staple the wire sculpture to a wood base. If color is needed, consider painting the base or the wire with acrylic paint.

"I learned that wire has a drawing quality similar to pencil or pen. Using wire makes it possible to draw in 3-D instead of 2-D."

Max Ilizarov (age 17). *Untitled,* 1998. Wire, 8" high (20 cm). Clarkstown High School North, New City, NY.

Helpful Hints
- Use a minimum amount of wire to show just the essence of the form; use more wire for a more solid form.
- Wrap wire loosely around a pencil to form coils in some parts of the sculpture.
- If you add extra lengths of wire to the sculpture, small pieces of wire tend to dangle and not stay in place. So, cut the extra piece of wire slightly longer than what you need, and work it back into the main part of the form.
- Use two different kinds of wire to add contrast to your sculpture.
- Consider modifying your composition to include additional figures.

Check it.
- Analyze the lines in your sculpture. Can you see main action lines that run through your art? Describe these lines.
- Is your sculpture balanced so that it does not topple over?
- Can others tell what action you portrayed in your sculpture?

- If you were to make another piece of art like this, what would you do differently?
- Look at your sculpture from all angles to better determine the success of its design.

Other Studio Projects
1 Using a brush and ink or paint, draw different kinds of lines—thick, thin, straight, curved, fast, slow—without making recognizable images. What are the characteristics of each line? Describe the personality of the lines.

2 Listen to two or three kinds of music for a few minutes each. Without drawing recognizable objects, try to capture the feeling and rhythm of the music with lines only.

Studio Experience
Wire Sculptures from Gesture Drawings

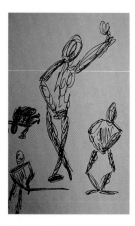

Eileen Kelly (age 14). *Dancing Figures*, 1998. Ink, 12" x 18" (30.5 x 45.7 cm). Notre Dame Academy, Worcester, Massachusetts.

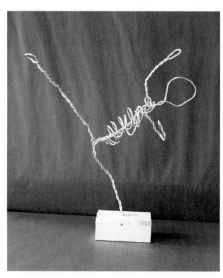

Erin Bednarek (age 15). *The Dancer*, 1998. Aluminum wire, 16" x 18" (40.6 x 45.7 cm). Notre Dame Academy, Worcester, Massachusetts.

Prepare

Time Needed:
Two 45-minute class periods
Lesson 1:
Do gesture drawings.
Lesson 2:
Form the sculptures.

Objectives
Students should be able to

- Understand how line can indicate movement.

- Draw a series of gesture drawings that emphasize motion.

- Use gesture drawings to analyze the main lines and forms in a subject.

- Create a wire sculpture based on a gesture drawing.

Materials
- black markers and/or pencils
- 12" x 18" drawing paper
- sculpture wire (about 5' per student)
- wire cutters, pliers
- wood base (1 per student)
- staple guns and staples
- hammers
 optional:
- acrylic paint
- brushes
- newspapers to cover painting area
- 12" x 18" colored paper

Notes on Materials
- Have students use both white and colored 12" x 18" paper for the gesture drawings—using markers for some poses and pencil for others—to vary this initial sketching process and to create extensions for other projects. Suggest that students try a variety of marker widths to create emphasis with lines of varying thickness. Students may draw more than one figure on a page.

- Provide 14-gauge aluminum sculpture wire, which students can bend with their hands. A 350-foot coil, enough for fifty students, is available from art-supply catalogs. Instead of aluminum wire, copper wire or plastic-covered electrical wire will also work.

- You might obtain wood scraps for the sculpture bases from construction sites and cabinetmakers or woodworking classes. Cut any two-by-fours into blocks.

Before You Start
- Bring in props such as sports equipment and musical instruments for students to hold as they model for the gesture drawings.

- Optional: To plan ahead for the Chapter 2 activity on shape collage, have students do some of their gesture drawings on colored paper and save them to cut out for the collage.

Teach
Thinking Critically
- Review **Think about it** with students. In addition to the suggested images from this chapter, focus on José de Rivera's *Construction 8* (fig.2–11). Ask students to compare the line and amount of stainless steel in this artwork to the amount of wire in Calder's sculpture (fig.1–7). Have students point out implied lines—lines that are suggested but not actually drawn.

- Line may indicate form. Ask students to describe the forms suggested by the lines in these artworks.

- Call on students to explain how each artwork is balanced and seems to support itself. Tell students that they will construct their own wire sculpture so that it is in balance.

Classroom Management

- Have a student stand on a desk or table and strike a pose. Direct him or her to pretend to be doing some specific action, such as dancing, playing a sport, or playing a musical instrument.

- Explain that students should make each gesture drawing quickly, in less than a minute.

- For variety, change models frequently, or pose two students together.

- Remind students that wire has sharp ends. For safety, spread students apart to minimize hazards to the body, particularly the eyes. If possible, use safety goggles.

Tip

If the staples attaching the sculpture to the base do not go completely into the wood, hammer them in. At least three staples are usually needed to keep the sculpture securely on the base.

Assess

Evaluation

Students may evaluate their sculpture by writing a description of it. In addition to the questions in **Check it** in the student text, you and the student may evaluate the success of the sculpture by having the student answer these questions:

- Describe the action in the sculpture. How successfully does it show movement?

- Is the sculpture stable?

- Does the sculpture seem complete?

- Would it benefit from more or less wire?

- Would the design be more pleasing if the sculpture were painted? If it is painted, is the color and application suitable for the design?

- What do you like best about your art?

Extend

Linking Design Elements and Principles

Movement

Instruct students to draw an action sequence in three gesture drawings, varying each pose slightly and using a different colored marker. For example, the first pose, drawn in red, is a kneeling person. In the second, drawn in purple, the person is beginning to stand. In the third, drawn in blue, the person is standing.

Interdisciplinary Connection

Language Arts, Performing Arts

Have students interpret Shakespeare's ghosts and spirits with wire sculptures covered with plaster gauze and painted with watercolors. Direct students to make quick gesture drawings of student models in poses from theatrical scenes, and then create wire sculptures from these drawings. Students then turn the sculptures into ghostlike forms by draping them with pieces of wet plaster-coated gauze. (This plaster-impregnated gauze is available from medical-supply sources or art-materials suppliers.)

Have students discuss the advantage of using gesture drawings to represent theatrical figures. How might set designers make use of gesture drawings?

Inquiry

Alexander Calder created wire sculptures, mobiles, and stabiles. Encourage students to research the types of figures and scenes Calder created with wire. Using their own wire sculpture experience to support their ideas, have students discuss why Calder might have chosen to use wire for these subjects.

Chapter 2 Organizer
Shape and Form

Chapter Overview
- Shapes are created by lines that join to enclose area and have only width and height.
- Forms have width, height, and depth.

Objective: Students will differentiate between various categories of two-dimensional shapes and three-dimensional forms. (Art criticism)
National Standards: 2. Students will use knowledge of structures and functions. (2a)

Objective: Students will create artworks demonstrating an effective use of form and shape. (Art production)
National Standards: 1. Students will understand and apply media, techniques, processes. **2.** Students will use knowledge of structures and functions. (2c)

8 Weeks	1 Semester	2 Semesters				Student Book Features
1	1	1	**Lesson 1:**	Categories of Shapes	Chapter Opener Geometric and Organic Shapes	
0	1	1-2	**Lesson 2:**	Categories of Shapes	Curved and Angular Shapes	Try it: drawing
0	0	1	**Lesson 3:**	Categories of Shapes	Positive and Negative Shapes	Try it: cut paper, About the Artist
0	1	1-2	**Lesson 4:**	Categories of Shapes	Positive and Negative Shapes	Try it: drawing or painting
0	0	1	**Lesson 5:**	Qualities of Shape	Light and Heavy Shapes	Try it: drawing
0	1	1	**Lesson 6:**	Qualities of Shape	Light and Heavy Shapes	Try it: sculpture
0	0	1	**Lesson 7:**	Qualities of Shape	Smooth and Textured Shapes	Try it: rubbing, Try it: collage, About the Artwork
0	0	1	**Lesson 8:**	Qualities of Shape	Static and Dynamic Shapes	Try it: sculpture, Try it: cut paper
0	0	1	**Lesson 9:**	Qualities of Shape	Static and Dynamic Shapes	Try it: sculpture, Try it: cut paper
0	0	1	**Lesson 10:**	Form and Light	Form and Light	Try it: lighting experiment
0	0	1	**Lesson 11:**	Form and Light	Form and Light	Try it: black and white design
1	1	1	**Chapter Review**		Another Look at Shape and Form	Review Questions
1	2	2				

Studio Experience: *Shape Collage*

Objectives: Students will perceive and appreciate artists' use of positive and negative shapes in artworks; demonstrate their understanding of positive and negative shapes in a cut-paper collage using repeated and overlapped geometric and organic shapes.

National Standard: Students will evaluate artworks' effectiveness in terms of organizational structures and functions (2b); create art using organizational structures and functions to solve art problems (2c).

- Light creates highlights and shadows on forms, influencing our perception.

- Shapes may be geometric or organic, curved or angular, positive or negative, light or heavy, smooth or textured, and static or dynamic.

34b

Objective: Students will understand how shapes and forms have been used by artists of different cultures and periods in history. (Art history/cultures)
National Standards: 4. Students will understand art in relation to history and cultures. (4e)

Objective: Students will develop and expand their perceptions of form and shape as art. (Aesthetics)
National Standards: 5. Students will reflect on and assess characteristics and merits of artworks. (5c)

Teacher Edition References	Ancillaries
Warm-up, Design Extension, Context, Interdisciplinary Connection, Materials and Techniques, Cooperative Learning	*Slide*: Indonesia, *Batik* (S&F-1) *Large Reproduction*: Emile Galle, *Aube et Crepuscule (Dawn and Dusk)*
HOTS, Context, Performing Arts	
Design Extension, HOTS, Context	*Slide*: Maurits C. Escher, *Day and Night* (S&F-2)
HOTS, Context	*Slide*: Maurits C. Escher, *Day and Night* (S&F-2)
HOTS, Context, Internet Connection	*Slide*: Alfred Bierstadt, *Sierra Nevada* (S&F-3)
HOTS, Context	*Slide*: Alfred Bierstadt, *Sierra Nevada* (S&F-3)
HOTS, Context	*Slide*: Lucas Samaras, *Chair with Nails* (S&F-4)
HOTS, Context	*Slide*: Guatemala, *Textile* (S&F-5)
HOTS, Context	*Slide*: Guatemala, *Textile* (S&F-5) *Large Reproduction*: Metepec, Teotihuacan. *Goddess holding flowering branches*
Design Extension, HOTS, Context, Portfolio Tip, Interdisciplinary Connection, Performing Arts	*Slide*: India, *Rock-cut Temples* (S&F-6)
HOTS, Context, Portfolio Tip	*Slide*: India, *Rock-cut Temples* (S&F-6)
HOTS, Context, Materials and Techniques	

Vocabulary

dynamic Constantly changing or moving; in a state of imbalance or tension. *(dinámico)*

form An element of design that is three-dimensional and encloses volume. *(forma)*

geometric shape A shape—such as a triangle or rectangle—that can be defined precisely by mathematical coordinates and measurements. *(figura geométrica)*

organic shape A shape that is free-form or irregular; the opposite of geometric shape. *(figura orgánica)*

shape An element of design that is two-dimensional and encloses area. *(figura)*

static Showing no movement or action. *(estático)*

Time Needed
One or two 45-minute class periods (extend as needed).
Lesson 1: Draw figure shapes;
Lesson 2: Cut, arrange, and paste shapes.

Studio Resource Binder
2.1 Design Your Own Monogram
2.2 Animal Sculptures
2.3 Eraser Print Postcards
2.4 Cross-contour Drawings
2.5 Styro-forms, carved/painted sculpture

Lesson 1
Categories of Shapes

pages 34–35

pages 36–37

Objectives

Students will be able to

- Differentiate between two-dimensional shapes and three-dimensional forms and also geometric and organic shapes and forms.

- Draw geometric and organic shapes and forms.

Chapter Opener

- Ask students to examine *Minoan vase decorated with an octopus* (fig.2–2) and describe the octopus shape on the jar and the form of the jar. Guide students to see how the curved shape of the octopus seems to fit the rounded form of the jar. Focus on *Trees* and *Freeway* (figs.2–1, 2–4). Discuss which areas are shapes in the flat photographs and which areas are forms in actuality.

- As students study the *Zapotec Urn* (fig.2–3), explain to them that the Zapotecs were a pre-Columbian civilization in southwestern Mexico. Encourage the students to notice shapes and forms which could be symbolic of rain or lightning. Point

out to them that the shapes around the eyes are reminiscent of clouds. The tongue is split like a snake's which moves as fast as lightning.

- Point out to students that the terms shape and form are often used interchangeably in speech and writing.

Teach: Geometric and Organic Shapes

- Explain to students that geometric shapes are usually precise and sharply defined. On the chalkboard, draw a square, a triangle, and a circle as examples of geometric shapes. Draw an amoeba shape as an example of an organic shape. Tell students that organic shapes are usually more free-flowing.

- Have students look around the room and then list geometric and organic forms that they see.

- Direct students' attention to the images on these pages. Ask students to identify geometric and organic shapes and forms in the images.

- Encourage students to imagine the geometric form of a robot and to contrast this with the organic form of a human. If you have a toy robot and a doll, show these to illustrate this point, or focus on the robot in

fig.2–28. Ask students to look at *Trees* and imagine how this organic form would look if it were drawn geometrically. Each section would probably be drawn quite straight and angular, but perhaps there would be some circular forms in the crown of the tree.

Maria Fetterhoff (age 18). *Kabuki Dancer*, 1997. Etching, 8 ⅝" x 5 ¾" (22 x 14.6 cm). Los Angeles County High School for the Arts, Los Angeles, California.

Computer Connection

Explore organic and geometric shapes in a painting or drawing program. Instruct students to draw a large, filled rectangle on the left side of their screen. Encourage students to cut and drag geometric shapes from the rectangle and create an arrangement of these shapes on the right side of the screen, leaving space between each shape. In a

new document or page, have students repeat this activity but create organic shapes.

After printing copies of each arrangement, students can discuss the different characteristics of the geometric and organic shapes. Ask students if they found it easier to construct the geometric or organic arrangement. Responses will vary. Further discussion will lead students to better understand the unique design problems associated with geometric and organic shapes.

Lesson 2
Categories of Shapes

pages 38–39

Objectives
Students will be able to

- Distinguish between curved and angular shapes.

- Demonstrate their ability to use curved and angular shapes in their own drawings.

Teach: Curved and Angular Shapes

- Ask students to look at the images on these pages, and to identify which have straight, angular shapes, and which have curved shapes. Lead students to compare the sculptures by de Rivera and Tucker, and note how the shapes in the de Rivera are curved and those in the Tucker are straight-edged.

- Direct students to do **Try it** on page 38 by drawing two designs, one with angular shapes and the other with curved shapes.

| **Try it** | page 38 |

Materials
- pencils or markers
- 8 1/2" x 11" paper, white
- compasses, rulers, french curves, triangles

Lesson 3
Categories of Shapes

pages 40-41

Objectives
Students will be able to

- Understand the difference between positive and negative shapes.

- Demonstrate this understanding in their creation of paper collages.

Teach: Positive and Negative Shapes

- Call for a volunteer to stand with his or her left hand on the left hip, and the right hand on the right hip. Be sure all students can see the model. Explain that the model's body is the positive shape and the spaces between the model's arms and body and around the body are the negative shapes.

- Ask students to note the negative and positive shapes in the Popayán headdress in the *Pendant figure* (fig.2–16) and in *Plus Reversed* by Anuszkiewicz (fig.2–13). Guide them in a comparison between the negative and positive shapes in those two works and in *The Library* by Jacob Lawrence (fig.2–15).

- After students have looked at *The Library*, allow them a few minutes to read the information about Jacob Lawrence and then search for shapes within this painting that suggest a library scene. Lead students in discussing why this library was important to him as he explored his African-American heritage and the

significant role it played in the subjects that he painted.

- Have students do **Try it** by cutting, arranging, and pasting black positive shapes. As a variation, students can use the paper from which they cut the positive shape, allowing the cut-out area to repeat the positive shape. Students may evaluate these shape collages by exchanging papers and pointing out the positive and negative spaces.

| **Try it** | page 40 |

Materials
- 8 1/2" x 11" (or larger) paper: white or cream, and black
- scissors
- glue

Lesson 4
Categories of Shapes

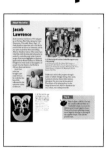

page 41

Objectives
Students will be able to demonstrate their understanding of the difference between positive and negative shapes in their drawing of a still life.

Teach: Positive and Negative Shapes

- In preparation for composing a still life drawing, students should study compositions of still lifes by other artists to understand how they utilized negative spaces. Refer students to fig.3–3, Chardin's *Still Life* and fig.4–2, Janet Fish's *Jump*.

Instruct students to notice what each artist has done with the areas around and behind the main objects. Are they empty or have they been filled with other items?

- Before students begin **Try it** on page 41, demonstrate the use of a viewfinder. Explain that the edge of the opening represents the edge of the picture plane. Show students how they can adjust the distance of the viewfinder from their eye to create more and less space around their subject. On the chalkboard, draw an illustration to show what they might see through their viewfinder as they look at their still life. Point out that viewfinders can be used to select the best positive and negative shape arrangements.

- Set up a simple still life with a few objects such as fruit or bottles. If the class is large, set up several still lifes around the room. Instruct students to use charcoal to draw the negative space around and between the objects in the still life before they draw the positive shapes.

Try it page 41
Materials • 8 1/2" x 11" (or smaller) drawing paper • viewfinders (rectangular cardboard with a cut-out area the size of a postage stamp, or an empty slide frame) • still-life objects ***options:*** • charcoal, or black tempera paint and brushes

Lesson 5
Qualities of Shape

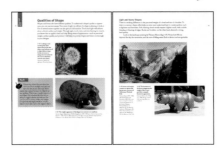

pages 42-43

Objectives
Students will be able to

- Perceive the difference between light and heavy shapes and forms.

- Demonstrate this understanding in their drawings of heavy and light objects.

Teach: Light and Heavy Shapes

- Focus on *Dandelion* (fig.2–17), *Hippopotamus* (fig.2–18), and *Cat* (fig.2–20). Ask students which object is the heaviest, which is the lightest, and how they can know this. Call on students to compare the actual dimensions of the cat and the hippopotamus images.

- As students study Moran's *The Grand Canyon of the Yellowstone*, (fig.2–19) ask them which objects seem to be heaviest. They should determine how important the figures are in this painting. The people seem small and insignificant in the middle of this majestic landscape. Thomas Moran's bigger- and better-than-life paintings of the western landscape inspired many people to move to the West. Moran wrote that he was not satisfied in painting nature as it looked, but considered it his duty as an artist to present the impression that nature made on him. Do the students consider this to be an ethical way to paint?

- Before students begin **Try it** on page 42, collect light and heavy objects such as feathers, flowers, leaves, rocks, wood, and models of animals for students to draw.

Try it page 42
Materials • pencils • 9" x 12" (or larger) drawing paper • collection of light objects and heavy objects

Frank Bassett (age 15). *Pony in the Reeds*, 1997. Sandstone (waste molds from foundry), 8" x 8" x 6" (20.3 x 20.3 x 15.2 cm). Quabbin Regional High School, Barre, Massachusetts.

Lesson 6
Qualities of Shape

pages 42–43

Objectives

Students will demonstrate their understanding of the difference between light and heavy shapes and forms in their sculptures of heavy and light objects.

Teach: Light and Heavy Shapes

Have students complete the **Try it** on page 42 by creating sculptures. Stress that they should create each sculpture with a medium that emphasizes the weight of the object.

Try it page 42

Materials
options:
- wire, wire cutters
- string, scissors, glue
- oil-based clay, clay tools
- wood scraps, woodworking tools

Lesson 7
Qualities of Shape

pages 44-45

Objectives

Students will be able to

- Perceive the difference between smooth and textured shapes and forms.

- Indicate this understanding in either texture rubbings or a collage.

Teach: Smooth and Textured Shapes

- Explain that the surface quality or texture of a form determines the way the form looks. To get students to notice textures, ask them to look around the room and find a rough-textured form. (This might be someone's sweater.) Then ask them to look for a smooth, reflective form. (This might be a wastebasket.)

- When students are looking at Meret Oppenheim's *Object* (fig.2–24), remind them that she was a Surrealist artist. Review with them the meaning of Surrealism. It was a twentieth-century art style in which unrelated objects and situations were often joined. Ask the students what seems to be unrelated in Oppenheim's *Object*. (Rarely do we find fur-covered cups, saucers, and spoons. The texture on this object is unexpected.)

- Call on students to explain why they would look twice at Oppenheim's *Object*. Encourage them to imagine changing the texture of objects in the room; for example, making the sweater shiny and the wastebasket fuzzy.

- Have students do one of the **Try its** on page 44 or 45.

 —If you do not have a collection of textured objects in the room (such as coins, a comb, tree bark, sand paper, bricks, heavy lace, burlap, feathers, and leaves), take students to areas in and around the school to find surfaces for their texture rubbings.

 —For students' texture collage, provide a variety of textured objects, such as beans, feathers, gravel, seeds, and bits of shiny paper and fabric.

Try it page 44

Materials
- copy, typing, or tracing paper
- collection of textured objects
- crayons or soft-leaded pencils

Try it page 45

Materials
- 9" x 12" (or larger) heavy corrugated cardboard
- collection of textured objects
- glue

Lesson 8
Qualities of Shape

pages 46–47

Objectives

Students will be able to

- Understand the impact that static and dynamic shapes can create in a work of art.

- Plan a sculpture or a collage that demonstrates their knowledge.

Teach: Static and Dynamic Shapes

- To demonstrate the difference between static and dynamic shapes, call on one volunteer to lie down on the floor or on a table; have another stand up very stiff and straight; and ask a third to lean against a wall so that his or her body is diagonal to it. Encourage the rest of the students to say any words that come to mind as they look at these poses.

- Direct students to note the feeling of solidarity and permanence in the *Four colossi of Ramses* (fig.2–25). Ask students to contrast this very stable feeling to the movement in Demuth's *Three Acrobats* (fig.2–26) and to describe how Demuth created a feeling of movement in his shapes.

- The Temple of Ramses II (fig.2–25) and the air terminal in Chicago (fig.2–27) are both important buildings for their time. Ask the students how the art shown here enhances each building's purpose or function. Students should consider how the medium of each of these works of art influences the meaning of the art.

- Call on students to name a few monumental forms. They might think of war memorials or monuments or the solid stable form of the school building. Are these forms static or dynamic?

- Guide students to plan and begin one of the **Try its** on page 46 or 47. They will complete their artwork in Lesson 9. For students making a cityscape, suggest they might use dark scraps of colored paper on a 9" x 12" piece of lighter colored paper.

Try it page 46

Materials
options:
- ceramic clay, 2 lbs. per student
- oil-based clay, 1 lb. per student
- clay tools
- toothpicks and oil-based clay, 1/8 lb. per student (use bits of clay to join toothpicks)

Try it page 47

Materials
- colored paper
- scissors
- glue
- X-acto knives

Lesson 9
Qualities of Shape

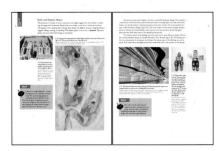

pages 46–47

Objectives

Students will demonstrate their understanding of static and dynamic shapes by completing a sculpture or a collage.

Teach: Static and Dynamic Shapes

- Guide students to complete the sculpture or collage they began in the previous lesson.

- If students wish to fire their clay sculptures, remind them either to keep the clay shapes thin or to hollow out the solid forms before firing. Students might use toothpicks and oil-based clay to quickly create sculptures.

- Display their projects and discuss which seem static and which seem dynamic.

Lesson 10
Form and Light

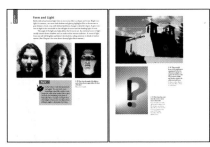

pages 48-49

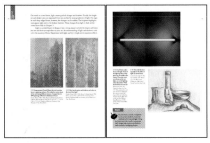

pages 50-51

Objectives

Students will be able to comprehend how light illuminates form and influences our perception of forms.

Teach:

- Explain to students that the type and strength of light shining on a form determines how we see this form. Focus on *Fiat Lux: Birds on the Beach* (fig.3–2) and guide students to see the way the light defines the texture of the landscape.

- Direct students' attention to the photograph of the church at Ranchos de Taos, New Mexico. Explain to students that Georgia O'Keeffe was fascinated by the form of the broad buttresses at the rear of this church and how changing light and shadows played over these forms. In 1929 and 1930 she created numerous paintings of these simple, bold, adobe walls. Encourage students to guess the function of these massive rounded forms near the corners of this structure. Buttresses were often used in European Romanesque and Gothic churches to support the heavy walls.

- Turn off the lights in the room and shine a flashlight on a student's face, moving the light nearer and farther from the face and at different angles around the face—above, below, and at a sharp angle on the side. Ask students to notice where the light is when it produces the darkest and then the longest shadows.

- Encourage students to find magazine fashion photographs with a dramatic use of light. Lead students to analyze these photos to determine where the light source is in each.

- Have students do **Try it** on page 48. Encourage groups of four or five students to experiment with the light to make the shadows very dramatic. Students may either sketch or photograph these arrangements. Guide students to discuss how varying the angles of light shining on an object changes the shape of the shadows.

Try it page 48

Materials
- collection of objects with varying surfaces and angles
- floodlight or lamp
 options:
- camera and film
- 9" x 12" (or larger) drawing paper, pencils or charcoal

Lesson 11
Form and Light

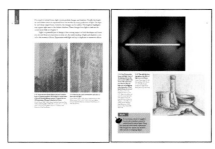

pages 50–51

Objectives
Students will be able to

- Comprehend how light illuminates form and influences our perception of forms.

- Demonstrate their understanding of this idea in their drawings of shadows.

Teach:

- Ask students what clues they would use to determine the time of day if they went outside without a watch. (Shadows and the position of the sun would indicate the time of day.) If no one mentions using the principle of a sundial, remind students of how sundials use shadows to indicate time. If necessary, explain that shadows are longer early and late in the day.

- Focus on Monet's paintings of the Rouen Cathedral (figs.2–32, 2–33) and call on students to explain how they know it is the time of day stated in each caption. Explain to students that Monet exhibited twenty versions of this cathedral in 1894. Although Monet was painting an image of the church, his real subject matter was light, shadows, and color.

- Before students begin **Try it** on page 51, scout out interesting shadows around the school at the time of day the class meets. Stair railings and bicycle racks often produce unusual shadows. Direct students to lay their paper on the floor or ground so that shadows fall on the paper. Have students select striking shadows and draw them with pencil. They may fill them in with ink or markers. As students display their work, discuss not only the shadow shapes but also the positive and negative shapes.

Try it page 51

Materials
- 18" x 24" paper, white
- pencils
- india ink and brushes, or wide-tipped black markers

34h

Judy Chen (age 16). *Carrot and Pepper.* Colored pencil. Los Angeles County High School for the Arts, Los Angeles, California.

Chapter Review

pages 52-53

Assess

- Assign students to write the answers to the review questions. Check their answers to ascertain that they are able to differentiate between various categories of two-dimensional shapes and three-dimensional forms. **(Art criticism)**

- Direct students to review the images in the chapter, select three pieces of art each of which are from a different culture, and describe the types of shapes and forms that are in these works. They should also explain how these shapes and forms enhance the function or meaning in this art. **(Art history/cultures, Art criticism)**

- Review with students the images of shape and form in this chapter. Lead them in imagining that they are museum curators compiling a list of art that they would like to exhibit. Which two images from this chapter would they include as excellent examples of shape and form and which two would they exclude? Instruct them to write an explanation for their choices using terms for shape and form which they learned in this chapter. This exercise will indicate development in students' perceptions of form and shape as art. **(Aesthetics)**

- With each student, review his or her work for evidence of an understanding of the effective use of curved and angular, positive and negative, light and heavy, smooth and textured, and static and dynamic shapes, as well as an understanding of the effects of light on form. **(Art production)**

Answers to Review Questions

1 A shape is two-dimensional, with only height and width; but a form is three-dimensional, with height, width, and depth. Examples of related shapes and forms might be a triangle to a triangular pyramid, a square to a cube, or a silhouette of a face to the actual face.

2 A geometric shape (such as a circle, square, or triangle) is a shape that can be defined precisely by mathematical coordinates and measurements. An organic shape (such as a plant, animal, or rock formation) is similar to forms found in nature, and is often rounded, curved, free-form, and irregular.

3 Positive shapes are the tangible representations of the solid forms in a design, whereas negative shapes are the areas that surround the positive shapes. Answers will vary.

4 Six qualities of shape are light, heavy, smooth, textured, static, and dynamic. For example, Botero's *Cat* (fig.2–20) is a heavy, smooth, and static form.

5 Light creates highlights and shadows, which define the form. Monet, Kumi Yamashita, and many other artists were interested in the effect of light on form.

6 Oppenheim's *Object* is a cup and saucer covered with fur. Usually this fur texture is not found on cups and saucers. It is considered surrealist in style.

7 Jacob Lawrence often depicts important figures and events in African-American history. He is African-American and these are the subjects that he knows best.

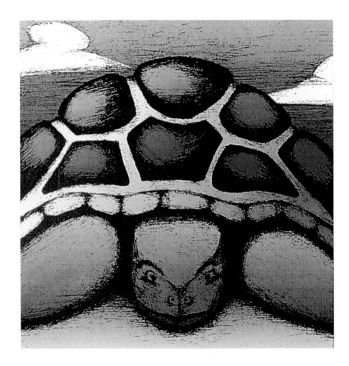

Michael Colucci (age 17). *Digital Tortoise*, 1998.
Computer graphic, 8" x 8" (20.3 x 20.3 cm).
Haverford High School, Havertown,
Pennsylvania.

34i

Michael Pacheco (age 18). *Unusual Relationships*, 1997. Colored pencil, 18" x 24" (45.7 x 61 cm). West Springfield High School, Springfield, Virginia.

Reteach

- Focus on the images on pages 52 and 53. Review the difference between geometric and organic forms and shapes. Ask students to list the geometric and then the organic shapes and forms in these images. Tell students that there are organic shapes in some of the human-made artworks. (The cactus is organic, as are some of the shapes in the Matisse collage and the Sharaku print.)

- Ask students which images use both curved and angular shapes. (*Les Cadona* [fig.2–38] and *Phoenix* [fig.2–36].)

- Review the difference between negative and positive shapes and forms. Call on students to select one of the images that they think uses negative space effectively and to point out the negative space to the rest of the class.

- Ask students which shapes and forms seem heavy and which seem light. Have students explain how the artists achieved this effect.

- Direct students to find examples of smooth and textured forms among these images. Ask how light was used to emphasize the texture of the forms.

- Lead students to discuss which shapes and forms pictured seem static and monumental and which seem dynamic with movement. Encourage students to explain how the artist created the sense of stability or movement.

Meeting Individual Needs

Students Acquiring English

Discuss and display visual examples of:

- organic and geometric shapes

- abstract and realistic forms

- traditional designs from various cultures (such as African, Asian, South American, and Native American) that exemplify different shapes or different types of forms.

Gifted and Talented

To demonstrate an understanding of the relationships between shapes and forms in design, have students create a sculpture using geometric or abstract forms. Students may construct the materials or use found objects. Upon completion, give each student the opportunity to express a new insight about the interaction of shape and form that he or she gained while creating the sculpture.

Students with Special Needs

Fine Motor Deficiency

Because kinesthetic problems might pose difficulty when cutting out shapes, provide colorful, precut shapes for students to identify as geometric or organic.

Students with Special Needs

Auditory Learners

Auditory learners may have difficulty with visual discrimination such as matching letters or forming shapes. Guide them to identify sounds which seem geometric or regular (a clock ticking), and sounds which seem organic or free-flowing (ocean waves). Students may move like robots or machines and then move in a freer, more organic way. Encourage them to correlate their movements to specific geometric or organic sounds (or musical selections).

2 Shape and Form

WHEN A LINE CURVES AROUND and crosses itself or intersects other lines to enclose a space, it creates a shape. Similar to a silhouette or an outline, a *shape* is two-dimensional. It has height and width, but no depth. It has one boundary and a single surface. We can easily identify many objects, from guitars to light bulbs, by their shape alone.

The word *form* describes something with three dimensions: length, width, and depth. Forms usually have weight and solidity. They may have only one continuous surface, like a Ping-Pong ball. Or they may have many surfaces, like a fish tank or a pinecone.

2–1 Consider the variety of shapes and forms that can be found on a single tree.
Trees. Photo by A. W. Porter.

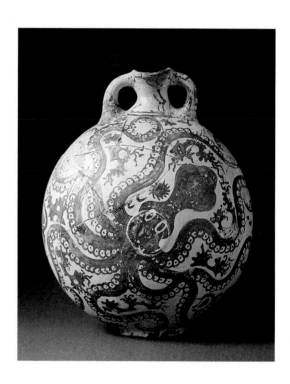

2–2 The artist has allowed the familiar shape of an octopus to surround this jar.
Minoan (from Palaikastro). *Minoan vase decorated with an octopus,* c. 1500 BC. 11" high (28 cm). Archaeological Museum, Herakleion, Crete, Greece.

Chapter Warm-up

To teach the difference between shape and form, have students examine a sheet of notebook paper. Explain to them that it has width and height, but not much depth. It is a shape. Guide students to roll the paper into a cylinder, with the two ends touching, and tape these together. Then have students flatten the cylinder and crease it twice to create a block form. Discuss how this has now become a form with height, width, and depth. Call on students to list shapes and forms that they can see in the artroom and out the window.

Sculptors, architects, and product designers generally work with forms. They create solid structures, which have actual volume. Cartoonists, painters, photographers, and collage artists, on the other hand, usually work in two dimensions, even when they are depicting forms. When an artist paints an apple, for example, he or she may use the apple's shape and add shading to create the illusion of three-dimensionality, or form. But the image itself has only two dimensions.

2–4 Designed for quick, efficient, and safe travel, a highway interchange creates sweeping forms in the landscape.
Freeway. Photo by J. Selleck.

2–3 The figure is created from a series of well-defined and precisely cut forms.
Pre-columbian (Zapotec, AD 200–900), *Urn in the form of Cocijo, God of Lightning and Rain,* from Monte Albán IIIa, AD 400–500. Fired clay, 28 1/2" x 21" x 18" (72.4 x 53.3 x 45.7 cm). Kimbell Art Museum, Fort Worth, Texas. Photo by Michael Bodycomb, 1987.

Context
The Zapotec were a pre-Columbian civilization that developed in what is now the Mexican state of Oaxaca. Ceramic sculpture was the primary art form of the Zapotec. Although their sculptures show little variation in type and the poses are standardized, the quality of these pieces is in the strength and vigor of their form and the precision of their execution.

Design Extension
Ask students to describe the form of the trees in fig.2–1. Lead them to think of metaphors for this shape. Examples: The trees are lace, or they are sentinels, or they are squirrel apartment houses. Have students draw a tree, as they see it in nature. Encourage them to write a metaphor for their tree and then draw the tree to emphasize the metaphor.

Categories of Shapes

Artists and designers use various types of shapes and forms to create their finished products. In this chapter, you will explore these types and how they affect you as both artist and viewer. Although the following sections often refer specifically to shapes, in most cases, the information may be applied to both shapes and forms.

Geometric and Organic Shapes

Shapes fit easily into two basic categories: geometric and organic. *Geometric shapes* are precise and sharply defined. Many of them are easy to recognize, such as circles, squares, and triangles. We often see such shapes in architecture. Also, many manufactured and hand-made products are based on geometric shapes. Nature shows us some geometric shapes and forms too. Honeybees make combs whose cells are in the shape of a hexagon, and an orange resembles the form of a sphere.

2–5 These rock formations have been shaped by natural forces such as wind and water.
Rock. Photo by A. W. Porter.

2–6 David Smith sculpted many similar works, which he also called *Cubi.* In all of them, he explored design problems dealing with simple geometric forms in space.
David Smith (1906–65). *Cubi XIV,* from the *Cubi* series, 1963. Stainless steel, 122 ½" high (311.2 cm). Purchase: Friends Fund. 32:1979, The Saint Louis Art Museum. ©Estate of David Smith, Licensed by VAGA, New York, NY.

Although you may recognize certain geometric shapes in nature, most natural objects have *organic shapes*. Organic shapes reflect the free-flowing aspects of growth. They are often curved or rounded and appear in a variety of informal and irregular shapes. The form of a pear is organic. So too is the shape of a maple leaf.

Look at the geometric and organic shapes and forms on these pages. Do you see obvious differences and similarities? The painting by Joan Miró (fig.2–8) uses mostly organic shapes that are curved and round. The photograph of the *Bonaventure Hotel* (fig.2–7) shows that the structure is made up of geometric forms—both straight-edged rectangular forms and curving cylindrical ones.

Materials and Techniques

Drypoint is a printmaking technique, so called because no acid bath is needed to create the printing plate. To create a drypoint, the artist uses a sharp tool, such as an etching needle, to scratch a design into a plastic or metal plate. This process creates burrs, which hold the ink the same way as intaglio (incised) lines. The plate is then inked and pulled in the traditional manner.

37

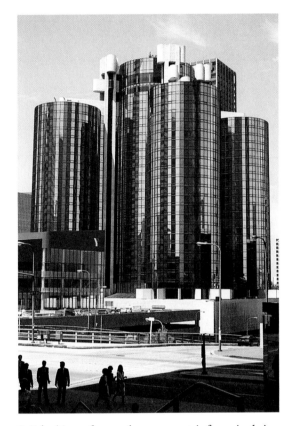

2–7 Architects frequently use geometric forms in their building designs. The cylindrical towers of glass and steel lend an air of elegance to the design of this hotel.

John Portman (b. 1924) and Associates. *Bonaventure Hotel*, 1975. Los Angeles. Photo by A. W. Porter.

2–8 How would you describe the various shapes that Miró uses in this work?

Joan Miró (1893–1983). *Series Black and Red (Série noire et rouge)*, 1938. Drypoint printed in black and red, 6 ⅝" x 10 ¼" (16.8 x 25.8 cm). ©The Cleveland Museum of Art, 1998, Bequests of Charles T. Brooks and Grover Higgins by exchange, 1981.25. ©1999 ARS, New York/ADAGP, Paris.

slide and a microscope that projects an enlarged image. Put a drop of salt water on the slide, and project the image on a screen. As the water evaporates, students can watch the crystals grow. Go through the same process with sugar and with alum. Have students paint watercolor pictures based on the crystal shapes.

Context

The Spanish painter Joan Miró is considered one of the leading figures in the Surrealist movement. For many years, he lived and worked in Paris, France.

Curved and Angular Shapes

Geometric and organic shapes may be either curved or angular. Shapes that are curved are graceful, and because the eye rapidly sweeps along them without interruption, they tend to imply movement.

Angular shapes, on the other hand, are straight-edged. They suggest strength and regularity. When you look at angular shapes, your eyes move along the shape and stop momentarily where one shape connects with another. These meeting or opposing shapes may add a sense of tension to a design. If an angular shape, for instance, leans to one side, it might suggest movement.

Compare the sculptures by José de Rivera (fig.2–11) and William Tucker (fig.2–12). The curved shapes of the first piece describe movement that is both fluid and predictable. The second sculpture expresses quite a different feeling. The objects leaning into one another give the piece a sense of tension. Although both sculptures convey motion, Tucker's sculpture shows opposing thrusts of horizontal, vertical, and angular forms.

Context
The shell of the nautilus is lined with mother-of-pearl. A chambered nautilus, a type of mollusk, is depicted here: its interior consists of a series of progressively larger compartments. The nautilus inhabits the largest, most recently made compartment.

2–9 The shape of the nautilus shell is more clearly defined by the bands of colors that accent the curve of the shell.
Nautilus shell. Photo by A. W. Porter.

2–10 The intertwining of these roots makes strong angular shapes.
Tree roots. Photo by A. W. Porter.

Higher-Order Thinking Skills
Guide students to classify the images on these two pages as either curved or angular. Focus on *Series Black and Red* (fig.2–8), which includes both angular and round shapes. Ask to which classification the entire composition seems to belong.

Try it
To explore the contrasting feelings of different shapes, draw two designs. Construct one with only curved shapes. Construct the other with only angular shapes. You may use rulers, compasses, french curves, and triangles to help you create the shapes.

Performing Arts
Globe Theater
Ask students what shape is formed by the proscenium in their school auditorium, or in any other area auditorium. The proscenium is probably not circular, but explain that in

2–11 This sculpture is made with a forged rod of stainless steel.

José de Rivera (b. 1904). *Construction 8*, 1954. Stainless steel forged rod, 10" x 16" x 13" (25.4 x 40.6 x 35.5 cm) including base. The Museum of Modern Art, New York. Gift of Mrs. Heinz Schulz. Photograph ©1998 The Museum of Modern Art, New York.

2–12 Notice the similarities between these cylinders and the roots in fig.2–10.

William Tucker (b. 1935). *Untitled*, 1967. Steel, 80" high (203 cm). Franklin Murphy Sculpture Garden, University of California, Los Angeles. Photo by J. Selleck.

Context

José de Rivera was born in West Baton Rouge, Louisiana, and became a self-taught sculptor. As the son of a sugar-mill engineer, he acquired the skills necessary to fit pipes and repair machinery, a background ideally suited to a career as a sculptor of metals. After machining his pieces, de Rivera polished them with a series of abrasive treatments, ending with a jeweler's buffer.

sixteenth-century England, one of the earliest playhouses was a round theater called the Globe Theater, which opened in 1599 and where many of Shakespeare's plays were staged. Have students debate the advantage of seeing a play in a circular theater versus one on a rectangular proscenium stage.

Positive and Negative Shapes

Every design—whether it is a painting, sculpture, building, or photograph—is made of positive and negative shapes. Positive shapes are the tangible, actual aspects of a design. In painting or drawing, they often represent solid forms, such as a bowl of fruit in a still life. In sculpture, the positive shapes are the solid forms of the sculpture itself.

Negative shapes are the areas that either surround the positive shapes or exist between them. In a still-life painting, they are the spaces around the bowl of fruit, between fruit forms, or in the background. In sculpture, the negative shapes are the empty spaces around and between the solid forms.

Positive and negative shapes are equally important. A successful design is one that carefully balances both. Look at the pre-Columbian *Pendant figure* (fig.2–16). Notice that the artist placed two curved openings above the figure's arms. These negative shapes echo both the curves of the figure's headdress above and those of the blade below. Together, the positive and negative shapes create a unified whole.

Sculptures and silhouettes present a strong contrast between positive and negative shapes. Sometimes, however, an artist prefers to blur the boundaries between them. Study *Plus Reversed* by Richard Anuszkiewicz (fig.2–13). Can you tell which shapes are positive and which are negative?

2–13 Anuszkiewicz explores optical illusion in his art, and his work helped lead the way to the development of the 1960s art movement called Op Art.
Richard Anuszkiewicz (b. 1930). *Plus Reversed,* 1969. Oil on canvas, 74 ¾" x 58 ¼" (189.6 x 148 cm). Jack S. Blanton Museum of Art, The University of Texas at Austin, Gift of Mari and James A. Michener, 1991. Photo by George Holmes. ©Richard Anuszkiewicz, licensed by VAGA, New York, NY.

2–14 The effectiveness of this piece relies heavily on the contrast between its positive and negative shapes.
Anna Atkins (1799–1871). *Pink Lady's Slipper, Collected in Portland (Cipripedium),* 1854. Cyanotype, 10 ³/₁₆" x 7 ¹⁵/₁₆" (25.8 x 20.2 cm). J. Paul Getty Museum, Los Angeles.

Try it

Create a design in which you balance positive and negative shapes. Use a sheet of white or cream-colored paper to represent the negative shapes. Cut a number of positive shapes from black paper. Arrange these into a variety of positions, and study the kinds of negative shapes you can produce. When you are satisfied with your design, glue down the black shapes.

Design Extension

Focus on the positive and negative shapes in Anna Atkins's *Pink Lady's Slipper* (fig.2–14). Have students note the shapes created with the plant and the edge of the page. Ask students to create a similar artwork by arranging leaves on light-sensitive paper (blueprint paper, which develops in water). Darken the room, and instruct students to lay the leaves on blueprint paper taped to stiff cardboard. As they arrange their leaves, encourage them to be aware of the negative shapes between the leaves and the edge of the paper. Have students place a piece of black paper over their arrangement, move to the sunlight, and remove the black paper to expose the arrangement to sunlight until the blue paper is almost white. Then help students to develop their work in water.

Jacob Lawrence

Jacob Lawrence was born in 1917 and grew up in Harlem, New York, during the Great Depression. The public library (fig.2–15) there played an important role in his life: he took his first art class in its basement, and he also spent many hours there researching African-American history. This research provided him with the ideas and information he needed to create his many series of painted images. Each series highlights an important figure (such as Harriet Tubman or Frederick Douglass) or event (such as the migration of people from the South to the North) in African-American history.

Jacob Lawrence has brought a personal vision to his work that has been little influenced by the upheavals within modern art.

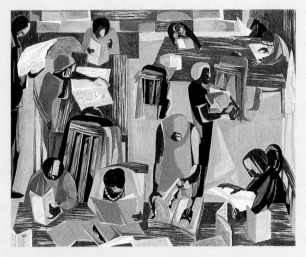

2–15 How has Jacob Lawrence unified the negative areas of this painting?

Jacob Lawrence (b. 1917). *The Library*, 1960. Tempera on fiberboard, 24" x 29 ⅞" (60.9 x 75.8 cm). National Museum of American Art, Smithsonian Institution, Washington, DC. Photo National Museum of American Art, Washington, DC/Art Resource, New York.

Unlike most artists who progress through a variety of stylistic changes during their career, Lawrence's style has shown little variation throughout the sixty years he has painted. The subjects of his painting focus on the things he knows best: African-American history, culture, and contemporary life.

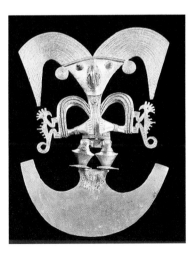

2–16 Note how the negative (empty) areas in this figure form an important part of the overall design.

Popayán (Cauca). *Pendant figure with headdress,* 1000–1600 AD. Cast and hammered gold, 6 ½" x 4 ¾" (16.5 x 12.1 cm). Museo del Oro, Banco de la República, Bogotá.

Higher-Order Thinking Skills

Buckminster Fuller was inspired by the shape of the dandelion to create his geodesic dome—a lightweight, easy-to-assemble but strong structure. (A well-known geodesic dome exists at EPCOT Center in Orlando.) Ask students to compare the geodesic dome with the structure of a dandelion.

Qualities of Shape

Shapes and forms also have different qualities. To understand a shape's quality or appearance, you can use your senses. Your sense of sight can tell you if a shape is pleasing to look at. Use of several senses together can also give you information. Touch and sight will tell you about a form's surface and weight. Through sight, touch, taste, and even hearing its crunch, you know that an apple is hard and crisp. Being aware of appearances—such as perceived weight, surface quality, and position—will help you portray shapes and forms convincingly in your designs.

2–17 Looking at and touching the white downy head of the dandelion weed informs us of its light delicate shape. Its fine structure is designed to be set free by the wind to distribute seeds for new plants.
Dandelion (Taraxacum officinale). Photo by J. Scott.

Try it

Choose two objects that are about the same size. Draw one light and soft, and draw the other heavy and solid. Try to capture the contrast between the objects' surface qualities. Then create a small sculpture of each object. Use materials like thin wire or string to suggest airiness and delicacy. Use clay or wood to convey solidity and weight. Compare the two representations of each object to each other and to the original object.

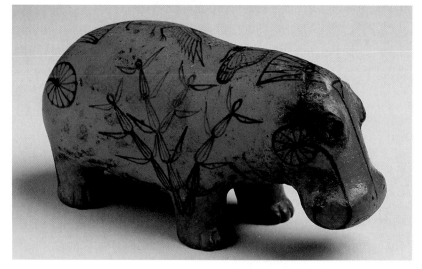

2–18 The weighty appearance of this hippo is in contrast to its small size.
Ancient Egypt. *Hippopotamus,* Middle Kingdom (c. 1991–1784 BC) or Second Intermediate Period (c. 1784–1570 BC). Blue faience, 8" x 3 ¾" (20.3 x 9.2 cm). Museum Appropriation. ©Museum of Art, Rhode Island School of Design. Photo by Del Bogart.

Internet Connection

Encourage students to research Buckminster Fuller, synergetics, and geodesic domes on the Internet. They may print their favorite illustration of a geodesic dome.

Light and Heavy Shapes

There is a striking difference in the perceived weight of a cloud and that of a boulder. To draw or construct shapes effectively, an artist must understand how to convey qualities such as lightness and heaviness. Soft, floating clouds usually require a lighter touch, with a subtle blending or blurring of edges. Rocks and boulders, on the other hand, demand a strong, hard quality.

Look at the landscape painting by Thomas Moran (fig.2–19). Notice how Moran depicted the sky, the mountains, and the mist of falling water. Each is distinct and recognizable.

Context
British-born Thomas Moran was the official artist for an 1870 U.S. government expedition to Yellowstone. Two of the paintings that resulted from the expedition, one of which was *The Grand Canyon of the Yellowstone* (fig.2–19), were purchased by Congress for the Capitol, and the artworks are often credited with helping to encourage the creation of a national park system.

2–19 Artists and tourists continue to capture this famous area, now part of Yellowstone National Park.

Thomas Moran (1837–1926). *The Grand Canyon of the Yellowstone*, 1872. Oil on canvas, 7' x 12' (2.13 x 3.66 m). Lent by the Department of the Interior Museum. National Museum of American Art, Smithsonian Institution, Washington, DC. Photo National Museum of American Art, Washington, DC/Art Resource, New York.

2–20 The heaviness of the forms exaggerates the weight of the cat and provides a uniquely humorous appearance.

Fernando Botero (b. 1932). *Cat*, 1984. Bronze, 119 ¾" (304 cm) long. Photo by J. Selleck.

Context
The human figures that Botero depicts show a resemblance to *Cat* (fig.2–20). Big, bulbous characters populate his paintings, which often are satirical in nature. A prolific artist, Botero has executed more than 1,000 paintings and over 6,000 drawings. He produces a multitude of sketches for each painting and sculpture he creates.

Smooth and Textured Shapes

Another important quality of a shape is its surface. Is the surface flat and reflective like a pane of glass? Or is it rough and pitted like tree bark? Your eyes and your fingers move easily across the smooth surfaces of glass, sanded wood, polished metal, and plastic. The speed of your observation is slowed by a textured surface, such as an intricately knitted sweater or the shell of a turtle.

Light strongly affects the surface qualities of a shape. A smooth surface reflects light easily, and the reflections can be very bright. A heavily textured surface tends to absorb light, thereby reflecting far less. Notice the difference between the smooth and textured surfaces in fig.2–23.

By emphasizing surface qualities, artists can create shapes and forms that are both interesting and lifelike. Pay attention to surface quality: doing so can help you appreciate the unique and the not-so-unique—in nature, in art, and in everyday objects.

2–21 How has the nighttime lighting enhanced the outer surface of this theater?
Welton Becket (1902–69) and Associates. *Mark Taper Forum*, Music Center, 1964–69. Los Angeles. Photo by A. W. Porter.

2–22 The artist uses smooth shapes to create a flowing sense in the chair's construction.
Alan Siegel (1913–78). *Torso Chair*, 1977. Silver painted wood, 47" x 29 ½" x 24" (119 x 74.9 x 61 cm). Courtesy of the Frederick R. Weisman Art Foundation.

Try it

Use lightweight paper and crayons or soft-leaded pencils to create rubbings. Choose a variety of surfaces: smooth, textured, and a mixture of both. Place the paper on the surface. Then rub a crayon across it until the surface texture becomes apparent. These experiments will help you create various surface textures in your own designs.

Context

The *Mark Taper Forum* (fig.2–21) is a small, award-winning theater that is part of the Music Center in downtown Los Angeles. Part of the same complex is the Dorothy Chandler Pavilion. The pavilion is used primarily for symphonies, operas, and some dance performances. The Academy Awards have also been featured there.

Higher-Order Thinking Skills

Direct students to notice the way Janet Fish used the smooth surfaces with reflections in *Jump* (fig.4–2). Ask them to look through the book and identify another particularly striking use of textured forms.

2–23 This student work demonstrates an effective combination of smooth and textured surfaces. The smooth, reflective wire and marbles stand out from the colored paper which absorbs the light.

Josh Jones (age 19). *Wire Screen.* Wire, colored paper, marble, 12" high (31 cm). Montgomery High School, Skillman, New Jersey.

Try it

Gather items with intriguing textural surfaces, such as pieces of tree bark, grains of sand, and various seeds. Design a texture collage by gluing the items onto different areas of cardboard. You might create a design that combines geometric and organic shapes.

45

About the Artwork

Meret Oppenheim

Object

We expect common objects to have certain recognizable surface textures. Artists, however, sometimes transform everyday items into ones that are surprisingly eerie and bizarre. Meret Oppenheim, the creator of *Object,* was a Swiss artist of Surrealism, a twentieth-century style of art in which artists combine normally unrelated objects and situations.

The idea for *Object* was born during an encounter between Oppenheim and Picasso in the Café Flore in Paris. Picasso admired Oppenheim's bracelet, which was made from brass and covered with fur, remarking that anything might be covered with fur. The story goes that Oppenheim then requested some hot water for her tea that had grown cold. The expression in French for a warm-up is *un peu plus de fourrure* ("a little more fur")—and the seed for the concept was planted.

Continuing the train of thought begun by her conversation with Picasso, Oppenheim, after leaving the café, immediately headed for a department store to purchase a teacup and spoon. The result was her renowned fur-lined cup, which is simply called *Object.*

The first few times that *Object* was exhibited, it received both praise and anger from the public. Unusual effects, such as those in *Object,* can provoke a strong psychological reaction in the viewer—even when the original form is simple and innocent. *Object* became the symbol of Surrealism; it is almost always mentioned in any discussion of the movement.

★ **Higher-Order Thinking Skills**
Focus on Frank Lloyd Wright's *Kaufmann House* (fig.1–13), and have students note the contrast of textures on the building. Wright used rocks quarried from the site to build the chimney and walls. Guide students to see how this texture contrasts with the smooth glass and concrete railings on the cantilevered decks.

2–24 Why does this artwork make many people feel so uncomfortable?

Meret Oppenheim (1913–1985). *Object (le dejeuner en fourrure),* 1936. Fur-covered cup, saucer, and spoon; cup 4 ⅜" (10.9 cm) diameter; saucer 9 ⅜" (23.7 cm) diameter; spoon 8" (20.2 cm) long; overall height 2 ⅞" (7.3 cm). The Museum of Modern Art, New York, Purchase. Photograph ©1998 The Museum of Modern Art, New York. ©1999 ARS, New York/ProLitteris, Zurich.

Static and Dynamic Shapes

The position of a shape or form is important and might suggest rest and stability or a feeling of energy and movement. Shapes that are in either a vertical or a horizontal position will appear to be standing still or resting; these shapes are *static*. Leaning or diagonal shapes suggest falling, running, or climbing. The shapes appear to be active, or *dynamic*. Dynamic shapes are associated with change or movement.

2–25 Describe how the artist achieved a sense of stability and permanence in these gigantic figures.

Ancient Egypt. *Four colossi of Ramses,* c. 1257 BC. From the Temple of Ramses II, 59' high (18 m). Abu Simbel. Photo by Richard Putney, University of Toledo, Toledo, Ohio.

Try it

Create two small sculptures—a static arrangement and a dynamic arrangement. You may use clay, paper, or toothpicks joined with bits of clay. Note the category of shapes you use to create each sculpture: Do you rely on certain categories to make a static arrangement and others for a dynamic one?

2–26 Compare the sweeping motion of these figures with the static poses of Ramses II (fig.2–25). What words would you use to describe each?

Charles Demuth (1883–1935). *Three Acrobats,* 1916. Watercolor and graphite on paper, 13" x 8" (33 x 20.3 cm). Amon Carter Museum, Fort Worth, Texas.

An artist may use static shapes to produce a peaceful landscape design. For example, a combination of vertical trees and a horizontal stream can imply quiet and calm. But static shapes can also be used to convey permanence and power. Look at the monumental carvings at Abu Simbel, in Egypt (fig.2–25). The static shapes of this ancient temple display a sense of solidity and immovability; such constructions announced to all that the great pharaohs who built them were to be obeyed and respected.

To achieve a more active feeling, an artist must turn to more dynamic shapes. Notice the curved and fluid shapes in Charles Demuth's *Three Acrobats* (fig.2–26). The shapes produce an atmosphere of movement and change; the figures seem to be whirling across the paper. Soft watercolors and light pencil lines underneath add to the airiness of the design.

2–27 The United Airlines terminal at Chicago's O'Hare International Airport uses dynamic shapes to create an eye-catching show for travelers.
Michael Hayden (b. 1943). *Sky's the Limit*, 1987. Neon tubes and mirrors, controlled by computers with synchronized music, 744' long (226.8 m). United Airlines Terminals, O'Hare International Airport, Chicago. Courtesy of United Airlines.

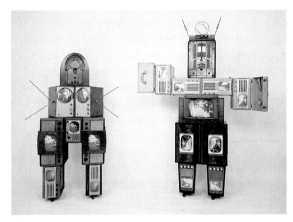

2–28 These robot sculptures by Nam June Paik are made of actual TVs and radios. The boxlike forms convey a sense of rigidity and awkwardness, but the lights and sounds of the TV screens and radio speakers add a dynamic quality that is not apparent in a still photograph.
Nam June Paik (b. 1932). *Family of Robot: Grandfather and Grandmother*, 1986. Video sculpture, grandmother: 80 ¾" x 50" x 19" (205 x 127 x 48 cm); grandfather: 101" x 73" x 20 ½" (256.5 x 185 x 52 cm). Courtesy of the Holly Solomon Gallery, New York.

Try it

Use only vertical and horizontal shapes to make a cityscape from cut paper. Contrast this to a work that emphasizes diagonal or other dynamic shapes. How are the works different?

★
Higher-Order Thinking Skills
Focus on Nam June Paik's *Family of Robot* (fig.2–28) and call on students to contrast the stable features with the dynamic aspects of this sculpture. Ask students to cite forms and shapes (such as blinking neon signs or video displays) in their community that are static but involve movement, as in this artwork.

Context
Nam June Paik was born in Seoul, Korea, and educated in Tokyo and Germany. He now lives in New York and incorporates electronics into his artwork. He is anti-TV, and in his work, he often stresses the negative aspects of TV.

Form and Light

Both artificial and natural light have an enormous effect on shapes and forms. Bright sunlight, for instance, can create dark shadows and glaring highlights. But as the sun sets or goes behind a cloud, crisp, well-defined landforms change to dark, flat shapes. A great contrast in light is also noticeable in the soft light of sunrise and the dazzling light of noon.

The angle of the light also helps define the forms we see. An overhead source of light usually creates shorter shadows and can make surface textures indistinct. A source of light from one side will lengthen and distort the shadows, calling attention to details of surface texture. (See Chapter 6 for more about the way light affects textures.)

2–29 How does the angle of the light in each of these three images define the form of the face?

Photos by T. Fiorelli.

Interdisciplinary Connection

Literature—Have students draw forms and shapes—such as trees —described in literature. For example, in *House on Mango Street,* Sandra Cisneros refers to four skinny trees growing up through cracks in the sidewalk —trees "with skinny necks and pointy elbows like mine." Henry Wadsworth Longfellow refers in *Evangeline* to the "murmuring pines and hemlocks that stand like Druids of old"; and in the *The Village Blacksmith,* to "the spreading chestnut tree."

Try it

Collect objects with varying surfaces and angles. You may wish to use something round, like a globe; something with a flat, shiny surface, like a piece of metal; and something with pleats or folds, like fabric or paper. Cast light from a floodlight or lamp onto the objects from different angles to dramatize the forms.

Performing Arts
Indonesian Shadow Puppets

Ask students if they ever made shadow images on the wall, creating visual forms with just their hands and light. For centuries, puppeteers on the island of Java, in Indonesia, have used intricately cut-out painted paper shapes to produce an array of shadow characters. The puppeteers use these puppets to perform stories of the eternal conflict between good and evil.

Design Extension

Kumi Yamashita (fig.2–31) believes that we should not have any preconceived ideas about the shape of shadows created by light on objects. Have groups of two or three students experiment in creating their own crazy shadows by slightly wrinkling paper, taping it to the wall, and holding a flashlight near the wall so that it throws light across the paper. When you get an interesting shadow, photograph it without a flash.

Design Extension

Have students shine a spotlight or flashlight on one of the sculptures that they made in the Try it on page 42 or the Try it on page 46. Encourage them to experiment with various positions for the light, noticing the shadows created and how this affects the look of their sculpture's form. Direct them to photograph, without a flash, the lighting that they like best.

2–30 The powerful forms of this building are emphasized by the late-afternoon sunlight cast against the exterior walls. The contrasts of light and shadow enhance the solid structural forms.

St. Francis of Assisi, Ranchos de Taos, New Mexico. Photo by A. W. Porter.

2–31 How does the artist draw the viewer's attention to this work?

Kumi Yamashita (b. 1968). *An Exclamation Mark,* 1995. Wood, light, cast shadow, 48" x 78" x 6" (121.9 x 198 x 15.2 cm). Courtesy of the artist. ©1995 Kumi Yamashita. Photo by Richard Nicol.

Context

Born in Japan, Kumi Yamashita currently lives in Seattle. She has created a series of artworks that explore the shapes cast by light on wooden forms she has cut. In *An Exclamation Mark* the shape of the question mark is created by shining a light on the wall sculpture from a very specific angle.

Higher-Order Thinking Skills

The design of the New Mexico church (fig.2–30) was influenced by European Baroque and Gothic cathedrals, such as Rouen Cathedral, which Monet painted (figs. 2–32, 2–33). Focus on the shadows of each structure and how these define the form. Then have students paint, during daylight, a picture of a building in their community, emphasizing the shadows. If possible, students should make two small sketches, each sketch at a different time of day, to see how the shadows vary.

On round or curved forms, light creates gradual changes and shadows. Usually, the brightest and darkest areas are separated from one another by many gradations of light. On angular and sharp-edged forms, however, the changes can be sudden. The brightest highlights may appear right next to the darkest shadows. These changes from light to dark are discussed more fully in Chapter 3.

Light is a powerful part of design; it has a strong impact on both the shapes and forms you see and those you reproduce in your art. An understanding of light and shadow is critical to the mastery of form. Experiment with light and try to duplicate its numerous effects.

2–32 Impressionist Claude Monet devoted countless hours to painting outdoors. He worked at various times of day and during different seasons. Compare his two 1894 paintings of Rouen Cathedral, in France.
Claude Monet (1840–1926). *Rouen Cathedral Façade and Tour d'Albane (Morning Effect)*, 1894. Oil on canvas, 41 ¹³/₁₆" x 29 ⅛" (106.1 x 73.9 cm), Tompkins Collection. Courtesy of the Museum of Fine Arts, Boston.

2–33 How has the artist used shadows and colors to show mid-day light?
Claude Monet (1840–1926), *Rouen Cathedral Façade*, 1894. Oil on canvas, 39 ¾" x 26 ⅛" (100.5 x 66.2 cm), Juliana Cheney Edwards Collection. Courtesy of the Museum of Fine Arts, Boston.

Context

Monet's sketchbooks reveal that the artist surveyed the entire cathedral at Rouen before settling on the façade as his motif. Monet worked on twenty-eight versions of the façade from late winter to early spring in 1892 and 1893. Set up in a draper's shop across the street from the cathedral, he would work on as many as nine canvases per day, moving from one to the next as the light changed over the course of the day. A friend provided him with a porter to carry his canvases and a screen to shield him from the sight of customers in the shop.

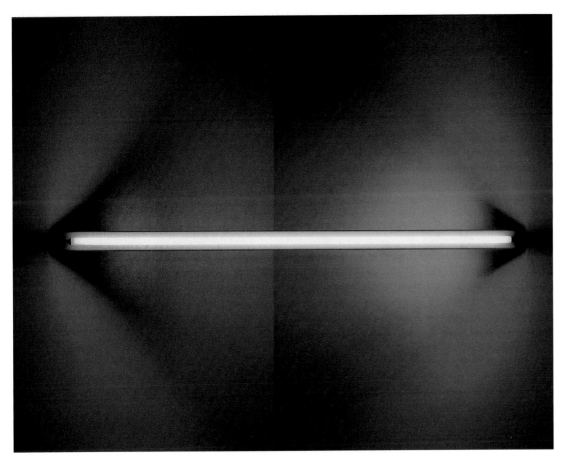

51

2–34 Dan Flavin makes forms with light. Some of the lighting tubes in this piece are not visible to the viewer. The artist wants us to focus on the cast light, not on the lighting tubes themselves. What kind of forms do you see?

Dan Flavin (1933–96), *Untitled (to Janie Lee) One*, 1971. Blue, pink, yellow, and green fluorescent light (first from edition of five), 96" long (243.8 cm). Columbus Museum of Art, Ohio: Gift of Mr. and Mrs. William King Westwater. ©1999 Estate of Dan Flavin/ARS, New York.

2–35 This still-life drawing explores the effect of light on curved forms.

Lauren Totero (age 15). *Still Life with Vase*, 1997. Pencil, 11" x 14" (28 x 36 cm). Clarkstown High School North, New City, New York.

Try it

In your home, school, or neighborhood, look at shadows created by artificial and by natural light. Using just black and white media, experiment with designs that capture any shadows with unusual or intriguing shapes.

Another Look at Shape and Form

Toshusai Sharaku (fig.2–39) presents one of the more intriguing mysteries in the history of art because little is known about his work and life. Over the course of ten months, beginning in the spring of 1794, approximately 140 prints were produced by an artist who signed his name Toshusai Sharaku. Some of Sharaku's prints are among the rarest and most expensive of Japanese prints. In stature, the works have been compared to those of Rembrandt. The prints depict famous actors of the Kabuki theater, in which all the actors are male. Segawa Kikunojo III was one of the best known of these actors.

2–36 Compare this sculpture with figs. 2–6, 2–11. What are their similarities and differences?

Hans Van De Bovenkamp (b. 1938). *Phoenix*, 1990. Painted steel, 12' x 10' x 11' (3.7 x 3 x 3.4 m). Photo by J. Selleck.

2–37 Using the terms you have learned in this chapter, how would you describe these natural forms?

Cactus. Photo by A.W. Porter.

2–38 What are the positive and negative areas in this painting?

Henri Matisse (1869–1954). *Les Cadona* (*The Acrobats*), from the *Jazz* series, 1947. Pochoir. Collection of the McNay Art Museum, San Antonio. Gift of Margaret Pace Willson and family. ©1999 Succession H. Matisse, Paris/ARS, New York.

Materials and Techniques

Pochoir (pronounced "Po-chwar") is a method of reproducing multicolor artworks by use of hand-cut metal stencils to achieve a rich, flat, even color. It was extensively practiced in France prior to the introduction of photographic color printing techniques about 1935. Many graphics in the Art Deco style were reproduced in this manner, which allowed intricate designs to be rendered with accuracy.

2–39 The Japanese are masters at making compositions built of shapes. Notice how flat the figure is. Can you see the area where the artist has added a sense of form?

Toshusai Sharaku (active 1794–95). *Segawa Kikunojo III as O-shizu,* 1794. Color woodcut, 14 ¹¹/₁₆" x 9 ¾" (37.3 x 24.5 cm). Philadelphia Museum of Art: The Samuel S. White III, and Vera White Collection.

2–41 This image was so popular when it was first created, it was even made into a postage stamp. How did the artist play with the shapes and forms to make a unified and playful artwork?

Robert Indiana (b. 1928). *Love,* 1972. Polychrome aluminum, 72" x 72" x 36" (182.9 x 182.9 x 91 cm). Galerie Denise René, New York.

53

2–40 Analyze how this student work makes use of shapes and forms to create a dynamic composition.

Rachel Youngs (age 17). *Dance,* 1998. Watercolor, 18" x 24" (45.7 x 61 cm). Wachusett Regional High School, Holden, Massachusetts.

★ Higher-Order Thinking Skills

Focus on Robert Indiana's *Love* (fig.2–41), and ask students if they have ever thought of letters simply as shapes. After students read the Career Portfolio on page 54, ask them to collect a variety of letters in different fonts. Have each student select three of the samples and write a description of the shapes of each lettering style, using terms they have learned in this chapter.

Review Questions (answers can be found on page 34i)

1. Define shape and form. Give an example of shape and a related form, such as a circle and a Ping-Pong ball.
2. What is the difference between a geometric and an organic shape? Give an example of each.
3. What are positive and negative shapes? Name one image in this chapter that you think shows an effective use of positive and negative shapes. Identify the main positive and negative shapes in the image.
4. List six qualities of shapes. Select one image in this chapter, and use the names of these qualities to describe the design.
5. How does light influence how we see form? Name an artist who was interested in the effect of light on form.
6. What is unusual about Meret Oppenheim's *Object*? What style of art is this?
7. What subjects does Jacob Lawrence depict in his painting series? Why did he choose to depict these subjects?

Career Portfolio
Interview with a Type Designer

The letters of the printed words you read in books and magazines are called type. A type designer carefully crafted the shape of each letter. Intrigued with type from an early age, **Tobias Frere-Jones** won an award for an original alphabet design at the age of 16. Born in 1970 in New York City, he is senior designer for a major type-design studio in Boston, Massachusetts.

How did you get interested in type?

Tobias There were always graphic-design materials and type-specimen books around. And I knew at some level that somebody, somewhere, has the job of drawing the letters. But it was only when I began to get some training as a writer that it made sense to bother with the shape of the actual letters. I was shown the sorts of things you could do with language, the power that it can have. Then it suddenly felt really important to go draw the letters themselves.

Tell me something about how you design letters.

Tobias There's a moment when I'm designing something new, when I've been wrestling around with the first few characters, trying to nail down the most general decisions about weight, width, proportion, curvature, and so on. After several hours of hammering away, it seems more like a game of form and color. At a certain point, I'll have just enough letters to actually spell something. So I'll run a proof and watch this piece

of paper come out on the laser printer; and it'll be real text, and it will mean something; and suddenly, these little forms, these completely abstract things that I was poking at, will have a substance to them.

Tell me about the most well-known typeface you've designed.

Tobias Dolores was the first one that was published. It was 1990. I was in the graphic design department at R.I.S.D. [RIZ•dee, Rhode Island School of Design], and I had spent a whole semester designing a very conservative, straightlaced sort of text face. After three months or so of that, I was completely insane. One night at the end of the semester, I turned over a napkin and just started goofing off. I finished the whole thing in about three days. Usually, it takes months and months refining all the details.

Then I took a short trip to Berlin to a type vendor, and I showed him the conservative text face; he wasn't really that interested in it. Very reluctantly, I showed him this other thing [Dolores] that was just so stupid and dumb that surely he would think I was joking. But he thought it was absolutely fabulous and dragged me off into the other room and showed me contracts and packaging and so on. I walked out of there with a contract; I accidentally got this published.

What advice would you give to a young person who's really interested in type?

Tobias Go to a local printer or service bureau, and get a type-specimen book. Spend a lot of time drawing, looking, and thinking. I think one of the important things is the ability to think abstractly. If you feel at home with more abstract concepts, this is definitely your line of work. For professional reasons, getting your hands on some technical experience with computers will help.

It must be pretty neat for you to see your type being used.

Tobias Actually, I went to the supermarket about a week ago. I was walking past the aisles of peanut butter, jelly, and jam, and so on, and there's this brand of peanut butter that says in big letters across the front, "Crunchy"—as opposed to "Creamy" —and it says it in Dolores. I have this jar of peanut butter in my office here. I've made the big time: I'm now on a jar of peanut butter.

Each of these words name a unique alphabet designed by Tobias Frere-Jones. Although our alphabet has only 26 letters, a type alphabet contains 220 characters, which includes uppercase (capital) and lowercase (noncapital) letters, numbers, punctuation marks, and accent characters for use in foreign languages.

Studio Experience
Shape Collage

Task: To create a paper collage with organic and geometric shapes that are overlapped and repeated.

Take a look.
- Fig.2–26, Charles Demuth, *Three Acrobats*.
- Fig.2–38, Henri Matisse, *Les Cadona*.

Think about it. Think about how you would answer the following questions relating to both the Matisse and the Demuth depiction of acrobats.
- Identify the geometric and organic shapes. Which shapes are angular? Which shapes are repeated?
- Which shapes are dynamic, creating a sense of movement? How has the artist positioned shapes on the page to create a sense of action? Which shapes are static?
- Identify positive and negative shapes. Are the black squares in the Matisse collage positive or negative shapes? Why do you think this?
- Which shapes overlap, and which touch the edge of the picture plane? How does this overlapping and extending of shapes to the edge of the picture affect the whole composition?
- How has the artist used shape to unify the composition?

Do it.

1 Cut both organic and geometric shapes from various colors of 9" x 12" paper. For example, to develop human shapes, use either a marker or a pencil to make a series of gesture drawings of action poses. Cut out several of the poses, saving the paper from which they were cut, perhaps for use as negative shapes and a means of repeating a shape. Turn the shapes over so that the drawing does not show.

2 Arrange the cut shapes on a contrasting color of 12" x 18" paper. Cut out additional organic and geometric shapes from paper of another color, and add these to your collage. You might want to cut out several versions of the same shape in various sizes or colors. Use an X-acto knife to cut out details and small interior shapes.

3 Before gluing down the shapes, experiment with overlapping and repeating shapes, and including negative shapes.

4 Use a glue stick or white glue to attach your shapes to the large piece of colored paper.

5 Near the lower edge of your composition in small lettering, write the title of your collage and sign your name with a marker.

Helpful Hints
- Sometimes, large background shapes, such as the white rectangle in Matisse's *Les Cadona*, can unify and stabilize a composition.
- By repeating shapes, you can form patterns and rhythms in your composition.

"This is a collage of two people dancing under moonlight. I used a dark background to make the other colors stand out. The 'explosive,' bright shapes were used to indicate exciting, happy movement. The yellow spiral floor was also used for this reason. The moon was used to express romance, and the reddish/purple color was chosen to show passion."
MacKenzie Lewis, (age 17). *Midnight Mambo*, 1998. 12" x 18" (30 x 46 cm). Notre Dame Academy, Worcester, Massachusetts.

- If you use an X-acto knife, cut on a cutting board or cardboard to protect your work surface. Keep fingers clear of the blade.

Check it.
- Describe the shapes in your collage. Which are organic, and which are geometric? Which shapes have you repeated, and which have you overlapped?
- Overall, is your design effective? Does it work together as one whole composition? How do the negative and positive shapes interact?
- Consider the craftsmanship in your artwork. Are the shapes neatly and securely glued? Does the quality of the cutting, such as uneven edges, detract from or add to the design?
- What is the strongest or best part of your collage?
- What did you learn in this project?
- What might you do differently the next time you create a similar collage?

Studio Experience
Shape Collage

MacKenzie Lewis, *Midnight Mambo*, 1998. Detail.

Prepare

Time Needed:
One or two 45-minute class periods (extend as needed)
Lesson 1:
Draw figure shapes (or use the gesture drawings from the activity in Chapter 1, which would eliminate the need for this lesson).
Lesson 2:
Cut, arrange, and paste shapes.

Objectives
Students should be able to

- Perceive and appreciate artists' use of positive and negative shapes in artworks.

- Demonstrate their understanding of positive and negative shapes in a cut-paper collage using repeated and overlapped geometric and organic shapes.

Materials
- markers that do not bleed through paper, or No. 2 pencils
- colored paper, three 9" x 12" pieces and one 12" x 18" piece per student
- scissors
- X-acto knives and cardboard to protect work surface
- glue stick or white glue

Notes on Materials
- White glue is more permanent than glue sticks.

- Limiting choice of colors for the paper will place more emphasis on shape.

- Students may cut small shapes from scraps of paper.

Before You Start
Option: For the cut-outs in this activity, have students use their gesture drawings on colored paper from the Chapter 1 Studio Experience.

Teach

Thinking Critically
- Have students review the images and then answer the questions in **Think about it**. Ask students to compare the point of view in Matisse's *Les Cadona* (fig.2–38) and Demuth's *Three Acrobats* (fig.2–26). (Matisse looks down at his subject, whereas Demuth is to the side of his acrobats.) How did Matisse create a wider view? (Matisse included the net, spectators, and arena, whereas Demuth focused on just the acrobats.)

- Call on students to describe the movement in both artworks. Point out how Demuth repeated organic curves not only in the bodies of the acrobats, but also in the negative spaces between the bodies, whereas Matisse used large rectangles to stabilize his composition.

- Ask how Matisse and Demuth emphasized the bodies of the acrobats. (Matisse placed his lighter forms on a dark background and made the trapeze shapes swinging towards them. Demuth made his acrobats' bodies large.)

- Suggest that students find other illustrations of art in this chapter that include important negative shapes. (*Pendant figure with headdress* [fig.2–16] and Lawrence's *The Library* [fig.2–15] are possible examples.)

Classroom Management
- To answer the questions in **Think about it**, divide the class into small groups, with each group answering one question. For larger classes, have one large group answer for the Matisse, and the other large group for the Demuth. The groups should report back to the class.

- Remind students to return any usable paper scraps to a scrap box.

- Students who do not complete their collage within the class time may clip their collage pieces together with their name visible on their large piece of colored paper. Have students store small collage pieces in an envelope.

Tip

Collages will stick to each other if they are stacked before the glue has dried. Either spread them out or stack them in a drying rack for at least thirty minutes.

Assess

Evaluation

- Ask students to evaluate their collage by writing the answers to the questions in **Check it**. Review their responses, and discuss any disagreement.

- Motivate students to describe their collage either verbally or in writing. Encourage them to explain any significance of shapes, and point out overlapped and repeated shapes.

Extend

Linking Design Elements and Principles

Color

Teach color theory by structuring this project slightly differently. Have students create the collage with complementary colors, with an analogous color scheme, or with just warm or cool colors.

Movement, Rhythm

Direct students to study how Demuth and Matisse created movement and rhythm in their works. Point out the movement in Demuth's composition by having students finger-trace the movement in the image, from the upper left, through the outstretched arms, to the center body, to the lower body, up through the lower figure's arms, and then back to the center of the image. For the Matisse image, show how the viewer's gaze is led in through the blue trapeze, and then moves around the black squares and yellow acrobat forms. Ask students if repeating and overlapping shapes in their own collage emphasize movement and rhythm. Ask: Is this an effect they had planned to create?

Contrast, Emphasis

Discuss how Matisse used contrast to emphasize his center of interest and how Demuth used size. Ask students if there is a definite center of interest in their collage.

Interdisciplinary Connections

Language Arts

Ask students to write a paragraph or poem describing their collage. Suggest that they use descriptive adjectives to tell about the shapes and colors in their composition. Remind them to convey the mood of their work by their choice of words. Have them note which qualities are more easily expressed with words and which are more effectively communicated visually.

Music

Focus on the Demuth and Matisse images and encourage students to imagine what music would be appropriate for each work. Ask how the rhythms would differ and which would be the faster of the two musical pieces. Tell students that Matisse's *Les Cadona* was originally in *Jazz*, his book of collage.

Inquiry

- Have students research why Matisse worked in the collage medium rather than paint. (He was ill and could not stand up to paint.) Some of Matisse's collages were made by assistants under his direction. Ask students if they believe these works should be credited to Matisse. Call on students to justify their answers.

- Because Picasso and Matisse were close friends, Matisse was familiar with the collages created by both Picasso and Braque as they developed their Cubist art style. Instruct students to find a collage by either Picasso or Braque and compare it to Matisse's *Les Cadona*. Picasso's collages from 1912 to 1915, such as *Still-life au Bon Marché* are particularly appropriate for this comparison. Ask students of what materials each collage was made and how the styles are similar.

Chapter 3 Organizer

Value

Chapter Overview

- Value refers to the lightness or darkness of grays and colors.
- Artists may use values to create moods, and use value contrasts to establish a work's center of interest.

Objective: Students will compare and contrast light (high-keyed) values and dark (low-keyed) values and understand how artists use these to establish mood and emphasis in artworks. (Art criticism)
National Standards: 2. Students will use knowledge of structures and functions. (2d)

Objective: Students will create artworks using a range of values and value contrasts. (Art production)
National Standards: 1. Students will understand and apply media, techniques, processes. (1a) **2.** Students will use knowledge of structures and functions. (2c)

8 Weeks	1 Semester	2 Semesters			Student Book Features
1	1	1	**Lesson 1:** Value	Chapter Opener	Try it: value chart
0	0	1	**Lesson 2:** Using Value in Design	Using Value in a Design	Discuss it, About the Artwork
0	0	2	**Lesson 3:** Light Values, Dark Values	Light Values, Dark Values	Try it: drawing, Try it: value chart, About the Artist
1	1	1	**Lesson 4:** Value Contrast	Value Contrast	Try it: collage, Note it, Try it: value experiment
1	1	1	**Chapter Review**	Another Look at Value	Review Questions
3	3	3			

Studio Experience: *Still Life Value Study*

Objectives: Students will understand how artists effectively use light, medium, and dark values in their artworks; demonstrate their ability to draw an effective still life by using light, medium, and dark values of charcoal and white conté crayon.

National Standard: Students will demonstrate ability to form/defend judgments about characteristics/structural purposes of art (2a); create art using organizational structures and functions to solve art problems (2c).

- Light must illuminate our environment in order for us to perceive values.

- The angle and intensity of light on an object determine the values on the object's surface.

Objective: Students will perceive and understand how artists of various periods have used the element of value in their art. (Art history/cultures)
National Standards: 4. Students will understand art in relation to history and cultures. (4a, 4e)

Objective: Students will develop aesthetic judgments based on the precepts of Baroque art, Surrealism, and Realism. (Aesthetics)
National Standards: 3. Students will choose and evaluate a range of subject matter, symbols, and ideas (3a) **5.** Students will reflect on and assess characteristics and merits of artworks. (5c)

Teacher Edition References	Ancillaries
Warm-up, HOTS, Context	*Slide*: Edward Hopper, *Nighthawks* (V-1)
Design Extension, Internet Connection, Context, Performing Arts, Materials and Techniques	*Slide*: Vincent van Gogh, *Saintes-Maries* (V-2)
Design Extension, HOTS, Context, Interdisciplinary Connection, Portfolio Tip	*Slides*: Harunobu, *Girl Contemplating a Landscape* (V-3); Yoruba, *Coronation cloth* (V-4) *Large Reproductions*: Pieter Brueghel The Elder, *Spring;* Carolyn Brady, *Last Red Tulips (Baltimore Spring)*
Design Extension, HOTS, Context, Performing Arts, Inquiry, Interdisciplinary Connection, Cooperative Learning	*Slides*: Chuck Close, *Bob* (V-5); Georges de La Tour, *The Repentant Magdalene* (V-6) *Large Reproductions*: Pieter Brueghel The Elder, *Spring;* Carolyn Brady, *Last Red Tulips (Baltimore Spring)*
HOTS, Context, Performing Arts	

Vocabulary

center of interest The area of an artwork toward which the eye is directed; the visual focal point of the work. *(foco de atención)*

high-keyed Describing colors or values that are light tints, created by the use of white, such as in pastel colors. *(tono alto)*

low-keyed Describing colors or values that are dark tints, usually created by the use of black or gray. *(tono bajo)*

value An element of design that refers to the lightness or darkness of grays and colors. *(valor)*

value contrast Dark and light values placed close together. Black against white creates the greatest value contrast. *(contraste de valor)*

Time Needed

Three 45-minute classes (extend as needed).
Lesson 1: Take a look, Think about it, introduce project, preliminary sketch;
Lesson 2: Draw;
Lesson 3: Draw and Check it.

Studio Resource Binder

3.1 Drawing of a Hand and Tools, pencil
3.2 High-key Plant Monotypes
3.3 Value Scale Landscape, black and white tempera
3.4 Hidden-picture Drawing, pen and ink
3.5 Drypoint Printing

Lesson 1
Value

pages 56–57

Objectives

Students will be able to

- Understand that value is the art element that relates to lightness or darkness of both neutrals and colors.

- Perceive that values in our environment are dependent on illumination by light sources.

- Demonstrate their understanding of value ranges by rendering a value chart with five different values.

- Perceive and discuss how artists use value in their designs.

Chapter Opener

- Ask students to study the art on pages 56–57 by Adams, Chardin, and Sun Han, and to estimate how many different values were used in each work.

- As students view the Ansel Adams photograph (fig.3–2), explain to them that this artist photographed his home state, California, in sharp clarity with a wide range of values.

- Have students do **Try it** on page 57, rendering two value charts with pencil, charcoal, or crayon—one chart with three values, and an expanded chart with five values. Suggest to students that they note the pressure changes on the drawing implements that help produce lights and darks.

Try it page 57

Materials
- pencils, charcoal, or crayons (Hint: Use pencils with soft graphite to obtain a wide range of values.)
- 8 1/2" x 11" drawing paper, white

Lesson 2
Using Value in a Design

pages 58–59

Objectives

Students will be able to

- Perceive that the direction of a light source will determine the position of shadows on an object.

- Perceive and comprehend that values are usually lighter in the distance and darker in the foreground in photographs and realistic two-dimensional art.

- Discern and appreciate how artists use values to establish moods and feelings in artworks.

Teach

- To help students see how the direction of a light source determines the shadows on a subject, dim the lights, and shine a bright flashlight on a student's face. Ask students to note where the shadows are and how sharp their edges appear. Move the light to several different positions around the student's head, calling attention to the changes in the shadows. Add a second light source (either another flashlight or the overhead light), and point out the blurring of the shadows and the less-distinct edges. Focus on the dramatic shadows formed by a single light source in La Tour's *Newborn Child* (fig.3–21).

Holli Williams (age 18). *Eternal Internal Fertilization*, 1997. White charcoal, 18" x 24" (45.7 x 61 cm). Plano Senior High School, Plano, Texas.

Jonathan Boatwright (age 16). *Absent.* Colored pencil, 14" x 11" (35.6 x 27.9 cm). Marion High School, Marion, South Carolina.

- Have students look at Browning's *Ghost Women of Essaouira* (fig.3–5). Ask what feelings the dark values evoke in them. Do they know what is lurking in the shadows? Encourage them to contrast the dark values and sense of mystery established in this picture with the light values in John Singer Sargent's *Muddy Alligators* (fig.3–10).

- Discuss *Ghost Women of Essaouira* with the students. Inform them that Colleen Browning is part of the new Realist movement in contemporary art. Challenge them to identify timeless elements in this painting as well as modern objects.

- Focus on *Grand Canyon* (fig.3–6) and the still from Harold Lloyd's *Safety Last* (fig.3–8) to determine how values vary from subjects in the foreground to those in the background. Students should notice that in landscapes or cityscapes lighter values are usually in the distance, whereas darker values are in the foreground.

- Bright lights are often used where precise vision is important—such as

an operating room or classroom—creating light values throughout the area. In other areas, bright lights contrast with dark to attract attention, such as a neon sign at night. Ask students to make a list of brightly lit environments. Discuss the purpose of the light in each and what type of shadows are likely to be created. Students might also explore the effects various lighting situations have upon those experiencing these environments.

- Instruct cooperative-learning groups of four or five students to answer the questions in **Discuss it**. After group members have selected several photographs and have answered the questions, call on groups to report to the class, citing the photographs that they think best illustrate the various uses of values.

Lesson 3
Light Values
Dark Values

pages 60–61

pages 62–63

Objectives
Students will be able to

- Compare and contrast high-keyed and low-keyed values and discuss why artists use certain values in their works.

- Demonstrate their understanding of values as they create collage value charts and pencil drawings of light and dark objects.

Teach

- Write *high-keyed* and *low-keyed* on the board, and have students look up the definition of each word in the glossary. From page 60 or 61, have each student select an image that is high-keyed. (Sargent's *Muddy Alligators* [fig.3–10] is an example of a high-keyed painting.)

- Direct students' attention to the images of low-keyed art on pages 62 and 63. Ask for comparisons between high-keyed and low-keyed works. Call on students to explain why an artist might choose to create either high-keyed or low-keyed works.

- Point out that Morandi used just a few values without strong contrasts in *Still Life* (fig.3–11). Ask students what a viewer would focus on when studying this painting.

- When students consider *Lady at Her Toilet* by Berthe Morisot (fig.3–12) as an example of high-keyed values, explain to them that Morisot was one of the few women artists painting with the French Impressionists in the late 1800s. Introduce them to some of the Impressionist characteristics in this painting. The subject is a contemporary woman in an everyday task painted with visible brushstrokes and light, bright colors.

- Explain to students that fig.3–9, *Years of Fear*, was painted by Matta, an artist born in Santiago, Chile who was educated as an architect, but became a Surrealist painter in Paris. If students do not know what Surrealist art is, they should look up the definition. (Artists combine unrelated objects and situations, often in dreamlike or unnatural settings.) Lead students in discussing the dreamlike qualities of this painting.

56d

56e

- Teach the students that the illustrations on pages 62 and 63 are dark values or low-keyed. After they have read about Louise Nevelson, discuss with them why she chose to paint her sculptures just one color, often a flat black. (The use of one color emphasizes the forms in her sculptures.) Ascertain that students understand that the term "monochromatic" means one color.

- Have students do the **Try its** on pages 60 and 61. Before they begin the second **Try it**, demonstrate how to shade a pencil drawing by using a wide range of medium to light values. Provide white objects, such as Ping-Pong balls, white Styrofoam shapes, very clean bones, or light cloth.

Try it page 60

Materials
- 8 1/2" x 11" paper, white
- old magazines
- scissors
- glue

Try it page 61

Materials
- pencils
- 8 1/2" x 11" drawing paper, white
- light-colored objects to draw

- Have students do the **Try its** on pages 62 and 63.

 —Students may create the dark-values chart on the same paper as the light-values chart.
 —After students have completed their dark-valued drawing, have them compare it to their light-valued drawing. Can they readily tell which object was light and which was dark?

Try it page 62

Materials
- 8 1/2" x 11" paper, white
- old magazines
- scissors
- glue

Try it page 63

Materials
- pencils
- 8 1/2" x 11" drawing paper, white
- dark-colored objects to draw

Ryan Congero (age 16). *Old Country Vegetables,* 1997. Watercolor and colored pencil, 15" x 19" (38.1 x 48.3 cm). Quabbin Regional High School, Barre, Massachusetts.

Lesson 4
Value Contrast

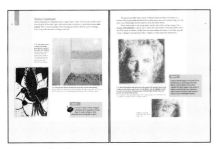

pages 64–65

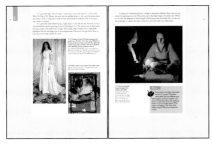

pages 66–67

Objectives

Students will be able to

- Understand and appreciate how artists create emphasis using contrasts of light and dark values within their works.

- Create collages with contrasts of light and dark values.

Teach

- Guide students to see how artists used contrasts of light and dark values in the images on pages 64–67. Remind students that the greatest value contrast is black in proximity to white. Ask students to squint their eyes as they look at the images on pages 64–67; this will help them see the greatest value contrasts.

 Explain that artists often use strong value contrasts to establish a center of interest. Discuss the center of interest in each image. Have students locate images from other chapters in which the artist used value contrast to establish a center of interest.

- As students look at the painting *New York, New York 10008* by Nemesio Antúnez (fig.3–17), explain to them that Antúnez was born in Santiago, Chile, and although he studied architecture at Columbia University in New York, he became a Surrealist painter.

 Encourage students to describe what they see in this painting and how they feel about this image. Remind them that Matta in Lesson 3 of this chapter was also a Surrealist artist born in Santiago, Chile.

- When students consider the value contrasts in La Tour's *Newborn Child*, fig.3–21, teach them that La Tour was a Baroque artist who often painted nocturnal scenes using light from a candle to emphasize his center of interest and create a dramatic mood. This dramatic contrast of light and dark values is often found in the works of other Baroque artists. In the past La Tour's paintings have been mistakenly attributed to Rembrandt and Caravaggio. Challenge the students to find similarities between La Tour's painting and that of Rembrandt, fig.9–19.

- Have students do **Try it** on page 64. Suggest that they use value contrast to create a center of interest.

Try it	page 64

Materials
- old magazines
- scissors
- glue
- 8 1/2" x 11" paper

- Instruct students to experiment with values by doing **Try it** on page 67. Have students glue the squares in place and then write a paragraph describing how the same values appear to be different in each combination. After students complete their paragraphs, they should share their observations with the class. Is there consensus in their findings?

56f

Try it	page 67

Materials
- 3" x 3" paper: white, black, and two values of gray
- 4" x 4" paper, medium gray
- scissors
- glue

Hal Lacy (age 17). *Untitled*, 1998. Acrylic and airbrush on illustration board, 5" x 7" (12.7 x 17.8 cm). Los Angeles County High School for the Arts, Los Angeles, California.

Chapter Review

56g

pages 68–69

Assess

- Assign students to answer the review questions and then work in small groups to discuss their answers. In doing this they will compare and contrast light, or high-keyed, values and dark, or low-keyed, values. They will also demonstrate that they perceive and understand how artists of various art periods have utilized values in their art. Each group should share their answers with the rest of the class. **(Art criticism and Art history/cultures)**

- Review the images in this chapter and discuss with the students how artists use values to establish mood and emphasis in artworks. Assign students to select a piece of art from this chapter to describe and to explain how values are used in this work. This may be written, done in small groups, or part of a class discussion. **(Art criticism)**

- To help students develop aesthetic judgments based on the precepts of Baroque art, Surrealism, and Realism, review with them the examples of these art styles found in this chapter. Surrealist Nemesio Antúnez in *New York, New York 10008* (fig.3–17) used values to establish an unnatural mood, while Realist Chardin in his *Still Life* (fig.3–3) utilized values for emphasis and to indicate form. Baroque artist La Tour in *Newborn Child* (fig.3–21) used value contrast to create a dramatic mood and for emphasis.

 Instruct students to find other pieces of art that Baroque, Surrealist, and Realist artists would probably appreciate because they share value characteristics that are similar to their works. This could be done in small groups. Then each student should select one piece that is particularly appealing because of the way the artist employed value. Discuss the reasons for the students' selections with the class. **(Aesthetics)**

Computer Connection

Instruct students to explore value contrast. In a painting or drawing program, guide students to fill boxes with a black and white gradient. They may overlap boxes, change box size, and choose black, white, or gray as a background color for different effects. Using the gradient editor, students may change the percentage of black used in various boxes. They may also experiment with the angle of the directional sweep and then discuss where the light source appears to be originating.

- Check to see that students have used a range of values and value contrasts in their work. Suggest that they use the value charts they rendered to analyze the value range in each of the artworks they created in this chapter. **(Art production)**

Answers to Review Questions

1 Value refers to the lightness or darkness of colors or gray tones.

2 Without light, we would not be able to see values. Areas of color or tones in direct light are lighter than those on surfaces facing away from the light, which are shadows or darker values.

3 The darker values are usually in the foreground of landscapes.

4 High-keyed colors have light values and have been mixed with white to create pastels; low-keyed colors have darker values and are often mixed with black or gray. *Muddy Alligators* (fig.3–10) has high-keyed values; *Aurora Borealis* (fig.3–13) has low-keyed values.

5 By creating value contrasts, artists can emphasize a center of interest.

6 Nevelson painted most of her sculptures black, white, or gold to emphasize and give power to forms in her art.

Christi Andrews (age 17). *Portrait of Young Sin*, 1997. Conté crayon, 25" x 30" (63.5 x 78.7 cm). West Springfield High School, Springfield, Virginia.

Meeting Individual Needs

Students Acquiring English

To ensure comprehension about the range of light and dark in a given artwork, regularly refer to other images as well as those in the book. Use black-and-white photographs, newspaper pictures, and reproductions. Whenever possible, include relevant, everyday images.

Students with Special Needs

Attention Deficit Disorder (ADD) and Attention Deficit Hyperactivity Disorder (ADHD)

For students who have trouble following multistep tasks, help them make their value charts one step at a time. Provide mild corrective feedback, both positive and negative.

Gifted and Talented

Discuss how dot matrices create values in black-and-white photographs. Have student pairs take black-and-white photographs of each other, draw a grid on their developed photograph, and create enlarged self-portraits that emphasize the values in the photograph.

Reteach

- To review the concepts about value in this chapter, focus on the images on pages 68 and 69. Remind students that values relate to the darkness or lightness of grays and colors. Ask them to select one image that is mostly high-keyed, or composed of light values. (Irwin's plastic disk sculpture [fig.3–22] has high-keyed values.)

- Call students' attention to the great contrasts of values in the Byzantine mosaic (fig.3–24). Ask where the artist used wide value contrasts. Suggest that students hypothesize as to why the artist focused attention on these parts of the design. (Byzantine artists often created dark lines around eyes, which they considered to be the windows to the soul.)

- Reiterate that values may indicate depth or distance in art. Have students select one of the images on this page and explain how values were used to create depth.

- Ask students to identify the light source in Yale Joel's *New York, Smoke* (fig.3–25). To review how values can create moods in art, have each student write a sentence describing the feeling established with the values in this photograph. Call on students to read their sentence either to a small group of students or to the whole class.

3 Value

ALL THE THINGS YOU SEE AROUND YOU ARE ILLUMINATED, or lit, by some light source. Without light, you would see nothing. No matter how bright your whitest clothes are, you cannot see them in absolute darkness. With a little light, the clothes begin to look gray. As the light increases, the white clothes look brighter.

Chapter Warm-up

Darken the room by turning off the lights and blocking from windows as much natural light as possible. Remind students that if the room were completely dark, they would not be able to see anything. Gradually add light: at first, perhaps light only one bulb; then add a projector light, open shades or blinds, and finally turn on all the lights so that the room is bright. At each level of brightness, ask students what values are visible, and to describe the values of any white surfaces, such as a projection screen or a white wall. Explain to students that this range of light to dark is value.

3–1 This value chart shows a range of nine steps from white to black. Most people can distinguish about thirty to forty steps, or value gradations, between black and white.

3–2 Much of the beauty in black-and-white photography is a result of gradations in value.
Ansel Adams (1902–84). *Fiat Lux: Birds on the Beach,* 1965. Contemporary print from original negative by Ansel Adams (6-UCSB-01.10) UCR/California Museum of Photography. Sweeney/Rubin Ansel Adams Fiat Lux Collection. University of California, Riverside.

Context

Ansel Adams was born in San Francisco, and spent much of his career photographing the California landscape. He is well known for his images of Yosemite National Park, and he is considered one of America's great nature photographers. The precision and clarity of his work indicate his complete mastery of all the technical aspects of photography. His images show a full range of values, from bright white to jet black.

This range of light and dark is called *value*, the lightness or darkness of grays and colors. In a black-and-white photograph, you can easily see the difference between the areas of light gray and white and the areas of medium gray and black. White is the lightest value, and black is the darkest—and there are an unlimited number of values between them. In this chapter, you will explore the use of value in a design, the differences between light and dark values, and value contrast.

• Black is sometimes described as the absence of light. Ask students to explain what this means.
• Shadows and highlights are determined by the direction of light sources, and the angle and intensity at which a light strikes a surface. Encourage students to imagine where the shadows will be in the scene in Ansel Adams's *Fiat Lux: Birds on the Beach* when the sun is directly overhead. Ask which surfaces will be lighter, reflecting the most light and therefore having lighter values.

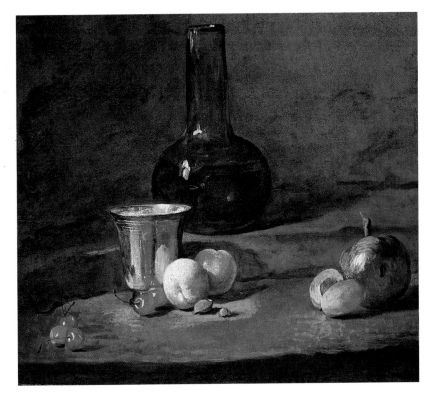

3–3 Where is your attention drawn in this image? How does the artist use value to create the center of interest?

Jean-Baptiste-Siméon Chardin (1699–1779). *The Silver Goblet (Le Goblet d'Argent)*, c. 1728. Oil on canvas, 16 ⅞" x 19" (42.9 x 48.3 cm). Purchase 55:1934; The Saint Louis Art Museum (Early European Art).

Try it

Use pencil, charcoal, or crayon to make a value chart with only three values: light, medium, and dark. Then make a second value chart with five values, from white to black.

3–4 This self-portrait is a study in values. Think about where the source of light must have been when the artist depicted her own face.

Sun Han (age 17). *Self-portrait*, 1996. Charcoal on paper, 18" x 24" (45.7 x 61 cm). Los Angeles County High School for the Arts, Los Angeles, California.

Internet Connection

Students interested in the technical aspects of black-and-white photography may wish to research the Zone System on the Internet. Ansel Adams developed the Zone System in the early 1930s. Ask students to consider, if Adams were still alive, to what extent he might be interested in digital photography. What evidence can they find on the Internet to support their opinion?

Design Extension
To experiment with values and how they can be used to create depth, have students tear 3" x 9" strips from three different values of gray paper. Ask them to arrange and then glue the strips on a single piece of white paper to create the illusion of depth by location and overlapping.

Using Value in a Design

The light in a painting or drawing may come from any single direction or from more than one direction. Areas facing a light source are lightest in value. Areas facing away from a light source are darker. Light also creates shadows. A single bright light creates shadows that are sharp and dark-valued. Multiple light sources or indirect lighting produces lighter shadows with softer edges. Shadows and varying shades of gray can create the illusion of three-dimensional space or volume.

Value may also be used to show depth. The farther away that objects are from the foreground in a landscape or cityscape, usually the lighter they are in value. Look at the image of the *Grand Canyon* (fig.3–6). In this photograph, the darkest areas are the canyon walls closest to the viewer. In the distance, the canyon becomes noticeably lighter. If an artist uses all light or all dark values, the space within his or her design may seem shallow, with little or no depth.

Artists often depict the actual effects of light, but sometimes they choose to alter or invent them. They may wish to emphasize darkness to convey a sense of mystery, or they might increase the brightness to suggest happiness or excitement. The values may not be realistic, but they can strengthen the mood to better suit the artist's intended effect.

3–5 In this image, the darkest area is farthest from the viewer. What is the effect of this?

Colleen Browning (b. 1929). *Ghost Women of Essaouira*, 1983. Oil on canvas, 40 ½" x 48 ⅜" (102.9 x 122.9 cm). Lulu H. and Kenneth Brasted, Sr. Memorial Fund, Wichita Art Museum, Witchita, Kansas.

3–6 When looking out a window, down a street, or across a field, notice how the objects farthest away from you are usually the lightest in value.

Grand Canyon. Photo by H. Ronan.

3–7 This study takes advantage of some ways value can be used to emphasize the mood of a work.

Lawrence Parks (age 17). *Self-portrait*, 1996. Graphite. Plano Senior High School, Plano, Texas.

Context
Colleen Browning was born in Ireland in 1929 and immigrated to the United States in 1949. An artist of the New Realist movement in contemporary art, her works show a compression of time. Point out to students that though *Ghost Women of Essaouira* (fig.3–5) might have an ancient, timeless quality about it, there are elements that place it firmly in the present. Challenge students to identify some of these elements (electrical wires on wall, bicycle, high-heeled shoes).

Harold Lloyd in *Safety Last*

The inspiration for *Safety Last* came to silent-film actor Harold Lloyd when he watched Bill Strothers (known as the "human fly") climb up the outside of a Los Angeles office building. Lloyd became so terrified while watching Strothers that he hid his eyes from what he was sure would end in disaster. Lloyd realized the suspenseful effect that such a scene would have on moviegoers, and incorporated similar scenes into several films over a ten-year span.

Safety Last is the story of a department-store clerk who tries to convince his visiting girlfriend that he is the store manager. In the process, the famous bespectacled character meets with some amazing obstacles. This still photo is from perhaps the best-known scene, a fast-paced, comic climb of a twelve-story building, during which Lloyd defends himself against attacking pigeons, spilled water, tilting

windows, and tangled nets. A stunt double served for much of the action.

For this shot, one of the most famous from early Hollywood, the camera placement exaggerates the distance between Lloyd and the street below. The lighting and composition of this scene, as well as the actor's expression, produce an emotional impact.

However, a sense of danger in *Safety Last* was present not only by design and acting. Lloyd reportedly dislocated his shoulder as he dangled from the clock. Also, Lloyd had one of Hollywood's best-kept secrets: because of injuries from the explosion of a faulty prop bomb, the actor had an artificial right hand. To make up for the loss, the actor worked hard to improve his athletic abilities. Despite these challenges, however, both the movie and Lloyd's life had happy endings.

3–8 How has the cinematographer used value to increase the tension in this scene?
Harold Lloyd in *Safety Last* (1923). The Museum of Modern Art, Film Stills Archive, New York.

Despite the increased use of acrylic as a medium, many artists today continue to use oil on canvas (fig.3–5). Oil has been a favorite among painters since the mid-sixteenth century. Its slow-drying quality allows the artist to work on a canvas, leave it for a time, and then return to make changes and additions. The exceptional blending qualities and its luminosity make oil an unsurpassed medium.

Discuss it

Look at various black-and-white photographs in this book. How did the photographers make objects or people contrast with their surroundings? Which works have few value changes? Which use a wide range of values? What different moods do these black-and-white images create?

Performing Arts
Dramatic Lighting

Ask the drama teacher to demonstrate the effects created on the stage by the various theatrical lights. Guide students to see the shadows created by footlights and spotlights. Have students draw one another on the stage in various types of lights, focusing on the changes in values in each type of illumination. Then encourage students to consider what type of dramatic scenes might utilize the type of illumination in their sketches.

Light Values

To depict happiness, warmth, or sunshine, an artist emphasizes lighter values. Think of the sun's glare at the beach or on newly fallen snow. The light is so bright that we often put on sunglasses, which darken the intensity of the light so that we can see more easily and clearly. In a work that captures the effects of such bright lighting, the shadows are often dark and clearly defined.

3–9 Light values stand out in this painting. They are high-keyed because white has been mixed with the colors.

Matta (Roberto Sebastiano Matta Echaurren) (b. 1911). *Years of Fear*, 1941. Oil on canvas, 44" x 56" (111.8 x 142 cm). Solomon R. Guggenheim Museum, New York. Photo by David Heald. ©The Solomon R. Guggenheim Foundation, New York (FN 72 1991).

3–10 Describe the kind of day depicted in this watercolor.

John Singer Sargent (1856–1925). *Muddy Alligators*, 1917. Watercolor over graphite on medium, textured, off-white wove paper, 14" x 20 ⅞" (35.5 x 53 cm). Worcester Art Museum, Worcester, Massachusetts, Museum purchase, Sustaining Membership Fund. Photo ©Worcester Art Museum.

An artwork with many light-valued colors is high-keyed. *High-keyed* colors have been mixed with white and are called pastel colors. Notice how Sargent uses light values in the watercolor of alligators (fig.3–10). The whiteness of the colors recreates the glare and heat of strong tropical sunlight.

Look at the still-life painting by Giorgio Morandi (fig.3–11), in which the artist worked with values that are close to one another. There are neither bright highlights nor dark shadows. The soft colors and subtle changes in value help emphasize a feeling of quiet and peacefulness. (See Chapter 4 for more about color and color relationships.)

3–11 Some artists choose to use only a few value changes in their work.
Georgio Morandi (1890–1964). *Still Life*, 1953. Oil on canvas, 8" x 15 ⅝" (20.3 x 39.7 cm). The Phillips Collection, Washington, DC. ©Estate of Giorgio Morandi/ Licensed by VAGA, New York, NY.

3–12 Berthe Morisot was an Impressionist. Impressionists were fascinated with the effect of light on color.
Berthe Morisot (1841–95). *Lady at Her Toilet*, c. 1875. Oil on canvas, 23 ¾" x 31 ⅝" (60.3 x 80.4 cm). Stickney Fund, 1924.127. Photograph ©1998 The Art Institute of Chicago, All Rights Reserved.

Try it

Draw a single white object, such as a piece of wrinkled paper or a golf ball. Use a pencil to shade the object with many light-valued grays.

Context

Berthe Morisot was a founding member of the Impressionists. Born in 1841 into a wealthy family, Morisot was privileged to take art lessons as a young girl. Her talent was quickly recognized, and she went to study with the landscape painter Corot in 1860. In the early 1870s, she joined the emerging circle of Impressionists. Mary Cassatt was Morisot's only female colleague among the Impressionists. For a woman to be a successful artist at this time was highly unusual, and the prevailing attitude is evident in a comment of Morisot's brother-in-law, Edouard Manet. Of Morisot, Manet said, "This woman's work is exceptional. Too bad she's not a man!"

Dark Values

To suggest dark and gloomy days, nighttime, or dim lighting, an artist uses darker values. The lack of brightness tells the viewer that the source of light—whether it is the sun or artificial lighting—is weak or far away. A painting or drawing that emphasizes dark values can convey feelings of cold or sadness.

A work that uses mainly dark-valued colors is low-keyed. ***Low-keyed*** colors have been mixed with black or gray. The use of charcoal to draw and shade an object on light-gray paper produces a low-keyed result. All the values will be dark; the lightest value will be the gray of the paper itself.

Look at the painting *Aurora Borealis* (fig.3–13), in which the artist chose to use little value contrast. The only brightness comes from the green and red light in the sky, known as the northern lights. These multicolored flashings are visible near the earth's poles. The low-keyed colors perfectly capture the atmosphere of a mysterious nighttime scene.

3–13 Compare this painting to fig.3–10. These two artworks clearly show the great difference in effect between light and dark values.
Frederick Edwin Church (1826–1900). *Aurora Borealis*, 1865. Oil on canvas, 56" x 83 ½" (142 x 212 cm). National Museum of American Art, Smithsonian Institution, Washington, DC. Photo National Museum of American Art, Washington, DC/Art Resource, New York.

3–14 What aspects of the underwater world did the artist bring out in this low-keyed painting?
Chris Polentz (b. 1962). *Long Range Sportfishing*, 1995. Acrylic on illustration board, 13" x 23" (33 x 58.5 cm). Courtesy of the artist.

Try it
Cut 1" squares of dark-gray values from magazines. Arrange them into a chart that shows value steps from medium-gray to black. This chart can show you a variety of grays to use in future designs.

Louise Nevelson

Born in Russia in 1899, Louise Berliawsky was attracted early in life to the visual excitement of her surroundings. When she was five, she and her family moved to Rockland, Maine. Louise knew from an early age that she was going to be an artist, and she tried to improve her skills in drawing and painting by devoting considerable energy to practice and study.

She married Charles Nevelson in 1920 and moved to New York City, where she pursued her interest in the fine arts. She delighted in learning about music, dance, and theater (she even had a brief career as an actress in Europe in 1931).

In 1935, Nevelson was hired as an artist and teacher under the Works Progress Administration (W.P.A.), a federal program that, among other activities, gave work to artists during the Depression. Nevelson began sculpting in terra cotta, and at different times worked with various materials such as plaster, Plexiglas, and steel—although she is best known for her monochromatic wood sculpture, such as *Sky Cathedral* (fig.3–15).

She enjoyed working with wood for what she called its quality of "livingness." To emphasize and give power to the forms, Nevelson painted her wood sculptures only black, white, or gold. Regarding her use of black, Nevelson said, "There is no color that will give you this feeling of totality. Of peace. Of greatness. Of quietness. Of excitement."

Nevelson's artwork gained important notice in the late 1950s. In 1959, a selection of her work was included in a show at the Museum of Modern Art in New York. She continued to be a fiercely independent and productive artist until her death in 1988.

Context
Within the general darkness of *Aurora Borealis* (fig.3–13) are several elements of brightness or light. The spectacular light effects of the aurora borealis accompany the more earthbound event of a dogsled bringing "light" in the form of help to a small ice-bound boat. Frederick Church traveled the world; the inspiration for this painting was generated by sketches he made on a 1859 trip to Labrador and Newfoundland.

63

Higher-Order Thinking Skills

Louise Nevelson painted many of her assemblage sculptures either completely black or completely white. Ask students to find an image of one of her sculptures in black and another in white. Have students compare the sculptures, noting how the dark and light values alter the pieces.

3–15 Louise Nevelson often painted her sculptures completely black or completely white.
Louise Nevelson (1899–1988). *Sky Cathedral,* 1958. Wood, 102 ½" x 133 ½" (260 x 339 cm). George B. and Jenny R. Matthews Fund, 1970, Albright-Knox Art Gallery, Buffalo, New York. ©1999 Estate of Louise Nevelson/ARS, NY.

Try it

Draw a single dark object, such as an acorn squash, a black checker, a wrinkled piece of black paper, a dark backpack, or a piece of dark fabric. Use a pencil to shade the object with many dark-valued grays.

Value Contrast

Artists emphasize not only dark values or light values in their work, but also include values from all parts of the scale. Light values placed next to medium or dark values creates *value contrast*. This contrast may help viewers distinguish between different parts of a design. It also may make one area of a design stand out.

3–16 The stark contrast in value in this design gives the piece a sense of immediacy and simplicity.
Michelle Spinnato (age 15). *Value Study*, 1998. Construction paper, newsprint, chalk, and magazine paper, 12" x 18" (30.5 x 45.7 cm). Atlanta International School, Atlanta, Georgia.

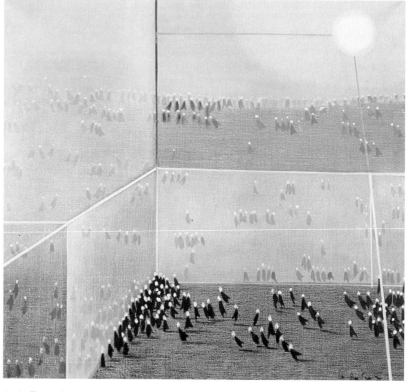

3–17 Describe how Nemesio Antúnez has used value contrast in this painting.
Nemesio Antúnez (b. 1918). *New York, New York 10008*, 1967. Oil on canvas, 22" x 24" (55.9 x 61 cm). Courtesy of the Couturier Galerie, Stamford, Connecticut. Photo ©Patricia Lambert.

Try it

Cut out 1" squares of dark- and light-valued grays from a magazine. Arrange them to create a collage or other design that shows strong value contrast.

Performing Arts
Film Noir: Black and White on Screen
Originally, movies were made in black and white. Of course, the color wasn't pure black or white, but actually contained a range of values seen in various shades of gray. With the development of color film, most directors wanted to capture the hues of the real world. However, in the 1940s and early 1950s, some Hollywood directors invented a new way to use black and white, in a genre called *film noir* (French for "dark film" or "black film"). The dark and dramatic lighting of these serious, gloomy films not only enhanced the mood and atmosphere, but also became a "character" in the movie

The greatest possible value contrast is between black and white. A woodcut or a linoleum-block print made with black ink on white paper uses such contrast. In fig.3–16, the artist's use of black helps the bird stand out from the nearby flower.

Some artists prefer to use strong value contrast only a little, perhaps saving it for a design's **center of interest**, a special area to which the artist wishes to draw the viewer's attention. The center of interest, usually where the artist wishes the viewer to look first, may also contain a design's most important object or figure, or other important information.

Context

Nemesio Antúnez, like Matta (fig.3–9), was born in Santiago, Chile; trained as an architect at Columbia University, in New York; and eventually abandoned architecture in favor of Surrealist painting. He served for some time as the director of the Contemporary Art Museum at the University of Chile. In 1965, he was the cultural attaché to the Chilean Embassy in the United States.

65

3–18 Kent Twitchell drew this self-portrait with graphite. He used dark values for the background and shadows on his face; he used the lightest value for highlights and the areas closest to the viewer. The medium grays bridge the light and dark values, and provide softer details within the face.
Kent Twitchell (b. 1942). *Study for Eyes Mural*, 1991. Graphite on paper, 9 ½" x 8 ¾" (24.1 x 22.2 cm). Collection of Joseph A. Gatto, Los Angeles, California.

Note it

Look at several images in this book. Try to find the place in each image where the lightest and the darkest values come together. In which images is the center of interest created by this area of greatest value contrast? In which is the center of interest created differently? Explain.

3–18a Kent Twitchell. *Study for Eyes Mural*, detail of fig.3–18.

itself. Examples of this unnerving genre include Orson Welles's *Lady from Shanghai*, John Huston's *The Maltese Falcon* and *Key Largo*, and Billy Wilder's *Double Indemnity* and *The Lost Weekend*. Ask students to name a film that they have seen in which the lighting and value of the colors (their darkness or brightness) was necessary to the plot, and to explain why. If possible, screen one of the above-mentioned films for students, and challenge them to identify the way the dark, moody lighting helps move the story along.

In a generally light-valued design, a dark shape or line will stand out. Look at *The White Girl* (fig.3–19). Notice how your eyes are quickly drawn to the top of the work, where the subject's face is composed of dark features and framed by dark hair. This is the painting's center of interest.

In a generally dark-valued design, a light shape or area will become the focus. Look at the seventeenth-century painting *Newborn Child* (fig.3–21). The entire scene is dark, with a burning candle as the only source of light. The candle itself is hidden, but it beautifully highlights the face and right arm of the young woman. The artist, Georges de La Tour, is famous for such bold, candle-lit scenes.

Design Extension

Leonardo da Vinci said: "If you wish to represent a night scene, have a great fire in it, for then the object which is closest to this fire will be most tinged with its colors, because that which is nearest to an object most shares in its nature." To explore dark values, have students paint a night scene. Suggest that they first study La Tour's *Newborn Child* to see how faces and objects appear when illuminated by a single bright light source. Point out to students that artists sometimes invent the light source in their work. Light may appear to come from several sources.

Cooperative Learning

Assign small groups of students to experiment photographing each other in bright sunlight, filtered shade, and then in darker shaded areas. After the prints are developed, encourage them to analyze the values in their photographs noting in which light conditions the greatest value contrasts occurred. Did these dramatic contrasts always result in the most effective pictures? Have pairs of students choose two prints to evaluate. One student should verbally compare the two prints using value terms introduced in this chapter. The partner can then make additional observations.

3–19 Though most know Whistler's painting of his mother best, *The White Girl* is what caused Whistler to become the first American painter after the eighteenth century to gain fame in Europe. Why do you think the artist called this painting *Symphony in White*?

James Abbott McNeill Whistler (1834–1903). *Symphony in White, No. 1: The White Girl*, 1862. Oil on canvas, 83 ⅞" x 42 ½" (213 x 107 cm). Harris Whittemore Collection ©1998 Board of Trustees, National Gallery of Art, Washington, DC.

3–20 How is value contrast used in this student work?

High school student (age 17). Los Angeles County High School for the Arts, Los Angeles.

Context

For 270 years, the name of Georges de La Tour was lost to history. Soon after his death, in 1652, La Tour's works were no longer in favor. Over the years, his paintings were attributed to other artists including Rembrandt and Caravaggio. In the first half of the twentieth century, La Tour was rediscovered. Scholars researched archives in La Tour's home province of Lorraine, and gradually a body of work was reclaimed for the

Finding the contrasting values in a design is sometimes difficult. First, shut out tiny details by squinting your eyes. Then look only at the larger shapes of similar value. When you do this, the elements of dark and light will become more noticeable. You can also use this technique to balance the value contrasts in your own work more effectively.

3–21 How has the artist focused the light of the candle on the child?
Georges de La Tour (1593–1652). *Newborn Child (Le Nouveau-Né)*, mid-1640s. Oil on canvas, 31 ¼" x 35 ⅞" (79 x 91 cm). Musée des Beaux-Arts, Rennes, France. ©Photo RMN, Ojéda/Hubert.

Try it

From a piece of medium-gray paper, cut four 1" squares. Then from white, black, and two different gray-valued papers, cut four 3" squares—one square of each value. Place the small gray shapes on the four larger shapes. What appears to happen to the value of the smaller shapes? Why do you think this occurs?

artist. There now are more than forty paintings attributed to him.

Beginning in the 1630s, La Tour turned his attention to nocturnal scenes, filling them with either religious figures or with figures that have the aura of holiness. Scholars dispute whether *Newborn Child* is a depiction of the Nativity. Some believe the painting should not be mistaken for a religious scene from the life of Christ.

★ Higher-Order Thinking Skills

The American artist James Abbott McNeill Whistler, who painted *The White Girl* (fig.3–19), often worked in grays, blacks, and whites, blending his colors carefully so that he could obtain a wide range of values. He was so interested in the composition of values that he titled his famous portrait of his mother, *Arrangement in Gray and Black No. 1: The Artist's Mother.* Have students find a copy of this painting (widely reproduced in art-history books such as Brommer's *Discovering Art History*), study the arrangement of the values to determine what Whistler was emphasizing, and then compare this use of values to that in *The White Girl*.

▲ Interdisciplinary Connection

Literature—Ask students to illustrate a scene from a story or play that is set at night. Have them first describe the light source and how that will affect the illumination of the subject. After students have completed their illustration, instruct them to compare the descriptive qualities that are possible with words to those that are possible with images. Ask when one form might have more impact than another in describing a particular scene.

Another Look at Value

3–22 Robert Irwin used acrylic lacquer on a plastic disk form. Light directed at the disk creates repetitions of the circular form through overlapping shadows and gradual changes between dark and light.

Robert Irwin (b. 1928). *Untitled*, 1968–69. Plastic, 54" diameter (137.2 cm). San Diego Museum of Art (Gift of the Frederick R. Weisman Art Foundation). © 1999 Robert Irwin/ARS, NY.

3–23 To achieve success, graphic designers must consider the art elements while planning their work. How would you describe the effect of the value contrast in this design?

James Porto (b. 1960). *Wired* magazine cover, November 1997. Digital image courtesy of the artist.

3–24 From a distance, the tiny pieces of color blend together to create a beautifully modeled form.

Christ, Deesis. Mosaic, mid-12th cent. Hagia Sophia, Istanbul. Erich Lessing/Art Resource, New York.

3–25 The eye of the photographer captured the profiles of these buildings in the smoke. How do the light values of the smoke give the viewer a sense of space?

Yale Joel (b. 1919). *New York, Smoke,* c. 1952. Yale Joel, Life Magazine ©1952 Time Inc.

Performing Arts
Kabuki Theater

Changing the value of a color adds nuance to a composition. The development of Japanese Kabuki theater, from its simple beginnings to a more complex form, can be seen as the adding of value.

Kabuki was likely the most popular dramatic entertainment during Japan's Edo period (c. 1600–1876). At first, Kabuki plots were quite simple, as though there were only one value to the theatrical expression. Over time, this changed, and the "color" of Kabuki gained a whole range of values, from dark to light. By 1680, actors in elaborate costumes performed complex stories amid lavish stage sets.

Review Questions (*answers can be found on page 56g*)

1. To what does the art element *value* refer?
2. Explain how light affects the value of colors or gray tones.
3. In landscapes, where are the darker values usually found?
4. What type of values do high-keyed and low-keyed colors have? Give the title of an image in this chapter that has mainly high-keyed values and that of another that has mainly low-keyed values.
5. How can artists use values to create a center of interest?
6. Why did Louise Nevelson paint most of her sculptures a monochromatic black, white, or gold?

Career Portfolio

Interview with a Cartographer

As a cartographer (mapmaker), **Paula Lee Robbins** uses value to give relief shadings of mountain ranges a three-dimensional look. The reliefs are done by hand, then scanned into a computer, where the maps are built in layers. Paula was born 1964 in Manitowoc, Wisconsin, and has been working with an international map-making company in Madison, Wisconsin, since 1987.

How did you get interested in map making?

Paula When I was about nine or ten, I started drawing on my own. I liked to draw things so they looked three-dimensional. The first thing I drew was my Dad's weight-lifting set down in our basement. I couldn't believe it turned out so nice. So I started drawing a lot after that. I would look at a black-and-white photograph and do a drawing that looked exactly like the photograph. I would use a pencil and my finger to blend the graphite to create the different values.

What was your favorite subject matter?

Paula I liked drawing landscapes and birds, sunsets, things like that. I would take my camera and go to the river and take photographs, then I would draw from them.

I also liked math and the sciences quite a bit. When I went to the University of Wisconsin Extension, in Manitowoc, I took some geology and geography courses. I also took a life drawing course [human subjects] and really enjoyed that. I was fascinated with geology and geography. We had a short session in cartography in our geography class—maybe a week we spent on cartography and

maps. I was very intrigued and I thought, well, maybe I could combine my art with geography. I had seen some relief shading and thought, hey, that looks interesting. I bet I could do that.

So, I majored in cartography. I took a lot of engineering classes. I took math classes and calculus. Advanced algebra turned out to be very useful, because you do calculations in cartography. I also took computer programming. Things just sort of fell into place.

What are your goals for the future?

Paula I would like to perfect my relief shading. I also want to learn more about Photoshop and Painter [software programs] and see how I can incorporate the computer with shaded relief. I also would like to fly, to travel more.

That's one thing that's interesting about maps; it takes you places in your mind that you may never go to—you probably *won't* ever go to. Because you can't go everywhere, physically. But mentally, it does take you places. That's what was intriguing to me also.

You see that there's so many places and different people in the world. It's like expanding your mind by looking at a map. Maps are not just about the land; they're also about the people, the cultures.

Designing a good map requires more than just a knowledge of geography. Paula Robbins uses her artistic skill to select colors that work together, devise a key, and produce relief shading for mountainous areas. She also chooses the style, size, and placement of type that organizes the names of rivers, cities, counties, and other information. This map of a portion of the Alaskan coastline was published in *National Geographic*.

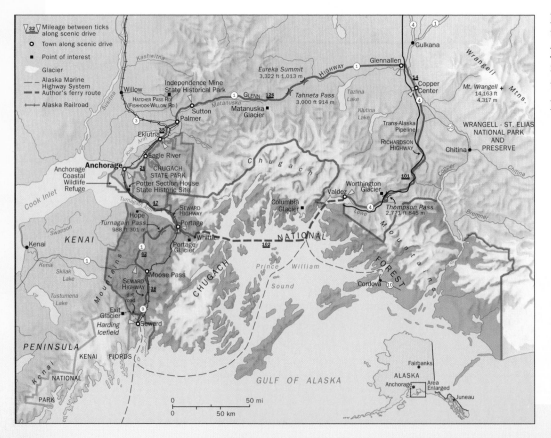

Studio Experience
Still Life Value Study

Task: To create and draw a still life using light, medium, and dark values of charcoal and white conté crayon.

Take a look. Review the following images in this chapter:
- Fig.3–3, Jean Baptiste-Siméon Chardin, *Still Life*
- Fig.3–4, Sun Han, *Self-portrait*
- Fig.3–14, Chris Polentz, *Untitled*
- Fig.3–18, Kent Twitchell, *Study for Eyes Mural*

Think about it. Look at the images listed above. Answer the following questions about each image:
- Where are the lightest and darkest values? The middle values? Where do the values shift slowly from dark to light? Where do light and dark contrast sharply? Where are the areas with the greatest contrast of value?
- From which direction is the light shining? What might the light source be?

Kendrick James (age 16). *Untitled*, 1998. Charcoal. Marion High School, Marion, South Carolina.

Do it.

1 Before beginning this activity, collect four or five objects that you would like to draw. Store these in a bag. At least three of the objects should be clearly three-dimensional.

2 On a piece of newsprint paper, practice creating light, dark, and several medium values with both vine and compressed charcoal. Notice which charcoal erases more easily and with which you are able to create the darkest values.

3 Make a small preliminary sketch of each of your objects. Include light, dark, and several medium values in your drawings. Use a kneaded eraser to make corrections; add highlights in some darker areas by erasing some of the charcoal.

4 As you arrange your objects into a still life, illuminate them with a desk lamp or other light source. Try positioning your objects and the light in several different ways, noticing the highlights, shadows, and value contrasts that are created in each arrangement. When you find an arrangement you like, begin to draw.

5 With the vine charcoal, lightly draw the still life on a medium-toned piece of 18" x 24" pastel paper. Draw the objects large, filling your page. Then shade the objects with the charcoal, creating a wide range of values from black to light gray. Add the lightest values with white conté crayon. In some areas, blend the white with a little black charcoal to create a lighter middle value. Use tissues, tortillons, and your fingers to achieve transition tones. As you draw, occasionally step back from your work to view it from a distance— or squint your eyes.

6 When you are done drawing and have checked your artwork, spray it with workable fixative in a well-ventilated place. Protect your drawing between work sessions by covering it with a piece of newsprint paper.

Helpful Hint

If you will move your still life at the end of each class period, arrange it on a paper or cardboard and mark the position of each object so that you can set these up in the same positions for the next drawing session. Also mark where your light source is.

Check it.
- Identify light, dark, and medium values in your composition. Have you effectively used a range of values?
- Where is the light source in your drawing? Can other students tell where the light source is?
- Where is the area with the greatest contrast of light and dark?
- What do you like best about this drawing?
- What might you do differently when you next create a similar drawing?
- What did you learn from this project?

Other Studio Projects

1 In separate containers, mix three ink washes of different gray values. Use only these three values to paint a landscape, a still life, or a portrait of a student model. You may wish to add a solid black contour or outline to finish your picture.

2 Use a variety of media in black, gray, and white to create a mixed-media painting. Emphasize the variety of materials by developing texture and value contrasts. Use media such as black ink, black and white crayons, black and white tempera or acrylics, black and white markers, pencils, and black and white paper.

Studio Experience

Still Life Value Study

Lester M. Shelley, Jr. (age 16). *Confusion Amongst Relatives*. Charcoal, 11" x 14" (27.9 x 35.6 cm). Marion High School, Marion, South Carolina.

Prepare

Time Needed:
Three 45-minute classes (extend as needed)
Lesson 1:
Do preliminary sketches.
Lesson 2:
Draw.
Lesson 3:
Draw and **Check it**.

Objectives

Students should be able to

- Understand how artists effectively use light, medium, and dark values in their artworks.

- Demonstrate their ability to create and draw an effective still life by using light, medium, and dark values of charcoal and white conté crayon.

Materials
- bag containing four or five objects to draw (see Before You Start and Notes on Materials), 1 per student
- newsprint paper, 18" x 24", for cover sheet and practice, 6 per student
- pastel paper, medium tones, such as light brown, blue, pink, or gray, 18" x 24", 1 per student
- black charcoal—soft vine and compressed sticks
- white conté crayon or white charcoal
- kneaded eraser
- desk lamp, 1 per student; or another light source, such as a spotlight or strong natural lighting for groups of students
- tissues or tortillons for blending
- workable fixative

Notes on Materials

- The size of the bag will limit the size of the objects that students draw. If storage space is limited, use small bags, such as sandwich bags, so that each student will have a small still life to set up each day. If you want larger still lifes that are not moved at the end of each class, have each student bring in one item and let groups of students arrange the items.

- For practice drawings, newsprint paper is inexpensive and produces a wide range of values.

- Provide a variety of charcoals. Vine charcoal erases easily, so it is a good choice for preliminary sketching. Compressed charcoal sticks may be used for large dark areas. Either white conté crayon, pastel, or white charcoal may be used to add light values on the medium-toned pastel paper.

- Provide unscented hair spray instead of fixative.

- Be sure to spray fixative or hair spray in a well-ventilated area or outdoors.

Before You Start
Several days before beginning this activity, distribute the bags for collecting still-life objects. Tell students to bring in four or five three-dimensional objects that have meaning to them. Have them include at least three objects that are clearly three-dimensional (as opposed to flat objects like tickets or postcards) so that they can learn to draw these forms with a variety of values.

Teach

Thinking Critically

- Focus on the images listed in **Take a look**. Ask students to compare the images and select the one that they think has the strongest value contrast. Ask: Why did the artist create

these value contrasts? How does the placement of very light values next to very dark values affect the emotion or mood of the picture?

- Direct students to select one of the images that they think effectively uses a wide range of values to indicate the rounded form of an object. Ask them to explain how shadows would change if the light source were directly in front of the subject.

Classroom Management

Limited space and availability of desk lamps may make the activity more feasible if students work together in groups to create a larger still life with a single light source.

Tips

- Dim the classroom lights to make greater contrasts between light areas and shadows, providing a wider range of values for students to draw.

- Beginning art students often outline objects with heavy dark lines in an effort to create dark values. Call students' attention to shadows on objects and the shapes that these dark values take as they transition to highlights on contoured surfaces.

Assess

Evaluation

Have students put their drawing up on a wall or easel and evaluate their own work. Encourage students to write an evaluation of their work by answering the questions in **Check it**, or ask them these questions:

- Where are the light, dark, and middle values?

- Where is the strongest contrast of light and dark? Is this pleasing to you? If not, why not? What would you do to change this?

- Is each object identifiable and distinct from other objects? If they blend together, do you like that? If

not, how can you change that? (By making one object either darker or lighter than the other and creating a greater difference in the values, the individual objects in the still life will be more distinguishable.)

- Are there effective transitions from dark to medium to light values?

- After students have considered their artwork, they might want to rework them by adding, deleting, or changing values with both charcoal and an eraser.

Extend

Meeting Individual Needs

Challenge

- Have students include a reproduction of a famous artwork in their still life. This could be in the form of a postcard, print, or art magazine illustration. The selected work should complement the student design.

- Instruct students to use white conté crayon to draw a still life on 18" x 24" black paper. They should use the crayon to make the real-life light areas light, leaving untouched the real-life areas that are dark. Students often reverse the lights and darks on a black ground, creating an X-ray, or negative, image.

Simplify

Have students draw with only black charcoal and not add the white conté crayon. They might also elect to include fewer or more simple objects in their still life.

Linking Design Elements and Principles

Emphasis

Ask students if they have created a center of interest in their composition by using a strong contrast of light and dark values. In what other ways have they created emphasis in their composition?

Balance

Tell students to consider where they might place the various still-life objects. Discuss symmetrical and asymmetrical arrangements of the still lifes. With a chalkboard sketch, demonstrate that if they center their objects in their picture, they will create a static, symmetrical balance; whereas if they put the focal point off center, they can create an asymmetrical balanced composition, which is usually more interesting.

Interdisciplinary Connections

Physical Science

In a dark room, encourage students to experiment illuminating the still lifes with a light bulb. As they put the light at different distances from the still life, they may measure the amount of light with a photography light meter. Ask them to make a statement about the relationship among the distance from the light source, its brightness, and the intensity of the light on the subject.

Inquiry

Have students research an artist, such as La Tour or Magritte, who made value an important part of his or her art. Ask students to find in the library or the Internet another artwork by this artist, in which value plays an important role, and to make a photocopy of it. Instruct students to label the darkest and lightest values.

Chapter 4 Organizer
Color

Chapter Overview
- Color has an important impact on our environment and emotions.
- Artists and designers use color harmonies, varying the value and intensity of hues.

Objective: Students will perceive and identify color properties and harmonies. (Art criticism)
National Standards: 2. Students will use knowledge of structures and functions. (2b)

Objective: Students will mix pigments and utilize art color harmonies in their own artworks. (Art production)
National Standards: 1. Students will understand and apply media, techniques, processes. **2.** Students will use knowledge of structures and functions. (2c)

8 Weeks	1 Semester	2 Semesters			**Student Book Features**
1	1	1	**Lesson 1:** The Source of Color	Chapter Opener The Source of Color, Neutrals	Try it: experiment, About the Artis
0	0	1	**Lesson 2:** The Properties of Color	Hue, Value, Intensity	Try it: color wheel, Note it, Try it: ing colors, About the Artwork
0	0	1	**Lesson 3:** Color Harmonies	Color Harmonies: analogous	Try it: analogous colors design, The Interaction of Color
0	0	1	**Lesson 4:** Color Harmonies	Color Harmonies: split-complementary	Try it: color experiment, The Intera of Color
0	0	1	**Lesson 5:** Color Harmonies	Color Harmonies: triadic, mono-chromatic	Try it: triadic colors design, Discuss it
0	0	1	**Lesson 6:** Warm and Cool Colors	Warm and Cool Colors	Note it
1	1	1	**Chapter Review**	Another Look at Color	Review Questions
2	3	3			

Studio Experience: *Color Harmonies with Pastels*

Objectives: Students will understand that color schemes may be used to create mood or emotion in art; perceive and understand analogous, complementary, split-complementary, triadic, and monochromatic color schemes in artworks; create a pastel painting using a specific color harmony.

National Standard: Students will identify artists' intentions, explore implications of purposes, and justify their analyses of particular arts' purposes (5a); create art using organizational structures and functions to solve art problems (2c); conceive/create artworks demonstrating understanding of relationship of their ideas to media, processes, and techniques (1b).

- We perceive color when light rays reflect into our eyes.
- Some colors seem cool; others seem warm.

- Neutrals are black, white, and gray.
- The spectrum contains red, yellow, blue, and the secondary and intermediate colors created by mixing these primaries.

Objective: Students will develop an appreciation and knowledge of the use of colors in a variety of cultures and art periods. (Art history/cultures)
National Standards: 4. Students will understand art in relation to history and cultures. (4a)

Objective: Students will perceive and appreciate color in their environment and in artworks. (Aesthetics)
National Standards: 2. Students will use knowledge of structures and functions. (2b) **5.** Students will reflect on and assess characteristics and merits of artworks. (5a)

Teacher Edition References	Ancillaries
Warm-up, HOTS, Context, Interdisciplinary Connection, Design Extension, Portfolio Tip, Internet Connection	*Slides*: Piet Mondrian, *Square Composition* (C-1); Isamu Noguchi, *Grey Sun* (C-2)
HOTS, Design Extension, Context, Portfolio Tip, Performing Arts, Materials and Techniques	*Slides*: Potowatami, *Bandolier Bag* (C-3); Jacob Lawrence, *Cabinet Makers* (C-4)
HOTS, Context, Inquiry	*Slide*: Jack Tworkov, *Friday* (C-5) *Large Reproductions*: Franz Marc, *Yellow Cow (Gelbe Kuh)*; Winslow Homer, *The Adirondack Guide*
HOTS, Context, Inquiry	*Slide*: Jack Tworkov, *Friday* (C-5) *Large Reproductions*: Franz Marc, *Yellow Cow (Gelbe Kuh)*; Winslow Homer, *The Adirondack Guide*
Design Extension, Context, Cooperative Learning	*Slide*: Jack Tworkov, *Friday* (C-5) *Large Reproductions*: Franz Marc, *Yellow Cow (Gelbe Kuh)*; Winslow Homer, *The Adirondack Guide*
Design Extension, Context, Interdisciplinary Connection, Performing Arts	*Slide*: Meindert Hobbema, *Wooded Landscape with a Water Mill* (C-6)
Design Extension, Materials and Techniques	

Studio Resource Binder

4.1 Geometric Color Study, painting
4.2 Acrylic "Stained Glass"
4.3 Pointillist Painting, acrylic painting
4.4 Cut-paper Mola Design, painted/cut paper
4.5 Batik Tie, applying color to cloth

Time Needed
Three 45-minute class periods.
Lesson 1: Experiment with color schemes and draw;
Lessons 2, 3: Add color with pastels.

Vocabulary

color harmony (or color scheme) Combinations of color—such as complementary or analogous colors—that can be defined by their positions on the color wheel. Particular color harmonies may be used to achieve specific effects. *(armonía cromática)*

complementary colors Any two colors that are opposite each other on the color wheel. *(complementarios)*

hue The name of a color, determined by its position in the spectrum. *(matiz/tono/color)*

intensity The strength, brightness, or purity of a color. Changing a color's value will also change its intensity. *(intensidad)*

neutral Having no easily seen hue. White, gray, and black are neutrals. *(color neutro)*

pigment The coloring material used in making painting and drawing media, dyes, inks, and toners. Pigments may be natural (made from earth or plants) or made from laboratory-prepared chemicals. *(pigmento)*

primary colors In subtractive color theory, such as when mixing pigments, the hues—red, yellow, and blue—from which all other colors are made. *(colores primario)*

shade A darker value of a hue, created by adding black or a darker complementary color to the original hue. *(sombra)*

spectrum The complete range of color that is present in white light. The spectrum colors are visible when light is refracted through a prism. *(espectro cromático)*

tint A lighter value of a hue, created by adding white to the original hue. *(matiz)*

tone A less intense value of a hue, created by adding gray to the original hue. *(tono)*

72b

Lesson 1
The Source of Color

72c

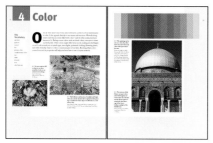

pages 72–73

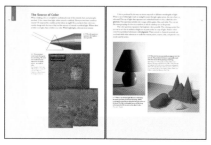

pages 74–75

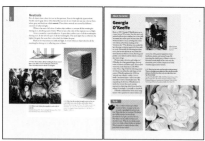

pages 76–77

Objectives

Students will be able to

- Perceive and appreciate colors in their environment and in artworks.

- Understand that color is created by light.

- Identify neutral colors.

Chapter Opener

- Ask students to look at real fall leaves or the photo of the leaf (fig.4–1) and to describe the colors they see. Encourage students to note the variation within just one leaf, and even the many colors in the predominately brown background of the photo.

- Guide students to note how many different colors are in the rusted metal in Dan Douke's *Zep* (fig.4–6).

- Direct students' attention to the color and light in Janet Fish's *Jump* (fig.4–2). Have them describe the color in different areas of this painting. Ask students how important color is in this art, and to imagine what it would look like in black and white.

| **Opener** | pages 72–73 |

Materials

- fall leaves or photos of fall leaves (optional)

Teach

- Call on students to describe a rainbow they have seen, and to explain how rainbows are made. Students have probably studied rainbows in science and know that they are caused by the refraction of light through water droplets.

- To make a light spectrum, or rainbow, in the classroom have students shine a white light through a prism onto a white surface. They can either hold the prism in sunlight or shine a projector bulb on the prism. Guide students to notice how bright and pure these colors are and to identify the colors in order. Call on students to explain how this spectrum is created from the white light, and then to compare the spectrum created with the prism with the spectrum in fig.4–5.

- Point out to students that the colors with which we paint are not as bright as the colors formed by light, such as those from the prism or on computer monitors. In fact, when graphic artists design on a computer, they must be aware that not all light colors can be reproduced with pigments: some of the colors are so bright that they cannot be printed.

Also, colors created by lights such as spotlights and computer monitors mix differently than pigments do.

- Shine a white light onto colored objects such as a green ball or an orange pumpkin. Explain to students that all the colors of the spectrum are hitting the ball and all except the color that they see are absorbed by the surface of the object. The color of the object is reflected to their eyes. Ask students what colors are reflected and absorbed by each of the objects in Kapoor's *As If to Celebrate, I Discovered a Mountain Blooming with Red Flowers* (fig.4–8).

- Allow students to experiment by shining light through colored gels or acetate and onto various objects, noticing how the colors are altered. Either borrow gels from a drama teacher, or use colored acetates for overhead transparencies. Remind students that these colors are mixed as lights, a process quite different from mixing with pigments.

Note: The primary colors in the pigment theory are red, yellow, and blue, which create a brown color when mixed together. Therefore, this is a subtractive color theory. In the additive light color theory, the primary colors cyan (blue), magenta (red-violet), and green create white when they are mixed together.

| **Teach** | pages 74–75 |

Materials

- prisms
- bright lights (projector bulbs or bright sunlight)
- colored items such as a green ball or orange pumpkin
- colored acetate or gels, several colors per 4 students

Teach: Neutrals

- Write the word *neutrals* on the chalkboard. Ask students what colors they could not find in the spectrum created by the prism. Explain that black, white, and gray are neutrals and are not in the spectrum.

- Have students do the **Try it** on page 77. Point out that because black absorbs all the light, and does not reflect any, it is known as the absence of color, whereas white, reflecting all the light, is the sum of all colors.

- As students study the neutrals in *The White Calico Flower*, fig.4–12, remind them that O'Keeffe was one of America's most famous abstract painters. Challenge them to explain why this painting might be considered abstract. If they do not remember the definition for abstract art, they should look it up in the glossary.

- Focus on the many colors in O'Keeffe's painting, and note how she has created grayed shadows to indicate the form of the flower.

Rachel Legsdin (age 16). *Reaction*. Acrylic, 18" x 14" (45.7 x 35.6 cm). Oakmont Regional High School, Ashburnham, Massachusetts.

Lesson 2
The Properties of Color

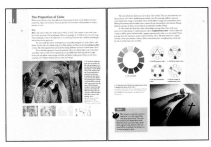

pages 78–79

pages 80–81

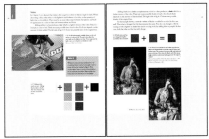

pages 82–83

Objectives

Students will be able to

- Identify primary, secondary, and intermediate colors.

- Demonstrate their understanding of how to mix primary hues to form the secondary and intermediate colors and arrange these hues in a color wheel.

- Perceive and identify the color properties of value, tint, shade, tone, and intensity.

- Identify complementary color harmonies in a color wheel and in artworks.

Teach: Hue

- After students have read the text on page 78, introduce them to color terms and the mixing of pigments. To model how colors are mixed to create a color wheel, first write the word *hue* on a large sheet of posterboard. Lead students in creating simple, quick color wheels. As you demonstrate, have students do **Try it** on page 79, making their own color wheels. Give each student a small amount of red, blue, and yellow paint. Explain that these are the primary colors, with which they can create all the colors of the pigment spectrum (color wheel).

 Demonstrate putting a dot of each primary color on the posterboard, spaced so that you can add the secondary and intermediate colors later. Have students mix the secondary colors by combining two primaries on smaller posterboard with tempera paint. (Alternately, have them mix either watercolor or tempera on heavy paper.)

 Demonstrate placing a dot of each secondary color between its primaries. Students can mix the intermediate colors by combining a primary with its neighboring secondary color.

- Write *complementary colors* on the demonstration posterboard. Explain to students that complementary colors are opposite each other on the color wheel. Call on students to list various complementary color schemes, such as red and green, and violet and yellow. Ask them to name the complement of one of the intermediates, such as red-orange. (blue-green) Have students make a complementary color scheme with two dots of color. Suggest that they look at Grant Wood's *Death on the Ridge Road* (fig.4–15) as an example of a painting with a complementary color scheme: most of the composition is composed of green, but the truck is red.

72e

Teach pages 78–83

Materials
- 22" x 28" white posterboard for demonstrations
- tempera or watercolor paints: red, yellow, blue, white, black

Try it page 79

Materials
- 9" x 12" (or larger) white posterboard or heavy paper, 1 per student
- tempera or watercolor paints: red, yellow, blue
- palettes
- brushes

- Call students' attention to the many small dots of colors and how they seem to blend in the color-separation image (fig.4–14). Commercial artists extensively use this phenomena of the eye's blending of colors (optical fusion). Focus on Seurat's Le Pont de Courbevoie (fig.4–23, 4–23a), in which the artist used pointillism, a technique that also relies on optical fusion. Grant Wood also applied his paint in small dots of color, building up thousands of points for the viewer's eye to blend. Have students study the grass in the foreground of Death on the Ridge Road to notice the dots of warm colors in the green area.

- Inform students that Grant Wood was an American Regionalist artist who painted scenes and people from his home state of Iowa during the first half of the twentieth century. Although he is known for his realism, he traveled to Europe and experimented with other painting styles. Encourage students to explain how Wood simplified and abstracted the subject to emphasize his message in Death on the Ridge Road.

Teach: Value

- As a review of Chapter 3, ask students to explain what value is. Remind them that value is the range from light to dark, and that the lightness or darkness of a color is its value. Write the word value on the demonstration board. Under it, write tint. Make a tint by mixing a color with white and putting it beside tint. Then write shade, and place a dot of black mixed with a color beside it. Call on students to pick out the lightest tints and the darkest shades in the photograph of the motorcycle (fig.4–16). Ask them where the light source is.

Teach: Intensity

- Explain to students that Seurat is usually considered to be a Post-Impressionist artist. Inspired by the use of color and visible brushstrokes of Impressionist painters such as Monet (figs.2–32, 2–33), Seurat developed his own style of painting.

- Write intensity on the demonstration board. Then have students do **Try it** on page 83. Stress that intensity has to do with brightness. Have students compare the intensity of the colors in the images on pages 82 and 83 and select one image that has intense colors and another that has less intense colors. Each student should explain his or her choice to another student; then, several students can defend their choice to the class.

Try it page 83

Materials
- white posterboard or heavy paper
- tempera or watercolor paints: red, yellow, blue
- palettes
- brushes

Lesson 3
Color Harmonies

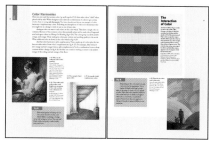

pages 84–85

Objectives
Students will be able to

- Recognize analogous color in works of art.

- Demonstrate their understanding of analogous color harmonies by creating their own design or painting with an analogous color harmony.

Teach

- Suggest that students use their color wheel from Lesson 2 and the color wheel (fig.4–14) on page 79 to discuss color harmonies.

Kehinde O. Wiley (age 18). *Intimation of My Familiar*, 1995. Oil on canvas, 36" x 48" (91.4 x 121.9 cm). Los Angeles County High School for the Arts, Los Angeles, California.

- Ask students to define analogous. If they are uncertain of the meaning, have them look up the definition. Explain that analogous colors are similar colors that are next to each other on the color wheel. Call on students to list several sets of analogous colors. Then focus on the analogous color harmonies in Fragonard's A Young Girl Reading (fig.4–24). Have students name the colors in this painting and then locate the brightest or most intense colors.

- After students have noted the analogous colors in Fragonard's A Young Girl Reading, direct their attention to her dress. Where have they seen clothes like this? What historical figures wore this type of dress? Students may recall history book illustrations of Martha Washington or Betsy Ross, or costumes in historical plays or movies such as 1776. Painted in France during the Rococo period, this artwork was completed at the time of the American Revolution.

- Direct students to do **Try it** on page 84. This project could be a tissue-paper or magazine picture collage, a tempera or acrylic painting, or a design made with felt-tip markers or oil pastels.

Try it page 84

Materials
- student color wheels from Lesson 2
- 12" x 18" white or manila paper **options:**
- tissue paper (assorted colors), magazines to cut, scissors, glue
- tempera or acrylic paints, palettes, brushes
- colored markers
- oil pastels

Lesson 4
Color Harmonies

pages 84–85

Objectives
Students will be able to

- Perceive and identify split-complementary color schemes in artworks.

- Perceive and understand that a color's appearance is partially dependent on its neighboring colors within an artwork.

Laura Bylenok. *Technicolor Fruit of Dreams*, 1998. Oil pastel, 12" x 12" (30.5 x 30.5 cm). Mercer Island High School, Mercer Island, Washington.

Teach
- Focus on the color wheels in figs.4–14d, 4–27. Review complementary colors, and explain that they are a type of color harmony.

 Demonstrate how to locate a split-complementary color scheme on the color wheel: look straight across the wheel toward the complement, and then "split off" to the

colors on both sides of it. Point out several split-complementary harmonies. Have students look at The Creation (fig.4–28) as an example of a split-complementary scheme. Ask them to name the colors in this color harmony. (Although muted, the colors yellow-green, blue-green, and red are present. Yellow-green can be seen in the sky background, blue-green in the globe, and red in the cloud shape above the human figure.)

- Instruct students that Aaron Douglas was a prominent artist during the Harlem Renaissance (1919–29), a period when African-American culture flourished. At that time many great African-American musicians, writers, and artists lived and worked in New York City's Harlem.

- From sets of colored markers or oil pastels, have students identify several split-complementary color combinations. Encourage them to create a design that has a split-complementary color scheme.

Teach page 85

Materials
- colored markers or oil pastels
- 12" x 18" white or manila paper

- Motivate students to do the **Try it** on page 85. Reemphasize that this demonstrates the theory that Albers was exploring in The Interaction of Color.

Try it page 85

Materials
options:
- magazines to cut, scissors
- 2" x 2" white drawing paper, tempera or acrylic paints, brushes

Lesson 5
Color Harmonies

pages 86–87

Objectives

Students will be able to

- Perceive and identify triadic color harmonies on a color wheel and in artworks.

- Create a two-part design which indicates their understanding of triadic color harmony.

- Perceive and identify monochromatic artworks

Teach

- After students look at the triadic color harmony example in fig.4–30, have them use the color wheel on page 79 (fig.4–14) to select several examples of triadic harmonies. Review the images on pages 86 and 87 that show triadic color harmony.

- Focus on fig.4–29, the feather headdress, guiding students to see how the colors used are a triadic color harmony. Lead students in discussing reasons for preserving objects such as this in climate controlled museums. See **Context** on page 86.

- To encourage discussion pose these questions: Are this headdress and the Cuna blouse (fig.4–21) works of art? Why or why not? When does clothing become art?

- Have students do **Try it** on page 87. Direct them to fold a 12" x 18" paper in half and use markers, tempera paint, or cut colored paper to create the first design on half of the paper. On the other half, ask students to create the second design. Pairs of students can then compare the moods or feelings produced by the two designs.

> **Try it** page 87
>
> **Materials**
> - 12" x 18" heavy white or manila paper
> *options:*
> - colored markers
> - tempera paint, palettes, brushes
> - colored paper, scissors, glue

- Ask students what *monochromatic* means. Discuss the roots of the word: *mono-* means "one," and *chroma* means "color." A monochromatic color harmony includes the varying tints and shades of one color: that is, one color plus black and white. Call students' attention to the various shades of blue in *Blue Coast* (fig.4–32) by Lyonel Feininger.

- Instruct students that Feininger's *Blue Coast* is an example of Cubism, a style of art in which the subject is abstracted to emphasize geometric shapes.

- Lead students in considering **Discuss it** on page 87. Have students look through design magazines to select examples of monochromatic, triadic, complementary, split-complementary, and analogous color harmonies.

> **Discuss it** page 87
>
> **Materials**
> - fashion, design, or interior-decorating magazines

Lesson 6
Warm and Cool Colors

pages 88–89

Objectives

Students will be able to

- Perceive and identify warm and cool colors and their characteristics in artworks.

- Perceive how warm and cool colors may indicate depth and demonstrate this understanding in a paper collage.

Teach

- Ask students to imagine being someplace cold, and to write a list of the colors that come to mind in this place. Then ask them to imagine being in a warm or hot place, and to list the colors evoked here. Next, focus on the color wheel in fig.4–33 and note the warm and cool colors. Have them determine whether the colors they listed are indeed on the warm and the cool sides of the wheel.

- Emphasize that artists often use warm and cool colors to convey messages and feelings in their art. As a contrast to Kandinsky's *Russian Beauty in a Landscape* (fig.4–36), ask students what feeling they think Porter was trying to convey with the warm colors in *Soldado Senegales* (fig.4–34).

- Inform students that in 1943 James Porter wrote *Modern Negro Art,* a book still widely used by scholars. A dedicated historian of African-American art, the artist recorded the activities of black contemporary artists and researched the lives and works of earlier black artists.

- For students to see that warm colors usually appear in the foreground, whereas cool colors tend to recede in a design, focus on these images:

Fig.3–10, John Singer Sargent, *Muddy Alligators*

Fig.4–2, Janet Fish, *Jump*

Fig.4–23, Georges Seurat, *Le Pont de Courbevoie*

Fig.4–35, *Raffia*

Next, have students note the contrast of warm and cool colors in *The Farm, The Village* (fig.4–37). Ask them what part of the picture they see first and why.

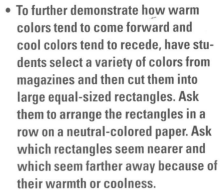

- To further demonstrate how warm colors tend to come forward and cool colors tend to recede, have students select a variety of colors from magazines and then cut them into large equal-sized rectangles. Ask them to arrange the rectangles in a row on a neutral-colored paper. Ask which rectangles seem nearer and which seem farther away because of their warmth or coolness.

 Encourage students to experiment with the illusion of distance and nearness by overlapping and changing the size and location of the rectangles. Have them glue their final arrangement onto the neutral-colored paper to create a collage. Each student should be able to explain what effects they were trying to achieve through their use of color.

- After discussing **Note it** on page 89, some students may wish to glue a warm-colored shape on one of the cool rectangles of their collage.

Teach pages 88–89

Materials
- magazines to cut
- 9" x 12" paper: white, black, or gray
- scissors
- glue

Sung W. Lee (age 17). *Memory*, 1997. Acrylic, 11" x 14" (27.9 x 35.6 cm). West Springfield High School, Springfield, Virginia.

Chapter Review

pages 90–91

Assess

- Have students write answers to the review questions, either outside of class or by pairs of students in class. Check students' answers. Correct any misconceptions, and reteach areas of uncertainty. **(Art criticism)**

- Call on students to locate examples of the color properties and harmonies referred to in the review questions, using art reproductions found in this chapter. **(Art criticism)**

- Challenge students to name a piece of art in this chapter that represents each of the following styles or cultures:

 French Rococo period
 Fragonard (fig.4–24)

 Harlem Renaissance
 Douglas (fig.4–28)

 French Post-Impressionism
 Seurat (fig.4–23)

 Karajá tribe of the Amazon
 headdress (fig.4–29)

 20th-century American abstract art
 de Kooning (fig.4–31), Feininger
 (fig.4–32), O'Keeffe (fig.4–12)

 American Regionalism
 Wood (fig.4–15)

 Write the list in the first column on the board. As the students review their examples with the rest of the class, they should describe the various color harmonies and properties in these works of art.
(Art history/cultures)

- Direct students to select either an object in their environment or an artwork that employs color in a manner that is especially appealing to them. They should use the color property and harmony names to write a description of this use of color and to explain why they appreciate the colors in this art or object. **(Aesthetics)**

- Check color wheels created by students to ascertain whether they understood how to mix colors. **(Art production)**

- Ask students to add their work from this chapter to their portfolios by selecting two pieces to mat or mount. Review the art with each student to determine if he or she understands the color theories involved in each project.

Reteach

- Focus on James Rosenquist's House of Fire (fig.4–38), and ask students to name some analogous colors in the painting. (the varying reds of the lipsticks)

- Ask students to select a warm and a cool image from this page. (House of Fire is warm, and Zodiac window [fig.4–40] is cool.) Ask how the artists used color to create moods. Guide students to see that the colors in Tulip (fig.4–39) seem to fit the lighthearted form.

- Call on students to describe the color harmonies in each image on pages 90 and 91. Students should use the terms tint, shade, intensity, and tone in their discussion.

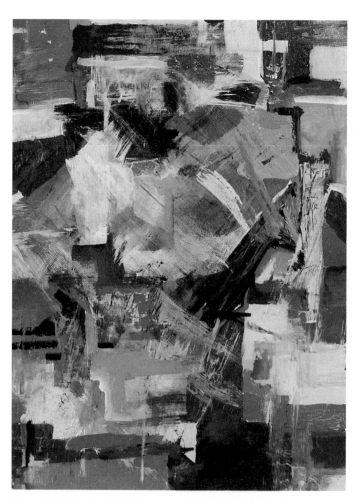

Fernando Ramirez (age 17). *Self-portrait*, 1997. Acrylic, 15" x 20" (38.1 x 50.8 cm). Los Angeles High School for the Arts, Los Angeles, California.

Meeting Individual Needs

Students Acquiring English

Display the key vocabulary words on the chalkboard. Integrate language skills by having students relate color descriptions of objects within the classroom. Present useful sentence structures or formulas for discussing vocabulary; for example, "red mixed with … will give you the color …"

Students with Special Needs

ADD or ADHD

Depending upon the student, use judgment about how and when to distribute materials. For example, distribute only one paint color at a time. Once students are familiar with the materials, gradually provide additional colors for completion of the activity.

Gifted and Talented

- Have students examine the images in this chapter or other visuals that you display. Challenge them to identify and compare and contrast how the various artists used the three qualities of color (hue, value, and intensity) in their artwork.

- Encourage students use colors in a drawing or painting to express moods.

Answers to Review Questions

1 Light strikes an object, and the lightwaves that are the color of the object are reflected to our eyes.

2 Black, white, and gray—known as neutrals—are not found in the light spectrum.

3 The primary hues (colors) are red, yellow, and blue; the secondary colors are orange, green, and violet; and the intermediate colors are red-orange, yellow-orange, blue-violet, red-violet, blue-green, and yellow-green.

4 Mixing two primaries together creates the secondary colors.

5 Value refers to the lightness or darkness of a color.

6 Lessen the intensity of a color by adding its complement or a neutral (black, white, or gray).

7 Color harmonies, or color schemes, are complementary, split-complementary, analogous, monochromatic, and triadic.

8 Georgia O'Keeffe wanted viewers to notice flowers, both in her paintings and in nature. The size of these flowers might startle viewers, causing them to stop and take a second look.

9 In pointillism the paint is applied to the canvas in small dots or dabs. Georges Seurat is known for his pointillism.

Computer Connection

In a drawing or painting program, guide students to create a color value chart. Create a row of nine rectangles and fill the center one with 50 percent of a chosen color. Fill each rectangle to the right of center with decreasing amounts of the color, at 10 percent intervals. The first will be 40 percent, the next 30 percent, and so on. Fill each rectangle to the left with increasing amounts of the color. Call on one student to print the chart in color, and display the chart. Ask students: Does this chart show tints of a color? (yes, because the white paper adds white to the color) Does it show shades? (no, because no black is added, only color pigment) Which rectangle shows the highest level of intensity? (the 90 percent filled rectangle)

4 Color

Key Vocabulary

spectrum

pigment

neutral

hue

primary colors

complementary colors

tint

shade

intensity

tone

color harmony

ONE OF THE MOST EXCITING AND POWERFUL ASPECTS of our environment is color. Color appeals directly to our senses and emotions. We walk along streets and shop in stores filled with color—and we often make purchases because of it. Perhaps some colors, such as school colors, cause you to cheer and feel pride. Other colors might affect your mood, making you feel happy or sad. Look around you at rusted signs, neon lights, patterned clothing, flowering plants, and other everyday objects. Color is a necessary part of our lives. Knowing where color comes from and its properties will help you learn how to use it in your artwork.

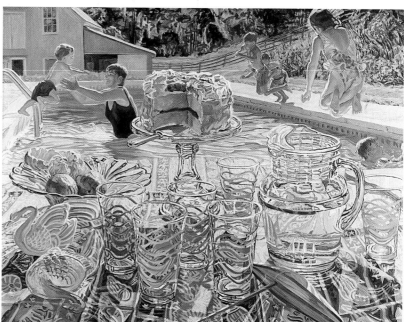

4–2 The brilliant combination of sunlight and bright colors on a sunny summer day is captured in this painting. Consider how these objects would look on a cold winter's day.

Janet Fish (b. 1938). *Jump*, 1995. Oil on canvas, 54" x 70" (137.2 x 177.8 cm). D. C. Moore Gallery, New York. Photo by Beth Phillips.

4–1 In some regions, fall is when we are most mindful of color in our natural surroundings.

Leaf in Lexington, Massachusetts. Photo by H. Ronan.

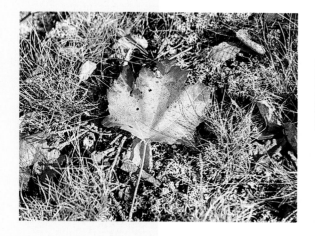

Chapter Warm-up
• To help students understand how important color is, either name or hold up color samples of the school colors or color combinations associated with holidays. Ask students what they think of when they see these colors.

• Discuss with students how important color is to them when they select clothes. Ask them to look around the classroom and notice how many different colors there are, both on their fellow students and in the room itself.

Higher-Order Thinking Skills
Have students select both a color and a black-and-white advertisement from a magazine. Ask them to write an analysis of the impact of color on the mood and meaning of the ad.

4–3 This painting can be seen as a color chart that shows the move from one color of the spectrum to the next.
Ellsworth Kelly (b. 1923). *Spectrum II*, 1966–67. Oil on canvas, 80" x 273" (203.2 x 693.6 cm). Funds given by the Shoenberg Foundation, Inc. 4:1967, The Saint Louis Art Museum (Modern Art) (ISM 15192).

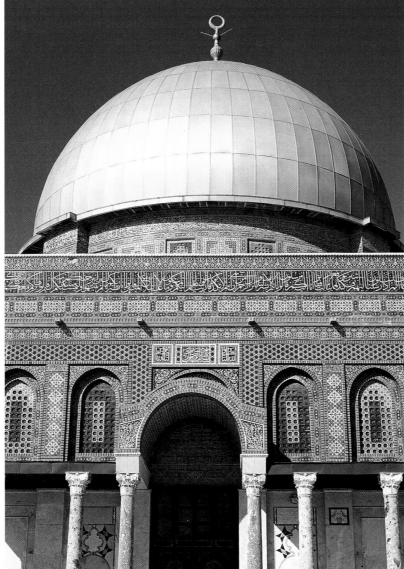

4–4 The exterior of this Islamic mosque is decorated with brightly colored ceramic tile. The tile and the dome's gold covering both take advantage of the direct, brilliant sunlight of the Middle East.
Dome of the Rock, Jerusalem, Israel, detail. Photo by L. Nelken.

Context

Kelly often works on a monumental scale. *Spectrum II* is more than twenty feet wide and consists of thirteen rectangular panels. Despite the huge scale of the piece, no brush-strokes are evident. Kelly belongs to that group of artists termed Hard-Edge. They use crisp clean edges and apply values and colors so that they are flat and even.

Interdisciplinary Connection

Science—So that students may experiment with making natural dyes from fall leaves, have them boil the leaves of a single species of tree in water for two minutes and then remove the leaves and put them into a jar of rubbing alcohol. Have students cover jars and place into a bowl of warm water for an hour. The color will leach from the leaves into the alcohol. Students may paint with this colored alcohol mixture.

Portfolio Tip

Encourage students to preserve the color studies that they create in this chapter—even the very simple ones. These examples will indicate to college admissions officers, other art educators, and job interviewers that they have studied and understand color theory.

Design Extension

Direct students to make charts that explain pigment and light color theories. Have them research light theory and compare it to the pigment color mixing theories. They should include the answers to these questions on their chart:
- What are the primary colors in each color theory?
- What colors do the primaries make when two are mixed together in both the light and the pigment mixing theories?
- In each color theory, what color is created when all three primaries are mixed?

Internet Connection

Color theory is a complex field of study that students may wish to further investigate by using the Internet. They can tailor their search depending upon the technical level with which they are comfortable. For example, using a search engine to find web sites related to "color wheel" will yield less advanced results than a search for "color+vision."

The Source of Color

When studying color, it is helpful to understand some of the scientific facts and principles involved. Color comes from light, either natural or artificial. Have you ever been outside at sunrise? Or surprised by a sudden power failure at night? If so, you know that colors constantly change with the time of day and the amount of natural or artificial light. Where there is little or no light, there is little or no color. With bright light, colors are more intense.

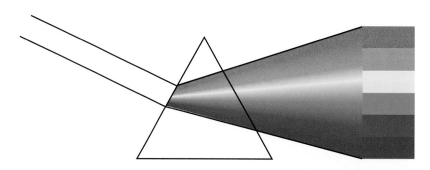

4–5 The color spectrum represents the brightest colors possible.

4–6 This painting is meant to give the appearance of rusting. The artist saw weathered metal—objects that we barely notice—as a study in color.
Dan Douke (b. 1943). *Zep*, 1985. Acrylic on canvas, 24" x 35" (61 x 88.9 cm). Collection of Bruce Everett, Northridge, California.

Color is produced by the way our vision responds to different wavelengths of light. When a ray of white light (such as sunlight) passes through a glass prism, the ray is bent, or refracted. This ray of light then separates into individual bands of color, called the color *spectrum*. This spectrum includes red, orange, yellow, green, blue, and violet. You can see this same grouping of colors in a rainbow, in which raindrops act as the prisms.

The color spectrum represents the brightest colors possible. The coloring matter that you use in art class is neither as bright nor as pure as that in a ray of light. Artists' colors come from powdered substances called *pigments*. These natural or chemical materials are combined with other substances to make the various paints, crayons, inks, and pencils commonly used by artists.

Interdisciplinary Connection
Social Studies— Choose flags from various countries, and have students investigate the symbolism of the colors in the flags.

75

4–8 This artist has incorporated pure pigment into his artwork. The powdered substance is generally mixed with other materials for painting or drawing.
Anish Kapoor (b. 1954). *As If to Celebrate, I Discovered a Mountain Blooming with Red Flowers*, 1981. Three drawings and sculpture with wood, cement, polystyrene, and pigment, 38 ¼" x 30" x 63" (97 x 76.2 x 160 cm) and 13" x 28 ⅛" (33 x 71.1 cm) and 32" (81.3). Tate Gallery, London. Photo Tate Gallery, London/Art Resource, New York.

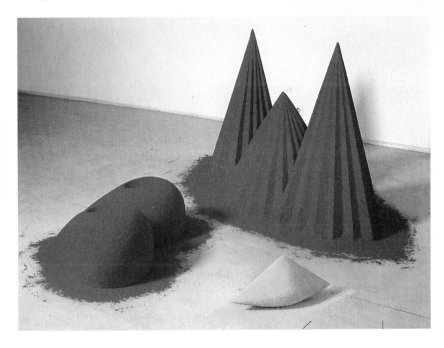

4–7 When a ray of white light falls onto a blue lamp, the entire spectrum of colors hits the lamp. All the wavelengths except blue are absorbed into the surface of the lamp. The blue wavelengths bounce off the lamp and are perceived by our eyes as the object's color.
Photo by T. Fiorelli.

Context
California artist Dan Douke approaches the use of color from an unusual point of view: he gets ideas from found objects. For *Zep* (fig.4–6), he represented two panels of rusted steel with a welded join. Douke carefully studied the objects before he began to paint with acrylic pigments on canvas. Such weathered materials—with chipped, faded, and rusted surfaces—are a challenge to an artist's skill and innovation.

Neutrals

Not all objects have colors that are in the spectrum. Stars in the night sky appear white. Smoke may be gray. Ink is often black. Because we do not clearly see any one color in them, white, gray, and black are called *neutrals*. These three neutrals are created by different amounts of reflected light.

White is the sum of all colors. A white object reflects to our eyes all the wavelengths shining on it, absorbing none of them. What we see is the color of the original source of light.

Gray is created by a partial reflection. A gray object reflects part of all the wavelengths shining on it. It also absorbs part of all the wavelengths. The more light that is reflected, the lighter the gray; the more that is absorbed, the darker the gray.

Black is the total absence of reflected light. It results when an object absorbs all the wavelengths shining on it, reflecting none of them.

4–9 Pure white reflects all the wavelengths from a ray of light. Gray reflects some wavelengths and absorbs some. Pure black absorbs all the wavelengths.

4–11 How has this student brought variety to her artwork which uses neutral colors and similar values?

Maryrose Mendoza (age 22). *Twin*, 1991. Fabric, wood, foam, and plastic. 12" x 12" x 20" (30.5 x 30.5 x 50.8 cm). Staff intern, Los Angeles County High School for the Arts, Los Angeles, California.

4–10 Black-and-white photography is made only of neutrals.

Emil Schulthess (1913–96). *Candlelight Meeting in Peru*, 1961. Emil Schulthess Erben Photoarchiv, Zürich.

Higher-Order Thinking Skills

Fashion designers often describe brown and tan—in addition to gray, white, and black—as neutral colors. Ask students to guess why designers might do this instead of using the strict art definition of a neutral as being only black, white, or gray. Have a volunteer read the definitions of *neutral* in an unabridged dictionary, and then call on students to select a definition that would include the fashion industry's expanded use of the term. ("of no particular color; indefinite")

About the Artist

Georgia O'Keeffe

Born in 1887, Georgia O'Keeffe grew up on a large farm in Wisconsin. She first drew and painted with an eye to realism, but as her skill increased, her artistic path became clear. She wisely decided to focus on being true to her own vision, rather than creating art for "everyone else." This decision was marked by her choosing to destroy nearly all of her earliest work. Eventually, by following her inner voice, she became known as one of the foremost American abstract artists. Her long and prolific career lasted until her death at ninety-nine years of age.

Flowers were a favorite early subject of O'Keeffe: she often painted large, close-up views of flowers and flower parts. Some views were even closer than that in *The White Calico Flower* (fig.4–12): the vibrating center of a flower was often the only shape on her canvas. O'Keeffe explained in 1939 that "nobody sees a flower—really—it is so small—we haven't time—and to see takes time, like to have a friend takes time." By magnifying the flowers, O'Keeffe tried to startle the viewer. She used a similar approach in depicting other forms found in nature; for example, a cornstalk or clamshell.

O'Keeffe combined her lively visual imagination with a passion for natural forms and

colors; she often gained inspiration from landforms, plants, and animal bones. By depicting the stark beauty of desert scenes or bleached animal skulls in her own way, she shared the power of her compositions with countless appreciative viewers.

4–12 How has the artist used neutrals in this painting? Where is the light most reflective? How do the neutrals influence the direction that your eyes take when viewing the painting?
Georgia O'Keeffe (1887–1986). *The White Calico Flower*, 1931. Oil on canvas, 30" x 36" (76.2 x 91.4 cm). Collection of the Whitney Museum of American Art. Purchase, 32.26. ©1999 The Georgia O'Keeffe Foundation/ARS, New York, NY.

Try it

Place a white swatch and a black swatch of fabric or paper in the sun or under a spotlight for several minutes. Then feel the two surfaces. The black one will be warmer because it has absorbed all the light rays from the sun. The white one has reflected them and absorbed none. Why do you think people often wear dark-colored clothes in winter? Why do people in warm climates often paint their houses white?

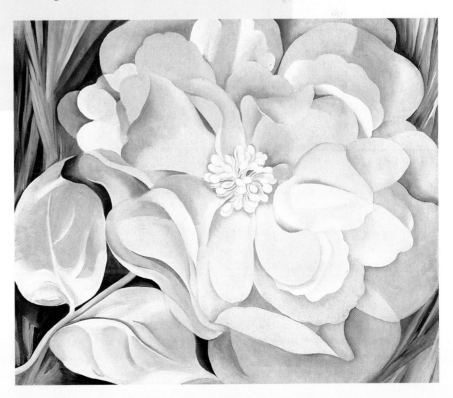

The Properties of Color

When artists discuss color, they talk about three properties that can be defined and measured: hue, value, and intensity. These properties are sometimes called qualities or characteristics of color.

Hue

Hue is the name of the color itself, such as "blue" or "red," and it refers to the color's position in the spectrum. The wavelength of blue, for example, is 19 millionths of an inch long. The wavelength of red is 30 millionths of an inch long. Each hue has a definite wavelength and position in the spectrum.

For easy study, the colors of the spectrum are usually arranged in a circle called a color wheel. Look at the color wheel in fig. 4–14. Red, yellow, and blue are the three *primary colors* or hues. All other pigment hues are made by mixing different amounts of these three colors.

If you mix the pigments of any two primary colors, you will produce one of the three secondary colors or hues. From experience, you probably know that red and blue make violet, red and yellow make orange, and blue and yellow make green. These are the three *secondary colors*. Notice their location on the color wheel.

Design Extension

Have students examine color separations in color comic strips from newspapers or comic books. They should use magnifying glasses or jewelers' loupes to study the color printing. Students can use markers to draw a color enlargement of one small section of the magnified comic print.

4–13 In this set of illustrations, you can see how the full-color printing process uses the three primary hues plus black to "create" all the colors of the original painting. One printing plate is produced, by electronic scanning and color separation, for each color shown. The printing press contains a separate area for each ink color to be printed onto the paper. When the paper completes its pass through the press, the result is the full-color image. The neutral values of the black plate add value contrast to the primary colors.

Albert W. Porter (b. 1923). *Hawaiian Mood*, 1987. Watercolor, 15" x 22" (38.1 x 55.9 cm). Courtesy of the artist.

Materials and Techniques

The primary printing ink colors cyan and magenta appear to be different hues than the blue and red shown on the color wheel in fig. 4–14a. Although they might be described as "light blue" and "pink," they function as the equivalent of the blue and red of tempera, oil paint, or other media.

The color wheel also shows six *intermediate colors* or hues. You can create these by mixing a primary color with a neighboring secondary color. For example, yellow (a primary color) mixed with orange (a secondary color) creates yellow-orange (an intermediate color). Mixing the primary and secondary colors creates the six intermediate colors shown. Mixing different amounts of these colors produces an unlimited number of hues.

A color wheel also illustrates other relationships among colors. One of the most important is the pairing of complementary colors. *Complementary colors* —such as blue and orange or yellow-green and red-violet—appear opposite each other on a color wheel. These pairings show the maximum visual contrast between colors. The line where two complementary colors meet seems to vibrate. Artists sometimes place complementary colors side by side to produce just such an effect.

79

Context

Grant Wood, who was strongly influenced by early Flemish painting, discovered the Flemish masters of the northern Renaissance during several trips he made to Europe in the 1920s. The realism, painstaking detail, and high color of Flemish art all appear in his paintings. The shades of red and green that Wood used in *Death on the Ridge Road* (fig.4–15) are often found together in the works of the Flemish painters Rogier van der Weyden and Jan van Eyck.

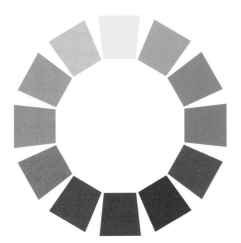

4–14 Color wheel.

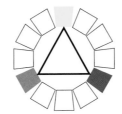

4–14a The primary colors.

4–14b The secondary colors.

4–14c The intermediate colors.

4–14d An example of complementary colors.

4–15 How has Grant Wood used complementary colors to heighten the drama of this scene?

Grant Wood (1892–1942). *Death on the Ridge Road*, 1935. Oil on masonite panel, 39" x 46 ¹/₁₆" (99 x 117 cm). Gift of Cole Porter, Williams College Museum of Art, Williamstown, Massachusetts.

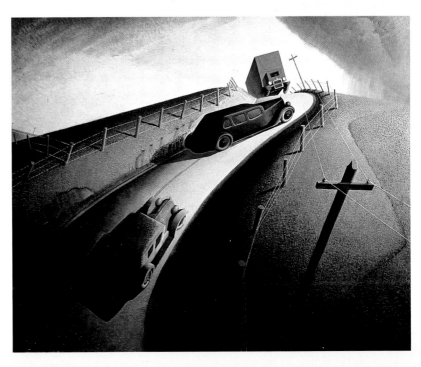

Try it

Mix tempera or watercolor paints to make your own color wheel. Start with the primary colors. Then mix the secondary and intermediate colors. Paint the colors on posterboard or heavy white paper. Are the mixtures what you expected? If not, perhaps the primary colors were not pure or clean.

Value

In Chapter 3, you learned that value is the range from white to black or light to dark. When discussing colors, value refers to the lightness and darkness of a color, or the quantity of light that a color reflects. There may be as many value steps between the lightest and darkest appearance of a color as there are between white and black.

Adding white to a hue produces a *tint*, which is a lighter version of the color. Pink, for example, is a tint of red. There are many possible tints of each color. Each tint depends on the amount of white added. The left side of fig.4–17 shows two possible tints of the original hue.

4–16 In this photograph, sunlight shines on the red surface of a motorcycle. The parts that reflect the most light are the lightest in value. Those opposite the light source, or in shadow, are darker in value.
Motorcycle. Photo by J. A. Gatto.

Note it

When you mix certain combinations of complementary colors, you might create a range of browns instead of grays. This occurs when there is more red and yellow in the mixture than blue. Remember this when the color brown is not available!

Portfolio Tip
Have students place a protective sheet of white paper between all pieces of art in their portfolio.

4–17 Adding white results in tints. Adding black results in shades. The value changes, but the hue remains the same.

Higher-Order Thinking Skills

Lead students to compare the black-and-white with the color reproduction of Eakins's *Miss Van Buren* (figs.4–19, 4–19a). Ask them to explain how the color reproduction affects the values and mood of the painting. Does the color provide any extra information about the subject that is not available in the black-and-white version? Ask students which version they prefer.

Adding black (or a darker complementary color) to a hue produces a *shade*, which is a darker version of the color. There are many possible shades of each color. Each shade depends on the amount of black added. The right side of fig.4–17 shows two possible shades of the original hue.

In the example shown, a neutral—white or black—is added to a color (in this case, red). The value is changed, but the hue remains the same. You also can change a color by mixing it with a lighter or darker hue (such as in fig.4–18, by adding blue to purple). In that case, both the value *and* the hue will change.

4–18 Both value and hue are changed if a lighter and darker hue are mixed.

81

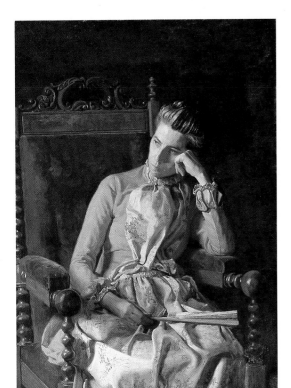

4–19 Notice how the black-and-white reproduction allows you immediately to see the range of values used by the artist. The contrast between sunlit and shadowed areas is obvious. How does the black-and-white image help you better understand and appreciate the range of values?
Thomas Eakins (1844–1916). *Miss Amelia Van Buren*, c. 1891. Oil on canvas, 45" x 32" (114.3 x 81.2 cm). The Phillips Collection, Washington, DC.

4–19a *Miss Amelia Van Buren*

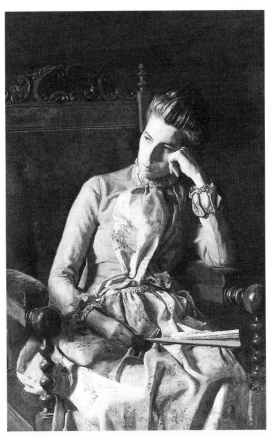

Design Extension
Make a collection of color swatches from a box of Coloraid® paper, from paint-sample chips, or from magazines or wallpaper books. Have students sort these into the various hues and then arrange them from light to dark values and from bright to dull intensities.

Higher-Order Thinking Skills
Ask students to use the color terms in this chapter to describe various hues of browns and tans. For example, a light tan might be a tint of a yellow-orange, or a dark brown might be a less intense shade of a yellow-green dulled by the addition of red and darkened with black.

Intensity

The third property of color is *intensity*. Intensity refers to the quality of light in a color. Intensity is different from value, which refers to the quantity of light that a color reflects. Intensity refers to the brighter and duller colors of the same hue. For an example, look at the two squares in fig.4–20. The top one has a higher degree of saturation, or strength. It is more intense than the one below it. Your investigations with color will show you that you cannot change value without changing intensity, even though these two properties of color are not the same.

You already know two ways to change the intensity of a color when mixing pigments: adding black to produce shades, or adding white to produce tints. After adding either of these neutrals, the resulting hue loses its intensity. The color becomes less and less intense as more black or white is added. A third way to change intensity is to mix any shade of gray with the hue. This is called a *tone.*

Mixing a color with its complementary color will also change intensity. As you mix complementary colors, bit by bit, a neutral gray is formed. This is because the complementary colors represent an equal balance of the three primary hues. In theory, the mixture should produce white, but the pigments in artists' materials are not as pure as the colors in a ray of light.

4–20 The top square has a higher degree of intensity than the bottom square.

4–21 How would you describe the intensity of the colors in this blouse?
Panama (Cuna People). *Child's blouse,* 20th century. From San Blas Island, Cuna Yala region. Private Collection, Orlando, Florida.

4–22 Analyze the blues in this painting. Which blue is most intense? Can you suggest what the artist did to the other blues in order to change their intensities?
William H. Johnson (1901–70). *Going to Church,* c. 1940–41. Oil on canvas, 38 ¼" x 44 ⅛" (97 x 112 cm). National Museum of American Art, Smithsonian Institution, Washington, DC. Photo National Museum of American Art, Washington, DC/Art Resource, New York.

Higher-Order Thinking Skills
Lead students in analyzing *Going to Church* (fig.4–22) by William H. Johnson, an African-American artist who was born in Florence, South Carolina but studied in New York and Europe. Guide students to note when this painting was created. Ask what they see in this painting. Ask: What is the subject? What colors did the artist use? Where has each color been repeated? How has the artist abstracted or simplified the objects in the painting? Are the colors realistic? What was the artist's purpose in creating the painting in this style? What do you like or dislike about this painting?

About the Artwork

Georges Seurat

Le Pont de Courbevoie

How is it that we can know a great deal about how artists from previous centuries worked? One way is to analyze clues they might have left behind. In the case of *Le Pont de Courbevoie*, Seurat made a careful sketch of the water scene he planned to paint.

The conté crayon study for the work shows that Seurat planned the composition of *Le Pont de Courbevoie* thoughtfully. The slight tilt of the sailboat masts, the position of the bridge and shoreline, and the curved tree on the right are found in the study and the painting. Seurat added items to the composition as he painted the canvas. These include the foreground sail, the two fishermen in the distant boat, and the two isolated figures in silhouette. The angled figure on the dock adds a sense of movement to the otherwise quiet composition. Seurat probably worked on the painting both in his studio

and at Courbevoie, perhaps during several visits to the riverside.

Through extensive research, scholars have also learned about Seurat's use of color. Scholars disagree about how he worked. Some say that Seurat based his decisions on a scientific color theory. Others believe that he worked instinctively, his brush creatively flowing with colors that interlock with those underneath.

Most scholars believe, however, that Seurat's palette contained an assortment of pure colors (hues), an assortment of colors mixed with white (tints), and various whites. Because Seurat could not always obtain pure pigments, he was forced to use some colors that were only close to what he wanted. Today, we do not see the painting as Seurat planned or painted it: within a few months of its completion, some of the pigments faded. We can only imagine the original effect.

4–23 Georges Seurat used a painting technique called *pointillism*, in which paint is applied to the canvas in small dots or dabs. From a distance, the eye blends these dots to make an array of colors and values. The stillness throughout this work is a result of both the painting technique and the low intensity of the colors.

Georges Seurat (1859–91). *Le Pont de Courbevoie*, 1886–87. Oil on canvas, 18" x 21" (45.7 x 53 cm). Courtauld Gallery, London.

4–23a
Le Pont de Courbevoie (detail).

Try it

Mix two of the primary colors to make a secondary color. Then add a small amount of this new color to its complementary color. To study the range of intensities, continue adding a little more of the complementary color.

Context

Off the coast of Panama lie the San Blas Islands in the Cuna Yala region, where the Cuna Indian women decorate their blouses (fig.4–21) with sewn cotton panels called *molas*. They sew these colorful appliqués with almost-invisible stitches. The colors are brilliant, and the designs are inspired by nature. Young girls learn this art, which is over 100 years old, from their mother and grand-mothers.

Context

Johnson (fig.4–22) spent much of his career painting images of African-American life. In 1946, Johnson stated, "In all my years of painting, I have had one absorbing and inspiring idea, and have worked towards it with unyielding zeal: to give—in simple and stark form—the story of the Negro as he has existed."

Color Harmonies

Have you ever said that certain colors "go well together"? Or that other colors "clash" when placed side by side? When designers and artists use combinations of colors to get certain results, they are using **color harmonies**. You have already read about one example of color harmony: complementary colors. Following are descriptions of other color harmonies that you might see in a design or wish to use in one of your own.

Analogous colors are next to each other on the color wheel. They have a single color in common. Because of this common color, they naturally relate well to each other. Fragonard used analogous colors in *A Young Girl Reading* (fig.4–24). The color group is yellow, yellow-orange, and orange. These analogous colors give a warm and soothing quality to the work. What additional color is shown in the color wheel in fig.4–25?

Another color harmony is *split complementary*. This is made up of a color plus the two hues on either side of that color's complement (see fig.4–27). For example, blue with yellow-orange and red-orange forms a split complementary. Such a combination forms a sharp contrast within a design. In fig.4–26, the blue urn creates a startling contrast to the yellow-orange of the ceiling and red-orange of the floor.

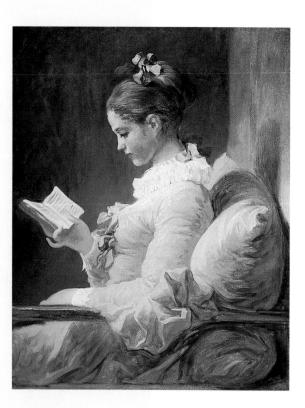

4–24 What are the analogous colors in this painting?

Honoré Fragonard (1732–1806). *A Young Girl Reading*, c. 1776. Oil on canvas, 32" x 25 ½" (81.1 x 64.8 cm). Gift of Mrs. Mellon Bruce in memory of her father, Andrew W. Mellon ©1998 Board of Trustees, National Gallery of Art, Washington, DC.

4–25 An example of analogous colors.

4–27 An example of split complementary colors.

4–26 Color studies such as this student work heighten our awareness of how color can help create a dynamic environment.

Iza Wojcik (age 17). *Down the Hall*, 1996. Oil on matte board, 18" x 24" (45.7 x 61 cm). Lake Highlands High School, Dallas, Texas.

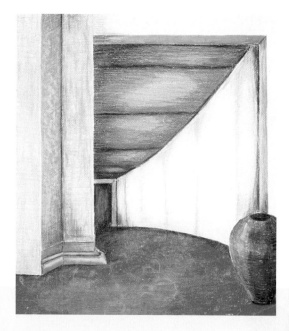

Try it

How many groups of analogous colors can you discover on the color wheel? Make a painting or design, using only analogous colors. You may add black, white, and gray to make shades, tints, and tones.

The Interaction of Color

Artist Josef Albers began a study of color in the 1950s called *Homage to the Square*, which he continued to develop until his death in 1976. His series showed that a color can produce unpredictable effects upon the colors in close proximity to it. For example, in this painting, Albers caused three colors to appear as two. The vertical ochre stripe, interrupted by yellow and dark blue stripes, appears to be two squares of different brown hues.

Josef Albers (1888–1976). First plate of *The Interaction of Color*, 1963. Bauhaus-Archiv Museum für Gestaltung, Berlin. ©1999 The Josef and Anni Albers Foundation/ARS, New York.

Context

A Young Girl Reading (fig.4–24) is one of a series of paintings that depicts young girls in peaceful solitude. Fragonard seems to have painted the series on speculation: Parisians at the time were decorating their homes in the late Rococo style, which favored such intimate scenes.

Context

Douglas (fig.4–28) was a leading figure of the Harlem Renaissance. From the 1920s to the 1940s, he was the most well-known name in the African-American visual arts.

Try it

Depending on the color next to it, any color may vary in appearance. Cut a square of bright color from a magazine, or use paint to create a 2" x 2" sample of color. Place this color swatch in different color environments: on darker and lighter solid colors, on neutrals, on patterned paper. Observe how the color appears to change when placed against different environments.

4–28 Describe the colors used in this work.

Aaron Douglas (1899–1979). *The Creation*, 1935. Oil on masonite, 48" x 36" (121.9 x 91 cm). The Gallery of Art, Howard University, Washington, DC.

Inquiry

Have students investigate the psychology of color and how color affects people's moods. Some colors make us excited, sad, or happy. For example, the color pink tends to increase feelings of tranquility, an association that has led to using it for prison walls. Studies on personality types and preferences for certain colors indicate, for example, that extroverts tend to prefer red, whereas introverts like grays.

Triadic harmony involves three equally spaced hues on the color wheel. The group of blue-green, red-violet, and yellow-orange is one example of a triadic harmony. Red, yellow, and blue (seen in fig.4–29) is another. Notice that Willem de Kooning used this combination in the painting *Untitled V* (fig.4–31). Look at the color wheel in fig.4–14. Which other triadic harmonies can you find?

4–29 This headdress is worn by men during various rituals. The breast feathers are arranged in the shape of rosettes around a bamboo center. With the help of a color wheel, name the triadic color harmony used in this work.

Amazon. Karajá tribe (Araguaia River, Mato Grosso, Brazil). *Lori-lori,* c. 1920. Tail and breast feathers of the blue and gold macaw, bamboo, and various plant fibers. Mekler Collection. Courtesy of Adam Mekler. Photo by E. Z. Smith, Fresno, California.

4–30 An example of triadic color harmony.

Context

The feather cap (fig.4–29) is a headdress made by the Karajá, a tribe of the southeast region of the Amazon, who use caps like this one in tribal ceremonies. Because of the warm and damp climate of the Amazon, feather caps normally fall prey to damage by insects. However, these caps are traditionally intended to serve their function and then be cast aside; a new piece is created for the next ceremony. Today, efforts are being made to preserve this art form: the fragile pieces are collected and stored in climate-controlled museums and other institutions.

4–31 Compare this painting to the feather cap in fig.4–29. Consider the decisions about color that each artist must have made when selecting feathers and paint.

Willem de Kooning (1904–97). *Untitled V,* 1983. Oil on canvas, 88" x 77" (223 x 195 cm). Courtesy of the Anthony d'Offay Gallery, London. ©1999, Willem de Kooning Revocable Trust/ ARS, New York, NY.

An artist may sometimes use only one color or hue within a design. If a painting is made using only one hue, plus black and white, it is called *monochromatic*. In a monochromatic work, contrast is created by the use of lights and darks. Because only one hue is used, all the parts of a monochromatic design work well together.

4–32 Why might the artist have chosen blue as the principle color in this work?
Lyonel Feininger (1871–1956). *Blue Coast*, 1944. Oil on canvas, 18" x 34" (45.7 x 86.4 cm). Columbus Museum of Art, Ohio: Museum Purchase, Howald Fund. ©1999 ARS, New York/VG Bild-Kunst, Bonn.

Discuss it

If you were a designer (interior, industrial, graphic, or fashion), what use would you make of color harmonies? Would you always use the hues at their full intensity? What might you mix with them to lessen their intensity?

Design Extension

To explore color harmonies, challenge students to use a monochromatic, analogous, complementary, split complementary, or triadic color harmony to paint one of their drawings from a previous assignment. Students could use their blind contour drawing from Try it on page 12 in Chapter 1.

Try it

Make a design with a triadic color harmony. Select the brightest hue for the smallest area of the design. Use the same triadic color harmony to create a different design, in which you use the brightest hue for the largest area. Then compare the moods or feelings produced by the two designs.

Cooperative Learning

To help students understand how advertisers use color harmonies, have them study color advertisements in newspapers and magazines. Ask them to select and label advertisements that use monochromatic, analogous, complementary, split complementary, and triadic color harmonies. Students can work in groups to create a poster of advertisements illustrating each type of color harmony.

Warm and Cool Colors

Warm colors are the hues that range from yellow to red-violet. These colors are associated with warm objects or circumstances. The colors of fire, the sun, and desert sand, for example, are in the warm-color range. Look at the color wheel (fig.4–33) and the line that divides it in half. This line separates the warm colors from the cool colors. The *cool colors* are the hues that range from yellow-green to violet. What are some examples of things that have these colors?

We react in certain ways to these colors. We sense that warm colors, especially reds and oranges, seem to come forward in a painting or photograph. These colors also make shapes and forms appear larger. We sense that cool colors, especially greens and blues, seem to recede, or move backward, in a design. These colors make shapes and forms appear smaller. Notice how Chagall contrasts warm and cool colors in *The Farm, The Village* (fig.4–37).

4–34 Notice how the artist picked up the warm reds, yellows, and oranges of the background and clothing, and used them to create accents on the brown skin of the figure.

James A. Porter (1905–71). *Soldado Senegales*, 1935. Oil on canvas, 38 ¼" x 30" (97.2 x 76.2 cm). National Museum of American Art, Smithsonian Institution, Washington, DC. Photo National Museum of American Art, Washington, DC/Art Resource, New York.

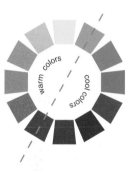

4–33 Warm and cool colors.

4–35 Raffia is a fiber product of the raffia palm of Madagascar, and is used as a textile.

Baule (Avikam or Dida), Ivory Coast. *Raffia work* with plangi and tritik decorative technique, fragment, 68 ¼" x 70 ½" (173 x 179 cm). Second half of 20th century. Depot Museum voor Volkenkunde, Rotterdam.

A painter's use of cool colors might emphasize the icy feeling of a wintry seascape. On the other hand, warm colors might express heat in a photograph of workers at a blast furnace. These examples are obvious, but artists and designers do use these characteristics of color to help communicate their feelings and ideas. Look at the painting *Russian Beauty in a Landscape* (fig.4–36). What do you think the artist hoped to convey by using such colors?

4–36 Compare and contrast this work with fig.4–34. How would you describe the individual and setting depicted in each?

Wassily Kandinsky (1866–1944). *Russian Beauty in a Landscape* (*Russiche Schöne*), 1904. Gouache, 16 ¾" x 10 ⅝" (42.6 x 27 cm). Städtische Galerie im Lenbachhaus, Munich.

Note it

If a design has mostly cool blues except for a spot of red-orange on it, the small area of warm color will seem to float above the surface. This occurs because of the length of the lightwaves reflected from the surface and the way your mind interprets them. How do you think an artist or designer might use this knowledge? If you wanted a room to appear larger, would you paint it with warm or cool colors?

4–37 Artists sometimes combine warm and cool colors. Compare this work to the painting *Death on the Ridge Road* (fig.4–15). How did each artist use the warm color?

Marc Chagall (1887–1985). *The Farm, The Village*, 1954–62. Oil on canvas, 24" x 29" (61 x 73.7 cm). Courtesy Christie's Images, London/Superstock. ©1999 ARS, New York/ADAGP, Paris.

Interdisciplinary Connection

Language Arts—Ask students to write a poem or story about Kandinsky's *Russian Beauty in a Landscape* (fig.4–36). They might imagine and then describe why the woman is dressed as she is and seated in this landscape.

Students might want to follow up this activity with a look at some well-known literary works which evoke cold environments (e.g., London's *Call of the Wild*) or chilly personalities (e.g., Darcy in Austen's *Pride and Prejudice* or James Harthouse in Dickens's *Hard Times*). What kinds of words do the writers use to "paint" their scenes?

Performing Arts
Colors in Space

George Balanchine, the great twentieth-century choreographer, pushed ballet from storytelling to a more modern emphasis on pure movement. He revolutionized the dance world with his "plotless" ballets, including *Jewels*, in 1967. He named each of the three parts—*Rubies, Diamonds, Emeralds*—after a precious stone, and thereby also evoked each jewel's color. Edward Villella, the original principal dancer in *Rubies*, described the movement in the ballet as "sparkling," "passionate," and "vivacious." Guide students to choreograph a brief sequence that conveys the sense of one of these sparkling colored gems.

Another Look at Color

**4–38 Which portion of
this painting shows anal-
ogous colors?**
James Rosenquist (b. 1933).
House of Fire, 1981. Oil on
canvas, 78" x 198" (198.1 x
502.9 cm). Purchase Arthur
Hoppock Hearn Fund,
George A. Hearn Fund, and
Lila Acheson Wallace Gift,
1982, 1982.90.1a-c. Photo
©1982 The Metropolitan
Museum of Art, New York.

**4–39 Compare the color intensities in this sculpture with those in the pastel drawing
in *The Millinery Shop* (fig.4–41).**
Karel Appel (b. 1921). *The Tulip*, 1971–86. Stainless steel and enamel, 84" x 108" (213.4 x 274.3
cm). Courtesy of the Marisa del Re Gallery, New York. ©1999 Karel Appel Foundation/ARS,
New York, NY.

**4–40 Use terms from this chapter to describe the
different ways color was used in this window.**
Chartres, Zodiac stained glass window from the south
ambulatory: *Labors of the months*, detail of February, Pisces.
13th cent. Cathedral, Chartres, France. Giraudon/Art
Resource, NY.

Context

The stained glass at the cathedral at
Chartres covers an area equal to 21,520
square feet (2,000 square meters). The struc-
ture has the most complete set of stained-
glass windows dating from the mid-twelfth
to the first part of the thirteenth century, the
great age of stained glass. Stained glass at
this time was composed primarily of blue
and red hues. Blue allows the greatest pen-
etration of light; red, the least. The color,
design, and size of each window was
planned according to its location in the
church. For example, on the north side, the
windows tend to have more blue glass, thus
allowing in more light. The orientation of the
sun and exterior structural elements such as
towers and buttresses were carefully con-
sidered during the design process.

4–41 Edgar Degas was a master of color. Consider how he used color to lead the eye through this scene. What kinds of colors did he use, and how did he arrange them in the composition?

Edgar Degas (1834–1917). *The Millinery Shop*, 1884/90. Oil on canvas, 39 ⅜" x 43 ⅜" (100 x 110 cm). Mr. and Mrs. Lewis Larned Coburn Memorial Collection, 1933.428. Photograph ©1998, The Art Institute of Chicago, All Rights Reserved.

Materials and Techniques

The design and creation of a medieval stained-glass window most likely began with a full-size cartoon drawing on parchment. The glass was placed on the cartoon and then cut and trimmed to fit the section of the composition for which it was intended. Details of the figures and other ornaments were added with paint. The glass was then refired to fuse the painted detail to the glass. Lead molds were made to hold the individual glass pieces. As a final step, the glass and lead were soldered together, and the overall scene or figure was framed in iron.

4–42 Analyze the color combinations used in this student work.

Autumn Denton (age 18), *Windows of My Life*, 1996. Oil pastels, 11" x 14" (28 x 35.5 cm). Lake Highlands High School, Dallas, Texas.

Review Questions (answers can be found on page 72)

1. How do we perceive color?
2. What colors are not found in the light spectrum? What is the term for these colors?
3. Name the primary, secondary, and intermediate hues used in mixing pigments.
4. How are the secondary colors created?
5. To what does the term *value* refer in color mixing?
6. Explain how to lessen the intensity of a color.
7. Name five types of color harmonies. List a set of colors as an example of each harmony.
8. Why did Georgia O'Keeffe make the flowers in her paintings so large?
9. Describe how paint is applied in pointillism. Which artist is known for developing the pointillism painting technique?

Career Portfolio

Interview with an Art Therapist

Color provides an important clue in the work of **Anna Riley-Hiscox**, who uses art as a means of communicating with her clients. Anna grew up in East Harlem, in New York City, earning scholarships that put her through college. She has a bachelor's degree in art, and a master's degree in marital and family therapy and art therapy. Anna currently works with children and adolescents at a non-profit agency in California. Off the job, her favorite form of artistic expression is painting gourds.

What is the purpose of art therapy?

Anna I think of art therapy as a vehicle of expression. Sometimes, people have problems or concerns they want to address, but they have a difficult time sitting and talking about emotional issues. We use art as another way of communicating, to help clients learn about new ways to handle difficult situations.

Please give an example.

Anna I was working with a fourteen-year-old client. Every time he came to the office, he would chitchat, and it was pretty superficial. Even after three or four sessions, he really had a difficult time expressing why he was in counseling. One day, I decided verbal therapy wasn't working. So, I said, "Hey, how about doing some art with me?"

He was a little reserved; he wasn't sure whether he actually wanted to do art. He said, "Well, I don't know how to draw." I said, "That's okay." I told him that he didn't have to be perfect. I showed him how to use markers to draw a mandala, a technique that many art therapists use. A mandala drawing is organized in a circle, and is used by many Native

Americans and indigenous people to express themselves.

I told my client to simply use line and color to draw, in the circle, how he was feeling. As soon as he started drawing, the room became very, very quiet. We didn't need to talk. He was really engaged in the process of art-making.

This client had taken a wrong turn in life, which resulted in him being arrested and released on probation. Through his drawing, he was able to express how he was feeling. He talked about how he could take the right path in life or the wrong path. Although his drawing was very simple, he was able to use it to express his vision of making the right choices in the future.

Describe what your work is like.

Anna I work with a variety of clients who have problems they would like to resolve. Like other mental-health professionals, I see my clients in weekly sessions. Art therapists work in many different situations. Some are in private practice; some work for mental health institutions. Others work in schools, prisons, halfway houses, or shelters.

What aspect of your work is most important to you?

Anna Seeing the transition of the kids and the teenagers that I work with. Seeing them come in very confused, with a very chaotic life, and watching them evolve by using art. I've had several kids tell me later that the art was really good for them, and that they're still doing art.

This simple mandala was drawn by a client of Anna Riley-Hiscox (discussed in this interview). He described his artwork by saying, "This represents the paths I could take in life. The blue could be the right way, the red could be the wrong way. The green represents in the middle. I can go either way, which is why I have the diamond shape in the middle." Anna's job is to help him problem-solve so he will have the information he needs to find the right path.

Studio Experience
Color Harmonies with Pastels

Task: To demonstrate understanding of a color harmony by using it in a pastel painting.

Take a look. Review the following images in this chapter:

- Fig.4–15, Grant Wood, *Death on the Ridge Road*
- Fig.4–28, Aaron Douglas, *The Creation*
- Fig.4–29, Karajá, *Lori-lori*
- Fig.4–32, Lyonel Feininger, *Blue Coast*
- Fig.4–38, James Rosenquist, *House of Fire*

Think about it. Study the five artworks listed above and the diagrams of the color schemes.

- Describe the color scheme or harmony in each. List the main colors in each painting; then label the color scheme. If a painting does not quite fit into a specific category, select the closest color scheme and explain how the colors in this art vary from that scheme.
- Compare the intensity of the colors among the paintings.
- How did each artist use color to emphasize certain parts of the composition?
- How did each artist treat the background?
- Describe the mood created by the color scheme in each painting.

Do it.

1 Choose a real-life object—a plant, leaf, shoe, hand, or insect—for your subject.

2 Select pastel sticks that form analogous, complementary, split-complementary, triadic, and monochromatic color harmonies. On scrap paper, experiment with various colors of pastels and color schemes. Try blending the pastels with a tissue or tortillon to create transition tones.

3 Look again at the diagrams. Decide which color scheme you will use to set the mood that you want. Consider the mood that will be created by the colors, rather than what color your subject is in real life. Pick a color of pastel paper that goes with your color scheme.

4 On a 9" x 12" piece of pastel paper, make a sampler of the colors that you will include. Lay down several large strokes, state the type of color scheme and mood, and check your work with your teacher.

5 With a pastel close to the color of the paper, sketch the outline of your subject on an 18" x 24" sheet of pastel paper. Draw the object twice more on this page. To fill the page, draw the objects large, overlap them near the center of the paper, and make them touch the edge of the page on at least two sides.

6 Before adding color, plan the colors for the various areas and shapes: not all need to be a flat color. You may want to vary the color in different areas, blending from one hue to another, or making the color shade from dark to light.

7 Complete your drawing with pastels.

8 Look at your pastel from a distance to evaluate it. If you wish, add more color or lighten or darken an area.

9 In a well-ventilated area, spray your pastel with fixative.

Helpful Hints

- Before you add pastels, consider the background. You could divide large areas of background into shapes or areas of color, as in fig.4–28.
- Thick, velvety applications of pastels that cover the whole surface of the paper are usually considered a painting; lighter applications with visible strokes are more like a drawing.
- Pastels sprayed with a workable fixative may smudge. Spray completed pastels with a clear acrylic spray.

Check it. After you have completed your pastel painting, prop it up. With a classmate, study it from a distance, and answer the following:

- What is the mood? Is it what you are trying to achieve?
- What is the color harmony?
- Would the work be improved by greater differences in hue, shades, or tints between areas of color?
- Would the colors go together better if some were repeated?

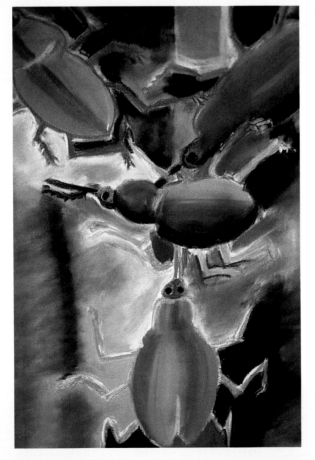

"What I like best about this picture is that it is a shock of blending, ethereal blues. The pastels allow for such nice color blending, and I feel like even the bugs look beautiful."

Dhavani Badwaik (age 16). *Beatle Blues*, 1995. Pastels, 18" x 24" (45.7 x 61 cm). Notre Dame Academy, Worcester, Massachusetts.

93

Studio Experience
Color Harmonies with Pastels

Dhavani Badwaik, *Beatle Blues*, 1995. Detail.

Prepare

Time Needed:
Three 45-minute class periods (extend as needed)
Lesson 1:
Experiment with color schemes and draw.
Lessons 2, 3:
Add color with pastels.

Objectives
Students should be able to

- Understand that various color schemes may be used to create mood or emotion in art.

- Perceive and understand analogous, complementary, split-complementary, triadic, and monochromatic color schemes in artworks.

- Create a pastel painting using a specific color harmony.

Materials
- objects such as toy animals, plants, or leaves to draw
- pastels, sets of at least 24 colors
- scrap paper for color experimentation
- 9" x 12" drawing or pastel paper
- tortillons or tissues for blending
- fixatives, both workable and clear acrylic spray

Notes on Materials
- Although pastels may be blended by layering one color on another, students will find this project easier to do with a large selection of colors.

- Soft pastels are easier to blend than hard pastels, but they are also more expensive and create more dust. Hard pastels produce less contrast. Point out to students that a velvety effect can be achieved by steaming or wetting the pastels. Several brands are rated safe for school use. If any students are allergic to pastel dust, have them wear protective dust masks. Oil pastels, which do not create dust, may be used instead.

- At the end of each work session, the pastel paintings should either be covered with a protective sheet of paper or sprayed with workable fixative or hair spray. Instruct students to read the directions on the fixative container to determine how far to hold the can from their art. Occasionally, a can is not shaken enough or a defective can does not spray smoothly, so students should begin spraying off the edge of the page to check that the can produces a fine mist, not large drops of liquid. Use spray fixatives in a well-ventilated space, or outdoors.

Before You Start
- Students could do the initial drawing of objects in an earlier lesson on line; or they could do the preparatory sketches as homework.

- If students are to draw the objects in class, either you and/or students should collect interesting items beforehand.

Teach

Thinking Critically
Ask students to look again at the art in **Take a look**. Direct each student to select one artwork and notice how the color contributes to the emotion. Ask students to imagine what music would go with this painting. Have them write a list of words describing the mood of the artwork, and ask how it would change if the colors were changed, for instance, from a bright to a pale scheme, or from cool to warm.

Classroom Management

- For **Think about it**, have students work in cooperative-learning groups of four, with each student analyzing a different artwork, and the entire group making a chart of the questions and answers. Ask each group to select the painting with the most (and the least) color intensity.

- Direct students in the cooperative-learning groups to check one another's labeling of color schemes on their sampler before having it checked by you.

Tip

Emphasize that the paintings will probably not be very realistic. The mood of the color should override consideration for realism.

Assess

Evaluation

After students complete the paintings, have them evaluate their art with another student, or write an evaluation of the project, using the questions in **Check it** as a guide.

Extend

Meeting Individual Needs

Challenge

- Have students create three paintings of the same subject, each in a different, specific color harmony.

- Ask students to look through the text and identify another image of each color harmony. Direct students to make their own interpretation of one of the images by creating a painting using the complements of those in the image. For example, if a red apple had violet shadows, the student's painting would be a green apple with yellow shadows.

Simplify

- Have students add color to the contour drawings with markers instead of pastels. To identify color harmonies, students set out only the colors that comprise their color scheme.

- Assign one color harmony.

Linking Design Elements and Principles

Shape

Direct students' attention to the shapes that they create as they overlap the objects in their drawing. Point out to them that the shapes formed around their objects become negative space or shapes.

Emphasis

Discuss with students different ways to emphasize a part of their composition. Suggest that they create a strong contrast of either color or value to emphasize one section of their painting. Point out that overlapping the shapes near the center of the picture will probably create a center of interest.

Interdisciplinary Connections

Chemistry

Ask students to read a chemistry textbook to learn which colors are produced as chemical precipitates and in specific chemical flame tests. Discover which colors are associated with certain elements. For example, cobalt is associated with blue, sulfur with yellow, iron with red, and copper with green.

Physics

Hold a prism in front of a white light so as to separate the light into the colors of the rainbow. Display the spectrum on a piece of white paper. Instruct students to notice the relationship of the positions of the colors, and to compare these positions to the placement of colors on a color wheel.

Technology

Direct students to research the difference between additive colors and subtractive colors. Ask students to use a color monitor and a drawing program such as Adobe Illustrator™ or Freehand™ to find colors in a computer color-selection palette that cannot be duplicated with paint or printed with ink. The very intense shades of magenta and green are dependent on more light than is possible to mix into an opaque paint.

Inquiry

Have students research artists (such as Matisse, Derain, Gauguin, and van Gogh) associated with nontraditional uses of color to discover how critics reacted to their paintings. (Critics were so shocked by Matisse's and Derain's explosive use of color that they described the gallery where their art was shown in 1905 as a "wild beast's cage." *Fauve* means "wild beast," so their art became known as Fauvism.)

Chapter 5 Organizer

Space

Chapter Overview
- The art element space may refer to the three-dimensional space used by sculptors and architects.

Objective: Students will perceive and comprehend how artists indicate and compose positive and negative space in artworks and architecture. (Art criticism)
National Standards: 2. Students will use knowledge of structures and functions. (2a)

Objective: Students will create sculptures, drawings, and collages showing composition of space. (Art production)
National Standards: 1. Students will understand and apply media, techniques, processes. **2.** Students will use knowledge of structures and functions. (2c)

8 Weeks	1 Semester	2 Semesters			Student Book Features
1	1	1	**Lesson 1:** Three-dimensional Space	Chapter Opener Positive and Negative Space Flowing Space	About the Artist
0	1	1	**Lesson 2:** Two-dimensional Space	The Picture Plane	Try it: photo collage
0	0	1	**Lesson 3:** Two-dimensional Space	Composition	
0	0	1	**Lesson 4:** Two-dimensional Space	Point of View	Try it: drawing, Discuss it
0	0	1	**Lesson 5:** The Illusion of Depth	Nonlinear Methods	Try it: shape cutouts
0	1	1	**Lesson 6:** The Illusion of Depth	Linear Perspective	
0	0	1	**Lesson 7:** The Illusion of Depth	Linear Perspective	Try it: drawing
0	0	2	**Lesson 8:** Subjective Space	Space That Deceives	
0	0	2	**Lesson 9:** Subjective Space	Cubism	Try it: drawing, About the Artwork
0	0	1	**Lesson 10:** Subjective Space	Cubism	Try it: drawing
0	0	1	**Lesson 11:** Subjective Space	Abstract and Nonrepresentational Art	Try it: shape and color cutouts
1	1	1	**Chapter Review**	Another Look at Space	Review Questions
2	3	3			

Studio Experience: *An Event in Clay*

Objectives: Students will appreciate the negative space in artworks; plan space around, between, and within their sculpture; demonstrate understanding of clay-sculpture techniques.

National Standard: Students will evaluate artworks' effectiveness in terms of organizational structures and functions (2b); create art using organizational structures and functions to solve art problems (2c); conceive/create artworks demonstrating understanding of relationship of their ideas to media, processes, and techniques (1b).

- This space may be positive or negative and flow in, around, and through art.
- Space may also refer to the two-dimensional plane in an artist's composition.

- Artists often create an illusion of depth on flat surfaces.
- Many contemporary artists abstract space and use it subjectively.

Objective: Students will perceive and comprehend how artists of various art periods and cultures use space in their artworks. (Art history/cultures)

National Standards: 4. Students will understand art in relation to history and cultures. (4e)

Objective: Students will develop an appreciation for the choices an artist makes in the composition of space and use this appreciation to discuss art. (Aesthetics)

National Standards: 5. Students will reflect on and assess characteristics and merits of artworks. (5c)

Teacher Edition References	Ancillaries
Warm-up, Design Extension, HOTS, Context, Performing Arts, Cooperative Learning	*Slide*: Papua, New Guinea, *Skull Rack* (S-1) *Large Reproductions*: Lu Zhi, *Distant Mountains*, Andy Goldsworthy, *Touchstone North*, Mackintosh, *Spurge, Withyham*
Design Extension, Context	*Slide*: Attic Greek, *Black Figure Cup* (S-2)
Design Extension, Performing Arts	
Context	
HOTS, Context, Internet Connection	*Slide*: Pablita Velarde, *Dressing a Young Girl for Her First Ceremonial Dance* (S-3) *Large Reproduction*: Andy Goldsworthy, *Touchstone North*
Design Extension, Context, Interdisciplinary Connection, Portfolio Tip	*Slide*: Lorenzo Ghiberti, *Gates of Paradise* (S-4) *Large Reproduction:* Lu Zhi, *Distant Mountains*
Design Extension, HOTS, Context, Interdisciplinary Connection, Inquiry	
Design Extension, Context	*Slide*: Bridget Riley, *Cataract III* (S-5)
Design Extension, Context, Materials and Techniques	*Slide*: Pablo Picasso, *Daniel-Henry Kahnweiler* (S-6)
Design Extension, Context, Materials and Techniques	
Design Extension, Context	
HOTS, Context	

Studio Resource Binder

5.1 Overlapping Shapes, cut paper
5.2 Surreal Collage, magazine or computer
5.3 Architectural Drawing, pastels
5.4 Figural Sculpture, plaster gauze/wire
5.5 Fantasy Chessboard, pencil/marker

Time Needed
Three 45-minute class periods.
Lesson 1: Draw and plan;
Lesson 2: Form the sculpture;
Lesson 3: Glaze or paint.

Vocabulary

abstract art Art that emphasizes design, or whose basic character has little visual reference to real or natural things. *(abstracto)*

composition The arrangement of elements such as line, value, and form within an artwork; principles of design are considered in order to achieve a successful composition. *(composición)*

linear perspective The technique by which artists create the illusion of depth on a flat surface. All parallel lines of projection converge at the vanishing point, and associated objects are rendered smaller the farther from the viewer they are intended to seem. *(perspectiva lineal)*

negative space The areas of an artwork not occupied by subject matter, but which contribute to the composition. In two-dimensional art, the negative space is usually the background. *(espacio negativa)*

nonrepresentational art Art that has no recognizable subject matter, that does not depict real or natural things in any way. Also called nonobjective art. *(arte no representativo)*

perspective An artist's representation of a three-dimensional world on a two-dimensional surface. *(perspectiva)*

picture plane The flat surface of a composition. *(superficie pictória)*

positive space The areas containing the subject matter in an artwork; the objects depicted, as opposed to the background or space around those objects. *(espacio positivo)*

vanishing point In a composition featuring linear perspective, that spot on the horizon toward which parallel lines appear to converge and at which they seem to disappear. *(punto de fuga)*

Lesson 1
Three-dimensional Space

pages 94–95

pages 96–97

pages 98–99

Objectives

Students will be able to

- Perceive and appreciate positive and negative space in two- and three-dimensional artworks, architecture, and objects in their environment.

- Become aware of various cues by which we perceive depth.

- Recognize a sculpture by Henry Moore and perceive and understand how he incorporated negative space within his artwork.

Chapter Opener

- To introduce students to the difference between two-dimensional and three-dimensional space, have them look at Shoffner's *Train on Zipper* (fig.5–4). Remind students that this is not a real train, just an artist's depiction of a train on a flat, two-dimensional painting surface. The *surface* of the canvas on which this was painted has only height and width, not depth. The artist created an illusion of space on a flat picture plane.

- Call on students to compare the space in Mantegna's *St. James Led to Martyrdom* (fig.5–1) to that in Shoffner's *Train on Zipper*. They should note that Mantegna crowded the figures together near the front of a picture plane, as if on the edge of a stage, whereas Shoffner leads the viewer far back into distant open space. Ask students to write several ways that each artist created an illusion of depth. Have them share their ideas with the class.

- Hold up a cylinder (a wastebasket or a large can). Point out that this form has three dimensions—height, width, and depth. Draw students' attention to the space within the cylinder, and ask students to explain the importance of this negative space to the design of the object.

Opener	page 96

Materials
- a cylinder such as a wastebasket or empty can

Teach:
Positive and Negative Space

- Have students identify the positive and negative spaces in the images on pages 96–99. This may be done as a cooperative-learning activity. Refer students to pages 40 and 41 for images of positive and negative shapes.

- Direct students' attention to the negative space in Moore's *Lincoln Center Reclining Figure* (fig.5–8). Ask if they can see the person in this sculpture. How has the artist abstracted and simplified his subject? What was important to the artist as he composed this sculpture? Remind students of Moore's experiences drawing reclining figures in the London underground subway tubes during World War II and how these drawings were often the inspiration for his later sculptures.

Teach:
Flowing Space

- Focus on the images on pages 98–99. In Johnson's *Glass House* (fig.5–10), point out that the interior and exterior spaces seem to merge because of the artist's extensive use of huge glass windows. Divide the class into small groups to study the other images on this page. Have each group explain how space flows around and through one of the examples of landscape, installation, and sculpture.

- As the students look at *Glass House*, teach them that this house is an example of contemporary architecture based on the International Style developed at the Bauhaus in Germany before World War II. These architects believed that "less is more." Challenge the students to explain how *Glass House* exemplifies this idea. How does the Moore sculpture reflect the same philosophy?

- Have students create sculptures that emphasize flowing spaces. Each student should pull a handful of clay from a large block of moist clay. Caution students not to smooth the clay into a ball, but to set their uneven handful on a board, turn the board around, and study it as a piece of art, noticing where the clay goes in and out.

After a few minutes, ask students to begin deepening some indentations and pulling out some protrusions. They may use clay tools if they wish. Gradually, they should turn some of their indentations into holes or negative spaces. When the sculptures are completed, have each student point out the negative and positive spaces in the sculpture and explain how space flows around and through this piece of art.

Teach pages 98–99

Materials

- moist clay, about 1 pound per student (have students pull their portion from bulk clay)
- work surface for clay, such as a small board or pan
- clay tools

Lesson 2
Two-dimensional Space

pages 100–101

Objectives

Students will be able to

- Understand that two-dimensional art is flat, lacking actual depth.

- Perceive and comprehend that some artists strive to create an illusion of depth on the picture plane while others, especially twentieth-century artists such as Matisse, often avoided any illusion of depth in their two-dimensional artwork.

- Compose a magazine collage by reorganizing the space in photographs which originally showed depth.

Teach:
The Picture Plane

- Review two-dimensional and three-dimensional space. Ask students to name examples of various types of two-dimensional art. They might name cartoons, paintings, prints, pencil sketches, and graphic designs.

- After students have read the description of a picture plane, ask them to identify the boundaries of the picture plane in each image on pages 100 and 101. Remind students that a flat picture plane sometimes has some depth: an artist might create a thick impasto of paint, as in the van Gogh painting (fig.5–14); or the artist might create a considerable surface texture, as in the student collage (fig.5–15).

- Refer students to figs.2–38 and 12–26, both by Henri Matisse. Explain to them that Matisse is composing only the surface of his picture plane in these artworks, with no attempt to indicate depth. In the early twentieth century Matisse was one of the leading contemporary artists to eschew the creation of an illusion of space on a flat picture plane. Beginning in the early Renaissance with the development of the rules of linear perspective, most artists had tried to create paintings which seemed like windows on a realistic three-dimensional scene.

- Have students do **Try it** on page 101. In their explanations of how the apparent space changed, they will likely notice that the depth in the original photograph has been destroyed and the flatness of the picture plane has become more apparent.

Try it page 101

Materials

- 12" x 18" drawing paper
- magazines to cut
- scissors
- glue sticks

94d

Lesson 3
Two-dimensional Space

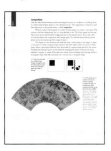

page 102

Objectives

Students will be able to

- Understand and define the organization of elements and their placement as composition.

- Perceive and appreciate the arrangement of positive and negative shapes and space in artworks.

- Create a collage composed of positive and negative shapes and space.

Teach:
Composition

- Ask students to look at the images on pages 102–103 and to note the division of space in each. Point out how space winds through *The Elegant Gathering in the Western Garden* (fig.5–18).

 Have students cut a 4" square and several smaller rectangles, triangles, and circles from black paper. (Do not distribute glue sticks until the end of this activity.) Instruct them to place the 4" black square on a sheet of white paper. Call on stu-

dents to tell what they see as positive and negative space. (Most will see the black as positive.) Have students add several more black shapes to the paper, creating a composition of black positive shapes encompassed by white negative space.

- Next, ask students to place the 4" black square in the middle of the white paper and then in one corner of the paper. In each instance, they should notice the space created between the edges of the paper and the edges of the square and how this space is affected by the position of the black square on the picture plane.

- As the students study fig.5–18, the fan painting, inform them that Japanese and Chinese artists have a long tradition of designing fans in this shape. The French Impressionist painter Edgar Degas was so inspired by Japanese art that he created some paintings in this fan format.

Teach page 102
Materials
• 9" x 12" black heavy paper
• pencils
• rulers
• scissors
• 8 1/2" x 11" white paper
• glue sticks

Lesson 4
Two-dimensional Space

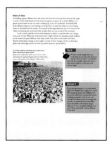

page 103

Objectives
Students will be able to

- Perceive and understand how artists manipulate composition of space and the appearance of objects by carefully selecting the viewpoint in their art.

- Draw a familiar object from an unusual viewpoint.

Teach: Point of View

- Students should read the **Discuss It** on page 103, then select a piece of art in this chapter that they think has an unusual or dramatic viewpoint. As a class discuss their selections, locating where the viewer might be in each piece of art. They should include *St. James Led to Martyrdom* (fig.5–1), *Coney Island Crowd* (fig.5–19), and *Paperworkers* (fig. 5–29).

- As students consider the viewpoint in Weegee's *Coney Island Crowd*, point out its date and ask them how this same scene might be different if it were photographed today.

- Demonstrate to students how to draw an object from different points of view before they begin the **Try It** on page 103. Suggest that they draw the same object from several angles.

Kathryn Hilsinger (age 17). *Self-portrait Underwater*, 1997. Oil on canvas, 20" x 24" (50.8 x 61 cm). David Prouty High School, Spencer, Massachusetts.

Try it page 103
Materials
• 12" x 18" drawing paper
• round objects such as plates, pie pans, hubcaps
• drawing media such as pencils, markers, colored pencils, and oil pastels

Lesson 5
The Illusion of Depth

pages 104–105

Objectives
Students will be able to

- Perceive and comprehend that artists may create an illusion of depth on a flat picture plane by overlapping and varying the position, size, color, and value of objects.

- Create a collage indicating depth by overlapping and varying the position, size, color, and value of objects.

Teach: Nonlinear Methods

- Tell students that artists use many different means to show depth or distance on a flat surface. Look ahead to Canaletto's *The Molo, Venice* (fig.5–28), and discuss how the artist indicated that some objects are closer to the viewer than others. Students may notice that objects in the distance are smaller and higher on the picture plane. In the background, colors are less intense, and values are lighter. Canaletto has also overlapped objects to create a sense

of depth. Guide students to see that parallel lines in the buildings come closer together in the distance. Explain that these means of showing distance are often used by Western artists.

- So that students understand how artists from different cultures indicate depth on a flat surface, focus on *The Meeting of the Theologians* (fig.5–20) from Central Asia and *The Elegant Gathering in the Western Garden* (fig.5–18) from China. Ask which figures are closest to the viewer in each artwork, and what techniques the artist used to show this. (The artists overlapped objects and placed them higher on the picture plane.)

- After students have studied Vanessa Bell's abstract painting (fig.5–21) and answered the question in the caption about how she created depth in this work, inform them about her life and her affiliation with the Bloomsbury group. Students may wish to research these literary connections.

- Have students do **Try it** on page 105.

Computer Connection

As an electronic alternative to the **Try it** on page 105, guide students to explore the spatial illusion of depth that is achieved when shapes of different sizes and values are overlapped. Encourage students to create at least ten shapes of different sizes using the oval, rectangle, or polygon tool in a drawing program. Fill the shapes with different values of a single color. Create a sense of depth by overlapping the shapes. Demonstrate to students that the illusion of depth will be greater if objects are overlapped from largest to smallest rather than intermixing sizes. This can be achieved by using the "move forward" and "move backward" commands. Allow time for students to try different arrangements, and print one or two examples in which a strong sense of depth has been created. Display the printouts and discuss the means by which depth has been achieved. Consider size, position, and value of the shapes in the composition.

| **Try it** | page 105 |

Materials
- 12" x 18" paper, assorted colors
- pencils
- scissors
- 12" x 18" paper, neutral colors (gray, white, or black),
- glue sticks

Lesson 6 The Illusion of Depth

pages 106–107

Objectives
Students will be able to

- Perceive and understand how artists create an illusion of depth using one-point perspective.

- Draw an object using one-point linear perspective.

Teach: Linear Perspective

- Explain to students that the rules for drawing linear perspective were developed in Florence, Italy in the early 1400s. Renaissance painters went out of their way to include linear perspective in their work. Refer students to fig.5–32, *The Tribute Money* by Masaccio, an early example of linear perspective painted shortly after Brunelleschi developed this technique for indicating depth. Leon Baptista Alberti popularized single-point linear perspective in his book on painting.

- Ask students to note how the horizontal lines of the colonnade and the sides of the pool seem to converge in a single point in the photograph of the Getty Villa (fig.5–23). Explain that the lines create linear perspective in the photograph and that the point where the horizontal lines seem to meet is called the vanishing point. Call on students to find the vanishing point in *Architectural Perspective: View of Ideal City* (fig.5–25). Explain that this artwork has one-point perspective, because there is only one vanishing point.

- Hold a up a large box. Ask students to identify which edges are parallel to each other. (The vertical edges are parallel to each other, the horizontal edges are parallel, and the depth edges are parallel.) You might mark these different lines with colored tape. Tell students that parallel lines seem to vanish to the same point.

 Give each student a box (or have them fold paper boxes.) They should mark each set of parallel lines on the box with a different color. Hold the large box so that one surface is parallel to the students' view (looking at it straight on), and show how the depth lines seem to converge. Have students look straight on at one plane of their box and then move the box above their line of sight, below their line of sight, and then to one side, noticing how the depth lines seem to converge at a point.

- Focus on the diagram of one-point perspective (fig.5–22). On the chalkboard, draw a horizon line with a vanishing point in the middle. Draw a square above the line, and draw lines from the corners to the vanishing point. Add the vertical lines for the back edge of the box. Have students draw on 8 1/2" x 11" paper, at least five one-point perspective views of their box: one above the horizon line, one below it, and others on the horizon line and to each side of the vanishing point.

Teach	page 107

Materials

- large box, such as a copy-paper box
- small boxes, or paper for folding paper boxes
- 8 1/2" x 11" paper
- pencils
- colored markers
 optional:
- colored tape

Lesson 7
The Illusion of Depth

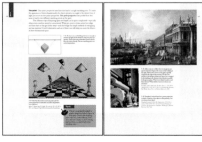

pages 108–109

Objectives
Students will be able to

- Perceive and comprehend that two-point linear perspective may be used to indicate depth on a flat picture plane and to give objects the appearance of three-dimensionality.

- Extend converging two-point perspective lines in photographs to their vanishing points.

Teach: Linear Perspective

- Point out the linear perspective in fig. 5–28, Canaletto's *The Molo, Venice*. After students answer and discuss the questions in the caption, ask who might have wanted a scene such as this in their home. Explain to students that Canaletto painted many similar views of Venice as souvenirs for wealthy tourists.

- Encourage students to study fig.5–26 and note how lines from "parallel" box edges are converging to two vanishing points. Focus on Ed Ruscha's *Standard Station* on page 9. Have students lay a ruler on "parallel" horizontal lines to extend these lines to their vanishing points.

- Direct students' attention to parallel lines within their own environment, noting how they seem to converge. For example, in many classrooms, the line where the ceiling and wall meet, the top and bottom of the windows, and the wall baseline are all parallel. Point out the converging parallel lines of any buildings or roads that can be seen from the classroom, or those of a long school corridor.

 To teach this concept, tape a sheet of clear acetate over a window that faces a scene with linear perspective, and trace over the scene with a projection marker.

Teach	page 107

Materials

- rulers
 optional:
- clear acetate
- projection markers

- Instruct students to do **Try it** on page 108. Have them glue their photograph or design onto drawing paper before they draw lines to the vanishing points.

Try it	page 108

Materials

- old magazines
- 18" x 24" drawing paper
- glue sticks
- permanent markers

Lesson 8
Subjective Space

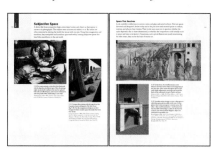

pages 110–111

Objectives
Students will be able to

- Perceive and comprehend how artists transform the illusion of space and depth in their art to confuse and surprise viewers.

- Alter the illusion of space in their own drawing.

Teach: Space That Deceives

- Focus on the images on pages 110–111. Call students' attention to Masaccio's *The Tribute Money* (fig.5–32) and Magritte's *Time Transfixed* (fig.5–33). Ask what type

of linear perspective is used in each painting. (*The Tribute Money* is one-point perspective, and *Time Transfixed* is two-point.) Direct students to select one of these images and each write a paragraph in which they describe how the artist manipulated space. They should suggest why the artist did this and what effect he was trying to achieve. Have students share their responses with the class.

- As students consider *The Tribute Money,* share with them the information about the Brancacci Chapel in Context, page 111. Students will probably be interested in the legend in this painting. In the center part of the fresco Jesus tells Peter, dressed in classical toga and white beard, to slit open the stomach of a fish to pay the tax collector who is in a contemporary Florentine short tunic. On the far left fisherman Peter has caught the fish and is extracting the money, and on the far right side he pays the tax collector.

- Point out to the students that figs. 5–31 and 5–33 are both Surrealist paintings with space distorted to create a mood and alter reality. Surrealist artists often create dreamlike or unnatural scenes. Challenge students to recall the surrealist artists that they studied in past chapters. (Nemesio Antúnez [fig. 3–17], Matta [fig. 3–9], Meret Oppenheim [fig. 2–24].)

- Encourage students to each select an image from pages 110–111 and create a subjective space using the artist's technique to draw their own picture with pencils, colored pencils, or markers. They may use rulers to plan, draw light guidelines, or add lines to their final drawing. For example, for Kertész's *Untitled* (fig. 5–30), a student might draw him- or herself reflected in a glass ornament or rounded hubcap; or, for Masaccio's *The Tribute Money*, a student might show three parts of a story in the same picture.

Teach pages 110–111
Materials
- 12" x 18" drawing paper
- pencils, colored pencils, or markers
- rulers

Lesson 9
Subjective Space

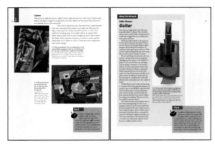

pages 112–113

Objectives
Students will be able to

- Perceive and understand how Cubists depicted space and forms, often combining more than one view of an object.

- Experiment with Cubist concepts by creating a drawing combining several views of the same object.

Teach: Cubism
- Have students study the Cubist images on pages 112–113 and then point out the various objects that they can discern in each image. Ask students to look for objects for which they see several sides at one time. For example, in Braque's *Still Life with Grapes and Clarinet* (fig. 5–35), the artist presented both a side and a top view of the vase.

- Teach the students about the beginnings of Cubism when Braque and Picasso, neighboring young artists in Paris during the early years of the twentieth century, worked together as they explored new ways to indicate space and forms. They literally shattered preconceived notions of

how art should look, eventually developing Cubism. During this time they also began pasting paper, cardboard, and even playing cards to their canvases in collages. Some of their early Cubist compositions are so much alike that it is difficult to tell which was made by Picasso and which by Braque.

- To stimulate an aesthetic discussion ask students if they consider this art to be "pretty." Does art have to be pretty? What would students guess that Cubists were most concerned about achieving in their art?

- Encourage students to do **Try it** on page 112.

Try it page 112
Materials
- 8 1/2" x 11" or 9" x 12" white paper
- markers, colored pencils, or oil pastels
- 12" x 18" drawing paper

Lesson 10
Subjective Space

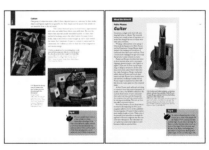

pages 112–113

Objectives
Students will be able to

- Perceive and comprehend how Cubist artists flattened forms in their compositions.

- Create a composition emphasizing the flatness of the picture plane by drawing the outside contour of objects.

Teach: Cubism

- As students study the Cubist artworks, point out to them that although the artists did indicate form in a few places, these works for the most part seem flat.

- Teach students that Juan Gris, a Spanish artist, was a close friend of Picasso's during the early beginnings of Cubism. Gris used brighter colors at a time when Picasso and Braque were using a more monochromatic palette. He also created many *papiers collés* (collages).

- Have students do **Try it** on page 113, drawing overlapping outlines of objects. Ask students to consider how they could indicate depth in their flat drawings if they wanted to. If time permits, allow students to draw a second version of the same objects, but adding values to the drawings to indicate depth.

> **Try it** page 113
>
> **Materials**
> - 9" x 12" white paper
> - pencils

Lesson 11
Subjective Space

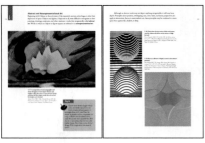

pages 114–115

Objectives

Students will be able to

- Understand that an illusion of depth may be found in representational, abstract, and nonrepresentational compositions.

- Create a sense of depth in an abstract or nonrepresentational paper collage.

Teach: Abstract and Nonrepresentational Art

- Call on students to explain the difference between abstract art and nonrepresentational art. (In abstract art, the subject matter, although altered or abstracted, may be recognizable; but in nonrepresentational art, there are no recognizable objects or figures.) Ask students to classify the art on pages 114–115 as either abstract or nonrepresentational.

- As students consider fig.5–37, Arthur Dove's *Thunder Shower*, inform them that Dove was in the group of artists who exhibited their work in Alfred Stieglitz's New York gallery. Stieglitz's second wife, Georgia O'Keeffe, was a good friend of Dove. If the students do not remember O'Keeffe, refer them back to page 77.

- Focus on the caption for Dove's *Thunder Shower*. Remind students that warm, bright colors appear to come forward. Call on students to find an image in Chapter 4 that illustrates the tendency of warm, bright colors to advance and that of cool, less intense colors to recede.

- Explain that fig.5–38 is an example of *Op* (short for optical illusion) *art*. Discuss with students what the optical illusion is in this painting and how the artist created this effect.

- Have students do **Try it** on page 114.

> **Try it** page 114
>
> **Materials**
> - paper, assorted colors
> - scissors
> - 12" x 18" paper for collage base
> - glue sticks
> *optional:*
> - rulers
> - pencils

Chapter Review

pages 116–117

Assess

- Assign students to write the answers to the review questions. Lead a class discussion of the answers. Evaluate students' answers to ascertain that they have perceived and comprehended how artists indicate and compose positive and negative space in two- and three-dimensional artworks and architecture. **(Art criticism)**

- In the review questions and the subsequent discussion, students should show evidence that they understand how artists of various art periods indicated and composed space in their artworks. These periods and styles might include the Middle Ages, Renaissance, Impressionism, Cubism, and Abstraction. **(Art history/cultures)**

- Review with each student his or her portfolio created in this chapter to verify that they created sculptures, drawings, and collages which all show an understanding of the variety of ways space is used in design. **(Art production)**

- Guide students in a discussion of the art displayed in their class exhibit. Students should select works in the exhibit that compose space in a manner similar to that of Cubist, Surrealist, Renaissance, and Mayan artists. Which works do they feel are particularly effective in using space to convey a mood or message? **(Art criticism, Art history/cultures, Aesthetics)**

Reteach

- Encourage students to study the images on pages 116–117. Ask them to identify one work that uses three-dimensional negative space effectively. (Houser's *Desert Dweller,* fig.5–41) Call on students to discuss the various means the artist used in *St. Matthew,* from the Lindisfarne Gospels (fig.5–40) to indicate depth (overlapping, position) and the flow of space in the composition of this work.

- In fig.5–42, *House of Stairs,* challenge students to follow sets of parallel lines back to their vanishing points. Escher understood linear perspective so well that he was able to manipulate it to create his own distorted world. He based these perspective lines on a curved grid.

- As students study fig.5–40, encourage them to try extending some of the parallel lines. Most of the parallel lines in this illumination from the Lindisfarne Gospels do not converge to a single vanishing point. Explain that the artist who drew this was not concerned about creating an exact replication of reality.

- When students consider how Caillebotte cut off the view of deep space with a bridge in fig.5–44, explain to them that Caillebotte, along with the other French Impressionists, was influenced by the unusual compositions of Japanese prints. Strong contrasts (such as that of the bridge's dark lines against the light background) and cropping the view of a major element (the bridge) were often found in the Japanese woodcuts imported to Paris in the late 1800s.

Answers to Review Questions

1 The art element space refers to the three-dimensionality of sculpture and architecture and to an illusion of depth in two-dimensional pieces.

2 Five means to create depth are: positioning distant objects higher on the picture plane than closer objects; overlapping the objects; varying the size of objects (smaller objects seem farther away); using bright colors on a neutral background to make objects seem closer; using darker values to make objects seem closer than those with lighter values.

3 The vanishing point is where parallel lines seem to meet. The horizon line represents the viewer's eye level.

4 Possible answers might include *Coffee Grinder and Glass* (fig.5–34) and *Still Life with Grapes and Clarinet* (fig.5–35), where the artist flattened space and fractured the forms by showing various views in the same picture.

5 Answers will vary. In *Sir-Ris* (fig.5–38), Vasarely used lines; in *Thunder Shower* (fig.5–37), Dove used color.

6 Henry Moore's use of negative space is innovative in his sculptures.

7 Georges Braque and Pablo Picasso worked together in developing the art of collage.

Meeting Individual Needs

Students Acquiring English

To explore the concept of space, have groups of students create a diorama of a familiar environment. Show and explain that a diorama is a partially enclosed exhibit consisting of models and a painted background. It can be made using a shoe box.

Discuss with students places and events which have different types of space. These might include rural or urban scenes, festivals or marketplaces. After they work on their projects, have students:

- Identify the positive and negative spaces within their dioramas.

- Describe how the repositioning of figures or objects changes the flow of space.

- Demonstrate how changing the orientation of the box affects the viewer's sense of depth and perspective.

Students with Special Needs

Visual Perceptual

Be aware that students with visual perceptual problems have trouble seeing a specific image within a competing background, such as identifying vanishing points within a picture, or finding a pencil on a crowded desk. Seek alternative means of teaching spatial concepts, such as having students manipulate solid forms on a table in order to demonstrate their understanding.

Gifted and Talented

Many gifted students are already adept at linear perspective. Building upon prior knowledge, have the students compose several drawings, changing the location of the vanishing point and/or the horizon line in each. Ask the students to compare and discuss their results.

5 Space

SPACE—SOMETIMES CROWDED, SOMETIMES OPEN—is all around you. It may be full of trees or water, clouds or clear air. It can be contained by walls or open to the horizon. When you swim in a pool, stand on a bridge, or ride through a tunnel, you are located or moving in space. The words *above, below, around, behind, into,* and *through* all indicate position or action in space.

In art, space refers to the three-dimensionality of sculpture and architecture. It might also refer to the sense of depth in a two-dimensional artwork. In this chapter, you'll explore these aspects of space, as well as the unusual sense of space in some modern and abstract art.

5–1 An artist consciously selects the angle from which we view a scene. This Renaissance artist chose to give us a "worm's-eye view."
Andrea Mantegna (1431–1506). *St. James Led to Martyrdom,* c.1455. Fresco, Ovetari Chapel, Church of the Eremitani, Padua, Italy (destroyed in 1944). Photo Art Resource.

5–2 The only way to appreciate this artwork fully is to walk through the space that is an integral part of the piece.
Isamu Noguchi (1904–88). *California Scenario,* 1980–82, Costa Mesa, California. Courtesy of the South Coast Plaza Alliance, Costa Mesa, California. Photo by Stan Klimck.

Chapter Warm-up

• Tell students that in this chapter, they will study how artists and designers manipulate space in their works. Ask students to note the space around them, and explain that this area was probably designed by an architect. Call on students to describe the space. Is it spacious, crowded, airy, or cramped? If there is a view from a window, have students note this space and compare it to the interior space. Next, ask students to look at a chair. Point out that there is space inside the chair form, between the legs and rungs, and also space around the chair, defined by the back and the seat. Explain that someone designed the chair and likely considered the relationship between the space and the chair's form.
• Focus on fig.5–2, a public area in which Isamu Noguchi manipulated space. Ask how

he divided and enclosed space. Then have students look at *Pelagos* by Barbara Hepworth (fig.5–3), and ask them to note the importance of space—both inside and around the form—to this sculpture.

5–4 There are two different sensations of space in this work. Can you describe them?

Terry Shoffner (b. 1947). *Train on Zipper*, 1981. Opaque watercolor, 19 ¾" x 23 ⅝" (50 x 60 cm). ©Terry Shoffner/SIS. Photo Prentice-Hall Canada.

5–3 Though you cannot walk through the space in Barbara Hepworth's sculpture, as you would with Noguchi's work (fig.5–2), consider how your eye "walks" through *Pelagos*.

Dame Barbara Hepworth (1903–75). *Pelagos*, 1946. Wood and mixed media, 14 ½" x 15 ¼" x 13" (36.8 x 38.7 x 33 cm). Tate Gallery, London/Art Resource, NY. ©Alan Bowness, Hepworth Estate.

★ Higher-Order Thinking Skills

Encourage students to compare the mood or message created by the use of space in Mantegna's *St. James Led to Martyrdom* (fig.5–1) with that in Shoffner's *Train on Zipper* (fig.5–4). Ask students to look in other chapters of the book to find an artwork in which space was used to create a mood. Have students identify the image and write a paragraph that explains the feeling created by the space in the artwork. Call on several volunteers to read their paragraphs. Based on their observations, launch a discussion of the range of feelings that it is possible to convey through the use of space.

Context

In *California Scenario* (fig.5–2), Isamu Noguchi represents environmental concepts important to California: forest, desert, land use, water use, and agriculture. People stroll the paths of the 1.6-acre garden, listen to the bubbling water, and view the sculptural elements. Of another of his garden pieces, Noguchi said, "I hope that when people walk through the garden they will hear a conversation going on, a very quiet conversation between walls and spaces, people and sculpture."

Three-dimensional Space

An object that has three-dimensional space has height, width, and depth. In art, architects and sculptors are those most likely to work with such space. Both a cabin beside a lake and a sculpture of a horse are three-dimensional structures: they have spaces that you can walk *inside of* or *around*.

Positive and Negative Space

In today's world, you are probably more aware of space that is filled with something than of space that seems empty. City spaces are crowded with buildings and people. Roads and highways are choked with automobiles. Your living spaces are filled with furniture. And your wall spaces are likely decorated with posters and memorabilia.

When a sculptor or architect creates a three-dimensional design, he or she must be concerned with both positive and negative spaces. The *positive space* is the object or struc-ture itself, such as the statue of Andrew Jackson (fig.5–6). The *negative space* is the area surrounding the object or structure, such as the blue sky and clouds around this statue. In a building, the negative space is also the area inside the structure.

5–5 The overcrowding of cities is often broken by empty, or negative, space in the form of plazas and spacious building entry-ways.
Viljo Revell (1910–64). *Ontario Civic Center* (New City Hall), 1961–65. Toronto, Canada.

5–6 What does the placement of this sculpture have to do with the idea of negative and positive space? Where are large monuments such as this generally placed?
Clark Mills (1815–83). *Andrew Jackson*, 1855. Bronze. Lafayette Park, Washington, DC.

5–7 How would the relationship between negative and positive space change if this room were filled with furniture?
Man painting an empty room. Photo by Jim Erickson.
©Stock Market, 1996.

Henry Moore

Born in 1898 and raised in Castleford, England, Henry Moore was the son of a coal miner. His surroundings as a child were those of a grim industrial area; yet, his curiosity led him to explore artistic possibilities. At the age of ten, he learned about Michelangelo and decided to become a sculptor. As a teenager, Moore practiced drawing and most likely would have become a schoolteacher except that World War I caused him to join the army instead. He was fortunate: he not only survived combat (most of the men in his regiment were killed or seriously wounded) but also received a military grant to attend the Leeds School of Art.

Moore's talent became evident at Leeds: after two years, he won a scholarship to the Royal College of Art. Living in London gave him access to the British Museum, which housed sculptures from around the world. These diverse artworks inspired Moore's sculptures throughout the rest of his life. Moore also enjoyed the Museum of Natural History, where he became intrigued by the forms of natural objects such as pebbles and bones.

Sculpture was not a popular art form when Moore began practicing it seriously. In fact, there were so few sculpture students at the Royal College that he had a large studio all to himself. This situation provided Moore with a sense of freedom that he might not otherwise have felt.

Drawing remained a vital part of Moore's creative work, even as he turned his attention to sculpting. For many years, his materials of choice were stone and wood, but by 1935, he began sketching ideas for metal sculpture. Moore originally approached sculpting primarily as a carver would, chipping away pieces to "reveal" the sculpture inside. Later, though, he turned to modeling—an additive process—for its relative speed. He chose to model with plaster, however, so that he could subtract areas by cutting away the material. Eventually, he worked in bronze, even building a foundry so that he could better understand the process of casting. Many of his bronze works include "carving marks"—final touches made to the plaster just before casting—as part of the sculpture.

During World War II, Moore spent an entire year creating a powerful series of drawings of people who took refuge from air raids in the London Underground. Moore's observation of these people—the feeling of enclosed space, and the relation of bodies to the space and to one another—had an enormous impact on him. The bomb shelter drawings, which typically showed rows of sleeping people, brought him recognition as an artist, and also gave direction to his future sculpting: many of his sculptures are of reclining figures.

Henry Moore became well-known for his innovative use of negative space. In *Lincoln Center Reclining Figure* (fig.5–8), the three-dimensional form of a figure is cut by negative space. The outside space flows around and through the form. In certain sections, the negative space even takes the place of the figure, which is characteristic of much of Moore's work.

5–8 Compare the negative space in this sculpture with that in fig.5–6. How do they differ? In which one is the negative space a vital part of the artwork?

Henry Moore (1898–1986). *Lincoln Center Reclining Figure*, 1963–64. Bronze, 28' long (8.5 m). Photo by H. Ronan.

Performing Arts
Negative Dance Space

Most Western artists think of negative space as empty, the blank areas not describing an object. Ask students to define what "negative" space in dance might look like. Paul Taylor, the famous modern-dance choreographer, created a duet with the barest of movement. Two dancers came out onto the stage, sat there until the end of the piece, and walked off; then the curtain came down. Taylor was challenging the definition of dance as "movement through space over time." By not dancing the performers were—in a sense—creating negative space. The dance critic gave the work a tongue-in-cheek review, printing a blank column with just his initials at the bottom.

Flowing Space

The division between outside and inside space is not always clear. We are all aware of the different feelings created by a room that has many large windows and one that has no windows at all. Architects add windows, skylights, and other devices to buildings to help make the exterior space flow through and become part of the interior.

5–9 When walking in this canyon, a visitor is very aware of how space flows through the rock formations.

Bryce Canyon. Photo by H. Ronan.

5–10 Imagine standing inside this house. How would your relationship with outdoor space differ from that which you experience in your classroom?

Philip Johnson (b. 1906). *Glass House,* 1949. New Canaan, Connecticut. Photo by Ezra Stroller, ©Esto.

Cooperative Learning

So that students may study the positive and negative space relationships discussed in pages 96 through 99, have them collaborate in groups of four. Assign each group one of the images on pages 96 to 99 to analyze for positive and negative spaces. One student should be the discussion leader, one the recorder, one the reporter, and one in charge of distributing art materials. After students have identified the positive and negative spaces, have them make a large diagram or copy of the image on either craft paper or posterboard. Ask them to use markers to color the negative spaces one color and the positive spaces another color. Have group members present their findings and diagram to the rest of the class.

Sculptures and other three-dimensional forms constructed with wire or glass or pierced with holes are other examples of flowing space. Such works tend to break the boundaries between positive and negative space. Our eyes move into, around, and through the form. Holes connect one side with another. Instead of simply surrounding a structure, air or sky might play a part in occupying or creating interior spaces.

Design Extension
Ask students to imagine how they might feel if they were to walk through Pfaff's *Kabuki* installation (fig.5–11). Ask what they might run into or dodge. Discuss how the artist created a sense of depth. So that students understand how space may be manipulated in an art installation, have groups of four students create a model in a box of a possible installation that deals with a social issue. After students have completed the models, have the class choose one and create a full-scale installation.

5–11 Judy Pfaff incorporated the space of the gallery into her installation.

Judy Pfaff (b. 1946). *Kabuki*, 1981. Courtesy of the Holly Solomon Gallery, New York, NY.

5–12 Compare and contrast the use of space here with that in fig.5–11. Notice how this artist contained the interior space of her sculpture.

Glenna Goodacre (b. 1939). *Philosopher's Rock*, Bronze, 8' high (2.43 m). Located at Barton Springs, Zilker Park, Austin, Texas. Photo by Daniel R. Anthony. Courtesy of Glenna Goodacre Ltd., Santa Fe.

Context

By using elements that project from the ceiling, walls, and floor, Judy Pfaff blurs the line between painting and sculpture. The viewer is surrounded by a multitude of shapes and brilliant colors. A vibrant energy pervades her installations. When she creates an installation, Pfaff will, on occasion, actually live at a gallery, working day and night as she constructs the piece. Because her installations are site-specific and very complex in design, they cannot be moved. The only means of preserving them is via photographic documentation.

Two-dimensional Space

The *surface* of a floor, a tabletop, a sheet of cardboard, or a piece of paper can be described in terms of two dimensions: height and width. The surface has no depth.

In art, examples of two-dimensional space are a quilt design of geometric shapes and a pencil sketch of a tree. In the quilt, a red square may be sewn above a yellow one. In the drawing, the tree may be in front of a house. However, both works are physically flat.

5–13 Cartoonists often prefer not to create any sense of depth beyond the surface of the picture plane.

Stone Soup ©1998 Jan Elliot. Reprinted with permission of Universal Press Syndicate. All rights reserved.

5–14 In many of his works, the Dutch painter Vincent van Gogh created surface depth on the canvas. He used thick applications of oil paint, called *impasto*.

Vincent van Gogh (1853–90). *Roulin's Baby,* 1888. Canvas, 13 ¾" x 9 ⅜" (35 x 23.9 cm). Chester Dale Collection, ©1988 Board of Trustees, National Gallery of Art, Washington, DC.

Design Extension

As an experiment with positive and negative spaces and how their arrangement can affect a piece of art, have students create three small collages. From one color of paper, they should cut at least ten same-shaped objects, such as leaves, bottles, or fruit. Then ask students to arrange several of the shapes on a contrasting color of paper. In the first collage, the shapes should not touch one another; in the second, the shapes should just touch one another; in the third, the shapes should overlap. Ask students to note the three-dimensional effects in each arrangement.

The Picture Plane

The flat surface on which an artist works—whether it be paper, canvas, or a wall—is called the *picture plane*. Most artists do not attempt to create much physical depth on the picture plane. Some may apply oil paint thickly to a canvas to create surface depth. Collage artists might build up a flat surface with fabric, sand, or bits of wood. Other artists sometimes cut or tear the canvas or paper as part of their working method. But most drawings and paintings are basically two-dimensional.

An artist might choose to create an illusion of depth by manipulating line, color, value, and shape. The image created by painting or drawing can have a sense of depth which causes the viewer to momentarily forget that the surface is flat. Notice how in *Mystic Seaport in Fog* (fig.5–16) your eye is drawn "into" the scene and "beyond" the picture plane.

5–15 This student gives physical depth to the surface of her image by using cut paper.
Alicia Smith (age 16). *Monet in Paper*, 1998. Paper relief, 13" x 18" (33 x 46 cm). Nashoba Regional High School, Bolton, Massachusetts.

5–16 In this photograph, the fog and soft light have transformed the sky, water, and buildings into a single flat surface.
Alfred Eisenstaedt (1898–1995). *Mystic Seaport in Fog*, 1969. Photo. Alfred Eisenstaedt, *Life* magazine.

Try it

Choose a full-page photograph, such as a cityscape or landscape, from a magazine. Cut it into equal-size squares or rectangles. Rearrange the pieces until you are pleased with the design. Glue your new arrangement onto another sheet of paper. Explain what happened to the space.

Context

Roulin, the postman of Arles, befriended van Gogh during the artist's stay in the town. Van Gogh painted six portraits of the postman and also executed portraits of Roulin's family. The baby, Marcelle, was a subject in several paintings. Unfortunately for the troubled van Gogh, his loyal friend was transferred to a higher post in Marseilles. Though the postman visited Arles occasionally, the departure of the well-meaning family left the artist with a feeling of loneliness that added to his psychological problems.

Design Extension
Point out to students
that *The Elegant
Gathering in the
Western Garden*
(fig.5–18) is on a fan-
shaped, not rectangular,
picture plane. For stu-
dents to explore the
idea of painting on
shapes other than rec-
tangles, give them
organic shapes of
paper. Ask them to paint
on these shapes, mak-
ing the space around
the subjects work with
the shape of the picture
plane.

Composition

Like the relationship between positive and negative spaces in a sculpture or building, there is a relationship between shapes in two-dimensional art. The organization of elements and their placement on the picture plane is called *composition*.

When you place a black square on a piece of white paper, you create a new space. The surface is still two-dimensional, but it is now divided in two. The black square has become the positive space, and the white background area is the negative space. If you add a few more black shapes, the composition will change again. You will see several black positive spaces and an encompassing white negative space.

The shapes in a two-dimensional work also have a relationship to the edges or shape of the paper or canvas. A square shape placed in the lower right corner of a piece of white paper creates a space quite different from that made by a square shape placed at the center. Similarly, the feeling of space can be altered by changing the shape of the picture plane, whether it is paper or canvas. Although most artists create drawings and paintings within a rectangular shape, they will sometimes use a round, oval, or irregular shape.

5–17 How does the addi-
tion of black shapes
change the negative space
from the original compo-
sition? Does the black
square also seem to
change?

5–18 The fan shape is a
traditional format in
Chinese painting.
Compare the space on
the right side of the
painting with that on the
left. How does it differ?
Attributed to Wei Zhujing
(16th century, China). *The
Elegant Gathering in the
Western Garden*, 16th century.
Fan painting, ink and colors
on gold-flecked paper.
6 ½" x 20" (16.9 x 51.6 cm).
Avery Brundage Collection,
Asian Art Museum of San
Francisco. ©1994 Asian Art
Museum of San Francisco.
All rights reserved.

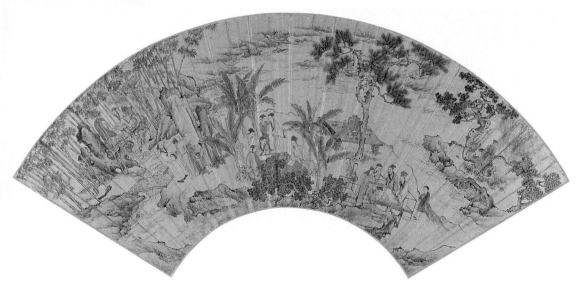

Performing Arts
Italian Musical "Space": Intermezzo
Ask students to think about the concept of space in time. Ask: What do you do to fill the "space" between early morning and late afternoon on a Saturday for which you have nothing planned? Explain that everything they do during the day fills up the space, even if they are just sitting around. Artists fill up space too—with images, colors, shapes, and even blank areas. In the eigh-teenth century, composers of serious operas didn't leave their intermissions "blank." They filled that period with an intermezzo, Italian for "interlude." This short comic opera contained two scenes for two or three characters, and was performed during the intermissions of a serious opera.

Point of View

A building appears different from the street than from the roof next door because the angle or point of view determines how the structure appears in space. A car looks different on a grease rack because we are not used to looking up at the car's underside. A baseball field looks different when you are standing on the pitcher's mound than when you are looking down on the field from the stands. A mountain looks huge when you are at its base, but the valley surrounding the mountain looks smaller when you are on top of the mountain.

Look around carefully, and see what happens to objects or people when you change your point of view. When you look down from a high window, for example, people walking on the street look quite different than they would if you were on the street with them. Spatial relationships change as your angle, or point of view, changes. Artists or photographers take advantage of point of view to produce dramatic spatial effects.

5–19 How would you describe the space in this scene? What is the observer's point of view?

Weegee (Arthur Fellig) (1899–1968). *Coney Island Crowd*, 1940. Gelatin silver print. Gruber Collection, Museum Ludwig, Cologne. 1977/839 Photo by Rheinisches Bildarchiv, Cologne. ©International Center of Photography, New York. Bequest of Wilma Wilcox.

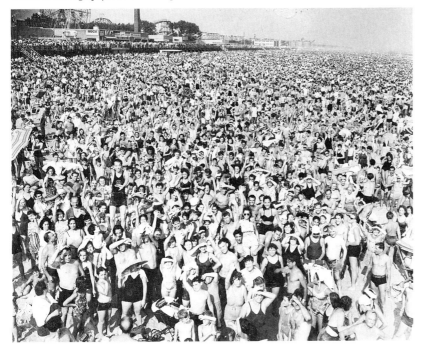

Try it

When you look straight down at a round plate, it is circular. But when you look at it from the side, it is a flattened oval. Choose a familiar object, and draw it from above or below, or from any other unusual angle.

Discuss it

To get this photograph of a crowded beach (fig.5–19), Weegee used a high point of view. The surprising scene is very different from the one he would have captured had he been standing among the crowd. As you read through this chapter, watch for images with dramatic or unusual points of view. Why do you think the artists of these images chose not to use a straightforward point of view? How would their works be different if they had?

Context

Arthur Fellig, called Weegee, was an American free-lance newspaper photographer whose specialty was sensational news stories. Today, however, he is noted particularly for his scenes of everyday life that capture an added dimension of empathy and wit.

The Illusion of Depth

Although artists may paint or draw on a flat surface, they often create the illusion or appearance of depth. To achieve this effect, they may choose from a variety of both simple and complex devices. Historically, artists from different cultures have relied more heavily on some methods than on others. Artists today often employ a combination of methods to create the illusion of depth.

You already know that shading and shadows help make a shape appear to have roundness or three-dimensionality. The techniques described in the following pages can help you create a greater sense of depth on a flat picture plane.

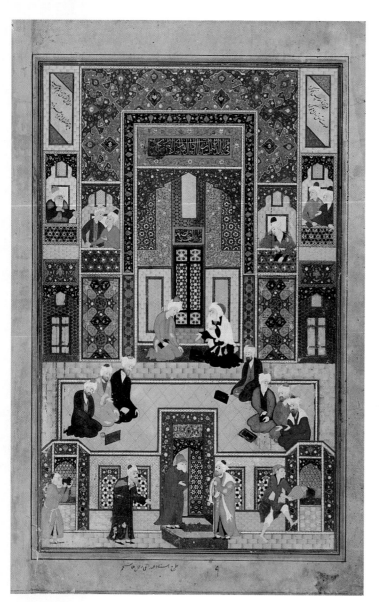

5–20 In this miniature, the artist worked with space in two different ways. The many patterns prevent an illusion of depth, so how is the viewer made to understand the arrangement of figures in space?

'Abd Allah Musawwir (active mid-16th century, Bukhara, Persia). *The Meeting of the Theologians*, 1540–50 (Uzbek Shaybanid Dynasty). Watercolor on paper, 11 ⅜" x 7 ½" (28.9 x 19 cm). Nelson Trust. Nelson Atkins Museum of Art, Kansas City, Missouri.

5–21 How is a sense of depth communicated in this purely abstract painting?

Vanessa Bell (1879–1961). *Abstract Painting*, c. 1914. Gouache on canvas, 17 ⅜" x 15 ¼" (44.1 x 38.7 cm). Tate Gallery, London. Photo Art Resource. ©Estate of Vanessa Bell.

Context

Vanessa Bell was the older sister of writer Virginia Woolf. Bell and her siblings (two brothers and Woolf)—along with E. M. Forster, Lytton Strachey, Vita Sackville-West, John Maynard Keynes, and others—formed the Bloomsbury group, a circle of writers, artists, and intellectuals who were extremely influential on the literary and cultural world of Britain before and after World War II. Bell is best known for her representational works, though she did paint a number of purely abstract pieces, including *Abstract Painting* (fig.5–21).

Nonlinear Methods

Position Place an object or shape higher on the page to make it seem farther away. In this diagram, the cat on the left seems closer.

Overlapping Place one shape on top of another to produce a feeling of depth. In this diagram, the apple (the top shape) appears to be in front of the orange.

Size Variation Combine similar objects of different sizes. The smaller objects will seem farther away than the larger ones. For example, trees in nature seem to become smaller as they recede into the distance.

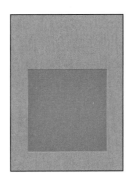

Color Use color to create a sense of depth. A shape of bold color on a more neutral-colored background appears to move forward.

Value Use different values. Lighter values tend to recede behind darker ones. In a landscape, you might use increasingly lighter shades of blue to create the illusion of a hazy atmosphere in the distance.

Higher-Order Thinking Skills

105

• *The Elegant Gathering in the Western Garden* (fig.5–18) utilizes devices for depicting space that are often used in Asian land-scapes. Have students compare this illusion of space to that in Moran's *The Grand Canyon of the Yellowstone* (fig.2–19). Ask students to list the techniques indicating space that they find in these images.

• Encourage students to find images in the text that illustrate each of the five nonlinear ways of showing depth.

Try it

Choose one object with a distinct shape—such as an apple, leaf, or butterfly—and draw the shape on colored paper seven or eight times, but in different sizes. Cut out the shapes, and place them on a neutral sheet of paper. Arrange some of the shapes so that they don't touch. Place some higher and some lower. Overlap others. Notice the various three-dimensional effects that occur. When you find an arrangement that you like, glue down the shapes.

Internet Connection

Ask students to search the World Wide Web for prints by Japanese artists such as Katsushika Hokusai and Ando Hiroshige to understand how they created an illusion of depth in their art. They may find gallery sites displaying *ukiyo-e* artwork and museum sites such as the Hokusai Museum in Japan. Students can share their findings with the rest of the class.

Linear Perspective

The method of depicting three-dimensional space on a two-dimensional surface is called *perspective*. When artists use lines to create depth, they are using *linear perspective*. Linear perspective is a much-used art technique, and is one of the best ways to create the illusion of depth in a drawing or painting.

One-point Outside your school or on your way home, close one eye and look up at the sides of a tall building or along the length of a street. You will notice that the sides of the building or the street appear to converge, or come together, in the distance.

During the Renaissance, Italian artists discovered that when straight lines are parallel, they seem to move away from the viewer and meet at a point in the distance. This point is called the *vanishing point*, because it is where the objects seem to disappear. When artists use linear perspective in combination with a single vanishing point, they are using *one-point perspective*.

Design Extension
So that students may further explore drawing one-point perspectives, have them print their name about 2" high in bold letters and then draw lines from the corners of each letter to a vanishing point a few inches above the letters. This will create an illusion of three-dimensional letters.

5–22 Diagram of one-point perspective. The line drawn parallel to the top edge of the composition is called the *horizon line*. It is an imaginary line that represents your eye level when you look straight ahead. The vanishing point is located on the horizon line. Notice that the square end of the object faces the viewer directly.

5–23 This museum is a replica of an ancient Roman villa. The original architect designed this garden and surrounding structures so that when a person stood at the center of the edge of the fountain, all of the architectural elements visually converged to a focal point, which is the central opening of the façade.
Main peristyle garden and façade, *Getty Villa*, Malibu, California. Photo by Julius Shulman.

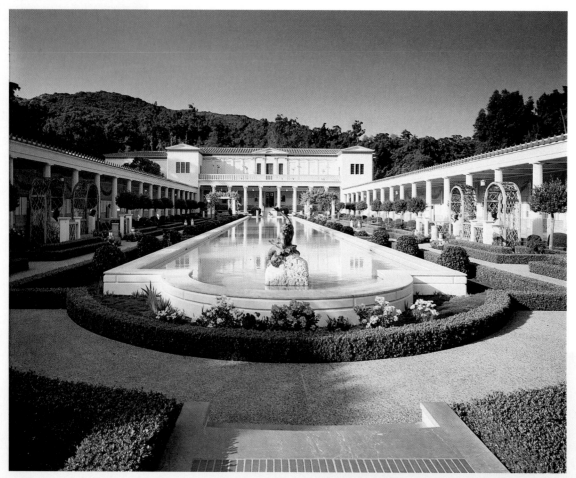

5–24 As evident in the student painting, one-point perspective is an excellent device for "pulling" the viewer into a scene.

Marion Bolognesi (age 15). *Bonaire*, 1997. Oil, 12" x 16" (30.5 x 40.6 cm). Quabbin Regional High School, Barre, Massachusetts.

5–25 Compare your eye movement when viewing this image and fig.5–20.

Anonymous (15th century, Italy). *Architectural Perspective: View of Ideal City*, 1490–95. Oil on wood, 32 ¾" x 86 ⅝" (83 x 220 cm). Walters Art Gallery, Baltimore.

Context

Architectural Perspective: View of Ideal City (fig.5–25) is one of a pair of Italian Renaissance panels that show huge empty plazas surrounded by Renaissance and Classical architecture. Both panels are believed to have been originally located in Urbino, Italy (the second panel currently is housed in the national museum there). The work is a study in linear perspective, a concept that had only just been discovered by the Florentines in the fifteenth century. The painting itself could almost be viewed as a visual treatise on perspective.

Two-point One-point perspective uses lines that lead to a single vanishing point. To create the appearance of three-dimensionality for objects placed at an angle to the viewer's line of sight, you must use two-point perspective. *Two-point perspective* uses parallel lines that seem to lead to two different vanishing points set far apart.

The different ways of depicting space and depth can be quite complicated—especially when artists combine several in one artwork. When you paint or draw, notice how edges and lines slant as they get farther away—and don't forget the simple methods of overlapping and size variation! Careful observation and use of these cues will help you create the illusion of three-dimensional space.

5–26 Books, boxes, and buildings that are at an angle to your line of sight can be shown by using two-point perspective. Notice that none of the three surfaces shown faces the viewer directly. The two vanishing points are on the horizon line.

5–27 How has this student used one-point and two-point perspective to make this surrealist composition more effective?
Jeffrey T. Metter (age 17). *Egypt.* Pen and ink, 18" x 12" (45.7 x 30.5 cm). Palisades High School, Kintnersville, Pennsylvania.

5–28 Allow your eye to follow the two imaginary perspective lines that begin at the corner of the building at the right. The line that moves to the right is quickly stopped by the edge of the painting. The line that extends to the left goes deeper into space, but is stopped by the building in the distance whose façade is parallel to the picture plane. Why do you think Canaletto used these devices? Where did he want you to focus your attention?

Canaletto (1697–1786, Italy). *The Molo, Venice,* c. 1735. Oil on canvas, 24 ½" x 39 ⅞" (62.3 x 101.3 cm). Kimbell Art Museum, Fort Worth, Texas. Photo by Michael Bodycomb, 1987.

5–29 Douglass Crockwell used two-point perspective to depict a number of the objects in this painting. Can you name at least three?

Douglass Crockwell (1904–68). *Paperworkers,* 1934. Oil on canvas, 36 ¼" x 48 ⅛" (92 x 122 cm). National Museum of American Art, Smithsonian Institution, Washington, DC/Art Resource, New York.

> ### ▲ Interdisciplinary Connection
>
> *Mathematics, Geometry*—Ask students to discuss what they know about parallel lines, such as the fact that they do not converge. Have them compare that with the linear-perspective rule that parallel lines seem to converge to a single point. Call on students to explain these discrepancies between math and art.

Context

The Molo, or wharf, in Venice is a busy area on the city's waterfront (fig.5–28). Located near the well-known St. Mark's Square, this area teems with boats and gondolas. In the eighteenth century, many wealthy British tourists visited Venice and commissioned Canaletto to paint this scene and others. These splendid souvenirs are the predecessors of the ubiquitous tourist postcard. Canaletto painted the Molo more than thirty times, each from a slightly different viewpoint. This type of painting is called a *veduta,* or view painting.

Subjective Space

A device like linear perspective helps artists depict scenes and objects as they appear in nature or in photographs. The subjects seem accurate and realistic to us. But artists are often interested in altering the world that we see with our eyes. Using their imagination and emotions, they manipulate and transform space and reality, creating subjective spaces that bear little resemblance to the real world.

5–30 For many centuries, artists have been fascinated with the depiction of reflected space. Here, the photographer momentarily confuses us because he captured both real and reflected space, and we must work hard to solve the puzzle of their relationship to each other.
André Kertész (1894–1985). *Untitled*, 1929. Gelatin silver print. ©1986 San Francisco Museum of Modern Art.

5–31 Compare this painting with the logical way that Canaletto constructed space in *The Molo*, *Venice* (fig.5–28). Use this comparison to help you see how Giorgio de Chirico created a space that makes the viewer very uneasy.
Giorgio de Chirico (1888–1978). *The Evil Genius of a King*, 1914–15. Oil on canvas, 24" x 19 ¾" (61 x 50.2 cm). The Museum of Modern Art, New York. Purchase. Photo ©1998 The Museum of Modern Art, New York. ©Foundation Giorgio de Chirico/Licensed by VAGA, New York, NY.

Space That Deceives

Look carefully at reflections in mirrors, water, and glass and metal surfaces. How are spaces distorted and deceptive? Artists today and in the past have used unusual spaces to confuse, surprise, and educate their viewers. Their works may cause you to question whether the space depicted is flat or three-dimensional, or whether the composition could actually occur in space and time as we know it. Sometimes, such optical illusions are purely entertaining. At other times, they can be the basis of serious art.

5–32 In this fresco, the early Renaissance artist Masaccio showed a series of three events happening at the same time. Other artists throughout history have made similar adjustments, seeming to go beyond the limits of the traditional concepts of space and time.
Masaccio (1401–c. 1428). *The Tribute Money*, c. 1427. Fresco. Brancacci Chapel, Santa Maria del Carmine, Florence. Photo Art Resource.

5–33 Surrealist artists attempt to create a deep space in which their personal dreamlike worlds exist. At first glance, their works may appear to imitate nature. But often—after careful examination—you'll notice that they bear little relationship to reality. In this fantastic creation, as in others by René Magritte, objects are combined in impossible ways.
René Magritte (1898–1967). *Time Transfixed*, 1938. Oil on canvas, 57 ⅞" x 38 ⅞" (147 x 98.7 cm). Joseph Winterbotham Collection, 1970.426. Photograph ©1998 The Art Institute of Chicago. All rights reserved. ©1999 C. Herscovici, Brussels/ARS, New York, NY.

Context

The Tribute Money (fig.5–32) is part of a fresco cycle in a chapel in the Church of Santa Maria del Carmine in Florence. Family ownership of a chapel in a church was a common practice in the Renaissance, and this chapel was owned by the Brancacci family, wealthy silk merchants who were part of the rising middle class that commissioned many of the great works of the Renaissance. Founded in the fourteenth century, the chapel was dedicated to St. Peter: for this reason, scenes from the saint's life decorate the walls. Peter is the figure who is repeated in each of the three separate incidents represented in *The Tribute Money*.

Cubism

One group of subjective artists, called Cubists, depicted space in a new way. In their works, objects and figures might be recognizable, but their shapes and the spaces they inhabit do not resemble those in the real world.

The Cubists flattened space, fractured forms, experimented with color, and added lines where none really exist. Because the objects they depicted usually resembled squares, or cubes, their method of working came to be called *Cubism*. In many Cubist works, objects seem both to stand straight up *and* to slant toward the viewer. Such treatment of space is contrary to nature and the camera lens, but it allows an artist to share his or her imagination and creative energy.

5–34 Do you think Juan Gris was working from a traditional still-life arrangement when he created this piece? If so, describe or sketch what it might have looked like.

Juan Gris (1887–1927). *Coffee Grinder and Glass*, 1915. Oil on paperboard, 15 ⅛" x 11 ½" (38.5 x 29.2 cm). Gift of Earle Grant in memory of Gerald T. Parker, Nelson Atkins Museum of Art, Kansas City, Missouri.

5–35 Review the description of Cubism in the text. In what ways does this painting fit that description?

Georges Braque (1882–1963). *Still Life with Grapes and Clarinet*, 1927. Oil on canvas, 24 ¼" x 28 ¾" (54 x 73 cm). The Phillips Collection, Washington, DC. ©1999 ARS, New York/ADAGP, Paris.

Context

Although Braque began his career as a house painter, by the age of eighteen he was engaged in the serious study of art. Braque met Picasso in 1907, and the two artists worked in close collaboration until the beginning of World War I. During this period, they jointly developed the Cubist style. In later decades, Braque's style diverged from Picasso's: Braque's work became less angular, and he focused primarily on still-life painting.

Design Extension

Have students research Paul Cézanne, an artist who greatly influenced Picasso's development of Cubism. (Picasso referred to Cézanne as "the father of us all.") Ask students to find some of Cézanne's still lifes to see how he began to simplify forms. Then call on students to compare some of Cézanne's works to the Cubist still lifes on pages 112–113. Encourage students to create their own Cubist painting of a still life.

Try it

Choose a simple object, such as a chair, a desk, or a lamp. Create three drawings of the object from different angles: perhaps a view from the side, from the top, and from below. Then combine parts of the three drawings into one to create your own Cubist composition.

Pablo Picasso
Guitar

Sometimes, a single work of art will cause long-held ideas to collapse. The twentieth century saw a steady stream of important artworks that changed the way we think about time, space, and form.

Working collaboratively in the spring of 1912, both the Spanish artist Pablo Picasso and the Frenchman Georges Braque experimented with breaking the boundaries of traditional ideas about space and form. Their creative minds challenged the age-old concept that art must consist of paint on canvas.

Picasso and Braque introduced real items to their canvases, items such as newspaper clippings, known as *papiers collés* ("glued-on papers"). This new art form was the beginning of collage as we know it. At the same time, both artists carried their Cubist ideas into three dimensions. Braque made paper reliefs, whereas Picasso used wood, sheet metal, and wire. Picasso's more durable materials survived, but Braque's studies did not. Picasso began to transform his Cubist still lifes from the canvas plane into the sculptural realm.

At first, Picasso used cardboard and string to construct *Guitar* (the restored maquette, or model, is also in the MOMA collection). He made his final version of more-permanent sheet metal and wire, and this became the first sculpture that had been created neither by carving nor modeling. This new art form was called *constructed sculpture*.

New ideas, however, are not always seen as successes in the beginning. In 1913, an art magazine called *Les Soirées de Paris* published four photographs of Picasso's Cubist constructions, similar in style to *Guitar*. Thirty-nine of the journal's forty subscribers so strongly disapproved of Picasso's sculptures that they canceled their subscription. The subscribers did not realize that constructed sculpture would become a widely accepted art form.

5–36 In this early Cubist sculpture, a projecting cylinder indicates the sound hole. Pablo Picasso, Georges Braque, and Juan Gris were the leading supporters of the Cubist style.

Pablo Picasso (1881–1973). *Guitar*, 1912. Sheet metal and wire, 30 ½" x 13 ¾" x 7 ⅝" (77.5 x 35 x 19.3 cm). The Museum of Modern Art, New York. Gift of the artist. Photo ©1998 The Museum of Modern Art, New York. ©Estate of Pablo Picasso/ARS, NY.

Materials and Techniques

113

The fine art of collage is a twentieth-century invention. The collaborative work of Picasso and Braque that resulted in Cubism also produced the collage. The mixed media of collage has been a consistently popular means of expression throughout the twentieth century, right up to today. Collage is composed of fragments of materials—such as photographs, newspapers, colored paper, fabric, and other odds and ends—pasted on a flat surface. An artist might also choose to use paint, crayon, or charcoal selectively on the surface of the collage.

Try it

To achieve a flattening effect of the picture plane, draw some simple still-life objects. With a pencil, draw the outside edges of each object, allowing the lines to overlap the other objects and continue off the page. Notice the unity and flatness of the objects and background that result. Compare your drawing with Gris's *Coffee Grinder and Glass* (fig.5–34).

Abstract and Nonrepresentational Art

Beginning with Cubism in the early years of the twentieth century, artists began to alter their depictions of space. Objects and figures, if depicted at all, were difficult to recognize in their paintings, drawings, sculptures, and other creations—works that are generally called *abstract art*. Works in which no objects or figures appear are referred to as *nonrepresentational art*.

5–37 A composition of contrasting lights and darks will appear to have depth. Warmer and brighter colors also seem to come forward. In this painting, the blue shapes recede; the red and yellow shapes move forward.

Arthur Dove (1880–1946). *Thunder Shower*, 1939–40. Oil and wax emulsion on canvas, 20 ¼" x 32" (51.2 81.3 cm). Amon Carter Museum, Fort Worth, Texas.

Try it

Choose three sheets of paper whose colors are closely related. Cut out similar shapes, perhaps squares or rectangles, from each color. Paste the shapes on another surface, completely covering it. Notice that the related colors make the picture seem relatively flat. Now choose a contrasting color. Cut out a few similar shapes. Place those on top of your design. What happened to the sense of space?

Design Extension

For students to appreciate the differences among realistic, abstract, and nonrepresentational art, have them create three oil-pastel or colored-pencil drawings of an object. Instruct them to render the first drawing as realistically as possible; to distort the second drawing to create an abstract artwork; and, in the third, to draw only the essence or mood of the object, with no recognizable objects in the drawing.

Although an abstract work may not depict anything recognizable, it still may have depth. Principles about position, overlapping, size, color, value, and linear perspective also apply to abstraction. Just as in more realistic art, these principles may be combined to create space that appears flat, shallow, or deep.

5–38 Notice how the top section of this work seems caved in, whereas the lower section seems to bulge forward.

Victor Vasarely (1908–97). *Sir-Ris*, 1952–62. Oil on canvas, 6' 6" x 3' 3" (198 x 99 cm) Reproduced with permission by the Janus Pannonius Múzeum, Pécs, Hungary. ©1999 ARS, New York, NY/ADAGP, Paris.

5–39 How is an illusion of depth created in this abstract painting?

John Ferren (1905–70). *Orange, Blue, Green*, 1969. Acrylic on canvas, 45 ⅛" x 50" (115 x 127 cm). Jack S. Blanton Museum of Art, The University of Texas at Austin. Purchased through the generosity of Mari and James A. Michener, 1970. Photo by Rick Hall.

Context

Born in Hungary, Victor Vasarely spent most of his career in France. In the 1930s he devoted himself to studies of color, optics, and graphics. He experimented with depth in his artworks by layering cellophane. He then concentrated on painting with oils and exploring abstract ideas. Vasarely's interest in optical illusions led him to originate the Op art style. His writings and artwork greatly influenced later Op artists.

Another Look at Space

5–40 Early medieval artists were masters of surface decoration and purposely did little to give the illusion of deep space.

St. Matthew, from the Lindisfarne Gospels, before AD 698. 13 ½" x 9 ¾" (34.3 x 24.8 cm). British Library, London.

⭐ Higher-Order Thinking Skills

St. Matthew, from the Lindisfarne Gospels (fig.5–40) was drawn before Alberti developed his rules of linear perspective during the Italian Renaissance. Ask students to compare this work to *Architectural Perspective: View of Ideal City* (fig.5–25). Ask them to describe how the drawing of St. Matthew might differ if it were drawn with the Renaissance technique of linear perspective.

5–42 Many artists use space to create an element of surprise in their work. What makes our eyes do a double take here?

M. C. Escher (1898–1972). *House of Stairs*, 1951. Lithograph, 18 ⅝ x 9 ⅜" (47 x 23.9 cm). ©1998 Cordon Art B. V., Baarn, Holland. All rights reserved.

⭐ Higher-Order Thinking Skills

Call on students to answer the question in the caption for *On the Europe Bridge* (fig.5–44). After they have discussed the answer, point out that some artists seek to limit the illusion of deep space in their work. To prevent a feeling of great depth, Caillebotte chose closely related colors.

5–43 Analyze the use of flowing space in this student work.

Lonnie Nimke (age 13). *Do-do Bird*, 1994. Metal and found object welding, 36" x 24" (91.4 x 61 cm). Manson Northwest Webster Community School, Barnum, Iowa.

5–44 In reality, the view from this bridge must extend quite far. How does Caillebotte's use of color prevent the illusion of deep space?

Gustave Caillebotte (1848–94). *On the Europe Bridge*, c. 1876–77. Oil on canvas, 41 ⅝" x 51 ½" (105.3 x 129.9 cm). Kimbell Art Museum, Fort Worth, Texas. Photo by Michael Bodycomb.

5–45 How does the Mayan sculptor of this ceramic piece contain the space and focus our attention?

Mayan. *Model of a ball game*. Pottery, 6 ½" x 14 ½" x 10 ⅝" (16.5 x 36.8 x 27 cm). Worcester Art Museum, Worcester, Massachusetts. Gift of Mr. and Mrs. Aldus Chapin Higgins. Photo ©Worcester Art Museum.

Context

Archaeologists have unearthed a number of ball courts (fig.5–45) in their excavations of the pre-Columbian world. They have also found several models of ball courts with players, which have provided some clues about how the ancient ball games were played. There were several different types of games, and the size of the ball was an important variable. Much like modern-day soccer, the ball was kept in play without the use of hands. Ancient players, however, could use only their elbows, hips, and knees to hit the ball.

Review Questions (*answers can be found on page 94j*)

1. Define the art element *space*.

2. List five means that artists use to create an illusion of depth on a flat surface.

3. In a linear-perspective drawing, what happens at the vanishing point? What does the horizon line represent?

4. Select a Cubist image from this chapter and describe how the artist abstracted space and forms.

5. Select an abstract or nonrepresentational image from this chapter, and explain how the artist indicated depth.

6. What is innovative in Henry Moore's sculptures?

7. Which two artists worked together in developing the art of collage?

Career Portfolio
Interview with an Architect

Space is a major consideration for architects, both in and around the buildings they design. Planning must include streets, sidewalks, and parks as part of the greater picture. Born in Seoul, South Korea, **Susie Kim** has degrees in architecture and urban design. She has worked on several large-scale projects in London, Boston, Beirut, Vietnam, and China.

Please describe what you do.

Susie We do architecture and urban design—designing cities.

When you design a city, is the city already there?

Susie Sometimes and sometimes not. Planning a new piece of a city within the old city is like an orchestration. Maybe you already have a violin section and a cello section, but you don't have the flute section or the woodwind section.

What makes a good city?

Susie It depends on the culture and some of the drawbacks of the culture. Generally, a good city with good pieces benefits other pieces, benefits the whole. Let's pull an example: Manhattan, Central Park. Can you imagine anyone putting in Central Park? Most developers would say that's stupid. But what that did was to bring value, which was a benefit to the city and its people. My partner and I don't believe in single-use cities. People need different experiences in a city.

Acting as a huge skylight, a garden space ensures that no desk in the 300-square-foot building is more than twenty feet away from daylight.
Susie Kim, *Atrium*. Photograph ©Steve Rosenthal, Auburndale, Massachusetts.

When did it click for you that architecture was a possibility?

Susie I wanted to go into a profession which was, at that time, not necessarily right for girls. I wanted to be either an architect or a pilot. Don't ask me why a pilot, other than I figured there weren't a lot of women in this profession. In a song in *The Fantasticks* [a long-running play in New York City], a girl says "Oh, please God, don't make me normal." That was one of my images.

Are there different kinds of architects?

Susie There are a lot of different things you can do with an architecture degree. One is practice: residential, commercial, institutional, a mixture, urban design. I also have a lot of friends who are teaching, which is incredibly valuable. You can also go into aspects of setting up public policy; policy-making jobs are more administrative and political.

What advice would you give to young people who are interested in architecture?

Susie A project in this profession is a very long process. To put up a building or to make a city takes a tremendous amount of patience. Tremendous. If you can count on your fingers ten important projects, that's probably five more than Michelangelo did. Think about it. How many buildings can you put up that are of a certain quality? It's a long process. It's not a profession for people who want instant gratification.

What is your role in a project?

Susie I'm a medium for creating something much larger than myself. That is the most rewarding thing about a project or a building, when it really has a life of its own that goes beyond yourself. But it's always amazing to me how much of a stranger it can seem. After five, ten years, you go back and look at it, and the building has its own life. That's when you know it's successful. It's no longer yours. It's somebody else's; it's part of the city, part of the fabric.

Studio Experience
An Event in Clay

Task: To create a clay sculpture of an event, such as a ceremony or game.

Take a look. Review the following images in this chapter:
- Fig.5–2, Isamu Noguchi, *California Scenario*
- Fig.5–11, Judy Pfaff, *Kabuki*
- Fig.5–12, Glenna Goodacre, *Philosopher's Rock*
- Fig.5–41, Allan Houser, *Desert Dweller*
- Fig.5–45, Mayan, *Model of a ball game*

Think about it.
- In each sculpture, notice how the figures or objects relate to one another. In which sculptures do the major elements seem to overlap? In which are they separate? How has each artist united the figures and objects to create a unified whole?
- Imagine that you are the same size as the elements in these sculptures. If you were moving through them, in which would you have to weave in and out between the figures and objects? In which could you stroll through the space?
- Point out the negative space in each sculpture.
- Find contrasts of shape, space, and form in each sculpture.

Do it.

1 To plan your sculpture of an event, make pencil drawings of some of the figures that you will include. Consider how the people are dressed and where they are in relation to one another. Include any objects—such as sports equipment, furniture, animals, plants, or architectural elements—that would be important to the scene.

2 Wedge the clay a few times to eliminate air bubbles.

3 On a foil-covered board, create an island of clay, which will be the sculp-

The artist who created this work is a tennis player, who competed in doubles tennis at a state championship level. She shared her passion for the game by making this sculpture.
Ashley Baran (age 17). *Tennis Match*, 1998. Clay, 10" x 5" (25.4 x 12.7 cm). Notre Dame Academy, Worcester, Massachusetts.

ture base: either flatten a ball of clay with your hands or use a rolling pin.

4 Create figures by pulling and shaping another piece of clay. Attach these clay figures securely to the base by scoring both the surface of the figure and the base where they are to join, applying slip, and then pressing the two pieces together. Pieces of clay must be securely joined together because clay shrinks as it dries.

5 As you build your sculpture, turn it around and work on it from different sides so that all viewpoints will be effective. Study it from various angles and from above. Create negative and positive spaces between the figures. Try arranging and bending the figures to enclose space. You might want to add texture to your sculpture.

6 After the figure is dry and has been fired, either apply ceramic glaze and refire it, or paint it with acrylic paints.

Helpful Hints
- Simplify the scene by showing just a few people.
- The sculpture base should be at least ¼" thick. If the base is too thin or too narrow, the sculpture may break easily or be unstable, tending to tip over.

Check it.
- What event did you depict in your sculpture? What main figures are in your sculpture?
- Describe the space in your sculpture. How have you incorporated negative space into your design?
- What other artworks influenced your creation?
- Consider the craftsmanship in your artwork. Did your piece stay together, even after it was fired? Describe the quality of the surface—the texture, glazing, or painting. Is it as you had envisioned it?
- What might you do differently the next time you create a similar work?

Studio Experience

An Event in Clay

Becky Ford (age 14). *Band*, 1996. Clay, 6" x 6" x 6" (15.2 x 15.2 x 15.2 cm). Notre Dame Academy, Worcester, Massachusetts.

Prepare

Time Needed:
Three 45-minute class periods (extend as needed if sculptures are large or detailed)
Lesson 1:
Draw and plan.
Lesson 2:
Form the sculpture.
Lesson 3:
Glaze or paint.

Objectives
Students should be able to

- Perceive and appreciate the negative space in artworks.

- Carefully plan the space around, between, and within the various figures in their sculpture.

- Demonstrate their understanding of hand-formed clay-sculpture techniques by creating a clay sculpture incorporating planned negative space.

Vocabulary
Review glossary definitions of these words with students.
- scoring
- slip
- wedge

Materials
- pencils
- drawing paper, 9" x 12"
- plywood or cardboard, approximately 10" x 10", covered with aluminum foil (1 per student)
- clay, ceramic or self-hardening (1 pound per student)
- clay tools such as tongue depressors, orange sticks, paper clips
- disposable containers for slip
 optional:
- rolling pins
- ceramic glazes or acrylic paints

Notes on Materials
- Make slip by mixing a small amount of clay with water in a paper cup or yogurt container.

- Under normal conditions, let the clay dry at least a week before firing.

- Bisque firing the clay before painting or glazing makes the clay sturdier for handling.

- If students glaze the final project, have them use underglazes rather than thicker glazes. In that way, students will usually have more control painting small details.

- Students may apply acrylic paints, school-grade watercolors, or diluted tempera to self-hardening clay or bisque-fired sculptures. The watercolors or tempera are absorbed into the porous clay, creating a matte, more pastel-like finish than that of the shiny acrylics. To make watercolors more permanent, spray with a clear acrylic finish, outdoors or in a well-ventilated area.

Before You Start
- Assign the drawings in an earlier class so that students may begin to consider what event they would like to portray.

- The beginning drawings could come from gesture drawings of student models. (See the Studio Experience in Chapter 1, page 33.)

- Possible subjects for this sculpture are ball games, ceremonies, family gatherings, school events, dances, historical events, and dramas.

Teach

Thinking Critically

- Focus on the images and the questions in **Think about it**. Ask students to compare the mood in Noguchi's *California Scenario* (fig.5–2) to that in Pfaff's *Kabuki* (fig.5–11). Have each student write one word to describe the mood in each piece. As students share their words with the class, have them note similarities in the responses.

- Ask students to compare the space in the Mayan *Model of a ball game* (fig.5–45) to that of Goodacre's *Philosopher's Rock* (fig.5–12). Ask students what each artist was trying to portray and how the artists used space to convey this meaning. Guide students to see how the artists shaped the figures to emphasize the personality of the individuals. How have the figures been abstracted or distorted in each sculpture? Why might the artist have done this?

Classroom Management

To cut the cleanup time, cover work areas with plastic tarps or newspapers.

Tips

- To keep unfinished sculptures moist from one class to the next, seal them in plastic bags or wrap.

- Even though the focus is on space, you might encourage students also to consider the surface quality or texture of their sculpture.

- If students are using ceramic clay that will be fired, the clay should not be thicker than 1". To prevent sculptures from exploding in the kiln, have students hollow out any thicker form and leave a hole for air to escape from it.

Assess

Evaluation

Ask students to evaluate their sculpture by answering the **Check it** questions before it dries so that they can make adjustments. Motivate them to look at the sculpture from several directions to determine the success of their design.

Extend

Linking Design Elements and Principles

Texture, Pattern

After students have created the major forms and spaces in the main activity, encourage them to create textures in their sculpture by scoring the clay, and to create patterns by repeating surface textures.

Form, Rhythm

Because the main activity lends itself to consideration of form, have students create forms that surround space. Using small pieces of clay for a visual demonstration, instruct students to consider different types of forms—such as rounded bulbous or thin columnar forms—that they might create. Show students that by repeating similar forms and spacing them at various intervals, they may create rhythm.

Color

If students paint or glaze their sculpture, have them consider the impact that color will have on the mood of the work. Ask students to imagine the mood that their sculpture would convey if painted with two colors, or with bright or dull colors.

Interdisciplinary Connections

Literature, Performing Arts

Ask students to create with clay a scene from a play they have seen or read. Tell them to consider the body language of the main characters, the setting, and any special props.

History

Ask students to select a significant historical event, such as a battle or the signing of a treaty, that they have studied and to depict it in clay. As a cooperative-learning project, each student could form one scene of a sequence of events.

Inquiry

- Have students research a sculpture, other than one represented in this book, that incorporates more than one figure. Possibilities are Michelangelo's *Pietà*, Barbara Hepworth's *Group III (Evocation)*, Marisol's *Last Supper*, August Rodin's *Burghers of Calais*, or Alberto Giacometti's *Composition with Seven Figures and One Head*. Have students draw the sculpture, carefully noting the artist's use of negative space.

- Assign students to research other equestrian statues in addition to *Andrew Jackson*. They might study Verrocchio's *Colleoni* monument in Venice, Donatello's *Gattamelata* in Padua, or a local monument. Ask them to compare and contrast the use of negative and positive space in each. Is there a similarity to the way equestrian figures are treated? Encourage students to investigate the technical difficulties associated with creating this traditional type of commemorative monument.

Texture

Chapter Overview
• Surface textures of many kinds—both natural and human-made—fill the environment.

Objective: Students will perceive and comprehend how texture may be indicated and used in two- and three-dimensional artworks. (Art criticism)
National Standards: 2. Students will use knowledge of structures and functions. (2a, 2b)

Objective: Students will create rubbings, sketches, reliefs, and baskets emphasizing texture. (Art production)
National Standards: 1. Students will understand and apply media, techniques, processes. (1b) **2.** Students will use knowledge of structures and functions. (2c)

8 Weeks	1 Semester	2 Semesters			Student Book Features
1	1	1	**Lesson 1:** Texture	Chapter Opener	Note it
0	1	1	**Lesson 2:** Surface Qualities	Real Textures	Try it: explore texture
0	0	1	**Lesson 3:** Surface Qualities	Implied Textures	Try it: collage, About the Artist
0	1	1	**Lesson 4:** Texture and Light	Texture and Light	Discuss it
0	0	1	**Lesson 5:** Artists and the Use of Texture	Three-dimensional Art	
0	0	1	**Lesson 6:** Artists and the Use of Texture	Two-dimensional Art	
0	1	1	**Lesson 7:** Artists and the Use of Texture	Texture in Your Environment	About the Artwork
1	1	1	**Chapter Review**	Another Look at Texture	Review Questions
3	3	3			

Studio Experience: *Coiled Baskets*

Objectives: Students will use texture as a design element; create a basket using the coiling technique; identify the fiber work of contemporary artists, as well as that of Native Americans.

National Standards: Students will create art using organizational structures and functions to solve art problems (2c); use media, techniques, and processes to achieve their intentions in their artworks (1a); differentiate characteristics and purposes of a variety of historical and cultural artworks (4a)

- Artists use both real textures and implied textures in their works.
- Depending on the medium used, artists may create textures in a number of ways.

- Perception of a textured surface depends upon the light shining on the surface.

Objective: Students will recognize how artists of various art periods and cultures indicated and utilized two- and three-dimensional textures in their artworks. (Art history/cultures)
National Standards: 4. Students will understand art in relation to history and cultures. (4c, 4d)

Objective: Students will develop a perception and appreciation of textures in the environment and in artworks. (Aesthetics)
National Standards: 6. Students will connect visual arts with other disciplines. (6c)

Teacher Edition References	Ancillaries
Warm-up, Design Extension, Context, Inquiry	
Design Extension, Context, Interdisciplinary Connection, Performing Arts	*Slide*: Pre-columbian, *Nunnery, East Building Facade*, (T-1) *Large Reproduction*: Tribesman from the Mendi Area
HOTS, Context, Materials and Techniques, Internet Connection	*Slide*: Rachel Ruysch, *Flower Still Life* (T-2) *Large Reproduction:* William Michael Harnett, *My Gems*
HOTS, Context, Portfolio Tip	*Slide*: Edward Weston, *Shell* (T-3)
Design Extension, Context, Cooperative Learning, Performing Arts	*Slide*: Lakota Sioux, *Woman Doll* (T-4)
Design Extension, Context, Internet Connection, Inquiry	*Slide*: Coptic, *Tapestry* (T-5)
Design Extension, Context, Inquiry, Interdisciplinary Connection, Portfolio Tip	*Slide*: Helmut Jahn, *State of Illinois Building* (T-6)

HOTS, Context, Interdisciplinary Connection

Vocabulary
implied texture The perceived surface quality in an artwork. *(textura implícita)*
real texture The actual surface quality of an artwork. *(textura real)*
texture An artwork's actual or implied surface quality, such as rough, smooth, or soft. *(textura)*

Studio Resource Binder

6.1 Cardboard Loom Weaving
6.2 Marbleized Paper
6.3 Layered Images, photocollage
6.4 Animal Rubbing, cardboard/crayon
6.5 Raised Surfaces, clay
6.6 Papermaking

Time Needed
Three 45-minute periods to teach the techniques and practice; students finish the basket at home.

Lesson 1
Texture

pages 120–121

Objectives
Students will be able to

- Perceive and appreciate textures in the natural and the human-made environment.

- Describe and sketch natural textures.

Chapter Opener
Before students do **Note it**, show them fig.6–5, the smooth river rocks; fig.6–7, the tree trunk and branches; and fig.6–28, the lichen. If possible, have students go outside to sketch textures such as these. Otherwise, bring in natural objects with texture, such as pine cones, leaves, tree bark, shells, and leaves for students to sketch.

Opener	pages 120–121

Materials
- pencils
 options:
- 9" x 12" drawing paper, 4 sheets per student
- sketchbooks
 optional:
- natural objects

Sarah Doyle (age 14). *The Pain of Dots*, 1997. Acrylic, 18" x 24" (45.7 x 61 cm). Palisades High School, Kintnersville, Pennsylvania.

Lesson 2
Surface Qualities

pages 122–123

Objectives
Students will be able to

- Differentiate between real and implied textures.

- Create pencil or crayon texture rubbings.

Teach: Real Textures
- After students have read pages 122 and 123, ask them to do the following:

 —explain the difference between real and implied textures.
 —do **Try it** on page 122: collect a series of distinctively textured objects, put each object into a paper bag and have classmates identify the object without looking, by touch.

—make pencil or crayon rubbings of several of the textures that they felt. Demonstrate placing a thin piece of typing paper on top of the texture and rubbing with the side of a pencil point or crayon to create a rubbing.

Try it	page 122

Materials
- assortment of textured objects
- paper bags

Teach	pages 122–123

Materials
- 8 1/2" x 11" lightweight paper (such as tracing paper)
- pencils or crayons

- Ask students to describe the texture in *Gaudí's Presence* (fig.6–8). Then focus on Gaudí's *Güell Park* (fig.6–29) and compare these two pieces. Call on students to suggest why Leigel titled his work *Gaudí's Presence*. Ask students to imagine how the painting might feel to the touch, and whether they consider the texture to be real or implied.

- Students probably learned about Ellis Island in their social studies classes. Review with them the role that this 1898 structure in the New York City harbor played during the first half of the twentieth century as thousands of families immigrated to the United States. Some students may be aware of their family members who came through this building.

- Have students walk around the school building and make rubbings of textures incorporated in the architecture. Suggest surfaces such as cement, bricks, and tiles. Demonstrate the procedure. Caution students to be certain no marks are made on the walls or floors.

Lesson 3
Surface Qualities

pages 124–125

Objectives
Students will be able to

- Perceive and appreciate implied textures in artworks by Vermeer and other artists.

- Create a landscape collage using magazine or newspaper implied textures.

Teach:
Implied Textures

- Review with students the difference between real and implied textures, then have them do the following:

 —study the implied textures in the images on pages 124 and 125.

 —list the different textures in Vermeer's *Street in Delft* (fig.6–13) and note how Vermeer indicated the appearance of each texture. Discuss Vermeer's use of strong contrasts of light and dark to give a tactile quality to the various materials.

 —describe or write a brief description of the texture found in Ray's *Jazz* (fig.6–10), Levine's *Work Boots* (fig.6–12), or Still's *R No. 2* (fig.6–11); have them also consider why the artists chose to use texture in the way they did. Ask several volunteers to present their thoughts to the rest of the class.

- Review with students the facts that are known about Vermeer. Point out that the attention to texture details found in Vermeer's art is often found in the art of other seventeenth-century Dutch artists such as Rembrandt van Rijn, Frans Hals, and Gerard Terborch. Encourage students to research Dutch works from the period to discover the types of subject matter that were favored in Holland at this time. Have them note how important texture was in each of the types they find. (Cityscapes, landscapes, and still lifes were particularly popular.)

- Instruct students to do **Try It** on page 124. When they have completed their landscapes, ask them to assess their work. Did they incorporate a variety of textures? Did they convey a sense of landscape?

Try it — page 124

Materials
- old magazines and newspapers
- scissors
- glue
- 12" x 18" heavy paper or tag board

Lesson 4
Texture and Light

120d

pages 126–127

Objectives
Students will be able to

- Experiment with light to understand how it affects the perception of texture.

- Draw a dramatically lit texture.

Teach

- After studying the images on pages 126–127, students can identify where the light source is in each image and describe the textures.

- Point out to students the size, medium, and date of fig.6–16, *Happy Wanderer* by Guthrie. Challenge students to compare this to fig.6–1, Duane Hanson's *Old Man Dozing*. How are these alike? (Students should mention the extreme realism of both pieces.)

- Focus on **Discuss it**, page 127. When students find an angle that creates a dramatic lighting that best enhances the texture of an object, have them draw the object with pencil or conté.

Discuss it — page 127

Materials
- 9" x 12" white drawing paper
- pencils or conté
- flashlight or floodlight
- assortment of textured objects

Lesson 5
Artists and the Use of Texture

pages 128–129

Objectives
Students will be able to

- Perceive and appreciate texture on three-dimensional artworks.

- Experiment in creating their own three-dimensional textures.

Teach:
Three-dimensional Art

- Focus on pages 128–129 and instruct students to list several ways that artists create texture in different media. Ask them to study the surface textures in the images on these pages, and to write and share adjectives that describe the textures in each image. Discuss how the surface texture in each was created. (The *Three clay containers* were built up of coils and small pieces of clay; the Chinese *Incense burner in bronze form* was thrown on a wheel and coated with a glaze that crackled; the marble of *A Little Boy* was carved and polished; *Spell of the Green Lizard* used the natural texture of fiber.)

- Explain that Desiderio, a Renaissance sculptor who is known for his delicate portrayal of children, was from the Tuscan town of Settignano where Michelangelo spent his early childhood with a stonecutter's family and acquired his love for marble.

- Allow students to create their own samples of three-dimensional textures in clay tiles. Demonstrate how to roll out the clay with a rolling pin and press textured gadgets and materials such as drinking straws, burlap, lace, and buttons into the clay slabs. To achieve a uniform thickness, students should roll the clay flanked by two 1/4"-thick boards to level the rolling pin. Ask students to cut some of the textured slabs into tiles. Have students work on a flat, nonporous surface: if flat tiles are left to dry on cardboard or paper, they will warp. If you do not have laminate or wooden boards, cover cardboard with plastic wrap or foil.

Teach pages 128–129

Materials
- clay, ceramic or self-hardening
- rolling pins
- wooden or laminate boards, or cardboard covered with plastic wrap or foil, about 9" x 12"
- gadgets, nature objects, and textures to press into clay
 optional:
- 1/4"-thick boards, at least 10" long by 2" wide

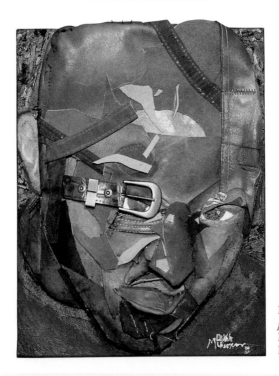

Dewayne McKinnon (age 17). *Self-portrait*. Leather and oil on canvas. Douglas Byrd Senior High School, Fayetteville, North Carolina.

Lesson 6
Artists and the Use of Texture

pages 130–131

Objectives
Students will be able to

- Understand and perceive how artists create texture in two-dimensional artworks.

- Experiment with watercolors and ink to create a variety of implied textures.

Teach:
Two-dimensional Art

- Review the concept of implied texture. Focus on the textures in the images on pages 130–131 and challenge students to describe how each texture was created. Explain that the

medium often affects the texture of an artwork. Point out the wood-grain texture created by the wood printing block in Schmidt-Rottluff's *House Behind Trees* (fig.6–24). Explain that Frankenthaler used a very thin coat of paint that allowed the texture of the canvas to become part of the work (fig.6–25). Ask students to note the size of Celmins's *Ocean: 7 Steps #1* (fig.6–23) and imagine how long this must have taken to draw. Call on students to select from an earlier chapter an image that they think has a particularly effective implied texture. Encourage students to discuss why the image they have chosen is so effective.

- Introduce students to the work of Helen Frankenthaler, an artist known for her abstract expressionist paintings made with thin washes of color on untreated canvas.

- Suggest that students experiment with watercolors and ink to create a variety of textures. Have them use a dry brush with black paint or ink on paper to produce the feathery look of grass and foliage. Then have them use a wet-on-wet technique with watercolor to simulate softer textures. They might experiment, applying the paint and ink with different objects, such as sticks and sponges.

Teach	page 131

Materials
- 12" x 16" watercolor paper
- india ink or black paint
- watercolors
- brushes
- water containers
- applicators such as sticks and sponges

Lesson 7
Artists and the Use of Texture

pages 132–133

Objectives
Students will be able to

- Notice and appreciate texture in their environment.

- Photograph or sketch environmental textures.

- Perceive and appreciate the textures used by Antonio Gaudí in *Güell Park* in Barcelona, Spain.

Teach: Texture in Your Environment

- Remind students that they are surrounded by a variety of textures, both natural and human-made. Ask students to list some of the textures in the photograph of the Los Angeles Plaza (fig.6–27). Then have them look at Gaudí's *Güell Park* (fig.6–29) as another use of textures in urban design. Point out that the mosaic tiles of the benches and wall contribute to an organic, joyful mood.

- After students read the information about Antonio Gaudí and Güell Park, lead them in discussing Gaudí's art. He is usually identified as an Art Nouveau architect due to his use of undulating waves and flowing lines. Art Nouveau was an abstract style that flourished in Europe and America from the 1880s through the 1930s. The Art Nouveau style also can be found in Mackintosh's poster, fig.8–4.

- Suggest to students that Gaudí may have been influenced by Moorish art. He was living on the southern coast of Spain where the Moors built mosques covered with ceramic tiles. The North African Moors invaded Spain during the eighth century and were not driven out until the late fifteenth century.

- Refer the students to fig.6–8, *Gaudí's Presence* by Franklin Liegel. Describe the similarities between this and the park bench in *Güell Park*.

- Send groups of students around the school building and grounds to create images of various textures. They may photograph or sketch several textures, such as the side of the building, decorative tiles, a brick walkway, or plants.

- Remind students to be aware of the light and how it falls on the textures. Suggest that they will probably take the most successful pictures in natural light without a flash. In groups of four, one student could select the location for the shot; another could take the photograph; another could record the number of the frame, note the subject, and who is taking the photo; and the fourth could carry any extra lights or props and direct whose turn it is to shoot. Have students rotate jobs after every two pictures so that each student takes several photos.

- Have students work within their group to mount their art on posterboard and label each texture as to what it is and where it was found. Suggest to students that they sort the textures into natural and human-made or rough and smooth.

Teach	page 132

Materials
options:
- cameras and film
- 9" x 12" white drawing paper, pencils

Chapter Review

pages 134–135

Assess

- Assign students to write the answers to the review questions. Discuss their answers to determine if they perceive and comprehend how artists indicate and use both implied and actual texture in two- and three-dimensional artworks. **(Art criticism)**

- Review with each student his or her portfolio of projects completed in this chapter. They should have created rubbings, sketches, reliefs, and baskets emphasizing texture. **(Art production)**

- To determine if students recognize how artists of various art periods and cultures, especially Jan Vermeer and Antonio Gaudí, indicate and use two- and three-dimensional textures in their artworks, select illustrations from this chapter for the students to describe and analyze. Their conclusions may be written or reported orally. **(Art history/cultures)**

- From the students' discussions, sketches, and photographs of texture determine if they developed a perception and appreciation of textures in the environment and in artworks. **(Aesthetics)**

- Create a class art exhibit featuring texture. Encourage students to comment on several works that they think show either an unusual texture or depict textures particularly well. **(Art criticism/ Aesthetics)**

Reteach

- Focus on the textures in the images on pages 134–135 and ask students to determine which are real and which are implied. Students might argue that because all the images are really photographs, all the textures are implied. If they do so, then ask which textures would be real and which would be implied in the actual art. Guide students to see the contrasts in textures in the *Fly whisk* (fig.6–31) and to count the different textures. Discuss the likelihood that such an elaborate tool for discouraging insects would have been a status symbol. Encourage students to imagine and describe the feel of the Guatemalan *Woven belt* (fig.6–30) if they were to run their fingers over it.

Computer Connection

Explore the illusion of implied texture using a paint program which allows texture filling and editing. In the artroom, set up an arrangement of objects that are highly textured such as fabrics, carpeting, and textured papers. Instruct students to select the pencil tool and create a contour drawing of the arrangement, being sure to fill an 8 1/2" x 11" area. Guide students to select and fill areas of their drawing with textures that most closely resemble the real textures that they see. After printing, discuss how implied textures fool our eyes so that we "experience" real textures.

- As students study the texture in fig.6–34, Audubon's *Common Merganser*, explain that Audubon was a nineteenth-century American painter and illustrator who painted hundreds of American bird illustrations. Ask students if they can surmise from this print what Audubon was most interested in showing in his art. Why might scientists value these illustrations?

Answers to Review Questions

1 Texture is the physical surface quality of a material, or how it feels or appears to feel to the touch.

2 Real textures may actually be touched, whereas implied textures are simulated or invented.

3 Light affects the readability of a surface. Depending on the angle of the light source, shadows might define the surface texture. If the light is dim, texture may be difficult to see; if the light is very bright, the texture may seem to wash out in a glare.

4 Artists create real textures by adding grog to clay, incising, sanding, gouging, and polishing clay, stone, and wood.

5 Students might mention the texture of the school building, natural textures such as tree bark, and textures on classroom furnishings.

6 Students may choose from a number of images. Their description should reflect a clear understanding of implied texture.

7 Vermeer painted ordinary scenes of people doing everyday tasks. He would add a sense of mystery by placing figures behind objects or viewing them through a doorway.

8 Gaudí used ceramic tile mosaic to create the texture on the park bench.

Meeting Individual Needs

Students Acquiring English

Discuss and display visual examples of implied and real textures. Communicate in a simple, clear manner that the term *texture* refers to the way things look or feel. Ask students to pronounce and to write the term, and to identify various examples within the classroom.

Discuss, using visual resources, the differences between real and implied textures. Tutorial assistance by other students can help reinforce newly acquired skills and information.

Students with Special Needs

Visually Impaired
Allow visually impaired students to explore textural qualities of their environment through tactile exploration. Working with clay is one means to demonstrate the different qualities of textures. Have students press small plaster molds or found objects into clay to achieve a variety of textures.

Gifted and Talented

Ask students to research artists who work in a variety of media, in both two and three dimensions, and incorporate texture as a means of expression. Ask students to report how and to what extent the textures are used, and to identify whether the textures are real or implied.

Jason Longhauser (age 16). *Raku pots*, 1997–98. Fired clay and raku glaze of ashes, 5"–14" (12.7–35.6 cm). Manson Northwest Webster Community School, Barnum, Iowa.

6 Texture

IMAGINE A LIFE IN WHICH EVERYTHING had the same surface look and feel. Fortunately, our world is full of a rich variety of surfaces that provide us with both information and visual pleasure.

One of the features of surface quality is *texture*, the physical surface structure of a material. Woven fabrics, for instance, have particular textural surfaces. They range from the closely knit fibers of silk to the heavy weave of burlap. We can often readily identify a material by its texture: glass is smooth and slick; sand is gritty and fine.

Chapter Warm-up

• To introduce students to texture and to call their attention to it in their environment, ask them to look around the classroom and describe how different surfaces might feel. For example, they might describe a desk surface as smooth and the ceiling tiles as grooved. Ask students to describe the textures in Alma-Tadema's *Interior of the Gold Room* (fig.6–2). Then have them compare the texture of the armchair in *How High the Moon* (fig.6–3) to that of a chair in the artroom. Ask which they think is probably more comfortable.

• Focus on fig.6–1, *Old Man Dozing* by Duane Hanson. Inform students that Hanson is known for his realistic sculptures of figures. Viewers have been known to speak to them and alert the police to intruders when they were glimpsed through the window of a closed museum. Hanson creates sectional silicone rubber and plaster of Paris molds of real people and casts them in polyester or vinyl.

6–1 Polyester and Fiberglas™—the materials used to create this sculpture—help make it look so realistic that from a short distance, an observer can be fooled into thinking it is a real person.
Duane Hanson (1926–96). *Old Man Dozing*, 1976. Cast vinyl polychromed with oil and mixed media, 48" x 24" x 38" (121.9 x 61 x 96.5 cm). Estate of Frederick R. Weisman.

6–2 Some artists delight in depicting textures as realistically as possible. Here, a remarkable number of different textures are represented.
Anna Alma-Tadema (c. 1865–1943). *Interior of the Gold Room, Townshend House*, London, c. 1883. Watercolor with scraping over graphite on paper, 20 ⅞" x 14 ⅛" (53 x 35.9 cm). The Nelson-Atkins Museum of Art, Kansas City, Missouri. (Bequest of Milton McGreevy).

Design Extension

Encourage students to experiment by making prints of textures from found objects such as leaves, stones, and crinkled newspaper. Have students apply ink or paint to the objects and print them on paper.

Texture might create diverse effects in a design. Just as some artists or craftspeople may focus on line, shape, or color, others concentrate on texture to capture a particular look or feel. In this chapter, you'll explore a wide range of textures, their effects on the viewer, and various methods of incorporating them into your own art.

6–3 Designers sometimes use an unexpected texture to add an element of surprise to their work.

Shiro Kuramata (b. 1934). *How High the Moon* armchair, 1986. Nickel-plated steel, 28 ¼" x 37 ⅜" x 32" (71.8 x 94.9 x 81.3 cm). Manufactured by Vitra Inc., Basel. Gift of Vitra Inc., 1988. The Metropolitan Museum of Art, New York.

6–4 How would you describe the texture of this flower?
Pinwheel/Protea. Photo by J. Scott.

6–5 Often, the forces of nature can change the texture of an object. These river rocks have been made smooth by the force of flowing water. What other natural or manufactured objects undergo such a change?
River rocks. Photo by N. W. Bedau.

Context

New materials have allowed contemporary artists to create artworks only dreamed of by previous generations of artists. Artists model and color some plastic media so that they replicate the look and feel of skin (fig.6–1). Hanson has taken full advantage of these polyesters to create a series of figures that represent typical, familiar Americans.

Note it

The outdoors presents many different natural textures. Some are obvious, such as the bark of a tree. Others are more subtle, such as fine spider webs or frost on a window pane. Write brief descriptions of outdoor textures that interest you. Make a small sketch next to each description. Try to capture the feeling of the texture in the marks you make.

Surface Qualities

Whether you are the viewer or the artist, you experience two kinds of textures: real and implied. ***Real textures*** are those that can actually be touched, such as the smooth surface of a bronze sculpture or the spiky surface of a cactus. ***Implied textures*** are those that are simulated, or invented. They include the roughness of a rock seen in a photograph and the fluffiness of a cloud depicted in an oil painting. Real textures offer both look and feel; implied ones provide only the appearance of texture.

Real Textures

Real textures are important because they provide clues about an animal's or object's nature and, to a large degree, about its function. The rugged texture of an elephant's skin seems quite logical for survival in the rough terrain and heat of Africa and Asia; the slick, smooth skin of a snake helps it maneuver swiftly in water and over the earth.

6–6 We often describe animals in terms of their texture. What words would you use to describe the texture of cat fur, snake skin, and porcupine quills?
Sleeping Roger, 1997. Photo by R. Banas.

6–7 This tree displays several textures. How many can you see?
Tree trunk and branches. Photo by J. Selleck.

Explore textures by touch only. With your eyes closed, let your hands identify objects and surfaces by the sensations delivered through your fingertips. Group together a number of objects that have different textures. Then study what creates these textures.

Many textures have a protective purpose. Fur provides warmth. Prickly plants and spiny animals give fair warning that their surfaces are unpleasant to touch—or eat; therefore, humans and other animals usually avoid them. Other textures attract. We enjoy the softness of cat fur, the smoothness of silk, and the reflective surface of polished wood.

Actual textures in artworks often provide visual interest—even when they cannot be touched. But for texture to be appealing, the artist must control its use. Too much texture or an inappropriate type can disturb the appearance of a surface. For instance, raised, bumpy, pebbly, or craggy textures are visually active; whereas smooth, woven, and finely textured surfaces are more restful. Artists sometimes include areas of refined or minimal texture as a visual rest from highly textured areas.

123

Performing Arts
Hearing Texture: Pastorale
Artworks might have either real or implied texture. Music also has texture. Harsh tones or melodious notes add an almost physical quality to a composition. A pastoral, such as Beethoven's *Symphony No. 6* ("*Pastoral*"), evokes a country scene. Play part of the symphony for students, and ask them what images come to mind. Then ask what kind of texture their favorite popular song creates. Cottony? Scrubby? Jagged?

6–8 Some artists create real textures on the surface of a canvas.

Franklyn Liegel (b. 1952). *Gaudí's Presence*, 1995. Mixed media on canvas, 44" x 59" (111.8 x 149.9 cm). Collection of Barbara and Kenneth Holland, Santa Fe, California. Courtesy of the artist.

6–9 Architects are highly selective in choosing textures to enrich the appearance of a building. Combinations of glass, wood, brick, stucco, stone, and metal offer textural variety and contrast. In this detail from a building at Ellis Island, notice how well the stone and brick surfaces work together.

Ellis Island, *Main building*, by Boring and Tilton, 1898. Detail of cornice, arch, and carving. Photo by H. Ronan.

Context

For decades, Ellis Island, in the harbor of New York City, was the prime immigration station of the United States. The building that housed the immigration processing offices was built in 1898 by Boring and Tilton. In 1907, its peak year, 1,285,349 immigrants passed through the Great Hall of the building. When the station closed in the early 1950s, the building fell into disrepair. In the 1980s it was restored, and in 1990 it was reopened to the public as part of the Statue of Liberty and the Ellis Island National Monument of the National Park Service.

Context
Marilyn Levine has been making realistic clay sculptures (fig.6–11) for more than twenty-five years. She reinforces clay with nylon fibers, rolls it into thin slabs, and uses these to build leather-like forms. She strives to depict the effects of worn—rather than new—leather objects, and because she emphasizes the scuffs that occur with every-day use, her sculptures have a homey, familiar look.

Implied Textures

All our experiences with real textures build memories that we experience again when we see similar implied textures. These memories also help us make judgments when we encounter unusual or unfamiliar textures. When an artist uses implied textures, he or she is "fooling our eyes" in a sense. We are seeing an impression, or something that is not really there, because in our imagination we can feel the texture portrayed.

Naturally, implied texture plays an important role in photography. Texture is essential in paintings and drawings that portray objects realistically. Artists also use familiar and invented textures to enhance their abstract or nonrepresentational art. In such works, textures can suggest certain feelings and moods, or even remain purposely ambiguous. Textures and textural contrasts can also function as organizational devices: they may unify an area or create patterns and movement within a composition. In any successful work of art, the artist has paid careful attention to texture and its effects.

6–10 The music style called "jazz" is very versatile. Here the artist seems to be emphasizing the smooth sound that characterizes some jazz. How does the texture of the painting help create that impression?
Man Ray (1890–1976). *Jazz*, c. 1919. Tempera and ink (aerograph) on paper, 28" x 22" (71.1 x 55.9 cm). Columbus Museum of Art, Ohio: Gift of Ferdinand Howald, ©1999 Man Ray Trust/ARS, New York, NY/ADAGP, Paris.

6–11 Notice the lifelike appearance of this sculpture and of Hanson's *Old Man Dozing* (fig.6–1). Why might an artist want to represent reality so precisely?
Marilyn Ann Levine (b. 1935). *Work Boots*, 1983. Ceramic, right boot: 8 ½" x 11 ¾" x 5 ¾" (21.6 x 29.9 x 14.6 cm); left boot: 9" x 11 ½" x 4 ½" (22.9 x 29.4 x 11.4 cm). O.K. Harris Works of Art, New York.

6–12 Brushstrokes themselves create texture. Here, the artist used broad sweeping strokes. What kind of strokes do you think Vermeer used in *Street in Delft* (fig.6–13)?
Clyfford Still (1904–80). *Untitled R No. 2*, 1947. Oil on canvas, 105" x 92" (266.7 x 233.7 cm). Private collection.

Try it
Cut out a number of implied textures from magazines or newspapers, and fit them together to construct a landscape.

Internet Connection
Students can search for implied texture in computer-generated art by accessing the Visual Arts category from the URL www.yahoo.com/Arts/ and proceeding to view on-line gallery images created using software such as KPT Bryce, RayDream, True-Space, or other 3D rendering programs. (See fig.8–14 for an example of such an image.) Why is the concept of implied texture central to the successful work of computer artists?

Jan Vermeer

Why are most people so fascinated when viewing a painting by Jan Vermeer? Vermeer's talent lay in his ability to transform an ordinary scene—he often painted people doing an everyday task, such as writing a letter—into a poetic and lasting impression. We are drawn into these scenes, often without realizing exactly why they hold such interest.

This sense of mystery is often heightened by visual devices: figures placed behind an object such as a table or chair, or seen through a doorway. Vermeer brings us into the mood of the scene with his great sensitivity to color and light, his skill in using (and subtly altering) perspective to create depth, and his amazing ability to render textures.

Vermeer rarely dated his paintings, but art historians have determined that he mastered the ability to portray textures by the time he was in his thirties. Highly skilled in painting surface appearances, he used a combination of impasto (thickly applied paint) and thin glazes. Whether depicting the sheen of a pearl or the roughness of bricks, he carefully recorded each material's unique texture. The exactness of these implied textures gives an air of great realism to his work.

Son of art dealer, weaver, and innkeeper Reynier Jansz, Jan Vermeer was born in Delft, Holland, in 1632 and lived there until

Jan Vermeer (1632–75). *The Painter and His Model as Clio,* 1665–66. Oil on canvas, 47 ¼" x 39 ⅜" (120 x 100 cm). Detail. Kunsthistorisches Museum, Vienna. Erich Lessing/Art Resource, NY.

6–13 Compare and contrast the many textures that are depicted in this scene.

Jan Vermeer. *Street in Delft,* c. 1658. 21 ⅜" x 17 ⅜" (54.3 x 44 cm). Rijksmuseum, Amsterdam. Art Resource, New York.

his death, in 1675. Nothing is known of his artistic training, and only thirty-eight paintings are firmly attributed to him. When he signed his paintings, Vermeer often used different signatures, or marks, making the art historians' task—to verify certain works as his—more challenging. Nothing is known of his personality. However, he is considered one of the most accomplished painters in art history. We can only guess at the kind of legacy he would have left had he lived longer.

The documents that outline Vermeer's life are those that relate to the history of Delft. Historians know that when he was twenty-one, Vermeer registered as a professional with a painters' guild. He was then also starting out in business, with the art dealership he inherited from his father. Although Vermeer was considered a master painter, no records indicate that he took students. During his lifetime and for almost the next two centuries, his works were not widely known. Then, in the eighteenth century, English painter Sir Joshua Reynolds "discovered" a Vermeer painting in Holland. Reynolds's praise for the work led to worldwide recognition of Vermeer's achievements.

Materials and Techniques

125

Vermeer is noted for the meticulous manner in which he approached his compositions. He often made changes as he painted, and he continually reworked his canvases as he tried to achieve just the right compositional balance. For example, in fig.6–13, *Street in Delft,* Vermeer had originally placed a seated woman doing handiwork at the entrance to the alleyway, where another woman leans over a barrel. However, he removed the seated woman after he had almost finished the painting. Her painted-over form can still be vaguely distinguished with the naked eye when viewing the painting. Had the figure remained, our clear view into the alleyway would have been obstructed. In the final version, we see that each woman and the two children are isolated and framed by an architectural element.

Higher-Order Thinking Skills

Have students find an example of implied rough texture and one of implied smooth texture in a previous chapter. For example, they might choose the grass in Wyeth's *Christina's World* (fig.1–28) and the lipsticks in Rosenquist's *House of Fire* (fig.4–38).

Texture and Light

Because texture is mainly a surface quality, the way that light falls on an object has a definite effect on the readability of the surface: when light hits an object, it strongly defines the texture of the object. If that same object is in shadow or dim light, the surface texture may be reduced or become imperceptible. When the light is right—that is, when it is bright enough and in the best position—the texture becomes active and dominant.

Even in bright light, however, the surface appearance of an object may change, depending on whether the light hits it from above or from an angle. If a rounded surface is lit from above, its texture may be smoothed out on top, strongly evident on the sides, and lost in the shadows below. The late afternoon sun, ideal light for dramatic outdoor photographs, emphasizes the texture of an object and causes strong shadows to be cast.

6–14 Brilliant sunlight and deep shadows often combine to create a heightened sense of texture.
Egyptian Sailboats on the Nile River, Egypt. Photo by A. W. Porter.

6–15 How does the light accent the texture of this wood?
Wood Grain Erosion, from *Driftwood Series.* Photo by J. Scott.

6–16 Here, the artist represented the textures of this engine as they would appear in direct, stark light. We are still able to distinguish the textures, though they are somewhat flatter than they would be if the light were altered by shadow.
Alexander J. Guthrie (b. 1920). *Happy Wanderer,* 1983. Watercolor, 25" x 30" (63.5 x 76 cm). Courtesy of the artist.

An artist might find that bright light is too strong for a highly polished surface: the light bounces off the surface and creates a glare. For surfaces that are smooth or finely textured, an artist might use indirect lighting to bring out their definition and character.

Because light is such a significant element in creating texture, artists sometimes test how materials look in various lighting situations. Before creating an outdoor sculpture, for instance, an artist might explore how shifting natural light will affect the final work. For artwork that will be displayed indoors, an artist might experiment with placement of light sources, which can enhance surface effects and highlight even the finest textures. This kind of critical analysis helps artists achieve the desired results from their designs.

6–17 The late afternoon sun emphasizes the surface detail of this building in historic Jerusalem.
Building in Jerusalem. Photo by L. Nelken.

127

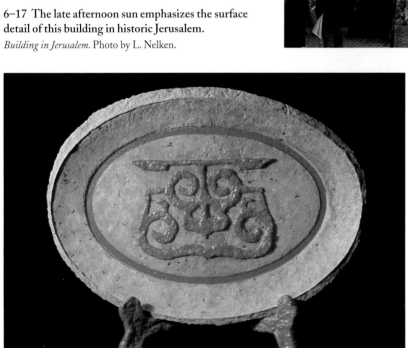

6–18 Note how the lighting in this student work emphasizes the subtleties in its texture.
Lauren DiColli (age 18). *Chinese Platter*, 1997. Handmade paper pulp and found plant materials, 17" x 24" (43.2 x 61 cm). Haverford High School, Havertown, Pennsylvania.

Discuss it

Experiment with light sources to alter the surface appearance of objects with different textures. What happens when a bumpy object is lit from the side, from behind, and from above? What happens to a smooth object or a transparent one? How can you create different textural effects by varying light and shadows?

Context
The Nile River in Egypt is home to a traditional style of sailboat called a *felucca* (fig.6–14). These slender vessels originated with the ancient Carthaginians, who used them for trading. The simple design includes a canopy for protection from Egypt's fierce sun.

Artists and the Use of Texture

Think about all the materials that artists can use to express their ideas: paint, clay, cloth, wood, ink, glass, metal, and stone. Each of these has a unique textural surface. Artists can use these materials and others—alone or in combination—to convey a variety of messages and emotions.

Three-dimensional Art

When artists create three-dimensional works, they usually turn to materials that have real textures. Potters, for instance, commonly use clay. Sculptors and installation artists may explore the uses of plastic, marble, and found objects—including broken plates, driftwood, and used car parts!

6–19 Examine the range of textures in these containers. Which container do you prefer? How did texture influence your choice?

Three clay containers. Student work from Villa Park High School, Villa Park, California.

6–20 Compare the texture of this ceramic with that of the clay container on the far right in fig.6–19. How are they similar? How are they different?

Qing (18th century, China). *Incense burner in bronze form.* Ge ware porcelain with off crackled glaze. 3 ¼" x 4 ⅝" (8.3 x 11.8 cm). Avery Brundage Collection, ©1996 Asian Art Museum of San Francisco. All rights reserved.

Pottery and Ceramics Pottery that has been *thrown*, or made on a wheel, usually has a uniform, smooth surface. But potters also use various tools and procedures to create pronounced textures. They may incise lines or draw into a piece. Before they *fire*, or bake, the clay, they might add glazes to produce a specific finish—smooth or rough, transparent or opaque, marbled or crackled. Some potters deliberately throw salt into the kiln during firing to pit the surface of the pottery and produce a texture similar to that of volcanic rock.

Sculpture Sculptors achieve textural qualities by selecting and combining materials with certain surface attributes. They also use tools to alter those surfaces. They might carve, gouge, sand, or polish the surface of wood. They might alter a metal surface by cutting, welding, rusting, or polishing. For centuries, artists have sculpted marble to simulate the soft folds of fabric and the appearance of human skin and hair. Italian sculptor Desiderio da Settignano, for instance, perfectly captured the smooth flesh of a young child's face (fig.6–21).

Today sculptors explore the potential of plastic and synthetic materials using processes such as vacuum forming and epoxy laminations.

Context
Desiderio (fig.6–21) has been called the greatest sculptor of children. The fluid and luminous nature of his carvings are unrivaled. He blurs the transition from one part of the form to the next, using no sharp edges. Bernini, Rodin, and other sculptors likely studied Desiderio's expert and unique handling of marble.

129

6–21 The soft textures of the child's hair and skin belie the cold, hard qualities of marble.
Desiderio da Settignano (1429/30–64). *A Little Boy*, 1455/60. Marble, 10 ⅜" x 9 ¾" x 5 ⅞" (263 x 247 x 150 cm). Andrew W. Mellon Collection. ©1988 Board of Trustees, National Gallery of Art, Washington, DC.

6–22 The familiar woven texture of basketry is used here to create a lively, tactile sculpture.
Carol Eckert (b. 1945). *Spell of the Green Lizard*, 1995. Cotton and wire, 11 ½" x 7" x 3 ½" (29 x 17.8 x 8.9 cm). Courtesy of the Connell Gallery/Great American Gallery, Atlanta.

Cooperative Learning
Clay Texture Tiles
In Lesson 5 on page 120e, students may work as a whole class or in cooperative-learning groups to make individual tiles of various textures and then mount them together on a large board to create a class "mural." As students decide where each tile will fit into the whole design, ask them to consider how textures look together, and suggest that they might emphasize contrasts in textures.

Performing Arts
The Texture of the Role
Artists can create the illusion of texture through drawing and painting, giving two-dimensional objects a tactile sense. In theater, actors "texture" their interpretation of a role. Voice quality, gestures, bearing, and other characteristics give a unique texture to the performance of every actor. Although hundreds of people have played the role of Shakespeare's Hamlet, each actor gives the young prince an individual twist.

Two-dimensional Art

Most two-dimensional art relies heavily on implied textures, which may be drawn, depicted in paint, or achieved by means of a print process. Textiles, however, may incorporate both implied and real textures.

Drawing and Printmaking In drawings, skillful artists can portray an array of textures—from wrinkles in a face to ripples in a pond. Artists might use charcoal, ink, colored pencils, or pastels to achieve different surface qualities; or they might choose to work on paper that has a smooth or a coarse texture of its own.

Printmaking—which involves transferring an image from a carved or etched surface onto paper—creates additional opportunities for artists. To create implied textures, printmakers might use the grain of a woodcut; the sharp, etched lines of a zinc plate; or the uneven textures of a linoleum block.

6–23 Vija Celmins depicted the texture of the ocean so well that the sound and feel of the ocean are immediately brought to mind.
Vija Celmins (b. 1939). *Ocean: 7 Steps #1*, 1972–73. Graphite on acrylic-sprayed paper, 12 ⅝" x 99 ⅛" (32 x 252 cm). Purchased with funds from Mr. and Mrs. Joshua A. Gollin. Whitney Museum of American Art, New York. Photograph ©1998 Whitney Museum of American Art.

6–23a *Ocean: 7 Steps #1*, detail.

6–24 How has Schmidt-Rottluff incorporated the grain of the wood medium into the image?
Karl Schmidt-Rottluff (1884–1976). *House Behind Trees*, 1911. Woodcut, 8" x 10 ⅜" (20.4 x 26.2 cm). ©British Museum, London.

Context
At age ten, Vija Celmins and her family arrived in the United States from Latvia and settled in Indianapolis. Celmins attended school in California and has been associated with the Los Angeles art scene. Known for her cosmic imagery done in graphite, she uses photographs of the moon, ocean, and desert to create drawings whose surface becomes one with the picture plane. In addition to these drawings, Celmins has done a number of sculptures that have ties to Op art (such as a huge comb at the Los Angeles County Museum of Art). Though these sculptures are very large in scale, they show great attention to surface detail.

Painting Like drawings, some painted images rely heavily on implied textures and the skill of the artist to reproduce them accurately. But painters also achieve textural effects with their materials. Painters might apply the medium thinly or thickly, or they might mix it with wax and other substances. Thick, textured applications of paint create highly energetic forms that almost seem to leave the surface of the canvas. Artists might apply paint with brushes, sponges, or palette knives, or by spraying or dripping. The surface on which they record images may range from finely textured canvas (fig.6–25) to rough burlap to smooth glass or wood.

Textiles Throughout the centuries, artisans and weavers have produced fibers and fabrics with rich textures. Early Egyptian fabrics are still unparalleled and are treasured for their finely woven materials. Museums around the world preserve examples of European tapestries made during the Middle Ages and Renaissance. The striking beauty of woven materials from the South Seas, the Andes, and Guatemala—as well as those crafted by Native Americans—also reflect great skill and inventiveness.

Inquiry
Basket and Textile Weaving
Both basket and textile 131 weavings are rich with textures. Have students research examples of weaving from different cultures. Groups of students might work together to create an exhibit of basket and textile weaving images from Africa, the Southwest United States, Egypt, South America, or Oceania.

6–25 Here, Helen Frankenthaler used such a thin layer of paint that the texture of the very finely woven canvas she chose to use shows through and becomes an important part of the painting.

Helen Frankenthaler (b. 1928). *Small's Paradise,* 1964. Acrylic on canvas, 100" x 93 ¾" (254 x 238 cm). Smithsonian Institution, Washington, DC. Photo National Museum of American Art, Washington, DC/Art Resource, NY. ©Helen Frankenthaler.

6–26 The tight, heavily textured weave of this Navajo saddle blanket contrasts with the looser texture of its fringe and tassles.

Navajo saddle blanket, late 19th century. Germantown yarn, 46" x 37 ½" (116.8 95.3 cm). Smithsonian Institution, Washington, DC. National Museum of the American Indian, Matthew M. Cushing Collection. Presented by Mrs. Nellie I.F. Cushing in his memory. Photo by Katherine Fogden.

Design Extension

Together with students, make a collection of fabric textures. Discuss uses of the various textile textures. For example, a fleece fabric would probably be used for warmth, whereas shiny vinyl or nylon might be used to repel rain or wind. Direct students to use one of the swatches as an inspiration to design an article of clothing. Have them use watercolors or acrylics to paint their clothing design and to try to render the texture of the fabric in their illustration as realistically as possible.

Texture in Your Environment

Each day, you encounter texture, as well as lines, shapes, forms, colors, values, and space. These elements of design are unavoidable aspects of your environment and essential parts of everyday life. They are crucial to interior design and exterior landscaping. And they are significant in the clothes you wear and in the advertisements that sell them.

City planners introduce textures in parks and squares, outdoor sculptures and fountains, and even the surfaces upon which we walk. Sidewalks and parking lots do not have to be great expanses of uninterrupted cement: they might contain textured bricks or other stonework, benches, and lighting fixtures. Even the simple addition of plants, grasses, and trees can provide relief, enjoyment, and visual interest.

Museums, hotels, churches, and temples all integrate texture into their design. Houses and apartment buildings offer many textural opportunities: materials used in carpeting, draperies, furniture, and wall coverings both provide textural variety and enhance our surroundings. Look around and study your environment. You'll discover that textures—and all the other elements of design—are essential aspects of seeing.

6–27 During the course of a day, we encounter so many textures that we usually do not notice them. How many common textures can you see in this image?
Overview of downtown Los Angeles plaza, Los Angeles, California. Photo by J. Selleck.

6–28 A walk outside often lets us appreciate the textures in the natural environment.
Lichen pattern on rock. Rust and yellow. Photo by J. Scott.

133

Antonio Gaudí
Güell Park

How might it feel to own a home in the midst of a city-garden fantasyland? Would you like to live surrounded by the wildly creative shapes, colors, and textures of Gaudí's creation? The plan for this park included sixty houses, a market, a medical center, schools, a chapel, and other facilities. Work began in 1900, and although never completed, Güell Park is one of the best-loved destinations in Barcelona. Under the imaginative direction of architect Antonio Gaudí, enough work was accomplished to provide a magical space in which to dream and play.

There are fountains made of colorful mosaics, a walkway with an arcade of angled trees, fanciful gatehouses, pathways lined with leaning columns, and a monumental staircase flanked by ceramic walls leading to the *Sala de les Cent Columnes*—eighty-six Doric columns supporting a mosaic-tile area decorated with dogs' heads. A giant mosaic dragon is close to the famous bench: its mosaic pieces suggest the dragon's scales. The mosaic bench surrounds the park's "central square" with a series of glistening ceramic curves. From this area is a panoramic view of the city below.

The concept for the bench—believed to be the longest one in the world—was Gaudí's, yet much of the detailed work was executed by artist Josep Jujol. To achieve mosaic tiling of the curved surfaces, traditionally-made flat tiles were broken and organically rejoined. This technique was also used by Gaudí in other artworks. The bench design was so innovative that some art historians see it as a forerunner of the abstract and surrealist movements. In fact, the park was known to be an inspiration for surrealist Salvador Dalí.

6–29 How would the rich texture of these benches strike you in the midst of a park's greenery?
Antonio Gaudí (1852–1916). *Güell Park benches*, 1900–14, Barcelona, Spain. Photo ©1991 Benedikt Taschen Verlag GmbH, Köln. Photo by François René Roland.

Güell Park was funded as an urban-development project by the financier and Barcelona art lover Eusebio Güell. Nearly fifty acres were acquired in a city area that needed renewal, and the site was intended to be a place where architecture was integrated into the natural surroundings. For the job, Güell commissioned Gaudí, who had a liking for nature and was known as an eccentric genius and religious mystic.

When Güell died, which brought a halt to the funding and the work, only two houses had been built. One of them was built as a model to encourage others to build and live there. The house was designed by Gaudí's colleague, Francesc Berenguer, and Gaudí himself lived there from 1906 until shortly before his death in 1926. Gaudí completed his work there by 1914; in 1922, the project was given to Barcelona by Güell's family, for use as city parkland.

Context
The great Spanish architect Antonio Gaudí is best noted for highly imaginative buildings that are organic in form and extraordinary in ornamental detail. Gaudí is most closely associated with his work in Barcelona, which includes Güell Park, Casa Milà, and the unfinished Church of Familia Sagrada.

Interdisciplinary Connection
Biology/Psychology— **Some parts of the body perceive textures more acutely than others. For instance, the fingers have a finer sense of touch than the back. Assign students to research in either a biology or psychology book how humans perceive textures. Have them make a poster that shows the path that nerve impulses travel from the fingers to the brain.**

Portfolio Tip
Students should include realistic, detailed renderings of both smooth and rough textures in their portfolios. These might be drawings or paintings of objects, people, or animals. For three-dimensional and large artworks, photograph the pieces against a neutral background in light that is bright enough and at a suitable angle to show the surface texture of the art. To feature a piece's interesting texture, photograph a close-up view.

Another Look at Texture

6–30 Using terms from this chapter, describe the texture of this belt.

Guatemala, *Woven belt*, 1972. Cotton, 83 ⅞" long (213 cm). Photo by Allan Koss.

Higher-Order Thinking Skills

Ask students to imagine being a curator for an exhibit for the visually impaired. (Some museums have such an exhibit.) They should consider which art elements would be most important as they make selections of artwork for this exhibit. Have students choose three images from this book and explain why each work would be appropriate for the exhibit.

6–31 Imagine running your fingers along this fly whisk from one end to the other. Write a description of the textural journey your fingers would take.

Austral Islands (Tubuaï). *Fly whisk*. Wood, plant fiber, feathers, and mother-of-pearl, 35" high (89 cm). ©1998 Peabody Museum of Natural History, Yale University, New Haven, Connecticut.

6–32 How has this student communicated the texture of a sunflower?

Rachel Shuman (age 17). *Flower of the Sun*, 1998. Acrylic, 15 ½" x 6 ½" (39.4 x 16.5 cm). Holliston High School, Holliston, Massachusetts.

Context

As a young boy, Audubon (fig.6–34) was fascinated with birds. As an adult, he took upon himself the task of documenting all of the known birds of North America. He traveled throughout the country, traversing the wilderness in order to record as many birds as possible. Oddly, Audubon could find no American willing to publish his compendium. He crossed the ocean in order to find an interested publisher. In Europe, he found immediate acclaim. Today, even more ironically, his name and ornithological depictions are familiar to most Americans. The National Audubon Society continues to champion Audubon's concern for the preservation of wildlife.

6–33 Note that this piece is made of metal, not fiber. How does your impression of the piece change when you realize it is not a typical basket? What other contrasts in texture does the artist use?

Ken Carlson (b. 1945). *Porcupine Basket*, 1993. Copper, woven and oxidized, 10" x 9 ½" (25.4 x 24.1 cm). White House Collection of American Crafts. ©1995 Harry N. Abrams, Inc. Photo by John Bigelow Taylor, New York.

6–34 This image is one of a series of prints of the birds of North America. Why is texture a vital element in a depiction such as this?

John James Audubon (1785–1851). *Common Merganser (Goosander)*, 1832. Hand-colored engraving from *Birds of America*. ©Abbeville Press Publishers, New York. Collection of the New York Historical Society.

Interdisciplinary Connection

Geology/Earth Science—Have students research in a geology book the scientific symbols for rocks such as sandstone, breccia, and folded schist. Discuss how these symbols relate to the actual texture of each rock. Encourage students to use these symbols in a painting or drawing of a cutaway view of earth strata in an imaginary landscape. Students might use these designs to make mosaics.

Review Questions (answers can be found on page 120g)

1. To what does the art element *texture* refer?

2. What is the difference between real and implied texture?

3. Explain why light is important to how people see texture.

4. What are some methods that artists use to create real textures?

5. Identify and describe three different textures in your environment.

6. Describe an example of implied texture from the images in this chapter.

7. What type of subjects did Vermeer often paint? How did he add a sense of mystery or intrigue to his subjects?

8. What material did Gaudí use to create a colorful texture on the bench in *Güell Park*, Barcelona?

Career Portfolio

Interview with a Weaver

Drawing from her Native American (Tlingit) heritage, **Clarissa Hudson** makes one-of-a-kind ceremonial robes. Some are traditional Chilkat woven robes like the one on page 150. Some, such as the robe on this page, are hand-stitched. Like other artwork meant to be worn and touched, texture is an important consideration in these robes. Born in Juneau, Alaska, Clarissa lives and works at her home in Pagosa Springs, Colorado.

Tell me about the "Eagle" robe.

Clarissa In the 1800s, when the first navy ships came to Alaska, the native people saw the wool navy blankets, and they traded furs for those. They saw how they could use them for ceremony, for some of their robes. They also saw the mother-of-pearl buttons that were on the clothing of the men on these navy ships. The buttons were mother-of-pearl with steel shanks—steel loops that came down off the back of the buttons. The shanks were pushed through the thick wool, and leather strips were used to hold the robe in place. You can always tell the very old

The eagle design in this robe is made entirely of mother-of-pearl buttons— about 800 of them! The edging is appliquéd work, cut-out wool that has been sewn to the main body.

Clarissa Lampe Hudson. *Eagle Robe*, 1988. 100% woven blanket-weight wool, two nickel metal faces (in the eyes), mother-of-pearl buttons, 5' x 6' (1.5 x 2m). Now part of the Native art collection of the Tlingit and Haida Central Council in Juneau, Alaska.

robes—that were done in the 1800s—because they had those steel shanks. You cannot buy these steel-shank buttons through a retail store any more, but sometimes you may come across them at an antique store or through a trader. I use mother-of-pearl buttons, that I get from a button company in Iowa.

How long does it take to make a robe?

Clarissa The appliquéd ones take about a month. The Chilkat woven robes take at least a year, a year to two years. Traditionally, they were made from thin strips of cedar bark and mountain goat wool. We now use New Zealand's merino wool because it is the closest thing, and the only thing that will work with the cedar bark. The bark is collected at a certain time of year and broken down into very thin little strips. When you soak it, it becomes very silky. As in knitting or crocheting, there is a specific fingering. We don't use a shuttle; it's all two-strand twining of two warp threads at a time. That's why a whole robe will take a year to make.

The woman who taught me how to weave had made fifty robes and

about twenty-five tunics. Her name was Jennie Thlunaut. She made seventy-five major garments in her lifetime, which was ninety-six years. Her speed, accuracy, and tension were superb and graceful because of her fingering. In watching Jennie weave, I was inspired by her grace and compelled to weave. She entrusted me with her knowledge and her skills, entrusted me to carry on the tradition. I apprenticed with her for a couple of months in 1986, and then she passed away about a month later.

Given the work that goes into them, the robes must be very expensive.

Clarissa For the appliquéd, button-blanket robes: I sold one for $350, and the most I have sold one for is $6,000. The woven ones—the Chilkat or raven's-tail robes that take a year or two to make—those go anywhere from $15,000 to $30,000.

Do you use traditional designs?

Clarissa Yes and no. My robes are usually based in personal experiences, visions, and dreams, interpretations of humankind; this is where the robe designs are not traditional. But, they have the look of traditional design because I stick to the form line art, the traditional art form. Traditionally, what you put on a robe is your clan crest—eagle clan, raven clan, killer whale clan—or an image of a story or clan history.

Studio Experience
Coiled Baskets

Task: To create a basket using the coiling technique.

Take a look. Look at the contemporary coiled sculptures of Carol Eckert, an example of which is shown in fig.6–22. You may also want to research Native American baskets. Can you tell how each kind of art was made?

Think about it.

- Texture can range from smooth to rough, flat to nubby. Think of various materials and the textures you could create from them.
- What did Native Americans do to create textural qualities in their baskets?
- What found objects could you use to decorate a basket?

Do it.

1 Read through steps 2–7, below, for how to make a coiled basket of rope and yarn. Then make a small practice sample. Try to enclose one or more found objects in your sample. When you feel that you understand the process, think about the textural look and shape you want for your actual basket. Decide on what found objects you will use to create texture.

2 Cut your core material (the rope) about 2–3' long. Taper one end by making a diagonal cut. To start the base of the basket, overlap the ends of the rope core and wrapping material (the yarn). If you are right-handed, hold the rope with your left hand and wrap with your right hand. Do the reverse if you are left-handed.

3 Wrap the rope core for about 1 ½", spacing the

yarn wraps about ¼" apart.

4 Fold the tapered end of the rope core back on itself, making the smallest hole possible. This forms the start of a base for your basket.

5 Now thread the yarn into a large, blunt needle. Again fold the rope core back on itself and join the core to the base with a wrapping stitch. To do this, wrap the new core twice, then bring the needle around the wrapped core and through the hole two times. Pull the yarn tight enough to hold the coils close together. Continue wrapping the core twice and then connecting it to the previous coil until the diameter of the base measures 5" or whatever other dimension you choose.

6 To start making the sides of the basket, hold the core on top of the previous row. Use the wrapping stitch to attach the first side row to the base. As you attach the core row upon row, the sides gradually take shape. To make the opening more narrow, place the new core inward, toward the center of the base; to make the opening larger, place the core outward, toward the outside of the base. If you wish, thread through

beads, buttons, or other objects to attach them to your basket as you wrap.

7 If your length of core is about to run out, work until 1" remains. Then cut the core on a diagonal. Hold together the tapered end of the core with the tapered end of the new core. Lightly tape around both; then wrap as usual. If your yarn is about to run out, leave 6" remaining. Lay the end of the new wrap along the core. Make a stitch or two around the core over the new wrap to secure it. Thread the needle with the new wrap. Wrap over the remaining old yarn and the core while making the next stitch.

8 To finish your basket, work the last row until you are within 2" or 3" of the place where you first started shaping the sides. Taper the end of the core, as in step 2. Continue to wrap and attach the core to the previous row, stitching a bit beyond where the tapered core ends. Take the needle and weave it through the wrap to bury the thread. You may have to change to a smaller needle if the wrap is tight. Cut off the remaining wrap.

Check it.

- What part of your basket concept was original and creative?
- How did you use found objects? Do they effectively create more texture?
- What might you do differently the next time you create a basket?

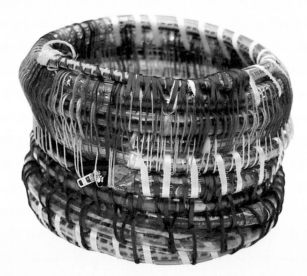

"I learned that incorporating many different materials with contrasting properties can create very interesting and appealing textures."

Brooke Erin Goldstein (age 16). *Invention Basket*, 1997. Bungie cord, plastic tubing (stuffed with batteries, beads, nuts, and bolts), yarn, ribbon, and embroidery thread, 5 ½" high (14 cm); 8" diameter (20.3 cm). Clarkstown High School North, New City, New York.

Studio Experience

Coiled Baskets

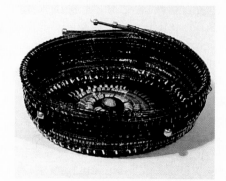

Loren Margelefsky (age 16). *Radiant Spiral*, 1997. Cable tubing and ribbon, 4 ½" high; 9" diameter (11.4; 22.9 cm). Clarkstown High School North, New City, New York.

Prepare

Time Needed:
Three 45-minute periods to teach the techniques and practice; students finish the basket at home. If the entire project is to be done in class, five or more 45-minute periods will be needed, depending on the size of the basket.

Objectives
Students should be able to

- Create a coiled basket that incorporates strong textural qualities.

- Identify the fiber work of contemporary artists, as well as that of Native Americans.

Vocabulary
Review glossary definitions of these words with students.
- base
- core
- wrap

Materials
- core material: any flexible rope, clothesline, coiling core, paper rush
- wrapping material: yarn, raffia
- large blunt tapestry needles
- scissors
- found objects (buttons, shells, feathers, etc.)
- masking tape

Notes on Materials
- The easiest wrap to use for a coiled basket is one that is strong and flexible, such as cotton clothesline rope. Strong yarn is the best wrap for beginners.

- Coiled baskets can be made with a variety of materials having an array of textures. Raffia gives a nice effect but can be difficult to use. If students use raffia, instruct them to soak it in warm water at least five or ten minutes, or until it looks transparent. The raffia then must be kept moist in a damp towel. Presoaked strands may also be kept in a small plastic bag (for no more than a week, or strands may mildew).

- If students use 3/32"-size paper rush for the core, have them use three strands together.

Teach

Thinking Critically
- Discuss the way Carol Eckert used the coiling technique to create figures in her sculptural work (fig.6–22). Describe the textural quality she has incorporated into her design.

- Ask students to compare the work of Eckert with traditional coiled-basket artworks. Are the textures similar or different? What variations in texture can you find in the traditional pieces?

Classroom Management
- Make visual aids: enlarge diagrams on a copy machine.

- Demonstrate the beginning of the base to small groups of students. Repeat the demonstration several times while also referring students to the visual aids.

Tips

Wrapping Variations

For students to create a variety of textural surfaces, instruct them in the use of different stitches to join the coil.

Pebble weave:

After wrapping two rows together, wrap horizontally around the stitch connecting the two cores. This creates a wider opening between rows.

Wigwam weave:

Make one wrap slightly to the right; then another wrap slightly to the left. Follow with a horizontal wrap, as in the pebble weave.

Figure eight:

To achieve a smooth effect and show no joining stitch, a figure eight stitch creates a tight, neat attachment of coils. Wrap between the core of the new row and the previous row, making the stitch follow the direction of a figure eight.

Free style:

Suggest other variations to students.

- Add a bead while making the vertical wrapping stitch; the bead will sit between the two cores.

- Wrap around feathers or other objects when joining rows.

Cooperative Learning

If any students are having difficulty, suggest that they watch other students who have begun to understand the technique of coiling. Students may work this way until you can help them individually.

Assess

Evaluation

Ask students to evaluate their basket by writing the answers to the questions in **Check it**. Review their responses, and discuss any disagreement. Both you and the student should evaluate the emphasis of texture as a design element.

Extend

Tie-ins to Other Design Elements and Principles

Shape and Form

Tell students that a basket maker takes control of the basket's elements and visualizes the anticipated form. For instance, when sewing a coiled basket, especially the sides, the artist must hold the core element consistently in order to achieve uniform sides. A basket does not shape itself—the artist shapes it, choosing from among many container forms.

Pattern

Instruct students to design a repeat pattern by using a variety of colored materials or by adding found or bought (natural or manufactured) objects.

Interdisciplinary Connections

Biology

Ask students to research what plants and animals are and were used by Native Americans in making baskets. For instance, the Tlingit of Alaska use the boiled juice of blueberries for a purple dye. Others once used animal sinew and teeth, feathers, porcupine quills, shells, and insect wings.

Resources

Hart, Carol, and Dan Hart. *Natural Basketry.* NY: Watson Guptill Publications, 1978.

James, George Wharton. *Indian Basketry and How to Make Baskets.* Glorieta, NM: The Rio Grande Press, Inc., 1970.

Mason, Otis T. *American Indian Basketry.* NY: Dover Publications, Inc., 1988.

Rowe, Ann Pollard and Rebecca Stevens, ed. *Ed Rossbach: 40 Years of Exploration and Innovation in Fiber Arts.* Asheville, NC: Lark Books, 1990.

Part Two: The Principles of Design

To help them combine the elements of design effectively, artists and designers follow certain guidelines, or principles. The principles of design are balance, unity, contrast, emphasis, pattern, movement, and rhythm. When used properly, these principles organize the parts of a design so that an artwork clearly communicates an artist's message or intention. They are used in all media—from painting to architecture to clothing design.

These principles are not binding, but are there to help you make choices: you may study, modify, or juggle them as you wish. You might think of them as recipes that have worked for a long time for many people. Like the elements of design, these principles are rarely used separately. Although one of them may be more obvious in a particular design, it usually will be supported by others. There are many ways to combine the principles; artists sometimes even deliberately ignore or distort them.

The six chapters of Part Two define the principles separately and contain images to explain each one. (As in Part One, the images are from both nature and the arts.) Balance, for example, might involve pairing an extended arm and an outstretched leg in a sculpture of the human figure. Or it may mean contrasting certain colors in a painting. Once you understand these principles, you will likely begin to notice them in your environment—and your increased understanding of how artworks are put together will help you become a more sensitive viewer and a more skillful designer.

In this work, there is a great variety of pattern. By creating a contrast rather than a harmony of pattern, the artist sought to communicate all the patterns that make up the memories of her childhood.

Ilisha Helfman (b. 1957). *The House I Keep in Mind,* from *Memories of Childhood*, 1994. Photoshop collage, 24" x 24" (61 x 61 cm). Courtesy of the artist and the Steinbaum Krauss Gallery, New York.

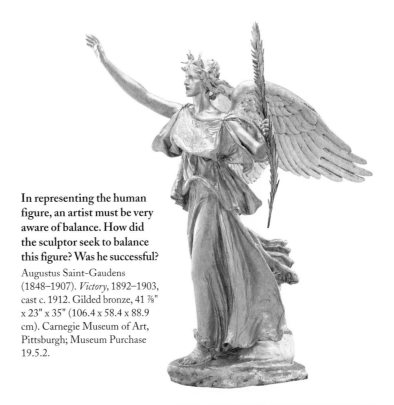

In representing the human figure, an artist must be very aware of balance. How did the sculptor seek to balance this figure? Was he successful?

Augustus Saint-Gaudens (1848–1907). *Victory*, 1892–1903, cast c. 1912. Gilded bronze, 41 ⅞" x 23" x 35" (106.4 x 58.4 x 88.9 cm). Carnegie Museum of Art, Pittsburgh; Museum Purchase 19.5.2.

Use your knowledge of color to analyze how Green created contrast in this painting.

Jonathan Green (20th cent). *Family Fishing*, 1989. Acrylic on canvas, 48" x 36". (121.9 x 91.4 cm). Collection of John and Barbara Langston. Photo by Tim Stamm.

Notice how Biggers used white both to unify this painting and to move our eye through the composition.

John Biggers (b. 1924). *Jubilee: Ghana Harvest Festival*, 1959-63. Tempera and acrylic on canvas, 38 ⅜" x 98" (97.5 x 248.9 cm). The Museum of Fine Arts, Houston. Museum Purchase with funds provided by Panhandle Eastern Corporation.

Artists sometimes use simplicity of design to emphasize a certain aspect of an artwork. What did the artist want to emphasize in this piece?

Human head effigy bottle, 1400–1650 (Late Mississippian culture/Nodena). Earthenware (Carson red on buff), 6 ⅛" x 7 ¼" (15.6 x 18.5). National Museum of the American Indian, Smithsonian Institution, Washington, DC. Photo by Bernard Palais.

Chapter 7 Organizer

Balance

Chapter Overview

- The art principle balance has to do with how various parts of a design relate to one another.

Objective: Students will identify symmetrical balance, approximate symmetry, asymmetrical balance, and radial balance in artworks and in their environment. (Art criticism)

National Standards: 3. Students will choose and evaluate a range of subject matter, symbols, and ideas. (3b)

Objective: Students will create artworks using various types of symmetrical and asymmetrical balance. (Art production)

National Standards: 1. Students will understand and apply media, techniques, processes. **2.** Students will use knowledge of structures and functions. (1b, 2c)

8 Weeks	1 Semester	2 Semesters			Student Book Features
1	1	1	**Lesson 1:** Symmetrical Balance	Chapter Opener Symmetrical Balance	Try it: experiment, About the Artwork
0	0	1	**Lesson 2:** Approximate Symmetry, Asymmetrical Balance	Approximate Symmetry, Asymmetrical Balance	Note it, Try it: experiment, About the Artist
0	0	2	**Lesson 3:** Asymmetrical Balance	Asymmetrical Balance	Try it: mobile
0	0	1	**Lesson 4:** Radial Balance	Radial Balance	Note it
1	1	1	**Chapter Review**	Another Look at Balance	Review Questions
2	3	3			

Studio Experience: *Balance in Nature*

Objectives: Students will identify symmetrical, asymmetrical, and radial balance in artworks; demonstrate their understanding of compositional balance by drawing a symmetrical object and creating a painting with either symmetrical or asymmetrical compositional balance.

National Standard: Students will evaluate artworks' effectiveness in terms of organizational structures and functions (2b); create art using organizational structures and functions to solve art problems (2c).

To create balance in their compositions, artists use the elements of design, such as space, shape, and color.

- Four important types of visual balance are symmetrical balance, approximate symmetry, asymmetrical balance, and radial balance.

Objective: Students will perceive and understand how artists from various cultures including India, Pueblo, medieval Europe and twentieth-century Europe have created balance in their artworks. (Art history/cultures)
National Standards: 4. Students will understand art in relation to history and cultures. (4e)

Objective: Students will appreciate the mood, feel, or dynamic energy that balance generates within artworks and the environment. (Aesthetics)
National Standards: 5. Students will reflect on and assess characteristics and merits of artworks. (5c)

Teacher Edition References	Ancillaries
Warm-up, HOTS, Context, Performing Arts	Slides: *Kouros from Anavysos* (B-1); Turkey, *Ahmet Mosque* (B-2)
Design Extension, Context, Inquiry, Performing Arts, Internet Connection	*Slides*: Malo, *Hopi Kachina* (B-3); *Chinese Mandarin Coat* (B-4); Henry Ossawa Tanner, *Palais de Justice, Tangier* (B-5) *Large Reproduction*: Ter Doest Cistercian abbey barn
Design Extension, Context, Inquiry, Internet Connection	*Large Reproduction:* Albrecht Dürer, *The Mills on the River Pegnitz*
Design Extension, HOTS, Context, Cooperative Learning, Materials and Techniques, Interdisciplinary Connection	Slide: Hannah Barnet, *Cloth, Cow's Eye pattern* (B-6)
Design Extension, Context, Portfolio Tip, Interdisciplinary Connection	

Vocabulary

approximate symmetry The organization of the parts of a composition such that each side of a vertical axis contains similar, but not identical, shapes or forms. *(simetría)*

asymmetrical balance The organization of the parts of a composition such that the sides of a vertical axis are visually equal without being identical. *(asimétrico)*

radial balance A composition that is based on a circle, with the design radiating from a central point. *(equilibrio radial)*

symmetrical balance The organization of the parts of a composition such that each side of a vertical axis mirrors the other. *(equilibrio simétrico)*

Time Needed
Three 45-minute class periods.
Lesson 1: Draw;
Lesson 2: Compose the painting and enlarge the drawing;
Lesson 3: Paint.

Studio Resource Binder
7.1 Coiled Clay Pot
7.2 Kaleidoscope Shield Design
7.3 Balance within African Masks, papier-mâché
7.4 Pennsylvania Dutch Hex Sign Banner, felt appliqué
7.5 Postage Stamp Design

Lesson 1
Symmetrical Balance

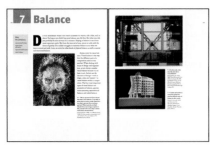

pages 140–141

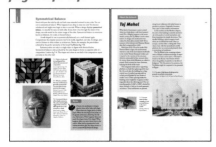

pages 142–143

Objectives

Students will be able to

- Differentiate between physical and visual balance.

- Understand that artists consider visual balance when they compose an artwork.

- Identify symmetrical balance in artworks and other objects.

- Experiment with visual balance as they create a paper collage.

Chapter Opener

- Explain that artists work not just with physical balance: they also often work with perceived balance. Similar to balancing the two pencils in the Chapter Warm-up, artists manipulate elements such as space, shape, and color to create a *sense* of balance.

- Ask students to note the balance in the images on pages 140–141, and to imagine dividing each composition in half with a vertical line. Discuss which composition would appear the same on both halves. (Chuck Close's *Lucas Woodcut,* fig.7–1).

Teach

- Focus on pages 142–143. Ask students to compare the symmetry in the *Portland Public Services Building* (fig.7–5) to that in *Nationale-Nederlanden Building* (fig.7–3).

- After students have read the description of the Taj Mahal (fig.7–8), lead them in discussing its history and design. Ask: What type of symmetry is used in its design? What elements are symmetrical? Where is it located? What is an iwan? Identify the iwans in this structure. Why was it built? Compare this tomb to local markers or monuments.

- Point out to students the symmetry in the Senufo *Mask* (fig.7–6). The Senufo and Baule people live in the Ivory Coast, Africa. Encourage students to verbalize how the human features of this mask have been simplified. Explain that Picasso was inspired by the African tradition of simplifying forms as he developed Cubism.

- Lead students in the **Try it** experience on page 142. Stress the importance of trying many arrangements before gluing down a composition. After students have completed their collage, encourage them to explain the balance in their composition to the rest of the class.

Try it	page 142

Materials

- 8 1/2" x 11" or 9" x 12" white paper
- scraps of colored papers
- scissors
- glue

Lesson 2
Approximate Symmetry, Asymmetrical Balance

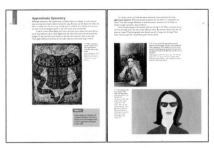

pages 144–145

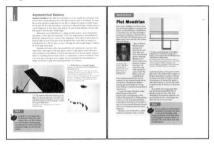

pages 146–147

Objectives
Students will be able to

- Recognize approximate symmetry and asymmetrical balance, and understand why artists would choose to use these types of balance.

- Experiment with physical asymmetrical balance.

Teach:
Approximate Symmetry

- After students have read the first three paragraphs, ask what the difference is between *symmetry* and *approximate symmetry*. (The two sides of a composition with approximate symmetry are almost alike, but varied; whereas with symmetrical balance, both sides are identical.)

- When students have answered the questions in the last paragraph about *Elinor Glyn* (fig.7–10), ask how the two halves of *Borderjacket* (fig.7–9) and *Ada in Aqua* (fig.7–11) are different.

- Explain that *Ada in Aqua* is a portrait of Alex Katz's wife. Point out how Katz has added impact to the composition of this work by isolating the oversized head. Remind students of popular media photographic composition—movies, magazines, and billboards. Often heads in these formats fill the whole screen or picture plane. Students might hypothesize about Katz's goal in painting a portrait like this. He has said that he wanted to create a big, flat, elegant style.

- For **Note it** on page 144, have pairs of students select an example of approximate symmetry and discuss their choice with the rest of the class.

Teach:
Asymmetrical Balance

- Explain that in an asymmetrically balanced composition, the focal point is not centered but is to one side. Ask students to locate a focal point in each of the images on pages 146–147.

- Call on students to recall any experiences they might have had with seesaws. Did a bigger person ever sit on the opposite end from them? Did they pair up with another child to balance the bigger person? What happened when they moved closer to the center of the seesaw? Lead students in experimenting with balancing weights such as paper clips and erasers on a ruler, as described in **Try it** on page 147.

- Assign students to read the information about Mondrian, and then describe how he developed his mature grid style. As students list the various art styles that he studied, point out examples of these in the text. (Realism, Chardin [fig.3–3], Impressionism, Monet [fig.2–32] and Seurat [fig.4–23], Post-Impressionism, Van Gogh [fig.1–9], and Cubism, Picasso [fig.5–36]).

 Ask: What was Mondrian trying to show and create in his paintings? (As Mondrian worked in the De Stijl style, he was striving to achieve perfect, harmonious compositions, devoid of anything extraneous.) Encourage students to remember architects from past chapters who shared this "less is more" philosophy. Refer them to fig.5–10, Philip Johnson's *Glass House*. Ask students to find similarities between Johnson's and Mondrian's style. Ask if students remember seeing buildings that might show evidence of Mondrian's influence. Many school buildings from 1950s and 1960s are metal and glass grids with bright colored panels.

Try it page 147

Materials
- rulers
- erasers, paper clips, or other small objects to use as weights

140d

Lesson 3
Asymmetrical Balance

pages 146–147

Objectives
Students will be able to

- Perceive how Alexander Calder achieved both physical and visual balance in his mobile sculpture.

- Create a physically and visually balanced mobile with a variety of shapes, forms, and colors.

Teach

- Discuss how Alexander Calder achieved balance in his mobile. Ask students which shapes and colors are repeated. Have them do **Try it** on page 146. Students might make the mobiles from colored paper, cardboard, or recycled objects, using string, yarn, or thin wire to suspend shapes and forms. A stick or coat hanger may be used as the top support. If possible, students should have a place to hang the sculptures as they work and then to display them. If students need more time to complete this project, either extend the lesson for another class period or encourage the students to work outside of class.

- Engage students in considering similarities of style in Calder and Mondrian's art. They should notice the simplification of shapes in both artists' works.

- Recount how Calder's mobiles and stabiles got their names. (See **Context** on page 146.) Brainstorm with students about other mobiles with which they are familiar—these could be anything from large community sculptures to children's crib toys.

- For the next lesson, assign students to read pages 148–149 and bring to class a radially balanced natural object such as a flower, sand dollar, sea-urchin shell, or seedpod.

Try it page 146

Materials
- coat hangers or sticks
- colored papers, cardboard, or recycled small objects
- string, yarn, or thin wire
- scissors
- straightedges
- wire cutters

Lesson 4
Radial Balance

pages 148–149

Objectives
Students will be able to

- Perceive and identify radial balance in art and in the environment.

- Sketch radially balanced objects.

Teach

- Focus on pages 148–149, and call on students to name other objects with radial balance. (clock faces, the iris of the eye) Ask them to review Chuck Close's *Lucas Woodcut* (fig.7–1) and decide if the work is radially balanced.

- As students study fig.7–17, the plate made by Maria Martinez, explain that Martinez is considered by some

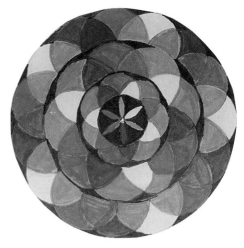

Cory Longhauser (age 14). *Wheel of colors*, 1998. Marker, color pencil, and tempera, 12" diameter (30.5 cm). Manson Northwest Webster Community School, Barnum, Iowa.

to be the most famous Native American artist of the twentieth century. Archaeological discoveries in Frijoles Canyon, near her home in the San Ildefonso Pueblo in New Mexico, led her to rediscover the ancient tradition of burnished black wares. She developed this black-on-black pottery in conjunction with Julian Martinez, her husband. Their son and other local artists have continued to revive and expand this technique of ancient origin.

- Have students do **Note it** on page 148.

- Direct students to create a display or still life of the radially balanced natural objects that they brought to class, and then to sketch the display.

Note it page 148

Materials
- 8 1/2" x 11" or 9" x 12" white paper, or sketchbooks
- pencils

- Call students' attention to the radial balance of the rose window from Angers, France (fig.7–15). If they look closely, they may see that although the main shapes are the same, the designs within the medallions vary. The thicker dark lines are stone supports, while the very thin lines within these are made of lead and hold the individual pieces of cut glass in place. Because so many of the worshippers were illiterate, these windows depicting Christian symbols and stories served an educational purpose. In an age lit only by candles and torches, huge windows such as this allowed colored, seemingly mystical light to bathe the dark cathedral interior.

Julia Ries (age 16). *Pinks and Greens,* 1996. Acrylic, 30" x 30" (76 x 76 cm). Palisades High School, Kintnersville, Pennsylvania.

Computer Connection

Compare and contrast symmetrical and asymmetrical balance using a drawing or painting program. Instruct students to create six different shapes with the line tool, oval tool, rectangle tool, and/or polygon tool and arrange the shapes on one-half of their computer screen. They may use a variety of colors or values to fill the shapes. Guide students to create a symmetrical design by selecting, copying, and flipping the entire design horizontally onto the other half of the screen. Save and print the document. Students can then create a new document with asymmetrical design by rearranging the shapes. If necessary, shapes can be resized to create enough "weight" to balance the new design. Use printed examples of the students' designs to involve the class in a discussion of the characteristics of symmetrical and asymmetrical balance.

Chapter Review

pages 150–151

Assess

• Assign students to write the answers to the review questions. Go over the answers to these questions with the class to determine that they can identify symmetrical balance, approximate symmetry, asymmetrical balance, and radial balance in artworks and in their environment.

• Review with each student his or her portfolio of artwork created in this chapter to ascertain that they created artworks using various types of symmetrical and asymmetrical balance. **(Art production)**

• To determine that students developed an appreciation for the mood, feel, or dynamic energy that balance generates within artworks, assign them to write a comparison of these qualities created by balance. They should focus their comparison on two artworks in this chapter which exhibit different types of balance. **(Aesthetics)**

• In order to evaluate the students' perception and understanding about how artists from various cultures including India, Pueblo, medieval Europe and twentieth-century Europe have created balance in their artworks, assign students to describe either in writing or in a class discussion the type of balance and feeling of stability that this balance creates in fig.7–8, the *Taj Mahal*; fig.7–14, Mondrian's *Composition with Blue and Yellow*; fig.7–17, Maria Martinez's *Plate*; and fig.7–15, *Cathedral rose window*. They should identify the culture or style of each piece in their discussion. **(Art history/cultures)**

Reteach

• Write *symmetrical balance, approximate symmetry, asymmetrical balance,* and *radial balance* on the board. Remind students that in symmetrically balanced compositions, both sides of the design are the same, whereas in designs with approximate symmetry, the halves are similar but not identical. Ask students to select an example of symmetrical balance and approximate symmetry from the images on pages 150–151. The Chilkat *Polychrome Shoulder Robe* (fig.7–19) is a good example of bilateral symmetrical balance, whereas Bravo's *Before the Game* (fig.7–20) demonstrates approximate symmetry.

• Students should notice the ovoid shapes with rounded corners and the black form lines in the *Polychrome Shoulder Robe* (fig.7–22) which are both often found in designs of Native Americans of the Pacific Northwest. What birds and animals do students recognize in this artwork?

• Divide the class into cooperative-learning groups of four or five students to find another example of each type of symmetry in the text. Write the titles of these images on a chart, and then direct the groups to arrange themselves into tableaux that illustrate each type of symmetry. One student may be the director, another the chart-maker, another the narrator to explain the tableaux to the class, and another the photographer to record the tableaux on film. Suggest that they get ideas for arrangements from images in the text, or, perhaps, specifically the images on the chart. Have the groups demonstrate their human-form compositions to the rest of the class. You might have the rest of the class sketch one of each group's tableaux.

Answers to Review Questions

1 Visual balance is the way that the different parts of a composition relate to one another.

2 Four significant types of visual balance are symmetrical balance, approximate symmetry, asymmetrical balance, and radial balance.

3 The halves of the symmetrically balanced design mirror each other.

4 In approximate symmetry, both sides of the design are almost symmetrical, but not quite.

5 Both approximate symmetry and asymmetry can break the possible monotony of a symmetrically balanced composition. Also, asymmetry can produce a sense of excitement and interest often not found in symmetrical designs.

Jacqueline Sansone (age 15). *Kaleidoscope*, 1997. Paper tiles and tempera, 15½" x 15½" (39.4 x 39.4 cm). Clarkstown High School North, New City, New York.

6 The Taj Mahal in Agra, India, exhibits symmetrical balance. It was built as a tomb. An iwan is a vaulted opening with an arched portal. There is a large central iwan with two stories of iwans on each side.

7 Experiments in Cubism led Mondrian to focus on De Stijl. He restricted himself to a palette of neutrals and primary colors, to vertical and horizontal lines, and to square or rectangular shapes.

Meeting Individual Needs

Students Acquiring English

The key vocabulary is particularly difficult. Say and write each term on the board so that students can match what they hear with the written form. To verify their comprehension, have students make four mask designs from cut paper shapes, each design illustrating one of the four types of balance. Ask students to describe the process they used to create each design.

Students with Special Needs

ADD
Design activities so that you can directly measure performance by observable behaviors as students complete sequential tasks. For example: Task 1: Students will identify certain shapes; Task 2: Students will be able to cut out the shapes; Task 3: Students will arrange the shapes into symmetrical designs: Task 4: Students will paste the arranged shapes onto paper.

Gifted and Talented

Have students refer to the Taj Mahal as an example of symmetrical design and then design their own symmetrical building. Challenge students to define the purpose of their structure and create floor plans and exterior drawings of the structure.

7 Balance

Key Vocabulary

symmetrical balance
approximate symmetry
asymmetrical balance
radial balance

Chapter Warm-up

• To introduce students to the principle of physical balance, have them try crossing two pencils and balancing one on the other. (Use regular six-sided pencils.) Lead students in a discussion about the difference between the physical balance point and the visual balance point.

• Encourage students to discover similarities between the photorealism of Richard Estes's *Eiffel Tower Restaurant,* fig.7–2, and that in fig.6–16, Guthrie's *Happy Wanderer.* They should notice the balance, point of view, style, and texture.

DO YOU REMEMBER WHEN YOU FIRST LEARNED TO SKATE, ride a bike, surf, or dance? As long as you didn't lose your balance, you felt fine. But when you did, you probably became nervous for a moment. Staying in balance is one of our most important needs. But from the time we're born, we are at odds with the forces of gravity. Our earliest struggles to maintain balance occur when we learn to stand and walk. Later, we strive for other kinds of physical balance, as well as mental and emotional balance.

Artists strive for visual balance. Visual balance is the way that the different parts of a composition relate to one another. When dealing with issues of design and organization, artists always consider visual balance because it is so basic to art. Artists use the elements of design—such as shape, color, and texture—to create balance within a composition. The four most important types of visual balance are symmetrical balance, approximate symmetry, asymmetrical balance, and radial balance.

7–1 This is a portrait of Close's friend the artist Lucas Samaras. Generally, an artist tries to convey certain characteristics about a person when creating a portrait. What traits do you think Chuck Close was trying to capture in this portrait? How does Close communicate these characteristics?

Chuck Close (b. 1940). *Lucas Woodcut,* detail, 1992–93. Color woodcut with pochoir, 46 ¼" x 36" (116.8 x 91.4 cm). Edition of 50. Published by Pace Prints.

7–2 In this work, what does the artist do to create balance?

Richard Estes (b. 1932). *Eiffel Tower Restaurant*, from *Urban Landscapes III*, 1981. Screenprint, 19 ¾" x 27 ½" (50 x 69.9 cm). ©Richard Estes/Licensed by VAGA, New York, NY/Marlborough Gallery, NY.

7–3 Artists and architects sometimes purposely avoid an obvious sense of balance in their works.

Frank O. Gehry (b. 1929) and Associates, Inc. *Nationale–Nederlanden Building*, Prague, Czech Republic. Model. Photo by Joshua White.

Performing Arts
Balance in the Air: Relevé
Ballet dancers always work to keep their balance. Relevé (pronounced "ruhl-VAY") is one way of raising the body on special ballet shoes called *points*. Ask students to stand and stretch until just their toes touch the floor. This is called *half-point*; when a dancer stands high on the balls of the feet it is referred to as *sur les demi-pointes*. Challenge them to try to keep their balance as they move their torsos and arms in all different directions. Explain that every position in ballet is carefully constructed. Have students skim a basic ballet book or encyclopedia for some positions which show the variety of ways the body can be balanced in dance.

Higher-Order Thinking Skills
Ask students to look more carefully at the almost-symmetrical balance in Richard Estes's *Eiffel Tower Restaurant* (fig.7–2). Call on students to describe the composition, noting what is different about each side. Discuss where the center of interest is in relation to the actual center of the picture plane. Have students cover the left edge of the image with a sheet of paper to increase the sense of symmetry. Ask whether the cropped composition or the printed image is more dynamic and interesting. Point out the size and the medium of this painting, and explain to students that this style of painting is known as *photorealism*. Discuss why this is an appropriate name for this painting technique.

Context

The Public Services Building in Portland (fig.7-5) has been called the first important Post-Modern architectural structure. Some people think that it resembles a child's building-block construction, and this effect, along with the use of very simplified classic forms, resulted in a building with a completely new look.

Symmetrical Balance

Stand with your feet side by side and both arms extended outward to your sides. You are now in symmetrical balance. What happens if you drop or raise one arm? You become unbalanced and might even begin to lean to one side. When a design displays *symmetrical balance*, it is exactly the same on both sides. If you drew a line through the center of the design, one side would be the mirror image of the other. Symmetrical balance is sometimes known as bilateral, two-sided, or formal balance.

A well-shaped fir tree is symmetrically balanced, as is a well-formed apple. Compositions that display symmetry tend to be stable, dignified, and calm. In design, symmetrical balance is often evident in architecture. Notice, for example, the peacefulness achieved by the perfect symmetry of the famed Taj Mahal (fig.7–8).

Symmetry refers not only to a single object or figure with identical halves. Symmetrical balance is also produced by the same shapes or forms on opposite sides of a composition. Look at fig.7–4. The shapes and colors on one half of the composition repeat precisely on the other half.

7–4 Variety of color and strong diagonal lines enliven this symmetrical composition.

Cory Longhauser (age 14). *Colorful Geometric Shapes*, 1997–98. Acrylic and tempera, 12" x 18" (30.5 x 45.7 cm). Manson Northwest Webster Community School, Barnum, Iowa.

7–5 Why do you think that most architecture is generally symmetrical? Can you think of some practical advantages?

Michael Graves (b. 1934). *Portland Public Services Building*, 1980–82. Portland, Oregon. Photo by J. Selleck.

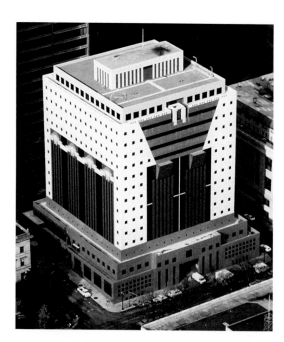

7–6 Ceremonial objects often display symmetry. The static, formal quality suggested by symmetry adds significance to the ceremony or ritual.

Mask, Senufo or Baule, Ivory Coast. Wood, 12" x 9" (30.5 x 22.9 cm). Collection of Joseph A. Gatto, Los Angeles, California.

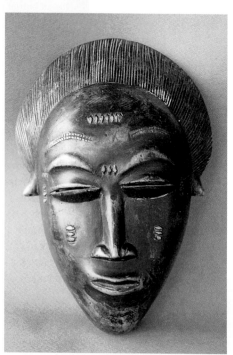

Try it

Choose two small pieces of paper equal in size, color, value, and shape. Place them on a larger piece of white paper. Move the two shapes away from an imaginary center line, observing the balance that occurs. What happens when you move the shapes toward the edges? What happens when you move them close to the center? After you've experimented with various locations, glue the shapes down to form a symmetrically balanced design.

Taj Mahal

What kind of monument comes to mind when you think about a well-loved person's tomb? For a Mughal emperor in the seventeenth century, the Taj Mahal is such a monument. Its design and construction was ordered by Shah Jahan (ruled 1628–58) in memory of his beloved wife Mumtaz Mahal, who died unexpectedly in 1630.

Built from 1632–38 on the bank of the Yamuna River at Agra, this architectural treasure is one of the most famous landmarks in the world. Twenty thousand workers participated in the creation of the structure, which is surrounded by four minarets (slender towers from which Moslems are called to prayer). Each minaret has three divisions, echoing the levels of the tomb.

The octagonal tomb and its supporting platform are built from gleaming white marble. On each side, the building has a large central *iwan* (a vaulted opening with an arched portal) flanked by two stories of smaller *iwans*. These openings make the building seem weightless: it appears to float magically above the reflecting pool. The surrounding garden (1,000' x 1,900'), divided by water channels, is laid out in total symmetrical balance. Trees and flowers are planted

along broad walkways with inlaid stones in geometric patterns. Originally, fountains were a part of this outdoor environment.

In the tradition of the Moslem religion, the style of the building is entirely symmetrical, with panels of carved inscriptions and flowering plants for simple decoration. Two smaller buildings, mirror images of each other, are set behind the tomb. One is a mosque, and the other a resting hall. They share a base with the mausoleum's marble platform, but are constructed primarily from a contrasting red sandstone.

The Taj Mahal is the crowning achievement of Islamic architectural design. It represents, by its form and location, a description found in the Koran: "the Throne of God above the gardens of paradise on the Day of Judgment." For the power of its presence, the Taj Mahal might be compared to the pyramids in Egypt.

7–8 The plan of this famous building and its grounds are perfectly symmetrical.
India (Agra). *Taj Mahal*, 1632–38. Photo by David Gyscek.

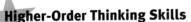

7–7 Can you think of other examples of symmetrical balance in the insect world?
Butterfly. Photo by Sparrel Wood.

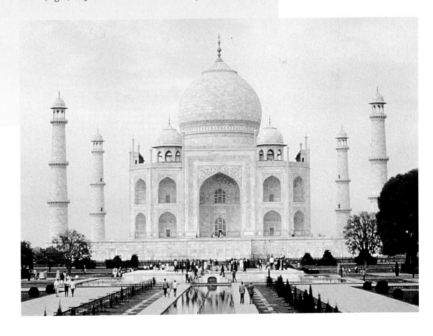

Higher-Order Thinking Skills

Ask students to consider the symmetry in the design of their school building. If possible, use an aerial photograph to assist students in better understanding the layout of the school. Is it symmetrical or almost symmetrical? How might the activities that take place within the structure have affected the design? Ask students to identify some community structures that have symmetrical design and some that have asymmetrical balance. Do certain types of buildings tend to be symmetrical and others asymmetrical? Does a building's purpose seem to have any influence on the type of balance chosen by the architect?

Approximate Symmetry

Although symmetry is the simplest way to achieve balance in a design, it can be monotonous and may fail to hold a viewer's interest for long. Because one side repeats the other, the effect is usually static. An artist may actually wish to establish such a feeling of monotony, but most artists and designers prefer to use a less severe form of symmetry.

Look in a mirror. Most likely, you'll notice that your face is *almost* symmetrically balanced. One eyebrow may be a little higher than the other. Your nose may not be perfectly straight. Or you may have more freckles on the left side of your face than on the right. These slight differences between the two sides make you more interesting to look at.

7–9 What variations in this piece make its symmetry approximate? Consider color as well as shape.

Dorte Christjansen (b. 1943). *Borderjacket*, 1992. Batik on silk (satin), 32" x 36" (81.3 x 91.3 cm). Commission/ Kremen.

Note it

Look at images of paintings and sculpture throughout this book to see how artists and designers have achieved approximate symmetry in their work.

In a design, artists can break the severe monotony of pure symmetry by using *approximate symmetry*. With approximate symmetry, the two sides of a composition are varied. They offer enough differences to hold the viewer's attention, but the halves are similar enough to provide a sense of balance.

Study the photograph of the woman with her cats (fig.7–10). What variations do you see? You probably notice that the cats are different colors. But did you observe that the cats' paws are crossed? The photographer also allowed one tail to hang over the edge. These minor variations give the composition greater visual interest.

Design Extension

Tape white paper to a wall. Cut out two sets of three or four small shapes of colored paper. Have students as a group create a composition that has approximate balance. They can pin or lightly tape the shapes as they move them to create a composition that they think best achieves asymmetrical balance.

Context

Katz often paints large-scale portraits of his friends and family, especially his wife, Ada, and son, Vincent. His goal is to give traditional portraiture a contemporary look. Often, Katz's oversized, cropped figures are compared to billboards and advertisements, with their flatly painted shapes of color and strong visual contrasts.

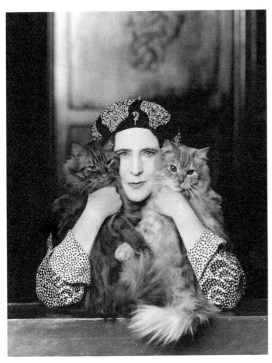

7–10 As you consider the approximate symmetry shown in this photograph, look also at the background of the composition. What might have been the artist's reason for including a generous amount of space above the subjects? How does this affect the artwork's sense of symmetry?

Paul Tanqueray (1905–91). *Elinor Glyn*, 1931. Bromide print, 9 ⅛" x 5 ½" (23.2 x 14.1 cm). Courtesy of the National Portrait Gallery, London. Reprinted with permission by Marc Bryan-Brown.

7–11 Several items cause the symmetry of this work to be approximate rather than perfect. Can you spot two?

Alex Katz (b. 1927). *Ada in Aqua*, 1963. Oil on canvas, 50 ¼" x 80" (127.6 x 203 cm). New Orleans Museum of Art, gift of the Frederick R. Weisman Foundation. ©Alex Katz/Licensed by VAGA, New York, NY/Marlborough Gallery, NY.

Design Extension
Lead students in analyz-
ing numbers and alpha-
bet letters to determine
which are symmetrical
and which are asym-
metrical. Have students
make two different
compositions—a sym-
metrical one composed
of symmetrical letter
and number forms, and
an asymmetrical one of
asymmetrical letters
and numerals. Students
might create a collage
or draw with stencils;
or they might create
their composition on
the computer.

Asymmetrical Balance

Asymmetrical balance (also called informal balance) is more complex than symmetrical bal-
ance. It often contrasts elements that at first glance may not seem to be balanced. For exam-
ple, an artist may place a large shape on one side of a design and a group of smaller shapes
on the other. Or, he or she may balance a small area of color with a larger, colorless space; or
a small, bright area of color with a large, dull one. In each of these examples, the two sides
will appear to have the same "visual weight."

Asymmetry can provide balance in a design and also produce a sense of excitement
and interest. Look at *Igor Stravinsky* (fig.7–12). In this unusual portrait, Arnold Newman
placed the composer's face in a corner of the composition. To his right, the black shape of a
piano lid takes up most of the space. Even though the face is very small, our attention is
naturally drawn to it. The fact that it is close to the edge also adds enough "weight" to balance
the much larger black shape.

Asymmetrical balance offers many possibilities and combinations to an artist, who
might balance light against dark, large against small, or rough against smooth. But asym-
metrical balance is more difficult to achieve than symmetrical, or formal, balance. Informal
balance is something that the viewer senses in a composition; it cannot be measured. There
is no center line or pairing of mirror images. As you manipulate the visual elements in a
design, you'll learn to judge when opposing elements are in balance.

7–12 The composer and the piano become one in this
image. Note the serious expression on Stravinsky's face.
Why do you think the photographer chose this compo-
sition? What impression does the image give you about
the composer and his music?
Arnold Newman (b. 1918). *Igor Stravinsky*, 1946. Print.
©Arnold Newman.

7–13 Mobiles display a continuously changing
asymmetry. It is this characteristic that makes them so
fascinating to the eye.
Alexander Calder (1898–1976). *Lobster Trap and Fish Tail*,
1939. Painted steel wire and sheet aluminum, 8'6" x 9'6" (2.6 x
2.9 m). The Museum of Modern Art, New York.
Commissioned by the Advisory Committee for the stairwell of
the museum. Photograph ©1998 The Museum of Modern
Art, New York ©1999 Estate of Alexander Calder/Artists
Rights Society (ARS), New York.

Try it

Study fig.7–13 and other mobiles
by Alexander Calder. Then make a
mobile of your own. Try to balance
your work visually by contrasting large
and small forms. To achieve equal visual
and physical weight, use color and size
variation.

Context
Alexander Calder (fig.7–13) was the son
and grandson of sculptors. His first
sculptural experiments were wire con-
structions (fig.1–7), but he then moved
on to what came to be called *mobiles*, a
term that Marcel Duchamp coined upon
seeing Calder's new creations.
Ironically, Jean Arp's response to the
term ("What were those things you did
last year—stabiles?") caused yet a

? **Inquiry**
Have students compare two views of the same subject composed with different types of balance. For example, they might compare Leonardo da Vinci's symmetrical *The Last Supper* to Tintoretto's asymmetrical version of the same scene, or Grünewald's approximately symmetrical *Isenheim Altarpiece Crucifixion* to that of Dalí. Call on students to compare the moods created by the different types of balance.

◆ **Internet Connection**
Guide students to search for a listing of Web sites using the term "asymmetrical balance." How many of the sites relate directly to the visual arts? How many are concerned with architecture? Students can list categories they find, which might include music, gardening, medicine, etc. A further comparison may be made of sites by searching for "symmetrical balance."

Piet Mondrian

If you want a challenge, try to find an artist who placed more emphasis on asymmetrical balance than Piet Mondrian. Considered by art historians to be one of the most influential pioneers of abstract art, Mondrian lived from 1872 until 1944. His paintings are now highly prized, yet he sold only a few of them during his lifetime.

Piet Mondrian, *Self-Portrait*, c. 1900. Oil on canvas mounted on masonite, 19 ⅞" x 15 ⅝" (50.4 x 39.7 cm). The Phillips Collection, Washington, DC.

Born in Holland, Mondrian began painting after observing the work of his father and uncle, who were both painters. Although Mondrian's best-known works are his geometric compositions (fig.7–14), many of his early works depicted the natural world. The flowers, trees, and windmills of the Dutch landscape provided him with the inspiration to use strong horizontal and vertical elements. Mondrian was skilled at painting representationally, and a strong sense of balance is evident in his portrayals of natural scenes.

Largely self-taught, Mondrian studied Realism, Impressionism, Post-Impressionism, and, beginning in 1910, Cubism. His experiments in Cubism led him to focus on a style of nonrepresentational work called *De Stijl* (Dutch for "the style"), a type of art that purposely eliminated emotion and a sense of humanness from the viewer's experience.

Mondrian restricted himself to a palette of neutrals and primary colors, to vertical

7–14 Keep in mind that though a work might be asymmetrical, it can still have a strong sense of balance. Can you analyze how Piet Mondrian maintained balance in this painting?
Piet Mondrian (1872–1944). *Composition with Blue and Yellow*, 1935. Oil on canvas, 28 ¾" x 27 ¼" (73 x 69.2 cm). Gift of the Joseph H. Hirshhorn Foundation, The Hirshhorn Museum and Sculpture Garden, Smithsonian Institution. 1972.72.205. Photo by Lee Stalsworth.

and horizontal lines, and to square or rectangular shapes. He worked within a regular, stable grid, using balance to achieve a dynamic but harmonious whole. Mondrian intended the paintings to be displayed flat against a wall, without frames, so that the wall would be experienced as an extension of the picture plane.

As an elderly man among many others who fled Europe during World War II, Mondrian made his way to New York. Although he died relatively unknown to the general public, he left a creative legacy that affects the way we view art today.

Try it

You can experience actual asymmetrical balance by placing a ruler across an outstretched forefinger, while resting your hand on a desk. Experiment by placing lighter and heavier objects on each side of the center. Move them until the ruler balances.

second term to be invented for Calder's work. *Mobile* and *stabile* have made their way into common art vocabulary, though the latter term is associated specifically with Calder's work.

Radial Balance

If the parts of a design turn around a central point, the design has *radial balance*. A bicycle wheel is an example of radial balance: the wheel has a central point from which the spokes radiate outward. The blossoms of sunflowers and daisies are other examples.

Designs based on radial balance are somewhat similar to those that use symmetrical balance: they are generally orderly and repetitious, and one side may be much like the other. But because the various elements in radial designs form a circular pattern, they often convey a greater sense of movement or energy. Look at the plate (fig.7–17) created by Maria Martinez. The design uses radial balance, and its circular repetition of feathers suggests a feeling of turning or spinning.

7–15 Rose windows are excellent examples of radial balance in architecture. This window is from the Cathedral of Angers, in France, which was completed during the 1200s. Rose windows such as this one were most often placed on the end walls of medieval churches to allow a burst of light to flood the interior.
Cathedral of St. Maurice, c. 1150–13th century, Angers, France. South transept of rose window.

7–16 We usually think of a daisy as a simple form, but if we look at it in terms of radial balance, it becomes a much more complex creation.
Daisy. Photo by N. W. Bedau.

Note it

Look for simple and complex radial designs in manufactured objects. You might notice buttons, plates, fountains, or hubcaps. Make sketches to use as ideas for later artworks.

As they do with symmetrical balance, artists often modify radial balance to add greater visual interest or tension. They may vary the number, direction, or arrangement of the design's parts. One example of this is the so-called rose window commonly found in a church or cathedral (see fig. 7–15). The "spokes" of this stained-glass architectural feature often depict a variety of scenes or figures, and, unlike the plate, the rose window would not look the same if it were turned upside down. Even with modifications, however, most radial designs tend to create an overall decorative effect.

7–17 Over her long lifetime, Pueblo artist Maria Martinez created many exquisite works, including this earthenware black-on-black plate. The ideas for this style came from prehistoric pottery discovered by archaeologists near her home in New Mexico.
Maria Poreka Martinez (1881–1980). *Plate*, c. 1943–1956. Slipped earthenware, 14 ½" diameter (36.8 cm). Gift of Mr. and Mrs. Charles Shucart. The Saint Louis Art Museum.

7–18 How has this artist used radial balance in her work?
Jessica Genelli (age 17). *In Good Times and Bad*, 1996. Oil pastel and watercolor. West Boylston Middle/High School, West Boylston, Massachusetts.

Materials and Techniques

Martinez (fig. 7–17) did not use a potter's wheel, but built the plate from hand-rolled coils of clay. When the clay was leather-hard, she covered it with *slip* (a liquified clay) and then polished it with a smooth river rock as her ancestors had done for generations before. The stylized matte engobe feather design was painted on the plate with a brush made from a yucca plant.

To achieve the black-on-black color, the pottery is fired in an outdoor fire of cow chips. At just the right moment the fire is smothered with powdered horse manure and wood ashes, reducing the oxygen to the clay. If the pottery was not smothered, it would be red, the color of the clay.

Interdisciplinary Connection

Mathematics, Geometry—Instruct students in using a ruler, protractor, and compass to divide a circle into twelve equal segments. This type of segmenting is readily visible in the rose window of the south transept of Chartres Cathedral (see Brommer, *Discovering Art History*). Have students determine how many degrees would be in each segment. Ask students to create a radial design in their segmented circle.

Cooperative Learning

Have groups of four, five, or six students arrange a still life with the radially balanced nature objects that they brought to class. Call on group members to explain their arrangements to the rest of the class, pointing out the mood or ambiance and functional advantages created by each.

Another Look at Balance

Context

Northwest Coast Indian painting and weaving make use of two basic elements: the *ovoid* and the *form line*. The ovoid is rectangular in shape, with curved rather than angular edges. The form line is a shape-defining, generally black line used throughout designs.

7–19 What type of symmetry is evident in this blanket?

Polychrome Shoulder Robe (Chilkat Blanket), late 19th century, Tlingit, Yakutat, Alaska. Wool, 32 ¾" x 61" (83.2 x 154.9 cm). Honolulu Academy of Arts Purchase, 1935.

7–21 Describe how balance is achieved in this three-dimensional work.

Erin Freeland (age 14). *Untitled*, 1998. Papier-mâché, 25" high (63.5 cm). Wachusett Regional High School, Holden, Massachusetts.

7–20 How did the artist maintain balance in this composition, despite the different pose of each athlete?

Claudio Bravo (b. 1936). *Before the Game*, 1983. Oil on canvas, 78 ½" x 94 ¼" (199 x 239 cm). ©Claudio Bravo/Licensed by VAGA, New York, NY/Marlborough Gallery.

Interdisciplinary Connection

Biology—Call students' attention to different types of symmetry found in living organisms. Encourage students to look through biology textbooks and make a list of bilaterally and radially symmetrical plants and animals.

Ask what features are often asymmetrical in animals. Suggest that students study and draw the symmetry in various branching and veining schemes in trees.

7-22 Empty space, or a void, is often used by Asian artists in a masterful manner. What effect does the emptiness here have on the viewer?

Nonomura Sotatsu (1576–1643). *The Zen Priest Choka*, Edo period. Hanging scroll, ink on paper, 37 ¾" x 14 ¾" (95.8 x 37.5 cm). ©The Cleveland Museum of Art, 1998, Norman O. and Ella S. Stone Memorial Fund, 1958.289.

7-23 Nakamura combines an overall radially balanced design with smaller areas of radial balance and symmetry. How many places can you see radial balance in this artwork?

Joel Nakamura (b. 1959). *Inspiration*, 1993. Poster for the 1993 AIGA Design Conference. Third in a series of four. Acrylic on archival board, 20" x 30" (50.8 x 76 cm). Courtesy of the artist. Photo by Art Works, Pasadena, CA.

Design Extension
Instruct students to create a poster that explains compositional balance. They should select magazine photographs that illustrate symmetrical balance, approximate symmetry, asymmetrical balance, and radial balance. Ask them to label each type of balance. Display the completed posters. Students could work in cooperative-learning groups to create the posters.

151

Review Questions (*answers can be found on page 140g*)

1. What is visual balance?
2. What are four types of visual balance? List an example of each from this book.
3. How do the two halves of a bilateral, or symmetrical, composition relate to each other?
4. How does approximate symmetry differ from bilateral symmetry?
5. Why might an artist wish to create an approximately symmetrical or asymmetrical design instead of a symmetrical one?
6. What type of balance does the design of the Taj Mahal display? Where is the Taj Mahal located? Why was it built? What is an *iwan*? Locate iwans in this structure.
7. Experiments in what art style led Mondrian to focus on a new style called De Stijl? Describe the restrictions that he placed on himself as he painted in the nonrepresentational De Stijl style.

Portfolio Tip
Provide students with acid-free papers and mounting materials so that their art will last longer. Tapes, mats, and backing materials with acid content will cause paper to turn brown within a few years.

Career Portfolio
Interview with a Web-site Designer

While still in high school, **David Lai** learned the basics of computer design on his own. "Just for fun," he wrote and published a book on how to design computer-screen icons. Born in 1975 in Manhattan, Kansas, David now works for a firm in California that specializes in interactive design.

What do you call your occupation?

David I'm in the design profession, but we almost always talk more about solving problems. Good design does have aesthetic components, which is important, but there is also a very important functional aspect. You have to create something of utility and value. We solve real-world communication problems.

While interning with a design company, David Lai sold his ideas to Nintendo for a Web site. "We wanted to create a site that made teens feel like they were breaking into Nintendo at night and could explore the different areas of the company. Our goal was to make visitors feel special, that they were seeing something only a few could."

We look at computers more as a tool than a specialty. Otherwise, I'd be nothing more than an operator. You can always learn a tool, but the more difficult things to learn are conceptual—sketching your ideas out on paper before you go to the computer. Too many people these days want to go straight from whatever is in their mind—and it's usually not very clear—directly to the computer. They think they need to buy all these computer books to learn the program, but the truth is that they need to know how to conceptualize more than they need the tools, the applications.

How is balance important in Web-site design?

David Well, there are so many different elements involved. There's content. There's visuals. There's audio. There's text, the copy itself. There really has to be a synergy between all of them to get something to work. You're always balancing different spaces or different shapes.

Can anybody design a Web site?

David Well, theoretically, yes. Just like anyone could be a doctor, if they really put their mind to it. There's such a wide range of people in this industry because it's very easy to enter into. Anyone can pick up a book and learn some basic HTML and some basic graphic stuff. HTML is the

basic programming language that you use to create Web pages. It's the foundation; it's the starting point. No Web site can be created without knowing some of that.

How do most people learn it?

David A lot of people learn it by looking at sites they really enjoy or respect, by taking them apart and looking at how the code was done. I think that's one of the great things about the Internet—it allows people to share information quickly. That includes sharing how sites are built, in that I can download the source code of any site and see how it was put together and learn from that.

What would you recommend to people interested in doing this for a living?

David I would recommend that they read as much as they can about the subject. There are so many good books out there on Web design.

Obviously, there's a more formalized way as well. There are a lot of good art-design schools out there, especially with today's booming computer-design industry. You can take courses on Web design, multimedia, interactive learning for CD-ROM work, 3D modeling for special effects for Hollywood—whatever. The important thing is that you just have to go out there and take risks.

Studio Experience
Balance in Nature

Task: To create a painting—with either symmetrical or asymmetrical balance—of a small symmetrical natural object.

Take a look. Review the following images:
- Fig. 7–1, Chuck Close, *Lucas Woodcut*
- Fig. 7–6, *Mask*
- Fig. 7–7, butterfly
- Fig. 7–13, Alexander Calder, *Lobster Trap and Fish Tail*
- Fig. 7–15, *Cathedral rose window*

Think about it.
- Notice the symmetrical balance in most of the images listed above. Imagine a vertical line drawn through the middle of each image. Each half of the image would be about the same. Point out the symmetrical details on each half of the images. Which image has radial symmetry?
- Compare the mood or stability of the symmetrical images to that in an asymmetrical composition, such as *Lobster Trap and Fish Tail* (fig.7–13).

Do it.

1 Select a small nature object with symmetrical balance. Study its details with a magnifying glass or loupe.

2 Fold an 8 ½" x 11" piece of bond paper in half.

3 With a soft pencil, draw one half of the object, arranging your drawing so that the center line of your subject is on the fold.

4 Refold the paper, and rub over the outside with a smooth, hard object like the back of a spoon, transferring the image to the other half of the paper.

5 Redraw any lines that did not transfer. You now have a symmetrical drawing.

6 To design a composition from your sketch, move a viewfinder made of two paper Ls over your sketch. Place the viewfinder so that you have a symmetrical composition. Change the size of the viewfinder opening; then consider some asymmetrical compositions by moving the viewfinder so that the center of the subject is not in the center of the opening. You may wish to use only a portion of your drawing, with the subject extending out of the picture plane.

7 Draw a line around the edge of your chosen composition.

8 Enlarge your composition to fill an 18" x 24" sheet of drawing paper. To do this, very lightly draw with a pencil and ruler a grid of 1" squares over your drawing. Then, very lightly draw a grid of 2" squares on the large paper. Copy each square from your small drawing onto the large paper.

9 Paint your drawing with black, white, and two colors of tempera paint. Consider which colors will suggest a mood for your subject. For some areas, you may want to mix your selected colors.

Helpful Hints
- Make dark pencil lines in your first drawing so that they will transfer to the other half of the paper.
- If you do not want to draw the grid on your small drawing, draw it on a sheet of tracing paper or acetate, and tape it over your drawing.
- Make light pencil lines on the grid so that they will not show in your finished painting.
- Periodically view your artwork from a distance. Check the contrast to determine if details that you want to stand out do so. Would your composition benefit from any changes, such as the addition of lines or a variation in color?

Check it.
- Is the balance in your completed artwork symmetrical, asymmetrical, or radial? Why is the composition pleasing or not pleasing to you?
- Is the color scheme appropriate for the composition?
- Is the drawing technique appropriate? What would you do to improve the painting technique?

153

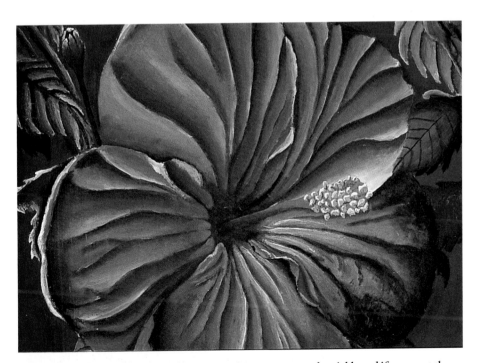

"I learned that when you work with tempera paint, you must work quickly and if you want the colors to blend together, then you need to make sure you use a lot of paint."

Aileen Delgado (age 17). *Hybiscus*, 1998. Tempera, 18" x 24" (45.7 x 61 cm). West Springfield High School, Springfield, Virginia.

Studio Experience
Balance in Nature

Elizabeth Holloway (age 16). *Spike*, 1998. Tempera paint and pencil, 18" x 24" (45.7 x 61 cm). West Springfield High School, Springfield, Virginia.

Prepare

Time Needed:
Three 45-minute class periods (extend as needed)
Lesson 1:
Draw.
Lesson 2:
Compose the painting and enlarge the drawing.
Lesson 3:
Paint.

Objectives
Students should be able to

- Identify symmetrical, asymmetrical, and radial balance in artworks.

- Demonstrate their understanding of compositional balance by drawing a symmetrical object and creating a painting with either symmetrical or asymmetrical compositional balance.

Materials
- symmetrical nature objects such as insects or small plants
- magnifying glasses and/or loupes
- 8 1/2" x 11" bond or drawing paper
- soft drawing pencil
- 18" x 24" drawing paper
- viewfinder made from two Ls cut from 8 1/2" x 11" paper
- pencils
- rulers
- tempera paint
- brushes
- water in containers
- palettes, such as scrap cardboard, for mixing colors
 optional:
- tape
- 8 1/2" x 11" tracing paper or acetate
- permanent markers

Notes on Materials
- Provide No. 2 (or softer) pencils so that the drawing will transfer from one side of the paper to the other.

- If students would rather not draw a grid, have them tape either tracing paper or acetate over their drawing and draw the grid on that, using a marker that does not bead on slick surfaces. You could provide reusable acetate grids made by photocopying a grid onto acetate.

Before You Start
Have students bring in nature objects, or borrow insect collections and nature specimens from the science department.

Teach

Thinking Critically
- Have students review the images and the questions in **Think about it**. Call on them to compare the mood of symmetrical and asymmetrical compositions. Ask: How does the symmetry change the visual movement within each image? (Compositions in which the focal point is off center usually have more movement; symmetrical compositions usually seem more static.)

- Encourage students to find examples of symmetrical and asymmetrical balance in images in other chapters of this book. Ask them to describe ways of changing the composition in a particular work which would result in a change to its dynamics or impact.

Classroom Management

- For **Thinking Critically**, have partners select a symmetrical and an asymmetrical image. To show how the dynamic impact of the piece can change, have one partner make a quick sketch of one of the images, altering the composition from symmetrical to asymmetrical; his or her partner alters the other composition from asymmetrical to symmetrical.

Tip

- If students select to enlarge a very small portion of their drawing, suggest that they make the squares in the grid on the large paper a little bigger.

- Explain that students need not use color realistically; consideration of the overall mood of the color scheme is more important.

Assess

Evaluation

- Assign students to write the answers to the questions in **Check it**.

- Ask each student to identify the center of interest or focal point in their painting (that part of the composition that is most important or they see first when they squint their eyes). How does the position of the focal point affect the overall balance of the artwork?

- Ask how the type of balance that they used affected the mood, feeling, or dynamic energy of this piece.

- Consider the design or balance, the craftsmanship (drawing and painting technique), the creativity or originality, and whether the final painting meets the requirements for this particular project (a painting of a symmetrical nature object using two colors, black, and white).

Extend

Linking Design Elements and Principles

Line
Emphasize line by encouraging students to consider line quality in their drawing. They may wish to make some lines thick and some thin, or some broken and some continuous.

Pattern
Encourage students to notice natural patterns in their nature object, such as the pattern on butterfly wings or that formed by the spots on a ladybug. Ask them to describe other patterns found in nature.

Emphasis
As students design their composition, discuss the placement of their center of interest and how it affects the balance of the composition.

Interdisciplinary Connections

Science
Integrate this project into biology lessons about insects. Students could make their drawing in the science lab or outdoors, as nature observation. By looking at objects under a microscope, students could draw details that cannot be seen without magnification.

Inquiry

- Assign students to investigate works by artists who drew from nature and made virtual scientific studies of nature. Students might use one of the following: Dürer's *Hare*, *Piece of Turf*, or *Feather*; a sketch of a plant or animal by Leonardo da Vinci; a bird by James Audubon; or Judith Leyster's *Tulip*. Have students make a copy (by hand, photocopier, or computer) of the work, write what its medium is, describe the composition, and explain how the work is symmetrical and/or asymmetrical.

- Have students who are interested in the stained-glass technique find and photocopy an image of a round or rose stained-glass window. Encourage them to research and write when the window was designed, where it is, and explain how it differs from the one in fig.7–15.

153b

Chapter 8 Organizer
Unity

Chapter Overview
- If a composition or artwork has a feeling of wholeness or completeness, it has unity.

Objective: Students will comprehend how the use of a dominant element such as color or texture and the repetition of shapes and forms may unify an artwork. (Art criticism)
National Standards: 2. Students will use knowledge of structures and functions. (2c, 2b)

Objective: Students will create a painting and other artworks which have unity or harmony. (Art production)
National Standards: 1. Students will understand and apply media, techniques, processes. (1a)

8 Weeks	1 Semester	2 Semesters			Student Book Features
1	1	1	**Lesson 1:** Dominance	Chapter Opener Dominance	Discuss it, About the Artwork
0	0	1	**Lesson 2:** Dominance	Dominance	Discuss it, About the Artwork
0	0	1	**Lesson 3:** Repetition of Visual Units	Repetition of Visual Units	
0	0	1	**Lesson 4:** Use of Color	Use of Color	Discuss it
0	0	1	**Lesson 5:** Use of Color	Use of Color	Try it: color study
0	0	2	**Lesson 6:** Surface Quality	Surface Quality	Try it: texture study, About the Artis
1	1	1	**Chapter Review**	Another Look at Unity	Note it, Review Questions
3	3	3			

Studio Experience: *Putting It All Together*

Objectives: Students will perceive and appreciate how artists create unity in their artwork, and how certain artworks are similar; demonstrate their understanding of unity by creating a unified painting; select paintings with a common element, theme, style, or technique, and justify their selection.

National Standard: Students will demonstrate ability to form/defend judgments about characteristics/structural purposes of art (2a); evaluate artworks' effectiveness in terms of organizational structures and functions (2b); create art using organizational structures and functions to solve art problems (2c); reflect on various interpretations to understand and evaluate artworks (5c).

- Artists create unity in their art by making all of the elements in their design work together.

- Some ways to create unity are to make one element dominant over subordinate elements, to repeat visual units, and to repeat a color or texture throughout a composition.

Objective: Students will perceive and appreciate how artists of various cultures and styles, including German Expressionism and twentieth-century American abstraction, create unity within their works. (Art history/cultures)
National Standards: 4. Students will understand art in relation to history and cultures. (4a)

Objective: Students will understand and appreciate why humans strive for harmony and unity in their environment and in art. (Aesthetics)
National Standards: 6. Students will connect visual arts with other disciplines. (6a)

Teacher Edition References	Ancillaries
Warm-up, Design Extension, HOTS, Context, Performing Arts, Inquiry, Inter-disciplinary Connection, Internet Connection	*Slides*: Deborah Butterfield, *Horse (kneeling)* (U-1); Susie Ponds, *Snake Quilt* (U-2)
Design Extension, Context, Inquiry	*Slides*: Deborah Butterfield, *Horse (kneeling)* (U-1); Susie Ponds, *Snake Quilt* (U-2) *Large Reproductions*: Minnie Sky Arrow, *Buckskin Dress*; Friedrich Hundertwasser, *High-rise Meadow House*
HOTS, Context, Inquiry, Performing Arts, Materials and Techniques	*Slide*: American Indian, *Chilkat Blanket* (U-3)
HOTS, Context, Inquiry	*Slide*: Nellie Mae Rowe, *Black Dog* (U-4)
HOTS, Context, Inquiry	*Slide*: Nellie Mae Rowe, *Black Dog* (U-4)
HOTS, Context, Inquiry	*Slide*: Jomon, *Storage Pot* (U-5)
Design Extension, Context, Interdisciplinary Connection	*Slide*: Mary Cassatt, *In the Loge* (U-6)

Vocabulary

dominance A concept that one primary element attracts more attention than anything else in a composition. The dominant element is usually a focal point in the composition. *(dominio)*

subordinate Describing anything that is of lesser importance than the dominant element in an artwork. *(subordinado)*

unity The sense of oneness or wholeness in a work of art. *(unidad)*

Studio Resource Binder

Time Needed
Three 45-minute class periods.
Lesson 1: Draw and plan;
Lessons 2, 3: Paint.

8.1 Inscribed Plaster Scrimshaw
8.2 Unifying Figures in Action, pastel drawing
8.3 Synthesizing Memorabilia, collage
8.4 Creating a Unified Book
8.5 Off the Wall, mural

Lesson 1
Dominance

pages 154–155

pages 156–157

Objectives

Students will be able to

- Perceive unity in artwork.

- Comprehend why unity is important in art.

- Perceive and understand how artists make one element dominant to unify an artwork.

Chapter Opener

- Focus on pages 154–155, and guide students to note how the artists created unity in artworks. Assign students to work in cooperative-learning groups of four to discuss one of the images and become "experts" on that piece of art: each group should note, and then explain to the rest of the class, the repetition of shapes, forms, colors, textures; and how forms flow together or overlap to create unity. If more than one group has analyzed a single work of art, ask the groups that chose the same work to compare their observations. Did each group reach the same conclusions? Explain to students who have chosen *Normandie, 1935*

(fig.8–2) that the artist based the shape on the funnels on a steamship, the S.S. *Normandie*.

Teach

- Ask students to look at the images on pages 156–157 and write what they consider to be the dominant element in each. Encourage students to share their findings to see if there is a consensus of opinion. They will probably notice that line, shape, and value are important in *Attack* (fig.8–7), color and shape in *Blue on White* (fig.8–6), and color and texture in *Field Workers* (fig.8–5).

- After students read the information about Käthe Kollwitz and her series of prints, *The Weavers Uprising*, discuss *Attack* with the class. Point out how she repeated similar lines and groups of lines throughout this print. Explain that Kollwitz is known as a German Expressionist. How has she used line and values to create emotion? Call attention to the lines in the bodies of the weavers. Can students read the body language in these figures?

 After studying this image, students may be inspired to draw an event which aroused emotions within them. Encourage them to use line to unify and suggest emotion, not necessarily realism. This could be a sketchbook assignment, begun in class and completed later.

> **Teach** page 157
> ### Materials
> - 9" x 12" drawing paper, or sketchbooks
> - pencils or markers

Pamela Dolan (age 15). *The Head*, 1996. Ceramic, 6" x 8" (15.2 x 20.3 cm). Quabbin Regional High School, Barre, Massachusetts.

Lesson 2
Dominance

pages 156–157

Objectives

Students will be able to

- Perceive and comprehend how dominance is used in magazine advertisements.

- Design an advertisement featuring a dominant object.

Teach

- Lead students in discussing fig.8–6, Ellsworth Kelly's *Blue on White*. Ask: How has Kelly made the central shape dominant? What type of color scheme is this? (monochromatic) How large is this painting? When was it made? Why would this type of art be considered minimalist? Although Kelly was born in New York, he lived in France from 1946 to 1954. During that time he was influenced by the modern art movement in Europe. Encourage the class to suggest European artists whom Kelly might have admired. Assign

Lindsey Bain (age 15). *Bugs,* 1997. Colored pencil on mylar, 8" x 10 ¼" (20.3 x 26 cm). Asheville High School, Asheville, North Carolina.

Teach

- Direct the class to look at *Façade of Lloyds Bank* (fig.8–9), and ask what features the architect repeated. Point out the repetition of shapes and colors in Stella's *Raqqa II* (fig.8–8), *Tunic with animal motif* (fig.8–10), and Ward's photo *Aerial, Beach* (fig.8–11).

- As students study fig.8–10 and look for the animal in the motif, inform them of the tradition and importance of loom weaving in Peru. (See Context and Materials and Techniques.)

- So that students may demonstrate their understanding of unity by repetition, instruct them to make a mosaic collage, on a 9" x 12" sheet of paper, of 1" squares cut from colored paper or magazines. Explain that they will achieve unity through the repetition of pieces of similar shapes and sizes.

students to look through this book, select an artist that they think might have influenced Kelly's art, and explain similarities to Kelly's style. Possible influences would be Matisse, figs.2–38 and 12–26; Mondrian, fig.7–14, and Miró, fig.2–8.

- The **Discuss it** can be expanded by letting students create their own advertisement. They can do this by cutting out one object from a magazine to be the dominant object and positioning it on white paper. Suggest that they use markers to write copy and draw subordinate elements.

Discuss	page 156

Materials
- magazines that contain automobile advertisements
 optional:
- 9" x 12" white paper
- scissors
- glue
- markers

Lesson 3
Repetition of Visual Units

pages 158–159

Objectives

Students will be able to

- Perceive and comprehend how repetition of visual elements creates unity in designs.

- Demonstrate their understanding of unity by repetition in their own paper mosaic collage.

Teach	page 158

Materials
- colored paper or old magazines
- scissors
- glue
- rulers
- pencils
- 9" x 12" white paper

Lesson 4
Use of Color

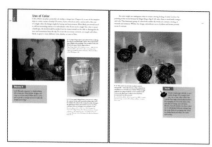

pages 160–161

Objectives

Students will be able to perceive and comprehend how color can unite an artwork.

Teach

- Focus on the use of color in the images on pages 160–161. Ask students if the color is realistic, and how the color unifies the art. Guide students to see the analogous color scheme in *Madame Camus* (fig.8–12) and to note how this unites the whole composition. At first glance

the students should notice the many variations of red in the background, the dress, and the furniture upholstery. Bathed in the red glow from a fire, Madame Camus—a skilled pianist and doctor's wife—holds a Japanese fan symbolic of both her and Degas' interest in Japanese art. The casual, asymmetrical composition of this painting with the objects cropped by the picture frame (the gilt mirror, statue, footstool, and chair) also indicates Degas' fascination with Japanese art.

- Extend **Discuss it** by suggesting that students use the ads to create a poster that illustrates unity through color.

Discuss it	page 160

Materials
- old magazines
 optional:
- 14" x 22" posterboard
- scissors
- glue

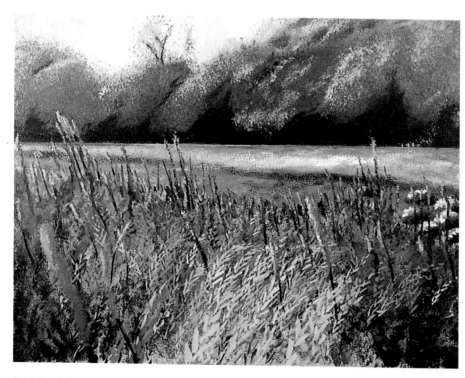

Selah Lynch (age 14). *Field of Purple*, 1997. Acrylic, 18" x 24" (45.7 x 61 cm). Palisades High School, Kintnersville, Pennsylvania.

Lesson 5
Use of Color

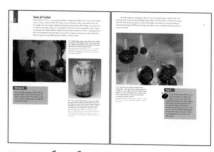

pages 160–161

Objectives

Students will be able to create a landscape, still life, or geometric design unified by color.

Teach

- Have students do **Try it** on page 161. If students wish to create a still life, set one up in the classroom. If they wish to create a landscape, suggest that they either sketch outdoors, if feasible, or portray a view from a window.

- To expand the **Try it** to two or three class periods, students can paint the landscape or still life and use a larger background (15" x 20" illustration board or 18" x 24" pastel paper).

Try it	page 161	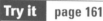

Materials
- 9" x 12" drawing paper
- colored markers or pencils
 optional:
- objects for a still life
- painting media such as tempera or acrylic paint, water, brushes; or pastels

- Point out to students that Henrietta Bailey purposely created the vase in fig.8–13 from southern clays and depicted plants that were indigenous to her region. As part of the American

Arts and Crafts Movement of the early 1900s, each piece produced in the Newcomb Pottery studio was different. These artists did not want their designs to look like they had been mass produced.

Matt Regonini (age 16). *Self-portrait*, 1997. Magazine collage, 13 ½" x 11 ½" (34.2 x 29.2 cm). Oakmont Regional High School, Ashburnham, Massachusetts.

Computer Connection

With drawing or painting software, students should create a square approximately one inch in size. Guide students to enlarge the square 400 percent, and then to create a free form design within the square. Upon completion, reduce the square back to its original size. Students then select, copy, and paste their small but detailed drawings across the screen. Suggest that monotony can be avoided by incorporating resized designs into the arrangement. Ask students to experiment with other elements to create interest. After students print their designs, discuss how unity is created through repetition of a visual unit. Call on students to suggest some of the many ways that variety can balance monotony without endangering unity.

Lesson 6
Surface Quality

pages 162–163

Objectives
Students will be able to perceive and understand how a dominant surface quality can unify an artwork.

Teach
- Lead students in comparing the texture in Cézanne's painting (fig.8–15) with that in Helen Frankenthaler's painting (fig.6–25), which she created with washes of oil paint thinned with turpentine. Remind students that this overall use of texture unifies a painting.

- After students have considered the surface texture of Cézanne's painting, teach them that in addition to the characteristic texture of his canvases, Cézanne usually simplified shapes in his paintings. Notice how the houses have become rectangles and the forms of plants and mountains have been reduced to spheres, cylinders, or cones. He also changed the perspective of the planes of objects. From these precepts Picasso began to develop Cubism and thus Cézanne became known as the father of modern art.

- Ask students to describe the surface texture of Noguchi's *Humpty Dumpty* (fig.8–17) and the texture variations of Bailey's *Vase* (fig.8–13). Assist students in comparing these textures to the texture of *Normandie, 1935* (fig.8–2). Ask how the texture unifies each design.

- Discuss with students the influence of Japanese, American, and European cultures on Noguchi's work. In addition to Gutzon Borglum, he also studied with the Romanian abstract sculptor, Constantin Brancusi. He understood Cubism and the simplification of forms. Many of Noguchi's stone carvings seem related to the quiet contemplative nature of traditional Japanese garden art.

- Instruct students to do **Try it** on page 162. They may make a clay tile, pot, or simple sculpture form and cover its surface with a texture by using techniques such as scraping with a serrated tool or comb, or indenting with the end of a plastic straw. If students make a coil pot, they might choose to create texture by leaving the coils exposed on the outside surface. Another option for this **Try it** is a drawing with a fingerprint texture. To do this, have students ink one fingertip on an ink pad and then press the fingertip repeatedly on white paper to create a drawing. Instruct students to concentrate on showing areas of shadows, not lines.

154f

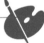

Try it　page 162

Materials
options:
- materials for drawing, painting, or printing media
- clay (any type) and clay tools
- ink pads
- 12" x 18" white paper

Chapter Review

pages 164–165

Assess

• Assign students to write the answers to the questions in the chapter review.

• Lead a class discussion about unity using their written answers to the review questions. As you go over the answers to these questions with the class, check to see that the students understand the major concepts about unity.

• Begin the class discussion by encouraging students to describe examples of unity that they see around them other than in artworks. They may list examples such as team uniforms or matching furniture in the classroom. Ask why people try to create unity in their environment; then review their answers to question 1 about why artists strive to create unity in their artworks. During this whole discussion they should indicate an understanding and appreciation of why humans strive for harmony and unity in their environment and in art. **(Aesthetics)**

• By listening to the students discuss their answers to questions 2–5, you may verify that they understand how the use of a dominant element such as color or texture and the repetition of shapes and forms can unify an artwork. **(Art criticism)**

• In the class discussion focus on questions 6 and 7. Then to determine that the students do perceive and appreciate how artists of various cultures and styles—including German Expressionism and twentieth-century American abstraction—create unity within their works, ask them to describe how Kollwitz and Noguchi unified their works of art in figs.8–7 and 8–17. **(Art history/cultures)**

• Review with each student their portfolio created in this chapter to determine that he/she created artworks which demonstrate an understanding of unity or harmony. **(Art production)**

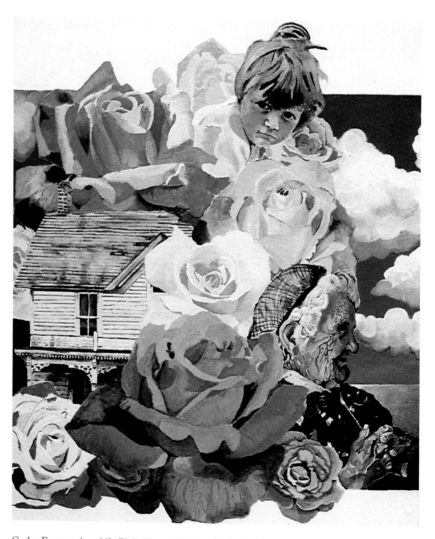

Carlee Freeman (age 16). *Eighty Years*, 1997. Acrylic, 24" x 30" (61 x 76 cm). Asheville High School, Asheville, North Carolina.

Reteach

- Review with students the reasons why artists and designers strive to create unity in their works. To reiterate ways that artists create unity, ask students to look at the images on pages 164–165 and then write or tell what means the artist used to unify each work. Guide students in determining the dominant element in each piece. (Soto [fig.8–18] and Miller [fig.8–19] used color. Lipchitz [fig.8–20] used repetition of form.)

- As students consider how Lipchitz created unity in his sculpture, inform them that Jacques Lipchitz shared his friend Pablo Picasso's interest in African art and Cubism. His sculptures were often geometric forms incorporating negative space.

- Encourage students to look back through the book and select an image that they think demonstrates a particularly effective sense of unity. Assign students to write a paragraph that describes this work of art and the means that the artist used to create unity in it. Have each student read his or her paragraph to small groups.

Answers to Review Questions

1 Artists often want their art to have a feeling of wholeness or harmony.

2 Four ways to create unity are to make one element dominant, repeat visual units, use monochromatic or analogous colors, and use a similar overall surface quality.

3 The dominant element is the major element in a design, whereas the less emphasized elements are the subordinate elements. Examples chosen by students may vary.

4 All the images on pages 158–159 repeat shapes to create unity, but students might name other images throughout the chapter.

5 All of the images on pages 162–163 use texture to create unity, but students might name other images throughout the chapter.

6 Kollwitz was inspired by a banned play, *The Weavers*, which dealt with the 1844 revolt of Silesian weavers who had lost their jobs.

7 With parents from Japan and the United States, Noguchi had ties to both countries. He studied in the United States, but he drew inspiration from the natural world, particularly Japanese settings.

Meeting Individual Needs

Students Acquiring English

Use familiar ideas or themes to convey the meaning of unity in works of art. Discuss with students their interpretations of the chapter vocabulary. The use of cultural cues (such as the "family") or subjects (such as a soccer team) can enhance the understanding and the meaning of unity as a design principle.

Students with Special Needs

ADHD

Students with behavioral problems will often respond to learning activities that are developmentally and creatively appropriate, and activities that use media not likely to frustrate them. For both comprehension of and success in an activity (such as the **Discuss its** on pages 156 and 160), have students cut out advertisements that depict their favorite sport, music, or fashions. Allow for a wide variety of both relevant and stimulating subject choices, as long as the goal is accomplished and the work is completed.

Gifted and Talented

Have students work independently or in small groups to design a floor plan of an artroom that will demonstrate their understanding of unity. In the drawing, students should arrange furniture, workstations, and equipment to create dominant and subordinate elements. Suggest to students that they analyze and discuss their work with their classmates.

8 Unity

YOU'VE PROBABLY HEARD A COACH or the school principal talk about teamwork or school spirit. He or she knows that a group can produce a much better result when all members work toward a common goal or purpose. When parts combine to create a sense of oneness, they display *unity*. Examples of unity are all around you. An aquarium might hold a number of fish that vary in color, texture, form, and size. However, what unifies these differences is the fact that all the creatures are fish. A successful dogsled team or tug-of-war players also display unity. Without unity, the dogs would run in different directions, and the tug-of-war players would not all pull at the same time.

Chapter Warm-up
Point out some familiar examples of unity: similar furniture might be seen in the artroom; uniforms worn by the school's sports teams unify the appearance of individual members. Have students look at the windows or other architectural features in the artroom and note whether their arrangement seems to harmonize with the overall design of the school building. Explain that artists and architects often try to make all the parts of whatever they design blend together into a unit. Ask students to think of other examples of unity in the design of their school or in that of other community buildings. For example, perhaps the same materials have been used throughout the building, or a type of plant has been repeated in the landscape design.

8–1 Architects often work on a grand scale, so it is essential that they incorporate design elements that serve to unify the whole.
Richard Meier (b. 1934) & Partners, *J. Paul Getty Museum*, 1997. The museum's entrance façade, seen from the tram arrival plaza at the Getty Center. Photo by Tom Bonner.

8–2 This pitcher is an example of the sleek, smooth style that dominated American art in the 1930s. The continuous lines of the piece and its unadorned surface make its unity both simple and perfect.
Peter Müller-Munk (1904–67). *Normandie, 1935*, c. 1935–41. Designed for the Revere Copper and Brass Company, Rome, New York. Chrome-plated brass, 12" x 9 ½" x 2 ¾" (30.5 x 24.1 x 7 cm). The Toledo Museum of Art. Purchased with funds from the Florence Scott Libbey Bequest in memory of her father, Maurice A. Scott, 1991.86.

Internet Connection
Ask students to search on-line for international commentary about the Getty Center in Los Angeles when it opened in the fall of 1997. Students should gain an understanding of architect Richard Meier's concern for unity of this structure with its surrounding environment (the museum is perched on a hill high above Los Angeles). Students can broaden this project to include a review of the materials used in the interior of the museum located at the Center. How do the materials reflect the desire for harmony between the art collection and the display area?

Artists are concerned with unity. They want their work to have a feeling of wholeness or harmony, and they achieve this when all the parts of a design work together. For example, an architect wants the windows, doors, roof, and walls of a building to look as if they belong together. If the parts don't work together, the result will be chaos and disorder. An artist can achieve a single, harmonious design in many ways, including the use of color, texture, and repetition of shapes or forms.

8–3 What design element helps unify this painting?
Gwen John (1876–1939). *A Corner of the Artist's Room, Paris,* 1907–09. Oil on canvas, 12 ½" x 10 ½" (31.7 x 26.7 cm). Sheffield Galleries and Museums Trust. Sheffield City Art Galleries/Bridgeman Art Library, London/New York.

8–4 At first glance, determining how an artwork is unified can be difficult. Careful examination allows the viewer to understand the way a design holds together.
Charles Rennie Mackintosh (1868–1928). *The Scottish Musical Review,* 1896. Lithograph, printed in color, 97" x 39" (246.3 x 99 cm). Glasgow Museums: Art Gallery & Museum, Kelvingrove.

THE SCOTTISH MUSICAL REVIEW

PUBLISHED ON THE 1ST OF EACH MONTH
PRICE TWO PENCE

Dominance

One way to achieve unity in a design is to make a single visual element play a major part. This element is then said to have **dominance** within the design. For example, an artist might create a sculpture from a single material that dominates and unifies the surface, or a painter might create a work with one color that occurs throughout most of the composition, creating a certain mood and unifying the parts.

Because a design sometimes needs variety, an artist may add other materials to a sculpture or more colors to a painting. These lesser parts are said to be **subordinate**, or secondary: they can both support the dominant subject and add variety to the design.

Look at Ellsworth Kelly's *Blue on White* (fig.8–6), which is clearly a single unit. The artist used one major shape and a single color that dominates and provides a sense of wholeness. The unusual shape of the painting creates an exciting relationship between the positive and negative spaces, and supplies the design with the necessary variety and interest.

8–5 Which elements in this painting would you call subordinate?

Ellis Wilson (1899–1977). *Field Workers.* Oil on masonite, 29 ¾" x 34 ⅞" (75.6 x 88.6 cm). National Museum of American Art, Smithsonian Institution, Washington, DC/Art Resource, NY.

8–6 Some works of modern art are called minimal because they make use of very simple shapes, forms, and color combinations. These works rely on the principle of dominance for their effect.

Ellsworth Kelly (b. 1923). *Blue on White*, 1961. Oil on canvas, 85 ⅝" x 67 ¾" (217.5 x 172.1 cm). Gift of S. C. Johnson & Son, Inc. National Museum of American Art, Smithsonian Institution, Washington, DC. Photo: NMAA, Washington, DC/Art Resource, NY.

Discuss it

Look through magazines to find several car advertisements that show one car in a dominant location in the composition. Discuss how all other features are subordinate to the dominant form and color.

Design Extension

Set up a still life in the artroom, using a few simple objects. Challenge students to create still-life collages from pieces of colored paper. Students should choose one object as the composition's center of interest. Have them tear the edges of their papers to represent all the objects except the chosen one; then cut clean, hard edges to focus attention on the center of interest. When their compositions are completed and glued together, display several of the artworks. Lead a discussion of dominance within the collages, focusing on whether the edge technique successfully created a sense of dominance for the chosen subject. How did the use of color affect the success of the compositions?

Käthe Kollwitz
Attack

Have you ever had strong feelings after seeing a movie or a play? Perhaps you later wrote about your feelings or created an artwork based on what you saw and felt.

One person who often worked with ideas based on what she observed firsthand was the German artist Käthe Kollwitz (1867–1945). One of her greatest works, a series of prints (etchings and lithographs) called *The Weavers' Uprising*, was based on a play she had seen.

The play *The Weavers*, written by Gerhart Hauptmann, was about the 1844 revolt of weavers who lived near the German-Polish border in Silesia and worked, in traditional style, on hand looms. Because of the industrial revolution, they were no longer an essential link in the economic chain, and their lives had become filled with hardship and suffering.

Although the play was banned from public performance in Berlin, it was performed in secret, beginning in 1893. Kollwitz may have attended the controversial play more than once. She made a thorough study of all available information about the revolt as she sketched ideas for her six-part series. Kollwitz created many preliminary studies and etchings before completing the work. Not content with all the etchings, she remade the first three images as lithographs, in a very unusual combination of techniques within a single series.

The first print, *Poverty*, shows a grieving mother attending her starving child, who is bedridden in a tiny room. The second is *Death*, which portrays parents and child with a skull-faced figure in the background, signifying death's presence; a single candle illuminates the cramped space. In *Deliberation* (also known as *Conspiracy*), the third print, Kollwitz expresses the urgency of a small group meeting to decide what must be done about the crisis their lives had become. The fourth print in the series, *Weavers on the March*, shows anger and determination as the

8–7 This print is part of a series that tells the story of an 1844 uprising of linen weavers in the German province of Silesia. How does Käthe Kollwitz use dominance to communicate the tension and emotion of the protest?

Käthe Kollwitz (1867–1945). *Attack (Sturm)*, from *The Weavers' Uprising (Weavers' Riot)*, 1897. Etching. Reproduced from the collections of The Library of Congress.

community of weavers heads toward the source of their oppression with a few farm tools as weapons. *Attack*, the fifth print, pictures the weavers storming the gate of the factory owner's villa. Women bend to dislodge stones from the roadway, handing them to the men to throw. Their weak attack is unsuccessful. In the final print, *The End*, a soldier's bullet has killed another of the impoverished weavers, whose body lies on his cabin floor.

Kollwitz presented the prints to her father on his seventieth birthday. He died shortly thereafter, and she was upset that he would not be able to see them at a public exhibition. She postponed public debut of *The Weavers Uprising* for over a year until 1898, when the epic work caused a sensation at the Berlin Art Exhibition.

Inquiry

Have students locate in the library the other five images in *The Weavers' Uprising* series. Does anyone think Kollwitz's decision to use lithography for the first three images affects the overall unity of the series? If so, in what way?

Context

Born in Mayfield, Kentucky, Wilson (fig.8–5) received his training at the Art Institute of Chicago. He expanded and enriched the basis of his subject matter—which focused on African Americans —after he won a $3,000 award in the early 1950s. The money allowed him to travel to Haiti, where he found new sources of inspiration. During his stay in Haiti, he painted *Field Workers*.

Repetition of Visual Units

Have you ever noticed that buildings within certain neighborhoods go well together? Or that one structure seems more unified than other buildings nearby? If so, you were responding to the repetition of visual units. For example, a high-rise structure may have rectangles and squares repeated over its surface, or the houses in a neighborhood might have similar shapes or be made of the same materials.

8–8 Analysis of this work will reveal a variety of repeating shapes. Can you find a shape that does not repeat?

Frank Stella (b. 1936). *Raqqa II,* 1970. Synthetic polymer and graphite on canvas, 120" x 300" (304.8 x 762 cm). North Carolina Museum of Art, Raleigh, Gift of Mr. and Mrs. Gordon Hanes.

8–9 Some buildings have more repeating visual units than others. Is there any repetition of architectural elements on your school building?

Richard Rogers (b. 1933), *Façade of Lloyds Bank,* London, detail, 1994. ©Oliver Radford.

Artists use repetition of visual units to develop a feeling of unity within a design. For example, an artist might repeat certain shapes in a textile design, or a photographer might frame a composition so that similar shapes or values are repeated. However, artists are aware that too much repetition of a single feature can produce monotony. Therefore, to add some variety, an artist might repeat a shape but give each a slightly different color or size, or he or she might repeat a color within a slightly different shape. If used carefully, such variations will increase interest but not disturb the unity of a composition.

8–10 The Nasca were an Andean people whose culture flourished from 100 to 700 AD in what is modern-day Peru. Repetition was an important part of their textile, as well as their ceramic, designs.

Tunic with animal motif, 600–700 AD, Nasca, Peru. Camelid fiber, dovetail tapestry weave, 22 ½" x 30 ¼" (56 x 77 cm). Dallas Museum of Art, 1970.20.MCD. The Eugene and Margaret McDermott Fund.

Materials and Techniques

By 400 BC, all weaving techniques in ancient Peru were fully developed. In the late Nasca period (600–700 AD), tapestry was the dominant technique. The ancient Andeans used relatively simple equipment in the creation of their extraordinary textile work. They often made cotton yarn with a spindle that they rotated in one hand while pulling from a cotton roll with the other hand. To weave the cloth, they used a continuous warp. The heddle was developed in ancient Peru before 400 BC, and the Andeans probably used an upright loom for wide pieces of cloth or for techniques requiring stationary tension. They also made use of portable looms when producing small pieces of cloth.

159

8–11 In this aerial photograph of a beach, circular umbrellas and rectangular towels repeat across the design. The variety of colors and positions creates visual interest.

Fred Ward (b. 1935). *Aerial, Beach*, c. 1966. Print. Courtesy of the artist.

Inquiry

Assign students to find several different artworks by either Frank Stella or Ellsworth Kelly, and to note the colors and shapes that the artists used to create unity. Encourage a discussion that compares unity in each of the artists' compositions. Guide students to see that Stella's later works are in a style different from the hard-edged art he created in the 1970s.

Use of Color

Color, which can play a powerful role within a design (see Chapter 4), is one of the simplest ways to create a sense of unity. Of course, if you covered an entire canvas with a flat coat of a single color, the design might be boring and monotonous. Most likely, you would need to add an interesting texture or a subordinate color. If you used a single blue color to paint a landscape, the work would be unified, but the viewer would not be able to distinguish the trees and mountains from the sky. To create the necessary contrasts, you might add white, black, or gray to create different tints, shades, or tones of blue.

8–12 Edgar Degas spent a great deal of time studying the effects of artificial light, and he often explored this type of light in his paintings. How would you describe the interior space that he depicted here?

Edgar Degas (1834–1917). *Madame Camus,* c. 1869–70. Oil on canvas, 28 ⅝" x 36 ¼" (72.7 x 92.1 cm). Chester Dale Collection. ©1998 The Board of Trustees, National Gallery of Art, Washington, DC.

Discuss it

Look through magazines to find clothing advertisements. How did the designer use color to achieve unity? What did he or she add to produce enough variety to make the design interesting?

8–13 Newcomb College Pottery was part of a college for women. In the early twentieth century, there were few choices for women who wanted to make a living in the field of art. Pottery decoration was one way they could put their art training to use and earn a wage.

Henrietta Bailey (1874–1950). *Vase,* 1916. Designed for Newcomb College Pottery, New Orleans, Louisiana. Painted earthenware, 10" high (25.4 cm); 7 ½" diameter (19.1 cm). Carnegie Museum of Art, Pittsburgh. John Berdan Memorial Fund, 81.53.

Inquiry

Henrietta Bailey completed the vase in fig.8–13 in New Orleans during the Arts and Crafts Movement in the early years of the twentieth century. She decorated this vase with trees draped with the Spanish moss typical of the South. Assign students to discover more about the Arts and Crafts Movement, and to find examples from this period of other pottery and furniture that use color to unify the design.

An artist might use analogous colors to retain a strong feeling of unity. Look at the painting of the seated woman by Edgar Degas (fig.8–12), who chose to work with oranges and reds. This dominant group of colors both unifies the work and conveys a feeling of warmth and intimacy. Within the design, subordinate areas of yellow and brown provide areas of contrast.

Higher-Order Thinking Skills

Ask students to find three images in other chapters which demonstrate different ways artists can create unity through color.

161

8–14 This artist's use of color to achieve unity is indisputable—what other features of his composition contribute to an overall sense of unity? What message might he be trying to help the viewer to understand? Can you also find ways in which variety has been incorporated into this artwork?

Kenneth B. Haas III (b. 1954). *Emerald City*, 1998. Computer-generated image created in PhotoShop and Bryce. Courtesy of the artist.

Try it

Create a landscape, still life, or geometric design. Use a single color, plus one or two other colors that contain that single color in their mixture. For example, use red as the main color, and add red-orange and red-violet. Because they all contain red, these colors can be intermixed without endangering the unity. Even if you change the values by adding black and white, the unity will remain.

Context

Funding of an art class that would produce a salable product was considered a novel experiment in 1895, when Sophie Newcomb Memorial College for Women did just that. The resulting enterprise became known as Newcomb College Pottery. Henrietta Bailey was one of many women who decorated the wares produced at the pottery. The blue-and-green tree with Spanish moss on Bailey's vase was the pottery's most popular motif. Activity at the pottery continued through the early 1940s.

Inquiry
Photographers some-
times employ an overall
texture to unify a com-
position and set a
mood. They may print
their photograph with a
grainy linen weave or
brushstroke filter. Ask
students to find exam-
ples of these photo-
graphic techniques in
magazines.

Surface Quality

Texture or surface quality is an important element of any design (see Chapter 6), and artists can use texture to develop a feeling of unity. For example, a painter might create a dominant surface quality by using similar brushstrokes on all parts of a work. The strokes might be wet, wide, thin, or transparent. Another painter might use a palette knife to make the paint look as though it had been buttered onto the canvas. Look at the work by Cézanne (fig.8–15), and then turn back to view a work by Seurat (fig.4–23) and one by van Gogh (fig.1–9). Note that consistent strokes unify the surface in each of these designs.

A sculptor might unify a work by using a single material. For instance, the rough or smooth quality of that material can impart an overall dominant texture to the piece. Or the sculptor might alter the surface quality of the piece with fingerprints, scratches, tool marks, and indentations. If these alterations cover much of the surface, they also can provide a characteristic that unifies the different parts of the sculpture.

To keep a design from losing visual interest, an artist might slightly vary the surface quality of a piece. A painter who uses similar brushstrokes might include a variety of colors or values. A sculptor or architect might include quiet areas in which the texture is reduced or not apparent. Similar to the use of color or repetition, the dominant surface quality will give each design a feeling of wholeness or harmony—and the added variations will help capture and hold a viewer's attention.

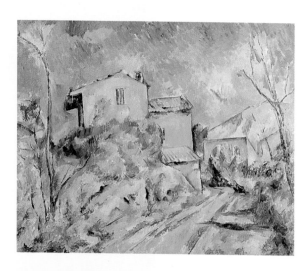

Try it

Create a simple drawing, painting, print, or ceramic piece in which the entire surface is united by a similar texture. For example, you might use only vertical lines to create texture in a drawing, or you might use a single tool to create texture in a clay sculpture. Examine and analyze the texture in your finished piece, in the works by other students, and in the images in this chapter.

8–15 Notice how Cézanne applied the paint in separate strokes. Experts believe that in this painting, Cézanne used a different shade of color every time he put his brush to the canvas. The unity of the work is visible in the consistency and clarity of each brush-stroke.

Paul Cézanne (1839–1906). *Maison Maria with a View of Château Noir,* c. 1895–98. Oil on canvas, 25 ⅝" x 31 ⅞" (65 x 81 cm). Acquired in 1982. Kimbell Art Museum, Fort Worth, Texas. Photo by Michael Bodycomb.

8–16 How has this student created unity of surface quality in his artwork?

Stephen Harris (age 16). *In Human Bondage,* 1996. Mixed media on multisurface, 30" x 40" (76 x 101.6 cm). Lake Highlands High School, Dallas, Texas.

Isamu Noguchi

Perhaps Isamu Noguchi did not choose to be a sculptor, but instead, sculpting "chose him." Born in Los Angeles in 1904 of an American mother and Japanese father, Noguchi spent his early years in Japan, but he returned to the United States at the age of thirteen. When he completed high school and was asked what he wanted to do next, he responded, "Be an artist." He surprised even himself with this answer: Noguchi's only experience making art had been a few years earlier in Japan, where he created a garden, did woodcarving, and studied woodworking.

Having taken a friend's advice to go to medical school, Noguchi had begun premed courses at Columbia University, when (at his mother's suggestion) he wandered into the Leonardo da Vinci Art School. Despite his lack of enthusiasm for sculpting, Noguchi was offered a scholarship by the school's director. After three months of studio work, Noguchi successfully exhibited his art, left medical school, and became a sculptor.

Known best for his sculptures in stone, Noguchi experimented and explored many media and techniques during his long life. He made drawings; practiced brush and ink; became a costume designer, industrial designer, landscape architect (of designs that ranged from intimate gardens to monumental earthworks), stage-set designer, and furniture designer. He sculpted in clay, wood, metal, paper, bamboo, water, and light. Noguchi was so versatile that critics became frustrated trying to explain his style.

In 1961, Noguchi established a studio and living quarters in a former factory building in Queens, New York. In 1981, he bought adjacent land and began design and construction of the Isamu Noguchi Garden Museum, which opened to the public in 1985. Today, the museum maintains a Web site (www.noguchi.org) that posts information about Noguchi's life and work.

Just before his death in 1988, Noguchi created plans for a 400-acre park in Sapporo, Japan. He was an artist who drew his inspiration from the natural world, particularly Japanese settings. Always thoughtful about the meaning of sculpture, Noguchi desired to make sculpture a part of daily life.

8–17 The unusual title of this work refers to the great skill and patience required to create the single, seamless surface of each interlocking piece of brittle slate.

Isamu Noguchi (1904–88). *Humpty Dumpty*, 1946. Ribbon slate, 58 ¾" x 20 ¾" x 18" (149.2 x 52.7 x 45.7 cm). Collection of the Whitney Museum of American Art. Purchase, 47.7.

Context

The late landscape by Cézanne (fig.8–15) depicts one the artist's favorite locales, the countryside just east of Aix-en-Provence, in the south of France. The two buildings mentioned in the title are the house on the left (Maison Maria) and the building at the turn of the road (Château Noir). One of Cézanne's most-repeated geographical motifs, Mont Sainte-Victoire, is visible in the distance on the right.

Higher-Order Thinking Skills

Point out to students that surface quality is a very important component of all sculpture. Ask each student to choose two scultupres in the text and describe how the artist has used texture to unify the work.

Another Look at Unity

8–18 Jesús Soto used many lines to create this artwork. What unifies the work despite its many individual parts?

Jesús Soto (b. 1923). *Esfera de Japon*, 1985. Paint, aluminum, and metal, 177" x 177" x 177" (450 x 450 x 450 cm). Courtesy of the artist. Photo by Luis Becena.

Note it

Start a clip file of art and graphic-art reproductions. With each reproduction, write a short statement about the unifying element, as well as the elements that create interest through variation. These could be pasted in a notebook, scrapbook, or sketchbook; filed in envelopes; or organized in page protectors in a binder.

8–19 This twirling, dynamic composition keeps our eye moving from one part of the painting to the next. What element of design did the artist use to unify the work?

Melissa Miller (b. 1951). *Salmon Run*, 1984. Oil on linen, 90" x 60" (228.6 x 152.3 cm). Shirley and Thomas J. Davis, Jr. Courtesy of the Lyons Matrix, Austin, Texas.

Design Extension

Interior decorators usually unify their designs. Ask students to look through interior-decorating magazines and analyze how decorators have created unity in their rooms. Using colored pencils or oil pastels, students may draw a variation of a room pictured in a magazine, adding colors, textures, or other elements in order to further increase the sense of unity. Encourage imaginative approaches; for example, the texture of a carpet could be repeated on a wall or ceiling.

8–21 How has this student achieved unity in her work?

Sharon Hess (age 16). *Paperclips.* Watercolor and felt tip, 18" x 24" (45.7 x 61 cm). Montgomery High School, Skillman, New Jersey.

8–20 Compare this sculpture to Soto's (fig.8–18). Can you name at least two similar ways in which these artists unified their work?

Jacques Lipchitz (1891–1973). *A Song of the Vowels*, 1932. Bronze, 156" high (396.2 cm). Sculpture Garden, University of California, Los Angeles. Photo by A. W. Porter. ©Estate of Jacques Lipchitz/Licensed by VAGA, New York, NY/Marlborough Gallery, NY.

Context

Although Miller focuses her work on the depiction of animals, both common and exotic, she did not start her career by doing so. After completing her B.F.A. at the University of Mexico, she moved to an area outside of Austin, where she concentrated on painting the Texas landscape. Soon she became much more interested in painting the local animal inhabitants, as well as barnyard animals. In *Salmon Run* (fig.8–19), Miller focuses on wild animals and juxtaposes the frantic movements of the salmon running upstream with the lumbering, but swift, actions of the bears as they feed on the fish.

Interdisciplinary Connection

Social Studies—Lead students in a discussion to consider the efforts of the United Nations to build unity and harmony throughout the world. Assign students to create posters that stress the unity of humanity and world peace. Encourage them to use a means of unifying a design that they studied in this chapter.

Review Questions (answers can be found on page 154h)

1. Why do artists often try to create unity in their artworks?

2. List four ways to create unity in an artwork.

3. Explain what dominant and subordinate elements are in a design. Name an example of an image in this chapter that has a dominant element. Identify that element.

4. Name an image in this chapter that uses repetition of shape to create unity.

5. Select one image in this chapter that uses an overall surface texture to create unity. Describe the texture.

6. Explain what prompted Käthe Kollwitz to create her series of prints, *The Weavers' Uprising.*

7. With what two countries was Noguchi most closely associated? How did these cultures influence his work?

Career Portfolio

Interview with a Gallery Owner

An art exhibit is generally unified by theme or other similarities. **Bernice Steinbaum** specializes in women artists and artists from different cultural and ethnic backgrounds. She helps build the careers of the artists she represents by making sure their work is seen by the public, and by acting as an agent for the sale of their work. Her gallery is in New York City.

How did you start your art gallery?

Bernice I studied art history; then taught. I was concerned that we were graduating college students with none of them able to get jobs in their chosen area of study. So I told my chairperson, "We have to add some different areas of study to the curriculum. We have to include museum studies, curatorial studies for children's museums," and other things I felt the university was ignoring. She said, "What are you complaining about? Your job pays your rent." That was devastating to me because I did not want to define my life as a way to pay the rent.

So, I said, "Okay, I'm going to open an art gallery." I took the work of artists that I had collected personally, and opened with a group show. I called *The New York Times*, and in my innocence—I would not have the courage now because I know too much—I called an art critic and said, "Listen, I read your writing every week, and it seems to me you should see what I'm about! And make sure you bring your cameraman." Sure

enough, she came, she did bring her cameraman, and she photographed this group exhibition. I got a full page in *The New York Times* art section, and I was in business.

How did you get interested in art?

Bernice I think one becomes obsessed with it. I guess I need a lot of visual stimulation. I think artists make magic, and for the rest of us—who can view their magic, no less get into the rooms where the potions are made—it's quite extraordinary. It gets me a tiny step closer to the magic.

As an art dealer, I often get to go to the studio prior to the rest of the world seeing the work. Occasionally, I get asked my opinion, and I find that very awesome. But I'm just as content to see it before everybody else, to be able to dream about and think about it and talk about it.

What advice would you give to young people who want to own a gallery some day?

Bernice Do not go into this because of money; go into it because of the passion—and that's sincere. I would

tell them to learn as much art history as they can. It's the discerning eye that makes the difference between good artists and other artists. I would tell them that working as an intern in a gallery during the summer or a Christmas vacation is an absolute must.

I think they have to see a lot of art—that means every show that comes through their town. Find out what the local museum schedule is, and look at their permanent collection. Become a member and hear the artists they're showing speak about their work. If they're very interested in art, they should get an art publication like *Art in America* or *ArtNews*—they're both readable.

And then take the basics in college—Art History 101 and 102—whether they're interested in becoming an art professional or not. We tend to be visual illiterates; we don't know that something we're looking at is good unless we see it in writing. We don't trust our eyes. Sometimes, that trust comes when you've seen enough art.

Bernice Steinbaum's appreciation for art goes beyond the main gallery where the one-person shows take place. In her private office, shown here, the art on the walls are works of artists that she represents. She thinks of it as her personal museum where the works change regularly depending on what the clients have bought. Photo by Marilyn G. Stewart.

Studio Experience
Putting It All Together

Task: To create a painting that demonstrates unity and coordinates with other artworks.

Take a look.
Review the following images:
- Fig. 8–6, Ellsworth Kelly, *Blue on White*
- Fig. 8–8, Frank Stella, *Raqqa II*
- Fig. 8–17, Isamu Noguchi, *Humpty Dumpty*

Think about it.
Study the images listed above.
- How is unity created in each artwork?
- Compare and contrast these artworks. Which have similar shapes? Which have similar surface textures? Which are similar in color?
- If you were to arrange these artworks in an exhibit, how would you order them so that there would be a unity or flow to the exhibit? Explain the reasons for your arrangement.

Do it.
1 Select an image in this chapter, and determine what the artist did to create unity in the artwork. From another chapter, select an image that goes with or is similar to the first work. Write the title, artist, and medium of each piece, and explain how the two pieces are alike.

2 Create a painting that is similar to the two artworks you selected. Imagine that your painting will be grouped in an exhibit with the two pieces you selected. For example, you might have chosen two works that show a group of people going someplace and include a wealth of details about the location. In a similar style, you could paint friends going shopping or to a ball game. Or, perhaps the overall texture of brushstrokes and use of light in the two works would inspire you to use a similar brush texture.

"I used color, texture, and variety to create my self-portrait. To keep the flat shapes from being boring, I overlapped them to stress differences."

Sharon Kim (age 16). *Self-portrait*, 1996. Oil pastel, 15" x 20" (38.1 x 50.8 cm). Plano Senior High School, Plano, Texas.

3 Think about what you will paint. Make several pencil sketches on paper or in your sketchbook. Use the same method to create unity as did the artists whose work you selected.

4 Lightly sketch your design onto a 15" x 20" illustration board.

5 Paint your picture with acrylic paints. After it dries, you may wish to add details with a small brush or a fine marker.

6 When you have completed your art and checked it, display it with copies of the two artworks that you originally selected.

Helpful Hints
- Do not copy your selected artworks, but use them as inspiration to express your own ideas.
- Because acrylic paint will harden brushes if it dries on the bristles, clean your brushes often as you paint. At the end of the painting session, clean the brushes with soap and water, and store them with bristles up.
- Acrylic paints dry very quickly. If your painting style requires blending, slow down the drying time by adding an acrylic retardant.
- If you use brushstrokes that create a good deal of texture and you want the paint to be thick, add acrylic gel to the paint. Use a palette knife to transfer the gel onto your palette, and mix the gel with the paint.
- If desired, use masking tape to create straight edges in your painting.

Check it.
- While working on your painting and after you have completed it, set it up and view it from a distance. Check it for unity: do all the parts seem to go together? Rework the painting if it does not look unified.
- How did you create unity in your composition?
- How well does your work coordinate with the two artworks you selected?
- In what ways is your painting original?

Studio Experience
Putting It All Together

Sharon Kim. *Self-portrait*, 1996. Detail.

Prepare

Time Needed:
Three 45-minute class periods
(extend as needed)
Lesson 1:
Draw and plan.
Lessons 2, 3:
Paint.

Objectives

Students should be able to

- Perceive and appreciate how artists create unity in their artwork.

- Perceive and appreciate how certain artworks are similar.

- Demonstrate their understanding of unity by creating a unified painting.

- Select paintings with a common element, theme, style, or technique, and justify their selection.

Materials
- pencils
- 8 1/2" x 11" typing or copy paper, or sketchbook
- 15" x 20" cold-press illustration board
- acrylic paints
- brushes
- water in containers
- palettes
- markers
 optional:
- acrylic retardant
- acrylic gel
- palette knives
- masking tape (painters' grade) or drafting tape

Notes on Materials

- Test the masking tape by sticking it to and then removing it from a scrap of illustration board: some brands of tape will remove the surface paper of the illustration board. Drafting tape works well because it will not tear the surface.

- Cold-press illustration board, which has a tooth to its surface, is suitable for pencil and for acrylic and tempera paints.

- Although some brush cleaners can remove dried acrylic paint from brushes, the fumes can be hazardous.

Before You Start

You might have students do the preparatory sketches for their painting outside of class, as homework.

Teach

Thinking Critically

- Direct students to review the images and the questions in **Think about it**. Ask them to describe the mood in each work and how each artist's style contributes to it.

- To consider how important unity is in delivering the artist's message, call on students to describe how the unity and arrangement of each composition focuses their attention on what the artist considered important. Ask what each artist tried to emphasize and convey. Suggest they describe what each work might look like if it were not unified.

Classroom Management

- Divide the class into groups of three to four students. Assign one of the images in **Take a look** to each group, and have each group member write how unity was achieved in the artwork (a variation of the first question in **Think about it**). After members share their ideas with their group, have groups report to the class.

- Direct the groups to answer the last two parts of **Think about it**. Have each group draw on the chalkboard how they would arrange these works in an exhibit. Ask groups to explain their arrangement to the class.

- Group members may work together to set up their materials—such as paints, brushes, and water—and clean their area at the end of class.

Assess

Evaluation

- Have each student discuss the unity in his or her work either with you or with another student. Then encourage students to write the answers to the questions in **Check it**.

- Display each painting with photocopies of the two artworks that influenced the student's work. Have students arrange an exhibit of the paintings. Encourage them to group paintings with similar themes or dominant elements, such as color, and to explain their arrangement.

- Assign each student to write an explanation of what they were trying to achieve or communicate in their artwork. Then ask pairs of students to write what they believe to be their partner's message. Encourage the pairs of students to compare and discuss their responses to the art. Challenge the artists to suggest ways to clarify their messages.

Extend

Linking Design Elements and Principles

Rhythm

To emphasize how unity is created by repetition of elements, have students study Stella's *Raqqa II* (fig.8–8) to see how one form was repeated to generate a rhythm or movement. Teach students to create a cut-paper collage by repeating one geometric shape. Direct them to cut several sizes of circles, rectangles, or triangles from various colors of paper. Point out that spacing the same shape at regular intervals can create rhythm in a composition. Suggest to students that they move the paper shapes into several different designs before gluing them down. Their arrangement could become the design for their acrylic painting.

Color

To help students understand that they can easily unify an artwork by using just one color, instruct them to paint their picture with a monochromatic color scheme, which uses white, gray, and black mixed with a color to create various tints, tones, and shades of that color.

Line, Movement

Ask students to locate implied lines in Stella's *Raqqa II*. Particularly in the large circle on the right, lines are interrupted, but the viewer's gaze seems to continue where the line might have continued. Point out how lines carry the viewer's eye through the composition. Ask students to find other images in this chapter containing lines that direct the viewer's eyes to move through the composition.

Interdisciplinary Connection

Math

Students may design a gallery to exhibit the art in **Take a look**. They should make a scale diagram that shows the size of each artwork and its position and location in the gallery. Have them include their own acrylic painting in the diagram.

Inquiry

- Encourage students to interview people in their community who arrange displays, such as museum or gallery directors, retailers, window dressers, interior decorators, or florists. Direct students to ask these workers what their major considerations are as they arrange their displays, and how they decide what to include and which items will be next to each other. Have students write a report about their findings.

- Suggest that students research the art of one of the artists listed in **Take a look**. Students should research reproductions of the artist's works in books, on CD-ROMs, and on the Internet. After they find several different examples, ask students to describe the style and elements that the artist repeated among the compositions.

Chapter 9 Organizer

Contrast

Objective: Students will perceive and comprehend how contrasts of materials, line, shape, form, size, light, color, textures, time, styles, and ideas may be used effectively in artworks. (Art criticism)
National Standards: 2. Students will use knowledge of structures and functions. (2a, 2b)

Objective: Students will create pop-art sculptures and other artworks using contrasts of art elements, and time, style, or size. (Art production)
National Standards: 1. Students will understand and apply media, techniques, processes. (1b)

8 Weeks	1 Semester	2 Semesters			Student Book Features
1	1	1	**Lesson 1:** Contrast	Chapter Opener	
0	0	1	**Lesson 2:** Contrasting Materials	Contrasting Materials	Try it: collage or sculpture
0	0	1	**Lesson 3:** Line Contrasts	Line Contrasts	
0	0	1	**Lesson 4:** Line Contrasts	Line Contrasts	
0	0	1	**Lesson 5:** Using Shape, Form, and Size	Using Shape, Form, and Size	
0	0	1	**Lesson 6:** Contrasting Dark and Light	Contrasting Dark and Light	Try it: value study, About the Arti…
0	0	3	**Lesson 7:** Color Contrasts	Color Contrasts	Try it: experiment, Try it: drawing painting
0	0	1	**Lesson 8:** Contrasting Textures	Contrasting Textures	About the Artwork
0	0	1	**Lesson 9:** Contrasting Textures	Contrasting Textures	About the Artwork
0	0	1	**Lesson 10:** Contrasts of Time and Style, Contrasting Ideas	Contrasts of Time and Style, Contrasting Ideas	
1	1	1	**Chapter Review**	Another Look at Contrast	Review Questions
9	9	0			

Studio Experience: *Pop-Art Sculpture*

Objectives: Students will demonstrate their understanding of Pop Art sculpture by completing a successful work; identify concepts behind the Pop Art movement; compare and contrast Pop Art sculptures; identify materials and methods of construction.

National Standard: Students will conceive/create artworks demonstrating understanding of relationship of their ideas to media, processes, and techniques (1b); describe function and explore meaning of specific art objects from varied cultures, times places (4b); analyze artworks' historical, aesthetic, and cultural relationships, justifying and using these analysis conclusions in their own art (4c); conceive/create artworks demonstrating understanding of relationship of their ideas to media, processes, and techniques (1b).

Visual artists and designers create interest in their works by using contrasts of materials, lines, shapes, forms, sizes, dark and light values, colors, textures, time periods, styles, and ideas.

Objective: Students will perceive and appreciate how artists of various cultures and styles including Realist Rosa Bonheur, African, Baroque, Anasazi, Renaissance, and twentieth-century artists use contrasts in their art. (Art history/cultures)
National Standards: 4. Students will understand art in relation to history and cultures. (4b)

Objective: Students will understand and appreciate that contrasts in both their environment and in art may add interest, attract attention, set moods, and establish changes of pace. (Aesthetics)
National Standards: 6. Students will connect visual arts with other disciplines. (6a)

Teacher Edition References	Ancillaries
Warm-up, HOTS, Context	
HOTS, Context	*Slide*: Pomo, *Two Baskets* (CT-1) *Large Reproduction*: Stan Herd, *The Harvest*
HOTS, Context, Materials and Techniques	*Slide*: Y. Sekkei, *Scroll: Swallows* (CT-2)
HOTS, Context, Materials and Techniques	*Slide*: Y. Sekkei, *Scroll: Swallows* (CT-2)
Design Extension, Context, Performing Arts	*Slide*: Claes Oldenburg, *Giant Ice Bag* (CT-3)
HOTS, Context, Inquiry	*Slide*: Edouard Vuillard, *Self-portrait* (CT-4) *Large Reproduction: The Harpist*
HOTS, Context, Portfolio Tip, Interdisciplinary Connection	
HOTS, Context, Internet Connection, Interdisciplinary Connections	*Slide*: Teke, *Mask* (CT-5)
HOTS, Context, Internet Connection, Interdisciplinary Connections	*Slide*: Teke, *Mask* (CT-5)
Design Extension, Context, Inquiry, Cooperative Learning	*Slide*: Miriam Schapiro, *Mary Cassatt and Me* (CT-6)
Design Extension, Context, Interdisciplinary Connections	

Vocabulary

This chapter utilizes a number of the vocabulary words that were previously introduced.

Time Needed
Nine 45-minute class periods. Lesson 1: Sketch and plan; Lesson 2: Make the paper model; Lessons 3, 4: Cut and build basic cardboard structure; Lessons 5, 6: Cover cardboard structure with paper strips and allow to dry; Lesson 7: Paint structure white; Lessons 8, 9: Add colors and details.

Studio Resource Binder
9.1 Dada Assemblage, found object sculpture
9.2 Fabric Collage, contrast in textures
9.3 Inside Out, symbolic sculpture
9.4 Combining Animals and Machines, colored pencil surrealism
9.5 Self-portrait with Headgear, high-contrast graphite drawing

Lesson 1
Contrast

pages 168–169

Objectives

Students will be able to recognize contrast in their surroundings and in artwork.

Chapter Opener

- Have students work in pairs to write a list of the contrasts in each fine art image on pages 168–169. In Käsebier's *Blessed Art Thou Among Women* (fig.9–2), there are strong value contrasts. In *I Need Some More Hair Products* (fig.9–3), Chu not only contrasted colors, but also paired Asian and Western symbols. Point out that the reflection in the mirror is an Asian man, but ask students how he thinks of himself. Students may notice the chopsticks holding the hot dog and the Christian shrine behind the Buddhist offering. Ask students what clashes of cultures and ideas they perceive in this painting. In Metsu's *Woman at Her Toilette* (fig.9–5), contrasts of light and dark highlight the center of interest. The mask, *Ngaady a mwaash* (fig.9–4), demonstrates both material and texture contrasts.

- Inform students that the Kuba kingdom is in Zaire, Africa. Students should use the map to note which countries are near Zaire. Point out the cowries (shells) on the mask in fig.9–4 and the texture contrasts the artist has created by adding this

second material. Encourage students to compare the textural contrasts on this mask to the smoother African mask in fig.7–6.

Opener page 168

Materials
- map of Africa or world

- As students study fig.9–2, *Blessed Art Thou Among Women*, ask them when this photograph was taken. Gertrude Käsebier was a founding member of the avant-garde Photo-Secession group in New York City which was led by photographer Alfred Stieglitz (Georgia O'Keeffe's husband). This group was influential in establishing photography as an art form.

- Both Gabriel Metsu (fig.9–5) and Jan Vermeer were Dutch artists painting genre scenes during the 1600s. Challenge students to discover differences and similarities between Vermeer's art (fig.6–13) and Metsu's. How did each artist create contrasts in these compositions? Students should notice both artists' use of light and textures.

Beth Bailey (age 16). *Self-portrait*, 1998. Oil pastels on velour, 13" x 19" (33 x 48.3 cm). Asheville High School, Asheville, North Carolina.

- Guide students to see how the artist used light in *Blessed Art Thou Among Women* and in *Woman at Her Toilette* to create contrast, set a mood, and focus our attention on a person.

- During the next class period students will be making collages or sculptures of found objects. Assign them to collect interesting textures that they could incorporate into a collage or sculpture. These may range from sandpaper to fabric scraps, or even bits of wood.

Lesson 2
Contrasting Materials

pages 170–171

Objectives

Students will be able to

- Perceive and comprehend how artists combine contrasting materials in their art.

- Create a collage or sculpture of contrasting textures, shapes, and colors.

Teach

- Call on students to describe in their own words the contrasts found in each of the images on pages 170–171.

- When students consider the contrasts between natural materials and those made by humans in fig.9–6, share with them the information about the Anasazi as described in the **Context**. If any students have visited Mesa Verde National Park or

other cliff dwellings, encourage them to recount their impressions of these structures.

- Have students do **Try it**. Collect a variety of materials for students to use, perhaps including wood scraps from a cabinetmaker or building site, old toys, recycled manufacturing materials, and fabric samples. Depending on the weight of the materials, students may use white glue, craft adhesives such as Weldbond® or tacky glue, staples, or a hot-glue gun. Students might want to add acrylic paint to their sculpture or collage.

Try it	page 170

Materials
options:
- fabric scraps, scissors, glue, cardboard or wood base (for collage)
- found objects (for sculptures)

optional:
- craft adhesive or hot-glue guns
- acrylic paint and brushes

Lesson 3
Line Contrasts

pages 172–173

Objectives
Students will be able to

- Perceive and understand how artists use line contrasts in their works.

- Create their own wash drawings to which they will add a variety of lines.

Teach
- Lead students in studying the contrasts of line in the images on pages 172–173.

- As students consider the variety of lines that Leonardo da Vinci used in the drawing in fig.9–10, explain that this was just one of many studies that he made for *Madonna of the Rocks*.

- Encourage students to create a mixed-media portrait or still life. Students might take turns modeling with a spotlight shining on one side of their face. Give students several containers of various values of ink washes (india ink diluted with water) and a jar of water. Demonstrate how to create brush drawings with the washes. In the next class period, after the washes have dried, the students will add details with pen and ink, thin markers, or fine-tipped brushes.

Teach	pages 172–173

Materials
- spotlight
- india ink (AP approved)
- containers for washes and water
- 12" x 18" white paper
- brushes

Lesson 4
Line Contrasts

pages 172-173

Objectives
Students will be able to add details to their wash drawings using a variety of lines.

Teach
- Before students continue work on their drawings, encourage them to look at them from a distance, to see where contrasts of line and values will enhance their composition. Demonstrate using pen and ink, thin markers, or fine-tipped brushes to add details over the washes. Refer students to the illustrations on pages 172–173 to study how these artists added details. They may find it useful to research children's book illustrations to see other examples of the wash technique, which is often achieved with the use of watercolor.

Teach	pages 172–173

Materials
- wash drawings from Lesson 3
- drawing media such as markers, ink pens, fine-tipped brushes and ink

Lesson 5
Using Shape, Form, and Size

pages 174–175

Objectives

Students will be able to

- Perceive and comprehend how artists contrast shape, form, and size.

- Create a magazine photograph collage which emphasizes contrasting shapes and sizes.

Teach

- Ask students to look for contrasts in the images other than the student work. Help them notice the contrasts of organic and geometric shapes in *Espresso Server* (fig.9–16). Explain to the students that *Espresso Server* is part of the White House collection of American crafts. Silversmith Thomas Muir has combined figurative images with the forms of tools and machines. In the New York School exhibition catalog cover (fig.9–14), students will see contrasts of light shapes against a darker background. As they look at this piece of art, call on a student to read the text on page 175 aloud. Discuss optical illusions that are created by the use of large and small shapes.

- Direct students to cut out several contrasting shapes and different-sized objects from magazines and combine them in a collage to emphasize their contrasts. For example, students might glue a large, round apple in or near a small, angular house. Students may wish to add

background or details with markers. When they have completed their collage, encourage them to explain their contrasts to a small group of students or to the rest of the class.

Teach pages 174–175

Materials

- 15" x 20" illustration board or heavy paper
- old magazines
- scissors
- glue
- scraps of a variety of textured papers
- colored markers

Wheeler Munroe (age 14). *Untitled*, 1997. Collage, 9¾" x 12¾" (24.8 x 32 cm). Asheville High School, Asheville, North Carolina.

Lesson 6
Contrasting Dark and Light

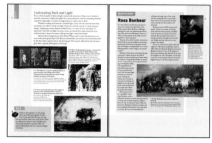

pages 176–177

Objectives

Students will be able to

- Perceive and appreciate contrasts of light and dark values in nature and art.

- Experiment with light and dark values by painting exaggerated value contrasts on a photograph.

Teach

- Focus on the Rembrandt and Bonheur images (figs.9–19, 9–20), and ask students to identify the areas with the greatest contrast between light and dark. So that they can easily note which part of each of these works they see first, suggest that they squint their eyes as they look. Explain that our view is usually attracted to the areas of strongest contrasts when we look at a painting or photograph. Help students note the light source in each image.

- After students have read the information about Rosa Bonheur's life, discuss the aspects of her life that were unusual for the 1800s but would not be today. In this discussion emphasize the lengths that she went to in order to paint her favorite subjects—animals.

- As students consider the contrasts in Rembrandt's landscape, ask: When was this painted? What other Dutch artist in this chapter painted during this same time period? (Metsu,

fig.9–5) What do these two paintings have in common? (In both the artists contrast lights and darks to emphasize and dramatize their subjects.) Explain to students that these artists worked during the Baroque period. Much of the art from this time attests to the artists' fascination with light and dramatic value contrasts.

- Demonstrate the procedure in **Try it** before students create their own study of value contrasts.

> **Try it** page 176
>
> **Materials**
> - old magazines with photographs of people
> - india ink (AP approved)
> - white tempera paint
> - containers for washes and water
> - 12" x 18" white paper
> - brushes

Lesson 7
Color Contrasts

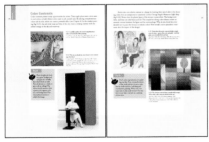

pages 178–179

Objectives
Students will be able to perceive and understand how artists create powerful effects using color contrasts.

Teach

- Ask students to look around the room for examples of color contrasts. They might notice light values against dark values, bright near dull, or the juxtaposition of complements in clothing, wall posters, or furnishings. Help students note the striking contrast that George Segal created by placing the white plaster body (fig.9–22) in front of a dark background. Ask them to describe the mood or feeling created by this white figure. Some students might note that the white of this otherwise realistic figure separates it from reality. Focus on Duane Hanson's similar, but realistically painted, sculpture (fig.6–1), and encourage students to contrast these two artworks.

- Discuss Alice Neel's portrait (fig.9–23) with students. Ask what personality traits she has revealed about this family. How do the color contrasts enhance the meaning in this painting? Recount how she was finally recognized as an artist when she was 74 years old. (This is described in **Context**.)

- Guide students to notice the color scheme in Paul Klee's *The Herald of Autumn* (fig.9–24), and to determine the type of color harmony. You might review color harmonies at this time (see page 84). Explain to students that Klee considered color to be very important in his work, even writing "I and colour are one. I am a painter!"

- Center a bright red circle on a larger bright green circle, and tape these to a large piece of white paper or wall so that all students can see. After students do **Try it**, suggest that they research the phenomenon of afterimage in an encyclopedia.

> **Try it** page 178
>
> **Materials**
> - bright green and bright red paper, about 5" x 7" to 8" x 10"
> - tape
> - large white paper or white wall

168f

- Before students do **Try it** on page 179, ask them to look again at the color contrasts and nonobjective designs in Klee's painting. For the activity itself, each student should use a viewfinder with a window about the size of a postage stamp. (Either give each student an empty 35mm slide frame, or have students cut a rectangular hole in a piece of paper.) When students are ready to begin their artwork, suggest that they use tempera or acrylic paint or oil pastels. Painting a picture will probably take one or two more class periods. To simplify, have students draw their design with colored markers on 9" x 12" paper.

> **Try it** page 179
>
> **Materials**
> - viewfinders
> *optional:*
> - drawing paper
> - tempera or acrylic paint, oil pastels, or colored markers

- In preparation for the next class, assign students to each make a list of three or four things that surround other things.

Lesson 8
Contrasting Textures

pages 180–181

Objectives

Students will be able to

- Perceive and comprehend how artists use contrasting textures to add interest to a design or strengthen a message.

- Describe a Benin plaque and explain why it was made.

- Plan a group or community sculpture or installation.

Teach

- Ask students to note the textures created by the artist in *Warrior and Attendants* (fig.9–28). Encourage students to imagine how it would feel to run their fingers over this sculpture. Ask which areas would be smooth and which would be rough.

- Students should locate Nigeria on a world or African map. After students have read the information about the Benin culture, ask: For whom was this plaque created? (Benin royalty) Lead the students in decoding the images. Who is most important? How did the artist indicate this? Can they locate the animal faces in the sculpture? What might they symbolize? Find cowries on another artwork in this chapter. (*Ngaady a mwaash* [fig.9–4])

- Guide students to notice the carved stucco and water against the smooth texture of the stone and tiles in the

photograph of Alhambra (fig.9–25). Discuss some texture contrasts that students can cite in the structure of their school building.

- Arrange the class into cooperative-learning groups of four to five students to condense their previously assigned written lists of things that surround other things into a group list of five things that surround. At this point they may sort their ideas into categories. As a class, create a master list from the group lists. Discuss the implications of these different types of surrounds. How does surrounding change the feeling or perception about an object? For example, imagine a fence around a house. Does it keep people and animals in or out? Is it welcoming or intimidating? Does the type of fence matter? Can surrounding create a sense of mystery? What type of contrasts may be created by these surrounding things?

 Direct students' attention to Christo's and Jeanne-Claude's *Surrounded Islands* (fig.9–27). Tell them to notice the contrasts of the natural texture with that of the polypropylene fabric and of the pink color with the water and foliage. Ask them to imagine how a project of this scale was created. Christo and Jeanne-Claude's projects usually involve communal efforts to create them in a short time. Four hundred thirty people helped create this project.

- Assign cooperative-learning groups of students to plan a sculpture or installation utilizing contrasts of textures and surrounding to change the meaning or symbolism of an object. This could be a site-specific installation in a public part of the school.

Lesson 9
Contrasting Textures

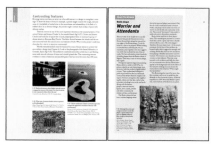

pages 180–181

Objectives

Students will be able to participate in creating a group or community sculpture or installation.

Teach

- Students should create the group sculptures or installations that they planned during the last lesson. By planning in one lesson and building in the next, students will have the opportunity to bring in other materials and objects for their art.

- Direct members of each group to photograph or sketch their piece and write an explanation of the symbolism in their sculpture. These explanations may be posted near the work so that viewers may better understand the artists' meaning.

- Allow each group to describe their sculpture or art to the rest of the class.

- This lesson can be simplified and incorporated into Lesson 8. Simplify the group sculpture project by having each student create a small sculpture of contrasting textures from recycled materials.

Teach	page 180

Materials
- choice of materials for sculptures
 optional:
- cameras and film

Lesson 10
Contrasts of Time and Style, Contrasting Ideas

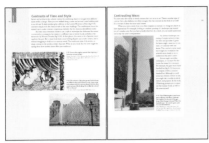

pages 182–183

Objectives
Students will be able to

- Recognize contrasts of time and style in artworks and architecture.

- Perceive and understand how artists combine contrasting ideas.

- Create their own design combining contrasts of time, style, or ideas.

Teach:
Contrasts of Time and Style

- After students read the first paragraph on page 182, direct their attention to fig.9–30, the photograph of I.M. Pei's glass pyramid at the Louvre. Ask them to describe the structures that they see in this photograph. Which were built first? Explain to students that the earliest buildings of the Louvre were begun in 1190 as a fortress to protect Paris from raiding Vikings. It was expanded through the 1600s into a grand Baroque palace. After the French Revolution, it was transformed into an art museum so that people other than the nobility could enjoy great art treasures.

 In 1989 I.M. Pei remodeled the interior adding this glass pyramid as an entrance. The glass allows natural light into the depths of the museum's interior. Encourage students to

imagine why many people strongly objected to the addition of this pyramid surrounded by these Baroque buildings. What culture do they usually associate with pyramids? Do they think that these two styles of architecture go together or complement each other? Note the element of surprise added to this courtyard by the addition of this starkly contemporary but ancient form.

- Assign groups of students to design a new entrance to their school. Encourage them to discuss whether their addition should blend in with the existing architecture, or contrast sharply with it. They should make a sketch of their idea and explain this to the class. Photocopies of a photograph or drawing of the school that the students could sketch their entrance on would make the designing easier. They can also draw on tracing paper over a reproduction of the school to experiment with ideas for the entrance. This project may be carried further by assigning students to create more completed drawings or models of their concepts.

Teach page 182
Materials
- 12" x 18" drawing paper
- pencils or markers
- rulers
 optional:
- photocopies of drawing or photograph of the school
- tracing paper

- Before the class discusses fig.9–29, Teraoka's *Hanauma Bay Series/Video Rental II*, show them examples of Japanese prints. Challenge students to point out the similarities in style between Teraoka's *Hanauma Bay* and traditional Japanese prints. Ask how they know that this was made during the

late twentieth century and not in an earlier century. They should note that the traditional style is a contrast to the contemporary subject matter.

Teach:
Contrasting Ideas

- Ask students what is surprising or different about the art in fig.9–31, Claes Oldenburg's *Batcolumn.* If students do not notice the size of the bat, ask them how large it is. Compare the size of this sculpture to the students' height. Explain that this is a contrast of ideas concerning the expected size of an object and the actual size of the art. Encourage students to remember other examples of surprising scale contrasts. They might discuss the gargantuan proportions of the Mt. Rushmore carvings and movie monsters that trample cities, or opposite scale relationships when people shrink to Lilliputian scale and wander through giant everyday objects. Refer students to fig.5–33, Magritte's *Time Transfixed.* Encourage students to discuss the unexpected scale of the train and room. Is the train normal size and the room huge, or the train tiny?

- Inform students that Claes Oldenburg is a Pop artist known for his oversized sculptures. "Pop" refers to popular mass media images such as those in comics, consumer objects, and advertising.

Chapter Review

pages 184–185

Assess

- Direct students to list contrasts in their surroundings or lives. In a class discussion encourage them to share some of these examples of contrasts with the rest of the class. How do these contrasts make their lives or environment more interesting, or change a pace or mood? Responses should indicate that students have developed an understanding and appreciation for the heightened interest, moods, and pace changes that contrasts can create in both their lives and environment as well as in art. **(Aesthetics)**

- Assign students to write the answers to the review questions. Lead a class discussion of the students' answers to determine that they do perceive and comprehend how contrasts of materials, line, shape, form, size, values, color, textures, time, styles, and ideas may be used effectively in artwork. **(Art criticism)**

- Review with each student his or her portfolio to ascertain that they did create examples of contrast using the art elements, as well as time, style, or size. **(Art production)**

- To determine that students do perceive and appreciate how artists of various cultures and styles including Realist Rosa Bonheur (fig.9–20), African cultures (fig.9–4), Spanish cultures (fig.9–25), Baroque (figs.9–5 and 9–19), and twentieth century artists (figs.9–3, 9–31, 9–32) use contrasts in their art, review a selection of these illustrations with students. Ask what was contrasted in each piece of art. How does this contrast add interest, attract attention, change the pace, or establish a mood? **(Art history/cultures)**

- Create a display of the completed artwork. Ask students to sort the artworks by what the major contrast is in each piece. For example, one group might contain works that contrast values, whereas another might contain works that contrast color or texture. Ask each student to select from each category one work that he or she feels has a particularly effective contrast of that element. **(Art criticism/aesthetics)**

Reteach

Have students look back through this chapter to review the different means of creating contrasts. Ask them to determine and then list the type of contrast in each image on pages 184–185. Review students' lists. Ruscha contrasted materials, colors, and ideas in *End* (fig.9–32). Norval Morrisseau contrasted colors, values, and shapes in *Shaman and Disciples* (fig.9–33). Akopyan (fig.9–34) created a contrast by the way he handled the foreground and background. He also created contrast in color and size.

Answers to Review Questions

1 Contrast is a principle of design that describes large differences in the elements of an artwork to achieve emphasis and interest.

2 Artists create contrasts to add interest, to develop a mood, to attract attention, or to delight the viewer.

Valerie Hacker (age 16). *In Flight*, 1997. Colored pencil, 18" x 24" (45.7 x 61 cm). Fleetwood Area High School, Fleetwood, Pennsylvania.

3 In their works, artists often contrast materials, lines, shapes, forms, sizes, values, colors, textures, styles, and ideas.

4 Colors may be contrasted by placing warm next to cool, or bold near soft or muted, and by putting complementary colors together.

5 White used infrared photography.

6 Bonheur's passion was painting large-scale studies of animals.

7 The Benin plaques were created to record the life and ceremonies of the *oba* (divine king). There are many different textures here, ranging from the smooth faces to the strips of bracelets and the feathered helmets.

Computer Connection

Explore contrast through variation of design elements using a painting or drawing program. Guide students to fill rectangles with a gradient made of dark color tones, filling their screen with overlapping rectangles of different sizes until the background can no longer be seen.

Set up an arrangement of objects from nature (branches, seashells, etc.). In a new document, students will select the pencil tool and draw an outline of part of the arrangement. Upon completion, fill the objects with one light-toned gradient, then copy and paste them into their first, background document. After printing, display the printouts and lead a discussion of the many ways students created contrast in their designs.

Meeting Individual Needs

Students Acquiring English

- Explain that the term *contrast* refers to large differences between two things; for example, rough and smooth, red and green, light and dark, big and small, old and new. Portray these differences by displaying examples of each and ask the students to identify those that are in contrast to each other. Include objects they are accustomed to seeing or using every day, such as a drinking glass and woven basket, or a soccer ball and an orange. This activity will help them correlate what they have learned about contrast with the images in this chapter.

- Assess comprehension of chapter concepts by having students give an oral presentation based on their reading of the chapter, in which they identify the main points and ideas. Have them relate chapter images to notes they have taken.

Students with Special Needs

Speech and Hearing Impairments
- Students with speech impairments may be reluctant to respond verbally in the classroom environment. Display and use appropriate, motivating graphics and props to establish association with contrast in artworks. Have students look at, and touch or feel selected objects and then describe or label their contrasting properties.

- Students with auditory perceptual problems will have trouble hearing sounds over background noise; for example, hearing your directions when others are talking. Providing preferential seating when performing the demonstrations will help compensate for this disability. These students may also experience difficulty hearing sounds in correct order and telling the difference between similar sounds. Verbal communication should be slow, distinct, and limited.

Gifted and Talented

- Discuss with students how artists, particularly graphic designers, have used the computer as a tool in creating artwork. Explain that a scanner is an input device designed to convert printed or drawn images—ranging from simple markings to complex graphic symbols—into files for use by various application programs. Demonstrate (with the aid of a technology specialist, if necessary) and explore with students how to use a scanner to create artworks. Ask students to scan one of their own works and then have them alter and manipulate the image to create contrast by color, line, shape, form, size, or texture. Critique and exhibit the artwork.

9 Contrast

OUR LIVES ARE FILLED WITH CONTRAST OF ALL KINDS. You probably feel joy at a holiday celebration, but sadness when you see illness or helplessness. In your neighborhood, tall old trees might stand next to small, newly planted ones. In the animal world, the dramatic black and white stripes of a zebra might contrast with the brilliant colorings of a butterfly. Whereas variety describes small differences within a design, *contrast* describes larger differences in the elements of a design.

9–1 In nature, contrast serves a variety of purposes, such as protection, camouflage, and attraction.
Flowering Cactus, Phoenix, Arizona. Photo by H. Ronan.

9–2 How does contrast help lead your eye to the center of interest in this image?
Gertrude Käsebier (1852–1934). *Blessed Art Thou Among Women*, 1899. Platinum print on Japanese tissue. 9 ¼" x 5 ½" (23.5 x 13.9 cm). Gift of Mrs. Hermine M. Turner. Museum of Modern Art, New York. Copy print ©1998 The Museum of Modern Art, New York.

There are many kinds of contrast. Filmmakers, musicians, authors, and dancers all use contrast in their work. They may use it to add interest, to change the pace, or to develop or underscore a mood. Visual artists also use bold contrasts, which include the contrast of natural with manufactured materials, large with small, dark with light, rough with smooth, shallowness with depth. The contrasts may delight our eyes, set a mood, or make a statement that grabs our attention or even spurs us to action.

9–3 Ken Chu incorporates design contrasts, as well as contrasts in content, in this work of art.

Ken Chu (b. 1953). *I Need Some More Hair Products,* 1988. Acrylic on foamcore, 21" x 25" x 5" (53 x 63.5 x 12.7 cm). Courtesy of the artist.

9–4 This mask displays variety through contrast in texture and materials. What different textures and materials can you find?

Africa (Kuba). *Ngaady a mwaash* (mask), 19th century. Wood, metal, paint, cloth, fibers, and shells, 13 ½" high (34.3 cm). The Baltimore Museum of Art, gift of Alan Wertzburger.

9–5 Gabriel Metsu was a contemporary of fellow Dutch artists Rembrandt van Rijn and Jan Vermeer. Like them, he was fascinated with the effects of light. The contrast of light and shadow, as well as texture, plays an important role in his paintings.

Gabriel Metsu (1629–67). *Woman at Her Toilette,* c. 1658. Oil on panel, 24" x 21 ½" (61 x 54.6 cm). Norton Simon Museum, Pasadena, California.

Context

The Kuba kingdom is in Zaire. Many of the ceremonial objects used by the Kuba people, including the king's regalia, display textural contrast. Cowries, a type of mollusk shell found in warm waters, are frequently used in Kuba decoration, and have been used as currency in parts of Africa and southern Asia.

Contrasting Materials

When an artist or designer combines two or more distinct materials within a single design, he or she is using contrast. Look at the armchair in fig.9–7. The soft, thick fabric cushion is quite different from the rigid glass that forms the back and "legs." Furniture designers might combine metal, fabric, wood, and plastic to create contrast in their products. Architects often use steel, brick, concrete, wood, and glass. In the art classroom, you might choose to use paint and sand or balsa wood and cotton. The texture, color, and weight of the materials provide the desired contrast.

9–6 The small, individual sun-dried bricks of these ancient Native American dwellings contrast with the massive cliffs into which they are built.
Cliff Palace, Mesa Verde National Park, Colorado, about 1100. Photo by H. Ronan.

9–7 When this chair was exhibited in 1939 along with an accompanying glass table and sidebar, the ensemble was praised by critics for its "comfort, convenience, and delights." The public, however, found the glass furniture too heavy and fragile.
Pittsburgh Plate Glass Company (founded 1883). *Armchair*, c. 1939. Glass, metal, and fabric, 29 ¼" x 23 ¼" x 22 ¾" (74.3 x 59.1 x 57.8 cm). Carnegie Museum of Art, Pittsburgh, Pennsylvania; Dupuy Fund 83.78.2.

Try it

Use fabric scraps or found objects to create a collage or sculpture in which you vary the textures, shapes, and colors. Approach the project in one of two ways: either think of what you want to make, and then gather the necessary materials; or, gather interesting materials, and let them "tell" you what to make.

Higher-Order Thinking Skills

Assign students to research assemblage sculptures and collages by Pablo Picasso and other artists to discover what materials they used. Students might find a head made of a toy car in Picasso's *Baboon and Young,* or bicycle parts in his *Bull's Head.* Ask students to describe the contrasts in these works. Encourage them to consider why the artists may have chosen to incorporate these contrasts.

Another way to contrast materials is to combine those from nature with those made by humans. Contrast might be shown by an arrangement of fresh flowers in a glass vase, or a photograph of telephone wires intermingled with tree branches. Even a statue designed for a park or garden displays a contrast between the manufactured object and its natural setting.

171

9–8 This photograph captures the contrast in materials on the exterior of a school building. The rough expanse of the stucco wall contrasts with the smooth, regular parts of the fence and railing. How did the photographer make use of the afternoon light to exaggerate this effect?

Stucco walls with railings. Photo by J. Selleck.

9–9 What three pairs of contrasting words might describe this student work?

Derek Tremblay (age 17). *Derek's Face*, 1998. Beans and tiles, 6" x 7" (15.2 x 17.8 cm). Whittier Technical School, Haverhill, Massachusetts.

Line Contrasts

Lines are one of the basic elements of design (see Chapter 1). Combining different types of lines—short, bold lines with long, spidery ones or horizontal lines with vertical ones—within a single design is one way to achieve contrast. Look at Leonardo da Vinci's study of a young girl's face (fig.9–10). The artist combined loose, curving lines with tightly drawn diagonals. He also created a contrast between the closeness of the lines at the center of interest and the openness of those farther from the subject's face.

Another way to achieve contrast with lines is by using different media, such as bold strokes of magic marker with lighter strokes of pastel crayon, or smooth gray pencil lines with textured lines of charcoal. In *Sneakers* (fig.9–11), the student artist used thin black lines of pen and ink over large washes of ink. You've probably seen this popular combination in many children's-book illustrations.

9–10 Throughout the centuries, the great masters often used relatively few lines in the creation of sketches, which focused their attention on a particular design problem that they were trying to solve. What design problem do you think Leonardo da Vinci was exploring in this drawing?

Leonardo da Vinci (1452–1519). Study for the angel's head in *The Virgin of the Rocks,* 1483. Silverpoint 7 ¼" x 6 ½" (19.1 x 16.5 cm). Palazzo Reale, Turin, Italy. Alinary/Art Resource, New York.

9–11 How has this student used line to create a contrast between the foreground and background?

Lauren DiColli (age 18). *Sneakers*, 1997. Pen and ink, 19" x 21" (48 x 53 cm). Haverford High School, Havertown, Pennsylvania.

9–12 In this painting, blurred yellow background lines are overlapped by a brighter, curving white line. The contrast creates a glowing, other-worldly quality.

Peter Alexander (b.1939). *Disco Doris*, 1984. Acrylic and fabric collage on velvet, 48" x 53" (121.9 x 134.6 cm). Frederick R. Weisman Art Foundation, Los Angeles.

Materials and Techniques

Silverpoint (fig.9–10) was a technique often used by Renaissance masters when making studies. Thin rods of silver encased in a wooden holder permitted the artists to draw with a delicacy and precision that was not possible with charcoal or chalk. (Graphite pencils did not come into use until the seventeenth century, and even at that time, they were somewhat crude.) With silverpoint, the paper to be used was coated with a white—or, more often, a tinted—pigment which best showed off the thin lines created by the hard metal. Artists frequently added white highlights to better emphasize the forms under study.

Using Shape, Form, and Size

Shape and form offer artists many opportunities for contrast. For instance, they might contrast rounded shapes with angular ones, or complex organic forms with simple geometric ones.

9–13 What contrasts in shape can you find in this work?

Mbuti (Zaire). *Bark cloth*, early-mid 20th century. Ground gardenia seed on barkcloth, 31" x 21" (78.7 x 53.3 cm). Courtesy of the Tambaran Gallery. Photo by Abby Remer, 1997.

Performing Arts
Spiritual Noise and Silence: Mbuti Singing

For the Mbuti of the Ituri rain forest in Africa, sound has magical and spiritual properties. Through a form of music similar to yodeling, the Mbuti communicate with one another and with what they believe are the spirits of the forest. Their music stresses silence, much as the women's drawings on bark cloth stress voids. The contrast of noise and quiet in their music is similar to that of the sounds and silence of the Mbuti's surroundings. For the Mbuti, silence is not the lack of sound, for the forest is always talking, but quiet, the absence of distracting, possibly human-produced noise. According to the Mbuti, "I hear noise, I refuse noise; I love quiet, the forest is quiet."

9–14 The New York School refers to a group of New York artists who were important in directing the course of modern art from the 1940s to the 1960s. This image appeared on the catalog cover to an exhibition of some of their art. Can you describe the humor in the poster? How does the contrast of the rounded tube tops and the angular bodies of the buildings make the design more interesting? How would the design change if realistic building tops had been used?

Louis Danziger (b. 1923). *The First Generation: New York School*, 1965. Catalog cover for the New York School exhibition at the Los Angeles County Museum of Art.

William Baziotes Hans Hofmann Richard Pousette-Dart
Willem De Kooning Franz Kline Ad Reinhardt
Arshile Gorky Robert Motherwell Mark Rothko
Adolph Gottlieb Barnett Newman Clyfford Still
Philip Guston Jackson Pollock Bradley Walker Tomlin

New York School

Artists might also combine shapes or forms of different sizes to create contrast within a design. Larger shapes generally seem to move forward (see Chapter 5) and may also appear heavier and more stationary. Smaller forms usually appear lighter and more free to move about. Look at the student painting (fig.9–15). There are several images of two girls that repeat in a variety of sizes. The largest forms appear solid and well anchored to their positions. The smallest figures seem to be caught in mid-motion.

Design Extension

In fig.9–14, the artist created a city of paint tubes. Ask students to write a list of three of their favorite possessions or objects, and then to imagine what a city or landscape would look like created from one of these. Encourage students to draw or paint their imaginary landscape, creating contrasts in the size and shape of the object.

9–15 This student artist actually gives the viewer a false sense of security in this strange space she has created. Notice how the larger, more securely placed figures are actually about to walk off the edge of the "stage."

Melissa A. Chung (age 16). *Untitled*, 1997. Mixed media collage of photographs, metal, and computer chips, 8 ¾" x 11 ¾" (22 x 30 cm). Montgomery High School, Skillman, New Jersey.

9–16 What contrasting forms did the designer use in this server?

Thomas P. Muir (b. 1956). *Espresso Server*, 1991. Sterling silver, nickel, and aluminum; formed, fabricated, cast, and oxidized, 10 ½" x 3 ¼" x 5 ¾" (26.7 x 8.3 x 14.6 cm). White House collection of American crafts, Washington, DC. Photo by John Bigelow Taylor.

Context

Muir's *Espresso Server* (fig.9–16) is part of the White House Collection of American Crafts. In 1993, President and Mrs. Clinton were instrumental in assembling seventy-two works by leading American craft artists.

The pieces, all created in the 1990s, were installed at various locations in the White House in December 1993 as part of the Year of American Craft. The pieces also toured the United States as part of this celebration.

Contrasting Dark and Light

You can find examples of dark and light contrasts all around you. Glance out a window to study the interaction of light and shade. On a sunny afternoon, look for interesting shadows created by bright light as it passes through a fence or under a pier or deck.

Whether working with natural or artificial light, artists over the centuries have been interested in the effects of dark and light. They have used the contrast to create dramatic designs, frightening moods, sharply modeled forms, or a sense of space and depth. To experiment with dark and light contrasts, artists can choose from many materials, from traditional ink or charcoal to neon or fluorescent light—even laser beams!

Special infrared negatives are what Minor White used to create the mysterious contrasts in his photograph (fig. 9–18). Because infrared film records heat, the warmth absorbed by the sky makes it appear dark in the photograph. The warmth reflected by the tree leaves gives them a ghostly white glow in the image.

9–17 This silkscreen is meant to celebrate the lives of Asian American women living in New York's Chinatown. How does the artist use contrast to help emphasize the purpose of this piece?

Tomie Arai (b. 1949). *Chinatown*, 1990. Silkscreen construction and mixed media, 22" x 40" (55.9 x 101.6 cm). Courtesy of the New Museum of Contemporary Art, New York and the artist. Photo by Fred Scruton.

9–18 Here, the photographer captures a contrast that is not visible to the naked eye. Minor White used an infrared technique to show variations in heat and cold.

Minor White (1908–76). *Toolshed in Cemetery*, from Rural Cathedrals Sequence, 1955. Gelatin silver print (from an infrared negative). Reproduction courtesy of the Minor White Archive, Princeton University. ©1982 by the trustees of Princeton University. All rights reserved.

9–19 If you stood in this landscape, what might you experience? How did Rembrandt use contrast to communicate the physical sensations of this scene?

Rembrandt van Rijn (1606–69). *Landscape with Three Trees*. Etching. Musée Conde, Chantilly, France. Giraudon/Art Resource, NY.

Try it

From an old magazine, cut out a large black-and-white photograph of a face. Use a brush and india ink to go over the dark and medium-dark tones in the photo. Then use white poster paint to cover the light areas. This sharp reduction to extreme white and extreme black dramatizes the contrasts of lights with darks.

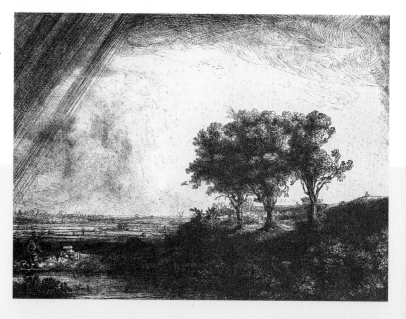

Rosa Bonheur

In a time when societal roles and expectations were much more rigid than today, Realist painter Rosa Bonheur challenged assumptions and won international admiration. She was born in Bordeaux, France, in 1822, and her parents, both artists, encouraged her to draw and paint.

Because of her father's artistic instruction, Rosa Bonheur became skilled at producing landscapes and historical and genre scenes. She then began an independent focus on her lifelong passion: serious, large-scale animal studies.

Bonheur's ideas about portraying animals were quite a departure from the typical domestic scenes of traditional women artists. To achieve a complete knowledge of animal forms, she spent time observing and sketching at stockyards, fields, and slaughterhouses, even dissecting carcasses to learn anatomy first-hand. She obtained legal permission to dress in men's clothing (in France, for a woman to wear men's clothing was illegal) so that she could move comfortably about the rough areas where she frequently worked.

Wearing her hair in an "unladylike" short style, Bonheur made a deliberate decision to avoid marriage, and, by so doing, she avoided losing her independence to take on domestic duties. This contributed to Bonheur's freedom to work, and she confidently followed her own clear path to success. She became financially self-sufficient through sales of her work, and was eventually able to purchase a large estate. On its grounds, she kept many animals that she studied and sketched.

Bonheur died in 1899, having established a body of artworks of animals, both wild and domesticated, and filled with the power and drama of outdoor settings. She had achieved a sense of energy and spirit through her masterful use of light and her attention to composition and detail.

The most well-known public acknowledgment of Bonheur's popularity came in 1864, when the Empress Eugénie presented Bonheur with the Cross of the Legion of Honor, proclaiming that females are as capable of genius as males. Bonheur was the first woman to be presented with the award, the highest honor of the French government.

Elizabeth Anna Klumpke (1856–1942). *Rosa Bonheur*, 1898. Oil on canvas, 46 ⅛" x 38 ⅝" (117.2 x 98 cm). The Metropolitan Museum of Art. Gift of the artist in memory of Rosa Bonheur, 1922. (22.222) Photograph ©1980 The Metropolitan Museum of Art.

9–20 How did Bonheur use contrast to direct our attention?

Rosa Bonheur (1822–99). *The Horse Fair*, 1855. Metropolitan Museum of Art, New York. Gift of Cornelius Vanderbilt. 1887. (87.25). Photograph ©1997 The Metropolitan Museum of Art.

Context

The Horse Fair (fig.9–20), which depicts a team of workhorses being exercised by their trainers, is a scene from the annual horse fair in Paris. The work was part of the Salon of 1853 in Paris, and was also exhibited in the major cities of England, where scenes of nature were especially popular. As part of this tour, the painting was shown at Buckingham Palace, where Queen Victoria requested a private viewing.

Inquiry

Assign students to look up the definition of *chiaroscuro*, the contrast of light and dark values often used in Baroque paintings. Then have them research paintings by Caravaggio, Rembrandt, and Velázquez to discover examples of chiaroscuro used by the old masters.

Higher-Order Thinking Skills
Have students re-examine the images in Chapter 4. Ask them to point out instances in which artists purposely avoided color contrast. Encourage students to propose why an artist might want to avoid color contrast.

Context
By combining Expressionism and Realism in her portraits of neighbors, friends, and family, Neel presented the vulnerabilities and shortcomings of her sitters. Although the humanness of these portraits might cause us to cringe, we are nonetheless drawn to their compelling insight. Neel's career went largely unnoticed until the 1970s, when the women's movement brought Neel and her work to light. She had her first one-woman show at the Whitney Museum when she was seventy-four. At that time, scholars began to realize that she was one the most under-rated American artists of the twentieth century.

Color Contrasts

Color contrasts present many opportunities for artists. They might place warm colors next to cool colors, or bold, vibrant colors next to soft, muted ones. By placing complementary colors side by side, artists can create a powerful effect (see Chapter 4). In the student painting (fig. 9–21), the red-violet road and blue of the city create a striking contrast with the yellow-orange of the sky and waterway.

9–21 Carefully analyze the use of complementary colors in the details of this painting.
Craig Marier, (age 18). *Blue City*, 1996. Acrylic, 24" x 24" (61 x 61 cm). Bartlett High School, Webster, Massachusetts.

9–22 Why do you think the artist chose to use contrasting colors here?
George Segal (b. 1924). *Woman in Coffee Shop*, 1983. Plaster, metal, plastic, wood, and glass, 80" x 60" x 52" (203 x 157.5 x 132.1 cm). Frederick R. Weisman Art Foundation, Los Angeles, California. ©George Segal/Licensed by VAGA, New York, NY.

Try it

Place a bright red circle on a green background, and gaze at it steadily for at least thirty seconds. Then look away at a white or gray wall (or ceiling). The colors should reverse so that a green circle appears to be on a red background. This visual phenonomenon is called afterimage.

Artists also can achieve contrast in a design by limiting their use of color or by choosing colors that are unexpected or unnatural. Look at George Segal's *Woman in Coffee Shop* (fig.9–22). Notice that the plaster figure of the woman is pure white. The background, table, and chair are solid black and red. This simple but strong color scheme creates an unusual contrast between the figure and her surroundings. Why do you think the artist decided not to paint the woman in realistic colors? How would a more naturalistic treatment alter the impact of the design?

9–23 Notice how the artist contrasts bright, simple areas of colors—green, blue, red, and pink—with the paler, more detailed flesh and hair.
Alice Neel (1900–84). *The Family*, 1980. Oil on canvas, 58" x 40" (147.3 x 101.6 cm). Robert Miller Gallery, New York.

Interdisciplinary Connection

Biology—Assign students to research color blindness to discover why many people have trouble distinguishing red from green. To compensate for the wide occurrence of red-green color blindness in the population, traffic-light engineers add blue to green lights so that more people can distinguish the red signal from the green one.

179

Try it

Find a color reproduction of a painting you like. Focus on small sections of the work until you locate an area that by itself could be a well-designed nonobjective painting. What color contrasts exist in this small section? You may wish to use these contrasts in a painting of your own.

9–24 The obvious contrast here is purple with orange. What other color contrasts did the artist use?
Paul Klee (1879-1940). *The Herald of Autumn*, 1922. Watercolor, 9 ⅝" x 12 ¼" (24.3 x 31.4 cm). Yale University Art Gallery, New Haven, Connecticut. Gift of the Collection Societe Anonyme.

Portfolio Tip

Often students must create slide portfolios of their art for college applications, Advanced Placement Art Portfolio reviews, and job interviews. Works with strong contrasts of light and dark values generally reproduce better than those with little contrast. Because very light valued pencil drawings are especially difficult to photograph, encourage those students developing competitive portfolios to emphasize value contrasts in their drawings.

Contrasting Textures

By using texture contrasts, an artist can often add interest to a design or strengthen a message. To show the horror of war, for example, a painter might contrast the rough, textured areas of a battlefield or barbed wire to the smoothness and vulnerability of the flesh of a soldier's face. In an abstract design, the painter might contrast thick strokes of paint with delicate washes.

Textural contrast is one of the most important elements in the unusual projects of the artists Christo and Jeanne-Claude. In *Surrounded Islands* (fig.9–27), Christo and Jeanne-Claude used millions of square feet of pink polypropylene fabric to surround a group of eleven islands in Biscayne Bay, Florida. The fabric floated between the islands and the sea and contrasted with the natural colors and textures of both. What similar project could your class plan for a site in or near your community?

Heavily textured surfaces must be balanced by areas of lesser texture to achieve balance within a design (see Chapter 6). Look at the photograph of the famed Alhambra, in Granada, Spain (fig.9–25). The architects combined intricately carved stucco and flowing water with smooth columns of stone and colorful glazed tiles. The contrasting textures combine to create a luxurious and peaceful palace that has stood for more than 600 years.

9–25 Built environments often display textural contrast to engage the interest of the visitor. Are there locations in your community where this is the case?
Court of the Lions, Alhambra, 1354–91. Granada, Spain.

9–26 What type of contrast besides texture is present in this photograph?
Allison Dinner (age 17). *Untitled*, 1997. Print, 5" x 7" (12.7 x 17.8 cm). Notre Dame Academy, Worcester, Massachusetts.

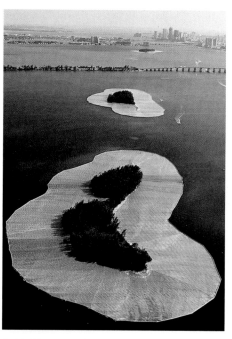

9–27 Christo and Jeanne-Claude's artwork temporarily changes the appearance of natural or human-built environments.
Christo (b. 1935) and Jeanne-Claude (b. 1935). *Surrounded Islands, Biscayne Bay, Greater Miami, Florida*, 1980–83. 6 ½ million sq. ft. of pink woven polypropylene fabric floating around eleven islands. Photo by Wolfgang Volz. ©Christo, 1983.

Benin plaque

Warrior and Attendants

African works of art usually have a specific purpose that goes far beyond decoration. Notice the nail holes along the top and bottom edges of the Benin plaque. Could the holes be a clue to its purpose? When looking at artworks from centuries past, we can sometimes piece together clues that suggest a way of life that included the use of the artworks. We have information about hundreds of similar plaques from the Benin culture of Nigeria. Their story is one of artisans, kings, and tragedy.

Portuguese explorers began documenting Benin culture as early as 1485. The city palaces, ruled by an *oba* (divine king), were decorated with fine works by highly skilled artisans. These craftworkers belonged to guilds that dated from the late thirteenth century. The artisans learned complex techniques of bronze casting from the neighboring Ife culture, but they also crafted other materials, including ivory, wood, and beads. Along with the famous plaques, there are animals, figures, altars, masks, jewelry and other accessories, fly whisks and fans, and furniture.

The Benin culture did not have a written language when

this richly textured plaque was created. Only the *oba* could commission brass or bronze works, and plaques such as this one were created to record the life and ceremonies of the *oba*. These metal "documents" were nailed to walls and posts in the palace courtyards.

Benin artists used size to show importance. The central figure pictured is a warrior chief who carries a spear and waves a fanlike sword (called an *eben*). He is the largest—therefore, the most important—of the people portrayed. At the base of his necklace are leopard teeth, which suggest his strength and cunning. Beside the chief are two attendants (one playing a flutelike instrument) and two warriors. The warriors carry shields and wear cowries on their helmets. They also wear leopard-tooth necklaces and bells that function as communication devices. River leaves appear in the background and on the fabric of the warriors' clothing. Can you locate the animal faces in the sculpture? What might they symbolize?

The Benin kingdom lasted for more than five centuries, and was at its peak from the fifteenth to the nineteenth century. A British expedition in 1897 destroyed Benin's capital city, and looted the artworks from its palace.

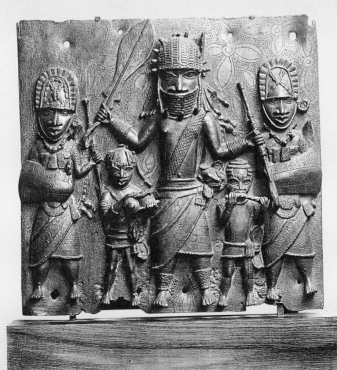

9–28 Although the artist used a single material to create this plaque, a great variety in texture was skillfully achieved. How would you describe the variation?

Africa (Nigeria, Benin culture). *Warrior and Attendants*, 16th–17th century. Brass, 14 ¾" x 15 ½" (37.5 x 39.4 cm). The Nelson-Atkins Museum of Art, Kansas City, Missouri. Purchase: Nelson Trust.

Internet Connection

Some artworks have been removed from their original culture or owners in unacceptable ways. To better understand the issues involved in these controversies, encourage students to research the Africa Reparations Movement, especially in regard to the Benin bronzes.

Interdisciplinary Connections

Social Studies—The Court of the Lions in Alhambra was created between 1354 and 1391 by Islamic Moors who invaded Spain in the eighth century and were not driven out until the fifteenth century, by Ferdinand and Isabella. As a result of the Moors' many years of rule, their architecture was incorporated into that of Spain and of her colonies in Central and South America and southwestern North America. Today, this influence is evident in southwestern architecture—colored tiles, stuccoed walls, horseshoe arches, and courtyards with fountains.

Science—Metal alloys have been used in casting sculpture for thousands of years. Have students research the difference between brass and bronze, and why one alloy might be chosen over the other for a particular work or series of works. Guide students to consider how the qualities of metals might provide an opportunity to create contrast in textures.

Context
Pei's pyramid structure
(fig.9–30) is the
entrance to the large
underground addition to
the Louvre, the largest
museum in the world.
The glass pyramid was
initially greeted with
dismay and criticism
but Parisians came to
accept Pei's creation.

Contrasts of Time and Style

Artists and architects also achieve contrast by combining objects or images from different times within a design. Have you ever walked along a street and noticed a new building next to an old one? A sleek modern glass addition to the Louvre Museum in Paris (fig.9–30) contrasts sharply with the classical style of the main buildings. The combination forces the viewer's eye to make constant comparisons between the two dramatically different styles.

An artist may sometimes choose to use a style or technique that dislocates the viewer momentarily or transports the viewer to a different time or world. Look carefully at the watercolor by Masami Teraoka (fig.9–29). At first glance, this seems to be a Japanese painting from the past. But a closer look finds a man holding flippers and a video camera, and a woman struggling to hold on to a samurai sword. The traditional style of the work is in sharp contrast to the modern subject depicted. What do you think that the artist might be saying about how modern times affect past traditions?

9–29 Artists often employ contrast when depicting a humorous or ironic subject.
Masami Teraoka (b. 1936). *Hanauma Bay Series/Video Rental II*, 1982. Watercolor on paper, 28 ¾" x 40 ⅝" (73 x 103 cm). Courtesy of the artist.

9–30 The architect of this glass pyramid, which forms an addition to the world-famous Louvre, chose a minimal, modern style that contrasts sharply with the older, ornate sections of the building. Do you like this contrast? Why or why not?
I. M. Pei (b. 1917). *Louvre Pyramid*, 1988. Paris, France.

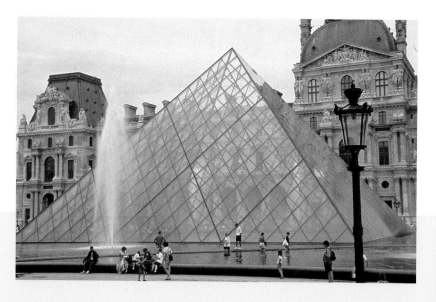

Design Extension
Assign students to find
other examples of tradi-
tional Japanese prints
by artists such as
Katsushika Hokusai or
Nonomura Sotatsu (see
fig.7–22), and to make a
list of characteristics
that they find common
to many of these prints.
Students might list
asymmetrical balance,
contrast of light and dark values, traditional
Japanese clothing and landscape, and sim-
plification of the subject matter. Challenge
students to create their version of a contem-
porary subject in the style of Japanese
prints such as Masami Teraoka's *Hanauma
Bay Series/Video Rental II* (fig.9–29).

Contrasting Ideas

You have seen the variety of visual contrasts that can occur in art. There is another type of contrast that is less definite, but often stronger, than the contrasts in the work of art itself. It is contrast of ideas that your mind creates.

When you view a work of art, you often compare or contrast it to things you know or have experienced. For example, looking at a realistic painting of a landscape may remind you of a similar scene that you have actually observed. As a result, you can easily understand and accept the artist's interpretation.

An abstract landscape consisting of simple vertical strokes for trees and splotches of green for leaves might cause you to contrast it to ordinary trees and leaves. This contrast in your mind encourages you to examine the artwork more closely to try to understand the artist's intent.

Artists might use styles, techniques, or concepts that dislocate the viewer for a moment. For example, the giant wire-frame baseball bat (fig. 9–31) forces you to compare it with a common baseball bat. Although you will notice an obvious contrast in size, you might also consider material, texture, and purpose. In the work, Oldenburg prompts you to examine the familiar world, as well as the artwork itself.

9–31 Claes Oldenburg has created many giant sculptures, including a clothespin and a lipstick. For the city of Chicago—home of the Chicago Cubs and White Sox baseball teams—he created a giant, open-form metal baseball bat.
Claes Oldenburg (b. 1929). *Batcolumn*, 1977. Cor-ten steel, 98.4' high (30 m). Social Security Building Plaza, Chicago. Courtesy of the artist.

Inquiry

Explain that artists and architects often work with forms that were created in the past. For example, in the Capitoline Museum in Rome is a statue of a wolf sculpted by the Etruscans in 500 BC. The figures of Romulus and Remus were added to the sculpture during the Renaissance. When I. M. Pei renovated the Louvre in Paris in the 1980s, he placed a modern glass pyramid adjacent to pre-nineteenth-century buildings. To ensure unity when he added the East Wing of the National Gallery to the existing museum in Washington, DC, Pei used stone from the same quarry that had been used for the original building. Assign students to research and describe one of these juxtapositions of old and new in which architects and artists combined contrasting styles of different eras.

183

Cooperative Learning

To conduct the research suggested in Inquiry, students might enjoy working in teams and focusing on local examples of contrast. A series of contrasting juxtapositions of architectural styles within the community could be considered. After the research is completed, each team could present its findings. Discussion should center around whether the juxtapositions enhanced or detracted from the old and new building styles that were combined.

Another Look at Contrast

9–32 Artist Ed Ruscha often uses words in his drawings and paintings. Here, he created a contrast in the viewer's mind between the image of a sunset and the word *end*. What other type of contrast can you find in his design?

Edward Ruscha (b.1937). *End,* 1983. Oil on canvas, 36" x 40" (91.4 x 101.6 cm). San Diego Museum of Art. Gift of the Frederick R. Weisman Art Foundation, Los Angeles. Courtesy of the artist.

9–33 Notice that strong, vivid images often do not display much contrast in value. Can you find other examples of strong, vivid images in this book? What types of contrast did the artists of these works use?

Norval Morrisseau (b. 1931). *Shaman and Disciples,* 1979. Acrylic on canvas, 71" x 83 ¼" (180.5 x 211.5 cm). Purchase 1979. 1979.34.7. McMichael Canadian Art Collection, Kleinburg, Ontario, Canada.

Context
Norval Morrisseau is an Ojibway artist from northwestern Ontario. In the early 1960s he began to paint the legends of the Ojibway culture. Morrisseau's unique style has been influential on a second generation of Woodland artists in northwest Ontario and Manitonlin Island.

Interdisciplinary Connections
English—Select a good hero and an evil villain from a literary selection for students to draw or paint. Suggest that students use art elements to create contrasts of good and evil. Students might contrast the good-natured Bilbo from *The Hobbit* with Smaug the evil dragon, Hamlet with Claudius, or Sherlock Holmes with Moriarty.
Music—Play music selections that have strong contrasts, such as a rest just before a forté section, as in the last line of the *Hallelujah Chorus* or in the *1812 Overture,* by Tchaikovsky. What purpose do such contrasts serve? What kind of visual contrast are they most similar to?

185

9–35 What kinds of contrast did the student artist use in this image?
Gabriel Burian-Mohr (age 17). *Untitled*, 1995. Computer graphic, 8 ½" x 11" (21.6 x 27.9 cm). Los Angeles County High School for the Arts, Los Angeles, California.

9–34 Loudvic Akopyan creates illustrations for movie posters, compact-disc cases, and video jackets. This illustration was used for a book cover. How did the artist use contrast to focus the viewer's attention?
Loudvic Akopyan (b. 1972). *Undercover Cleo*, 1995. Colored pencil and acrylic, 10" x 14" (25.4 x 35.6 cm). Courtesy of the artist.

Design Extension
Lead students in discussing how people have several dimensions to their personality. For example, at home, some people might consider themselves to be soft, kind, gentle, and loving to their family; on the athletic field, however, they might be loud and aggressive. Instruct students to use markers to make two designs that symbolize two roles or personalities that they have. Challenge them to join these contrasting designs so that they form a unified design.

Review Questions (*answers can be found on page 168i*)

1. What is contrast?
2. Why do artists create contrasts in their work?
3. List six broad categories of what visual artists often contrast in their art.
4. What are some ways to create color contrasts?
5. What special photographic process did Minor White use in *Toolshed in Cemetery* (fig.9–18) to create high contrasts?

6. What subjects was Rosa Bonheur passionate about painting?
7. Why were plaques such as the one in fig.9–28 created by the Benin artists? Describe three different textures on this plaque.

Career Portfolio
Interview with an Industrial Designer

When designing a product, **José Pérez** has to consider the contrast between how something looks and how it functions, then make both work together. Born in 1966 in Guayaquil, Ecuador, José grew up speaking Spanish. He attended Notre Dame University, then obtained his master's degree at the University of Illinois. He now works for a firm in Chicago.

How would you describe your career?

José It's the perfect match between art and science. Because they are such different things, they are difficult to reconcile, so it's a pretty hard thing to do.

What did you study to become an industrial designer?

José Industrial design is either taught from the art point of view or you learn it through science schools, so you have more of a science or engineering background. As an industrial designer, you are primarily asked to be creative.

During design school you take drawing classes, and you take manufacturing classes to learn about materials and processes. You take a couple of business classes to learn how to work on teams with people and how to present your work. You take some writing classes so you know how to write about your work. When it comes down to it, you need to be able to communicate your ideas.

How do you go about designing a product?

José You are usually asked to work in teams. There will be an industrial designer, an engineer, a person from marketing. You have to have a basic understanding what the restrictions are in terms of how you are going to make and manufacture something. At the same time, you have to keep aware of the beauty of the thing. Most of the time, you're buying something because you need the function that a product provides. But you also are choosing. When you go out, you have, okay, twenty telephones here: which one should I buy?

That's where industrial design makes an impact. You want people to say, "This one is more beautiful than that one, and given that it's the same price, I'm going to buy this one."

Tell me about the camera you designed.

José That was a very fun thing, the single-use camera. What we did was to approach it from the outside. What do we think a camera should be? Should we use more hefty handles so it's easier to grab? Should we make it smaller? Should we move the viewfinder to the right side? Where should we put the shutter button?

We are all used to cameras that are more or less boxes with some details. We basically took the box and redefined it in a way that would fit better in your hand. That's what industrial design does—improve upon something that was done before, making something better, or easier, or making new things.

Does it bother you that people won't know your name when they pick up that camera?

José It doesn't bother me. I think what it comes down to is that you get chills through your body when you go into a store and say, "Hey, wait a minute, that's the camera that I made!" You don't have to go to that one museum to see that one painting; you can go to the store at the corner of your block or three blocks away to see your product!

An industrial designer will sketch ideas and sometimes sculpt a foam model when visualizing a product. *Kodak Advantix camera.*

Studio Experience
Pop-Art Sculpture

Task: To demonstrate a contrast in size by sketching a common object, enlarging the sketch, and making it into a sculpture using cardboard and acrylic paint.

Take a look. Review the following images:
- Fig. 9–22, George Segal, *Woman in Coffee Shop*
- Fig. 9–31, Claes Oldenburg, *Batcolumn*

Think about it.
- What are the similarities and differences between the sculptures listed above? What makes an artwork Pop Art?
- How is the depiction of Segal's *Woman in Coffee Shop* different from its real-life equivalent?
- What materials were used in these sculptures? Does the type of material affect the shape or form of the subject? Does the material enhance or detract from the sculpture?

Do it.
1 Select a common, simple object, and draw several sketches of it, showing it from different angles. This will help you determine the shape and size of your sculpture.

2 Before starting your 3D cardboard sculpture, practice by making a small mock-up with oak-tag board or other stiff paper. Visualize your finished object; then imagine it flattened out. How would you reassemble it as a 3D object? Bend, fold, and score the paper to get the form you desire, lightly holding sections together with masking tape. When you're satisfied, you can take apart the mock-up and use the flattened paper as a guide for cutting out the final cardboard version.

3 Decide on the final, larger-than-actual size of your sculpture. Use a utility knife and metal ruler or straightedge to cut the cardboard sections. Be sure to use a cutting board.

4 Use masking tape, duct tape, or a hot-glue gun to join the cardboard sections into a form.

5 Hold the newspaper as though you were reading it, and tear strips 2" to 3" wide. Consider the size of your sculpture, and estimate and tear enough strips to last for one class period. Once your hands are sticky with glue, it is difficult to stop and tear more strips.

6 Pour a mixture of glue and water into a plastic bowl, and, with one hand, dip a single strip of newspaper into the mixture. Pull the strip from the mixture, and slide it between the first and second fingers of your other hand to wipe off the extra glue. Apply two to three layers of newspaper strips to your cardboard form, alternating the direction of the layers.

7 To dry the form and let air circulate around it, place it on an empty bowl or a block of wood.

8 For a stronger sculpture, repeat steps 6 and 7 as needed, alternating between newspaper and brown paper towels torn into patches.

9 Paint the form with one coat of white acrylic paint.

10 Either freehand or with the aid of an opaque projector, draw the details of your object onto the sculpture form. Paint your form. Depending on the object, add details and embellishments with materials such as yarn, felt, or cotton batting. Give your sculpture a final coat of acrylic medium.

Helpful Hints
- For round forms, cover an inflated balloon with the glue-and-paper mixture. Use rolled newspaper to make a cylindrical form.
- To change the surface and contour of your sculpture, tape wadded and folded newspaper to the cardboard.
- If mimicking a product—such as a box of cereal—that requires letters, you may use a lettering stencil.

Check it.
- What were your reasons for selecting the particular sketch that you used for the sculpture?
- What problems, if any, did you have constructing your sculpture?
- What elements make your sculpture Pop Art?
- How does your sculpture successfully represent Pop artists' ideas about media, advertising images, and our culture?

187

"Unlike painting, drawing, or sculpture alone, creating a gigantic piece of pie became a combination of each of these media forms. I also had an opportunity to understand the challenge faced by Pop artists: the creation of something so diverse from everyday life that its appearance would provoke the viewer to examine the world around them in a new way."

Jeffrey Michael Shanahan (age 18). *Pie,* 1997. Airbrush, papier-mâché, cloth, and cotton batting, 18 ½" x 26" x 17" (47 x 66 x 43.2 cm). Holy Name Catholic Junior Senior High School, Worcester, Massachusetts.

Studio Experience
Pop-Art Sculpture

Michelle Cieply (age 16). *Starlight Mint*, 1997. Papier-mâché, 19" diameter (48.3 cm). Holy Name Catholic Junior Senior High School, Worcester, Massachusetts.

Prepare

Time Needed:
Nine 45-minute class periods; extend as needed.

Lesson 1:
Sketch and plan.

Lesson 2:
Make the paper model.

Lessons 3, 4:
Cut and build the basic cardboard structure.

Lessons 5, 6:
Cover the cardboard structure with paper strips and allow to dry.

Lesson 7:
Paint the structure white.

Lessons 8, 9:
Add colors and details.

Objectives

Students should be able to

- **Demonstrate their understanding of contrast in size by completing a Pop-Art sculpture.**

- **Identify concepts behind the Pop Art movement.**

- **Compare and contrast Pop-Art sculptures.**

- **Identify materials and methods of construction.**

Materials

for planning:
- pencils
- drawing paper
- scissors

for making the sculpture:
- utility knives
- metal rulers and/or straightedges
- cutting boards
- oak-tag board
- sheets of corrugated cardboard, 36" x 48"
- masking tape, duct tape, and/or hot-glue gun
- newspaper
- one-gallon plastic containers with tight-fitting lids
- white glue, about a gallon
- plastic bowls
- brushes
- acrylic paint, white and assorted colors
- acrylic medium (matte or gloss)

optional:
- assorted embellishment materials (cotton batting, yarn, felt, beads, string, lace, trim)
- opaque projector
- lettering stencils

Notes on Materials

- Corrugated cardboard is expensive. Contact a local box company or moving company for any extra cardboard that they might donate.

- Twelve-ounce whipped-topping plastic containers are useful for individual portions of the water-and-glue mixture.

- You can also use old paneling, masonite, or 1/4" plywood. Self-healing mats or pieces of chipboard make good cutting boards.

- To save money, buy inexpensive white acrylic house paint.

- Substitute tempera paint for acrylic paint. Add a little liquid soap to the paint to make it adhere better and allow for easier cleanup.

Before You Start

- Have students visit a supermarket and list twenty-five eye-catching products.

- Have students describe to the class an attention-getting TV commercial.

- Arrange a classroom display of Pop Art books and photographs.

- Demonstrate how to score and bend cardboard.

Teach

Thinking Critically

- Discuss with students what makes an artwork Pop Art (art based on popular items found in society)

- Have students review the images and the questions in **Think about it**.

- From newspapers and magazines, suggest that students cut out advertisements for products. Tack them to a bulletin board, and discuss what these items reveal about our society.

Classroom Management

- Set up a cutting area for large cardboard pieces. Include a metal straightedge, a utility knife, and a 2' x 4' cutting board.

- Explain and set up safety procedures for using the utility knife and the hot-glue gun.

- When students are ready to lay on paper strips with glue, prepare a 50-50 or 60-40 mixture of white glue to water in a gallon container. Try different ratios of glue to water to find the ideal mixture. Shake well. Pour mixed glue into plastic bowls (one bowl per student).

- Remind students to use soap and water to wash out the acrylic brushes.

Tip

- Pictures cut from mail-order catalogs might help students with ideas for their object.

- After students have applied the paper strips, the sculptures may need to dry for a couple of class periods before they are ready to paint. Have students rotate the forms so that they dry completely.

Assess

Meeting Individual Needs

Simplify

Pair up students who have difficulty developing ideas, and have them work together to develop the project.

Evaluation

- Have students write the answers to the questions in **Check it**. Discuss the answers with each student.

- Assign students to write a comparison of their sculpture and the common object that they represented. They should consider size, shape, color, and texture. Are there significant contrasts in shape, color, and texture that limit the impact of the size contrast?

Extend

Linking Design Elements and Principles

Shape/Form

As students begin to design their objects remind them to consider the type of forms and shapes that they will be sculpting. Is their object bulbous and organic or is it geometrical with angular corners and straight sides? How will their object appear from different views? It should be three dimensional with height, width, and depth.

They may create their sculptures by joining basic forms such as a cone and sphere into an ice cream cone.

Texture

The surface texture of the pop art will play an important role in making this a recognizable object. Brainstorm with the students about what type of materials they can use to create various textures.

Color

Review color mixing with the class before they paint their sculptures. Most students will probably want to match their colors to the commercial object they are depicting, but some may be more expressive in their use of color.

Interdisciplinary Connections

Language Arts

Ask students to imagine that they are the object depicted in their sculpture, and have them write a description of being on a supermarket shelf, surrounded by identical objects.

Inquiry

- Encourage students to research and list a number of scientific advancements made between 1900 and 1970 and then write an essay describing how Pop artists might have been influenced by these developments.

Chapter 10 Organizer

Emphasis

Chapter Overview

- To develop or emphasize their main idea, theme, or center of interest, artists first consider their message.

Objective: Students will perceive and comprehend how artists create emphasis in their works by relying on one art element; simplifying the design; and grouping, centering, enlarging, repeating, and isolating subjects. (Art criticism)
National Standards: 2. Students will use knowledge of structures and functions. (2a)

Objective: Students will create artworks including a photomontage by experimenting with a variety of methods to create emphasis. (Art production)
National Standards: 1. Students will understand and apply media, techniques, processes. (1b)

8 Weeks	1 Semester	2 Semesters			Student Book Features
1	1	1	**Lesson 1:** Emphasis	Chapter Opener	
0	0	1	**Lesson 2:** Emphasizing: Line, or Shape and Form	Emphasizing One Element of Design: Line, or Shape and Form	Try it: sketch
0	1	2	**Lesson 3:** Emphasizing: Value, Color, Space, or Texture	Emphasizing One Element of Design: Value, Color, Space, or Texture	Try it: various media, Note it
0	1	2	**Lesson 4:** Emphasizing: Value, Color, Space, or Texture	Emphasizing One Element of Design: Value, Color, Space, or Texture	Try it: various media, Note it
0	1	2	**Lesson 5:** Emphasizing: Value, Color, Space, or Texture	Emphasizing One Element of Design: Value, Color, Space, or Texture	Try it: various media, Note it
0	0	2	**Lesson 6:** Using Simplicity	Using Simplicity	Try it: collage, About the Artist, Style
0	1	2	**Lesson 7:** Using Placement and Grouping	Using Placement and Grouping	Discuss it
0	1	2	**Lesson 8:** Emphasis Through Isolation	Emphasis Through Isolation	Discuss it, About the Artwork
0	0	1	**Lesson 9:** Using Size and Repetition	Using Size and Repetition	
0	0	1	**Lesson 10:** Using Size and Repetition	Using Size and Repetition	
1	1	1	**Chapter Review**	Another Look at Emphasis	Review Questions
2	3	3			

Studio Experience: *Emphasis in a Photomontage*

Objectives: Students will appreciate the effective use of photographs and emphasis in advertising and fine art; understand various means that artists use to emphasize the focal point; appreciate how artists use emphasis to communicate meaning; create a photomontage that emphasizes one center of interest.

National Standard: Students will identify artists' intentions, explore implications of purposes, and justify their analyses of particular arts' purposes (5a); apply subjects, symbols, ideas in artworks and use skills gained in problem solving in daily life (3b); create art using organizational structures and functions to solve art problems (2c).

- Ways to achieve emphasis in a composition are to rely on one art element, exaggerate shapes or forms, simplify the design, use special placement, group elements, isolate the main subject, emphasize the scale of an object, and repeat elements.

Objective: Students will understand how artists and architects of various cultures and periods including west Africa, Japan, China, ancient Greece, and twentieth-century America and Europe create emphasis in their art. (Art history/cultures)
National Standards: 4. Students will understand art in relation to history and cultures. (4a)

Objective: Students will understand how the use of emphasis in two-dimensional and three-dimensional artwork can influence the manner in which a work is perceived by the viewer. (Aesthetics)
National Standards: 5. Students will reflect on and assess characteristics and merits of artworks. (5d)

Teacher Edition References	Ancillaries
Warm-up, HOTS, Context, Cooperative Learning	
Design Extension, Context, Internet Connection	*Slide*: Persia, *King's Mosque* (E-1)
HOTS, Context, Performing Arts	
HOTS, Context, Performing Arts	
HOTS, Context, Performing Arts	
Design Extension, Context, Materials and Techniques	*Slides*: Korea, *Tea Bowl* (E-2); Alfred Bendiner, *Marcel Duchamp* (E-3)
HOTS, Context, Interdisciplinary Connection	*Slide*: Standish Backus, *Uninhabited* (E-4)
HOTS, Context, Portfolio Tip, Cooperative Learning	
HOTS, Context, Interdisciplinary Connections	*Slide*: Fritz Scholder, *Indian in the Snow* (E-5) *Large Reproduction*: Gary VanWyk, *Emily Mapheelo's House, 1992, Basotho, South Africa*
HOTS, Context, Interdisciplinary Connections	*Slide*: Ashanti, *Adinkra cloth from Kumasi, Omnipotence of God* (E-6) *Large Reproduction*: Ann Johnston, *Merry-go-round 2*
HOTS, Context, Inquiry, Performing Arts	

Vocabulary

caricature A depiction that exaggerates features or characteristics of a subject to an unnatural, ridiculous, or absurd degree. *(caricatura)*

scale The relative size of a figure or object, compared to others of its kind, its environment, or humans. *(escala)*

style The distinctive character contained in the artworks of an individual, a group of artists, a period of time, an entire society, or a geographical location. *(estilo)*

Time Needed
Three 45-minute class periods.
Lesson 1: Cut out magazine photographs;
Lesson 2: Arrange cutouts;
Lesson 3: Glue cutouts.

Studio Resource Binder
10.1 Multi-surfaced Drawings, collage
10.2 Abstracted Object, white charcoal
10.3 Spotlight on Still Life
10.4 Significant You, oversized self-portrait
10.5 German Expressionism, painting

Lesson 1
Emphasis

pages 188–189

Objectives

Students will be able to understand that artists use a variety of methods to emphasize their message or aspects of their designs.

Chapter Opener

- Focus on pages 188–189. Explain that artists make decisions concerning what the message or focus will be in their art. Ask students to work together in small groups to decide what each artist was most interested in communicating. Then have a member from each group report to the rest of the class. Students will probably notice, for instance, Muriel Castanis's fascination with the draping and folding of cloth. Suggest that students consider the photographer's viewpoint when taking the picture of the orchid or the Native American dancer. Ask what might have been nearby that the photographer chose to ignore.

- As the students study fig.10–3, the Igbo wrap, review the location of Nigeria on a world map as well as the information in **Context** on page 189.

> **Opener** | pages 188–189
> ### Materials
> - map of Africa or world

Teach

- Show students how to make a pie graph of what is significant to them. Draw a large circle on the board or on chart paper, and divide it into pie-shaped segments representing the relative significance of things, relationships, and characteristics in a person's life. A sample pie graph might indicate that the most important thing in the person's life is family, followed closely by soccer, and then his or her dog, schoolwork, and television.

- After students have drawn their graphs, call on volunteers to share what they diagrammed as most significant in their life, and to show how they illustrated this. (They probably made that aspect the largest segment in the graph.) Ask students how they might visually emphasize this most important segment even more. They might suggest coloring the segment, making it a different color than the rest of the segments, adding contrast to it, separating it out from the rest of the pie, or pointing an arrow to it.

> **Teach** | page 188
> ### Materials
> - 8 1/2" x 11" white copy paper
> - pencils
> - compasses
> - rulers

Lesson 2
Emphasizing: Line, or Shape and Form

pages 190–191

Objectives

Students will be able to

- Perceive and comprehend that artists often emphasize one art element to organize a design and establish a focal point.

- Emphasize an art element in sketches of natural objects.

Teach

- Explain that artists experiment with different art elements to create emphasis within their works. As students look at *Vietnam Veterans Memorial Wall* by Maya Ying Lin (fig.10–6) and *Briar* by Ellsworth Kelly (fig.10–8), encourage them to compare and contrast the two works. Ask what element the artist has emphasized and how the emphasis of this element communicates the art's message. In each work, the artist created a quiet, elegant piece of art with a very simple design.

- Point out to the students that when Maya Lin designed the *Vietnam Veterans Memorial Wall*, she was a college student. The monument consists of the names of more than 58,000 casualties, engraved on two black granite walls. This extensive listing focuses the viewer's attention on the enormous loss of human life that resulted from the war. The names are arranged in chronological

order according to when the person died, which emphasizes an association with fallen comrades and creates an interactive work of art as viewers search for loved ones.

The long visual lines of the walls lead visitors down into the monument, out of the busy bustle of Washington, DC. These lines also are aligned to direct the view to the Washington monument. If students have visited the *Vietnam Veterans Memorial Wall*, encourage them to share impressions of their experience.

- When viewing the Giacometti sculpture, fig.10–7, review with the students the events in Europe preceding the creation of this sculpture. World War II, concentration camps, bombed cities, and then the poverty and depression of Europeans following the war influenced the hopelessness which Giacometti's figurative sculptures express.

- For **Try it** on page 190, collect enough shells, bark, leaves, rocks, and other natural objects so that each student can study one object. Students may exchange objects periodically so that each student is able to study and sketch three items. If feasible, take students outdoors to complete this **Try it**. You might assign this activity to be done outside of class.

Try it | page 190

Materials
- objects from nature
- students' sketchbooks, or 9" x 12" drawing paper
- drawing media such as pencils, markers, ink pens, and colored pencils

Lesson 3
Emphasizing: Value, Color, Space, or Texture

pages 192–193

Objectives
Students will be able to

- Perceive and understand how artists create emphasis with value.

- Analyze emphasis in an artwork which they create.

Teach
- Call students' attention to Géricault's *Portrait of a Man* (fig.10–9) and its dramatic lights and darks that emphasize the man's facial expression. Ask what mood Géricault has created with his use of dark values. Géricault was a French Romanticist painter who worked during the early 1800s.

- The **Try it** activity extends into the next two class periods with students using a different medium in each lesson to create an artwork based on the same subject and then analyzing which art elements they emphasized with each medium. Certain materials will be particularly suited to emphasis of particular elements. For example, form is often the main element in clay pieces, while line may be naturally emphasized in ink drawings.

- After students have read the **Try it** on page 192 reiterate that they will be creating the same subject in three different media for three class periods. They may wish to use experimental media such as Styrofoam™, sand, or found objects.

- Because students have just studied Géricault's *Portrait of a Man* which has dramatic light contrasts, you may choose for the students to try a two-dimensional medium to render a dramatically lit portrait, their hand, or another subject.

Try it | page 192

Materials
- three-dimensional media, such as clay, plaster, papier-mâché, and wire; or two-dimensional media, such as pencil, marker, charcoal, crayon resist, conté crayon, or finger paint; or experimental materials
- appropriate paper for the selected media
- clay tools, wire cutters, and other appropriate tools for the selected media

- When the students have completed this piece, they should analyze it carefully, noticing which art element dominates their composition. Instruct them to write which art element is most prevalent on the back or bottom of the piece.

- Extend **Note it** (page 193) by having students sketch one of the dominant structures. Lead a class discussion about the dominant structures in the community and the design elements emphasized in them.

Lesson 4
Emphasizing: Value, Color, Space, or Texture

pages 192–193

Objectives
Students will be able to

- Perceive and comprehend how artists create emphasis with color, space, and texture.

- Create a piece of art with the same subject as the piece they made in Lesson 3, but in a different medium.

Teach
- Inform students that the Ming dynasty (1368–1644) marked a high point in Chinese art. Point out how the single solid color glaze used for the bowl (fig.10–10) would highlight any imperfections in the form.

- As a class answer and discuss the questions posed in the last paragraph on page 193 comparing the emphasis in the Chinese bowl, *Extreme Tennis* (fig.10–12) and *The Charm of Subsistence* (fig.10–11).

- Students should notice the large dimensions of the basket in fig.10–11. Puryear was a minimalist sculptor who was influenced by the building techniques and materials of west Africa.

- Assign students to analyze a skyline and dominant community structures before the next class period, as described in **Note it**. (This will be the background for a class discussion in Lesson 5.)

- Continue the **Try it** activity begun in Lesson 3. Students will create a work of art based on the same subject as in the previous class but in a different medium. Offer them a variety of media to choose from, but encourage them to include both two- and three-dimensional works in their series of three pieces.

- As in the last lesson, when they have completed this piece, the students should analyze it carefully, noticing which art element dominates their composition and label this art element on the back of the piece. At the end of this series, they might notice a preference for certain art elements in their own works.

Lesson 5
Emphasizing: Value, Color, Space, or Texture

pages 192–193

Objectives
Students will be able to

- Perceive the dominance of an art element in the structures of their community.

- Create a piece of art with the same subject as the piece that they made in Lessons 3 and 4, but in a different medium.

Teach
- Lead a class discussion based on the **Note It**. Which building or structure dominated the skyline of the street that each student analyzed? List these on the board. What are the predominant design elements in each of these structures?

- Continue the **Try it** activity begun in Lesson 3. Students will create another work of art based on the same subject as in the previous two classes but in a different medium. Offer them a variety of media to choose from, but encourage them to include both two- and three-dimensional works in their series of three pieces.

- As in the previous two lessons, when they have completed their art the students should analyze it carefully. They should label the back of each piece with the art element that dominates their composition. Students should display their three related pieces together. Do any design elements seem important in two or more of these works?

 Encourage students to consider the art elements in other students' series, noting which element each student seems to stress repeatedly. Do any of the series exhibit the development of a personal style? Assign them to write an analysis of their three works to display with their art in a class art exhibit.

Mark Tucker (age 15). *The Offering*, 1995. Oil, 10" x 14" (25.4 x 35.6 cm). Lake Highlands High School, Dallas, Texas.

Lesson 6
Using Simplicity

pages 194–195

Objectives
Students will be able to

- Perceive and understand how artists simplify their designs to emphasize a main idea or point.

- Create magazine collages using simplified backgrounds to emphasize the center of interest.

Teach
- Ask students to look at the preceding pages and select one or two images in which the design was kept simple to emphasize the main subject.

- Point out the simplification of form in the Robus sculpture (fig.10–13), and ask what in this form suggests grief.

- Focus on the photograph of the Wallace and Gromit animated figures (fig.10–14), and ask how the artist created expression on these characters' faces. So that students may see how other cartoon artists simplify bodies and faces of their characters, have them look through newspaper cartoons and select one strip with simplified figures.

 Inform students that Nick Park has received three academy awards for his stop-action animated features. Encourage students who have seen Wallace and Gromit videos to describe them to the class. If you have access to one of Park's features or another stop-action animation video, show a short portion of it.

Lead the class in discussing how these cartoon characters were simplified and how the simplification emphasizes each character's personality. Inform students that the puppet animation technique has traditionally been more popular in Europe than in the United States, but it has slowly been gaining ground in the American market.

- Focus on the style of the Chinese painting by Wang Yani (fig.10–15). Ask what words come to mind as students look at the painting. Either assign them to write a paragraph comparing the style of Géricault's portrait (fig.10–9) with the group portrait by Alice Neel (fig.9–23), or lead a class discussion about the two portraits. Encourage students to compare line quality, use of light-and-dark value contrast, point of view, and composition.

- Have students do **Try it** on page 194. This **Try it** experience may be expanded by creating two collages, one with a simplified background behind the main subject and one with a busy background. Ask students: In which collage is the center of interest most apparent?

Try it page 194

Materials
- 9" x 12" construction or drawing paper
- old magazines with photographs
- scissors
- glue

- For the next lesson, have students bring in several magazine advertisements, at least one with a coupon. They should also bring in consumer product packages or images of packages as described in **Discuss it** on page 196.

Lesson 7
Using Placement and Grouping

pages 196–197

Objectives
Students will be able to perceive and comprehend how artists use placement and grouping to emphasize their message and center of interest.

Teach
- Use several magazine advertisements to point out Western reading of both text and pictorial materials from left to right and top to bottom. Show how, within an ad, messages often begin in the upper left corner of the layout and move through the page to the lower right corner, where the reader is given the final—usually, the most important—message. Indicate that coupons offered within food ads often appear in the lower right of the layout. Analyze the layouts in the advertisements that the students brought in. Ask: How did the artists emphasize a product or message? Call students' attention to the zoo advertisement (fig.10–20), and ask where the ad begins (upper left) and where the dominant image is (right side).

- Discuss the diagram (fig.10–16), which illustrates what is known as the *rule of thirds*. Ask students to determine where the center of interest is in Dorothea Lange's *Tractored Out* (fig.10–17), and to explain how

this relates to the diagram of ideal placements. Ask students to review Andrew Wyeth's *Christina's World* (fig.1–28), and to determine how Wyeth's placement of the main subjects relates to the diagram. Challenge students to find another image in the text that has the main subject near the intersection of lines that divide the composition into thirds.

- Direct students' attention to the Japanese screens (fig.10–18) to see another means of achieving interest. Explain that by grouping objects together, artists can emphasize the whole group. Share with students the information in **Context** on page 196.

- Using packages of consumer products such as cereal boxes, direct the students to critique the package designs as described in **Discuss it** on page 196. They should work in cooperative groups of four to five students, record their discussion, and then participate in a whole class discussion summarizing their opinions.

- This consideration of package design may be extended by assigning students to use markers to draw their own package designs either in the next class or as homework.

- To carry package design further, assign each student to design a package for a product such as a new cereal. Students should first make sketches of each side of the package. They may cover existing cereal boxes with white paper and paint their own eye-catching design on the box. Suggest that cooperative-learning groups evaluate the package designs. Direct each group to select one of their packages to market. Help them create a one-minute commercial that emphasizes the package. If possible, video tape each commercial.

Discuss it	page 196

Materials
optional:
- empty cereal boxes and craft paper, or 9" x 12" drawing paper
- pencils
- tempera or acrylic paint
- video tape cassette, recorder, and monitor

- For the next lesson, bring in some portraits taken by professional photographers.

Lesson 8
Emphasis Through Isolation

pages 198–199

Objectives
Students will be able to

- Perceive and comprehend how artists and architects emphasize their subjects by isolating them.

- Create artworks illustrating emphasis of their subject by central placement, grouping, and isolation.

Teach
- Focus on fig.10–21 and guide students to see how John Chalapatas emphasized the main subject by isolating it against a plain background. Show students some photographs taken by professional photographers, paying attention to the backgrounds which usually are plain so that the viewer's attention is focused

on the face. Help students see how Ahearn emphasized the figures in *Janel and Audrey* (fig.10–23) by separating them from groups of other children. Challenge students to compare the focus on these two girls to that on the people in Weegee's *Coney Island Crowd* (fig.5–19). Ask which figures seem more important as individuals. You might remind students of the *Where's Waldo* books and how difficult it is to find Waldo in the crowd.

- Focus on the photograph of the Parthenon (fig.10–22), and encourage students to note where the structure is situated in relation to the rest of Athens. Originally, the Acropolis, the rock on which the Parthenon was built, was the site of other Greek temples. Challenge students to think of monuments or famous buildings in their own community or in nearby communities. Ask: Where are they situated in relation to other structures? Has space been cleared around them so that they are visible for a distance? Do they sit up high? Are they crowded by other buildings? Were they always this way? Direct students to compare the location of the Parthenon, on the Acropolis, to the site of the new Getty Center (fig.8–1), in Los Angeles. Ask students why the architects would want to situate their structures on a hill overlooking a city.

- Encourage students to experiment with emphasis of subject matter in photographs. Student groups of four may work together to photograph one another to illustrate central placement, grouping, and isolation as means of emphasizing their subject matter. For example, they may photograph a face so that it is in one of the locations indicated in the chart on page 196; they may group their subjects together; and they may isolate a figure against a plain background.

188g

- If cameras are not available, direct students to draw objects and use markers to add backgrounds in three 4" x 6 1/2" compositions—one illustrating emphasis by placement, another by grouping the subjects, and a third by showing isolation of the center of interest. Alternatively, students can use computers for this project, drawing three rectangles and placing clip art in each rectangle to illustrate the different means of creating emphasis.

Teach	pages 198–199

Materials
- professionally-photographed portraits
 options:
- cameras and film
- 12" x 18" drawing paper (cut into 4" x 6 1/2" pieces), drawing media (pencils, markers)

Lesson 9
Using Size and Repetition

pages 200–201

Objectives
Students will be able to

- Understand that artists may emphasize a subject by enlarging its size or scale.

- Create an artwork illustrating altered scale.

Teach
- Explain scale by placing some toy figures or dolls next to an everyday object, such as a shoe. Ask students

to imagine how the shoe would appear to these dolls, or how the artroom would look to an ant on the floor. Remind students of movies—such as *Honey, I Shrunk the Kids*; *Gulliver's Travels*; and *Toy Story*—in which small characters viewed the world on a different scale.

- Direct students to look at Turrell's *Roden Crater* (fig.10–24) and Oldenburg's *Batcolumn* (fig.9–31), and point out the dimensions of these artworks. Ask students to compare the size of these sculptures to some structure that they know. Suggest that students look through the book to find other examples of oversized art. If necessary, point out that the size of these works is what calls attention to them.

- Ask students to look through magazines and cut out two unrelated objects that are different in scale, and to place the two together on a piece of paper to notice how the meaning of these objects changes when the scale is altered. After students have experimented with the arrangement of these objects, have them glue them to the paper.

- Instead of the magazine collages students could experiment arranging small toys with regular-size objects to create installations. Students may sketch or photograph their creations.

Teach	page 200–201

Materials
- old magazines with photographs
- 12" x 18" drawing or colored paper
- scissors
- glue
 options:
- toy figures or dolls
- 12" x 18" drawing paper, drawing media (pencils, markers)
- cameras and film

Lesson 10
Using Size and Repetition

pages 200–201

Objectives
Students will be able to

- Perceive and comprehend that artists may create emphasis by repeating objects or figures.

- Create a cut paper collage repeating shapes to create interest.

Teach
- Call students' attention to Willie Cole's *Domestic ID IV* (fig.10–25) and Maria Teokotai's *Ina and the Shark* (fig.10–26). Help students note how many times the artist repeated each shape, and how this repetition emphasizes the shape. Point out that in Teokotai's quilt are shapes of water and the fish, both of which are important to the Polynesian island cultures. Inform students that Cole's scorched fabric "brands" were inspired by carved wooden masks from the Dan people of Liberia, Guinea, and the Ivory Coast, Africa. Ask if students think Cole's use of different brands of irons as a stamping device could suggest tribal associations. Why might Cole have surrounded these images with a battered window frame? Does the frame influence how repetition of images creates emphasis in this work? Lead students in a discussion of some possible answers.

- Refer students to *Plus Reversed* (fig.2–13) and *Raqqa II* (fig.8–8) to see how emphasis is created by repeating shapes.

- Instruct students to cut out about ten shapes of the same object from colored paper. (To save time, students might fold or layer paper together so that they can cut out several shapes at once.) Ask them to arrange these on a 12" x 18" piece of colored paper. Encourage students to notice how the shape is emphasized by repetition, and to experiment with several arrangements.

Teach	pages 200–201
Materials	
• 12" x 18" colored paper	
• glue	
• scissors	

Chapter Review

pages 202–203

Assess

- Assign students to write the answers to the questions in the chapter review. Check over and discuss the answers to these questions with the class to see that the students perceive and comprehend how artists create emphasis in their works by relying on one art element; simplifying the design; and grouping, centering, enlarging, repeating, and isolating subjects. (**Art criticism**)

- To evaluate their understanding of emphasizing an art element, display the three pieces that the students made of one subject in Lessons 3–5 together with their written analysis of the art elements emphasized in the works. Direct the students to look for a style or repetition of a particular art element within each other's art. Do they agree with the artist about which element was emphasized in each work? Larger classes should work in small groups to analyze the group's projects. (**Art production/criticism**)

- If the students completed the package design extension project in Lesson 7, each cooperative-learning group will evaluate their group's designs to decide which they will be able to most effectively market in their group commercial. (**Art production/criticism**)

- Review with each student the portfolio created in this chapter to ascertain that she/he did experiment with a variety of methods to create emphasis. (**Art production**)

- To evaluate students' understanding of how artists and architects of various cultures and periods including west Africa, Japan, China, ancient Greece, and twentieth-century America and Europe create emphasis in their art, write this list of cultures on the board. Then assign students to find an example of each culture's art in the chapter and write an analysis of how emphasis was achieved in each piece. Lead the class in considering their written responses. (**Art history/cultures**)

- During this chapter and in preceding lessons, students should be developing an appreciation for the similarities and differences between art and architecture and how the design principle emphasis is important to both disciplines. To review and assess these understandings and appreciation, refer the students to fig.10–6, the *Vietnam Veterans Memorial Wall,* and fig.10–22, the *Parthenon.* Lead the students in discussing these monuments.

Computer Connection

Ask a student to pose in various action positions. With painting or drawing software, instruct students to use the pencil tool and create four contour action drawings on a single page. After filling three of the contour figures with the same color, students will select each of the three figures and create multiple copies on a new page. Guide students as they use their knowledge of design to create a pleasing arrangement. Instruct students to return to the fourth contour image and fill it with a color which is complementary to the color used previously. Students should add one copy of the new figure to their arrangement. Discuss how the emphasis of color has created a focal point in their work.

Ask: Are these art, architecture, or some of both? Why do you think so? Would you consider one to be more art than architecture or vice versa? What are the dominant art elements in each of these monuments? What has each artist emphasized in these forms? How has each one created this emphasis?

If you were on a cultural council seeking to erect a community structure, why or why not would you fund these? What arguments would you present to the town council or governing board to either recommend spending or not spending money on these?

How are art and architecture alike? Why do you think that architectural students are often required to take art courses? Find an example of a building in the book which demonstrates emphasis. (**Aesthetics**)

Reteach

- Review with students the various ways to create emphasis. Have students name the methods, and write them on the board. They should mention emphasizing one design element, simplifying the design, using central placement and grouping, isolating the main center of interest, enlarging the size, and repeating. Ask students to study the images on pages 202–203 to determine how each artist created emphasis.

- Have pairs of students create a chart in which they list each artwork on pages 202–203, the means used to create emphasis, and the effect emphasis has on their understanding of the artwork.

- As students discuss the portrait (fig.10–28) by the Italian Renaissance artist Piero della Francesca, they should mention how the head set against the plain sky dominates this composition by its large scale relative to the landscape. Piero della Francesca is known for his ability to simplify shapes and indicate three-dimensional forms. In this painting, he has made a dramatic contrast in depth by locating the subject very close to the viewer but in front of a distant landscape—without transitions between the foreground and background.

- During the discussion of Edward Weston's photograph, fig.10–29, students will probably notice how repetition of lines creates an emphasis on the texture of the sandstone. Explain to students that Weston often emphasized the form of ordinary objects in his photographs. He was a member of Group f.64, formed in 1932 by photographers who used small aperture settings for their camera lens in order to show fine details. Ansel Adams (fig.3–2) and Imogen Cunningham (fig.1–17) were also in this group.

Answers to Review Questions

1 Scale refers to the relative size of a figure or object, compared to others of its kind, its environment, or humans.

2 A caricature is a depiction that exaggerates features or characteristics of a subject to an unnatural, ridiculous, or absurd degree.

3 Ways to achieve emphasis in a composition are to rely on one art element, exaggerate shapes or forms, simplify the design, use special placement, group elements, isolate the main subject, emphasize the scale of an object, and repeat elements.

4 Architects leave open land around their buildings to help unify the feeling of the space and to emphasize their designs.

5 Image choices and explanations will vary.

6 Wang Yani simplified the background by leaving the area blank around the birds and framing the main subject with a simplified rock and leaves.

7 John Ahearn makes plaster casts of his subject's body and then casts it in plaster, Fiberglas™, or bronze.

Meeting Individual Needs

Students Acquiring English

Present an overview of the chapter, and review prior knowledge of line, shape and form, value, color, space, and texture elements. Form small heterogeneous (by language and cultural background, and academic and language proficiency) task groups to allow for more varied and stimulating interaction. Referring to the images in the chapter, ask students to identify, analyze, and discuss the methods used to achieve emphasis by
- using a single element (pp. 190–193)
- simplification of composition (pp. 194–195)
- special placement (pp. 196–197)
- isolation (pp. 198–199)
- size and repetition (pp. 200–201)
 Be sure that students understand the purpose of this activity, and encourage them to ask questions in order to complete the task.

Determine comprehension by having students from each group report what aspect of design is emphasized and by what means.

Students with Special Needs

Distinct Learning Styles
The hands-on activities in the chapter are excellent for students who have trouble with reading comprehension. See **Try it** on pages 192 and 194. Written assignments may accommodate those who have problems verbalizing information. See **Try it** on page 190.

Gifted and Talented

Have students research the works of two of their favorite artists, and use reproductions or other visuals to analyze and explain the methods that the artist used to achieve emphasis, and whether the artist relied on a single element in an artwork.

10 Emphasis

Key Vocabulary

caricature

style

scale

EMPHASIS IS THE SIGNIFICANCE, OR IMPORTANCE, that you give to something. In your life, you might feel that a certain friend, family member, or personal goal is very important. But did you feel the same way last year? Five years ago? Throughout your life, you're met with changing ideas and situations. You identify them, sort them out, and give them different levels of importance, or emphasis. The factors that are significant to you could be rather insignificant to others. And, as you grow and change, each factor might remain just as important, gain importance, or lose its emphasis in your life.

Chapter Warm-up
Explain that emphasis is the placing of special significance on something or making something important. Lead students in a discussion about what has been especially significant to them in their lives. Ask them to think of who or what was most important in their lives when they were in elementary school. Then ask who or what was most important to them last year, and how that person or thing affected or changed their life.

10–1 Many parts of plants are emphasized through color, shape, line, or other characteristics. This emphasis likely evolved to attract insects to help with pollination. *Orchid*. Photo by J. A. Gatto.

10–2 Since the 1970s, Muriel Castanis has made classicized figures such as *Daphne*. Her figures emphasize the strength and dignity of the female form. What design elements did Castanis use to make her point?
Muriel Castanis (b. 1926). *Daphne*, 1986. Cloth and epoxy, 76" x 41" x 31" (193 x 104.1 x 78.7 cm). Courtesy of O. K. Harris Works of Art, New York. Photo by D. James Dee.

Higher-Order Thinking Skills
Have students research Italian Gothic altarpieces such as the *Maestà* by Duccio or those by Cimabue and Giotto to analyze how these artists emphasized the important figures. (They usually placed the most important figure in the center of the composition on a flat gold-leaf background and made the surrounding figures smaller in scale. Students might notice that the size of each figure is not related to the actual size of humans but to the relative importance or holiness of the figure.)

Artists also sort out the various ideas and elements that make up the subject matter of their work. Composers, choreographers, and writers each have ways of developing a main idea, theme, or center of interest. They have to answer questions such as "What is my work about?" or "What am I trying to say?" Visual artists may simply choose to emphasize a single aspect of a design, but they must also decide *how* to emphasize it. They usually choose from a variety of methods to achieve emphasis, which include relying on a single element of design, simplifying the overall composition, and using special placement.

10–3 Artists often focus on specific design elements in their work. Igbo weavers are well-known for their emphasis on color and geometric shape.
Africa (Nigeria, Igbo culture). *Woman's Shawl*, early twentieth century. Cotton fibers, 55" x 35" (139.7 x 88.9 cm). Virginia Museum of Arts, Richmond, Virginia. Gift of A. Thompson Ellwanger. Photo: Catherine Wetzel. ©1999 Virginia Museum of Fine Arts.

Cooperative Learning
Because there are many opportunities for cooperative-learning activities in this chapter, you might form student groups of four or five in the first class and let them work together throughout all the lessons. As students look at the images on pages 188–189, they may work in their groups to discover the messages in the art.

189

10–5 What do you think the designer is seeking to emphasize in this work?
Jess (Jess Collins) (b. 1923). *Midday Forfit: Feignting Spell II*, 1971. "Paste-up": magazine pages, jigsaw-puzzle pieces, tapestry, lithographic mural, wood, and straight pin, 50" x 70" x 1 ¾" (127 x 177.8 x 4.5 cm). Collection of the Museum of Contemporary Art, Chicago, restricted gift of MCA Collectors Group, Men's Council and Women's Board; Kundstadter Bequest Fund in honor of Sigmund Kunstadter; and National Endowment for the Arts Purchase Grant.

10–4 This feathered headdress was created to be part of a ceremony that involves dance and music. What aspects of the headdress might the maker have tried to emphasize when making the piece? Keep in mind that it is meant to work in unison with the dancing and music.
Native American Dancer. Photo by J. A. Gatto.

Context
The Igbo, or Ibo, are one of four major ethnic groups in Nigeria, Africa. They live predominantly in the southeastern part of the country. The weavers of the Akwete region in southern Nigeria are famous for the style of wrap seen in fig.10–3. In addition to their textiles, the Igbo are known for their wood carvings. Their carved doors and stools show the same fascination with geometric shapes that is evident in the shawl.

Emphasizing One Element of Design: Line, or Shape and Form

Part of your experience in art has been—and will continue to be—the exploration and manipulation of the elements of design: line, shape and form, value, color, space, and texture. Unlike many other areas of knowledge, art has no set rules or formulas for using these elements. Instead, visual artists must experiment with them to develop a clear importance within their designs. If they don't, their works will fail to communicate a main idea or theme.

Emphasis of one particular element can help an artist organize a design and establish a focal point for the viewer. Look at the photograph of the Vietnam Veterans Memorial Wall (fig.10–6), designed by Maya Ying Lin. Her simple but powerful design emphasizes the converging lines of the wall, as well as the engraved lines that record the names of those who died. Compare the memorial to the drawing by Ellsworth Kelly (fig.10–8). Here too, the artist used a simple design; each leaf repeats a similar shape. The overall effect is one of gracefulness and quiet.

Internet Connection

Maya Lin's *Vietnam Veterans Memorial Wall* inspired people to create related works in honor of those whose lives were lost. Two of these works are the *Virtual Wall* and the *Moving Wall*. Students may wish to explore the information about these memorials on the Internet. Also, ask them to discover how items such as teddy bears, childhood photos, and military rations are collected nightly by National Park rangers to become the Vietnam Veterans Memorial Collection. Afterward, lead them in a discussion of why they think the *Virtual Wall* and the *Moving Wall* either should or should not be categorized as works of art.

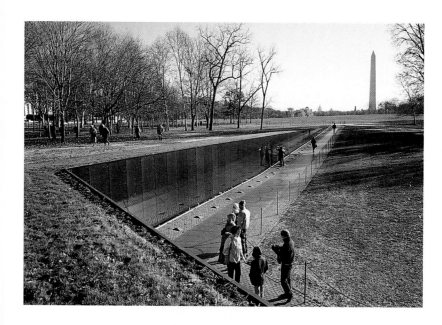

10–6 This memorial emphasizes line in its design. The lines in the granite and the walk beside it keep our attention focused on the many rows of names that themselves form lines on the polished granite.
Maya Ying Lin (b. 1960). *Vietnam Veterans Memorial Wall*, 1982. Black polished granite 493' long (150 m). Washington, DC. Photo by Robert Hersh.

Try it

Select three natural forms, such as a shell, a leaf, and a rock, and observe the elements of design in each object. Although subtle variations of line, form, value, color, and texture are evident, one element will usually seem to dominate. Write notes of your observations, explaining what element is dominant and why you think so. Then make a sketch of each object.

Context

Maya Lin was a twenty-one-year-old architectural student at Yale University when her design for the Vietnam Veterans Memorial was chosen from more than 1,400 other entries in a public competition. However, her simple, untraditional design brought as much criticism as praise, mostly because many people had expected a realistic depiction of war heroes. Some of the early controversy was eventually quelled when a sculpture of three servicemen was commissioned and placed to the side of the wall. In the time since its dedication, the memorial has come to be viewed as a place of healing and reconciliation. Most visitors are deeply affected by its simple power.

Distorting or exaggerating shapes and forms is another way to achieve emphasis. For example, an artist might create a *caricature*, a depiction that emphasizes a distinguishing feature of a subject, such as a strong chin or large eyes. An artist might also create unusual or bizarre shapes or forms to achieve emphasis. The sculpture by Alberto Giacometti (fig.10–7) emphasizes fragile form. A simplified body with elongated arms and legs gives the piece an eerie, dreamlike quality. Giacometti began creating a series of sculptures, of which *Walking Male* is a part, in Europe about the time that World War II ended. Possibly, the figures reflect the fear and helplessness that many people felt during and after the war.

⭐ **Design Extension**
Assign students to bring in caricatures from newspapers and magazines, and analyze these to determine which features the artist exaggerated. In most caricatures, the heads are large in comparison to the rest of the body. For instance, the artist often emphasizes the eyes, mouth, or nose. One example is Gene Mater's self-portrait on page 32. Have students draw a caricature of a favorite film star or politician.

191

10–7 What other images in the text have an unusual or exaggerated form?
Alberto Giacometti (1901–66). *Walking Male*, 1960. Bronze, 37 ½" x 11 ¹/₁₆" x 9 ⅞" (95 x 28 x 25 cm). Fondation Maeght, Saint Paul-de-Vence, France. Erich Lessing/Art Resource, NY. ©1999 ARS, New York/AD AGP, Paris.

10–8 What do you think the artist might have been trying to capture in this simple sketch from nature?
Ellsworth Kelly (b. 1923). *Briar*, 1963. Graphite on paper, 22 ⅜" x 28 ⅜" (56.8 x 72.1 cm). Whitney Museum of American Art, New York. Purchase, with funds from the Neysa McMein Purchase Award.

Context
Public buildings and monuments are often met with criticism when they first are proposed or erected. If the architecture or monument is exceptional, and appropriate in design, the public generally comes to recognize and appreciate its beauty and meaning. (Other structures that underwent this initial criticism are I. M. Pei's addition to the Louvre, fig.9–30, and Frank Lloyd Wright's Solomon R. Guggenheim Museum, in New York City.) Encourage a discussion to explore the reasons for these transformations in opinion.

Emphasizing One Element of Design: Value, Color, Space, or Texture

Placing light values next to dark values is a common way to create contrast within a composition (see Chapter 3), and artists often make the center of interest the area of greatest contrast. Look at *Portrait Study of a Man* (fig.10–9), in which Géricault, a famous early-nineteenth-century French painter, used dramatic lights and darks to emphasize the expression on his subject's face. This emphasis of dark values often conveys moods of gloom, mystery, drama, or threat, whereas a composition with predominantly light values tends to produce opposite effects. Today, the TV, film, and advertising industries still rely on the use of light and dark to create dramatic moods and eye-catching compositions.

10–9 How does the use of value in this portrait influence our impression of the sitter and his state of mind?
Théodore Géricault (1791–1824). *Portrait Study of a Man*, c. 1818–19. Oil on canvas, 18 ⅜" x 15 ⅛" (46.7 x 38.4 cm). J. Paul Getty Museum, Los Angeles, California.

10–10 During the 900s, the Chinese invented the fine white ceramic known as *porcelain*. Today, these treasures are collected and preserved by museums worldwide.
China (Ming dynasty). *Bowl*, 1506–22. Porcelain, 6 ⅜" diameter (16.2 cm). San Antonio Museum of Art, San Antonio, Texas.

Higher-Order Thinking Skills

Photographers often use high contrasts of light and dark values to create moods and to emphasize subjects within their compositions. Ask students to look in fashion or photography magazines to find examples of dramatic lighting that creates emphasis and mood. Have students choose one example and write an analysis of the mood.

Try it

Explore the use of various traditional or experimental art media and materials by depicting one subject in three different media. Which elements of design do you find yourself emphasizing? Do you see a preference evolving for one element of design over another in your art? If so, describe how you use it within your designs.

Context

Porcelain created during the Ming dynasty marked a high point in the history of Chinese ceramics. The perfection in form, glazing, and technique is evident in this yellow bowl (fig.10–10). Monochrome glazing was developed during the Ming era. Point out that the single color would emphasize any imperfections in the form or glazing.

The designer of the Chinese porcelain bowl (fig.10–10) emphasized its simple yet perfect form with a pure yellow glaze. Made in the 1500s during the Ming dynasty, the piece is a fine example of the elegance and perfection that are features of much Chinese and Japanese design. The color yellow symbolized the Chinese emperor, who was equated with the powerful and life-giving sun.

Compare the design of the yellow bowl to the images of the tennis player (fig.10–12) and the woven basket (fig.10–11). How does each work emphasize a different element of design? Notice that the chosen element in each design seems well matched to the form. How would the illustration of the tennis player be different if the artist had decided to emphasize a single color? Why might that have changed the image's main point or center of interest?

193

Performing Arts
Where's the Beat?
Artists use color, line, shape, and composition to emphasize portions of their work. In African drumming, musicians create clear, evocative rhythms that strongly emphasize certain beats over others. Have students listen to recordings of African drumming, such as that by Mustapha Tetty Addy, the master drummer from Ghana, West Africa. Challenge students to see if they can intuitively find the music's emphasis.

10–11 American artist Martin Puryear says that he is "a builder, not a maker." In the 1960s, he spent two years in Sierra Leone, West Africa. While there, he encountered designs that were quite different from those of a modern industrial society. Many of his sculptures are based on forms and materials that West Africans use in their traditional crafts and buildings.

Martin Puryear (b. 1941). *The Charm of Subsistence*, 1989. Rattan and gumwood, 84 ¼" x 66" x 7 ½" (214 x 167.6 x 19 cm). Saint Louis Art Museum.

10–12 In this design, illustrator Chris Polentz places the greatest emphasis on the representation of three-dimensional space. The viewer gets the feeling of being directly on the other side of the net. Exaggerated perspective heightens this effect.

Christopher R. Polentz (b. 1962). *Extreme Tennis*, 1995. Acrylic on illustration board, 15" x 20" (38.1 x 50.8 cm). Courtesy of the artist.

Note it

The next time you walk down a street, determine which building or structure dominates the skyline, and what one element of design is emphasized. Make a list of visually dominant structures in your community, and describe the design elements in each.

Higher-Order Thinking Skills
Ask students to compare and contrast the Martin Puryear piece (fig.10–11) to the work of Maya Ying Lin (fig.10–6). Ask: What is the most important element in each? How do the textures compare? How are the works alike stylistically? (They are both minimalist, synthesized to a simple shape.)

Using Simplicity

We are not comfortable with haphazard or disordered arrangements, so we generally appreciate visual order in a design. One way to achieve order and to clarify the center of interest is to keep a design simple. Because simplicity allows the viewer to quickly see the artist's main idea or point, it almost always contributes to emphasis.

In cartoons and comics, artists often simplify the bodies and faces of their characters. They may choose to place emphasis on only the eyes and mouth so that viewers can easily figure out a character's feelings or personality. Look at the expressions on the faces of Wallace and Gromit (fig.10–14). How can you tell what the characters are thinking in this scene?

You've probably noticed that shapes and forms also gain importance when they are set off against plain, uncluttered backgrounds. If a background is more dominant or detailed than the center of interest, the main subject may be difficult to find. Look at the watercolor painting by Wang Yani (fig.10–15), who included small, dark ovals to represent a pebbly surface. However, she left blank the area around the two birds. To frame the main subject, she painted the large rock and leaves without great detail.

10–13 Conveying an idea with great simplicity is quite difficult. Why do you think this is so?

Hugo Robus (1885–1964). *Figure in Grief,* 1952. Bronze (from edition of 6), 12" high (30.5 cm). Columbus Museum of Art, Ohio.

10–14 Would these characters be more or less effective if their creator had put a great deal of detail into their faces and bodies? Why?

Nick Park (b. 1958). *Wallace and Gromit—A Close Shave,* 1995. ™ & ©Wallace & Gromit Ltd/Aardman Animations Ltd 1995.

About the Artist

Wang Yani

At a very young age, Chinese artist Wang Yani became famous for her work. She was born in 1975, and lived in an environment that included the beauty of mist-shrouded mountains, green hills, ancient temples, and the clear Chiajiang River. Surrounded by nature, Yani was keenly observant, and she showed both a gifted memory and a lively imagination.

Yani watched her father, a painter, as he worked, and he provided her with art materials as soon as she could use a pencil and charcoal stick. At the age of two, she scribbled, as most children do, but then she became serious about her picturemaking. Before the age of three, she surprised her father by asking if she might paint.

Her father decided not to influence her with formal art training, and instead he gave her the opportunity to paint as often as she liked. She painted birds, animals, houses, the sun, and children. Pictures flowed from her as a kind of language, and her father encouraged her strong, broad strokes.

Yani loved animals, and she became fascinated while watching the monkeys at the Nanning Zoo. The three-year-old artist began to paint her impressions of the playful monkeys she had seen. Over the next few years, she painted hundreds of monkey scenes. News of Yani's talent began to spread.

10–15 Asian painters frequently leave areas of their work blank. They achieve a delicate balance between negative and positive space and make it clear where we should focus our attention.
Wang Yani (age 13). *A Happy Episode*, 1988. 19" x 26" (48.3 x 66 cm). Photo by Zheng Zhensun.

When she was four, exhibits of her work were held in Beijing, Shanghai, and Guangzhou. One of her monkey pictures was issued as a Chinese postage stamp.

To many of her paintings, Yani adds an inscription, words that make a statement, such as the one on her painting *Animals' Autumn*: "Autumn seems to be a withering season for trees, but the animals are happy." She also adds her red artist's seal, which varies in size and shape, to each completed work.

By the age of sixteen, Yani had painted more than ten thousand pictures. Solo exhibitions of her work have been held in Japan, Hong Kong, Germany, Great Britain, and the United States.

Style

Wang Yani works in the traditional method of Chinese painting: her finished works are similar to those that have been created by Chinese artists for hundreds of years. Although each painter who uses this method may have a distinctive aspect to his or her compositions, the group as a whole works in a similar *style*—the characteristics that distinguish the work of an individual or group of artists.

Style may be defined by the general subject matter, method of composition, choice of colors, or even types of materials. Compare the portrait by Géricault (fig.10–9) with the group portrait by Alice Neel (fig.9–23). Describe each style of painting. How would you compare the two styles of painting? How would you describe your own style?

Using Placement and Grouping

In Western culture, we read from left to right and top to bottom. The significance of this eye movement from upper left to lower right permits artists and designers to create emphasis through placement. For example, many Western visual artists place the center of interest on the right side of a composition. The viewer's eyes will start "reading" the composition at the left and be drawn across to the right. Also, magazine and newspaper layout artists generally place the more expensive and important ads on the right-hand pages.

This concept of ideal locations for placement of subject matter has been an important part of design since ancient Greece. Look at fig.10–16. Along with the importance of right-hand placement, three other areas are ideal for achieving emphasis. When you place the center of interest at or near one of these four locations, your subject matter will receive added emphasis. Your design also will have a strong asymmetrical composition.

Another way in which artists can achieve emphasis is by grouping many shapes or forms. The collected objects or figures visually attract one another and easily become the dominant point or center of interest. In such designs, the entire group is usually viewed as one entity. The closer the forms are to one another, the stronger their attraction and emphasis will be.

10–16 In this diagram illustrating the rule of thirds, ideal positions are shown for an artwork's center of interest. Notice that the four positions are slightly removed from the center of the picture plane. When an object or figure is placed in the exact center, what occurs is an undesired bull's-eye effect which causes the viewer to ignore all other parts of the design.

10–17 In this image, the rows of soil move the viewer's eye to the abandoned farmhouse. Notice that the photographer located the building in one of the ideal center of interest positions.
Dorothea Lange (1895–1965). *Tractored Out*, c. 1938. Silver print. Reproduced from the Collections of the Library of Congress.

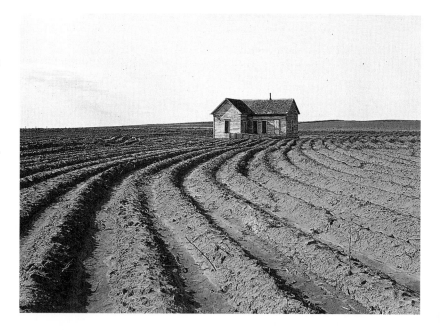

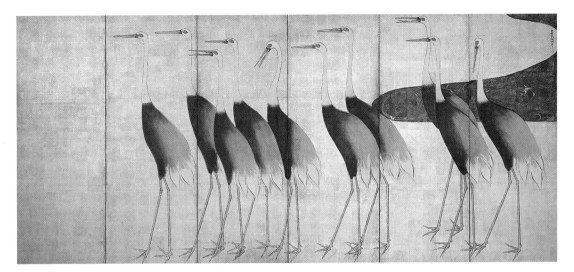

197

Context
In the sixteenth through
eighteenth centuries,
the folding screen
(fig.10–18) was a vehicle
for some of the greatest
painting produced in
Japan. The screens,
portable and decora-
tive, were particularly
popular with the rich
merchant class,
although the aristocracy
was also fond of them.

10–18 What traits in these birds did the artist choose
to emphasize by grouping them in this way?

Ogata Korin (1658–1716). *Cranes*, 17th–18th century. Ink,
color, and gold on paper, 65 ⅜" x 146" (166 x 371 cm). Freer
Gallery of Art, Smithsonian Institution, Washington, DC.

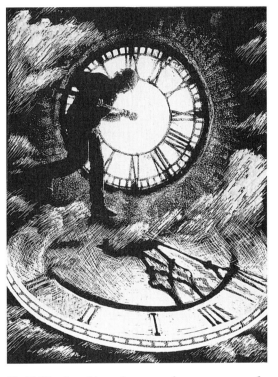

10–19 How has this student created a strong center of
interest in his work?

Jeremy Emerson (age 18). *Time*, 1993. Pen and ink, 10" x 7 ½"
(25.4 x 19 cm). Plano Senior High School, Plano, Texas.

TO A
CHILD
USED TO
SEEING
THINGS
ON
A 19" TV
SCREEN,
IT CAN BE
QUITE AN
EXPERIENCE.

POLAR BEARS AT THE NORTH CAROLINA ZOO, ASHEBORO

10–20 Why must designers of advertisements be espe-
cially aware of emphasis in their work? If emphasis is
missing or misplaced, what might happen?

Polar Bears at the North Carolina Zoo, Asheboro, 1995–96.
Created by Loeffler Ketchum Mountjoy Advertising,
Charlotte, North Carolina.

with sides in an 8 to 13 ratio, and then
encourage them to experiment folding
and dividing this rectangle into sec-
tions and noting what shapes they
create. For example, they might fold
one short side of the rectangle diago-

nally to line up with one long side.
After they unfold it, they should draw a
line from the point where the diagonal
crease and long side meet to the other
long side. Assign students to find and
study an image of Leonardo da Vinci's

Madonna of the Rocks and Claude
Lorraine's *Embarkation of St. Ursula*,
and discuss the location of the main
figure—then compare these locations
to some of the points they discovered in
folding the rectangle.

Portfolio Tip
Show students
examples of borrowed
professional portfolios,
perhaps your own or
that of a friend.

Emphasis Through Isolation

When one object or figure is separated or removed from others, it becomes isolated. To achieve isolation in a design, an artist or designer might place the main subject against an absolutely plain background. This method of creating emphasis, which is closely related to the use of simplicity and placement, is commonly used in two-dimensional designs such as photographs, drawings, and advertisements. Look at the painting by John Chalapatas (fig.10–21), in which the artist used a red background to dramatically isolate the foreground subject (the skeleton). Some sculptors also use isolation. The casual quality of John Ahearn's two neighborhood girls (fig.10–23) recalls a snapshot taken against a wall or other plain background.

Sculptors and architects are also concerned with placement or location. Because some sculptors intend their works to be seen "in the round" (from many different viewpoints), emphasis by isolation is important. Have you ever noticed that sculptures in museums and galleries are frequently placed on a base or pedestal? This helps separate the piece from its surroundings and allows the viewer to move around it easily.

Architects must always consider the relationship between a planned structure and its surroundings. A building can sometimes be viewed from several sides—or perhaps just one side. Whenever possible, architects use available land around their buildings to help unify the feeling of the space and to emphasize their designs. Often, however, the future of a building and its environment is beyond the control of the architect. Over time, nearby buildings may be torn down, thereby exposing sides never meant to be seen; or new structures may become overpowering neighbors. Such changes can dramatically alter the original emphasis of the structure.

10–21 This student has used emphasis through isolation in his painting. Are there other ways he has used emphasis?
John Chalapatas (age 18). *Untitled*, 1997. Oil pastels, 18" x 24" (45.7 x 61 cm). Oakmont Regional High School, Ashburnham, Massachusetts.

10–22 Many of the Classical structures that once crowded this hilltop in Athens, Greece are no longer standing. Although pollution and tourists threaten the fragile building's well-being, the Parthenon continues to display emphasis through its isolation high atop the Acropolis.
View from the Mouseion. Acropolis, Athens. SEF/Art Resource, NY.

Discuss it

Look through the images in this and other art books. How do the works of certain artists or designers consistently emphasize the same elements of design? Who are some of your favorite artists? What aspect of their style helps you identify their work?

About the Artwork

John Ahearn

Janel and Audrey

Artist John Ahearn believes in connecting artworks to real life. Can you think of a better way to create a powerful connection than by using plaster casts made from real, live people? When the artist paints his cast sculptures, he takes great care to achieve a likeness of each person.

Throughout the 1980s, Ahearn often worked with a partner, artist Rigoberto Torres. Together they created many such sculptures, portraying their neighbors in the South Bronx of New York. They sometimes set up their artmaking on the sidewalk, where people would wait for their turn to "become" a sculpture. Ahearn and Torres would pass art materials through the windows of Ahearn's rented ground-floor rooms.

When he learned of plaster casting in 1979, Ahearn was an alternative-arts journalist for a Manhattan artists' collaborative. A friend was repairing some plaster life casts for the American Museum of Natural History, and Ahearn became fascinated with the process and began experimenting. He developed his own working style, creating sculptures from plaster casts of people he knew. After his twin brother commented that Ahearn's artwork was "too safe," the artist moved to the Bronx, where he met high-school student Rigoberto Torres. Torres was enthusiastic about learning the casting process and offered to help Ahearn.

The artists found people in the inner city who were willing to be models. First, they coated their models with a gel so that the plaster could be removed after it hardened.

10–23 How does isolation help us better focus on the girls? What would happen if there were a background?

John Ahearn (b. 1951). *Janel and Audrey*, 1983. Acrylic on plaster, 32" x 32" x 9" (81.3 x 81.3 x 22.9 cm). Courtesy of Alexander and Bonin, New York. ©D. James Dee, 1991.

The models put straws into their nostrils so that they could breathe throughout the procedure. Ahearn and Torres then wrapped the parts of the bodies to be cast, completely encasing them in wet plaster bandages. Later, they carefully removed the hard plaster, which they would use as a mold. After pouring plaster into this mold, the artists had a sculptural form that they then painted. For any models who wished, Ahearn made a cast of their face for them to keep.

Ahearn has described himself as "an itinerant portrait painter." By representing everyday "slices of life," Ahearn and Torres have brought art to the community in a new way. They have immortalized common people in artworks, thereby enabling people to see themselves and art in a positive and meaningful way.

Ahearn reconstructs some of his sculptures in Fiberglas™ in order to make them freestanding. He has cast some of his works in bronze, for outdoor display. His sculptures appear throughout the South Bronx, in people's homes, in public spaces—and in galleries.

Higher-Order Thinking Skills

John Ahearn painted his sculpture of *Janel and Audrey* realistically. Ask students to compare this rendering to that in George Segal's *Woman in Coffee Shop* (fig.9–22). Ask: How does the coloring affect their feelings about these sculptures? Discuss how each artist emphasized his subject, and what mood or message each artist conveys.

Cooperative Learning

If students use cameras for Lesson 8, organize them into cooperative groups to photograph each other in compositions illustrating emphasis by placement, grouping, and isolation. Encourage them to try different locations and backgrounds to illustrate these various means of emphasizing a subject or focal point. They should each take turns being the photographer, director, subject(s), and recorder.

Context

The ancient Greeks placed an emphasis on perfect proportions. To ensure that the Parthenon did not look distorted from a distance, they adjusted its design to compensate for optical illusions. For example, the base of the temple and the entablature curve slightly upward toward their centers, which compensates for the human tendency to perceive sagging at the center of a long horizontal line. The columns were made to swell a bit, and they lean slightly inward. There is less space between the columns that are closer to the corners. These adjustments give the building a unified appearance as it sits high above the city of Athens.

Using Size and Repetition

One way to achieve contrast is to combine shapes or forms of different sizes (see Chapter 9). Size can also create emphasis within a design. You're probably familiar with ads in which products are emphasized by being bigger—and therefore more important—than other, similar products around them. Contemporary architects design increasingly taller skyscrapers to tower above city skylines; and certain visual artists, including Christo and Jeanne-Claude (fig.9–27) and James Turrell (fig.10-24), enjoy working on projects of gargantuan size.

What these artists and designers are doing is emphasizing scale in their designs. *Scale* is the relative size of a figure or object. For example, a house is larger in scale than a desk. Scale also describes objects and figures that are depicted much larger or smaller than life-size. For instance, the sculptor of the Statue of Liberty greatly increased the scale of the human figure. Sculptors Muriel Castanis (fig.10–2) and Claes Oldenburg (fig.9–31) have also exaggerated scale in their works in order to create attention-getting designs.

An artwork also displays emphasis if it includes repetition of objects or figures—regardless of their size or scale. When many forms appear on a picture plane or in a three-dimensional sculpture, the emphasis of the forms is reinforced. An image of a crowded beach, for example, offers greater emphasis when dozens of people are bunched together than when only five or six are shown. The concept of a jungle or dense forest is more impressive when many trees, rather than just a few, are depicted. In general, more repetition of a shape, form, or color creates more emphasis in a design.

10–24 In this work in progress, Turrell has emphasized space and light, as well as size, by coordinating its open areas with the passing effects of the sun, moon, and stars.

James Turrell (b. 1943). *Roden Crater*, begun 1975. Modified cinder cone of dormant volcano in Arizona. Diameter at completion to be 3000' (914.4 m). Photo by James Turrell, 1993.

10–25 Many layers of symbolism can be found in this work. In one layer, Cole represents black or African laborers in domestic situations. A second layer is the portrayal of African tribes, shown by masklike stamped "faces" of the irons. A third level of meaning is signified by the similarity of the iron shapes to a slave ship's layout. Would you say that the principle of emphasis through repetition has been successfully used by Cole?

Willie Cole (b. 1959). *Domestic ID IV*, 1992. Iron scorches and pencil on paper in window frame, 34" x 32" x 2" (86.4 x 81.3 x 5 cm). Courtesy Alexander and Bonin, New York.

201

10–26 Repetition often provides the viewer with clues about what is important in a work. In this quilt, what imagery is emphasized?

Maria Teokotai and others. *Ina and the Shark*, c. 1990. Tivaevae (ceremonial quilt, Cook Islands), 101" x 97 ⅛" (257 x 247 cm). Museum of New Zealand (Te Papa Tongarewa), Wellington.

involving scale changes, such as Lewis Carroll's *Alice's Adventures in Wonderland* and Jonathan Swift's *Gulliver's Travels*.

Another Look at Emphasis

10–27 Analyze this work to discover how Coe used placement to create emphasis.

Anne Coe (b. 1949). *Migrating Mutants*, 1986. Acrylic on canvas, 61" x 61" (154.9 x 154.9 cm). Horwitch Newman Gallery, Scottsdale, Arizona. Courtesy of the artist.

10–28 This is a portrait of a very powerful fifteenth-century Italian nobleman. How did the artist emphasize the nobleman's importance?

Piero della Francesca (1410/20–92). *Portrait of Federico da Montefeltro, Duke of Urbino*, 1465–70. Tempera on wood, 18" x 13" (47 x 33 cm). Uffizi, Florence. Scala/Art Resource, NY.

10–29 What element of design has the photographer emphasized in this work?

Edward Weston (1886–1958). *Sandstone Erosion, Point Lobos*, 1942. Gelatin silver print, 16" x 20" (40.6 x 50.8 cm). Los Angeles County Museum of Art, anonymous gift.

Context

Anne Coe often portrays animals, both real and imagined, in her paintings. Growing up on a ranch surrounded by open space, she was influenced by landscape in a powerful way. She sometimes chooses to emphasize her subjects, whether animals or people, by placing them in exaggerated, "larger-than-life" situations.

Inquiry

Assign students to find a reproduction of the companion piece to *The Duke of Urbino*, *The Duchess of Urbino*, and to analyze another work by Piero della Francesca by noting how he emphasized the center of interest.

10–30 Converging lines can emphasize the center of interest in a design. In this work, the wall on the right and the review stand at left lead our eyes to the focal point of the work, the speeding bicycles.

Antonio Ruíz (1897–1964). *The Bicycle Race, Texcoco*, 1938. Oil on canvas, 14 ½" x 16 ½" (36.8 x 41.9 cm). Philadelphia Museum of Art: Purchased by Nebinger Fund.

10–31 How has this student used repetition of form to create emphasis in this work?

Jorge Medrano (age 18). *Repetitive*, 1998. Styrofoam, 30" x 20" x 15" (76 x 50.8 x 38 cm). James W. Robinson, Jr. Secondary School, Fairfax, Virginia.

Review Questions *(answers can be found on page 188j)*

1. What does scale refer to in art?

2. What is a caricature?

3. List at least five ways to create emphasis in a design.

4. Why do architects often leave open areas of land around their structures?

5. Select one image from this chapter, and explain what the artist emphasized and how he or she created this emphasis.

6. Name a Chinese art prodigy known for her paintings of animals, especially monkeys. How did she emphasize her main subject in the illustration in this book?

7. Describe the process that John Ahearn uses to create his realistic three-dimensional portraits.

Performing Arts
Avoiding Musical Monotony

In a musical score, composers indicate to musicians what to emphasize. For instance, a notation might be *allegro* (brisk and lively), *andante* (moderately slow), *scherzando* (light and playful), *con brio* (in a brisk manner), or *staccato* (played in short, separate notes). Call on students to describe differences among the various notations.

Higher-Order Thinking Skills

After students have studied the three landscapes on pages 202–203 (figs.10–27, 10–28, 10–29), discuss the point of view in each, the importance of the landscape in the composition, and the degree of abstraction in each.

Career Portfolio
Interview with a Photojournalist

Photo ©Barbara Hakim.

Capturing images from the world of possibilities around her, **Dorothy Littell Greco** works with emphasis every time she frames and shoots a photograph. Whether on assignment or pursuing her own ideas, her aim is to compose a shot that makes a statement, tells a story, or records an event. Born in 1960 in Franklin, New Jersey, Dorothy lives in Boston, Massachusetts.

How do you describe your career or your type of art?

Dorothy I make still photographs which appear in newspapers, magazines, books, and corporate publications. I work in an editorial/reportage style, which means my images are naturalistic, rather than ones that are conceived and executed in a studio.

How did you enter into this type of work?

Dorothy As a child as young as five or six, I can remember taking my Kodak camera with me on vacations. As a teenager, I began to get more serious about photography. I taught myself using my dad's old camera and took a course at night school my senior year. For two years, I worked as the high-school yearbook photographer, which influenced my decision to study photography in college. I have a B.S. degree in journalism, with my concentration in photography.

Describe what your working day is like.

Dorothy Since I am self-employed, no two days are the same. Some days, I get a phone call at noon from a newspaper asking me to do an assignment at two. I spend some days in the darkroom printing, or at my light table, editing slides. I rarely have more than one assignment per day, and generally each shoot takes me three to four hours.

If I have to make the photograph inside, I may have to take several cases of lighting equipment with me. Occasionally, I hire an assistant to help me carry my gear and set up lights. I may also be asked to fly to a location and spend several days or weeks making photographs for a client. Since the sun is so important to my work, I often get started about an hour before sunrise and continue shooting until just after dark. At midday, when the sun is at its peak, I caption my film, eat, and rest.

I have photographed presidents, princes, and refugees. I've sat courtside during the NBA Championship and shot the World Series. I've also waited for hours, sometimes even days, in a fire station, a hospital, and a courtroom for something—anything—to happen so that I could make a photo. Every day brings new challenges, and I can no longer imagine having a "normal" job.

How would you describe your creative process?

Dorothy Normally I go into a shoot with some ideas about how I want to make an image. Sometimes it is very specific, and sometimes very general. When I actually arrive, the light may be poor, or my subject might inform me that I have only ten minutes to get the photo. My equipment has to be an extension of my body so I don't have to think about the mechanics. Then I just try and let the situation unfold, responding as best I can, working as quickly as possible.

Each time I have an assignment, I make an attempt to gain my subject's trust and to give something back to them. When this happens, both of us know it, and it's tremendously rewarding. It's also very satisfying artistically to enter a situation with a few vague ideas, to emerge an hour later with exposed film, and then to see the image in the paper or magazine a short time later.

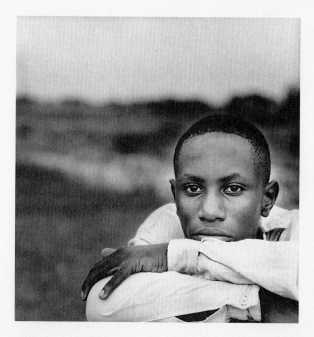

This teenage boy was photographed for a book project titled *A Dry Roof and a Cow*, published by the Mennonite Central Committee. Photographed in natural light with a medium-format camera, the image captures the innocence and vulnerability of this young Haitian immigrant.

Dorothy Littell Greco, *Wesley Jeudy*, 1992. Photo courtesy of the artist.

Studio Experience
Emphasis in a Photomontage

Task: To create a photomontage that emphasizes one center of interest.

Take a look. Review the following images:

- Fig.10–5, Jess, *Midday Forfit: Feignting Spell II*
- Fig.10–27, Anne Coe, *Migrating Mutants*
- Fig.4–38, James Rosenquist, *House of Fire*

Think about it.

- What is the main focal point of each image listed in **Take a look**? How has each artist emphasized the center of interest? In each image, what object is near the center of the layout? Were contrast of color or value used to emphasize the focal point? Which lines lead to the center of interest? What other means of creating emphasis were used?

- Compare the location of the center of interest in each image to fig.10–16. Which image has a center-of-interest position that is shown in the diagram?

- Look through magazines for an advertisement that combines several photographs. How did the advertising artist group or join photographs to emphasize a section of the layout? Locate the focal point. Is it close to the center of the ad? How did the artist use contrasts of value, color, texture, and shape to emphasize the center of interest? Did the artist use line to emphasize the focal point? Discuss any other means used to create emphasis in the ad.

Do it.

1 To create a photomontage in which you emphasize one center of interest, first look through old picture magazines and cut out five to ten photographs of objects, people, and interesting textures and colors. As you search for photographs, start to develop a theme or subject for your montage. Store the cutouts in an envelope.

2 Try arranging the cutouts in various ways. Experiment by joining subjects that you normally would not find together.

3 Think about how you can emphasize your subject and meaning. Try grouping or overlapping your cutouts to create one center of interest. You can arrange them on different background colors, values, and textures to create contrasts so that they will stand out. Consider moving the center of interest to one of the four points shown in the diagram on page 196. You might add lines cut from strips of magazine photographs to lead to your center of interest and make it more noticeable.

4 Check your arrangement of cutouts for just one important center of interest. If it has more than one, rearrange the cutouts, perhaps by removing some or by grouping them closer together to form a focal point.

5 When you are satisfied with the emphasis in your montage, glue your cutouts to the posterboard.

6 Prop up your artwork on an easel or wall, step back, and check it with another student or your teacher. Answer the questions in **Check it**.

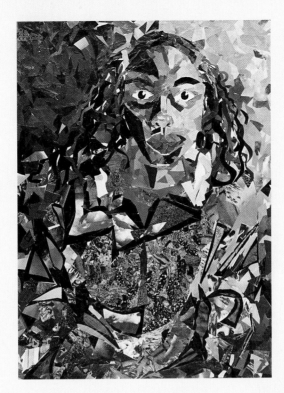

Helpful Hint

Carefully trim the magazine photographs to the edge of the image without leaving an outline or bits of background around the contours. Then the cutout photographs will seem less like pieces of cut paper.

Check it.

- Describe your photomontage. What did you emphasize? What is your focal point or center of interest? Does your montage have just one focal point?

- Which of the following did you use to emphasize the center of interest?
 — Contrast of values, colors, or textures?
 — Line?
 — An off-center or on-center location?
 — A larger scale or size of the focal point, in relation to the other parts of the design?

 Did you use any other means to create emphasis?

- Consider the craftsmanship of your artwork. Did you trim the cutouts close to the edge of the images? Are your photographs glued neatly? Are these points important for the effectiveness of your work?

Studio Experience
Emphasis in a Photomontage

Robert Miles (age 18). *a little hope on a rainy day in december...*, 1998. Computer graphic, 8 ½" x 11" (21.6 x 27.9 cm). Dakota Ridge School, Littleton, Colorado.

Prepare

Time Needed:
Three 45-minute class periods (extend as needed)
Lesson 1:
Cut out magazine photographs.
Lesson 2:
Arrange cutouts.
Lesson 3:
Glue cutouts.

Objectives
Students should be able to

- Appreciate the effective use of photographs and emphasis in advertising and fine art.

- Understand various means that artists use to emphasize the focal point in their art.

- Appreciate how artists use emphasis to communicate meaning.

- Create a photomontage that emphasizes one center of interest.

Vocabulary
Review the glossary definition for photomontage with students.

> ### Materials
> - picture magazines
> - scissors
> - envelopes
> - 11" x 14" posterboard
> - glue
> *optional:*
> - Polaroid or digital camera

Notes on Materials
Although glue sticks are easier to use, their glue is not as permanent as white glue, which should be applied sparingly to avoid wrinkles.

Before You Start
Before beginning the activity, ask students to find and bring in magazine advertisements of grouped or joined photographs to use for the last part of **Think about it**.

Teach

Thinking Critically
Focus again on Coe's *Migrating Mutants* (fig, 10–27) and Rosenquist's *House of Fire* (fig.4–38). Ask students to explain how each artist distorted reality to emphasize the subject matter. They should note that in these works the subjects seem realistic at first glance, but on a closer examination, they are surreal. Lizards usually are not larger than power poles, and lipsticks are not larger than buckets of molten steel and grocery bags.

These artists combined subjects usually not found together and distorted scale to emphasize a concept. What was each artist emphasizing with these distortions? By using unexpected scale changes, Coe has emphasized the size of the lizards and ecological mutations. Rosenquist's use of color and space for emphasis, in addition to scale, creates a startling image that demands attention. The interpretation of the combined subject matter is left to each viewer.

Classroom Management

- Divide the class into groups of four, five, or six students. For the last part of **Think about it**, ask each group to select one magazine ad that they think demonstrates an effective use of emphasis, discuss their analysis of the ad, and share the analysis with the rest of the class.

- Tell students that you will photograph their group after all the members have arranged themselves into a tableau that emphasizes one person. Students might point at the emphasized person, have that person stand closest to the camera, or have the person stand in front of a board to create value contrast. You may wish to use a camera that provides an "instant" image, such as a Polaroid or digital camera. After students study the photograph, discuss how they created emphasis and if their method was effective. Discuss other, more subtle ways they could have created emphasis.

Tips

- Students might get some arrangement ideas by looking at TV ads in which graphics are joined into photomontages.

- As an optional approach to this activity, have students cut out and incorporate type fragments in their photomontage.

- Reminder: Old magazines can be acquired from a variety of sources. Ask faculty, students, parents, and the school librarian for copies they might otherwise plan to discard. You might also ask staff at your local recycling center to be on the lookout and set some magazines aside.

Assess

Evaluation

Assign each student to write the answers to the questions in **Check it** and then discuss the answers with you.

Extend

Meeting Individual Needs

Challenge

Have students use photographs that they have taken themselves. Students might also develop and print their photographs.

Linking Design Elements and Principles

Contrast of Color, Value, Texture

Remind students that emphasis may be created by contrasting colors, values, and textures. For example, warm colors in the main objects may contrast against a cool background; a bright focal point might contrast against a dull background; or a light center of interest might be placed against a dark area.

Interdisciplinary Connections

Music

Call on students to describe how emphasis is created in music. They might suggest a sudden, loud drum roll or a trumpet blast following a soft, quiet section. Play a recording of instrumental music that creates emphasis, such as part of Richard Strauss's *Thus Spake Zarathustra*, the theme for the movie *2001: A Space Odyssey*. Play the piece again, and have students use color markers to illustrate the emphasis in the music. As an extension, broaden the discussion

to include movie soundtracks and the way they are used to emphasize certain scenes or characters in a movie. In addition to *2001: A Space Odyssey*, students could analyze the *Star Wars* soundtrack.

Language Arts

Ask students to choose either *Migrating Mutants* (fig.10–27) or *The Bicycle Race, Texcoco* (fig.10–30) to write a vignette that tells what took place before the scene depicted and what will happen next.

Technology

Explain to students that most advertising photomontages today are created on computers. If students have access to a scanner and a computer with software that allows them to combine and manipulate images, have them create their photomontage electronically. They might also use copyright-free photographs from CD-ROMs .

Inquiry

Have students research advertisements made before the advent of photography. Suggest that they search for images in books about the history of advertising. Ask each student to select an advertisement and bring a copy of it to class. Call on students to explain how the artist emphasized the product in the ad.

Chapter 11 Organizer

Pattern

Chapter Overview

- Both natural and manufactured patterns occur throughout our world.
- Artists create visual pattern by repeating one or more element.

Objective: Students will recognize and identify row, grid, half-drop, alternating, radial, random, and border and band patterns in their environment and in works of art. (Art criticism)
National Standards: 2. Students will use knowledge of structures and functions. (2b)

Objective: Students will understand how Michelangelo an artists of twentieth-century European/American, Native American, and other cultures create and utilize patterns to unify and enrich their artworks. (Art history/cultures)
National Standards: 4. Students will understand art in relation to history and cultures. (4a)

8 Weeks	1 Semester	2 Semesters			Student Book Features
1	1	1	**Lesson 1:** Patterns in Nature	Chapter Opener Patterns in Nature	Note it, Discuss it
0	0	1	**Lesson 2:** Patterns in Nature	Patterns in Nature	Note it, Discuss it
0	2	2	**Lesson 3:** Patterns in Manufactured Designs	Patterns in Manufactured Designs	Try it: various media, Note it, About the Artwork
0	0	1	**Lesson 4:** Basic Types of Planned Patterns	Rows	Try it: printmaking
0	1	1	**Lesson 5:** Basic Types of Planned Patterns	Grids	Try it: drawing
0	1	2	**Lesson 6:** Basic Types of Planned Patterns	Grids	Try it: sculpture
0	1	2	**Lesson 7:** Basic Types of Planned Patterns	Half-drop Designs Alternating Patterns	Try it: pattern prints, Try it: experiment
0	0	2	**Lesson 8:** Basic Types of Planned Patterns	Radial Patterns	Try it: drawing, About the Artist
0	0	2	**Lesson 9:** Basic Types of Planned Patterns	Borders and Bands	
0	0	1	**Lesson 10:** Random Patterns	Random Patterns	Try it: painting or drawing
1	1	1	**Chapter Review**	Another Look at Pattern	Review Questions
0	4	4			

Studio Experience: *Pattern Prints*

Objectives: Students will examine patterns to perceive and appreciate how motifs are repeated; draw patterns found in nature; carve and print a linoleum-block print based on a natural pattern; demonstrate understanding of repeated motifs in patterns by printing patterns with repeat schemes.

National Standard: Students will describe origins of specific images and ideas and explain their value in artworks (3c); use medi techniques and processes to achieve their intentions in their artworks (1a); conceive/create artworks demonstrating understanding of relationship of their ideas to media, processes, and techniques (1b); create art using organizational structures and functions to sol art problems (2c).

- Pattern may organize or unify a design, as well as add interest and visual enrichment.
- Although all patterns have a basic repeated unit, or motif, they may be either random or planned.
- Planned patterns include row, grid, half-drop, radial, alternating, and border.

Objective: Students will demonstrate their ability to create various types of patterns and use them effectively in their own art. (Art production)
National Standards: 1. Students will understand and apply media, techniques, processes. (1a) **2.** Students will use knowledge of structures and functions. (2c)

Objective: Students will perceive and appreciate natural and manufactured patterns in their environment and develop an understanding of how artists use environmental patterns as an inspiration for creating artworks. (Aesthetics)
National Standards: 3. Students will choose and evaluate a range of subject matter, symbols, and ideas. (3c)

Teacher Edition References	Ancillaries
Warm-up, Design Extension, Context, Inquiry	*Slide*: Ansel Adams, *Face of Half Dome, Yosemite Valley* (P-1)
Design Extension, Context	*Slide*: Ansel Adams, *Face of Half Dome, Yosemite Valley* (P-1)
Design Extension, Context, Performing Arts, Inquiry	*Slide*: François Drouais, *Marquise d'Aiguirandes* (P-2) *Large Reproduction*: William Morris, *Strawberry Thief*
HOTS, Context, Internet Connection, Materials and Techniques, Performing Arts, Portfolio Tip	*Slide*: Henricodi Camodia, *Milan Cathedral* (P-3)
Design Extension, Context, Inquiry	*Slide*: Peru, *Poncho fragment* (P-4)
Design Extension, Context, Inquiry	*Slide*: Peru, *Poncho fragment* (P-4)
Design Extension, Context	
HOTS, Context, Interdisciplinary Connection	
HOTS, Context	*Slide*: Islamic, *Kazak rug* (P-5)
Design Extension, Context, Cooperative Learning	*Slide*: Rome, *Barrel vault mosaic* (P-6) *Large Reproduction*: Jasper Johns, *Savarin*
HOTS, Context, Interdisciplinary Connection, Internet Connection	

Vocabulary

half-drop design A specific kind of row pattern with the vertical orientation of each row evenly spaced to half the height of its preceding row, and with a shifted horizontal position. *(diseño de semidescenso)*

motif The two- or three-dimensional unit that is repeated to form a pattern. *(motivo)*

pattern A principle of design in which the repetition of elements or combination of elements forms a recognizable organization. *(patrón)*

planned pattern The consistent, orderly repetition of motifs, whether found in nature or created by an artist. Planned patterns include row, grid, half-drop, radial, alternating, and border. *(patrón planeado)*

random pattern The repetition of an element or elements in an inconsistent or unplanned way. *(patrón aleatorio)*

Time Needed
Four 45-minute class periods.
Lesson 1: Draw;
Lesson 2: Carve the block;
Lesson 3: Print patterns;
Lesson 4: Mount two prints.

Studio Resource Binder
11.1 Self-portrait Silhouette
11.2 African Cloth, printmaking
11.3 Mosaic Masks
11.4 Painted Quilts
11.5 Computer Grid Portrait
11.6 Interlocking Shapes, marker and colored pencil

Lesson 1
Patterns in Nature

pages 206–207

pages 208–209

Objectives

Students should be able to

- Recognize patterns in nature, their surroundings, and in artwork.

- Identify motifs in patterns.

Chapter Opener

- Focus on *Car wheel* (fig.11–1) and *Native American pot* (fig.11–4) and guide students to notice the patterns in each image. What has been repeated to create a pattern? Think of examples of similar patterns. For example, the wire wheel may remind students of radial patterns such as flower petals or stained-glass windows. Ask: What type of balance is illustrated in the car wheel? (radial) Refer students to *Cathedral rose window* (fig.7–15) to see the radial pattern. Ask students what was repeated in *Biplane over flower fields* (fig.11–2), and whether anyone has been in a plane or tall building and noticed patterns such as this. For another example of an artist inspired by patterns from an aerial view, direct students to page 103.

- As students study the Native American pot, explain to them that pottery such as this was created by the Pueblo people of the southwestern United States from local materials. These pots are traditionally hand-formed round shapes decorated with symbolic abstractions of nature such as sky, birds, and feathers.

Teach

- Direct students' attention to the Faith Ringgold quilt (fig.11–3), and ask them to list the different patterns in it. Remind students to look for small patterns of repeated elements, and then to squint their eyes to look at the overall quilt for larger patterns formed by the quilt pieces. If you have any quilts, share them with the class and discuss the patterns in the printed fabrics and those created by repetition of quilt pieces.

Teach	pages 206–207

Materials
optional:
- quilts

- As students study the peacock vase in fig.11–8, remind them that the Tiffany studio was famous for its stained-glass windows and lamps. If there is a local example of Tiffany stained glass with which students are familiar, discuss that. Perhaps a local church has a stained-glass window from the early twentieth century in the Tiffany style or a restaurant has "stained-glass" lamp shades reminiscent of Tiffany.

- Refer students to *The Meeting of the Theologians* (fig.5–20), and discuss the artist's many uses of pattern. Ask students to find examples of repeated patterns within this art.

- Call on students to name nature patterns not mentioned in the text. Direct their attention to the patterns in the images on pages 208–209, and explain that every pattern has a motif, a basic unit that is repeated. Help students find and identify the motif in each image.

- Have students do **Note it**. If sending students outside is not possible, bring in a collection of nature objects. Ask students to write the answers to the questions in **Discuss it** (page 209) in the space below their sketches.

Note it	page 208

Materials
- nature objects
 options:
- students' sketchbooks or 9" x 12" drawing paper, pencils or markers
- camera and film

- Assign students to collect a few small nature objects that they will press into clay to form patterns in the next lesson, and also to use for prints in Lesson 5. You might choose to assign the sketches or photographs, the collection of nature objects, and the answering of questions to be done outside of class time.

Lesson 2
Patterns in Nature

pages 208–209

Objectives
Students will be able to

- Discuss patterns in the local landscape.

- Create patterns in clay using textured objects from nature.

Teach

- The **Discuss it** can be done as a class discussion or in smaller groups of four or five students.

- Students will create tiles from nature object impressions. Direct students to look at the Benin plaque (fig.9–28), to notice how patterns are developed with incised and raised textures.

- On a nonporous board, show students how to evenly roll out clay into slabs with a rolling pin, cut the slabs into tiles, and press the nature objects into the clay to create repeated patterns in relief. Encourage students to exchange objects so that they can incorporate several motifs into their pattern. If students use ceramic clay, they might glaze and fire the tiles. If they use self-hardening clay, they might paint it with acrylics after the clay has dried. Students could arrange their tiles into a class mosaic. Save the nature objects for Lesson 4.

Teach pages 209–209
Materials
- clay, 1 lb per student
- clay tools, including rolling pins and knives
- nonporous board
- nature objects (such as shells, acorns, and leaves) from Lesson 1
- ceramic glaze or acrylic paints
- brushes

Lesson 3
Patterns in Manufactured Designs

pages 210–211

Objectives
Students will be able to

- Perceive and comprehend how artists use pattern in manufactured designs.

- Create a small object whose pattern is determined by its materials.

- Perceive and appreciate pattern in Navajo weaving.

Teach

- Challenge students to think of patterns in their home and clothes. They should consider how designers mixed and matched these patterns to create interest and harmony. Have students look through decorating and fashion magazines to note how designers use visual patterns. (Students can use the library as a resource for magazines or for books on interior or fashion design.) Assign students to select an interior-design or fashion photograph that illustrates an effective use of pattern, and to explain to others why the pattern works well in the design.

- Focus on pages 210–211 and note how the patterns seem to complement the shape or form of the object in each image. As students consider the pattern of the Navajo blanket (fig.11–11), lead them in discussing the information about the history of Navajo weaving in **About the Artwork**. How have other cultures influenced this ancient art form?

- Direct students to look through the book to find patterns on other pottery and textile images, such as those on pages 27, 159, and 189. Then have students do **Try it**. You might choose to guide them to create textured clay pots, weave baskets, or chip-carve soft-wood boxes. (To chip-carve a balsa-wood box, make patterns of V- or wedge-shaped cuts to chip out small diamond and triangular indentations from the surface. This project will take four or five class periods. The pots and baskets may take an extra class period.)

Try it page 210
Materials
- decorating and/or fashion magazines
 options:
- clay, 1 lb per student, and clay tools
- basket-weaving material, such as reeds
- soft-wood (balsa) boxes and X-acto knives

206d

Lesson 4
Basic Types of Planned Patterns

pages 212–213

Objectives
Students will be able to

- Perceive and appreciate row patterns.

- Print a simple pattern design.

Teach: Planned Patterns
- Show students a collection of various patterned papers and fabrics, and ask the class to look at the images on pages 212–213. Challenge students to find the regular repeats in the printed patterns.

Teach	pages 212–213

Materials
- assorted patterned papers and fabrics, such as wallpaper or fabric samples and wrapping papers
- world map

Teach: Rows
- Point out the simplest pattern—a repeated motif in rows or columns—in fig.11–13 and fig.11–14. (So that students also consider architectural elements that are repeated in rows, ask them to note the windows in the school, if they are repeated in a row pattern.) Guide students to see that the hunched figure-like sculptures in the photograph create a regular repeat in a row, as do rows of

bottles in the Warhol print (fig.11–13). Challenge students to hypothesize as to why Warhol selected a Coca-Cola® bottle as his motif, and what message the repetition of the icon creates.

- For **Try it** on page 213, students should find a small natural or manufactured object to use for a print motif. They may use the nature objects from Lesson 1, or you might provide them with an assortment of gadgets such as buttons, spools, potato mashers, children's wooden alphabet blocks with raised designs, checkers, small bottles, seashells, and walnut shells.

 Show students how to roll out block-printing ink with a brayer on a flat inking plate, and demonstrate how to press the gadget onto the inked surface or how to roll ink onto the object with the brayer. Then press the object onto the printing paper in patterns, experimenting with different patterns. Use a paper surface such as newspaper under the printing paper in order to achieve better impressions. Encourage students also to experiment by printing the shapes close to one another and manipulating the negative shapes that form when two or more motifs abut.

Jon F. Williams (age 16). *Frog Metamorph*, 1998. Ink, 9" x 12" (22.9 x 30.5 cm). Asheville High School, Asheville, North Carolina.

After students have created several pages of patterns, ask them to mount and display their favorite one. Save the other patterned pages in a class file of patterns, textures, and unusual papers; let students use these for collages, book covers, greeting cards, and origami.

Try it	page 213

Materials
- nature objects or manufactured gadgets for printing
- brayers
- inking plates, such as pie tins, Styrofoam™ trays, or cookie sheets
- printing ink, water soluble
- 12" x 18" printing papers, such as construction or rice paper

- As students study the *Indonesian Batik* (fig.11–12) pattern, explain to them that this printing technique was developed in Southeast Asia. Challenge them to locate Java and Indonesia on a world map. Introduce them to the batik process in which hot wax is traditionally applied to cloth with a small copper "tjanting" tool. When the fabric is dipped in dye, the wax resists the color.

Teach	page 212–213

Materials
- world map

Lesson 5
Basic Types of Planned Patterns

pages 214–215

Objectives
Students will be able to

- Identify grid patterns.

- Create a two-dimensional grid pattern design.

Teach: Grids

- Draw a grid (a series of crossing vertical and horizontal lines) on the board, and display some examples of grids, such as graph paper, a globe or world map with longitude and latitude lines, and a school yearbook page of small, individual photographs, if they are in a grid. Show students a map with grid patterns of streets.

Teach page 214

Materials
- graph paper
- world map or globe
- photocopies or enlargement of a street map
 optional:
- school yearbook

- Ask: Can you think of other grid pattern examples? (Floor or bathroom-tile patterns, plaid fabric, or a calendar page are some examples.) Ask students to identify the grid patterns in the images on pages 214–215. Guide them to see how an overall grid pattern produces equal emphasis throughout the entire design, and how the grid pattern wraps around the round form of Freund's sculpture (fig.11–18). Then focus on pages 212–213 and lead students to choose images whose patterns are arranged in a grid. (*Apartment building* and *Green Coca-Cola Bottles*)

- Before students do the **Try it** on page 214 demonstrate how to draw a series of points spaced 1" apart in straight rows and columns. Students might wish to create the grid of dots on a computer.

Try it page 214

Materials
- 9" x 12" white drawing paper
- pencils
- rulers
- colored markers

- Point out to students that sculptor Bruce Freund fused and curved glass rods to create the sculpture in fig.11–18. Challenge students to describe the style of this sculpture and relate it to other pieces of art in this text. They should note the simplification of form in this sculpture which is also found in other contemporary art and architecture such as I.M. Pei's *Louvre Pyramid* (fig.9–30).

206f

Lesson 6
Basic Types of Planned Patterns

pages 214–215

Objectives

Students will be able to create a three-dimensional grid pattern design.

Teach: Grids

• After students have considered Winsor's *Bound Grid* (fig.11–19), share with them the information in **Context** about how she began working in this medium. Initiate a debate by asking "Is this art? Are these art materials?"

• Have students do the **Try it** on page 215. They may want to join their structure with a fast-drying craft glue or hot glue. If students prefer to join squares of cardboard or heavy paper, demonstrate how to cut short slits in the edges with an X-acto or utility knife. Students may wish to paint their sculpture with acrylic or tempera paints. If necessary, extend the **Try it** activity for another class period.

• To simplify and shorten this to one class period, have students use only toothpicks and plasticine clay.

Try it page 215

Materials
• assorted sculpture materials: paper, toothpicks, cardboard, balsa wood
• fast-drying craft glue or hot-glue gun
• X-acto or utility knives

Lesson 7
Basic Types of Planned Patterns

pages 216–217

Objectives

Students will be able to

• Recognize half-drop and alternating patterns.

• Print a half-drop or alternating pattern.

• Create a mixed-media half drop or alternating pattern.

Teach: Half-drop Designs and Alternating Patterns

• Focus on *Artichoke* (fig.11–21) and *Spectators* (fig.11–20), examples of half-drop repeats, and lead students to see how each row of motifs is shifted horizontally from the row above it by one element of the motif. Then have students look at the Ferdinand Andri poster (fig.11–22). Ask: How are the patterns in these images different from a half-drop design? (Two motifs are used alternately in these patterns.) Explain that these are known as *alternating patterns*. Ask students to cite other examples of either alternating or half-drop patterns. (These patterns are often found in knitted sweaters.)

• When students study the Andri poster, expand on its caption by providing additional information about the secession movement. This group of artists broke from the prevailing academic traditions of using

Renaissance style as the model for all branches of art.

The Secessionists combined arts and crafts with interior decoration and fine arts to develop a soft, fluid style which became extremely popular and was mass produced, much to the dismay of the group's leading artists. Encourage students to notice similarities in style between this poster and that of Charles Rennie Mackintosh, fig.8–4. The Vienna artists and Mackintosh's Glasgow group shared similar art philosophies and visited each other's exhibits.

• In one class period the students will probably be able to do either the **Try it** on page 216 or the one on page 217. To lead students through the **Try it** on page 216, organize the class into cooperative-learning groups of four students. Give each student an eraser and then demonstrate how to trace around the shape of one side of the eraser to make a 1" square on a small piece of paper. Draw a simple geometric motif in the square. Transfer this design to the eraser by placing the pencil drawing against the eraser and rubbing firmly with the side of the pencil. Then carve the motif on one side of the eraser with an X-acto knife or linoleum cutter. Ink the erasers on ink pads and then stamp them on paper.

Remind students to wipe the ink from their erasers with a damp paper towel before changing colors; otherwise, the ink pads quickly become dirty. Students may make several colors in each motif by coloring their eraser stamp with water-soluble markers, and then lightly blowing their own moist breath on the eraser just before stamping it on paper.

• Alternatively, this project may be done by cutting shapes out of sponges using scissors. Create ink pads by folding several layers of

paper towels in a lid or saucer and saturating the towels with tempera paint.

- Students may create a half-drop or alternating pattern. As an alternative, have students create a half-drop pattern; then give them another sheet of paper and ask them to create an alternating pattern, using their motif and another one from a group member.

Try it page 216

Materials
- 18" x 24" drawing or colored paper
- 8 1/2" x 11" copy or tracing paper
 options:
- erasers (1" cube gum), pencils, and knives (X-acto or linoleum cutters), ink pads or water soluble markers in several colors, damp paper towels or sponges
- 3" sponges, scissors, paper towels, tempera paint, saucers or lids

- To make the pattern suggested in the **Try it** on page 217, reinforce with students how to create alternating and half-drop patterns. Students should create five or more repetitions of two different motifs using colored paper, ink, and colored pencils. After they cut these out, encourage them to experiment with different arrangements before they glue them down.

Try it page 217

Materials
- variety of media (assorted colors of paper, ink, and colored pencils)
- scissors
- 18" x 24" white paper
- glue

Lesson 8
Basic Types of Planned Patterns

pages 218–219

Objectives
Students will be able to

- Perceive and comprehend radial patterns.

- Create a design based on radial patterns.

Teach: Radial Patterns
- After students have read **About the Artist,** either as a class or in small cooperative learning groups summarize Michelangelo's life. Make a time line or chart noting the date and his age when he created certain works of art and the medium of the work. If you have other Michelangelo reproductions, show these to the class and suggest that students include these on their charts.

 Michelangelo painted the ceiling of the Sistine Chapel from 1508–12. He worked on the architectural design for St. Peter's Cathedral in the Vatican in Rome from 1546–64. St. Peter's dome was built to his design. Note other important events that happened during his life such as Columbus' discovery of America in 1492, the beginning of the Protestant Reformation in 1517, and the sack of Rome by the French in 1527. Discuss how each of these events might have influenced Michelangelo and his art.

- Point out to students the radial pattern in the pavement of the Campidoglio. Add that Michelangelo believed civic plazas such as this should be symmetrical, just as the two sides of the human body mirror each other.

- Help students note how patterns radiate outward from the center in the images on pages 218–219. Ask: Can you give examples of other radial patterns? What other examples of radial patterns are in this book? (Images of radial balance are on pages 148–149.)

- For **Try it** on page 218, students may use markers or colored pencils on 9" x 12" paper for the preliminary sketches. They should complete their final drawing on illustration board or heavy drawing paper. Students may wish to add color with markers, colored pencils, or tempera or acrylic paints.

Try it page 218

Materials
- various objects with radial patterns, such as hubcaps, oranges sliced across the segments, or flowers
- 9" x 12" white paper
- markers or colored pencils
- 10" x 15" illustration board or heavy drawing paper
- tempera or acrylic paints
 optional:
- compasses

- To keep this lesson to one class period, students may just sketch the radial objects. To draw and color the design in markers will require another 45 minutes; painting the designs will take at least two classes after the initial drawings.

Lesson 9
Basic Types of Planned Patterns

pages 220–221

Objectives

Students will be able to

- Recognize borders and bands as patterns and understand why artists use them in their designs.

- Design a band or stripe for a vehicle that emphasizes its shape and function.

Teach: Borders and Bands

- Focus on the border of the Dedham pottery in fig.11–27. Ask what part of the plate is emphasized by the border. Point out that the crackle glaze on this piece relates to that of Ming porcelains (fig.10–10). Encourage students to explain how the glaze decoration affects the overall design of each piece.

- Ask students to identify the borders and repeated motifs in the images on pages 220–221, and then to cite other examples of borders in clothes or in the school architecture. Discuss how borders or bands can enhance the shape of a car, boat, bike, or bus.

 Assign students to design a band or strip for a vehicle that not only emphasizes the shape of the vehicle, but also indicates a function or desirable quality of it. To inspire creative thought, ask how the stripe on a racing car would be different from one on a bus used to transport

rafters to a river. Instruct students to draw a simple outline of the vehicle, and then to draw their design on it with colored pencils or markers. For models, students might use actual vehicles in the parking lot or toy models. They can also choose to invent their own design. If students do not complete their designs within the class period, they may need to finish them outside of class or you might extend the lesson for another class period.

Teach pages 220–221

Materials
- vehicle models
- 9" x 12" or larger white drawing paper
- pencils
- colored pencils or markers

Computer Connection

Arrange a still life and instruct students to complete a contour drawing of the objects using drawing software with the pencil tool set to make a black line. Guide students to fill the shapes they have created. First, choose from a variety of planned patterns built into the software. Then, demonstrate how to edit patterns. Encourage students to experiment with different patterns until their picture has visual interest, avoiding bold and similar patterns that often clash. Allow students to print out copies of their drawings with a variety of different fill patterns. Discuss with the class which patterns work best.

Maeve Cook (age 16). *Quilt*, 1996. Acrylic, 36" x 36" (91.4 x 91.4 cm). Palisades High School, Kintnersville, Pennsylvania.

Lesson 10
Random Patterns

pages 222–223

Objectives

Students will be able to

- Recognize and appreciate random patterns.

- Create a design combining random and planned patterns.

Teach

- Challenge students to think of and list random patterns other than those mentioned in the text. They might list oil floating on the surface of a water puddle, raindrops splashing on a sidewalk, or the pebbles in a conglomerate rock. Focus on the images of random patterns on pages 222–223.

- As students study the photograph by Berenice Abbott, fig.11–32, explain to them that she spent four years photographing New York City during the Depression of the 1930s for the Federal Art Project. Remind students of any projects in your community completed during this same time period which were also funded through federal work programs. In addition to art, even some schools were built by the Works Progress Administration. Many artists in New York City received money from these federal programs.

- Before students do **Try it** on page 222, demonstrate how to draw and paint a planned pattern and then add a random pattern by dripping or spattering paint. Have examples to show, prepared ahead of time. Demonstrate efficient ways of working.

Materials

- examples of random pattern paintings
- 9" x 12" heavy paper or 15" x 20" illustration board
- pencils
- tempera or acrylic paints
- brushes

 Simplify:

 Have students work on smaller paper.

Emilie Huysman (age 18). *Confusion*, 1998. Watercolor, 9" x 9" (22.9 x 22.9 cm). Stonington High School, Pawcatuck, Connecticut.

Chapter Review

pages 224–225

Assess

- Assign students to write the answers to the Review Questions. Go over the answers with the class to see that students understand the concepts. From their answers you may ascertain that they can recognize and identify row, grid, half-drop, alternating, radial, random, and border and band patterns in their environment and in works of art. **(Art criticism)**

- To evaluate the three-dimensional pieces, create a class display of the student sculptures. Lead the class in discussing these works by asking which sculptures demonstrate an effective use of a repeated motif. Ask students to describe what they see in the sculptures, and then to check with the artists to see if the descriptions coincide with their thoughts about the artwork. **(Art production)**

- To evaluate the two-dimensional patterns that students have created throughout the chapter, have them stack their papers in a portfolio with the ones that they like best on the top. Ask students to number the back of each print for identification and write what type of pattern it is. Direct students to write a descriptive paragraph of one work that they feel is a good example of a particular pattern type. Have them suggest possible uses for the pattern, such as a book cover, a textile design, a wall covering, or a work of art. **(Art production)**

• To evaluate each student's understanding of how Michelangelo and artists of twentieth-century European/American, Native American, and other cultures create and utilize patterns to unify and enrich their artworks, assign the students to select a work by Michelangelo, a Native American artist, and an American or European artist in this chapter. They should identify the type of pattern in this piece and explain how this pattern contributes to the overall design of the work. Discuss their choices and analyses with the whole class. **(Art history/cultures)**

• To be sure that each student did perceive and develop an appreciation for natural and manufactured patterns in their environment, direct students to identify and describe several natural and manufactured patterns. Which design elements seem most important in each of these patterns? Artists are often inspired by environmental patterns. Direct students to find examples of art in which the artist incorporated a natural or human-made pattern into his or her work. For example, students may notice how Tiffany used the peacock feather pattern on his vase (fig.11–8). This may be an in class discussion or an out of class written assignment. Review their responses with the class. **(Aesthetics)**

Reteach

• Have students identify the type of pattern in each image on pages 224–225. Ask what motifs are repeated in each piece. In *Ceramic tile wall* (fig.11–34), small tiles form a circular motif that is part of a larger alternating pattern interspersed with a smaller grid pattern. The photograph of the *New York Hilton Hotel Under Construction* (fig.11–37) has a strong grid design, whereas the mosaics in *Watts Tower* (fig.11–36) form a random pattern. The page from the *Book of Kells* (fig.11–35) includes border, radial, and row patterns.

• As students identify the patterns from the *Book of Kells*, inform them that there were at least four artists who

worked on the illuminated manuscript. These highly skilled artists not only created patterns of geometric and abstract designs, but also wove human figures and animals imaginatively into the text. Often, animals and foliage patterns were combined and stylized to form letters. Challenge students to find animal motifs in fig.11–35.

Rebecca Carson (age 16). *Blue Night-Out*, 1997. Oil on mat board, 18" x 24" (45.7 x 61 cm). Lake Highlands, Dallas, Texas.

Answers to Review Questions

1 Visual pattern is the repetition of one or more elements.

2 Examples of manufactured patterns are a brick wall and a printed piece of material. Examples of natural patterns are ripples in sand dunes and the radial arrangement of petals on a flower.

3 Pattern helps to organize or unify an area or object, and provides visual enrichment and interest.

4 The six basic types of planned patterns are:

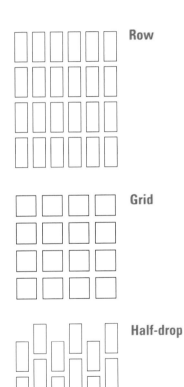

Row

Grid

Half-drop

Alternating

Radial

Band

Border

5 A random pattern is a repetition of an element or elements in an inconsistent or unplanned way.

6 The Spanish introduced sheep for wool, European-style treadle looms, and European dyes. The Pueblo taught the Navajo to weave on upright looms. The Navajo adopted Pueblo dyes and decorative patterns.

7 The Campidoglio pavement is in a radial pattern design.

Meeting Individual Needs

Students Acquiring English

Display and discuss examples of objects that depict the key vocabulary. Explain that the term *pattern* has many different meanings, and have students share their own interpretations. Have students bring to class an example of an object that reflects their understanding of a particular kind of visual pattern. Encourage students to talk about the pattern of the object and their perception of it in a show-and-tell format.

Students with Special Needs

Learning Disabled
Printmaking is an excellent way to explore the concept of pattern in design. Vegetable and stick printing or Styrofoam™ prints are appropriate for special-needs students. (Linoleum and wood might be too difficult to master, and the tools too sharp.) Have students print simple shapes in a repeat pattern design, limiting color selection. Some students may need a larger work area or a separate area because of physical needs or management issues.

Gifted and Talented

Have students take close-up shots of a variety of patterns found in nature, such as flowers, seashells, and bark. Display the prints, and have students identify and discuss the types of patterns that the photographs represent.

11 Pattern

PATTERN APPLIES TO A VARIETY OF HUMAN ACTIVITIES. Patterns are used for cutting out and assembling clothing. Flight patterns direct the movements of airplanes. Behavior patterns indicate how people act in certain situations. A visual *pattern* is the repetition of one or more elements, such as the stripes on a raccoon's tail, the repeated shapes of the waves in an ocean, and the alternating colors in a field of flowers.

11–1 Pattern helps provide our everyday visual world with richness and variety.
Car wheel. Photo by J. Selleck.

11–2 Seen from above, landscape patterns produce unique effects. Occupants of this biplane view the colorful area patterns of flower fields at Carlsbad Ranch, north of San Diego, California.
Biplane over flower fields. Los Angeles Times. Photo by Con Keyes.

Pattern can add variety to sculpted surfaces or help create contrast in a photograph or painting. Like texture, pattern can also reinforce or highlight shapes and forms. To capture the viewer's attention, an artist might create a strong and colorful pattern of large shapes. To produce a more reserved or refined effect, the artist might choose a subtle, muted pattern of small or close-knit elements. In general, pattern has two main functions in art and design: it helps organize or unify an area or object, and it provides visual enrichment and interest. Look at the pot (fig.11–3) and the quilt (fig.11–4). How would their impact be altered if these works did not have patterns?

207

11–3 What different patterns can you see in this quilt? Notice that there are small sections of pattern within the large, overall patterns in the design.

Faith Ringgold (b. 1930). *The Wedding: Lover's Quilt No. 1*, 1986. Acrylic on canvas, quilted with pieced border, 77 ½" x 58" (196.9 x 147.3 cm). Private collection. ©Faith Ringgold, 1986.

11–4 All cultures use pattern for decoration. There seems to be a natural human delight in surface pattern. *Native American pot*. Photo by A. W. Porter.

Design Extension

Secure a copy of *Tar Beach*, Faith Ringgold's children's book so that students may see other examples of her work. Another resource is the video tape *Faith Ringgold: The Last Story Quilt*, in which the artist talks about the African and American influences on her art, how she began her career, and her philosophies about art. ("If you want to do it, you can do it.")

Lead students in creating a class quilt. Ask students each to create a 9" identity-square collage on colored paper. Using symbols to represent their major interests, they should make the square express their identity or self-image. Suggest the use of cut-paper shapes, and drawing and writing with markers. Encourage students to create patterns with the shapes. Arrange the completed squares on large sheets of craft paper to form a class quilt. During this process students should think about what squares go together and why. Is it possible to create a pattern or patterns in the overall quilt design? When a final arrangement is agreed upon, glue the pieces.

? Inquiry

Invite a local quilting artist to bring examples of his or her work to your class (or arrange a field trip for your students to visit a quilting-association exhibit, if there is one in your area). Ask the quilter to explain the process involved in creating a quilt, and to describe quilts or patterns that were used by early settlers in your state.

Patterns in Nature

Many patterns are commonly found in nature. You probably can identify quite a few animals by their patterns alone: a leopard by its spots, a tiger by its stripes, or a peacock by its plumage. These natural patterns may camouflage an animal or help it to attract a mate. Other patterns in nature are broader, such as a cloud-filled sky or the ripples of a wheat field. Still other patterns—such as those in pine cones, wood grain, and hundreds of flower species—are more intricate, and intriguing patterns are evident in cross-sections of trees, fruits, and vegetables.

Note it

Search for patterns in one small section of a park or other landscape near your home or school. You will find that even rocks, grassy areas, exposed earth, and tree bark have patterned qualities. Sketch the patterns that you discover, or photograph some of the natural patterns that you find most appealing.

11–5 Some patterns in nature are temporary because they are created by momentary weather conditions. What are some other such patterns?
Wheat field scenic. Photo by J. Scott.

11–6 Peacocks, with their characteristic iridescent green and blue feathers, originated in Asia. The brilliant feathers are found on male birds and are used to attract females during courtship.
Two peacock feathers, terminal "eye" portion. Photo by J. Scott.

Design Extension

Many animals have camouflaging patterns that enable them to blend into their surroundings. Direct students to look at nature magazines, books, and videos to discover more about these natural camouflages. Have students draw or paint a picture of an animal in its habitat, emphasizing how the animal blends into its environment. Students may create a picture in which the viewer must search to find the camouflaged animal.

Every pattern—whether natural or manufactured—involves the repeated placement of a basic unit, called a *motif*. In one pattern, a motif may be a simple dot, a line, a square, or a squiggle. In another pattern, it may be a complex shape or form with an intricate texture or bold color.

The motifs in nature's patterns are a rich resource and great inspiration for designers and artists. Many of the motifs in fabric, weavings, and everyday objects have been borrowed or adapted from the patterns in plants and animals. Artists sometimes even use actual plant materials to press into clay or to print designs on paper. Careful observation of patterns in nature will help you transfer those impressions to your own creative work.

11–8 Compare the pattern on this vase to the real peacock feathers in fig.11–6. Louis Comfort Tiffany (1848–1933). *Peacock Vase*, 1892–96. Favrile glass. 14 ⅛" x 11 ½" (35.9 x 29.5 cm). The Metropolitan Museum of Art. Gift of H.O. Havemeyer, 1896. Photo ©1991, The Metropolitan Museum of Art, New York.

11–7 The patterning that occurs in wood is a constant presence not only in nature, but also in our built environment. Consider how patterning in wood paneling, tables, and bowls makes these objects appealing to the eye.

Wood pattern, Monster face, from the *Driftwood* series. Photo by J. Scott.

Discuss it

Discuss with classmates the patterns in the local landscape and the sensations you get from them. Do certain patterns reflect the growth of a form? Do some patterns serve as protection? How do the patterns enhance the forms? What patterns in other areas of nature are similar to the ones that you have found?

Context

Louis Comfort Tiffany invented a process for making opalescent glass, called Tiffany Favrile glass. The vases, windows, and lamps that he designed and produced in his New York studio were all done in the Art Nouveau style, which is notable for its curvilinear designs and the inspiration it took from organic forms.

Patterns in Manufactured Designs

Most people like to bring variety and interest to their surroundings by adding decoration. Pattern, an important aspect of the decorative things that we buy and make, is in the fabric of a pillow, the design of a rug or blanket, or the way that objects are displayed on a shelf. Consumers often plan their purchases so that patterns will work well together.

Graphic artists, landscape architects, filmmakers, and fashion designers all use pattern. In fact, this list could include the manufacturers and designers of almost any product. To create effective patterns in their work, these visual artists must juggle the elements of design. The patterns that they create may be subdued and subtly integrated with the object. Or they may be bold and invigorating, like the pattern in the Navajo blanket (fig.11–11).

Sometimes, the material determines the pattern. Have you ever watched a mason fit bricks together to build a wall? Or a craftsperson bend reeds to form a basket? If so, you've witnessed the growth of pattern from material. Different materials lend themselves to specific patterns, whether they are stacked, folded, tied, or even combined with other materials. The materials available to today's artists are highly diverse, ranging from palm fronds to plywood, and paper to plastic.

11–9 Look carefully at your school or home surroundings. What manufactured pattern can you find that you hadn't noticed in the past?
Stone wall. Photo by A. W. Porter.

11–10 The artist of this vase combined pattern and texture to create an unusual surface.
Doyle Lane (20th cent.), *Ceramic pot,* 8 ½" tall (21.6 cm), 6" diameter (15.2 cm). Collection of Shirl and Albert W. Porter. Photo by A. W. Porter.

About the Artwork

Navajo Beeldleí

This chief's blanket was made for wearing, and would drape to move with the body. Its simple beauty comes from a balanced arrangement of design elements. The striped pattern with diamond shapes is typical of blankets created by Navajo women in the mid-nineteenth century.

Weaving is affected by the availability of fibers and dyes to the artisan. In the case of the Navajo—who were originally nomadic—a combination of factors led to favorable conditions for weavers, who became renowned for their brightly woven fabrics with strong patterns.

The Navajo who came to the southwest United States by 1500 were skilled basket weavers. The neighboring Pueblo were textile weavers who grew cotton for fiber as early as 700 AD. In 1540, the Spanish began to colonize the area, bringing sheep and European-style treadle looms.

The Pueblo likely taught the Navajo to weave cloth on upright looms. The Pueblo, Navajo, and Spanish exchanged certain techniques, designs, and materials. For example, when the Spanish brought sheep to the region, the Navajo began shepherding. They wove fine-wool blankets that were worn as clothing, as well as used for sleeping or for covering walls or floors. Leaders wore striped blankets as an indication of their status.

The Navajo originally adopted both dyes and decorative patterns from the Pueblo. Later, at trading posts, they obtained European pigments to add to their natural plant dyes from sage, indigo, and walnut.

11–11 Notice how this design makes use of diagonals to break the horizontal repetition. What other devices were used to avoid monotony?

Navajo Beeldleí (Chief's blanket), 1870–75. Handspun wool and raveled yarn, 49 ¼" x 71 ⅝" (125 x 181.9 cm). Collected by Douglas D. Graham at Zuni during his term as first U.S. Indian Agent (1880–85). Presented by his nieces. National Museum of the American Indian, Smithsonian Institution, Washington, DC.

Until Spanish settlers came to the area, the Navajo had no good source for the color red. At first, the Navajo unraveled Spanish bayeta cloth to acquire red fibers. Later, they used commercially available aniline dyes.

Through the early twentieth century, the colors and patterns used by Navajo weavers became increasingly complex. Today, many Navajo women produce handwoven textiles specifically as art objects. Frank Stella and Jasper Johns, contemporary male artists, have been powerfully influenced by the work of these women.

Note it

Explore indoor and outdoor environments to find patterns. Look for obvious, broad, large patterns, such as those on the sides of buildings. Then look more closely for smaller patterns, such as those in pavement, bicycle stands, and landscaping. Note how patterns create rich surface appearances and help us identify forms.

Inquiry

Navajo blankets are woven in a variety of patterns. Encourage students to explore museums, galleries, books, and the Internet to find other Navajo woven patterns. Assign them to compare and contrast the patterns and colors of several of these textiles. They may be interested in discovering the relationship among tourism, railroads, and the development of this weaving industry in the southwestern United States. At the beginning of the twentieth century, eastern tourists who visited the Southwest by railway encouraged the Native American artists to modify their traditional designs to produce easily transportable and salable souvenirs.

for a popular, dignified dance. In the American colonies, all upper-class children learned the dance as part of their education. Challenge students to find rhythmic patterns in hip-hop, jazz, or funk music.

Basic Types of Planned Patterns

Whether produced by nature or manufactured by people, most visual patterns fall into a category called *planned pattern*. A planned pattern is a precise, regular repetition of motifs. Its overall design is consistent and cohesive, and examples may be seen in clothing, wrapping paper, jewelry, architectural surfaces, *and* in nature. To achieve contrast and balance within a design, artists might pair a small planned pattern with a large, plain area. Some designers also might combine two patterns. However, not all patterns work well together. For instance, bold patterns or patterns whose motifs are of similar size and dominance will often clash.

When you create planned patterns, give careful consideration to materials, the motifs, and the way you repeat the motifs. Will you place the motifs in a row or in a grid pattern? Will you stagger them or alternate them with other motifs? Will the patterns radiate from a central point, or will they occur in bands and borders?

11–12 What words would you use to describe the patterns in this fabric?
Indonesian Batik, 1995. Photo by T. Fiorelli.

11–13 This painting is meant to remind us of the walls of patterns that greet us at the grocery store. What factors do you think package designers must take into account when creating a container that is to sit on a supermarket shelf?

Andy Warhol (1926–87). *Green Coca-Cola Bottles,* 1962. Oil on canvas, 6' 10" x 8' 9" (2.1 x 2.7 m). Collection of the Whitney Museum of American Art, New York. Purchase, with funds from the friends of the Whitney Museum of American Art, 68.25.

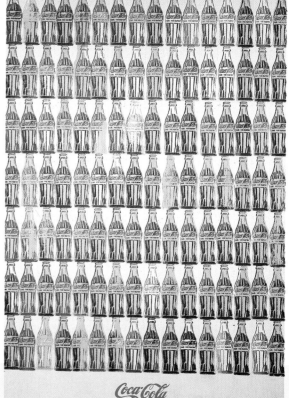

Context
The technique of fabric dyeing called *batik* was developed into an art form in Southeast Asia, particularly Java and other parts of Indonesia. Batik textiles have been produced in Java for over 1,000 years.

Rows

The simplest pattern is achieved by repeating the motif in a single row or along several similar rows or columns. You've most likely encountered this kind of pattern in supermarkets and stores, where bottles are arranged in rows and boxes are aligned on shelves. Plowed fields, rows of flowers, and beaded necklaces are other examples of these simple planned patterns. Look at fig.11–14, in which the artist creates pattern through rows of sculptures.

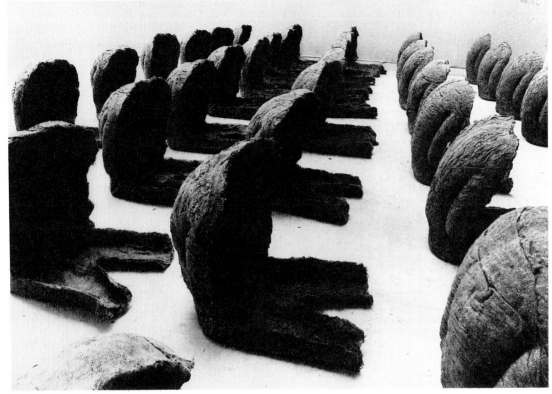

11–14 Notice the rows formed by the individual sculptures. Why might the artist have placed them this way?
Magdalena Abakanowicz (b. 1930). *Backs* series. 1976–80. Burlap and resin, 3 different sizes: 24" x 19 ⅝" x 21 ⅝" (61 x 50 x 55 cm), 27 ¼" x 22" x 26" (69 x 56 x 66 cm), 28 ¼" x 23 ¼" x 27 ¼" (72 x 59 x 69 cm). ©Magdalena Abakanowicz/ Licensed by VAGA, New York, NY/Marlborough Gallery, NY.

11–15 Architecture abounds in planned patterns, as is evident in banks of windows or ribbons of concrete that adorn the façades of buildings.
Apartment building. Photo by J. Selleck.

Materials and Techniques

The batik process begins by painting, stamping, or dripping melted wax on the area of the fabric *not* to be dyed. The material is then immersed in a dye bath, and then the wax is removed in a hot-water rinse. Multicolored effects are achieved with additional waxing and baths.

Performing Arts
Patterns in Space: Square Dancing

Dancers can also create patterns with lines and circles. In square dancing, groups of couples listen to a caller, who sings out directions that tell the pairs where to move in relationship to one another. If you had a bird's-eye view of the dancers, you would see the shapes—stars, circles, squares, and so on—appear and then merge into one another.

213

Portfolio Tip
Discuss with students various means of presenting their work to college and job interviewers. Explain that often they may hand carry their work, for which they should have a lightweight portfolio case with a handle. Show them either actual examples or pictures in art supply catalogs. Encourage students to create their own portfolio cases with pieces of cardboard and rope, tape, or yarn to create a handle.

Try it

Look for small, intriguing objects, both natural and manufactured, to use as printable motifs. Choose one or two to create a simple pattern design for wallpaper, wrapping paper, or fabric. Ink the object and press it onto a sheet of heavy paper. You might reverse the motif to produce mirror-image patterns; or cut a motif into segments, and use both the whole and the parts to form a planned pattern.

Design Extension
Buckminster Fuller was inspired by natural forms for some of his architectural designs: he based his geodesic dome on the structure of a dandelion. Fuller believed that students needed a broad education in both the arts and sciences so that they could make creative connections between subjects. Ask students to find a picture of a geodesic dome (such as the one at EPCOT Center, in Orlando), and to compare its structure to that of the dandelion in fig.2–17. Challenge students to imagine houses based on natural shelters. Examples might include prairie-dog tunnels, nautilus shells, hermit-crab shells, or bird nests. Have students draw their ideas.

Grids

A grid pattern is formed by intersecting vertical and horizontal lines or shapes. Similar to rows, the motifs in a grid pattern are usually spaced at equal or roughly equal intervals. You can find grid patterns in checkerboards, automobile grills, waffles, and honeycombs. Intersecting streets in many cities have been designed to form a grid, and most contemporary architecture also utilizes a grid structure. An overall grid pattern provides equal emphasis throughout a design.

Although you may think of grids as being arranged up and down, they also may be diagonal or circular. Notice the grid pattern at the top of the lighthouse (fig.11–17) and in the glass sculpture (fig.11–18). The lines of a geodesic dome and the intersecting longitude and latitude lines on a globe are other grid patterns: the lines that make up these grids cover a sphere.

11–16 The uniform grid pattern of a Japanese window screen diffuses light.

Japanese window screen. Photo by A. W. Porter.

11–17 Crisscrossing structural strips encase a lighthouse beacon. Note that the open-grid pattern has the opposite purpose of the compact grid of the Japanese screen (fig.11–16).

Lighthouse. Photo by A.W. Porter.

Try it

Mark out a series of points 1" apart both vertically and horizontally on a sheet of paper. Then draw lines connecting these points to form a grid. This simple construction is itself an example of a grid pattern. Use it as the basis for developing a more complex grid pattern by adding repeated shapes, colors, or a combination of elements.

11–18 Artist Bruce Freund uses fused glass rods to create a curved-grid form.

Bruce Freund (b. 1953). *Glass piece*, 1988. 16" x 16" x 16" (40.6 x 40.6 x 40.6 cm). Courtesy of the artist, from his collection. Photo by B. Freund.

11–19 Though her sculpture is based on the grid, artist Jackie Winsor provides variation in spacing and tilted grid lines to bring an organic quality to this work.

Jackie Winsor (b. 1941). *Bound Grid*, 1971–72. Wood and twine, 84" x 84" x 8" (213.3 x 213.3 x 20.3 cm). Fonds Nationale d'Art Contemporain, Paris (formerly CNAC). Photo courtesy of the Paula Cooper Gallery, New York.

Try it

Use paper, cardboard, toothpicks, or balsa wood to build a three-dimensional form with a gridlike structure. You'll find that simple grids give physical and visual strength to a design. To make your design more complicated or unusual, you may wish to overlap different grid patterns or add strong colors and textures.

Context

Canadian-born Winsor comes from a long line of Newfoundland ship captains and farmers. A family move to Boston when she was in her teens led Winsor to begin studying art. Her teachers encouraged her to attend art school, where her talents flourished. She eventually moved to New York and rented space on Canal Street, where she encountered a neighborhood commercial district that sold cord and heavy ropes used on ocean liners. An inspired switch to these materials came about after she discovered that the plastics she had been working with were toxic. Her forms—though minimalist and based on the cube, grid, or sphere—are more organic than the hard-edged geometry generally evident in minimalist sculpture. Winsor's materials include rope, pine, saplings, brick, and cement.

Inquiry

Assign students to research Modernism and its roots in the Bauhaus, in Germany, before World War II, and to find examples of Modernist buildings based on a grid, such as structures by Ludwig Mies van der Rohe and Walter Gropius. Discuss the meaning of the Modernist maxim "less is more" and how this relates to the extensive use of grids in Modernist designs.

Half-drop Designs

Designs made simply of linear or grid patterns can be rigid and monotonous. To make a more complicated or interesting design, an artist might manipulate the placement of motifs within a pattern. A *half-drop design* lowers each row of motifs half the height of the row above it. It also can stagger the rows so that they are no longer in perfect alignment. A half-drop design creates a pattern that seems to have a wavy movement. The scales on a fish and the leaves of an artichoke are examples of half-drop designs found in nature.

11-20 What pattern is created by the seating design of a stadium or theater? This painting utilizes a predominantly half-drop design, but notice where the pattern is varied. Why might the artist have chosen to do this?

Diana Ong (b. 1940). *Spectators*, 1994. Watercolor, 6" x 7 ½" (15.2 x 19.1cm). ©Superstock.

11–21 The half-drop pattern is complex. Can you think of some other instances in nature where it occurs?

Artichoke. Photo by T. Fiorelli.

Try it

Use inked pieces of sponge or carved erasers to create a half-drop or alternating pattern.

Design Extension

Slice in half several fruits—such as apples, pears, lemons, limes, and oranges—so that students may study the structure of the segments. Slice some of the fruits lengthwise and others crosswise. Students can use a biology textbook to help them identify the accessory tissue, endocarp, fleshy pericarp tissue, seed, and calyx. Then have them print row, alternating, and half-drop patterns with the sliced fruit.

Alternating Patterns

Alternating patterns are similar to half-drop designs, but they are much less rigid. An alternating pattern is not limited to equally spaced rows of similar elements. The space between rows may change, or each row may contain a different number of motifs. The motifs themselves may vary in shape, size, color, and so on. An alternating pattern also may use a linear or grid design that combines two different motifs. In each case, however, this planned pattern requires a system of organization that is logical and consistent.

Look at the graphic design in the Andri poster (fig.11–22), which combines two alternating patterns. The top half contains a red-and-white cloud motif on a black background. The rows of clouds get thinner and closer together as they approach the horizon line. At the center is a triangular group of trees. Each row contains a different number of trees, and the trees themselves vary in color and size.

11–22 This poster, designed in Austria in 1906, announces the twenty-sixth exhibition (*Ausstellung*) of the secession movement in Vienna. This movement, formed at the very end of the 1800s by a group of forward-looking Viennese artists, wanted to breathe new life and modern thinking into all art forms.
Ferdinand Andri (1871–1956). *XXVI Ausstellung Secession Exhibition*, 1906. Courtesy of the Vereinigung bildender Künstler Wiener Secession, Vienna.

Context

Diana Ong works in a spontaneous and quick style, without use of preliminary sketches. She has worked in many media. In recent years Ong has become a leader in "digital painting" (computer-generated fine art). Her first solo exhibit, at age 57, featured works created with both traditional and digital media. A special code was used to identify her computer-generated prints, because it is difficult to distinguish them from those painted with watercolor or tempera.

Radial Patterns

A radial pattern, like radial balance (see Chapter 7), is based on a branching out from a central point. Star shapes, asterisks, wheel spokes, and many fireworks are examples of radial patterns. The motifs of a radial pattern not only extend outward from the center, but they also usually occur at regularly spaced intervals. Radial patterns are generally active and structurally strong. Some even have an explosive quality. They speed up our eye movement as we trace the motifs that move outward, inward, or around the pattern.

Radial patterns give artists the opportunity to convey dynamic movement and contrast. Small, bursting patterns may be contrasted with large, slowly accelerating radial designs. Radial patterns of similar size also may be combined to create an overall tie-dye pattern. In Roszak's *Star Burst* (fig.11–24), the radiating lines might depict an explosion, the end of the world, or deep space.

Try it

Make a series of drawings from objects or surfaces that have definite radial patterns. Use several of these studies to develop your own finished design.

11–23 Many flowers and plants display radial patterns. In this cactus, the pattern allows a maximum amount of surface area for absorbing water.
Silversword cactus. Photo by J. Scott.

11–24 Note how the artist used value contrast to increase the energy of the radial pattern used in this image.
Theodore Roszak (1907–81). *Star Burst*, 1954. India ink and colored ink on paper, 43 ½" x 79" (110.5 x 200 cm). Collection of the Whitney Museum of American Art, New York. Gift of Mrs. Theodore Roszak, 83.33.10.

Michelangelo Buonarroti

Daniele da Volterra (Daniele Ricciarelli) (1509–66). *Bust of Michelangelo*, 1565. Detail of bronze bust, 32" high (81.3 cm). Accademia, Florence, Italy. Alinari/Art Resource, NY.

Known as one of the most talented artists of all time, Michelangelo was an Italian sculptor, painter, poet, and architect who lived from 1475 to 1564. From an early age, he was devoted to the study and practice of art.

Michelangelo spent innumerable hours learning about the human body, not only by drawing from live models and studying early Greek and Roman statuary, but also by dissecting bodies. His reputation as "the greatest sculptor in Italy" was earned at the age of twenty-nine by his marble carving of *David*.

Michelangelo was also highly skilled at drawing and painting, and completed many works of biblical scenes. He was a master of *fresco*, a technique of painting with pigment on walls of wet plaster. By commission to Pope Julius II, he painted the ceiling of the

11–25a Oval, or elliptical, shapes were considered undesirable by architects and planners in Michelangelo's time. His use of the oval as a basis for the pavement pattern design was a powerful artistic statement. Michelangelo (1475–1564). *Campidoglio*, 1538–64. Plan, Rome. Engraving by Dupérac.

enormous Sistine Chapel, a monumental work that took him four years to accomplish. During the project, he spent so many hours working overhead that his body became accustomed to that position; as a result, in order to read a letter, he held it over his head!

In the last thirty years of his life, Michelangelo spent most of his time working on architectural plans. He was commissioned in 1537 by Pope Paul III to redesign the Campidoglio in Rome, a hilltop area that included two palaces. The position of the existing palaces, which are placed at an angle, posed a challenge. Michelangelo's design included a third building to add an unconventional trapezoidal symmetry to the plaza.

Best known for the monumental forms of his sculptures and paintings, Michelangelo so successfully designed buildings and urban spaces that his work on the Campidoglio has been hailed as one of the most significant efforts in the history of urban planning. The Campidoglio is an excellent example of how an artist especially known for an emphasis on one element or principle of design (form) will often stretch creativity and genius in another direction (pattern) in order to solve a specific visual or design problem.

11–25 The radial pattern of the pavement unifies the buildings in this hilltop plaza, by creating a cohesive space. What other function does the pattern serve? Michelangelo (1475–1564). *Campidoglio*, 1538–64. Pavement, Rome.

Interdisciplinary Connection

Mathematics—Lead students in creating radial patterns by intersecting the diameter of a circle with a series of interlocking and overlapping arcs. Encourage students to use a compass, ruler, and pencil to discover geometrical relationships created by intersecting a circle with other circles and arcs. Students may wish to add color to their designs with markers or colored pencils.

Borders and Bands

Another way to add pattern is to enrich a surface with a decorative border or band. Since the Renaissance, sports teams have identified themselves by adding bands of color to their uniforms and flag. Household items, cars, planes, and pottery are some of the many other items also decorated in this way.

Context

The Dedham Pottery (fig.11–27) opened in 1891 in the town of Dedham, southwest of Boston. The company is best known for dinnerware that is covered with a crackle glaze. Hugh Robertson, the head of the pottery when it opened, had serendipitously produced the unusual glaze in 1886. The crackle resembles that on Chinese ceramics of the Ming dynasty (see fig.10–10), and the dinnerware was decorated with a hand-painted border. The best-known motif is the parade of white rabbits that make their way around the rim of the pieces they decorate. The Dedham Pottery closed in 1943.

⭐ **Higher-Order Thinking Skills**

Encourage students to notice the frames around the artworks when they visit a museum or art gallery. Picture frames are a form of border design that emphasizes an artwork. Urge students to note what types of frames are used with different styles of art. They should notice that many of the artworks created before the twentieth century are usually framed with heavy, carved, gilded frames, whereas those on more contemporary works are usually much plainer. Some artists, notably Georgia O'Keeffe and Georges Seurat, even painted the frames on their art. Challenge students to explain why there has been a change in the way art is framed.

11–26 Architects often use decorative bands to relieve large expanses of plain wall surface or to help define and divide space.
Carved architectural detail. Photo by A. W. Porter

11–27 How would you explain the way the border of this plate works both to stop the eye and to keep it moving?
Dedham Pottery. *Plate,* c. 1900–28. 10" diameter (25.4 cm). Courtesy of the Dedham Historical Society, Dedham, Massachusetts. Photo ©Forrest Frazier Photography.

Artists and designers frequently use borders and bands to emphasize the edge of a form or to highlight a particular area. Architects might design a patterned border to run along the top edge of a wall. A potter might create bands of indentations in a clay bowl or use glazes to add a border to a ceramic plate. Look in your closet: most likely, you have a shirt or sweater whose neck or sleeves are decorated to add emphasis to the design.

Borders and bands can make a composition visually stronger. They may add a color, shape, or texture that will add contrast and increase interest. They also can lend elegance and individuality to a design. In some ways, adding a decorative border or band is similar to underlining a word for emphasis. If you were designing the side panels of a racing car, what kinds of lines and colors would you suggest?

11–28 What pattern device was used in this title page? Why would a book designer want to make a title page particularly inviting to the eye?
Bruce Rogers (1870–1957). Title page from *Fra Luca de Pacioli*, by Stanley Morison. 12 ½" x 8 ¼" (31.8 x 21 cm). The Grolier Club, New York, 1933.

11-29 How has a decorative band been used on this work? How would the appearance of the vase change if the band were removed?
Ben Julian (age 18). *Blue Boy*, 1998. Earthenware with blue stain, 6" x 6" x 10" (15.2 x 15.2 x 25.4 cm). James W. Robinson, Jr. Secondary School, Fairfax, Virginia.

Higher-Order Thinking Skills
Focus on the images on pages 220–221. Ask students what art element or elements are stressed in each of the borders and how the use of these elements enhances the overall design.

FRA·LUCA
DE·PACIOLI
OᶠBORGO·S
SEPOLCRO
Bʸ STANLEY
MORISON
THE·GRO·
LIER·CLUB
NEW·YORK
MCMXXXIII

Random Patterns

Sometimes, patterns just happen. Have you ever noticed a pattern of crisscrossed footprints in mud or sand? Or one produced by a spilled or splattered liquid? A pattern created by chance or without an orderly organization is called a ***random pattern***. Aging wall surfaces are good places to discover random patterns; many artists have been inspired by the interesting effects of weathered wood, peeling paint, and faded signs.

Random patterns usually have nonuniform surfaces and asymmetrical compositions, and they may also contain irregular or unusual elements. These conditions often make random patterns more expressive and visually exciting than planned patterns. The lack of a rigid plan often contributes a feeling of wildness or energy to the design. In the student painting (fig.11–33), a random pattern was achieved with ink and charcoal.

11–30 Close inspection of nature's forms can reveal intriguing patterns like these random clusters of ice on twigs.
Ice-covered shrub twigs. Photo by J. Scott.

Try it

Look at patterns in your environment to find a mixture of random and planned patterns. Make one or two designs in which you use both types. One possibility is to combine carefully drawn and spaced line arrangements with splattered or randomly applied paint or ink.

Design Extension

Have students compare and contrast *Lines of light* (fig.11–31) and *Nightview, New York, 1932* (fig.11–32), and hypothesize as to how each was created. Ask: What are the most important art elements in each photograph? Students may want to try photographing points of light, such as candles and flashlights, in a dark room without a camera flash.

11–31 Notice that random patterns can have a wildness that is not present in even the most energetic radial patterns.
Lines of light. Photo by A. W. Porter.

Context

While living in Paris in the early 1920s, Abbott (fig.11–32) developed an interest in photography and was greatly inspired and influenced by the French photographer Eugene Atget, who had spent thirty years documenting the city of Paris. Abbott decided to embark on a similar project to capture New York City on film, and she began her photography campaign in 1929. In 1935, her documentation was funded by the

11–32 In what ways does this image show random patterning?
Berenice Abbott (1898–1991). *Nightview, New York, 1932.* Gelatin silver print. © Berenice Abbott/Commerce Graphics Ltd., Inc.

11-33 The random placement of paint in this work gives it a feeling of liveliness. The viewer's eyes are in constant motion.

Kenny Holmes (age 18). *Untitled #7*, 1998. Ink and charcoal, 20 ½" x 7" (52 x 18 cm). James W. Robinson, Jr. Secondary School, Fairfax, Virginia.

"Changing New York" unit of the Federal Art Project. She spent the next four years working full-time to photograph the buildings, bridges, highways, churches, and other structures that formed the face of the city.

Another Look at Pattern

11–34 Because Moslems are forbidden to include figures in their religious art, Moslem artists over the centuries developed a style that incorporates magnificently intricate patterns.
Ceramic tile wall, c. 1500. From the Friday Mosque, Isfahan, Persia (Iran).

11–35 In early medieval times, manuscript artists were masters of densely packed, intricate patterns. Note that the decorative border in fig.11–28 was derived from the Celtic tradition of interwoven pattern found in the *Book of Kells*.
Ireland. *Book of Kells*. TCD MS 58 fol 188r (the opening page of Luke's gospel). The Board of Trinity College, Dublin, Ireland.

11–36 Pattern is sometimes colorful and bold; but in some instances, it is quiet and understated. Think of a familiar outdoor space. What kind of patterning does it have?

Simon Rodia (1875–1965). *Watts Tower*, detail. Photo by A. W. Porter.

11–37 A photographer can spot patterns that many of us might miss. How did the artist frame this image in order to emphasize pattern?

Lee Lockwood (b. 1932). *New York Hilton Hotel Under Construction*, 1962. Print. ©Lee Lockwood/Time Inc.

Review Questions (answers can be found on page 206l)

1. What is visual pattern?

2. Give an example of a manufactured and a natural pattern.

3. What are two main functions of pattern?

4. List six basic types of planned patterns. Draw a small example of each.

5. What is a random pattern?

6. Explain how other cultures have influenced Navajo blanket weaving.

7. What type of pattern did Michelangelo use in his design for the Campidoglio pavement in Rome?

Internet Connection

It is now possible to see a nearly identical replica of the *Book of Kells* without traveling to Ireland. Suggest that students search the Internet to discover what special considerations were involved in the manufacture of this limited-edition fine art facsimile.

Interdisciplinary Connection

Science—Discuss how patterns in nature are formed. Assign students to find images of natural patterns in their science books. Point out the patterns formed by tree rings, ripples in beach sand or in a ripple tank, salt and alum crystals, and snowflakes. Ask students to choose one example and to research the scientific explanation for the pattern.

Career Portfolio

Interview with a Fabric Designer

Pattern is an essential principle of fabric design, which is based on repeated images. **Wesley Mancini** discovered his flair for fabric design while studying art education at the Philadelphia College of Art. He went on to obtain a master's degree in fiber from Cranbrook Academy of Art. He now has twenty-two people working for his company in Charlotte, North Carolina.

As a fabric designer, what is your specialty?

Wesley: Woven fabrics for the home, primarily for upholstery and interiors. We've been expanding into bedding—bedspreads, dust ruffles, and pillow shams. Once we got into printed fabric, that market expanded into tabletops (table linens, place mats, napkins) and shower curtains, as well as printed upholstery and draperies.

What does upholstery include?

Wesley: Primarily sofas and chairs. However, the fabrics can be used for drapery or whatever an interior decorator would like to use them for. I've seen the fabrics used as apparel for vests, or the top part of boots, eyeglass cases—basically anywhere that a textile can be used, even lampshades.

What is the difference between print design and woven design?

Wesley: They are very different sensibilities. Just because you're a good woven designer doesn't necessarily mean you're a good print designer.

With the print designs, the art is the most important thing. You have to be able to paint with techniques. A painted design is printed on fabric in much the same way that pictures are printed on paper.

Woven designs include the structure of the fabric itself. There is a lot of linear thinking, figuring out constructions and weaves, so it is mathematical. You're designing the elements, making the yarns, dyeing them, deciding the sizes, and then figuring out the structure and how they are all going to fit together. The art department paints the art, and a styling department assigns different weaves to each of those colors. They also determine what yarns are going to be woven and the number of yarns per inch in the horizontal direction, as well as the vertical direction. The editing department scans the art into a computer and puts in the number of yarns, vertically and horizontally.

What advice would you give to someone interested in this field?

Wesley: Go out and see what is selling in stores. See what colors are selling. See what kinds of designs are out there. If you want to go into apparel, that would be a different kind of design than if you were picking upholstery. I would pick schools that are known for that particular thing. You don't have to be a fabric designer: you can be a fiber artist and make one-of-a-kind pieces.

For fabric design to work, a pattern must hold together when repeated throughout the cloth. A fabric artist first draws the design in rough pencil, and then paints the section to be repeated. That section is scanned into a computer, where it is copied, rotated, and mirrored to make the whole image. Many different color schemes may be applied to one design. Can you find the triangular pattern within the fabric?

Wesley Mancini. *Fabric design with markings and color guide.* Courtesy of the artist. Photo by T. Fiorelli.

Studio Experience
Pattern Prints

Task: To draw natural patterns, carve one as a linoleum-block print, and then print several patterns with repeat schemes.

Take a look. Review the following photographs of nature images:
- Fig. 11–6, *Peacock feathers*
- Fig. 11–21, *Artichoke*
- Fig. 11–23, *Silversword cactus*

Then review these illustrations of human-made patterns:
- Fig. 11–3, Faith Ringgold, *The Wedding: Lover's Quilt No. 1*
- Fig. 11–34, *Ceramic tile wall* from Friday Mosque
- Fig. 11–37, Lee Lockwood, *New York Hilton Hotel Under Construction*

Think about it.
- Study the nature photographs listed above. Note that the focus in each is on the zoomed-in pattern of the natural object. In each image, what element created the pattern?
- Study the human-made patterns, and identify several of the motifs in each pattern. Notice how some motifs have been joined together to form a larger unit that is repeated. How do the motifs vary from row to row in each pattern?

Do it.
1 On drawing paper, make several pencil drawings of patterns found in nature.

2 Select a portion of one drawing as the design for your linoleum-block print. Later, you will print this many times as a motif. Transfer your pencil drawing to the linoleum block: place your drawing facedown on the linoleum, and rub over the back of the paper with the side of a pencil or the back of a spoon. Your print will be the reverse of your carved print block.

3 Use linoleum cutters to carve away the areas of your design that will be the

"Complementary color systems of paints and colored paper were followed during the printing process. For instance, warm-colored paints were printed on cool-colored papers, and then cool-colored paints were printed on warm-colored papers. I also looked at artwork made by quilt makers to influence the way I arranged the finished prints."

Erica Wallin (age 16). *Butterfly Wing Quilt*, 1998, detail. Linoleum print on colored paper, 17" x 17 ½" (43.2 x 44.5 cm). Clarkstown High School North, New City, New York.

227

color of the paper. Do not carve too deeply. Always keep hands behind the blade. If bench hooks or C-clamps are available, use them to hold the linoleum in place.

4 Make a proof print by inking the block with water-soluble ink and printing it on paper.

5 Pull the paper from the block. Study your print to decide if you want to cut away any more of the linoleum. Using your block as a motif, print repeated patterns on larger sheets of paper. Try different types of repeated patterns. Print your block in grid, half-drop, radial, and random patterns. Experiment by turning the block in different directions, leaving varying amounts of space between the prints, and using several colors.

6 Mount your two favorite patterns on colored paper or cardboard.

7 *Option:* To produce an effect similar to the student work on this page, vary your block prints by using different colors of ink and paper. Then, cut the prints in half diagonally and reassemble the blocks.

Helpful Hints
- To get an idea of what your print will look like before you ink the block, make a rubbing by placing a piece of thin paper over the block and rubbing the paper with the flat edge of a pencil lead.
- Each time you ink your block, set it on a clean page of a recycled magazine or telephone book. This will keep your work surface free of wet ink.

Check it.
- What type of repeat scheme did you use in each pattern?
- Consider the craftsmanship of your artwork:
 — Did you ink and print your block correctly?
 — Did you put too little or too much ink on your block?
 — Did you apply enough pressure to create an even, sharp print? Does this matter in your pattern?
 — Are there any stray spots of ink on your paper? If so, does this interfere with the effectiveness of the pattern? Do they accidentally add to the success of your design?
- What do you like best about the two patterns?
- What might you do differently the next time you create a similar piece of art?

Studio Experience
Pattern Prints

Lauren Totero (age 15). *Born of Earth*, 1998. Linoleum print, 15" x 15" (38.1 x 38.1 cm). Clarkstown High School North, New City, New York.

Prepare

Time Needed:
Four 45-minute class periods (extend as needed)
Lesson 1:
Draw.
Lesson 2:
Carve the block.
Lesson 3:
Print patterns.
Lesson 4:
Mount two prints.

Objectives
Students should be able to

- Examine both natural and human-made patterns to perceive and appreciate how motifs are repeated.

- Draw several patterns found in nature.

- Carve and print a linoleum-block print based on a natural pattern.

- Demonstrate understanding of repeated motifs in patterns by printing—from a linoleum block onto paper—patterns with various repeat schemes.

Materials
- nature objects with patterns (leaves, shells, feathers, and so on)
- No. 2 pencils
- 9" x 12" drawing or bond paper
- 4" x 4" linoleum blocks
- linoleum cutters with both wide and narrow gouges
- water-soluble block printing inks: red, yellow, blue, black, white
- inking plates (cookie sheets, disposable aluminum trays or pie pans, Styrofoam™ meat trays)
- rubber brayers
- variety of papers, 18" x 24", for pattern prints
- recycled magazines
- colored paper or cardboard
 optional:
- bench hooks or C-clamps (recommended if using traditional linoleum)

Notes on Materials
- *Printing blocks:* Buy either traditional battleship linoleum or softer varieties of rubber printing material. The soft rubber linoleum substitutes are easier to cut, but some break down with repeated use of solvents if using oil-based ink (see **Meeting Individual Needs**). Some also collapse under printing pressure so fine lines do not print. For economy, buy the printing block material in large sheets, and cut it into 4" x 4" squares with a utility knife and ruler.

- *Paper:* For printing, have students use a variety of papers, such as drawing, craft, rice, construction, and newspaper.

Before You Start
- Either collect natural objects with patterns yourself, or assign each student to bring in an object.

- Sharpen linoleum cutters with a sharpening stone.

Teach

Thinking Critically
Direct students to identify the type of repetition—grid, half-drop, radial, random—used in each of the three human-made patterns listed in **Take a look**. Because some of the patterns could fall into two categories, ask students to explain what features in the pattern influenced their classification.

Classroom Management
- Have students work in groups of four, five, or six to set out supplies, cover the work area with newspapers, and do cleanup of their area and equipment.

- If there is a lack of storage space for the nature objects, or a shortage of time, have students do the drawings of nature patterns outside of class, as a sketchbook assignment.

Cooperative Learning

After students have carved and made a print, organize them into groups of four to create their patterns. Instruct students to print patterns using their block and the blocks of the other students in their group. Instead of repeating one motif, they will repeat four. Display the groups' patterns together. Ask each group what kind of design problems they needed to solve before determining the final pattern.

Tips

- For safety, instruct students to hold the linoleum in place with either a bench hook or C-clamps while they are carving. Hands always belong behind the blade. It is awkward at first, but students get used to working this way.

- To find an interesting section of their drawing to turn into a print, have students use a viewfinder made of two paper Ls or 4" square openings cut in bond paper. (See #6 on page 153, the Balance in Nature activity.)

- Save the printed patterns that students do not mount. They can be used for the Design Extension on page 240.

Assess

Evaluation

- As students select which paper patterns to mount, they will be evaluating their art. Have them explain to another student why they chose these particular patterns.

- Assign students to write the answers to the questions in **Check it**.

Extend
Meeting Individual Needs

Challenge

Encourage students to print a pattern on cloth or a T-shirt. Demonstrate how to stretch and tape the fabric flat on a piece of cardboard so that there are no wrinkles, then use an oil-based ink to print a pattern on the fabric. Before the cloth is washed, students should set the ink with heat after ink has dried by either ironing the fabric or drying it in a clothes dryer set on high heat.

Linking Design Elements and Principles

Contrast

When students select the drawings for their prints, remind them to consider which shapes and lines will be dark and which will be light. Students may want to create more contrasts of lights and darks within their prints.

Shape

As students print their patterns, ask them to note the various shapes formed when they print their blocks in different directions side by side. This will be most striking if the images on the block are asymmetrical or touch the edge of the block.

Color

- Provide students with only the primary colors of printing ink, and encourage them to mix the inks to create other colors.

- Have students repeat colors in their patterns.

- Instruct students to print each pattern in a specific color scheme. For example, one pattern could have analogous color harmony, and another could have a complementary color scheme.

Interdisciplinary Connections

Science

Assign students to find and draw a repeated natural pattern from an image in a biology, chemistry, or physics book. Challenge them to report on how or why this pattern was created. For example, they might draw zebra stripes and report that these are natural camouflage; or they might draw patterns from crystals, which indicate internal atomic arrangement.

Mathematics

Have students write number patterns and create illustrations of them. For example, 2 4 6 8 could be ◆◆ ◆◆◆◆ ◆◆◆◆◆◆ ◆◆◆◆◆◆◆◆ or 2 4 42 44.

Inquiry

Direct students to research patterns found in the art of other cultures. Divide the class into groups, and assign a different culture to each. Possibilities are India, China, Japan, Southeast Asia, Oceania and Highland Asia, the Islamic Middle East, West Africa, South America, or Native America (the Pacific Northwest or the Southwest). Students should make a poster that illustrates at least three patterns typical of the culture's art.

Chapter 12 Organizer

Movement and Rhythm

Chapter Overview

- Artists can create movement within their designs in several ways. They might make their art or part of it actually move, or they might record or indicate action.

Objective: Students will perceive and identify various types of movement and rhythm in artworks. (Art criticism)
National Standards: 2. Students will use knowledge of structures and functions. (2b)

Objective: Students will create a comic strip, pop-art painting, mobile, and other artworks incorporating movement and rhythm in their design. (Art production)
National Standards: 1. Students will understand and apply media, techniques, processes. (1b) **2.** Students will use knowledge of structures and functions. (2c)

8 Weeks	1 Semester	2 Semesters			Student Book Features
1	1	1	**Lesson 1:** Movement and Rhythm	Chapter Opener	
1	1	2	**Lesson 2:** Actual Movement	Actual Movement	Try it: mobile
0	1	1	**Lesson 3:** Recorded Action	Recorded Action	Try it: drawing
0	1	1	**Lesson 4:** Compositional Movement	Compositional Movement in Three-dimensional Art Compositional Movement in Two-dimensional Art	Discuss it, About the Artwork
0	1	1	**Lesson 5:** Types of Rhythm	Regular	
0	1	2	**Lesson 6:** Types of Rhythm	Flowing	Try it: drawing or painting, About the Artist
0	2	2	**Lesson 7:** Types of Rhythm	Alternating Progressive	
0	0	2	**Lesson 8:** Types of Rhythm	Unexpected	Try it: various media
1	1	1	**Chapter Review**	Another Look at Movement and Rhythm	Review Questions
0	0	6			

Studio Experience: *Action!*

Objectives: Students will perceive and understand how artists create implied action and graphic movement; draw an action-sequence comic strip; create a painting based on a frame of their comic strip that demonstrates graphic movement.

National Standard: Students will evaluate artworks' effectiveness in terms of organizational structures and functions (2b); use media, techniques, and processes to achieve their intentions in their artworks (1a); create art using organizational structures and functions to solve art problems (2c).

- Using compositional balance, artists direct the viewer's gaze through a design.
- Visual rhythm refers to the type of movement within a design.

- Rhythms may be regular, flowing, alternating, progressive, or even unexpected.

Objective: Students will understand how Frans Hals, Henri Matisse, and artists of ancient Greece, and various other periods and cultures created movement in their art. (Art history/cultures)
National Standards: 4. Students will understand art in relation to history and cultures. (4a)

Objective: Students will develop an understanding of how a culture's values and beliefs can influence the design of its art and architecture. (Aesthetics)
National Standards: 3. Students will choose and evaluate a range of subject matter, symbols, and ideas. (3c)

Teacher Edition References	Ancillaries
Warm-up, Design Extension, Context, Performing Arts	
HOTS, Context, Inquiry	*Slide*: Jean Tinguely, *Motorized Sculpture* (MR-1)
Design Extension, Context, Portfolio Tip, Inquiry	*Slide*: New Mexico, *Kiowa Dancers* (MR-2)
HOTS, Context, Portfolio Tip, Inquiry, Cooperative Learning	*Slides*: Alma Woodsey Thomas, *Eclipse* (MR-3); Oceania, *Helmet mask* (MR-4)
Design Extension, Context, Interdisciplinary Connection	*Large Reproduction*: Suzuki Haranobu, *Young Woman in a Summer Shower*
Design Extension, Context, Internet Connection	*Slide*: Dale Chihuly, *Macchia Single* (MR-5)
HOTS, Context, Inquiry	*Large Reproduction*: Michael James, *Quilt No. 150, Rehoboth Meander*
HOTS, Context, Interdisciplinary Connection, Performing Arts	*Slide*: Anni Albers, *Tapestry: Orange Black & White* (MR-6)
HOTS, Context	

Vocabulary

compositional movement A path that the viewer's gaze is directed to follow because of the arrangement of elements in an artwork. *(movimiento composicional)*

kinetic art Three-dimensional sculpture that contains moving parts. *(escultura cinética)*

progressive rhythm A pattern in which each series of motifs incorporates a predictable change. *(ritmo progresivo)*

visual rhythm The result of pattern combined with implied movement. Elements or motifs are combined to create a series of regular pauses (stops and starts) for the viewer's eyes, similar to the way a drumbeat creates a series of pauses for the listener's ears. *(ritmo visual)*

Time Needed
Six 45-minute class periods.
Lesson 1: Draw and plan;
Lesson 2: Draw comic strip;
Lesson 3: Enlarge one frame;
Lessons 4–6: Paint.

Studio Resource Binder
12.1 Type Collage
12.2 Arbitrary Styles, figures with superimposed images
12.3 On the Move, mobile
12.4 Graphic Progression, computer drawing
12.5 Rhythmic Figures in Clay

Lesson 1
Movement and Rhythm

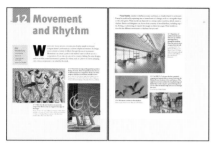

pages 228–229

Objectives

Students will be able to

- Understand the difference between actual movement and visual movement.

- Perceive and comprehend visual rhythm in artworks.

Chapter Opener

- Recruit a student volunteer to demonstrate a dance step or a sports move. Point out that this is actual movement. Then ask if there is movement in Miriam Schapiro's *Master of Ceremonies* (fig.12–1). Ask: Does anything actually move in this composition? Does anything seem to move? Is there any other movement going on as you look at this piece of art? How about you, the viewer? Point out that the viewer's gaze moves through the composition following paths created by the artist—in this case, through the swirling forms of the bodies and the background. This movement in a design is visual movement.

 Instruct students to either write two words that describe the movement in *Master of Ceremonies*, or review their descriptive words from the **Chapter Warm-up**. Compile a list of the words that the class wrote. Many of them are probably similar. Explain to the students that their descriptors such as jumpy, fast,

swinging, and swirling describe the way their eye moves through the art. Some of the words describe the rhythm of that movement. Notice how the patterns in the background and frame, and the placement of the figures, add to the visual movement in the whole work.

- Discuss how visual movement is created in figs.12–2, 12–4, and 12–5. Figure 12–4 shows the actual movement of birds flying whereas in *Tin Toy*, the drawings will seem to move when the whole animation sequence is viewed. Students should notice the diagonals in the still frame from *Tin Toy* and Kirk's sculpture, *Avion*. These diagonals draw the eye through the composition.

- In studying how architect Louis Kahn created visual movement through the lobby of the *Kimball Art Museum* (fig.12–3), point out how the repetition of elements both on the window and ceiling leads the viewer's eye down the hall, and how our eyes also follow the long horizontal lines of the walls. Stainless steel reflectors spread light over the concrete vaulted ceiling. As students consider this structure, introduce them to Kahn and some of his architectural theories. In 1905 when he was four, he came to the United States with his family from Estonia (the northernmost Baltic republic in what was

once the Soviet Union). He studied and taught in Pennsylvania. His buildings reflect his belief that there is an inherent order in all things and that architecture should not only serve human needs but also be an art form.

- To experiment with recording movement in compositions, organize students into cooperative-learning groups to photograph actual movement. They should photograph each other in motions such as dancing, jumping, or running. With Polaroid cameras, they will be able to see their results at once, but with one-hour film developing, they may view their photographs in the next class period or in Lesson 3 when they discuss recorded action. In their prints, they might notice blurred images indicating action.

- Instead of photographs, students could make very quick sketches of people in motion. A physical education class might provide possible subjects for this.

Opener	pages 228–229

Materials
options:
- cameras (1 for each two to five students), film
- drawing paper, drawing media such as pencils or markers

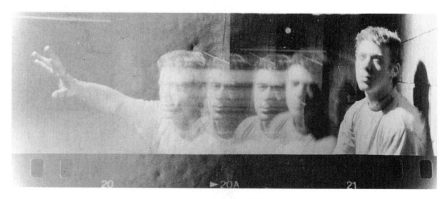

Alex Friend (age 17). *The Reach*, 1997. Print. Marlboro High School, Marlboro, Massachusetts.

Lesson 2
Actual Movement

pages 230–231

Objectives
Students will be able to

- Perceive and comprehend how artists create actual movement in their art.

- Create a mobile.

Teach

- Explain that there can be actual movement in sculptures. Write *kinetic* on the chalkboard, and remind students that kinetic sculptures move or have moving parts. Call on students to describe what moves or changes in each image on pages 230–231. Have students look back at *Sky's the Limit* (fig.2–27) and Nam June Paik's *Family of Robot* (fig.2–28). Ask students to describe the movement in these two designs.

- When students study Bernini's *Fountain of the Four Rivers* (fig.12–8), explain that Bernini was a leading Roman sculptor and architect during the Baroque period, a time when artists were fascinated with movement and dramatic contrasts of values. In addition to the many fountains Bernini created in Rome, he also designed the colonnade on the facade of St. Peter's Cathedral in the Vatican. Inform the class that each figure portrayed in the fountain corresponds to one of the great rivers of the world. (See **Context**.) Ask: What

is moving in this art? (Students should notice that the water is actually moving with light sparkling off the water and flying droplets. There is also visual movement in the twisting bodies of the figures.)

- Before students do **Try it**, demonstrate how to begin constructing the mobile. Students may suspend cardboard shapes, or found and natural objects from wire or string. Urge students to consider how their shapes will affect both the compositional and actual rhythm and movement. They may wish to paint their shapes or forms with acrylic paints.

Try it page 231

Materials
- cardboard, or small found objects
- scissors
- glue
- wire, string, or nylon cord
- wire cutters
- coat hangers, dowels, or sticks
optional:
- acrylic paints
- brushes

Lesson 3
Recorded Action

pages 232–233

Objectives
Students will be able to

- Perceive and understand how artists record action in their works.

- Create their own drawings which suggest movement.

Teach

- Focus on pages 232–233, and ask students how we actually see motion, compared to how it is captured in film. Our eyes follow a moving object, but film records a series of individual images that are played in rapid succession to indicate movement. Have students compare the movement in Da Silva's photograph (fig.12–9) with that in Edgerton's *Densmore Shute Bends the Shaft* (fig.12–10). Ask how Edgerton's photograph indicates motion, and have students compare this means to that in *Lines of light* (fig.11–31). Explain that Edgerton, an American electrical engineer, developed the modern electronic flash, a light which flashed intermittently for use with stroboscopic and high speed photography. He is famous for his photographs of movement too fast for the human eye to comprehend.

- Call on students to describe how the sculptor indicated motion in *Nike of Samothrace* (fig.12–11). Help them note the great size of this sculpture, in contrast to its delicate carving. Explain that this sculpture represents

a winged goddess of victory as she alights on a ship.

- Point out the actual movement lines in Tom Purvis's *East Coast by London and North Eastern Railway* (fig.12–12). Refer students to Lichtenstein's *Whaam!* (fig.12–35), and ask how the artist indicated motion. Students might compare this to the motion lines in Purvis's print.

- If students took action photographs in Lesson 1, they should also note the action in these prints and how it is indicated in two dimensions.

- Recruit a volunteer model to take a simple pose, perhaps standing with a guitar or sitting on a stool. Before students begin **Try it**, show them how to do the layered drawings of the same figure from different angles. Students might use three different colors of markers, pencils, or crayons for each composite sketch. Encourage students to do two or three of these layered drawings.

Try it page 233

Materials
- three different colors of markers, pencils, or crayons
- 12" x 18" white paper

Lesson 4
Compositional Movement

pages 234–235

pages 236–237

Objectives

Students will be able to perceive and comprehend how artists and architects create compositional movement in two- and three-dimensional designs.

Teach:
Compositional Movement in Three-dimensional Art

- Explain that compositional movement has to do with how the viewer's gaze is directed through a composition. As students look at fig.12–11, *Nike of Samothrace*, point out the movement in this piece, through the major folds and the stretch of the wings. Put a chair on a desk so that all students can study it. Ask where the main lines of movement are in the chair. Then turn it around so that students can note how it looks from different viewpoints.

 Call students' attention to Houser's sculpture in fig.12–13a,b and how its appearance changes when viewed from different vantage points. Ask them to study the move-

ment in Graves's library (fig.12–15) and in Salisbury Cathedral (fig.12–14). Discuss the feeling of height in each work, and ask which building feels taller, and why.

- Lead the students in considering how both buildings, the library and the cathedral, were planned to become part of their urban environment. Graves purposely incorporated elements of the Spanish mission style into his design, making this structure blend into the existing community. (See **Context**.) Gothic designers, however, went to great lengths to raise their cathedrals over the surrounding structures so that the church dominated the community.

 Discuss with students each community's beliefs about the functions of these two buildings and how this determined their scale and design. Point out how the library is designed to welcome the community into it with a covered entrance that juts out from the main part of the building, while the height and volume of the Gothic cathedral awe the viewer, making worshipers feel small and humble in so large a space.

Teach:
Compositional Movement in Two-dimensional Art

- Focus on the movement in each image on pages 236–237. Point out how Hals created movement in his painting (fig.12–19) by overlapping figures, repeating colors and shapes, contrasting values, using directional lines in draperies to lead the eye, and facing the figures on the composition's outer edges toward the center. Ask students to analyze the movement in Sherman's film still (fig.12–16) and de Brunhoff's Babar illustration (fig.12–17), and to write a word to describe the movement in each composition. In de Brunhoff's illustration, the dancing figures

create obvious movement, but so do the color and diagonal lines used in the composition. In Sherman's film still, the lines of the stairs and railings sweep the viewer's gaze through the composition.

Inform students that Cindy Sherman is more than a traditional photographer who takes pictures; she is also the model and subject of her compositions. By wearing costumes and masks, she creates various identities. She has said that she is "trying to make other people recognize something of themselves rather than me." Her works explore how women create their own self-images.

- Call attention to the subjects' clothes in *Banquet of Officers of the Civic Guard of St. George at Haarlem* (fig.12–19). Ask: Do they remind you of another group of people? (Someone should mention the Pilgrims.) Recall with students that about eight years before this painting was created, the Pilgrims were in the Netherlands before coming to America. This should help students connect the time and style of this painting with an event with which they are already familiar.

Explain that because Holland was Protestant at this time, most commissions for art came from the growing middle class for their homes and guild halls, not for churches. Dutch artists were dependent on commissions such as this to earn their livings. Be certain that students understand how art commissions work. (Individuals pay the artist to create an artwork.)

- Have students do **Discuss it**. A single work can be discussed by the class, or several choices can be provided so that students can also compare and contrast movement in each.

Computer Connection

Students will create compositional movement by directing the viewer's eye around a page. Using drawing or painting software, guide students to choose an arrowhead style for lines they draw. Instruct them to create a path of small arrows that begins in a top corner of the page and leads the viewer's eye around the page and off a bottom corner. Their designs can be enhanced by adding arrows and lines of varying lengths that echo the original movement. Encourage students to stop when they have achieved a balance between empty and filled space. Ask: What might happen to the flowing eye movement if the design becomes cluttered? (The sense of unity may be lost.) Discuss how other elements might be used in a similar way and how successfully each could be rendered by computer programs. As an optional challenge, have students combine elements of shape and value on their computers to create a sense of movement.

Lesson 5
Types of Rhythm

pages 238–239

Objectives
Students will be able to

- **Understand and identify visual rhythms in artworks.**

- **Express musical rhythms in drawings.**

Teach: Regular

- Discuss the rhythm in each image on pages 238–239. Review pattern—the repetition of a motif—with students, and ask how rhythm seems to be related to pattern. Have students write a word to describe the rhythm in each image; then, compare and discuss their answers. As they look at figs.12–21, 12–22, and 12–23, note the regular rhythm and pattern created by repeating the same forms.

- As students consider the rhythm in Judd's sculpture (fig.12–22), ask how they would describe the style of this art. Does it remind them of other pieces that they have studied? Remind them of the simplicity of Mondrian's work (fig.7–14), and Philip Johnson's *Glass House* (fig.5–10). Judd is a minimalist, seeking to represent aesthetic values of art with basic geometric forms. The repetition of highly refined boxes is part of his search for ultimate unity.

- Play several pieces of music with strong rhythms. Along with rock, rap, and classical selections, play Native American, Hawaiian, and African

music, if possible. Encourage students to clap, tap, or move to the music. Ask them what type of strokes —such as staccato or smooth, slow-flowing strokes—they envision as they hear each selection. Have students use markers to draw, or mark, the rhythm of several pieces.

Teach	pages 238–239

Materials
- recordings of several pieces of music with varying rhythms
- 12" x 18" white paper
- markers

Lesson 6
Types of Rhythm

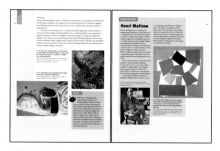

pages 240–241

Objectives
Students will be able to

- Perceive and identify flowing rhythms.

- Paint or draw flowing rhythm patterns.

Teach: Flowing
- Lead students in noting smooth, flowing natural rhythms such as billowing clouds, undulating hills, and the curve of a seashell. Ask students to trace with their fingertips the flowing movement in each image on pages 240–241. Direct students to look back through the book to find other examples of flowing rhythms. In this chapter, they might cite *Nike of Samothrace* (fig.12–11).

- Discuss with students how Matisse's health affected his art. In 1941 Matisse underwent two serious intestinal operations which left him a semi-invalid, able to stand on his feet only for short periods of time. With the help of assistants he continued to work from his bed for the rest of his life. Note that he painted the paper that he used for his cutouts with gouache (opaque watercolor).

- Draw several horizontal wavy lines on the board, and then draw a series of circles between the lines (this should resemble a horizontal string of pearls). Add a few more lines above and below the first ones, but this time vary the space between the lines so that the lines are only about 1" apart at some points, and 4" apart at other points. Begin to fill in the space between the lines with circles.

 Then have students do **Try it**. Emphasize to students that they may use shapes other than circles as their motif. When drawings are complete, ask students to describe the sense of rhythm in their work. Ask: Is this the type of flowing movement they intended to create?

Try it	page 240

Materials
- 10" x 15" illustration board or watercolor paper
- pencils
- watercolor, acrylic, or tempera paints
- brushes

Lesson 7
Types of Rhythm

pages 242–243

Objectives
Students will be able to

- Perceive and identify alternating and progressive rhythms in artworks.

- Create a progressive visual rhythm in a drawing or painting of a metamorphosis of a letter into an object or animal.

Teach: Alternating
- Ask students to describe the rhythm, patterns, and motifs in Thiebaud's *Candied Apples* (fig.12–27) and Porter's *Untitled* (fig.12–28). They should notice that motifs are interspersed, creating alternating patterns and rhythms. As students consider the alternating pattern formed by the candy apples, ask them what the multiple images of the same subject mean to them. After some thought and discussion students will probably mention candy stores or counters, which can then lead to consumerism and mass marketing. Explain that Thiebaud is a Pop artist known for his images of American foods. In his series of paintings and prints depicting multiple sweet confections, he alludes to the American abundance of food, prosperity, consumerism, and mass marketing.

Teach: Progressive

- Focus on John Biggers's *Shotguns* (fig.12–30). Biggers has often used triangle patterns from shotgun roofs in his work, in a style reminiscent of African textile patterns. One explanation of the term "shotguns" is that they are houses in which a bullet fired from a shotgun could pass directly through the front door and out the back door. Another explanation, according to Biggers, is that the term was adapted from *shogon,* which means "God's house" in the Yoruba language. Students may wish to research the origins of these houses on the Internet.

- So that students can explore progressive rhythm, have them create a metamorphosis, a series of five gradually changing drawings, throughout which they turn a letter into an animal or object.

 Instruct students to print the first letter of their first name on the computer or to copy the letter from a magazine or type book. Encourage them to consider several different fonts, and to study the letter to see what it evokes. Guide students to plan their work by first making several thumbnail sketches of different ideas, figuring out five equally spaced transitions in their metamorphosis so that there is about the same amount of change from one drawing to the next: any leaps or uneven changes will cause a disruption to the rhythm.

 Have students use five pieces of illustration board or a strip of paper divided into five sections to draw or glue their letter in the first block and draw their final animal or object in the last block. Suggest to students that they draw the midpoint transformation and then fill in the remaining two blocks. To simplify this activity, have students use pencils instead of the suggested media. A variation on

this project is to draw all five metamorphoses overlapping slightly on one sheet of paper.

Teach | page 243

Materials

- 8 1/2" x 11" white copy paper for thumbnails
- examples of various type fonts from font books, computers, or magazines
- approximately 8" x 8" illustration board; or 5" x 24" strips of paper divided into five sections
- markers, colored pencils, ink, or watercolors
- scissors
- glue

Lesson 8
Types of Rhythm

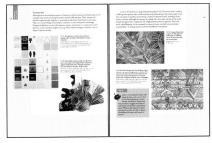

pages 244–245

Objectives

Students will be able to

- Perceive and comprehend unexpected rhythms in artworks.

- Experiment with art media to visually suggest musical movements and rhythms in a design.

Teach: Unexpected

- To introduce students to unexpected rhythms, encourage them to describe the rhythm in *Rhapsody* (fig.12–31). Ask what the artist repeated, and whether it forms a pattern. Point out to students that Jennifer Bartlett's work is on a huge scale but organized around a grid. Then, students

can trace the flow of movement and identify the rhythm and repeated elements in *The Decanter* (fig.12–32). They should notice that the movement is not only out from the center, but also around the circle shapes.

- Challenge students to compare the size of *The Decanter* to something in the room. Enrich the discussion by adding that artist Frank Stella went to high school at Philips Academy in Massachusetts before going on to Princeton University. During the 1960s he created huge shaped canvases similar to Op Art. (For example, see fig.8–8 from his protractor series.) However his latest works such as this piece are large aluminum and mixed-media constructions designed to project off a wall. Scrawling paint marks similar to subway graffiti cover the complex surfaces.

- Have students do **Try it**, creating either a two- or three-dimensional work. Although the use of oil or chalk pastels will likely take the least amount of time, students might use watercolors, acrylics, tempera paints, clay, or collage. Display together the works based on the same music. Students other than the artist might evaluate each work by identifying which piece of music the work represents, and by explaining how well the artist captured the rhythm and mood of the music.

Try it | page 245

Materials

- oil or chalk pastels, watercolors, acrylics, tempera paints, clay, or collage materials (magazines or assorted papers, glue, X-acto knives, scissors)
- 3 recordings of pieces of music with varying rhythms
- 18" x 24" paper, either pastel or watercolor paper, depending on drawing or painting media used

Chapter Review

pages 246–247

Assess

- Assign students to write the answers to the questions in the chapter review. Go over the answers to the questions with the class to see that students understand the concepts. These answers and their participation in previous class discussions should indicate that students did perceive and can identify various types of movement and rhythms in artworks. **(Art criticism)**

- To ascertain that the students do understand how artists throughout time created movement in their art, ask them to explain the movement in artworks by Hals and Matisse, a classical Greek sculpture, and another piece of their choice. If they write these analyses, encourage them to share their understandings in a class discussion. **(Art history/cultures)**

- To assess if students did develop an understanding of how a culture's values and beliefs can influence the design of its art and architecture, review with them the previous class discussions in Lesson 4 about Frans Hals's art subjects and why he painted these group portraits. Ask the students why he favored painting group portraits of middle class Dutch. (There was an emphasis on secular art in Holland at this time. The affluent middle class were the Dutch art patrons.)

Dominka Stasinsky. Inset drawing.
Lake Highlands High School, Dallas, Texas.

Then review the class discussion from Lesson 4 about how a society's beliefs can influence its architecture. Ask students to explain why upward movement was emphasized in Gothic cathedrals. Why did Gothic architects choose to tower their cathedrals above the rest of the town? (The upward movement in Gothic cathedrals leads the viewer's gaze heavenward and the dominance of the cathedral over the town indicated the importance of the church and religion in medieval life. The contrast in the height and volume of the cathedrals to their everyday dwellings would also create a sense of awe, making the viewer seem very small and humble in relation to their God.)

Why did the residents of San Juan Capistrano, California choose to include references to Spanish mission architecture in their library building? (San Juan Capistrano wanted the library to blend in with the local architecture and to reflect the value the community places on its architectural heritage. Also this structure is designed to welcome the community into it with an entrance that juts out from the main part of the building.) Lead a class discussion based on students' explanations. **(Art history/cultures/Aesthetics)**

- If the artworks based on the rhythm and movement in a musical selection (**Try it** on page 245) have not been evaluated, direct students to sort the art into groups, according to which piece of music was illustrated. Have students identify which works are particularly effective in creating the rhythm and movement of the music.

- Review with each student his or her portfolio created in this chapter. Check to see that they did create artworks incorporating movement and rhythm in their design. **(Art production)**

- Instruct students to select several of their works that they have created from the whole course to display in a school art exhibit.

- Assign students to write an analysis of the art elements and principles in one of the artworks that they created during the course.

Reteach

- Review with students the different means of creating movement, both actual and recorded, in two or three dimensions. Also review regular, flowing, alternating, progressive, and unexpected rhythms.

- While students consider the flowing movement in the body lines and the rhythm in the repetition of the fingers in fig.12–37, *Elder Wrapped in Blanket*, explain that the artist Phineas Kamangira was born in Zimbabwe in 1952 into a large, poor family. When his family could no longer afford to send him to school, he began observing a sculptor in his rural village. At sixteen he left home, moving to Harare (the capital of Zimbabwe) to become an artist. At first he could not find work and slept in the street, but eventually he became a member in an artists' cooperative that supplies artists with tools and stones.

- Challenge students to describe all the different types of movement and rhythms in Lichenstein's *Whaam!* (fig.12–35). They will readily see indications of movement of the subjects in the painting with the vapor trails and the explosion, but then they should also describe the compositional movement. The plane points in toward the explosion. Notice the radial repetitions in the explosion. Where have colors been repeated throughout this painting? Roy Lichtenstein, an American Pop artist, parodied comic strips to reveal the mindless violence that too often occurs in our culture. Call attention to the size of this painting and guide the students in imagining how this comic book subject seems when it fills a wall.

- Suggest that students compare and contrast the movement and rhythm in David Smith's *Cockfight* (fig.12–38) with that in *Jockey from Artemisium* (fig.12–36). Direct students to write an analysis of each piece: its rhythm and movement, the direction of the movement, and what elements were repeated.

Answers to Review Questions

1 Kinetic art is art that actually moves.

2 For art that moves, students might list any of the images on pages 230–231. Da Silva's photograph (fig.12–9) and Edgerton's *Densmore Shute Bends the Shaft* (fig.12–10) record actual movement. There are many examples of compositional movement in this chapter.

3 Artists try to create compositional movement in order to lead the viewer's eye across a composition or to the center of interest. Without it, a composition would lack unity.

4 Some of the ways to indicate or record real action on a flat surface are to show objects that are moving; use lines, such as a vapor trail, that show where an object has been; blur images; and use multiple or repeated images.

5 Rhythm may be regular, flowing, alternating, progressive, or unexpected.

6 Hals was commissioned to paint a group portrait. A similar, contemporary work would be a team, class, or club photograph.

7 Throughout his life, Matisse simplified shape and color. At the end of his life he worked with cut paper collages, *papier-découpés*. He cut papers colored with gouache.

Meeting Individual Needs

Students Acquiring English

Use visuals to explain the meaning of the key vocabulary. Focus on the chapter images to clarify the differences between design movement and rhythm. Clarify that visual rhythm is similar to rhythm in music and dance, and is closely related to movement.

Students with Special Needs

ADD

Structure students' time so that stillness is interspersed with immobility, and use this factor as a means of demonstrating how movement and rhythm are used in the visual arts. Display examples of artwork that illustrate various types of visual movement and/or rhythm. Ask students to describe how these principles are used within the works and have student volunteers act out a variety of expressive dance movements and/or rhythms.

Gifted and Talented

So that students may further explore movement in two-dimensional art, instruct them to photograph, draw, or paint a landscape, using directional lines to create movement. Suggest to students that they avoid using obvious leading lines such as a road, street, river, row of trees, or fence to move the viewer's gaze through the composition. Movement should be achieved in a subtle yet clear manner. After students have completed their works, display the pieces and encourage a group discussion of any rhythmic elements that appear in the artworks. The discussion should reinforce student understanding of the distinctions between rhythm and movement as well as the manner in which they can work together in a composition.

12 Movement and Rhythm

Key
Vocabulary

visual rhythm

kinetic art

compositional movement

progressive rhythm

WHEN YOU WALK ACROSS A ROOM, you display simple movement. A figure skater's performance is a more complex movement. In design, artists achieve a variety of effects through the use of movement. Movement can create a path for the viewer's eyes to follow across a composition. It can also set a mood or convey a feeling. In some designs, such as mobiles, actual movement is present. In others, such as a photo of a horse jumping over a fence, movement is recorded by the work.

12–1 How does the artist lead your eye across the composition? How is your eye stopped at the edges of the image?
Miriam Schapiro (b. 1923). *Master of Ceremonies*, 1985. Acrylic and fabric on canvas, 90" x 144" (228.6 x 365.8 cm). Collection of Elaine and Stephen Wynn. Courtesy of the Steinbaum Krauss Gallery, New York, New York.

12–2 Notice how curving and diagonal lines provide a feeling of motion. Artists frequently use these devices to add movement to a composition. In the case of this sculpture, the blue circular forms actually do move.
Jerome Kirk (b. 1923). *Avion*, 1986. Painted aluminum and stainless steel, 312" x 300" x 120" (792.5 x 762 x 304.8 cm). Irvine, California. Courtesy of the artist. Photo by J. Selleck.

Chapter Warm-up
Ask students to write the name of something that moves, and then to imagine how they might show this object in motion in a drawing or sculpture. Have them write a word or two to describe the movement or rhythm in each image on pages 228–229. Discuss their descriptions.

Visual rhythm, similar to rhythm in music and dance, is closely related to movement. It may be produced by repeating one or several units of a design, such as a triangular shape or the color green. These motifs are depicted in a certain order or pattern, which creates a rhythm. Artists and designers can choose from a variety of visual rhythms, including regular, flowing, or alternating. Compare the images on these two pages. How would you describe the different movements or rhythms that you see?

During the mesmerizing Plains Indian hoop dance, dancers perform with up to twenty-eight hoops swirling around their arms, legs, neck, ankles, waist, knees, and so forth. The hoops, made of either wood or reeds, represent the days of the lunar cycle. Dancers skillfully twirl the hoops to tell visual stories about the way all things are connected, and yet grow individually. The designs relate to fish, eagles, buffalo, and flowers. Ask students what other rhythms or movements they can identify in nature.

12–3 Repetition of architectural elements often sets up a rhythm that helps lead us through the building. Here, the verticals move our gaze down the hall.

Louis Kahn (1901–74). *Kimbell Art Museum*, Fort Worth, Texas, 1972. West lobby with window wall and view into south galleries. Photo by Michael Bodycomb.

12–4 Movement in nature is often rhythmic.
Birds in flight, North Carolina. Photo by N. W. Bedau.

12–5 In 1988 *Tin Toy* became the first completely computerized animated film to win an Oscar from the Motion Picture Academy of Arts and Sciences. Why might the artist have included the long black diagonal shadow lines in this computer-generated image from *Tin Toy*? How do the lines help move your eye through the scene?
From *Tin Toy.* ©1988 PIXAR.

Design Extension
So that students may further explore rhythm and movement, have them create collages, using shape to suggest motion. First, focus on Miriam Schapiro's *Master of Ceremonies* (fig.12–1), in which the patterns are combined to develop vibrating, swirling movement. Then, have students draw simple figure contours from student models in dance and sports poses, and fill in the contours and the background with patterns cut from magazines or wrapping paper. Instruct students to create movement by repeating the patterns and cutting background shapes that complement the movement in the figures.

Context
The design of Kahn's *Kimbell Art Museum* has as its basis the Roman barrel vault. The building is composed of a series of barrel-vaulted bays measuring 20 feet by 100 feet.

The only permanent walls in the building are around the perimeter. This allows maximum flexibility in the exhibition space where there are movable partition walls.

Actual Movement

Certain works of art, such as motorized sculptures, actually move and change over time. Their form at any given moment may be different from the form they represented seconds before. Gravity may produce or begin the action in some constructions, whereas air currents or wind may move or change others. Art that includes actively moving parts is called *kinetic art*. Some pieces of kinetic art move rapidly; others change almost imperceptibly. The movement may be programmed, or it may need to be started manually.

12–6 Mobiles are constructed to be highly sensitive to changes in air currents. The frequent motion of a mobile provides a constantly changing work of art.

Julio Le Parc (b. 1928). *Continual Mobile, Continual Light*, 1963. Painted wood, aluminum, and nylon threads, 63" x 63" x 8 ¼" (160 x 160 x 21 cm). Tate Gallery, London/Art Resource, NY.

12–7 A photograph of an artwork that has actual movement is limiting. One of the most essential characteristics of the work of art cannot be captured by the camera.

Bruce Nauman (b. 1941). *Double Poke in the Eye*, 1985. Edition of 40. Neon, 24" x 35" x 6 ½" (61 x 88.9 x 16.5 cm). Collection of the New Museum of Contemporary Art, New York.

Higher-Order Thinking Skills

Challenge students to compare and contrast the movement in the hallway shown in O'Hare International Airport (fig.2–27) with that in the Kimbell Art Museum (fig.12–3). Call on them to describe the mood or feeling in each, and to imagine these passageways with people in them. Discuss how the movement of the people would vary in each, and why the design is appropriate for its location.

Other works of art display actual physical movement without changing position. Flashing lights, continuously moving water, and the use of video monitors and TV screens are all ways of incorporating action into a design. The colored neon lights in Nauman's sculpture (fig.12–7) blink on and off repeatedly to create a hypnotizing effect, whereas the flow of water creates the movement in Bernini's sculpture (fig.12–8). To produce constant change and motion, Bernini and other Baroque sculptors often designed enormous, elaborate fountains, combining carved marble with flowing and spraying water.

12–8 The sculptor Gianlorenzo Bernini took into account the sound that splashing water would make in this fountain. He calculated its mechanics so that the sound would be highly pleasing. The sound adds to the feeling of constant movement that is a trademark of this famous Roman landmark.

Gianlorenzo Bernini (1598–1680). *Fountain of the Four Rivers*, 1648–51. Travertine and marble. Piazza Navona, Rome. Photo by J. Selleck.

231

Inquiry

Movement is one of the most important principles in most of Bernini's sculptures and fountains. Assign students to research his sculptures and fountains that feature movement, such as *David* and *Equestrian* figure of Constantine and to write an analysis of the movement in two of the artworks.

Inquiry

So that students understand how compositional movement has varied from one time period to the next, assign them to find reproductions of Michelangelo's and Bernini's sculptures of David, and to compare and contrast the movement in each. (Bernini's *David* is much more animated than Michelangelo's.)

Try it

Use shapes or forms of different sizes to construct a simple mobile. Consider how the kinds of shapes will affect both the compositional and the actual movement and rhythm. Create first those elements that will hang at the bottom of the mobile, and vary the lengths of wire or string.

Context

The *Fountain of the Four Rivers* (fig.12–8) is located in the center of the Piazza Navona, in Rome, one of the great urban spaces designed during the Baroque era and the site of the ancient stadium of Domitian. Although there is a small fountain at each end of the piazza, Bernini's creation dominates. The four rivers represented are the Nile, Ganges, Danube, and Plata. The fountain, made of marble, has a Roman obelisk that extends up from its center.

Recorded Action

One of the marvelous qualities of vision is the ability to shift our eyes to follow action. We can see a speeding car off to the left and follow it as it zooms to the right. If we couldn't follow the movement of the car, we would see only a blur. This kind of image is like a moving image captured by film or videotape. However, the images in paintings and photographs don't move—and even several sequential photographs or drawings cannot display fluid action—but they can record movement or freeze a moment of action.

12–9 How does the photographer use contrast in values to emphasize the change from stillness to motion in this image?

Akiko DaSilva (age 18). *Untitled*, 1996. Print. Los Angeles County High School for the Arts, Los Angeles, California.

12–10 A 1/100,000-second strobe flashed every 1/100 second to make this extraordinary image.

Dr. Harold E. Edgerton (1903–90). *Densmore Shute Bends the Shaft*, 1938. Print. ©Harold and Esther Edgerton Foundation, 1998. Courtesy of Palm Press, Inc.

Design Extension

So that students may further explore the depiction of motion, ask them to make a simple flip book by drawing a figure successively on about twenty pages of a small memo pad, changing the figure's position slightly from one page to the next. When the pages are flipped, the figure seems to move. This illustrates the concept behind animation, and could be a starting point for the production of their own animated sequences. Students might create animation on a computer, or use a camcorder or Super 8 camera (see "Other Studio Projects" on page 249).

Art records action in various ways. A photograph of a vapor trail etched across the sky indicates an airplane's movement. Compositions that include falling leaves, flapping or curling flags and banners, and spirals of smoke also imply movement. Other designs may exhibit motion through techniques such as blurred images. Da Silva recorded a figure climbing a staircase (fig.12–9). The blurry movement contrasts with the stillness of the girl at the left.

A design also can capture action through the use of multiple images. Look at the photograph of a golfer (fig.12–10), for which the artist used a strobe light to repeatedly stop and record sequential moments of a single motion. Because the multiple images are recorded on one piece of film, they give the sense of continuous fluid movement.

233

Try it

Draw a model from one angle. Then use a different color or drawing medium to draw the model from another angle. Draw the second pose on top of the first one. Then draw one more pose in another color on top of the first two. How does your drawing suggest movement? What might you add to emphasize movement or change?

12–11 In this partially ruined ancient sculpture, rippling garments capture the movement of a winged figure as she descends from the sky.
Ancient Greece. *Nike of Samothrace,* c. 200–190 BC. Marble, 8' high (2.44 m). The Louvre, Paris.

12–12 The artist has designed this advertisement for maximum effect. The movement of the figures and waves sends a message of fun-filled action.
Tom Purvis (1888–1959). *East Coast by London and North Eastern Railway.* Color lithograph poster, 40" x 50" (101.6 x 127 cm). Victoria and Albert Museum, London/Art Resource, NY.

Context

Nike of Samothrace (fig.12–11), or *Winged Victory,* originally overlooked the harbor at Samothrace, in ancient Greece. The sculpture represents a figure alighting on a ship to bestow a crown of victory. Point out that the negative space around the figure becomes very important when we imagine the wind whipping the drapery around the figure.

**Higher-Order
Thinking Skills**
Have students compare
and contrast the height
and movement of the
vaults in fig.12–14,
Salisbury Cathedral, to
that in the Kimbell Art
Museum (fig.12–3). Ask
how the architect of the
Gothic cathedral
emphasized the feeling
of height, and how the
architect of the Kimbell
Art Museum created a
compressed effect.

Context
The library at San Juan
Capistrano (fig.12–15) is
directly across the
street from the famous
mission in that town.
The library gives a nod
to the older building
complex, as it incorpo-
rates some of the ele-
ments of the Spanish
mission style. One of
the tenets of Post-
Modern architecture, of
which Graves is a lead-
ing practitioner, is to
take the surrounding
environment into
account when design-
ing new structures.

Portfolio Tip
Photographs of three-
dimensional work for
student portfolios
should include two or
more views.

Compositional Movement

Compositional movement is neither action nor a record of action. It is experienced by comparing the positions of stationary objects or spaces within a design. Although a picket fence cannot move, it definitely conveys movement as it leads your eye from one end of the fence to the other. Compositional movement may be generated by contrast, emphasis, direction lines, shapes and colors, and other devices—and it can occur in both three-dimensional and two-dimensional art.

12–13a,b Multiple images of a three-dimensional art-work can offer some notion of the changes that occur as a viewer walks around it. There is no substitute, however, for experiencing a work of art firsthand.

Allan Houser (1914–94). *Desert Dweller*, 1990. Bronze, edition of 18, 7 ¼" x 8 ½" x 3" (18.4 x 21.6 x 7.6 cm). ©Allan Houser, Inc.

Compositional Movement in Three-dimensional Art

When we stand in front of a building or sculpture, our attention is drawn first to any large shape, textured surface, or area of contrasting values. Then we might notice the details of construction. In most three-dimensional art, compositional movement cannot be read or judged from a single point of view. A stationary sculpture will display change or movement as a viewer walks around it. Each new angle of vision often creates a shape or form that greatly contrasts with those seen from other angles. Compare the two views of Houser's *Desert Dweller* (fig.12–13a,b). Much of this sculpture design depends upon the relationship between negative and positive space, yet when the face is viewed frontally the appearance of the piece dramatically changes. The emphasis from this perspective is on the elongation of the face and the relationship of the forms.

Architects can produce movement by creating physical paths or other indicators that lead people to a building's entrance. Look at the photograph of a library (fig.12–15). The entryway juts out and is covered by an large arch and flanked by tall pillars and hedges. The doorway itself is a large opening of contrasting value. All these elements contribute to the compositional movement in the design of one structure. And when several buildings are clustered, movement is increased as a viewer's attention shifts from one structure to another.

Inquiry
Direct students to study the movement created by the major architectural lines in the *Public Library of San Juan Capistrano* (fig.12–15). Students may want to find out more about Michael Graves and his Post-Modern architecture. One of his most famous designs is the *Portland Public Services Building* (fig.7–5), completed in 1984. He also designed hotels at Disney World, in Florida.

12–14 Gothic architects, trying to lead the eyes of worshipers toward God, built the interiors of their cathedrals as tall as possible. These great heights convey a feeling of strong vertical movement. High, narrow windows, ribbed columns, and exterior spires all enhance and strengthen this sense of movement toward heaven. Salisbury Cathedral, 1220–1380. Salisbury, England. Interior view of nave facing west.

12–15 Generally, an architect gives a visual cue to let us know where to find a building's entrance. Here, the curved arch attracts and holds the eye amidst the many verticals. The eye has a tendency to keep wandering back to the arch, as though the arch were creating a circle around the point of access. Michael Graves (b. 1934). *San Juan Capistrano Library*, San Juan Capistrano, California, 1983. Photo by J. Selleck.

Context
Jean de Brunhoff wrote the original *Story of Babar*. Published in Paris in 1931, it was translated and published in the United States in 1933. When Jean died in 1937, his son, Laurent, penned the sequels that continued the adventures of Babar, Celeste, Alexander, Arthur, Zephir, and the other endearing characters (fig.2–17).

Compositional Movement in Two-dimensional Art

To create compositional movement in works such as paintings and photographs, artists manipulate the elements of design. Their goal may be to lead a viewer's eye across a composition or to the center of interest. This ability to control or direct eye movement is essential in two-dimensional art. Without it, a composition would lack unity.

Our eyes tend to move across a picture plane along a path from upper left to lower right. As with three-dimensional art, our attention may be drawn to and pause at large shapes, a textured surface, or an area of contrasting values. Then we begin to examine details. We may notice that other objects or areas have their own set of lesser movements—also determined by lines, shadows, colors, or textures.

Artists and designers sometimes include objects such as arrows to point our attention in a certain direction. Shapes that have a definite front and back (such as cars and animals) prompt us to look in the direction toward which those objects face. In *Beach Blanket* (fig.12–17), the illustrator causes our eyes to move back and forth as we follow the conflicting directions of the many moving characters. Remember that lines of sight (or the gaze of one person toward another) also can create compositional movement.

12–16 Compare this image to fig.12–19. How are they similar? What differences do you see?
Cindy Sherman (b. 1954). *Untitled Film Still #65*, 1980. Gelatin silver print. The Museum of Contemporary Art, Los Angeles.

12–17 Notice how the illustrator used color both to keep our eyes focused on the center of interest and to create compositional movement among the figures.
Laurent de Brunhoff (b. 1925). *Beach Blanket*, 1990. Ink and watercolor, 11 ½" 16" (29 x 40.6 cm). Babar Characters™ and ©Laurent de Brunhoff. All Rights Reserved.

12–18 An object, such as the apple in the lower right of this painting, placed at the "edge" of the picture plane draws our attention. The viewer's eye is led along the line of apples to the last one at the back of the composition.
Sung W. Lee (age 18). *Apples on Table*, 1997. Mixed media, 24" x 18" (61 x 45.7 cm). West Springfield High School, Springfield, Virginia.

About the Artwork

Frans Hals

Banquet of Officers of the Civic Guard of St. George at Haarlem

Imagine that you are a member of a group, such as a soccer team, in the early seventeenth century, and that your team would like a group picture. Because photography has not yet been invented, perhaps you would get together and hire a painter to make your picture. How would your group like to be portrayed? Would you pose in rows—kneeling, seated, and standing—or would you prefer an image of the team gathered in conversation with your coach?

In Holland at the time that Hals created this artwork, associated groups of people were often painted by artists. Such groups could have been men who traveled together on a pilgrimage or were members of a company of archers or riflemen. Dutch group portraits typically presented people posed stiffly in rows, with no sense of life or movement.

Frans Hals had great skill in capturing a likeness, and he became well known for his ability to show the nuances of each person's face. In 1627, he was commissioned to paint this portrait, in which he included diagonal components, most likely in an effort to enliven the work. Although the angled body positions affect the sense of drama in the scene, the overall composition is not considered successful. The figures seem detached from one another, so the efforts to show the group interacting are incomplete.

Nevertheless, the painter's contribution to the history of art was significant. Hals established a legacy as a gifted portrait artist, utterly convincing in his portrayal of each person's characteristics. In addition, he paved the way for more innovative treatments of composition in group portraits.

12–19 What gestures and glances contribute to the sense of diagonal movement? What other diagonals are present in the composition?

Frans Hals (1581–1666). *Banquet of Officers of the Civic Guard of St. George at Haarlem*, 1627. Oil on canvas, 5' 10" x 8' 5 ⅜" (2 x 2.6 m). Frans Hals Museum, Haarlem, the Netherlands.

Discuss it

Study a reproduction of a famous painting. Then discuss the answers to these questions: How does the artist lead the viewer's eye through and around the painting? Is the movement accomplished with line, color, shape, value, or some other device?

Types of Rhythm

When a musical band starts to play, do you drum your fingers on a table or tap your foot? Do you experience a special feeling when fall comes each year or when school lets out for summer? The repetitious beat of music and the repeated pattern of activities related to seasonal change are both examples of rhythm. So, too, is the continuous crashing of waves on a beach. Rhythm is fundamental to our lives. We are surrounded by it, and we learn to walk, run, dance, talk, and eat in patterns of repetition.

In art, visual rhythm, which is similar to pattern, may be produced by repeating one or more motifs in a recognizable or predictable order. Visual rhythm can be easy to read, or it can be extremely complex. Both artists and designers use rhythm to help organize a composition, and also to create interest, emphasis, or unity. They might vary visual rhythm by changing the size, position, or direction of the repeated motifs and by altering the intervals between them. They might also combine two or more rhythms. In your work, practice and experimentation will help you to determine which rhythms work best in certain situations.

12–20 Visual rhythm in nature is often accompanied by sound rhythm.
Rock and wave action, from *Driftwood Series.* Photo by J. Scott.

12–21 This wall sculpture is completely regular in its rhythm. If the work were extended, the addition would be highly predictable.
Donald Judd (1928–94). *Untitled,* 1967–80. Galvanized steel and Plexiglas, ten units, each unit 9" x 40" x 31" (15.6 x 68.6 x 61 cm). Frederick R. Weisman Art Foundation, Los Angeles, California. ©Estate of Donald Judd/Licensed by VAGA, New York, NY.

Regular

Look at Judd's sculpture (fig.12–21), in which the design repeats a rectangular form, and the space between the forms remains constant. This is an example of regular rhythm. Regular rhythm creates a repeated pattern that is both predictable and continuous. The pattern may be restricted to the borders or edges of a design, or it may cover the entire surface of a building or a sheet of wrapping paper. Note how a photographer captured the regular repetition of rows of seats at a sports arena (fig.12–22).

12–22 A series of similar elements placed at a constant interval produces a regular rhythm.

Tennis-court seats. Photo by J. Selleck.

12–23 A regular rhythm is created in this student work by the row of similar marching figures.

Jang Cho (age 18). *Mannequin Center Stage*, 1997. Colored pencil, 11" x 14" (27.9 x 35.6 cm). Lake Highlands High School, Dallas, Texas.

Interdisciplinary Connection

Science—Ask students to list rhythms that they find in nature. These might include the changing of the seasons, the rhythm of ocean waves, and biorhythms. Challenge them to name the type of rhythm they associate with each phenomenon.

Interdisciplinary Connection

Music—Instruct students to select rhythmic compositions to complement different pieces of art. For example, they might select a slow classical piece to go with Rembrandt's *Landscape with Three Trees* (fig.9–19) and a ragtime piece for Schapiro's *Master of Ceremonies* (fig.12–1). Ask students to match similar types of movement and rhythm in works of art and pieces of music.

Flowing

Smooth, flowing rhythms seem to unify whole compositions in a peaceful but powerful way. Usually, large movements that sweep across an entire work tie each of the parts together. Some flowing rhythms move along curved, circular, or wavy paths, and may be similar to radial patterns.

In nature, the swirling form of a seashell, smoothly rolling hills, and the winds of a hurricane are all examples of flowing rhythms. In art, flowing rhythm can communicate freedom and grace. Artists and designers commonly employ it in landscapes, figurative designs, and in abstract and nonrepresentational works. Flowing rhythms produce compositional movement along a definite path. In fig.12–24, the viewer is led from the immediate foreground into the distance. This motion creates a flowing rhythm that is continuous and without sudden change in direction.

12–24 Notice that the flowing lines created by rhythmical fish shapes and background plants combine with the dominant plant shape to contribute to a unified sense of flowing rhythm.

John Forbes (b. 1946) and Jeanne Rosen (b. 1954). *Residential Window,* 1985. Stained glass, 4' x 4' (1.2 x 1.2 m). Courtesy Bonny Doon Art Glass, Santa Cruz, CA.

12–25 This design contrasts sharply with the regular rhythms that are typical of architecture.

Don M. Ramos (20th cent.). *O'Neill guest house,* 1978, Los Angeles, California. Photo by J. Selleck.

Try it

With paint or drawing media, explore patterns that move in flowing rhythms. Plan your composition to include a series of wavy lines so that each line echoes the path of the lines closest to it. Consider how much space to leave between the lines: you might vary the amount to obtain different effects. Allow enough space to add a series of shapes to form a pattern. You could select motifs that emphasize the sense of flowing movement or rhythm, and you could also increase or decrease the size of the units as the pattern advances.

Context

Considered the first old master of the twentieth century, Henri Matisse explored many artistic expressions in his long and productive life. He first became known as a founder of Fauvism, in 1905. The French word "fauves," which means "wild beasts," was a term used by an art critic to convey his shock at the violently bright colors and energetic brushstrokes shown by Matisse and his fellow painters.

Henri Matisse

Matisse found great joy in creating art, asserting that the purpose of his artwork was to bring pleasure to the viewer. He worked as an artist from 1890 until his death in 1954 at the age of eighty-five. During this time, the art world underwent major changes. Matisse was influenced by movements such as Impressionism and Cubism, yet he held firm to his own path—a steady movement toward extreme simplicity of shape and color. Matisse sculpted as well as drew and painted, concentrating much of his effort on portraying the human form and exploring the use of color.

One of the few artists to achieve fame and popularity within his lifetime, Matisse became known for his outstanding ability to simplify a complex subject, extracting the pure elements of shape, as in *The Snail* (fig.12–26). To create a sense of movement, he would often exaggerate and distort shapes.

In his final years, Matisse was ill and bedridden. However, he continued to create art, composing powerful abstract collages—*papiers-découpés*—from brightly painted paper cutouts. He was able to work, cutting paper with scissors, from his bed. At first, he used the cutout pieces to plan paintings, but later he made them the actual materials of his artworks. Despite his physical discomfort, Matisse felt that reading poetry and creating art made life worth living.

Henri Matisse. *Self-portrait*, 1918. Courtesy Musée Matisse. Art Resource, NY. ©1999 Succession H. Matisse, Paris/ARS, New York.

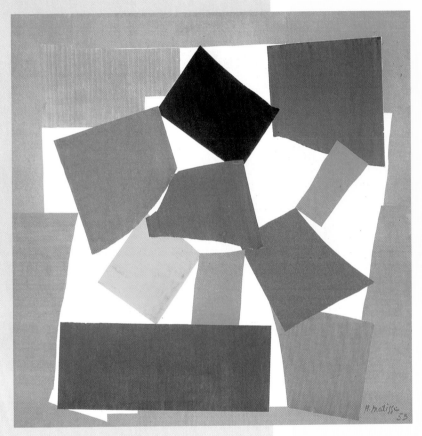

12–26 This work—which can be seen as an exploration of the boundary between abstract and representational art—is one of the last that Matisse completed. How did he include flowing rhythm in this work?

Henri Matisse (1869–1954). *The Snail*, 1953. Gouache on cut and pasted paper, 112 ¾" x 113" (287 x 288 cm). Tate Gallery, London/Art Resource, NY ©1999 Succession H. Matisse, Paris/ARS, NY.

Internet Connection

Henri Matisse loved dancing, flowers, and curved, flowing lines. He spent many hours depicting the human body in motion. See if students can find images of *Dance, Joy of Life, The Swimming Pool,* and *Acrobats* on the Internet to discover what movements the artist repeated in his compositions.

Alternating

Regular and flowing rhythms tend to be pleasing because they are predictable and contribute to order and unity. But if rhythms are *too* much the same, they can be monotonous. For example, if all the high-rise buildings in a city were exactly the same height and shape, they would create a dull skyline. Variety is what helps overcome such boredom and can create needed interest in a composition.

By pairing periods of excitement or suspense with moments of quiet and relief, authors of books and directors of movies use alternating rhythm to sustain interest. In design, this type of rhythm might be created with a simple wallpaper pattern that alternates vertical rows of small flowers with vertical stripes. Examine the woodcut (fig.12–27), in which the artist used rows of round apples to create one rhythm, and tall angular sticks to create another. The two work together to provide interest and variety.

12–27 Compare this image with fig.12–22. What rhythmic differences and similarities can you find?
Wayne Thiebaud (b. 1920). *Candied Apples*, 1987. Edition of 200, no. 20. Print, 16 ½" x 15" (41.9 x 38.1 cm). Courtesy of the Allan Stone Gallery, New York, NY.

12–28 What are the alternating patterns in this work?
Katherine Porter (b. 1941). *Untitled*, 1981. Charcoal, gouache, and crayon on paper, 26 ¼" x 40 ¼" (66.4 x 101.4 cm). Courtesy of the Fogg Art Museum, Harvard University Art Museums. Acquired through the Deknatel Purchase Fund.

★ Higher-Order Thinking Skills

In *Shotguns* (fig.12–30), John Biggers intended to reflect jazz rhythms by using the simple repetition of rows of increasingly larger triangles, and the row of female figures that change in complex ways as the motif is repeated across the composition. Challenge students to identify additional motifs and rhythms in *Shotguns* (a significant rhythm is provided by the railroad track), and to explain how movement is implied.

Progressive

Like alternating rhythm, ***progressive rhythm*** also brings variety to a composition. A rhythm is progressive when its repeated motifs change in a predictable or regular way. A simple example would be a design in which a shape increases or decreases in size each time it is repeated. A more complex example of progressive rhythm is a pattern in which a motif turns a little or becomes darker each time it is repeated. In the student work (fig.12–29), notice how (in a series of five steps) the car progressively changes into a bird.

Context

Biggers was one of the first black American artists to travel to Africa, in 1957, and his work was profoundly shaped by his time in Ghana, Nigeria, Togo, and Benin. He usually features African or African-American women in his drawings, paintings, and sculpture, portraying them as strong people who live with dignity and joy, despite many struggles. Other, related themes in his work are the connectedness of all life, the energy of the universe, ancestral stories, and spirituality.

243

12–30 A "shotgun" is a kind of row house built originally by Haitian slaves. Biggers was born in this type of small house in North Carolina. His richly patterned painting combines progressive rhythms.

John Biggers (b. 1924). *Shotguns*, 1987. Acrylic on canvas, 41 ¾" x 32" (106 x 81.3 cm). Private Collection. Courtesy of the artist.

12–29 In this composition the eye of the viewer is rhythmically led from bottom to top where one is inclined to imagine the bird flying out of the picture plane.

Jason Foor (age 18). *Untitled*, 1995. Pencil 24" x 18" (61 x 45.7 cm). Plano Senior High School, Plano, Texas.

Inquiry

M. C. Escher utilized progressive rhythms in many of his prints and drawings. Assign students to look up his works and discover how he gradually changed one shape into another across a page in an interlocking pattern. Have students bring examples of his progressive rhythms to class to share.

Unexpected

Although most visual rhythms produce a feeling of orderly interaction between the parts of a design, some artists and designers prefer unpredictable rhythms. These unexpected rhythms might be jerky, irregular, or spontaneous, like those often found in jazz music. They can convey feelings of excitement, confusion, or unfocused power and energy. Unexpected rhythms can also add suspense, tension, and variety to a composition. Such rhythms can be created by irregular spacing and by random changes in the size, color, or shape of repeated motifs.

12–31 Though there is much in this work that is unpredictable, the design is held together by repeating squares.

Jennifer Bartlett (b. 1941). *Rhapsody*, detail, 1975–76. Enamel, silkscreen grid on baked enamel, steel plates, 7' 6" x 153' (2.3 x 46.6 m). Courtesy of the artist and the Paula Cooper Gallery, New York, NY.

12–32 Frank Stella combines simple cone-like forms and circular shapes with irregular shapes. The paint is applied in bold, thick strokes. Though unexpected, there are rhythms in this piece. What are they?

Frank Stella (b. 1936). *The Decanter*, 1987. Cast aluminum and mixed media, 109 ¾" x 137" x 75 ¾" (278 x 348 x 192 cm). Photo ©1987 Steven Sloman, New York.

★ Higher-Order Thinking Skills

Have students study the rhythms and movements in art from other cultures. They might choose Pueblo pottery, which uses curving rhythms, bands, and geometric patterns. Ask students to identify certain styles that are based on a common rhythm.

● Context

For *Rhapsody* (fig.12–31), her first major installation, Bartlett filled the gallery walls with 988 one-foot squares of silkscreened enamel. Though huge in scale, the artist's installations are manageable for viewing because they are broken down into small pieces. In *Rhapsody*, she repeats the same house, tree, mountain, and ocean in a myriad of variations.

Look at the detail from a large wall painting (fig.12–31). The entire work is made up of 988 separate squares; only a small sampling is reproduced here. The viewer's gaze moves from one square to another, encountering a variety of repeated motifs, including circles, houses, and trees. Although the squares are orderly, the color, style, and size of the motifs change throughout the composition. No single planned pattern is apparent. The entire work, called *Rhapsody*, can be compared to a piece of music in which notes are played unpredictably—at varying volumes and even by different instruments.

12–33 Compare this painting to fig.12–25. Although both works make use of flowing curves, the ones in this work are not predictable.

Rhythmical grid. Photo by A. W. Porter.

Passionate Movement and Rhythm: Flamenco

245

Spanish flamenco dancers create alluring movements, emphatically stamping their feet and clapping their hands in dynamic syncopation. Colorful costumes enhance their brilliant execution. Flamenco is believed to have originated in the early nineteenth century in Andalusia as a highly emotional song accompanied by guitar. By the mid-nineteenth century, its popularity had spread throughout Spain.

12–34 Ken Scharf incorporated a few rhythmic sections, but there is no sense of a single pattern or rhythm. The artist uses television and cartoons for inspiration. He creates zany creatures from geometric and organic shapes with a background of spirals, loops, and squiggles.

Kenny Scharf (b. 1958). *Travel Time*, 1984. Acrylic and spray paint on canvas, 79" x 103 ¼" (206 x 262.2 cm). Courtesy of the Tony Shafrazi Gallery, New York, New York.

Try it

Listen to various kinds of music with distinctive beats, such as rock, classical, Caribbean, flamenco, country-western, and lullabies. Experiment with art media to suggest the variety of movements and rhythms in each kind of music. Without depicting any recognizable objects or forms, try only to capture the feeling of the music and convey its journey.

Interdisciplinary Connection

Literature—Much poetry, like art and music, has rhythm with a recurring beat or accent. Have students read poems with various meters, encouraging them to tap or clap the rhythm. Assign students to illustrate a poem by using lines, shapes, forms, colors, textures, and contrasts to emphasize its rhythm. Tell students that this drawing or painting is not to be a stiff, literal depiction of the subject matter, but instead an attempt to convey the mood of the piece with motion and rhythm.

Another Look at Movement and Rhythm

Context

The bronze *Jockey from Artemisium* (fig.12–36) was discovered among the remains of a ship-wreck off Cape Artemisium. The horse that belongs with the rider was found in frag-ments. Scholars believe that the figure is not meant to represent a specific jockey, but is a generic representation of a young boy who would participate in a horse-racing event.

12–35 How did Lichtenstein express action in this painting?

Roy Lichtenstein (1923–97). *Whaam!*, 1963. Magna acrylic and oil on canvas, two canvases, each 68" x 80" (172.7 x 203 cm). Tate Gallery, London/Art Resource, NY. ©Contemporary Art Services, NY.

12–36 This figure was part of a group that included a now-lost bronze horse running at full gallop. Imagine how the movement in this piece would have been enhanced when the boy was perched on the horse.

Ancient Greece. *Jockey from Artemisium*, 240–200 BC. Bronze. National Museum, Athens.

12–37 How is your eye directed to move across the surface of this sculpture?

Phineas Kamangira (20th cent.). *Elder Wrapped in Blanket*, c. 1990. Chiweshe Serpentine, 36" high (91.4 cm). Courtesy of Ukama Press/Zimbabwe Sculpture, Inc. and Mike Spirelli Photography.

Context

Quick-To-See Smith (fig.12–39) is a Native American of French, Cree, Salish, and Shoshone heritage. She is a contemporary artist whose work shows a variety of influences. She has developed a style com-bining Native American traditions and con- temporary ideas. Quick-To-See Smith uti-lizes the forms and symbols found in Indian pictographs and organic and geometric designs in her work. In *The Great Divide* she emphasizes the division between traditional Native American life and modern life.

12–38 What element of art plays an important role in supporting the dynamic rhythm of this sculpture?
David Smith (1906–65). *Cockfight*, 1945. Steel, 45" high (114.5 cm). Saint Louis Museum of Art. ©Estate of David Smith/ Licensed by VAGA, New York, NY.

12–39 What words would you use to describe the movement and rhythm in this painting?
Jaune Quick-To-See Smith (b. 1940). *The Great Divide*, 1985. Oil on canvas, 72" x 60" (182.9 x 152 cm). Collection of St. Paul Company, St. Paul, MN. Courtesy of the Steinbaum Krauss Gallery, New York, New York.

Review Questions (*answers can be found on page 228j*)

1. What is kinetic art?

2. Give an example of an artwork that actually moves, one that records a real movement, and one that displays effective compositional movement.

3. Why do artists try to create compositional movement within their two-dimensional designs?

4. What are two ways to record or indicate actual movement on a flat surface?

5. List five types of rhythm.

6. Why did Frans Hals paint the *Banquet of Officers of the Civic Guard of St. George at Haarlem*? What type of current images are created for a similar purpose?

7. Despite the influence of various art movements throughout his long life, what remained constant in Matisse's art? With what medium did Matisse create most of his later works?

★ **Higher-Order Thinking Skills**

Ask students to compare *Cockfight* (fig.12–38) with *Cubi XIV* (fig.2–6). Guide students in recognizing that although *Cubi XIV* is entirely abstract, the artist was grappling with the same visual problems—balance and the interaction of negative and positive space—that he had explored earlier, in *Cockfight*.

Career Portfolio

Interview with a Storyboard Illustrator

Before a motion picture can be made, someone must visualize and plan it. The job of **Raymond Prado** is to illustrate the progression of a film script in step-by-step drawings known as a storyboard. Born in 1967 in Denver, Colorado, Raymond now lives in Los Angeles, California, and works on location, as needed. His resumé includes a variety of major films, such as *Broken Arrow*, *Dolores Claiborne*, and *How to Make an American Quilt*.

How would you define your job?

Ray An artist is somebody who has something to say and has mastered some media of expression. Going by that, I really don't consider myself an artist, but more of an arts collaborator. The real art is the film. The storyboards—nobody is really supposed to see them. It's kind of like a hidden art. It's like the blueprints for a building. When you see the Chrysler Building in New York, you don't see the blueprints. You see the finished product. And that's kind of what I do.

Did you study art in school?

Ray Yes, in Dartmouth College, I studied fine arts. I studied a lot of art history; but it was a liberal-arts curriculum, which is something I recommend for all aspiring artists, if they're going to go to college. If I had gone to strictly an art school, I wouldn't have gotten a chance to play football in college. You can tell from

the movie *The Program* that I used my football knowledge toward designing plays for the film. That's basically why I was hired. I worked with the director and the stunt coordinator to come up with football plays that would be exciting for film.

So, you help determine the action as well as draw it.

Ray Oh, absolutely. You just lay it down on paper, and it gets to film that way. When it's time to shoot, they look at my little drawings and

coordinate what days they're going to shoot what shots. The storyboards are also utilized through editing so the editors know what goes where.

Some production companies get financing from a big studio based on what the storyboards look like. It's important that I work very quickly: everything has to be done in a relatively short amount of time.

You can see a lot of movement in a single frame.

Ray That's exactly the idea. Basically, I'm on hand to communicate the director's ideas as economically and succinctly as I can. For *The Program*, we basically broke down the sports sequence and split it up into little pieces that they would film whenever they had the opportunity to have a large audience.

We were at a couple of big football games in South Carolina. We had fifteen minutes to shoot what we could, utilizing the whole crowd. In less than a minute, at half-time, they transformed the stadium in South Carolina so they could shoot the plays. They looked at the storyboards and saw what was important to catch in the widest shots. We had our fake football teams out there. They would go through the plays, and the audience would be coaxed by the P.A. system to cheer when they should cheer, and it was a big acting job for everyone.

A storyboard consists of hundreds of small, quick sketches that show the action in a film from beginning to end. The drawings are made, usually from imagination, *before* filming begins. These frames show planned football action for *The Program*.

Studio Experience
Action!

Task: To draw an action-sequence comic strip, and then enlarge and paint one frame that demonstrates graphic movement.

Take a look. Review the following images:

• Fig. 12–1, Miriam Schapiro, *Master of Ceremonies*
• Fig. 12–17, Laurent de Brunhoff, *Beach Blanket*
• Fig. 12–35, Roy Lichtenstein, *Whaam!*

Think about it. For each of the images listed above, answer these questions.

• The artist created implied action to indicate that the subject had moved. What word describes this action?
• How did the artist create graphic movement to direct your view through the picture plane? Note any overlapped objects, repeated shapes or colors, and patterns.
• How would you describe the rhythm in the image?

Do it.

1 Look at newspaper comic strips, and note how artists create stories and indicate motion both within a frame and from one frame to the next.

2 From a story or play, select an action sequence to illustrate in three to five frames.

3 Plan your action sequence. Draw each frame several ways. For each frame, think about how you can direct the reader's view through the scene. Try overlapping objects and using directional lines to create movement. Also think about the action of the figures from one frame to the next. How will the subject change in each frame?

4 When you have a series of frames that you like, lightly redraw them on drawing paper. Use a ruler to draw the edges of the frames.

5 Use a black felt-tip marker to draw over your lines. Sign your name to the last frame.

6 Select one frame to make into a painting. Choose a frame that has good visual movement through its composition. You might want to modify your drawing to emphasize the movement.

7 Enlarge your frame, and lightly redraw in pencil onto a canvas board or a gessoed panel.

8 Paint your picture with acrylic paints.

Helpful Hints

• See the activity in Chapter 7 (page 153) for directions on how to enlarge your drawing.
• To create sharp straight lines or edges of shapes on your acrylic painting, put masking tape down along the line; paint; and remove the tape.
• Clean brushes thoroughly with soap and water at the end of each painting session. Even a little acrylic paint left in a brush will stiffen the bristles.

Check it.

• In your comic strip, did you create an implied action from one frame to the next?
• Describe the graphic movement through the composition of your large painting. How would you describe the rhythm?
• What do you like best about the comic strip?
• What do you like best about the painting?
• What did you learn in this project?
• What might you do differently the next time you create a similar piece of art?

Other Studio Projects

Using a Super 8 motion picture camera or a camcorder with single frame capability, create your own animated action sequence. Break down an action (such as a person walking) into a series of smaller movements. Draw each movement and record it on two frames of film or tape. Play back your action sequence.

249

Jon Williams (age 16). *Zarm's Way*, 1998. Acrylic and colored pencil, 16" x 20" (40.6 x 50.8 cm). Asheville High School, Asheville, North Carolina.

Studio Experience
Action!

Jon Williams (age 16). *Zarm's Way*, detail.

Prepare

Time Needed:
Six 45-minute class periods
(extend as needed)
Lesson 1:
Draw ideas for the comic strip.
Lesson 2:
Draw the comic strip in felt-tip marker.
Lesson 3:
Enlarge one frame.
Lessons 4–6:
Paint.

Objectives
Students should be able to

- Perceive and understand how artists create implied action and graphic movement in their art.

- Draw a three- to five-frame action-sequence comic strip.

- Create an acrylic painting based on a frame of their comic strip that demonstrates graphic movement through its composition.

Materials
- newspaper comic strips
- 8 1/2" x 11" white paper (typing or copy)
- pencils
- 12" x 18" drawing paper
- rulers
- black felt-tip markers
- canvas-covered board, stretched canvas, or Masonite panel coated with gesso, 18" x 24" or larger
- acrylic paints: red, yellow, blue, white, black; other colors optional
- brushes, assorted sizes
- palettes
 optional:
- 8 1/2" x 11" acetate or tracing paper grids
- masking tape

Notes on Materials
Acrylic paint dries rapidly. To keep the paint moist from one painting session to the next, have students put a folded moist paper towel on their palette of leftover paints, and then cover and seal the palette with plastic wrap.

Before You Start
- Assign students to bring in newspaper comic strips. Also ask them to think of an action scene from a story or play that they would like to illustrate. Confer with Language Arts/English teachers about what literature students have been studying.

- If students will not be using prepared canvases, have them either stretch canvas on frames or coat pieces of Masonite or posterboard with gesso.

Teach
Thinking Critically
- Help students compare the movement in the images in **Take a look**. Ask which image has the slowest visual movement; which has fluid movement; and which has fast, violent movement. Have students also compare the direction—vertical, horizontal, or diagonal—of the movement. Discuss how the rhythm and movement in each image influences its meaning or mood.

- Ask students to explain how Lichtenstein created visual movement in *Whaam!* (fig.12–35), and have them describe its rhythms. Ask what makes up the path that leads their vision through this image.

Classroom Management

Arrange students in groups of four, five, or six to gather supplies, cover their work surface, and clean up. Group members might also work together to answer the questions in **Think about it**. Each group could critique the visual movement in a different artwork and report their findings to the whole class.

Tips

- Provide easels or some other means of creating a painting surface more vertical than a flat table, so that students do not distort their painting due to their viewing angle. If you do not have easels, students may either tack their painting to the wall or put a stack of books under the top of the painting board.

- If students want to draw figures in action poses in their comic strip and painting, have them model for one another so that they can make quick gesture drawings of the action (see the activity in Chapter 1, page 33). Point out to students that Lichtenstein rarely showed the whole figure in his artworks.

Assess

Evaluation

Display the paintings where students can step back and look at their work from a distance. After students discuss their work with either you or another student, have them write the answers to the questions in **Check it**. Discuss their answers individually.

Extend

Linking Design Elements and Principles

Contrast

Point out to students that contrast in value can be used to create movement in a composition. When their paintings are complete and are on display, encourage a discussion about the use of contrast in the painting. Which ones made use of contrast in their depiction? Is there one that is particularly successful in using a contrast of values to emphasize movement? What other types of contrast can be found in the paintings?

As students study the images in **Take a look**, they should consider the contrast of values, patterns, shapes, and colors in each image. Encourage them to create contrast in both their comic strip and painting.

Interdisciplinary Connections

Literature

Assign groups of students to break a short literature selection into small, manageable segments. Each student should choose a segment to illustrate as a comic strip. Display each group's completed strips together so that they tell the entire story.

Mathematics

Instruct students in the mathematics involved in enlarging and scaling their drawing. Have them measure the small drawing surface and the large painting surface and then set up a ratio.

Inquiry

- Encourage students to research famous "strips" of historical art, such as *The Bayeux Tapestry*, which depicts the Battle of Hastings; Trajan's column in the Roman forum, which features a relief of the emperor's conquests; or the Parthenon frieze of the procession for Athena. Have students explain how events in these works are arranged to create a flow of movement.

- Assign students to research a famous animator or cartoonist. Possibilities include Walt Disney (*Cinderella, Sleeping Beauty*), Winsor McCay (*Gertie the Dinosaur*), Bill Waterson (*Calvin and Hobbes*), Laurent de Brunhoff (*Babar*), Gary Larson (*The Far Side*), Jim Davis (*Garfield*), and Charles M. Schulz (*Peanuts*). Have each student display photocopied samples of the artist's work and explain to the class the ways that the artist depicted movement in the samples.

Guide to Artists

A

Magdalena Abakanowicz (b. 1930, Poland). mahg-de-lay-nah ah-bah-kah-noe-vits

Berenice Abbott (1898–1991, US). ber-a-nees ab-bet

Ansel Adams (1902–84, US). an-sull ad-ams

John Ahearn (b. 1951, US). ay-hern

Loudvic Akopyan (b. 1972, US). lude-vic ay-kope-yon

Josef Albers (1888–1976, Germany–US). yo-zef ahl-bers

Peter Alexander (b. 1939, US). alek-zand-er

Anna Alma-Tadema (c. 1865–1943, England). al-muh-tad-uh-muh

Ferdinand Andri (1871–1956, Austria). ahn-dree

Stephen Antonakos (b. 1926, US). ann-ton-ah-kiss

Nemesio Antúnez (b. 1918, Chile). nay-mayz-yo ahn-too-nes

Richard Anuszkiewicz (b. 1930, US). a-noo-skay-vich

Karel Appel (b. 1921, The Netherlands). kar-el ah-pel

Tomie Arai (b. 1949, US) toe-mee-a uh-rye

Anna Atkins (1799–1871, England) at-kinz

John James Audubon (1785–1851, US). aw-deh-bahn

B

Henrietta Bailey (1874–1950, US). bay-ley

Jennifer Bartlett (b. 1941, US). bart-let

Baule (Ivory Coast). bau-lay

Welton Becket (1902–69, US). well-tun bek-et

Vanessa Bell (1879–1961, England). bell

Benin culture (Nigeria, Africa). beh-neen

Gianlorenzo Bernini (1598–1680, Italy). jahn-low-rens-oh bair-nee-nee

John Biggers (b. 1924, US). big-urz

Rosa Bonheur (1822–99, France). rosa bon-err

Fernando Botero (b. 1932, Colombia). fair-nahn-doh boh-tay-roh

Hans Van De Bovenkamp (b. 1938, The Netherlands). honz vahn day boh-ven-kahmp

Georges Braque (1882–1963, France). zjorzj brahk

Claudio Bravo (b. 1936, Chile). claw-dee-oh bra-voh

Colleen Browning (b. 1929, Ireland-US). brown-ing

Pieter Brueghel the Younger (1564/5-1637/8, The Netherlands). peet-er brew-gul

Laurent de Brunhoff (b. 1925, France). lor-enn da broon-hoff

Byzantine (Istanbul, Turkey). biz-ahn-teen

C

Gustave Caillebotte (1848–94, France). goo-stahv kai-ee-bot

Alexander Calder (1898–1976, US). call-der

Canaletto (1697–1768, Italy). can-ah-let-toe

Ken Carlson (b. 1945, US). carl-sen

Muriel Castanis (b. 1926, US). myur-ee-ul cuh-stahn-iss

Vija Celmins (b. 1939, Latvia–US). vee-yah sel-minz

Paul Cézanne (1839–1906, France). say-zahn

Marc Chagall (1887-1985, Russia-France). mark sha-gahl

Jean-Baptiste-Siméon Chardin (1699–1779, France). zhahn-bat-teest-see-may-ohn shar-dan

Georgio de Chirico (1888–1978, Italy). jor-jyoh day key-ree-coh

Dorte Christjansen (b. 1943, Danish-US). door-teh krist-jan-sen

Christo (b. 1935, Bulgaria). kriss-toe

Ken Chu (b. 1953, Hong Kong–US). choo

Frederic Edwin Church (1826–1900, US). cherch

Chuck Close (b. 1940, US). klohs

Henry Cobb (b. 1859–1931, US). cob

Anne Coe (b. 1949, US). koh

Willie Cole (b. 1959, US). kole

Jess Collins (b. 1923, US). cahl-inz

Douglas Crockwell (1904–68, US). krok-well

Cuna People (Panama). koon-ah (pan-ah-mah)

Imogen Cunningham (1883–1976, US). im-a-jean cun-ning-ham

D

Salvador Dali (1904–89, Spain). sahl-vah-door dah-lee

Louis Danziger (b. 1923, US). dahn-tsig-er

Edgar Degas (1834–1917, France). ed-gahr day-gah

Willem de Kooning (1904–1997, The Netherlands–US). vil-em deh-koon-ing

Charles Demuth (1883–1935, US). day-mooth

Desiderio da Settignano (1429/30–1464, florentine). dez-eh-der-ee-oh da set-tee-yahn-oh

Laddie John Dill (b. 1943, US). lad-ee jon dil

James Doolin (b. 1932, US). dool-en

Aaron Douglas (1899–1979, US). dug-les

Dan Douke (b. 1943, US). doo-kay

Arthur Dove (1880–1946, US). duv

Albrecht Dürer (1471–1528, Germany). ahl-brecht dur-er

E

Thomas Eakins (1844–1916, US). ay-kins

Carol Eckert (b. 1945, US). ek-urt

Harold E. Edgerton (1903–90, US). ej-er-ten

Alexandre-Gustave Eiffel (1832–1923, France). al-ex-andr-goo-stahv ee-fel

Alfred Eisenstaedt (1898–1995, Poland–US). eye-zen-shhtat

M. C. Escher (1898–1972, The Netherlands). esh-er

Richard Estes (b. 1932, US). ess-teez

F

Lyonel Feininger (1871–1956, US). fie-ning-ur

John Ferren (1905–70, US). feh-ren

Janet Fish (b. 1938, US). fish

Dan Flavin (1933–96, US). flay-vin

John Forbes (b. 1946, US). forbz

Jean-Honoré Fragonard (1732–1806, France). zhahn-oh-no-reh fra-go-narh

Piero della Francesca (1410/20–92, Italy). pyay-roh del-lah fran-ches-kah

Helen Frankenthaler (b. 1928, US). frank-en-thal-er

Bruce Freund (b. 1953, US). froint

David Furman (b. 1947, US). fur-man

G

Antoni Gaudí (1852–1916, Spain). an-toh-nee gow-dee

Frank O. Gehry (b. 1929, US). geh-ree

Théodore Géricault (1791–1824, France). tay-oh-dor zhay-ree-koh

Alberto Giacometti (1901–66, Italy). al-bair-toe zhah-co-met-ee

Sylvia Glass (20th century, US). glass

Vincent van Gogh (1853–1890, The Netherlands). vin-sent vahn go

Glenna Goodacre (b. 1939, US). good-ake-er

Michael Graves (b. 1934, US). grayvz

Jonathan Green (20th century, US). green

Charles Sumner Greene (1868–1957, US). green

Henry Mather Greene (1870–1954, US). green

Juan Gris (1887–1927, Spain/active in France). wahn grees

Alexander Guthrie (b. 1920, US). guth-ree

H

Kenneth B. Haas III (b. 1954, US). haws

Ekaku Hakuin (1685–1768, Japan). ay-kah-koo ha-koo-in

Frans Hals (1581–1666, The Netherlands). frahns hahls

Duane Hanson (1926–96, US). dwane han-son

Maren Hassinger (b. 1947, US). mar-en ha-sing-er

Michael Hayden (b. 1943, Canada). hay-den

Ilisha Helfman (b. 1957, US). help-man

Dame Barbara Hepworth (1903–75, England). hep-werth

David Hockney (b. 1937, England). hawk-nee

Allan Houser (1914–94, Chiricahua/Apache/US). how-zer

I

Igbo culture (Nigeria, Africa). eeg-bo

Robert Indiana (b. 1928, US). indee-an-a

Irian Jaya (Lake Sentani, New Guinea). eer-ee-in jie-yah (lake sen-tah-nee, noo ghin-ee)

Robert Irwin (b. 1928, US). er-win

J

Jeanne-Claude (b. 1935, France). zhahn-kload

Yale Joel (b. 1919, US). jole

Gwen John (1876–1939, Wales). jon

Philip Johnson (b. 1906, US). jon-sehn

William H. Johnson (1901–70, US). jon-sehn

Donald Judd (1928–94, US). jud

K

Frida Kahlo (1910–53, Mexico). free-dah kah-low

Louis I. Kahn (1901–74, US). kahn

Phineas Kamangira (20th Century, Zimbabwe). fin-ee-ess ka-man-gee-ra

Wassily Kandinsky (1866–1944, Russia). vahs-i-lee kan-dins-key

Anish Kapoor (b. 1954, India–England). ah-neesh kah-poor

Karajá tribe. Amazon. (Araguaia River, Mato Grosso, Brazil). ka-ra-ha (are-uh-gwy-uh, mah-too gross-oo)

Gertrude Käsebier (1852–1934, US). ger-trood kay-zah-beer

Alex Katz (b. 1927, US). catz

Ellsworth Kelly (b. 1923, US). elz-wurth kell-ee

André Kertész (1894–1985, Hungary–US). ahn-dray ker-tesh

Jerome Kirk (b. 1923, US). jeh-rome kurk

Paul Klee (1879–1940, Switzerland). clay

Elizabeth Anna Klumpke (1856–1942, US). klom-key

Käthe Kollwitz (1867–1945, Germany). kay-teh kahl-vits

Ogata Korin (1658–1716, Japan). oh-gah-tah code-een

Margaret Korisheli (b. 1959, US). kor-uh-shell-ee

Kuba (Africa). koo-ba

Shiro Kuramata (b. 1934, Japan). shee-roe koo-rah-mah-tah

L

Doyle Lane (20th century, US). lane

Dorothea Lange (1895–1965, US). dor-uh-thee-uh lang

Georges de La Tour (1593–1652, France). zjorzj de la toor

Jacob Lawrence (b. 1917, US). lor-ense

Leonardo Da Vinci (1452–1519, Italy). lay-oh-nar-doh dah vin-chee

Julio Le Parc (b. 1928, Argentina-France). hule-yoh leh park

Marilyn Ann Levine (b. 1935, Canada–US). leh-veen

Roy Lichtenstein (1923–97, US). lick-ten-stine

Franklyn Liegel (b. 1952, US). lee-gul

Maya Ying Lin (b. 1959, US). my-uh ying lin

Jacques Lipchitz (1891–1973, Lithuania–France). zjahk leep-sheets

Lee Lockwood (b. 1932, US). lok-wood

M

Charles Rennie Mackintosh (1868–1928, Scotland). ren-ee mak-in-tosh

René Magritte (1898–1967, Belgium). ren-ay mah-greet

Sylvia Plimack Mangold (b. 1938, US). plim-ick man-gold

Andrea Mantegna (1431–1506, Italy). ahn-dray-ah man-ten-ya

Maori (New Zealand). may-or-ee

Maria Martinez (1881–1980, US). ma-ree-ah mar-tee-nes

Masaccio (1401–1428, Italy). ma-zaht-choh

Henri Matisse (1869–1954, France). ahn-ree mah-teece

Roberto Matta (b. 1911, Chile). may-tah

Mayan (200BC–AD500, Mexico). my-en

Mbuti (Zaire). mm-boo-tee

Richard Meier (b. 1934, US). my-er

Gabriel Metsu (1629–67, The Netherlands). gah-bree-el met-sue

Michelangelo (1475–1564, Italy). mee-kel-an-jay-loh

Melissa Miller (b. 1951, US). mill-er

Clark Mills (1815–83, US). milz

Ming dynasty (14th–17th cent., China). ming

Minoan (Palaikastro). mih-no-in

Joan Miró (1893–1983, Spain). joe-on mee-roh

Moche culture (Peru) mo-shay

Piet Mondrian (1872–1944, The Netherlands). pate mohn-dree-ahn

Claude Monet (1840–1926, France). kload moh-nay

Henry Moore (1898–1986, England). more

Thomas Moran (1837–1926, US). me-ran

Georgio Morandi (1890–1964, Italy). jor-jyoh moh-ran-dee

Berthe Morisot (1841–95, France). bairt moh-ree-zoh

Norval Morrisseau (b. 1933, Canada). nor-vahl moh-ree-soh

Philip Moulthrop (b. 1947, US). mowl-thrup

Thomas P. Muir (b. 1956, US). mure

Peter Müller-Munk (1904–67, Germany). mew-ler-monk

'Abd Allah Musawwir (active mid-16th cent., Bukhara, Persia). ab-da ah-lah muh-sa weer

N

Joel Nakamura (b. 1959, US). naka-moora

Nasca (Peru, 100–700 AD). nass-kuh

Bruce Nauman (b. 1941, US). naw-men

Alice Neel (1900–84, US). neel

Louise Nevelson (1899–1988, Russia–US). nev-ul-sun

Arnold Newman (b. 1918, US). new-men

Nodena culture (Late Mississippian culture, US) noe-dee-nah

Isamu Noguchi (1904–88, Japan–US). ees-sah-moo noh-goo-chee

O

Georgia O'Keeffe (1887–1986, US) jor-jah o-kefe

Claes Oldenburg (b. 1929, Sweden–US). klahss old-en-berg

Diana Ong (b. 1940, China-US). ong

Meret Oppenheim (1913–85, Germany). meh-ray ahp-uhn-hym

P

Nam June Paik (b. 1932, Korea). nahm joon peak

Nick Park (b. 1958, England). park

I. M. Pei (b. 1917, China–US). pay

Judy Pfaff (b. 1946, England–US). faf

Pablo Picasso (1881–1973 Spain/active in France). pah-blo pee-kahs-oh

Christopher Polentz (b. 1962, US). po-lents

James A. Porter (1905–71, US). port-er

Katherine Porter (b. 1941, US). port-er

James Porto (b. 1960, US). port-o

John Portman (b. 1924, US). port-man

Tom Purvis (1888–1959, Great Britain). pur-viss

Martin Puryear (b. 1941, US). per-yeer

Q

Qing dynasty (18th cent., China). king

R

Don M. Ramos (20th century, US). ray-mohs

Anthony Ravielli (1910–97, US). rah-vee-el-ee

Man Ray (1890-1976, US). ray

Rembrandt van Rijn (1606–69, The Netherlands). rem-brant van rhine

Viljo Revell (1910–64, finland). vil-ee-o reh-vell

Faith Ringgold (b. 1930, US). ring-gold

José de Rivera (b. 1904, US). ho-say da ree-vay-rah

Hugo Robus (1885–1964, US). roe-buss

Simon Rodia (1875–1965, Italy–US). roh-dee-ah

Bruce Rogers (1870–1957, US). raw-jerz

Richard Rogers (b. 1933, Great Britain). rawj-erz

Jeanne Rosen (b. 1954, US). roz-en

James Rosenquist (b. 1933, US). roh-zen-kwist

Theodore Roszak (1907–81, US). thee-ah-door ro-shak

Antonio Ruíz (1897–1964, Mexico). roo-eez

Edward Ruscha (b. 1937, US). roo-shay

S

Kay Sage (1898-1963, US). saje

Augustus Saint-Gaudens (1848–1907, Ireland-US). aw-gus-tus saint-gawd-unz

John Singer Sargent (1856–1925, US). sar-jent

Miriam Schapiro (b. 1923, Canada-US). mee-ree-um sha-peer-oh

Kenny Scharf (b. 1958, US). sharf

Egon Schiele (1890–1918, Austria). ay-gon she-luh

Karl Schmidt-Rottluff (1884–1976, Switzerland). shmit-rot-loof

Emil Schulthess (1913–96, Switzerland). shul-tess

George Segal (b. 1924, US). see-gul

Senufo/Baule (Ivory Coast, Africa). sehn-noo-fo

Georges Seurat (1859–91, France). zjorzj suh-rah

Ben Shahn (1898–1969, Lithuania–US). shan

Toshusai Sharaku (act. 1794–95, Japan). toh-shu-sah-ee shah-rah-kew

Cindy Sherman (b. 1954, US). shur-man

Terry Shoffner (b. 1947, Canada). shof-ner

Alan Siegal (1913–78, US). see-gul

David Smith (1906–65, US). smith

Jaune Quick-To-See Smith (b. 1940, Salish Cree Shoshone/US). zjhohn kwik to see smith

Nonomura Sotatsu (1576–1643, Japan). soh-taht-soo

Jesús Soto (b. 1923, Venezuela). hay-zoos soh-toe

Pat Steir (b. 1938, US). steer

Frank Stella (b. 1936, US). stell-a

Varvara Stepanova (1894–1958, Russia). var-var-ah ste-pah-no-vah

Clyfford Still (1904–80, US). still

T

Paul Tanqueray (1905–91, Great Britain). tonk-eh-ray

Sir John Tenniel (1820–1914, England). ten-ee-ul

Maria Teokotai tay-oh-kah-tai

Masami Teraoka (b. 1936, Japan/active in US). ma-sa-mee te-ra-oh-kah

Wayne Thiebaud (b. 1920, US). tee-bow

Louis Comfort Tiffany (1848-1933, US). tiff-ah-nee

Tintoretto (1518–94, Italy). teen-toe-ret-toe

Norman Kelly Tjampijinpa (b. 1954, Australia). jam-pee-jin-pa

Tlingit, Yakutat (Alaska). tlin-get yah-kuh-tat

Niklaus Troxler (b. 1947, Switzerland). nee-klos troks-ler

Tubuai (Austral Islands). too-bwa-ee (oss-trul eye-lands)

William Tucker (b. 1935, England-Canada). tuk-er

James Turrell (b. 1943, US). tur-el

Kent Twitchell (b. 1942, US). twit-shell

V

Victor Vasarely (1908-97, Hungary–France). va-sah-rell-ee

Jan Vermeer (1632–75, The Netherlands). yahn fare-meer

Daniele da Volterra (Daniele Ricciarelli) (1509–66, Italy). dan-yell-ay da vahl-tare-ah

W

Fred Ward (b. 1935, US). ward

Andy Warhol (1928–87, US). war-hall

Weegee (Arthur Fellig) (1899–1968, Poland–US). wee-jee (fel-ig)

Edward Weston (1886–1958, US). west-en

James Abbott McNeill Whistler (1834–1903, US-England). hwis-ler

Minor White (1908–76, US). wite

Ellis Wilson (1899–1977, US). wil-sen

Jackie Winsor (b. 1941, US). win-zer

Tyrus Wong (b. 1910, China–US). tie-rus wong

Grant Wood (1892–1942, US). wood

Frank Lloyd Wright (1867–1959, US). rite

Andrew Wyeth (b. 1917, US). why-eth

Y

Kumi Yamashita (b. 1968, Japan–US). koo-me ya-ma-shee-ta

Wang Yani (b. 1975, China). ya-nee

Z

Zapotec (pre-Columbian, AD 200–900). zah-puh-tek

Victor Hugo Zayas (b. 1961). zye-yes

Wei Zhujing, (16th cent., China). way zjoo-jing

Glossary

abstract art Art that emphasizes design, or whose basic character has little visual reference to real or natural things. (*abstracto*)

analogous colors Hues that are next to each other on the color wheel and have a single color in common. For example, yellow-green, yellow, and yellow-orange are analogous colors. (*colores análogos*)

approximate symmetry The organization of the parts of a composition such that each side of a vertical axis contains similar, but not identical, shapes or forms. (*simetría*)

asymmetrical balance The organization of the parts of a composition such that the sides of a vertical axis are visually equal without being identical. (*asimétrico*)

base The foundation or support of an object. The rest of the object is built on top of the base. In a rope and yarn basket or a coiled clay pot, the base is formed by winding the rope or clay in a circle until it forms a flat surface. (*base*)

calligraphy Precise, elegant handwriting or lettering done by hand. The word "calligraphic" is sometimes used to describe a line in an artwork that has the flowing elegance of calligraphy. (*caligrafía*)

caricature A depiction that exaggerates features or characteristics of a subject to an unnatural, ridiculous, or absurd degree. (*caricatura*)

center of interest The area of an artwork toward which the eye is directed; the visual focal point of the work. (*foco de atención*)

color harmony Combinations of color—such as complementary or analogous colors—that can be defined by their positions on the color wheel. Particular color harmonies may be used to achieve specific effects. (*armonía cromática*)

complementary colors Any two colors that are opposite each other on the color wheel. (*complementarios*)

composition The arrangement of elements such as line, value, and form within an artwork; principles of design are considered in order to achieve a successful composition. (*composición*)

compositional movement A path that the viewer's gaze is directed to follow because of the arrangement of elements in an artwork. (*movimiento composicional*)

constructed sculpture Sculpture that is not carved or modeled but is created by combining materials like wire, metal, cardboard, wood, or found objects. First used by Picasso in the early twentieth century. (*escultura ensamblada*)

contour lines Lines that describe a shape of a figure or an object and also include interior detail. These lines can vary in thickness. (*líneas de perfil*)

contrast A principle of design that refers to differences in elements such as color, texture, value, and shape. Contrasts usually add excitement, drama and interest to artworks. (*contraste*)

cool colors The hues that range from yellow-green to violet on the color wheel. (*colores fríos*)

core The material used to form the basic shape of an object. In a coiled rope and yarn basket, the core is the rope. (*material bàsico*)

crosshatchings Closely-spaced, parallel lines that overlap at angles to each other. Cross-hatching is used primarily in drawing and printmaking to create areas of shading. (*sombreado de líneas entrecruzadas*)

Cubism An early twentieth-century movement led by Pablo Picasso and Georges Braque. The artists used small squares or cubes to represent their subjects. Objects are often shown from several different points of view at once, which flattens three-dimensional space. Cubist paintings are often monochromatic and sometimes contain elements of collage. (*Cubismo*)

dominance A concept that one primary element attracts more attention than anything else in a composition. The dominant element is usually a focal point in the composition. (*dominio*)

dynamic Constantly changing or moving; in a state of imbalance or tension. (*dinámico*)

eber A fanlike sword in Benin culture. (*eber*)

fire To bake a ceramic object in a kiln. Firing pottery at a high temperature causes it to harden permanently. (*cocer*)

form An element of design that is three-dimensional and encloses volume. (*forma*)

fresco A technique of painting in which pigments suspended in water are applied to a thin layer of wet plaster so that the plaster absorbs the color and the painting becomes part of the wall. (*fresco*)

geometric shape A shape—such as a triangle or rectangle—that can be defined precisely by mathematical coordinates and measurements. (*figura geométrica*)

gesture line An energetic type of line that catches the movements and gestures of an active figure. (*línea gestual*)

half-drop design A specific kind of row pattern with the vertical orientation of each row evenly spaced to half the height of its preceding row, and with a shifted horizontal position. (*diseño de semidescenso*)

high-keyed Describing colors or values that are light tints, created by the use of white, such as in pastel colors. (*tono alto*)

hue The name of a color, determined by its position in the spectrum. (*matiz/tono/color*)

implied line A suggested line—one that was not actually drawn or incorporated—in a work of art. (*línea implícita*)

implied texture The perceived surface quality in an artwork. (*textura implícita*)

intensity The strength, brightness, or purity of a color. Changing a color's value will also change its intensity. (*intensidad*)

intermediate colors Colors created by mixing equal amounts of primary colors with their neighboring secondary colors. For example, mixing yellow (a primary color) with orange (a secondary color) creates the intermediate color yellow-orange. (*color intermedio*)

iwan A vaulted opening with an arched portal. (*iwan*)

kinetic art Three-dimensional sculpture that contains moving parts. (*escultura cinética*)

linear perspective The technique by which artists create the illusion of depth on a flat surface. All parallel lines of projection converge at the vanishing point, and associated objects are rendered smaller the farther from the viewer they are intended to seem. (*perspectiva lineal*)

line of sight A type of implied line from a figure's eyes to a viewed object, directing the attention of the viewer of a design from one part of it to another. (*línea de la vista*)

line personality The general characteristics of a line, such as its direction, movement, quality, or weight. (*personalidad de la línea*)

low-keyed Describing colors or values that are dark tints, usually created by the use of black or gray. (*tono bajo*)

monochromatic Of only one color. A monochromatic painting uses a single hue, plus black and white. The use of lights and darks creates contrast in the work. Most drawings are monochromatic because they use only one color of ink or lead. (*monocromático*)

motif The two- or three-dimensional unit that is repeated to form a pattern. (*motivo*)

negative space The areas of an artwork not occupied by subject matter, but which contribute to the composition. In two-dimensional art, the negative space is usually the background. (*espacio negativa*)

neutral Having no easily seen hue. White, gray, and black are neutrals. (*color neutro*)

nonrepresentational art Art that has no recognizable subject matter, that does not depict real or natural things in any way. Also called nonobjective art. (*arte no representativo*)

oba A divine king in Benin culture. (*oba*)

one-point perspective Linear perspective used in combination with a single vanishing point. Used to show three-dimensional objects on a two-dimensional surface. (*perspectiva de un punto*)

organic shape A shape that is freeform or irregular; the opposite of geometric shape. (*figura orgánica*)

outline A line that defines the outer edge of a silhouette, or the line made by the edges of an object. (*contorno*)

papiers collés A French term meaning "glued-on papers." The Cubists used this technique, the beginning of collage, when they attached items like newspaper clippings to their paintings. (*papiers collés*)

papiers découpés Abstract collage, from the French term meaning "cut-out papers." (*papiers découpés*)

pattern A principle of design in which the repetition of elements or combination of elements forms a recognizable organization. (*patrón*)

perspective An artist's representation of a three-dimensional world on a two-dimensional surface. (*perspectiva*)

photomontage A composition formed of several pictures, usually pasted together. (*montage*)

picture plane The flat surface of a composition. (*superficie pictória*)

pigment The coloring material used in making painting and drawing media, dyes, inks, and toners. Pigments may be natural (made from earth or plants) or made from laboratory-prepared chemicals. (*pigmento*)

planned pattern The consistent, orderly repetition of motifs, whether found in nature or created by an artist. Planned patterns include row, grid, half-drop, radial, alternating, and border. (*patrón planeado*)

positive space The areas containing the subject matter in an artwork; the objects depicted, as opposed to the background or space around those objects. (*espacio positivo*)

primary colors In subtractive color theory, such as when mixing pigments, the hues—red, yellow, and blue—from which all other colors are made. (*color primario*)

progressive rhythm A pattern in which each series of motifs incorporates a predictable change. (*ritmo progresivo*)

radial balance A composition that is based on a circle, with the design radiating from a central point. (*equilibrio radial*)

random pattern The repetition of an element or elements in an inconsistent or unplanned way. (*patrón aleatorio*)

real texture The actual surface quality of an artwork. (*textura real*)

scale The relative size of a figure or object, compared to others of its kind, its environment, or humans. (*escala*)

scoring Scratching grooves or lines into surfaces of clay pieces that will be joined together. Scoring helps the pieces of clay to bond during the firing process. (*marca*)

secondary colors Colors produced by mixing equal amounts of any two primary colors. The secondary colors are violet (red mixed with blue), orange (red mixed with yellow) and green (blue mixed with yellow). (*color secundario*)

shade A darker value of a hue, created by adding black or a darker complementary color to the original hue. (*sombra*)

shape An element of design that is two-dimensional and encloses area. (*figura*)

sketch line A quick line that captures the appearance of an object or the impression of a place. (*línea de bosquejo*)

slip Clay thinned with water to create a thick liquid. Slip is used on scored areas to bind pieces of clay together. (*barbotina*)

spectrum The complete range of color that is present in white light. The spectrum colors are visible when light is refracted through a prism. (*espectro cromático*)

split complementary A color plus the two hues next to that color's complement. For example, blue forms a split complementary with yellow-orange and red-orange. (*color complementario dividido*)

static Showing no movement or action. (*estático*)

structural lines Lines that hold a design together. (*líneas estructurales*)

style The distinctive character contained in the artworks of an individual, a group of artists, a period of time, an entire society, or a geographical location. (*estilo*)

subordinate Anything that is of lesser importance than the dominant element in an artwork. (*subordinado*)

surface A plane that can be described in terms of two dimensions: height and width. A surface has no depth. (*superficie*)

symmetrical balance The organization of the parts of a composition such that each side of a vertical axis mirrors the other. (*equilibrio simétrico*)

texture An artwork's actual or implied surface quality, such as rough, smooth, or soft. (*textura*)

thrown pottery Ceramic objects made by forming clay on the spinning disc of a potter's wheel, producing a symmetrical round form. (*cerámica a torno*)

tint A lighter value of a hue, created by adding white to the original hue. (*matiz*)

tone A less intense value of a hue, created by adding gray to the original hue. (*tono*)

tortillon A small stump of tightly rolled paper, pointed at one end, used to blend pencil, charcoal, and pastel. (*difumino*)

triadic harmony A combination of three equally-spaced hues on the color wheel. Examples are red, yellow, and blue, or blue-green, red-violet, and yellow-orange. (*tríada cromática*)

two-point perspective A way to show three-dimensional objects on a two-dimensional surface, using two widely-set vanishing points and two sets of converging lines to represent forms. These forms are seen from an angle and have two receding sides. (*perspectiva de dos puntos*)

unity The sense of oneness or wholeness in a work of art. (*unidad*)

vacuum forming A method of shaping a plastic sheet over a solid relief pattern. The plastic is heated until it is pliable and when a vacuum is created under the form, the plastic is drawn down onto the pattern like a skin. (*moldeado al vacío*)

value An element of design that refers to the lightness or darkness of grays and colors. (*valor*)

value contrast Dark and light values placed close together. Black in proximity to white creates the greatest value contrast. (*contraste de valor*)

vanishing point In a composition featuring linear perspective, that spot on the horizon toward which parallel lines appear to converge and at which they seem to disappear. (*punto de fuga*)

visual rhythm The result of pattern combined with implied movement. Elements or motifs are combined to create a series of regular pauses (stops and starts) for the viewer's eyes, similar to the way a drumbeat creates a series of pauses for the listener's ears. (*ritmo visual*)

warm colors The hues that range from yellow to red-violet on the color wheel. (*colores cálidos*)

wedge To homogenize a ball of clay by repeatedly cutting it with a wire and pounding it together until it is fully blended. This process removes bubbles that could cause a piece of pottery to crack in the kiln. (*acuñar*)

wrap A material used to cover another material. In a rope and yarn basket, the yarn that is wound around the rope is the wrap. (*envoltura*)

Bibliography

Albers, Josef. *Interaction of Color*. New Haven: Yale University Press, 1994.

Alekzander, Terri. Ed. *Fresh Ideas in Brochure Design*. Cincinnati: North Light Books, 1997.

Arnheim, Rudolf. *Art and Visual Perception: A Psychology of the Creative Eye*. Berkeley: University of California Press, 1997.

Berryman, Gregg. *Notes on Graphic Design and Visual Communication*. Rev. ed. Menlo Park, CA: Crisp Publications, Inc., 1990.

Birks, Tony. *The Complete Potter's Companion*. Rev. ed. Boston: Bulfinch Press Book, Little Brown and Company, 1998.

Billcliffe, Roger. *Charles Rennie Mackintosh: Textile Designs*. San Francisco: Pomegranate Artbooks, 1993.

Birren, Faber. *Color and Human Response: Aspects of Light and Color Bearing on the Reactions of Living Things and the Welfare of Human Beings*. New York: John Wiley and Sons, 1984.

Bourges, Jean. *Color Bytes*. Worcester, MA: Davis Publications, Inc., 1997.

Brommer, Gerald, and Gatto, Joseph A. *Careers in Art*. Worcester, MA: Davis Publications, Inc., 1999.

Carter, Rob. *Typographic Specimens: The Great Typefaces*. New York: John Wiley and Sons, 1997.

Carter, Rob; Day, Ben; and Miller, A. Ed. *Typographic Design: Form and Communication*. 2nd ed. New York: John Wiley and Sons, 1997.

Ching, Frank D. *Architecture: Form, Space, and Order*. 2nd ed. New York: John Wiley and Sons, 1996.

Dormer, Peter. *The New Ceramics Trends and Traditions*. 2nd ed. New York: Thames and Hudson, 1994.

Edwards, Betty. *Drawing on the Right Side of the Brain*. Rev. ed. New York: The Putnam Publishing Group, 1989.

Eidelberg, Martin. *Designed For Delight: Alternative Aspects of Twentieth Century Decorative Arts*. New York: Abbeville Press, and Paris: flammarion, in Association with Montreal Museum of Decorative Arts, 1997.

English, Marc. *Designing Identities, Graphic Design as a Business Strategy*. Gloucester, MA: Rockport Publishers, 1997.

Ernst, Bruno. *The Magic Mirror of M.C. Escher (Taschen Series)*. New York: Taschen America, 1995.

fichner-Rathus, Lois. *Understanding Art*. 5th ed. Englewood Cliffs, NJ: Prentice Hall, 1997.

Gatta, Kevin; Lange, Gusty; and Lyons, Marylin. *Foundations of Graphic Design*. Worcester, MA: Davis Publications, Inc., 1991.

Gilbert, Rita. *Living With Art*, 5th ed. New York: McGraw-Hill, 1997.

Hale, Nathan Cabot. *Abstraction in Art and Nature*. New York: Dover Publications, 1993.

Heller, Steven. *Graphic Style from Victorian to Post-Modern*. New York: Harry N. Abrams, Inc. Publishers, 1994.

Itten, Johannes. *The Art of Color: The Subjective Experience and Objective Rationale of Color*. New York: John Wiley and Sons, 1974.

Itten, Johannes. *Design and Form: The Basic Course at the Bauhaus and Later*. Rev. ed. New York: John Wiley and Sons, 1997.

Itten, Johannes, Birrren, Faber. Ed. *The Elements of Color: A Treatise on the Color System by Johannes Itten*. New York: John Wiley and Sons, 1985.

Lauer, David A. *Design Basics*, 4th ed. Fort Worth: Harcourt Brace College Publishers, 1994.

Lucie-Smith, Edward. *The Thames and Hudson Dictionary of Art Terms*. New York: Thames and Hudson, 1988.

Martin, Diana and Haller, Lynn. *Graphic Design, Inspirations and Innovations 2*. Cincinnati: North Light Books, 1997.

McCloud, Scott. *Understanding Comics: The Invisible Art*. New York: HarperCollins, 1994.

McLuhan, Marshall. *Understanding Media: Extensions of Man*. Cambridge: MIT Press, 1994.

Meggs, Phillip B. *History of Graphic Design*. 2nd ed. New York: John Wiley and Sons, 1992.

Miller, Anastatia R. and Brown, Jared M. *What Logos Do and How They Do It*. Gloucester, MA: Rockport Publishers, 1997.

Montague, John. *Basic Perspective Drawing*. 3rd ed. New York: John Wiley and Sons, 1998.

Murphy, Pat, and Dunham, Judith. Ed. *By Nature's Design: An Exploratorium Book*. San Francisco: Chronicle Books, 1993.

Parola, Rene. *Optical Art: Theory and Practice*. New York: Dover Publications, 1996.

Pina, Leslie. *Alexander Girard Designs for Herman Miller*. Atglen, PA: Schiffer Publishing Ltd, 1998.

Preble, Duane; Preble, Sarah; and Frank, Patrick. *Artforms: An Introduction to the Visual Arts*. 6th ed. New York: Addison Wesley Longman, 1999.

Read, Herbert, and Stangos, Nikos. *The Thames and Hudson Dictionary of Art and Artists*. 2nd ed. London: Thames and Hudson, 1994.

Richer, Paul, and Hale, Robert B. Ed. *Artistic Anatomy*. New York: Watson-Guptill Publishers, 1986.

Roberts, Marie MacDonnell. *The Artist's Design: Probing the Hidden Order*. Walnut Creek, CA: Fradema Press, 1993.

Roukes, Nicholas. *Art Synectics*. Worcester, MA: Davis Publications, Inc., 1984.

Roukes, Nicholas. *Design Synectics*. Worcester, MA: Davis Publications, Inc., 1988.

Sarnoff, Bob. *Cartoons & Comics*. Worcester, MA: Davis Publications, Inc., 1989.

Sawahata, Lesa. *Building Great Designs with Paper*. Gloucester, MA: Rockport Publishers, Inc., 1998.

Sayre, Henry M. *A World of Art*. 2nd ed. Englewood Cliffs, NJ: Prentice Hall, 1996.

Schwartzman, Arnold. *Designage: The Art of Decorative Sign*. San Francisco: Chronicle Books, 1998.

Shadrin, Richard L. *Design & Drawing*. Worcester, MA: Davis Publications, Inc., 1992.

Sparke, Penny. *A Century of Design: Design Pioneers of the 20th Century*. Hauppauge, NY: Barrons, 1998.

Stoops, Jack, and Samuelson, Jerry. *Design Dialogue*. Worcester, MA: Davis Publications, Inc., 1990.

Supon Design Group. *Visual Impact*. Washington, D.C.: Design Editions, a Division of Supon Design Group, 1998.

Tambini, Michael. *The Look of the Century*. New York: DK Publishing Inc., 1996.

Young, Doyald. *Logotypes and Letterforms*. Berkeley: Design Press/McGraw-Hill, 1993.

Zelanski, Paul. *Design Principles and Problems*. 2nd ed. Fort Worth: Harcourt Brace College Publishers, 1995.

Zelanski, Paul, and fischer, Mary Pat. *The Art of Seeing*. 4th ed. Englewood Cliffs, NJ: Prentice Hall, 1998.

Acknowledgments

A book of this kind would be impossible without the generous participation of students, teachers, artists, photographers, companies, galleries and museums.

The primary authors, Joseph Gatto, Albert Porter, and Jack Selleck are deeply appreciative to have been able to include all of the artists and their work in this book. We wish to to extend a special thanks to the following artists and agents: Loudvic Akopyan, Jennifer Bartlett, John Biggers, Christo and Jeanne Claude, Hans Van De Bovenkamp, Lois Danziger, Laddie John Dill, Dan Douke, John Forbes, Tobias Frere-Jones, Bruce Freund, David Furman, Frank O. Gehry, Sylvia Glass, Glenna Goodacre, Dorothy Little Greco, Alexander J. Guthrie, Kenneth B. Haas III, Maren Hassinger, Ilisha Helfman, Allan Houser, Clarissa Hudson, Susie Kim, Jerome Kirk, David Lai, Alexander Lavrentiev, Franlyn J. Liegel, Wesley Mancini, Gene Mater, Adam Meckler, Claes Oldenburg, José Pérez, Christopher Polentz, James Porto, Ray Prado, Richard Putney, Oliver Radford, Anthony Ravielli, Anna Riley-Hiscox, Paula Robbins, Jeanne Rosen, Edward Ruscha, Jesús Soto, Berenice Steinbaum, Mesami Teraoka, Niklaus Troxler, James Turrell, Kent Twitchell, Fred Ward, Tyrus Wong, Victor Hugo Zayas.

Thanks must also go to the staffs of museums and galleries who were especially helpful in providing artwork from their collections: Amon Carter Museum, Anthony d'Offay Gallery, Bonny Doon Art Glass, Holly Solomon Gallery, The J. Paul Getty Museum, Jack S. Blanton Museum of Art of The University of Texas at Austin, Kimbell Art Museum, Marisa Del Re Gallery, Inc., Nelson-Atkins Museum of Art, Norton-Simon Museum of Art, Paula Cooper Gallery, Robert Miller Gallery, San Diego Museum of Art, Steinbaum Krauss Gallery, Tambaran Gallery, and Vereinigung bildender Künstler Wiener Secession.

A special thank you to Nora Halpern-Brougher, Mary Ellen Powell, and the Frederick R. Weisman Art Foundation; Christine Normile and the Sherry Frumkin Gallery; and Anna Ganahl and the Art Center College of Design, Pasadena, California.

We also wish to thank the teachers who shared their expertise and submitted examples of their student artwork. Special thanks to the following teachers: Barbara Levine, Clarkstown High School, New City, NY; Sallye Mahan-Cox, James W. Robinson, Jr. Secondary School, Fairfax, VA; Kaye Passmore, Notre Dame Academy, Worcester, MA; Richard Shilale, Holy Name Catholic Junior Senior High School, Worcester, MA.

Thank you to the companies, corporations, and associations who graciously assisted in providing materials for the book: Anne Kohs and Associates, Inc., Frank O. Gehry and Associates, Los Angeles Times Syndicate, M. Knoedler and Company, Inc., Mary Zlot and Associates, the Meckler Corporation, North Carolina Zoological Park, Pei Cobb Freed and Partners, Pixar, Portland Public Services Building, Public Information Office of the Jet Propulsion Laboratory at the California Institute of Technology in association with the National Aeronautics and Space Administration, United Airlines, Vitra Inc. Diane Pritchett and South Coast Metro Alliance, Costa Mesa, California.

A special thank you to John Scott for his excellent photographs that significantly helped to reinforce design concepts. Thanks to Susan Quinn, Geri Thigpen, and Shirl Porter for typing parts of the manuscript and for their insightful suggestions. Thank you also to Gerald Brommer for his helpful advice.

The authors are also grateful for the cooperation and dedication of the Davis Publications staff under the leadership of editor Helen Ronan.

Hopefully, the efforts of all of us will aid students in developing a greater understanding and appreciation of design and its importance in their lives.

Index

258

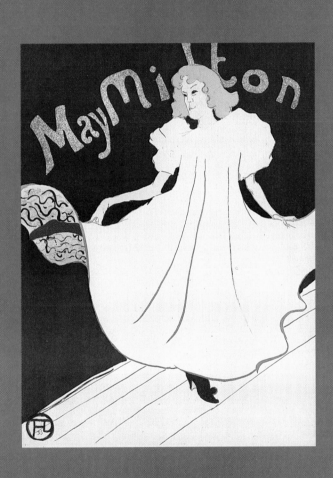

For those who love art, finding a career that allows artistic growth and expression can be a challenge. Young people with artistic talent have many viable options for art-related careers, but they need to be informed. The **Career Portfolios** included in this text are meant to spark curiosity about what is possible. To further expand awareness, try some of the following ideas.

Encourage Creative Thinking and Discussion

Have students read the Career Portfolio page, then ask:

- Why do you think this profession was included in the chapter about this design element or principle?
- Does the artist talk about early interests and hobbies that led to this career path?
- What training or skills are needed for this profession?
- Does the artist offer advice for someone new to their field?
- What do you find appealing about this profession? What do you think you would dislike about this job?

Take Action

- Bring in examples of similar artworks to those done by the artists profiled, or assign this task to students. For example, collect some topographic maps, type catalogs, a clip from an action movie (for storyboard artist), printed or woven fabric, comic strips, news magazine photographs, and so forth.
- Organize field trips to the graphics department of a newspaper, a factory that designs and prints T-shirts (or other clothing), an advertising arts

agency or publisher, or artisans such as potters or weavers.

- Assign students to interview art professionals in their community.
- Invite artists and designers to your classroom. Ask them to bring samples of their art and explain their career paths, especially professional training they have completed.
- Participate in a career fair for your school. In a series of seminars, students may meet with professionals in small groups.
- Discover which colleges offer training in these careers. *Careers in Art* (see Bibliography) provides a listing of colleges and universities in the United States and Canada that offer an undergraduate degree in art. Internet research is another valuable tool for obtaining this information.
- Have students read the classified ads in a large city newspaper. List the art-related jobs. Note what skills are required in these jobs; for example, computer proficiency or specific hands-on experience. (Ads can be copied, enlarged, and displayed for discussion.)
- Discuss the importance of portfolios in job interviews for arts professions. See pages T-262–T-266 for information on portfolios.
- Explain what internships are and how important they are in the arts.
- Assign students to research professions on the Internet.

Additional Resources

Support student interest in a featured occupation by providing the following information. The *Studio Resource Binder* that accompanies this text also gives more detailed versions of the Career Portfolio interviews.

Chapter 1, Cartoonist

Gag cartoons, comic strips, cartoon panels, political satire, editorial cartoons, advertising, and illustrations are various products within the cartooning field. Whether drawing for entertainment or to influence public opinion, cartoonists must work quickly and sell their ideas in a competitive market.
Organizations:
Association of American Editorial Cartoonists, 4101 Lake Boone Trail, Suite 201, Raleigh, NC 27607 (919) 787-5181
National Cartoonists Society, Columbus Circle Station, P.O. Box 20267, New York, NY 10023-1484 (904) 767-0657
Web sites:
www.reuben.org/main.htm for books, videos, schools, web links, and more

Chapter 2, Type Designer

Designing letterforms may be simple in concept, as evidenced by thousands of available type fonts—yet, designing type with a lasting presence requires skill, knowledge, and persistence.
Organizations:
Type Directors Club, 60 East 42nd Street, Suite 721, New York, NY 10165
Society of Typographic Aficionados, P.O. Box 673, Mansfield, MA 02048 (508) 643-2247
Web sites:
www.adobe.com/type/browser/info/main .html for information on typography
www.itcfonts.com/itc/ulc/index.html for the online version of *Upper and Lower Case*, the quarterly International Journal of Graphic Design and Digital Media, which has a focus on typography.

Chapter 3, Cartographer

Mapmaking will always be in demand for our constantly changing world. The technical tools in this field continue to grow at a rapid pace, yet an aptitude for art and geography is at the core of this profession.
Organizations:
North American Cartographic Information Society, P.O. Box 399, Milwaukee, WI 53201

Web sites:
www.nacis.org/ for salary survey, professional journal, and more

Chapter 4, Art Therapist

A human-service profession, art therapy uses art as a vehicle for positive human change. Art therapists combine their love of art with their training and skill as counselors in order to assist patients suffering from psychological trauma or illness.

Organizations:
American Art Therapy Association (AATA), 1202 Allanson Road, Mundelein, Illinois 60060-3808 (847) 949-6064
National Coalition of Arts Therapies Associations (NCATA), 2000 Century Plaza Ste. 108, Columbia MD 21044 410-997-4040

Web sites:
www.arttherapy.org/ for general information, educational programs, professional links, and more

Chapter 5, Architect

Some architects coordinate large projects; some design homes, schools, small office buildings, stores, or the grounds surrounding these buildings; others specialize in remodeling existing structures. Architects supervise construction and coordinate specialists (engineers, contractors, manufacturers' representatives, attorneys, etc.). They must work with mathematics, visualize in three dimensions, and understand complex systems and how they function.

Organizations:
American Institute of Architects (AIA), 1735 New York Ave. N.W., Washington, DC 20006 (202) 626-7300

Web sites:
www.clr.utoronto.ca/ has a virtual library of architecture, offering information on education and jobs, and many links.
http://gladstone.uoregon.edu:80/~aias/ is the site for the University of Oregon chapter of the American Institute of Architecture Students.

Chapter 6, Weaver

Weavers use a variety of looms and fibers made from a wide range of materials. Usually, they create their own designs—whether complex or elegantly simple. Products range in size from purses and shawls to blankets and wall hangings.

Organizations:
Handweavers Guild of America, Inc., Two Executive Concourse, Suite 201, 3327 Duluth Highway, Duluth, GA 30096-3301 (770) 495-7702

Web sites:
www.weavespindye.org/ offers information on education and links, plus more.

Chapter 7, Web Site Designer

Combining technological expertise with a solid art background can lead to success as a web site designer. This fairly new field is rapidly expanding.

Organizations:
Graphic Artists Guild, 90 John St., Room 403, New York, NY 10038 www.gag.org/
Internet Professional Publishers Association, www.ippa.org/

Web sites:
www.hotbot.com/web/ offers up-to-the-minute web development links.
www.webartists.com/ is the home page for the International Association of Web Artists.

Chapter 8, Gallery Owner

In addition to controlling the operations involved in directing an art gallery, art dealers provide an important cultural function. They encourage collectors of art and enable artists to further their careers.

Organizations:
Art Dealers Association of America, 575 Madison Ave., New York, NY 10022 (212) 940-8590

Web sites:
www.artdealers.org/ offers gallery-related links throughout the U.S.

Chapter 9, Industrial Designer

Whether focusing on toys, furniture, automobiles, household items, package design, or airline interiors, the industrial designer's goal is to enhance product quality and functionality.

Organizations:
The Association of Women Industrial Designers, P.O. Box 468, Old Chelsea Station, New York, NY 10011
The Organization of Black Designers, 300 M St. SW, Ste. N110, Washington, DC 20024 (202) 659-3918

Web sites:
www.ifda.com is the home page for the International Furnishings and Design Association.
www.design-engine.com/ is an on-line magazine.

Chapter 10, Photojournalist

Photojournalists work for newspapers, television stations, and magazines. Their challenge is to extract exciting images from routine assignments.

Organizations:
American Society of Media Photographers, 14 Washington Rd., Ste. 502, Princeton Junction, NJ 08550 (609) 799-8300

Web sites:
www.asmp.org/ for publications, links.

Chapter 11, Fabric Designer

Fabric design may involve designing woven fabric, printed fabric, wallpaper, or other patterned surfaces. CAD software is often used for fabric design.

Organizations:
Surface Design Association, P.O. Box 20799, Oakland, CA 94620-0799
Textile Fibre Forum, P.O. Box 38, The Gap, Q4061, Australia

Web sites:
http://penland.org is the home page for the Pennland School of Crafts.
www.textileweb.com for an overview of the textile industry.

Chapter 12, Storyboard Illustrator

Storyboard artists often work in animated film production, as well as for film and advertising. This work is essential to mapping out the content of a film.

Organizations:
Society of Illustrators, 128 E. 63 St., New York, NY 10021 (212) 838-2560

Web sites:
www.motionartists.com for samples of work by storyboard illustrators.

Portfolio Planning

Portfolios and Displays

portfolio 1: a flat portable case (as a briefcase, a large heavy envelope, or a loose-leaf binder) for carrying papers or drawings.[1]

Explain to students how professional artists, designers, and artisans utilize portfolios. Portfolios contain a select representation of an artist's best work. Artists show the art in their portfolios to gallery owners with the hope of having their work displayed. Graphic artists and interior decorators encourage clients to preview the art in their portfolios to facilitate an understanding of their style. Even floor tile installers display portfolios featuring photographs of their past projects.

Similarly, high school students who are planning a career in art or design will wish to collect their best work in a portfolio to show to university or art school admissions staff. They may wish to use their artwork from this course as a basis for assembling such a portfolio.

There are further reasons for all students to create portfolios as the semester progresses. Assessment (both by the teacher and self-assessment) is a key component of learning and in an art curriculum, the portfolio is integral to assessment. For an understanding of portfolios and their use as assessment tools, read **Portfolios** on the next page.

As you plan your semester, think about ways in which you can maximize the effectiveness of your students' portfolios. For example, do you wish to expand on the standard "best-works" portfolio by adding a "mini-portfolio" for certain projects?

Portfolios

As each chapter is completed, students add to their course portfolio by saving their most successful work. Sculpture or other three-dimensional work can be photographed and the slide or print included in the portfolio.

At the close of the semester, students can choose their best work for inclusion in a final portfolio and/or art show.

- Students may make their portfolio from two pieces of posterboard hinged together with tape.
- In their portfolio, students should include artwork that is representative of the categories discussed in the text; for example, for Chapter 1 they should include drawings with a variety of line types, line personality, line quality, and line combinations. Their drawings should show line creating texture and pattern.
- Unless their work is on heavy board, it should be matted or mounted to preserve it. Students may produce slide portfolios of their works. These are beneficial for interviews and for jurying processes.
- A placeholder can be made for any artwork that is currently on display and therefore not included in the student's portfolio. Information can be written on a piece of paper, including the chapter or project, medium, and title of work. When the display is dismantled, the work should be returned to the portfolio.

The following materials will be needed for student portfolios.

- student work
- heavy paper or posterboard
- tape

See **Management** on page T-265 for pertinent ideas and suggestions related to storage of portfolios.

Displays

The following materials will be needed for displaying student work.

- matting or mounting board
- standards
- tape
- utility knives
- straightedges

To display student art, you will need standards (structures built for or serving as a base of support for three-dimensional art), easels, bulletin boards, or walls on which art may be taped or hung. Display standards may be made from large cardboard boxes which are either painted or covered with craft paper.

Labels for each student's work may be made using a computer. In addition to the student's name, these may include their age, title of artwork, medium, and name of art course. If you group the projects together by assignment, include a card that briefly describes the assignment.

[1] *Webster's Third New International Dictionary*, Springfield, MA: G. & C. Merriam Co., 1981.

Portfolios

Excerpted from *Assessment in Art Education* by Donna Kay Beattie

In the past, the student art portfolio was viewed as a container for, or collection of, student artworks or products. More recently, as the art portfolio is increasingly used as a means of understanding and revealing processes, its definition has expanded to include a "purposeful collection of student work that tells the story of the student's efforts, progress, or achievement in (a) given area(s)".[1]

Whether referred to generally as the "art portfolio," or more specifically as the "process folio," "mini-portfolio,"[2] and "best-works portfolio,"[3] the portfolio as used in the art classroom today emphasizes *significant* evidence about the progress, achievements, and experiences of the student. The art portfolio, in its expanded definition, can replace other types of assessments and function as a teaching tool as well in that it motivates and challenges students, promotes learning through reflection and self-assessment, encourages student-teacher collaborations, validates different learning styles and approaches, and encourages the research, resolution, and communication of ideas. The art portfolio underscores to both students and parents the importance of growth and development. Finally, the portfolio provides an important tool for evaluating the curriculum and determining necessary changes.

Terms to Know

best-works portfolio Includes only students' best work, accumulated over a specified time period.

expanded art portfolio A thick base of information representing rich qualitative and ample quantitative evidence pertaining to a wide variety of thinking processes and art products.

mini-portfolio An abbreviated portfolio that focuses on a collection of art products based on a single theme, project, or artistic activity; a collection of evidence derived from a holistic task that addresses each of the four art disciplines; or a single unit of study. Several mini-portfolios can serve as the basis for a larger portfolio.

process folio A portfolio of evidence about student growth and learning, with an emphasis on process.

Evidence

The earmark of a good art portfolio is its depth, regardless of the amount of time it spans. To be used as a performance assessment tool, the art portfolio should:

- specify the goals of the school, program, or student in a letter of introduction by the student.
- reveal evidence about learning in the four disciplines including knowledge of content, processes, conditions (or why certain processes are more appropriate), metacognition, art motor skills, and values, attitudes, and interests.
- reveal three kinds of physical evidence: primary, secondary, and extrinsic.[4]
- reveal a complete picture of and relate to specific goals of the art curriculum, a unit of study, or a specific discipline area.
- show progress over time.
- show significant achievements. A "best piece" can be specified with a note of explanation.
- reveal learning difficulties.
- reveal what is significant to the student.
- involve the student in the process of selection, reflection, and justification.
- include didactic information, (i.e., materials annotated by the student and/or teacher to include dates, explanations relating evidence to assignments and objectives, and reasons for inclusion).
- reflect adherence to performance standards.

In addition to such evidence, the art portfolio might also include a table of contents or outline of portfolio organization, a timeline of due dates for required entries, an exit letter describing major entries and reflection on learning outcomes, and a skills chart in which students indicate skills emphasized in specific entries or in the entire portfolio. A scoring rubric describing performance criteria and qualifying standards can be included in the portfolio. A statement explaining how performance standards are translated into exit levels of achievement might also be added to

the portfolio. The **Student Checklist for Portfolio Evidence** shows a sample checklist of evidence the art educator might require for student portfolios.

Evaluation

Because of their breadth, depth of content, and amenability to diverse reviewing and assessing techniques, portfolios offer a wealth of multi-layered information about student learning. Portfolios reveal students in both *maximum* and *typical performance postures* and, for this reason, serve in both summative and formative assessment roles.

Three scoring approaches are applicable to portfolio evaluation: *holistic, analytic,* and *modified holistic.* The teacher might use the holistic approach to score the portfolio if he or she is not interested in the separate entries but in the portfolio as a single example of student performance—or, if time does not permit separate scoring of key individual entries. If the portfolio is a summative examination of students' abilities to produce a body of work on their own based on a theme, or is a mini-portfolio focusing on a unit of study, then the holistic approach is also appropriate.

A holistic approach judges, rates, or scores the entire portfolio as a single corpus of information. The following assessment criteria can be used to score the art portfolio holistically.

Researching:

- selection and development of themes, problems, issues, techniques, and processes through study, research, or exploration
- variety of appropriate sources

Student Checklist for Portfolio Evidence

Please place a check beside all evidence that you have included in your portfolio.

1 Include in your portfolio two letters to the teacher.

☐ introductory letter explaining your portfolio, your main purpose for creating it, and your goals pertaining to it

☐ exit letter describing major entries and reflecting on your learning outcomes in modes of thinking related to the artist, art historian, critic, and aesthetician

2 Include a Table of Contents or outline of the organization of the portfolio.

☐ Table of Contents

3 Include in your portfolio all materials that relate to solving your assigned problem(s).

☐ notes on the way you think about the problem, your interpretation of it, and how your thinking has changed

☐ "brainstorming" ideas for solving the problem

☐ research materials and sources that helped you solve the problem(s) or gave you insights or hints about what direction to pursue

Creating:

- personalized and expressive approach to the area of study (i.e., art history, criticism, aesthetics, or art production)
- conceptual importance
- intellectual and creative curiosity driving art study and work
- demonstration of knowledge and skills pertaining to visual lan-

☐ notes on the way you solve problems (i.e., your personal artistic problem-solving process)

☐ sketches, studies, or rough drafts that helped you practice and/or determine the solution(s) to the problem(s)

4 Include in your portfolio your final product(s) and specific materials that relate to it.

☐ final product(s) or visual evidence of it

☐ brief self-evaluation statement and judgment or scoring of the process that you went through to arrive at the final work piece(s)

☐ brief self-evaluation statement and judgment or scoring of the final work piece(s)

☐ brief argument (oral or written form), supporting your judgment of your portfolio. Your argument should take into account the total situation and the above-stated guidelines. Present your main points clearly and include reasons and rebuttals for anticipated challenges.

☐ brief description of your commitment and attitude toward creating the portfolio

guage, structures, forms, and vocabulary

Responding:

- responsiveness to personal, social, cultural, historical, philosophical, technological, environmental, economic, and aesthetic contexts and stimuli in the area of study
- demonstration of description, classification, analysis, interpre-

tation, and judgment of information and art images
- responsiveness to feedback
- depth of revision

Resolving:
- personalized and expressive solutions to problems or tasks in area of study
- completeness of collection (depth and breadth of entries)
- achievement of predetermined goals and objectives (student's, teacher's, school's)
- improvement from past performances

Communicating:
- presentation
- demonstration of self-reflection and self-assessment
- connection to other content areas and to daily life

When the portfolio is perceived as a repository of different types of knowledge, each requiring its own mark, then an analytic scoring approach is preferred. This approach evaluates and scores parts or characteristics of the product or process separately. For example, a teacher might give a separate score for the art history component, the art studio process, and the metacognitive skills of reflection. Each of the above-stated holistic criteria could be defined with degrees of quality, given a separate score, and then summed to obtain a single score. Cognitive processes, discipline-specific processes, and basic core skills also might be set up as criteria, examined, and rated.

The analytical scoring approach to portfolio evaluation need not exclude a holistic score. If the teacher wants discrete information about various areas of art learn-

ing, but also wants an overall or global score, then the modified holistic approach is best. A *modified holistic scoring approach* combines both scoring plans by scoring the whole first and then several major individual parts or attributes that support the global score. When combining both scoring plans, neither the holistic nor the analytic component is usually as detailed or comprehensive as each is when used independently.

Whatever approach art educators choose, portfolio evaluation utilizes a variety of assessment and scoring and judging strategies, such as checklists; rating scales; questionnaires; teacher, peer, parent, and other interviews; and student self-assessments. Different types of assessment strategies yield different kinds and levels of information. Assessment strategies, along with performance criteria and judging or scoring strategies, should be clearly understood by all involved. Ideally, evaluation should provide supportive information for judgments made by the art educator and enable the art educator to make needed changes in teaching and instruction. Evaluation should be documented in progress charts.

Interpretation

When the portfolio has been evaluated, the results need to be interpreted. Beyond a score or grade, the teacher determines what the portfolio really says about student learning, as individuals and as a class; the effectiveness of the curriculum; and the learning environment. The portfolio helps teachers address crucial questions about these three topics.

For a more meaningful interpreta-

tion of the portfolio, teachers might want to consider the following:

- To what extent have students' needs been met?
- What new needs have emerged for the students?
- Where will students go from here?
- What do the portfolios say about the classroom context? The learning environment? The art curriculum?
- What other kinds of information are revealed? Unexpected information?
- What evidence should be retained? What evidence might go to the next teacher?

Assessment hint
After answering these questions, write a summary or, even better, a personal letter to the student that describes what you discovered. The summary or personal letter can be placed in the student's portfolio.

Management
One of the most crucial issues the art teacher faces is managing the portfolios. Start by thinking about the design of the portfolio container. Will the portfolio container be large folded or stapled sheets of cardboard? A box? The computer?

What about storage? Where the portfolios will be stored is a major consideration (and problem) for the art educator. For storing large portfolios, consider cupboards or shelving accessible to students. If the portfolio will be used to examine students' abilities to produce a body of work independently within a specified time period, or, if it contains secondary evidence such as the teacher's observation notes, logs,

evaluative reports, quizzes, assessment formats, or report cards, then security is crucial, and such portfolios would need to be kept in locked spaces.

How and when will the portfolio be integrated with instruction? How will portfolios be managed and monitored in a classroom setting? How will portfolios be shared? Classroom time should be periodically set aside for students and teachers to organize and work on the emerging portfolios. Blocks of time are also required for reviewing and evaluating portfolios. Moreover, the art educator needs time to develop, implement, monitor, and make changes and revisions in the entire portfolio management system. Finally, procedures for sharing portfolios with parents, other teachers, other students, and other stakeholders also need to be planned and executed.

Certainly, the art teacher of 700 students will have to create a portfolio style and management system that accommodates so many children. The portfolio may be conceived differently, as a smaller corpus of information—a *mini-portfolio*.

The Mini-Portfolio

The mini-portfolio can be likened to a thick file containing all manner of materials relating to the file's label. An easy way for students to organize their art learning, the mini-portfolio sorts the art curriculum into bite-size chunks. Because of its brevity and documentary nature, the mini-portfolio can be used to collect evidence representing each of the four art disciplines as demonstrated in a single integrated task or a unit of study.

The mini-portfolio might be a collection of art products, with supporting procedural evidence and materials, based on a theme or an art activity. As such, the mini-portfolio might be used to assess how well students can set a personal theme and develop a body of work independent of the teacher or in some degree of collaboration with the teacher. The smaller portfolio could also be used to examine skills and processes specific to one particular unit of study. For the elementary teacher of art whose curricula may be organized around many units of study, the mini-portfolio works well for documenting each unit.

The mini-portfolio maintains characteristics of the expanded portfolio in that it contains all significant evidence of a performance, performance criteria and a scoring rubric, skills chart, places to enter grades or marks, and a progress chart. Yet, it remains manageable and relatively simple to monitor. The mini-portfolio is simple to create, using lightweight tag board or construction paper, and is easily stored. Using the mini-portfolio enables students to take less significant work home during the course or school year, while retaining in the school setting benchmark works in each discipline to serve as the basis of a best-works portfolio. Finally, the mini-portfolio can be assessed and scored using holistic, analytic, or modified holistic scoring approaches.

Notes

[1] J.A. Arter, "Portfolios in Practice: What Is a Portfolio?" (paper presented at the annual meeting of the American Educational Research Association, San Francisco, CA, April 1992) ERIC, ED 346156.

[2] D.K. Beattie, "The Mini-Portfolio: Locus of a Successful Performance Examination," Art Education 42: no. 2 (1994): pp. 14–18.

[3] A.J. Nitko, Educational Assessment of Students, 2d ed. (Englewood Cliffs, NJ: Charles E. Merrill Publishing Co., 1996).

[4] H.G. Mackintosh, "The Use of Portfolios in School-Based Assessment: Some Issues" (paper presented at the nineteenth annual conference of the International Association for Educational Assessment, Reduit, Mauritius, 1993).

[5] See note 2 above.

This excerpt is reprinted from:
Beattie, Donna Kaye. *Assessment in Art Education*. Art Education in Practice Series, ed. Marilyn G. Stewart. Worcester, MA: Davis Publications, Inc., 1997.

g Through
ɪ. **Stewart**

phobias that
for us in recent
think we should
phobia." People are
to enter into the
sophy for a variety of
of which is the suspi-
the terminology is foreign,
t, and convoluted. To career-
ed students, philosophy as a
ɉect to be encountered in univer-
ty courses seems far removed from
heir immediate needs. There is a
perception that philosophers only
think, talk, and write—that their
world is one of thought, not action.
Our action-filled world dictates
that there is no time to while away
hours by simply thinking. This view
of philosophical inquiry fails to rec-
ognize the dynamic potential of
philosophical discussions to help us
clarify and refine our ideas. It also
fails to recognize how our ideas are
importantly connected to our
actions and how much more mean-
ingful our actions are when seen in
light of larger visions of the world
and our place within it. As Plato
quotes Socrates, "The life which is
unexamined is not worth living."

Children have beliefs about
art and often raise philosophical
questions about art. As we acquire
language, we acquire concepts. As
children learn to use the term "art,"
they learn how the term is most
often used within their language
community. They may not be aware
that they have beliefs about art, but
they bring their beliefs to bear upon
the comments they make and the
questions they ask. For instance,
when a child worries that her art-
work is too much like another
child's and is therefore not good,
she probably holds the belief that an
artwork is good to the extent that it
is original or unique. The origin of
this belief cannot be specifically
identified; it is the sort of assump-
tion that we learn indirectly from
being in a particular language com-
munity. Most teachers of art have
experienced the situation in which
students wonder why a certain work
of art or a certain kind of art is
thought to be good. They ask,
"Why is this art?" and make com-
ments such as "Even I could have
done *that!*" When students raise
such issues, they typically subscribe
to certain beliefs about what art is
and also what *good* art is. These
beliefs become more meaningful
when they have been examined and
their implications made explicit.

Assumptions Guiding Practice

Capitalizing on the tendency of
children to ask why, and having an
interest in helping children develop
the thinking skills required to
address their queries, several
philosophers and educators have
developed strategies for teaching
students how to take part in philo-
sophical inquiry. Increased attention
to teaching aesthetics has followed a
widespread emphasis on broadening
our conceptions of art education,
and has led to recommendations that
the study of art include emphasis on
art-historical inquiry, art criticism,
and studio production, as well as
aesthetics or philosophical inquiry.[1]

As is often the case with rec-
ommendations or prescriptions for
curriculum development, certain
assumptions about children and
philosophical inquiry support most
discussions about teaching aesthet-
ics as a type of philosophical
inquiry. These assumptions include
the following:

Assumption 1
Children have beliefs about art.
Children have beliefs about making,
perceiving, and responding to art;
and about the role of art in society.
Children formulate their beliefs out
of their experiences, and because
children's experiences are widely
varied, so too are their beliefs. Some
children have more deeply embed-
ded beliefs than others. All chil-
dren, however, are influenced by
their beliefs when they make deci-
sions about objects they create and
when they respond to objects creat-
ed by others.

Assumption 2
Children raise questions about art.
Children often raise questions
about making, perceiving, and
responding to art; and about the
role of art in society. Like the
woman leaving the Museum of
Modern Art, they sometimes won-
der whether something considered
art by others is, indeed, art.
Depending on their beliefs, they
may question why an abstract paint-
ing, for instance, is considered good
when it fails to correspond realisti-
cally to things they have seen in the
world. Children may question the
merit of a work of art that makes
them feel sad, believing that art
should make people feel good or
happy. A child may question
whether it's a good thing to have art

that shows bad things happening, believing that such art condones bad behavior. In this case, the child might well believe that art should have a positive effect on behavior. Children may believe that artworks should not be messy. They might find that much of what is considered art is messy, which prompts questions about its merit. Indeed, they might consider some of their own artworks to be messy and therefore not worthy of serious attention. Because they hold certain beliefs and encounter experiences that call their beliefs into question, children readily and routinely ask philosophical questions.

Assumption 3
Children can and should reflect on their beliefs.

One of the most important goals of schooling is to broaden children's experiences and thus their conceptions of the world. Within the area of art teaching, there is much to be gained by providing opportunities for children to reflect on their beliefs and their questions about art and related concepts and ideas. This is accomplished by challenging their beliefs, whether by showing them artworks that fall outside their conceptions of art, or by exposing them to thinking that does not correspond to their own. Critical reflection about the merits of one's beliefs cannot take place without awareness of these beliefs.

Another broad goal of schooling is to develop children's critical thinking. A child can learn to think critically about art-related matters through an examination of the merits of competing beliefs. Critical thinking can be addressed through the teaching of art when students

are given opportunities to think seriously about art, their perceptions of and response to art, and the role of art in culture.

Assumption 4
Children can and should discuss their views with others.

While it is certainly good to have children be reflective about their own beliefs and questions about art, they can benefit further by discussing their beliefs and questions with others. In such discussions, children see that not everyone necessarily shares their beliefs. If the rules of discussion include listening carefully and withholding judgment, children can seriously consider other views; they can "try on" and weigh the merits of the competing views. Children may find that a change in belief makes sense. Or, they may find that even though an alternative view has merit, they do not change their beliefs but do learn to respect the alternative view.

Assumption 5
While engaging in philosophical discussions, children can and should develop their skills in good reasoning.

In order to reflect on their beliefs and to discuss philosophical issues related to art, children must develop their abilities to listen well, to make distinctions, to identify assumptions, to offer carefully constructed reasons for their views, to raise carefully constructed questions about the views of others, to weigh their own reasons and those of others for particular views, and to imagine alternative solutions to issues. Reasoning skills can be taught directly and indirectly, and can be refined through practice.

Assumption 6

Criti
trans
curric

The dev
skills is an
cation. Critic
taught and pra
of the curricul
taught and practi
program. Art teac
learners understand
thinking skills develop
subject areas can also be
Accord-ingly, teachers o
ject areas can help learne
the skills developed in art to
other areas.

Assumption 7
Engagement in philosophical inquiry is integral to engagement in the study of art.

Students in art classes make objects that connect to their experiences, dreams, and ideas. They also respond to their own artworks and those of others in an effort to understand themselves and their relationships with the broader world. In a curriculum that helps them in these efforts, students learn how to carefully consider their own artworks and those of others in their social-historical contexts, seeking to interpret their meanings and judge their merit. Making art is connected to beliefs about art—what counts as art, what makes an artwork meaningful and good, and how art reflects individual and social beliefs. Response to our own art and that created by others is also connected to such beliefs. Art-making and responding is intentional, authentic, and meaningful to the extent that we are aware of the implications of the activity. Without

opportunities to reflect critically on their beliefs about art, students tend to view art-making as a chance to simply manipulate materials, and art viewing as a time to offer thoughtless reactions to artworks.

Notes

[1] See, for example, Gilbert Clark, Michael Day, and Dwaine Greer, "Discipline-Based Art Education: Becoming Students of Art," The Journal of Aesthetic Education 21: No. 2, (1987): 129–193.

This excerpt is reprinted from: Stewart, Marilyn G. *Thinking Through Aesthetics*. Art Education in Practice Series. Worcester, MA: Davis Publications, Inc., 1997.

Art materials can be costly and teachers work on restricted budgets. At times, the thought of providing adequate supplies to every student can be discouraging. Yet with some thoughtful planning and cooperation, the challenge can be met.

Be always on the lookout for alternative sources of painting, drawing, sculpting, and craft supplies. Encourage your students to be on the lookout as well.

Low-cost Materials

- Buying in bulk can often save money. For example, gallons of paint may be purchased and stored in smaller containers for a longer shelf life. Ask students to save any plastic beverage bottles with closable spouts for use as paint storage containers.
- Paper mills, merchants, or recycling firms may sell end rolls of paper for considerably less money than cut and packaged paper.
- Wallpaper from an outlet store or garage sale makes a fine surface.
- Home-improvement superstores or lumberyards often sell 1/4"-thick sheets of 4' x 8' Masonite inexpensively and will cut them into any size you specify for a minimal fee. Pretreat the surface with gesso or size with house paint.
- Newsprint or white butcher paper is a good choice for drawing exercises and can be used with most dry, moist, and wet media. Newsprint is more suited for dry media—but, experiment!

- Grocery, department store, and even small (lunch-size) brown bags can be used for printing and drawing. This paper offers a good surface for ink, wash, and combined media.
- Large ice cream tubs may be obtained from stores after they are emptied.
- Paper merchants provide free samples to printing companies and design firms. After a year or two, these are frequently discarded as new ones become available. Although small in size, they contain a variety of colors and textures.
- Printing firms may sell excess paper by the pound. Clay-coated papers can be used a surface for ballpoint pen, markers, ink, wax crayons, oil pastels, grease pencils, acrylics, oils, and some combined media.
- Shipping boxes gleaned from stores provide large sheets of cardboard, a very worthwhile drawing surface. It may be primed, or used as is. The tan surface is compatible with compressed charcoal, conte, pen, brush and ink, acrylic and oil paints, and other media.
- Gator board and foam core trim pieces can be found at custom photography processing plants. These may be used for drawing, or as presentation boards.
- Shoe polish can be used as a drawing or painting material. It contains analine dye.
- Soda straws and coffee stirrers can be cut on a diagonal for use as drawing pens.

Found Objects

Humans can be wasteful. Be open to adapting or developing projects from materials considered unusable. Develop a "scavenger mentality" and relish the opportunity to find new ways to make use of discarded materials. Use these "found objects" for a variety of design projects.

Off-cuts from woodworking or cabinetry shops can often be obtained free of charge. Ask contractors and builders to set aside scraps of lumber, wallboard, electrical wire, and other materials from their construction sites.

Magazines

A number of the projects in *Exploring Visual Design* call for the use of magazines. Old magazines and newspapers can be acquired from a variety of sources. Ask faculty, students, parents, and the school librarian for copies they might otherwise plan to discard. You might also ask staff at your local recycling center to be on the lookout and set some magazines aside.

Running a classified advertisement or asking local radio stations to air a public service announcement will likely bring you as many magazines as you will need for a semester or longer.

Safety in the Classroom

The secondary art program utilizes all kinds of specialized equipment, materials and tools. Precautions must be taken to insure that working with art materials does not lead to student illness or injury. **Failure to take necessary precautions may result in litigation if students become ill or are injured in the art room.** While restrictions are necessary, the teacher should be assured that nontoxic materials can usually be substituted for toxic ones with little or no extra cost, and good classroom management will prevent accidents.

Under the art material labeling law passed by Congress in October, 1988, every manufacturer, distributor, retailer and some purchasers (schools) have a legal responsibility to comply with this law. The law amended the Federal Hazardous Substances Act to require art and craft materials manufacturers to evaluate their products for their ability to cause chronic illness and to place labels on those that do.

CP, AP, and HL. What do they mean? The Art and Craft Materials Institute, Inc. has sponsored a certification program for art materials, certifying that these products are nontoxic and meet standards of quality and performance.

CP (Certified Product) are nontoxic, even if *ingested, inhaled* or *absorbed,* and meet or exceed specific quality standards of material, workmanship, working qualities and color.

AP (Approved Products) are nontoxic, even if *ingested, inhaled* or *absorbed.* Some nontoxic products bear the **HL (Health Label)** seal with the wording, "Nontoxic," "No Health Labeling Required." Products requiring cautions bear the HL label with appropriate cautionary and safe use instructions.

Teachers should check with their school administrators to determine if the state board of education has prepared a document concerning art and craft materials that cannot be used in the classroom, and listed products that may be used in all grade levels. If no list is locally available, contact The Art and Craft Materials Institute, Inc., 715 Boylston Street, Boston, MA, 02116 for a list of art products bearing the CP, AP, or HL/Nontoxic Seal.

In addition to determining that only nontoxic media are available in the classroom, the teacher is responsible for instruction in how to use all tools and equipment correctly and safely.

Make sure that the artroom has accident preventing items such as the following:

- Signs on or near all work areas and equipment where injury might occur if students are careless, or should have instruction prior to use of the equipment.
- Protective equipment such as safety glasses, respiratory masks and gloves.
- A first aid kit containing antiseptics, bandages and compresses.
- Adequate ventilation to exhaust fumes from kilns, dust and procedures such as melting wax for batik.
- Safety storage cabinets and safety cans for flammable liquids. You are better off not to keep them in the classroom.
- Self-closing waste cans for saturated rags.
- Soap and water wash-up facilities.
- Lock cabinets for hazardous tools and equipment.
- Rules posted beside all machines.

Precautions the teacher may take:

- Always demonstrate the use of hand and power tools and machines.
- During demonstrations, caution students concerning any potential hazards related to incorrect use of equipment.
- Give safety tests before permitting students to use tools and machines, and keep the tests on file.
- Establish a safety zone around all hazardous equipment.
- Establish a dress code for safety indicating rules about clothing, jewelry and hair in order to prevent accidents.
- Establish a code of behavior conducive to the safety of individuals and their classmates, and enforce it.
- Keep aisles and exits clear.
- Be aware of any special problems among students such as allergy, epilepsy, fainting or handicap.

Some "Do Nots" for the Safety Conscious Art Teacher:

- Do not absent yourself from the art room when pupils are present.
- Do not ignore irresponsible behavior and immature actions in the art room.
- Do not make the use of all tools and machines compulsory.
- Do not permit students to work in the art room without supervision.
- Do not permit pupils that you believe to be accident prone to use power equipment. Check on the eligibility of some mainstreamed students to use power tools.

Teachers should demonstrate constant concern for safety in the art room, and teach by example to help students accept responsibility for accident prevention. For a thorough discussion of health and safety hazards associated with specific media and procedures see *Safety in the Artroom* by Charles Qualley, 1986.

Art Materials

Media

CHAPTER	1	2	3	4	5	6	7	8	9	10	11	12
basket-weaving material											●	
beads									●			
cardboard		●			●	●	●		●		●	●
ceramic glaze					●						●	
charcoal, black	●	●	●							●		
charcoal, white			●									
clay, ceramic		●			●	●		●		●	●	●
clay, oil-based		●										
clay, self-hardening					●	●						
colored pencil					●			●		●	●	●
Conté crayon			●			●				●		
crayons		●	●			●				●		●
fabric scraps/samples										●	●	
felt									●			
felt-tip markers	●	●		●	●		●	●	●	●	●	●
finger paint										●		
fixative, workable				●	●							
fixative, clear acrylic					●							
glue/craft adhesive			●	●	●	●	●	●	●	●	●	●
india ink	●	●				●			●		●	●
ink pads								●			●	
linoleum blocks											●	
magazines				●	●	●	●		●	●	●	●
newsprint	●		●			●				●		●
paint, acrylic	●				●	●			●	●	●	●
paint gel, acrylic								●				
paint retardant, acrylic								●				
paint, tempera			●		●		●	●		●	●	●
papier-mâché										●		
pastels/pastel pencils					●	●		●	●		●	
pen and ink										●	●	
pencils	●	●	●		●	●	●	●	●	●	●	●
plaster of Paris	●									●		
printing ink, water soluble											●	
raffia						●						
rope, cord, clothesline						●						●
string/yarn		●				●	●		●			●
tape, colored					●							
tape, drafting								●				
tape, duct										●		
tape, masking						●	●	●	●			●
watercolor				●	●	●						●
wire	●	●					●			●		●
wood, scraps		●										
wood, plywood					●							
wood, balsa										●		

Paper/Surfaces

CHAPTER	1	2	3	4	5	6	7	8	9	10	11	12
acetate, clear				●		●						●
acetate or gels, colored				●								
acrylic medium, matte or gloss										●		
canvas or canvas covered board												●
cereal boxes, empty										●		
coiling core					●							
illustration board								●	●		●	●
manila paper				●								
oak tag board									●			
paper, colored		●		●	●		●	●		●		
9" x 12" or smaller		●	●	●				●				
12" x 18"	●	●		●						●		
18" x 24"										●		
paper, construction										●	●	
paper, craft										●		
paper, graph										●		
paper, heavy, white				●		●				●		
colored					●							
paper, pastel												
9" x 12"				●								
18" x 24"			●									●
paper rush						●						
paper, white									●	●		
8 1/2" x 11" or smaller	●	●	●	●	●		●	●		●	●	●
9" x 12"		●		●	●	●		●		●	●	
12" x 18"	●			●	●			●	●	●		
18" x 24"		●			●		●					
paper, rice										●		
paper, textured scraps									●			
paper, tissue colored				●								
paper, tracing		●				●	●				●	●
paper, wall										●		
paper, watercolor						●						
paper, wrapping										●		
poster board												
11" x 14" or smaller				●					●			
14" x 20"							●					
22" x 28"				●								
sketchbook						●	●	●		●	●	
tag board					●							
wood (for base)	●							●				

● = required, ● = optional

Tools

CHAPTER	1	2	3	4	5	6	7	8	9	10	11	12
bench hooks or C-clamps											•	
brayers											•	
brushes	•	•		•		•	•	•	•		•	•
carving tools	•											
clay tools		•			•			•		•	•	
compasses		•								•	•	
eraser	•						•				•	
french curves		•										
glue gun									•		•	
hammer	•											
kneaded erasers			•									
lettering stencils									•			
linoleum cutters											•	
orange sticks					•							
palettes				•			•	•				•
palette knives								•				
plastic containers/lids					•	•	•	•	•		•	
protractors	•											
pliers	•											
rolling pins						•	•				•	
ruler/straight edge		•				•	•	•	•	•	•	•
scissors	•	•	•	•	•	•	•	•	•	•	•	•
staple gun/staples	•											
sticks and twigs	•						•	•				•
tapestry needles						•						
tissue				•	•							
triangles		•										
tongue depressors					•							
toothpicks		•									•	
tortillons				•	•							
utility knives									•			
wire cutters	•	•					•			•		•
woodworking tools		•										
X-acto knives		•									•	•

Other

CHAPTER	1	2	3	4	5	6	7	8	9	10	11	12
aluminum foil					•	•						
boards 1/4" thick						•						
boxes, different sizes					•							
boxes, soft wood (balsa)											•	
bright light source				•								
camera/film	•					•			•	•	•	•
coat hangers								•				•
cotton batting									•			
cutting boards									•			
cylinder					•							
dowels												•
envelopes										•		
fall leaves				•								
floodlights, flashlights, lamps	•	•				•				•		
font examples												•
inking plates (pie tins, foam trays, or cookie sheets)					•							
lace/trim										•		
large box					•							
magnifying glasses/loupes							•					
map of Africa/world										•	•	•
music with varying rhythms												•
newspaper comic strips												•
objects, colored				•	•							
objects, found (buttons, shells)					•		•			•		
objects, nature	•					•				•	•	
objects, round					•							
objects, still-life	•	•	•	•				•				
objects, symmetrical nature							•					
objects, textured				•			•					
objects, toy/dolls										•		
objects with radial patterns											•	
opaque projector									•			
paintings, random patterns					•							
paper bags					•							
paper clips					•	•						
photograph/drawing of school					•							
plastic wrap					•							
Polaroid/digital camera										•		
prisms					•							
portraits (professional photog.)									•			
quilts												•
school yearbook												•
sponges/paper towels						•						•
street map, enlargement										•		
student color wheels					•							
student wash drawings										•		
vehicle models												•
video tape equipment									•			
viewfinders		•					•		•			
work surface for clay, paint, wood					•	•				•	•	

Distributors, Manufacturers, General

Armada Art Materials, Inc., Hamilton, NJ

Art Extension Press, Westport, CT

Art Supplies Wholesale, Beverly, MA

Beckley Cardy Group, Mansfield, OH

Bluebird Manufacturing, Fort Collins, CO

Cascade School Supply, North Adams, MA

Cheap Joe's Art Stuff, Boone, NC

Daniel Smith Artists' Materials, Seattle, WA

Dick Blick Art Materials, Galesburg, IL

Fiskars, Inc., Wausau, WI

General Pencil Co., Redwood City, CA

Graphic Chemical & Ink Co., Chicago, IL

Lou Davis Wholesale, Lake Geneva, WI

Nasco Arts and Crafts, Fort Arkinson, WI

Parent Child Press, Hollidaysburg, PA

Rich Art Color Co., Inc., Northvale, NJ

Sax Arts and Crafts, New Berlin, WI

School Specialty, Appleton, WI

SK Merchandising Corp., Olyphant, PA

Speedball Art Products Co., Statesville, NC

The Testor Corporation, Rockford, IL

Triarco Arts and Crafts, Inc., Plymouth, MN

TSI, Inc., Seattle, WA

United Art and Education Supply, Ft. Wayne, IN

Utrecht Manufacturing Corp., Brooklyn, NY

Vanguard Crafts, Inc., Brooklyn, NY

Winsor and Newton, Piscataway, NY

World of Learning, Inc., Richmond, VA

Adhesives, Fixatives
Glue, Paste, Rubber Cement, Wax Systems

American Art Clay Co., Inc., Indianapolis, IN

Art Supplies Wholesale, Beverly, MA

Binney & Smith, Inc., Easton, PA

The Compleat Sculptor, Inc., New York, NY

Cascade School Supplies, North Adams, MA

Dixon Ticonderoga Co., Maitland, fl

Lou Davis Wholesale, Lake Geneva, WI

M & M Distributors, Tennent, NY

Mile Hi Ceramics, Denver, CO

MAS International, Inc., West Palm Beach, fl

Portage, Akron, OH

Sax Arts and Crafts, New Berlin, WI

School Specialty, Appleton, WI

The Stikkiworks Co./Lectrostik, Glendale Heights, IL

TSI, Inc., Seattle, WA

World Class Learning Materials, Baltimore, MD

Painting Fixatives

Binney & Smith, Inc., Easton, PA

Cascade School Supplies, North Adams, MA

Lou Davis Wholesale, Lake Geneva, WI

M & M Distributors, Tennent, NJ

MAS International, Inc., West Palm Beach, FL

Sax Arts and Crafts, New Berlin, WI

Spray and Dry Adhesives

Art Supplies Wholesale, Beverly, MA

Binney & Smith, Inc., Easton, PA

Cascade School Supplies, North Adams, MA

Lou Davis Wholesale, Lake Geneva, WI

M & M Distributors, Tennent, NJ

MAS International, West Palm Beach, FL

Sax Arts and Crafts, New Berlin, WI

School Specialty, Appleton, WI

Calligraphy Supplies

Art Supplies Wholesale, Beverly, MA

Daniel Smith Artists' Materials, Seattle, WA

Fascinating Folds, Glendale, AZ

Gagne, Inc., Johnson City, NY

MAS Internatioanl, Inc., West Palm Beach, FL

Sakura of America, Hayward, CA

Saral Paper Corp., New York, NY

Sax Arts and Crafts, New Berlin, WI

School Specialty, Appleton, WI

Speedball Art Products Co., Statesville, NC

Utrecht Manufacturing Co., Brooklyn, NY

Ceramics
Clays and Glazes

American Art Clay, Co., Inc., Indianapolis, IN

American Ceramic Supply Co., Fort Worth, TX

A.R.T. Studio Clay Co., Sturtevant, WI

Bailey Ceramic Supply, Kingston, NY

Cascade School Supplies, North Adams, MA

Chavant, Inc., Red Bank, NJ

Continental Clay Co., Minneapolis, MN

Creative Paperclay" Co., Inc., Camarillo, CA

Georgie's Ceramic and Clay Co., Portland, OR

Krueger Pottery, Inc., St. Louis, MO

Laguna Clay Co., City of Industry, CA

Lou Davis Wholesale, Lake Geneva, WI

MAS International, West Palm Beach, FL

Mid-South Ceramic Supply, Nashville, TN

Mile Hi Ceramics, Denver, CO

Minnesota Clay USA, Bloomington, MN

Polyform Products Co., Elk Grove Village, IL

Sax Arts and Crafts, New Berlin, WI

School Specialty, Appleton WI

Sheffield Pottery, Inc., Sheffield, MA

Spectrum Glazes, Ontario, Canada

Standard Ceramic Supply, Pittsburgh, PA

Texas Pottery Supply, Fort Worth, TX

Kilns

AIM Kiln Mfg., Corvallis, OR

American Art Clay Co., Inc., Indianapolis, IN

A.R.T. Studio Clay Co., Sturtevant, WI

Bailey Ceramic Supply, Kingston, NY

Cascade School Supplies, North Adams, MA

Contemporary Kiln, Inc., Novato, CA

Continental Clay Co., Minneapolis, MN

Georgie's Ceramic and Clay Co., Portland, OR

Great Lakes Clay and Supply, Carpentersville, IL

Krueger Pottery, Inc., St. Louis, MO

L & L Kiln Manufacturing, Inc., Aston, PA

Laguna Clay Co., City of Industry, CA

Lou Davis Wholesale, Lake Geneva, WI

MAS International, West Palm Beach, FL

Mid-South Ceramic Supply, Nashville, TN

Minnesota Clay USA, Minneapolis, MN

Paragon Industries, Inc., Mesquite, TX

Sax Arts and Crafts, New Berlin, WI

School Specialty, Appleton, WI

Sheffield Pottery, Inc., Sheffield, MA

Skutt Ceramic Products, Portland, OR

Texas Pottery Supply, Fort Worth, TX

Kiln Venting Systems

AIM Kiln Mfg., Corvallis, OR

American Art Clay Co., Inc., Indianapolis, MN

American Ceramic Supply Co., Fort Worth, TX

A.R.T. Studio Clay Co., Sturtevant, WI

Bailey Ceramic Supply, Kingston, NY

Cascade School Supplies, North Adams, MA

Continental Clay Co., Minneapolis, MN

Georgie's Ceramic and Clay Co., Portland, OR

Great Lakes Clay and Supply, Carpentersville, IL

Mile Hi Ceramics, Denver, CO

Minnesota Clay USA, Minneapolis, MN

Paragon Industries, Inc., Mesquite, TX

Sax Arts and Crafts, New Berlin, WI

School Specialty, Appleton, WI

Sheffield Pottery, Inc., Sheffield, MA

Skutt Ceramic Products, Portland, OR

TSI, Inc., Seattle, WA

Texas Pottery Supply, Fort Worth, TX

Vent-A-Kiln Corp., Buffalo, NY

Tools and Supplies

American Art Clay Co., Inc., Indianapolis, IN

American Ceramic Supply Co., Fort Worth, TX

A.R.T. Studio Clay Co., Sturtevant, WI

Bailey Ceramic Supply, Kingston, NY

The Compleat Sculptor, Inc., New York, NY

Cascade School Supplies, North Adams, MA

Continental Clay Co., Minneapolis, MN

Debcor, Inc., South Holland, IL

Georgie's Ceramic and Clay Co., Portland, OR

Great Lakes Clay and Supply, Carpentersville, IL

Krueger Pottery, Inc., St. Louis, MO

Laguna Clay Co., City of Industry, CA

Loew-Cornell, Inc., Teaneck, NJ

Lou Davis Wholesale, Lake Geneva, WI

MAS International, West Palm Beach, FL

Mid-South Ceramic Supply, Nashville, TN

Mile Hi Ceramics, Denver, CO

Minnesota Clay USA, Minneapolis, MN

Paragon Industries, Inc., Mesquite, TX

The Potters Shop, Needham, MA

Saral Paper Corp., New York, NY

Sax Arts and Crafts, New Berlin, WI

School Specialty, Appleton, WI

Sheffield Pottery, Inc., Sheffield, MA

Standard Ceramic Supply, Pittsburgh, PA

TSI, Inc., Seattle, WA

Texas Pottery Supply, Fort Worth, TX

Color Wheels

Cheap Joe's Art Stuff, Boone, NC

MAS International, Inc., West Palm Beach, FL

Sax Arts and Crafts, New Berlin, WI

School Specialty, Appleton, WI

World Class Learning Materials, Inc., Baltimore, MD

Cutters, Knives, and Scissors

Alto's EZ Mat, Inc., Ellensburg, WA

Binney & Smith, Inc., Easton, PA

Cascade School Supplies, North Adams, MA

The Compleat Sculptor, New York, NY

Fiskars, Inc., Wausau, WI

Hunt Manufacturing Co., Philadelphia, PA

Lou Davis Wholesale, Lake Geneva, WI

M & M Distributors, Tennent, NJ

Portage, Akron, OH

Russell Harrington Cutlery, Inc., Southbridge, MA

Sax Arts and Crafts, New Berlin, WI

School Specialty, Appleton, WI

Speedball Art Products Co., Statesville, NC

TSI, Inc., Seattle, WA

Drawing Supplies
Boards

Art Supplies Wholesale, Beverly, MA

Cascade School Supplies, North Adams, MA

Cheap Joe's Art Stuff, Boone, NC

Crescent Cardboard Co., Wheeling, IL

Double R Publishing, Hudson, NY

MAS International, Inc., West Palm Beach, FL

Sax Arts and Crafts, New Berlin, WI

School Specialty, Appleton, WI

Scratch-Art Co., Inc., Avon, MA

TSI, Inc., Seattle, WA

Crayons

Art Supplies Wholesale, Beverly, MA

Binney & Smith, Easton, PA

Cascade School Supplies, North Adams, MA

Dixon Ticonderoga Co., Maitland, FL

General Pencil Co., Redwood City, CA

MAS International, Inc., West Palm Beach, FL

Sax Arts and Crafts, New Berlin, WI

School Specialty, Appleton, WI

Scratch-Art Co., Inc., Avon, MA

TSI, Inc., Seattle, WA

Ink

Art Supplies Wholesale, Beverly, MA

Cascade School Supplies, North Adams, MA

Cheap Joe's Art Stuff, Boone, NC

Daniel Smith Artists' Materials, Seattle, WA

Graphic Chemical & Ink Co., Chicago, IL

MAS International, Inc., West Palm Beach, FL

Rock Paint Dist. Corp., Milton, WI

Sax Arts and Crafts, New Berlin, WI

School Specialty, Appelton, WI

Speedball Art Products Co., Statesville, NC

Utrecht Manufacturing, Brooklyn, NY

TSI, Inc., Seattle, WA

World Class Learning Materials, Inc., Baltimore, MD

Markers

Art Supplies Wholesale, Beverly, MA

Binney & Smith, Inc., Easton, PA

Cascade School Supplies, North Adams, MA

Dixon Ticonderoga Co., Maitland, FL

Drimark Products, Inc., Port Washington, NY

Great Lakes Clay and Supply, Carpentersville, IL

MAS International, Inc., West Palm Beach, FL

SK Merchandising Corp., Olyphant, PA

Sakura of America, Hayward, CA

Sax Arts and Crafts, New Berlin, WI

School Specialty, Appelton, WI

TSI, Inc., Seattle, WA

Paper & Pads

Art Supplies Wholesale, Beverly, MA

B & J Supply, Appleton, WI

Cascade School Supplies, North Adams, MA

Cheap Joe's Art Stuff, Boone, NC

Colorations, Inc., Duluth, GA

Crescent Cardboard Co., Wheeling, IL

MAS International, Inc., West Palm Beach, FL

Pacon Corp., Appleton, WI

Sax Arts and Crafts, New Berlin, WI

School Specialty, Appleton, WI

TSI, Inc., Seattle, WA

WJ Fantasy, Inc., Bridgeport, CT

Pastels/Chalk

Art Supplies Wholesale, Beverly, MA

Binney & Smith, Inc., Easton, PA

Cascade School Supplies, North Adams, MA

Cheap Joe's Art Stuff, Boone, NC

Colorations, Inc., Duluth, GA

Dixon Ticonderoga Co., Maitland, FL

General Pencil Co., Redwood City, CA

Loew-Cornell, Inc., Teaneck, NJ

MAS International, Inc., West Palm Beach, FL

Sakura of America, Hayward, CA

Sax Arts and Crafts, New Berlin, WI

School Specialty, Appleton, WI

TSI, Inc., Seattle, WA

World Class Learning Materials, Inc., Baltimore, MD

Pencils (Charcoal & Colored)

Art Supplies Wholesale, Beverly, MA

Binney & Smith, Inc., Easton, PA

Cascade School Supplies, North Adams, MA

Cheap Joe's Art Stuff, Boone, NC

Dixon Ticonderoga Co., Maitland, FL

General Pencil Co., Redwood City, CA

MAS International, Inc., West Palm Beach, FL

Sakura of America, Hayward, CA

Sanford Corp., Bellwood, IL

Sax Arts and Crafts, New Berlin, WI

School Specialty, Appleton, WI

TSI, Inc., Seattle, WA

Pens

Art Supplies Wholesale, Beverly, MA

Cascade School Supplies, North Adams, MA

Cheap Joe's Art Stuff, Boone, NC

Dixon Ticonderoga Co., Maitland, FL

General Pencil Co., Redwood City, CA

MAS International, Inc., West Palm Beach, FL

Sakura of America, Hayward, CA

Sanford Corp., Bellwood, IL

Sax Arts and Crafts, New Berlin, WI

School Specialty, Appleton, WI

TSI, Inc., Seattle, WA

Fabrics

Burlap, Felt, Silk

Cascade School Supplies, North Adams, MA

Chicago Canvas & Supply, Chicago, IL

Sax Arts and Crafts, New Berlin, WI

School Specialty, Appleton, WI

Silkpaint Corp., Waldron, MO

Testfabrics, Inc., West Pittston, PA

Painting and Dyeing Supplies

General

American Art Clay Co., Inc., Indianapolis, IN

Binney & Smith, Inc., Easton, PA

Chicago Canvas & Supply, Chicago, IL

DEKA®/Decart, Inc., Morrisville, VT

PRO Chemical and Dye, Inc., Somerset, MA

Sax Arts and Crafts, New Berlin, WI

School Specialty, Appleton, WI

Silkpaint Corp., Waldron, MO

Silkpainting

DEKA®/Decart, Inc., Morrisville, VT

PRO Chemical and Dye, Inc., Somerset, MA

Sax Arts and Crafts, New Berlin, WI

School Specialty, Appleton, WI

Silkpaint Corp., Waldron, MO

Testfabrics, Inc., West Pittston, PA

Painting Supplies

Brushes, Cleaners

American Art Clay Co., Inc., Indianapolis, IN

Art Supplies Wholesale, Beverly, MA

Binney & Smith, Inc., Easton, PA

Cascade School Supplies, North Adams, MA

Cheap Joe's Art Stuff, Boone, NC

Colour Shapers, Belle Mead, NJ

Continental Clay Co., Minneapolis, MN

Daniel Smith Artists' Materials, Seattle, WA

Georgie's Ceramic and Clay Co., Portland, OR

General Pencil Co., Redwood City, CA

Great Lakes Clay and Supply, Carpentersville, IL

HK Holbein, Williston, VT

Loew-Cornell, Inc., Teaneck, NJ

Lou Davis Wholesale, Lake Geneva, WI

M & M Distributors, Tennent, NJ

Martin/F. Weber Co., Philadelphia, PA

MAS International, Inc., West Palm Beach, FL

Mile Hi Ceramics, Denver, CO

Sax Arts and Crafts, New Berlin, WI

School Specialty, Appleton, WI

TSI, Inc., Seattle, WA

World Class Learning

Materials, Inc., Baltimore, MD

Xcaliber Corp., Lyndhurst, NJ

Canvas & Supplies

Art Supplies Wholesale, Beverly, MA

Cascade School Supplies, North Adams, MA

Cheap Joe's Art Stuff, Boone, NC

Chicago Canvas & Supply, Chicago, IL

Crescent Cardboard Co., Wheeling, IL

Daniel Smith Artists' Materials, Seattle, WA

HK Holbein, Williston, VT

MAS International, Inc., West Palm Beach, FL

Sax Arts and Crafts, New Berlin, WI

TSI, Inc., Seattle, WA

Easels

Art Supplies Wholesale, Beverly, MA

Cascade School Supplies, North Adams, MA

Cheap Joe's Art Stuff, Boone, NC

Daniel Smith Artists' Materials, Seattle, WA

HK Holbein, Williston, VT

M & M Distributors, Tennent, NJ

Martin/F. Weber Co., Philadelphia, PA

MAS International, Inc., West Palm Beach, FL

Sax Arts and Crafts, New Berlin, WI

School Specialty, Appleton, WI

TSI, Inc., Seattle, WA

Paints (Acrylics, Oils, Tempera, Watercolor)

Art Supplies Wholesale, Beverly, MA

Binney & Smith, Inc., Easton, PA

Cascade School Supplies, North Adams, MA

Cheap Joe's Art Stuff, Boone, NC

Chroma, Inc., Lititz, PA

Colorations, Inc., Duluth, GA

Daniel Smith Artists' Materials, Seattle, WA

Dixon Ticonderoga Co., Maitland, FL

Golden Artist Colors, Inc., New Berlin, NY

Graphic Chemical & Ink Co., Chicago, IL

HK Holbein, Williston, VT

Loew-Cornell, Inc., Teaneck, NJ

Lou Davis Wholesale, Lake Geneva, WI

M & M Distributors, Tennent, NJ

Martin/F. Weber Co., Philadelphia, PA

MAS International, Inc., West Palm Beach, FK

Sakura of America, Hayward, CA

Sax Arts and Crafts, New Berlin, WI

School Specialty, Appleton, WI

Speedball Art Products Co., Statesville, NC

TSI, Inc., Seattle, WA

The Testor Corp., Rockford, IL

Palettes

Cascade School Supplies, North Adams, MA

Cheap Joe's Art Stuff, Boone, NC

Lou Davis Wholesale, Lake Geneva, WI

Sakura of America, Hayward, CA

Sax Arts and Crafts, New Berlin, WI

Speedball Art Products Co., Statesville, NC

Paper
Watercolor, Construction, Tissue, Tracing, Transfer, etc.

Art Supplies Wholesale, Beverly, MA

B&J Supply, Appleton, WI

Cascade School Supplies, North Adams, MA

Cheap Joe's Art Stuff, Boone, NC

Daniel Smith Artists' Materials, Seattle, WA

HK Holbein, Williston, VT

Hunt Manufacturing, Philadelphia, PA

Saral Paper Co., New York, NY

Sax Arts and Crafts, New Berlin, WI

Technical Papers Corp., Dedham, MA

Papermaking & Marbling Supplies

DEKA®/Decart, Inc., Morrisville, VT

Fascinating Folds, Glendale, AZ

Gold's Artworks, Lumberton, NC

Hunt Manufactuing Co., Philadelphia, PA

PRO Chemical & Dye, Inc., Somerset, MA

Sax Arts and Crafts, New Berlin, WI

Photographic Supplies

Blueprints-Printables, Burlingame, CA

D'Ing Products, Lyndhurst, OH

Sax Arts and Crafts, New Berlin, WI

School Specialty, Appleton, WI

Printmaking
Blockprinting, Presses, Tools, Supplies

Art Supplies Wholesale, Beverly, MA

Daniel Smith Artists' Supplies, Seattle, WA

Graphic Chemical & Ink Co., Chicago, IL

Rock Paint, Milton, WI

Scratch-Art Co., Inc., Avon, MA

Speedball Art Products Co., Statesville, NC

Etching, Presses, Tools, Supplies

American Art Clay Co., Inc., Indianapolis, IN

Conrad Machine Co., Whitehall, MI

Daniel Smith Artists' Supplies, Seattle, WA

Sax Arts and Crafts, New Berlin, WI

School Specialty, Appleton, WI

Sculpture Supplies

A.R.T. Studio Clay Co., Sturtevant, WI

American Art Clay Co., Inc., Indianapolis, IN

Bailey Ceramic Supply, Kingston, NY

Binney & Smith, Inc., Easton, PA

Continental Clay Co., Minneapolis, MN

Creative Paperclay" Co., Inc., Camarillo, CA

MAS International, Inc., West Palm Beach, FL

Mile Hi Ceramics, Denver, CO

Sierra Hills Stone, Angles Camp, CA

TSI, Inc., Seattle, WA

Texas Pottery Supply, Fort Worth, TX

Yarns, Fibers, Plastic Lace, Weaving Supplies

Cascade School Supplies, North Adams, MA

Harrisville Designs, Harrisville, NH

Sax Arts and Crafts, New Berlin, WI

School Specialty, Appleton, WI

abstracción Obra de arte abstracto que se basa generalmente en un tema identificable, en la cual el artista omite detalles, simplifica o reorganiza los elementos visuales. Las obras de arte abstracto que no tienen un tema identificable se llaman arte no objetivo. *(abstraction)*

abstracto Ver abstracción. *(abstract)*

acuñar Homogeneizar una bola de arcilla cortándola repetidamente con un alambre y aplastándola hasta que está totalmente mezclada. Este proceso elimina las burbujas que en el horno podrían causar la fractura de una pieza de cerámica. *(wedge)*

análogos Colores que están estrechamente relacionados porque tienen un color en común. Por ejemplo, el azul, el azul violeta y el violeta contienen todos el color azul. Los colores análogos aparecen yuxtapuestos en la escala cromática. *(analogous)*

armonía cromática Combinaciones de color—como colores complementarios o análogos—que pueden definirse por sus posiciones en la escala cromática. Pueden utilizarse determinadas armonías cromáticas para lograr efectos específicos. *(color harmony)*

arte no representativo Arte que no tiene ningún tema reconocible, que no plasma cosas reales o naturales de ninguna manera. También se denomina arte no objetivo. *(nonrepresentational art)*

asimétrico Una clase de equilibrio visual en el que los dos lados de la composición son diferentes y aún así están en equilibrio; iguales visualmente sin ser idénticos. Se le llama también equilibrio informal. *(asymmetrical)*

barbotina Arcilla que se ha hecho menos espesa con agua o vinagre, para formar un líquido espeso. La barbotina se usa en las muescas para unir pedazos de arcilla. *(slip)*

base Plataforma o soporte de un objeto. El resto del objeto se construye sobre la base. En una cesta de cuerda o hilo, o en una vasija de arcilla con volutas, la base se forma haciendo una espiral con la cuerda o la arcilla hasta que forma una superficie plana. *(base)*

caligrafía Líneas que fluyen, hechas con pinceladas similares a la escritura oriental. El arte de escribir letras y palabras en un estilo hermoso y ornamentado usando plumas o pinceles. *(calligraphy)*

caricatura Un dibujo en el que los rasgos distintivos de una persona o animal, tales como la nariz, las orejas, o la boca, se distorsionan o exageran con propósito cómico o crítico. Las caricaturas se usan a menudo en los editoriales. *(caricature)*

cerámica a torno Objetos de cerámica hechos a base de formar arcilla en el disco giratorio de un torno de alfarero, lo cual produce una forma redonda simétrica. *(thrown pottery)*

cocer Poner al horno un objeto de cerámica. Cocer objetos de cerámica a altas temperaturas los endurece permanentemente. *(fire)*

color complementario dividido Una combinación de color que se basa en un matiz, y en los matices que están a cada lado de sus complementarios en la escala cromática. El naranja, el azul-violeta y el azul-verde son colores complementarios divididos. *(split complement)*

color intermedio Un color creado al mezclar un color secundario con un color primario. El azul verde, el amarillo verde, el amarillo naranja, el rojo naranja, el rojo violeta y el azul violeta son colores intermedios. *(intermediate color)*

color neutro Un color que no se asocia con un matiz, tal como el negro, el blanco o el gris. Los arquitectos y los diseñadores consideran como neutras las ligeras variaciones del negro, blanco, marrón y gris porque muchos otros colores se pueden mezclar con ellos en combinaciones de colores agradables. *(neutral color)*

color primario Uno de los tres colores básicos (rojo, amarillo y azul) que no pueden ser creados mezclando colores y que sirven como base para mezclar otros colores. Con referencia a la luz, los colores primarios son el rojo, el verde y el azul. *(primary color)*

color secundario Un color que se logra mezclando partes iguales de dos colores primarios. Verde, naranja y violeta son los colores secundarios. El verde se hace mezclando azul y amarillo. El naranja se hace mezclando rojo y amarillo. El violeta se hace mezclando rojo y azul. *(secondary color)*

colores cálidos A los colores cálidos se les da este nombre porque a menudo se les asocia con el fuego y el sol, y le recuerdan a la gente lugares, cosas y sentimientos cálidos. Los colores cálidos están relacionados y van desde el rojo hasta los naranjas y los amarillos. *(warm colors)*

colores fríos Colores que a menudo se asocian con lugares, cosas o sentimientos fríos. Es aquella familia de colores que comprende desde el verde hasta los azules y violetas. *(cool colors)*

complementarios Colores que están directamente opuestos en la escala cromática, tales como el rojo y el verde, el azul y el naranja, el violeta y el amarillo. Cuando los colores complementarios se mezclan forman un marrón neutro o gris. Cuando se yuxtaponen en una obra de arte, crean contrastes fuertes. *(complementary)*

composición La creación, formación o diseño de algo por medio del arreglo de distintas partes para crear un todo unificado. *(composition)*

contorno Una línea que define el borde de una silueta o la línea creada por los bordes de un objeto. *(outline)*

contraste Una diferencia apreciable entre dos cosas: por ejemplo, áspero y suave, amarillo y morado, luz y sombra. Los contrastes generalmente le añaden entusiasmo, dramatismo e interés a las obras de arte. *(contrast)*

contraste de valor Valores oscuros y claros colocados muy cerca. El negro contra el blanco crea el mayor contraste de valor. *(value contrast)*

Cubismo Movimiento de principios del siglo XX encabezado por Pablo Picasso y Georges Braque. Los artistas usaban pequeños cuadrados o cubos para representar sus temas. A menudo se muestran los objetos desde diferentes puntos de vista a la vez, lo cual aplana el espacio tridimensional. Las pinturas cubistas son con frecuencia monocromáticas y en ocasiones contienen elementos de collage. *(Cubism)*

difumino Rollito de papel muy apretado y terminado en punta que sirve para suavizar el lápiz, el carboncillo y el pastel. *(tortillon)*

dinámico Se refiere a fuerzas de movimiento reales o implícitas. *(dynamic)*

diseño de semidescenso Un tipo específico de patrón de filas con la orientación vertical de cada fila dispuesta justo a la mitad de la altura de la fila anterior y con una posición horizontal desplazada. *(half-drop design)*

dominio El concepto de que un elemento primario atrae más atención que ninguna otra cosa en una composición. El elemento dominante suele ser un punto focal de la composición. *(dominance)*

eber Una espada similar a un abanico en la cultura Benín. *(eber)*

envoltura Material que se utiliza para revestir otro material. En una cesta de cuerda e hilo, el hilo que se enrolla alrededor de la cuerda es la envoltura. *(wrap)*

equilibrio radial Una composición que se basa en un círculo de cuyo centro irradia el diseño. *(radial balance)*

equilibrio simétrico La organización de las partes de una composición tal que cada lado de un eje vertical refleja el otro. *(symmetrical balance)*

escala La proporción entre dos conjuntos de dimensiones. Por ejemplo, si una imagen es dibujada a escala, todas sus partes son igualmente más pequeñas o más grandes que las partes del original. *(scale)*

escultura cinética Una escultura que se mueve o que tiene elementos que se mueven. El movimiento puede ser producido por la fuerza del aire, la gravedad, la electricidad, etc. *(kinetic sculpture)*

escultura ensamblada Cualquier escultura cuyas partes han sido unidas para completar la obra. *(constructed sculpture)*

espacio/forma negativa El espacio que circunda figuras o formas sólidas en una obra de arte. *(negative shape/space)*

espacio/forma positivo Las figuras o espacios principales en una obra de arte, no el fondo ni el espacio circundante. *(positive space/shape)*

espectro cromático Una banda de colores que se produce cuando la luz blanca pasa a través de un prisma y se divide en difer- entes longitudes de onda. Los colores visibles aparecen siempre en el mismo orden, de acuerdo con la longitud de onda, desde la más larga hasta la más corta, así: rojo, naranja, amarillo, verde, azul y violeta. Una escala cromática muestra aproximadamente el espectro visible dispuesto en un círculo. *(color spectrum)*

estático(a) En apariencia inactivo o sin movimiento. *(static)*

estilo El carácter distintivo contenido en las obras de arte de un individuo, de un grupo de artistas, de una época, de toda una sociedad o de una zona geográfica. *(style)*

figura Forma plana que se crea cuando se juntan líneas implícitas o reales que cierran un espacio. Un cambio de color o una sombra pueden definir una figura. Las figuras se pueden dividir en varios tipos: geométricas (cuadrado, triángulo, círculo) y orgánicas (contornos irregulares). *(shape)*

figura geométrica Una figura—como un triángulo o un rectángulo—que puede definirse con precisión por medio de coordenadas y mediciones. *(geometric shape)*

figura orgánica Una figura que tiene forma libre o bien es irregular; lo opuesto de una figura geométrica. *(organic shape)*

foco de atención Aquella parte de una obra de arte hacia la que el ojo del observador es atraída en forma inmediata o consistente. Generalmente es la parte más importante de la obra de arte. *(center of interest)*

forma Cualquier objeto tridimensional. Una forma puede ser medida de arriba abajo (altura), de lado a lado (anchura) y de adelante hacia atrás (profundidad). Es además un término que se refiere a la estructura o diseño de una obra. *(form)*

fresco Una técnica de pintura en la que los pigmentos se aplican a una capa delgada de yeso húmedo para que se absorban, volviéndose la pintura parte de la pared. *(fresco)*

intensidad La brillantez u opacidad de un color. Un color puro se considera un color de alta intensidad. Un color apagado (un color mezclado con su complementario) se le considera un color de baja intensidad. *(intensity)*

iwan Una abertura abovedada con un portal en forma de arco. *(iwan)*

línea de bosquejo Una línea rápida que capta el aspecto de un objeto o la impresión de un lugar. *(sketch line)*

línea de la vista Un tipo de línea implícita que va desde los ojos de una figura hasta un objeto que se divisa, dirigiendo la atención del observador de un diseño desde una de sus partes a otra. *(line of sight)*

línea gestual Un tipo de línea enérgica que capta los movimientos y gestos de una figura activa. *(gesture line)*

línea implícita Una línea que se adivina—que en realidad no se trazó—en un diseño. *(implied line)*

líneas de perfil Líneas que describen la forma de una figura o de un objeto, y también incluyen detalles del interior. El grosor de estas líneas es variable. *(contour lines)*

líneas estructurales Líneas que dan unidad a un diseño. *(structural lines)*

marca Cuando se hace presión con un instrumento puntiagudo en un papel o cartulina sin atravesarlo, creando una línea por donde se dobla fácilmente. Cuando se trabaja con arcilla, los artistas marcan muescas o rayan la superficie de la arcilla por donde ésta se va a juntar. *(score)*

material básico El material que se utiliza para formar la forma básica de un objeto. En una cesta de cuerda trenzada y de hilo, el material básico es la cuerda. *(core)*

matiz/tono/color El nombre común de un color en o relacionado al espectro, tal como amarillo, amarillo anaranjado, azul violeta, verde. *(hue)*

moldeado al vacío Método para dar forma al plástico que se coloca sobre un relieve sólido. Se calienta el plástico hasta que se hace maleable y cuando se crea un vacío por debajo del molde, el plástico es succionado hacia el relieve como si fuera una piel. *(vacuum forming)*

monocromático(a) Consistente en un solo color o matiz, lo cual incluye sus matices y sombras. *(monochromatic)*

montage Una clase especial de collage, hecho con pedazos de fotografías u otras imágenes. *(photomontage)*

motivo La unidad tri o bidimensional que se repite para formar un patrón. *(motif)*

movimiento composicional Una senda por la cual la vista del observador es

dirigida a seguir debido a la disposición de los elementos en una obra de arte. *(compositional movement)*

oba Dios divino de la cultura Benín. *(oba)*

papiers collés Término francés que significa "papeles pegados". Los cubistas usaban esta técnica, el principio del collage, cuando añadían objetos como recortes de periódico a sus pinturas. *(papiers collés)*

papier découpés Collage abstracto. Término francés que significa "papeles recortados." *(papier découpés)*

patrón Las líneas, colores o figuras que se han escogido y que se repiten una y otra vez de acuerdo con un plan. Puede ser también un modelo o guía para hacer algo. *(pattern)*

patrón aleatorio La repetición de un elemento o elementos de una forma inconsistente o no planeada. *(random pattern)*

patrón planeado La repetición ordenada y consistente de motivos, bien sea los que se encuentran en la naturaleza o los creados por un artista. Los patrones planeados incluyen la fila, la cuadrícula, el semidescenso, el radial, el alternado y el extremo. *(planned pattern)*

personalidad de la línea Las características generales de una línea, como su dirección, movimiento, calidad o peso. *(line personality)*

perspectiva Una técnica para crear la ilusión de profundidad en una superficie bidimensional. *(perspective)*

perspectiva de dos puntos Una forma de mostrar objetos tridimensionales sobre una superficie bidimensional usando dos puntos de fuga dispuestos bien lejos el uno del otro y dos conjuntos de líneas convergentes para representar formas. Estas formas son vistas desde un ángulo y tienen dos lados alejados. *(two-point perspective)*

perspectiva de un punto Perspectiva lineal que se usa en combinación con un único punto de fuga. Se utiliza para mostrar objetos tridimensionales sobre una superficie bidimensional. *(one-point perspective)*

perspectiva lineal Un sistema de dibujo o pintura que se usa para crear la ilusión de profundidad en una superficie plana. Las líneas de los edificios u otros objetos están inclinadas hacia adentro, haciéndolas aparecer como si se extendieran hacia atrás en el espacio. Si las líneas se alargan se encuentran en un punto colocado sobre una línea horizontal imaginaria que representa el nivel de los ojos. Al punto en el cual se encuentran las líneas se le llama el "punto de fuga." *(linear perspective)*

pigmento Cualquier material colorante, generalmente un polvo fino que se mezcla con un líquido o un aglutinante para hacer pintura, tinta o crayón. *(pigment)*

punto de fuga En un dibujo en perspectiva, uno o más puntos en el horizonte donde las líneas paralelas que se pierden en la distancia parecen encontrarse. *(vanishing point)*

ritmo progresivo Un patrón o ritmo que se desarrolla paso a paso desde lo más grande hasta lo más pequeño o desde lo más brillante hasta lo más apagado. *(progressive rhythm)*

ritmo visual El resultado de un patrón combinado con un movimiento implícito. Elementos o motivos se combinan para crear una serie de pausas regulares (paradas y comienzos) para los ojos del observador, similar a la forma en que el sonido de un tambor crea una serie de pausas para los oídos del oyente. *(visual rhythm)*

simétrico(a) Una clase de equilibrio en el cual el contenido a ambos lados de una línea central es exactamente o casi el mismo, como una imagen reflejada en un espejo en la que las cosas a ambos lados de una línea central son idénticas. Por ejemplo, las alas de una mariposa son simétricas. Se le conoce también como "equilibrio formal." *(symmetrical)*

sombra Cualquier valor oscuro de un color que se logra generalmente añadiendo negro. *(shade)*

sombreado de líneas entrecruzadas La técnica que consiste en dibujar líneas muy juntas en direcciones opuestas para crear áreas oscuras en un dibujo o grabado. *(cross-hatch)*

subordinado Cualquier elemento de una obra de arte que es menos importante que el principal. *(subordinate)*

superficie Un plano que puede describirse con dos dimensiones: altura y ancho. Una superficie no tiene profundidad. (surface)

superficie pictórica La superficie de una obra de arte bidimensional. *(picture plane)*

textura La textura se percibe por medio del tacto y la vista. La textura se refiere a la manera como una superficie se experimenta al tacto (textura real) o a la vista (textura simulada). Las texturas se describen con palabras como burda, sedosa, de guijarro. *(texture)*

textura implícita La calidad de la superficie que se percibe de una obra de arte. *(implied texture)*

textura real La calidad de la superficie real de una obra de arte. *(real texture)*

tono La modificación del color (matiz) mediante la adición de gris. *(tone)*

tono/matiz Un valor suave o una variación de un color puro que usualmente se logra agregando blanco. Por ejemplo, rosado es un tono del rojo. *(tint)*

tono alto Describe colores o valores que son matices claros, creados por el uso del blanco, como en los colores pastel. *(high-keyed)*

tono bajo Describe colores o valores que son matices oscuros, por lo general creados por el uso del negro o el gris. *(low-keyed)*

tríada cromática Una combinación de colores basada en tres colores cualesquiera, que están espaciados equidistantemente en la escala cromática. *(color triad)*

unidad Sensación de que todas las partes de un diseño funcionan como un conjunto. *(unity)*

valor Elemento de arte que se refiere a la oscuridad o luminosidad de una superficie. El valor depende de la cantidad de luz que refleja una superficie. Los tintes son los valores luminosos de un color puro. Las sombras son los valores oscuros de un color puro. El valor puede ser también un elemento importante en las obras de arte en las que el color está ausente o es muy sutil, tales como en dibujos, grabados y fotografías. *(value)*

Grades 9–12

Visual Arts

In grades 9–12, students extend their study of the visual arts. They continue to use a wide range of subject matter, symbols, meaningful images, and visual expressions. They grow more sophisticated in their employment of the visual arts to reflect their feelings and emotions and continue to expand their abilities to evaluate the merits of their efforts. These standards provide a framework for that study in a way that promotes the maturing students' thinking, working, communicating, reasoning, and investigating skills. The standards also provide for their growing familiarity with the ideas, concepts, issues, dilemmas, and knowledge important in the visual arts. As students gain this knowledge and these skills, they gain in the ability to apply knowledge and skills in the visual arts to their widening personal worlds.

The visual arts range from the folk arts, drawing, and painting, to sculpture and design, from architecture to film and video—and any of these can be used to help students meet the educational goals embodied in these standards. For example, graphic design (or any other field within the visual arts) can be used as the basis for creative activity, historical and cultural investigations, or analysis throughout the standards. The visual arts involve varied tools, techniques, and processes—all of which also provide opportunities for working toward the standards. It is the responsibility of practitioners to choose from among the array of possibilities offered by the visual arts to accomplish specific educational objectives in specific circumstances.

To meet the standards, students must learn vocabularies and concepts associated with various types of work in the visual arts. As they develop greater fluency in communication in visual, oral, and written form, they must exhibit greater artistic competence through all of these avenues.

In grades 9–12, students develop deeper and more profound works of visual art that reflect the maturation of their creative and problem-solving skills. Students understand the multifaceted interplay of different media, styles, forms, techniques, and processes in the creation of their work.

Students develop increasing abilities to pose insightful questions about contexts, processes, and criteria for evaluation. They use these questions to examine works in light of various analytical methods and to express sophisticated ideas about visual relationships using precise terminology. They can evaluate artistic character and aesthetic qualities in works of art, nature, and human-made environments. They can reflect on the nature of human involvement in art as a viewer, creator, and participant.

Students understand the relationships among art forms and between their own work and that of others. They are able to relate understandings about the historical and cultural contexts of art to situations in contemporary life. They have a broad and in-depth understanding of the meaning and import of the visual world in which they live.

Grades 9–12 Standards

1. Content Standard: Understanding and applying media, techniques and processes

Achievement Standard, Proficient:
a. Students apply media, techniques, and processes with sufficient skill, confidence, and sensitivity that their intentions are carried out in their artworks

b. Students conceive and create works of visual art that demonstrate an understanding of how the communication of their ideas relates to the media, techniques, and processes they use

Achievement Standard, Advanced:
c. Students communicate ideas regularly at a high level of effectiveness in at least one visual arts medium

d. Students initiate, define, and solve challenging visual arts problems independently using intellectual skills such as analysis, synthesis, and evaluation

2. Content Standard: Using knowledge of structures and functions

Achievement Standard, Proficient:
a. Students demonstrate the ability to form and defend judgments about the characteristics and structures to accomplish commercial, personal, communal, or other purposes of art

b. Students evaluate the effectiveness of artworks in terms of organizational structures and functions

c. Students create artworks that use organizational principles and functions to solve specific visual arts problems

Achievement Standard, Advanced:

d. Students demonstrate the ability to compare two or more perspectives about the use of organizational principles and functions in artwork and to defend personal evaluations of these perspectives

e. Students create multiple solutions to specific visual arts problems that demonstrate competence in producing effective relationships between structural choices and artistic functions

3. Content Standard: Choosing and evaluating a range of subject matter, symbols, and ideas

Achievement Standard, Proficient:

a. Students reflect on how artworks differ visually, spatially, temporally, and functionally, and describe how these are related to history and culture

b. Students apply subjects, symbols, and ideas in their artworks and use the skills gained to solve problems in daily life

Achievement Standard, Advanced:

c. Students describe the origins of specific images and ideas and explain why they are of value in their artwork and in the work of others

d. Students evaluate and defend the validity of sources for content and the manner in which subject matter, symbols, and images are used in the student's works and in significant works by others

4. Content Standard: Understanding the visual arts in relation to history and cultures

Achievement Standard, Proficient:

a. Students differentiate among a variety of historical and cultural contexts in terms of characteristics and purposes of works of art

b. Students describe the function and explore the meaning of specific art objects within varied cultures, times and places

c. Students analyze relationships of works of art to one another in terms of history, aesthetics, and culture, justifying conclusions made in the analysis and using such conclusions to inform their own art making

Achievement Standard, Advanced:

d. Students analyze and interpret artworks for relationships among form, context, purposes, and critical models, showing understanding of the work of critics, historians, aestheticians, and artists

e. Students analyze common characteristics of visual arts evident across time and among cultural/ethnic groups to formulate analyses, evaluations, and interpretations of meaning

5. Content Standard: Reflecting upon and assessing the characteristics and merits of their work and the work of others

Achievement Standard, Proficient:

a. Students identify intentions of those creating artworks, explore the implications of various purposes, and justify their analyses of purposes in particular works

b. Students describe meanings of artworks by analyzing how specific works are created and how they relate to historical and cultural contexts

c. Students reflect analytically on various interpretations as a means for understanding and evaluating works of visual art

Achievement Standard, Advanced:

d. Students correlate responses to works of visual art with various techniques for communicating meanings, ideas, attitudes, views, and intentions

6. Content Standard: Making connections between visual arts and other disciplines

Achievement Standard, Proficient:

a. Students compare the materials, technologies, media, and processes of the visual arts with those of other arts disciplines as they are used in creation and types of analysis

b. Students compare characteristics of visual arts within a particular historical period or style with ideas, or themes in the humanities or sciences

Achievement Standard, Advanced:

c. Students synthesize the creative and analytical principles and techniques of the visual arts and selected other arts disciplines, the humanities, or the sciences

Excerpted with permission from *The National Visual Arts Standards* published by the National Art Education Association, 1994.